MAKING IT MODERN

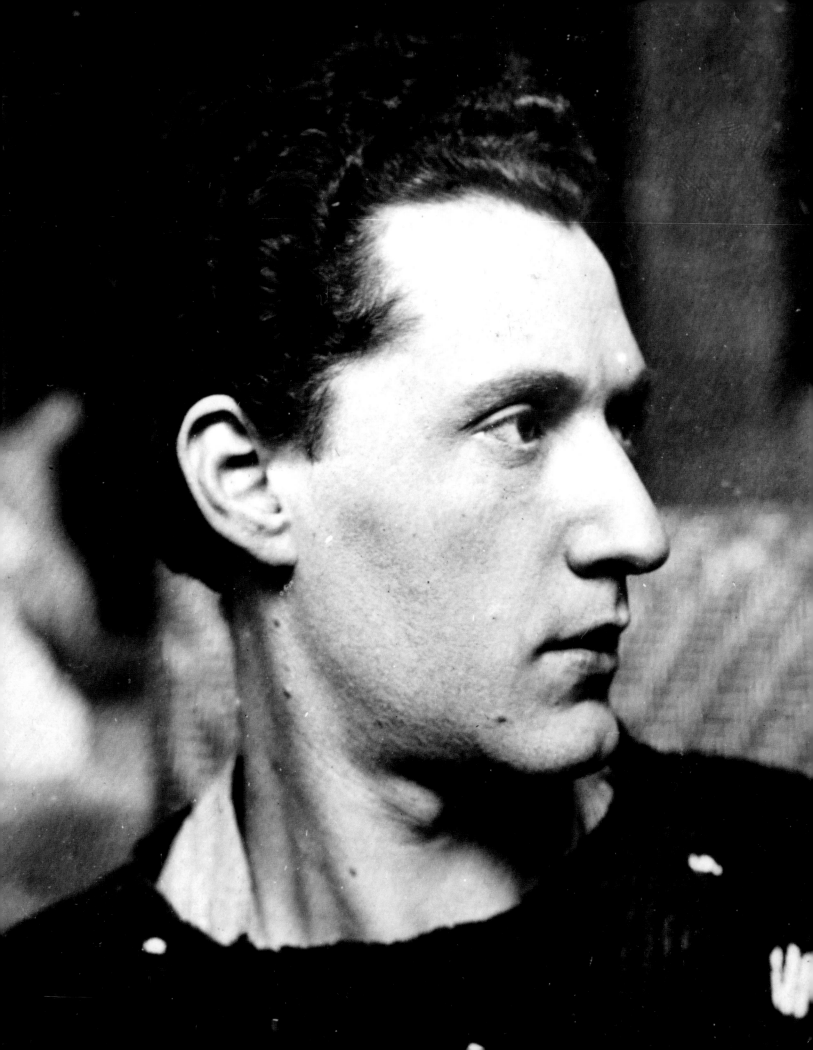

MAKING IT MODERN

The Folk Art Collection of Elie and Viola Nadelman

Margaret K. Hofer and Roberta J.M. Olson

Contributions by
Kenneth L. Ames, Barbara Haskell, Cynthia Nadelman, and Elizabeth Stillinger

NEW-YORK
HISTORICAL
SOCIETY
MUSEUM & LIBRARY

New-York Historical Society
In association with D Giles Limited, London

Published by the New-York Historical Society in association with D Giles Limited, London, on the occasion of the exhibition *Making It Modern: The Folk Art Collection of Elie and Viola Nadelman*, held at the Albuquerque Museum of Art and History, Albuquerque, NM (September 6–November 29, 2015); the New-York Historical Society (May 20–August 21, 2016); and the Addison Gallery of American Art, Andover, MA (September 17–December 31, 2016).

The New-York Historical Society recognizes the Henry Luce Foundation for its exceptional commitment to *Making It Modern: The Folk Art Collection of Elie and Viola Nadelman*. Generous support has also been provided by the National Endowment for the Arts. Additional support has been provided by the Greater Hudson Heritage Network and the American Folk Art Society. The exhibition publication is made possible, in part, by Furthermore: a program of the J.M. Kaplan Fund.

First published in 2015 by GILES
An imprint of D Giles Limited
4 Crescent Stables
139 Upper Richmond Road
London, SW15 2TN, UK
www.gilesltd.com

ISBN: 978-1-907804-29-8

For the New-York Historical Society:
Editor: Anne H. Hoy
Photography of all objects in the N-YHS collections by Glenn Castellano

For D Giles Limited:
Copyedited and proofread by David Rose
Designed by Hoop Design

Produced by GILES, an imprint of D Giles Limited, London
Printed and bound in Hong Kong

Front cover: Unidentified French makers, Milliner's heads, 1820–70 (cat. 9)
Back cover: Unidentified maker, probably English, Jumping jack, 1830–70 (cat. 81)
Frontispiece: Elie Nadelman, ca. 1915. Nadelman Papers
End piece: Sculptures by Elie Nadelman in the parlor of the deceased artist's home (Alderbrook, Riverdale, NY), 1947

CONTENTS

6 Foreword
 Louise Mirrer

7 Preface
 Roberta J.M. Olson and Margaret K. Hofer

8 Acknowledgments
 Margaret K. Hofer and Roberta J.M. Olson

9 Notes to the Reader

11 The History of the Nadelman Folk Art Collection
 Roberta J.M. Olson and Margaret K. Hofer

41 The Nadelmans in Context: Early Collectors of Folk Art in America
 Elizabeth Stillinger

57 Manhattan to Munich: The Nadelmans' Sources for Folk Art
 Margaret K. Hofer

73 The Term "Folk Art" Once Again
 Kenneth L. Ames

83 Classical Echoes in the Nadelmans' Folk Art Collection
 Roberta J.M. Olson

95 Viola Nadelman as a Collector
 Cynthia Nadelman

105 Nadelman and Folk Art: The Question of Influence
 Barbara Haskell

115 **CATALOGUE** The Nadelman Folk Art Collection

329 **CATALOGUE** Selected Sculptures by Elie Nadelman

356 Appendix I: Checklist of Dealers and Auction Houses Patronized by the Nadelmans, 1923–36

361 Appendix II: Museum of Folk Arts Guide, 1935

367 Frequently Cited Sources

369 Photography Credits

370 Index

FOREWORD

The acquisition of the Nadelman folk art collection in 1937 radically transformed the tenor of the New-York Historical Society (N-YHS), an institution by then already 133 years old. With the purchase, the Historical Society was able to capitalize on the contemporary surge of interest in the art of the "common man" and to enliven its formal art galleries—where traditional fine art previously held command— with engaging displays of vernacular objects marked by exuberant color, flat pattern, and simplicity of form. Despite the magnitude of the diverse collection and its former distinction in the Nadelmans' pioneering Museum of Folk and Peasant Arts (MFPA), the N-YHS has not undertaken a scholarly study of it until now. With this landmark volume, which investigates its genesis, history, and impact, we have revitalized Elie and Viola Nadelman's visionary enterprise and given it the long-overdue examination that it deserves.

Many individuals played important roles in bringing this project to fruition. I would like to single out the curatorial team of Margaret K. Hofer, Curator of Decorative Arts, and Roberta J.M. Olson, Curator of Drawings, for originating the concept of the exhibition and leading it through its successful realization with impeccable scholarship and unfailing dedication. Museum Director Emerita Linda S. Ferber championed the project from its inception, and her successor, Brian T. Allen, also supported the exhibition. N-YHS is deeply grateful to the ten institutions and two individuals whose loans allowed us to broaden the scope of the project to consider Elie Nadelman's later sculptures as they relate to his folk art collecting. A particular debt is owed to Cynthia Nadelman for providing access to the Nadelman Papers (NP) and sharing a wealth of knowledge about her grandparents' pioneering museum.

This ambitious undertaking would not have been possible without the support of several key sponsors. The Henry Luce Foundation provided generous leadership funding for the exhibition and publication, for which we are extremely grateful. Additional support for the catalogue was provided by the National Endowment for the Arts, the American Folk Art Society, and Furthermore: a program of the J.M. Kaplan Fund. The Greater Hudson Heritage Network assisted by underwriting conservation of the commanding ship figurehead "Rosa Isabella." We also thank Sotheby's for their support of the traveling exhibition. As always, New-York Historical's Board of Trustees—led by Chair Pam Schafler, Executive Committee Chairman Roger Hertog, and Vice Chair Rick Reiss—has been instrumental to this undertaking.

Louise Mirrer
President and CEO
New-York Historical Society

PREFACE

The unique character of the Nadelman folk art trove resulted from the vision and dedication of the sculptor Elie Nadelman and his wife, Viola Spiess Flannery. As the first comprehensive consideration of their holdings, the exhibition and its accompanying catalogue, *Making It Modern: The Folk Art Collection of Elie and Viola Nadelman,* tells the dramatic story of the couple's adventures as innovative collectors and founders of the groundbreaking Museum of Folk and Peasant Arts (MFPA) in Riverdale, New York.

The exhibition will tour as part of the Historical Society's "Sharing a National Treasure" Traveling Exhibitions Program, our ongoing campaign to bring our collections to the attention of national audiences by partnering with other museums. We are delighted that *Making It Modern* will be shown at the Albuquerque Museum of Art and History in Albuquerque, New Mexico; and the Addison Gallery of American Art in Andover, Massachusetts.

In this volume, the curators, together with a quartet of scholars, examine different facets of the Nadelmans' folk art collection in six provocative essays. Our joint essay, "The History of the Nadelman Folk Art Collection," outlines the Nadelmans' activities—from their earliest joint acquisitions in 1920 through their tragic deaccessioning during the Depression to the arrival of their collection at the N-YHS. Independent scholar Elizabeth Stillinger considers the couple's collecting in a broader spectrum ("The Nadelmans in Context: Early Collectors of Folk Art in America"). Margaret Hofer in "Manhattan to Munich: The Nadelmans' Sources for Folk Art" charts the chronology of their purchases, identifies their favorite dealers, and redresses misconceptions about the couple's collecting patterns. Kenneth L. Ames, Professor at the Bard Graduate Center, New York City, addresses an ever-controversial topic: the definition of folk art ("The Term 'Folk Art' Once Again"). In "Classical Echoes in the Nadelmans' Folk Art Collection," Roberta Olson considers the innate classicism of Elie Nadelman's art and his patriotism for his adopted country, together with classical elements in selected folk art objects the Nadelmans acquired. In "Viola Nadelman as a Collector," independent scholar and writer Cynthia Nadelman offers a charming, intimate account of her grandmother's taste and her role in gathering the collection. Finally, Barbara Haskell, Curator at the Whitney Museum of American Art, grapples with the influences informing Elie Nadelman's sculpture ("Nadelman and Folk Art: The Question of Influence").

To suggest the range of the couple's sprawling holdings, we explore some 216 highlights in eighty-seven catalogue entries. Our research resulted in exciting discoveries, including identifying the sitter in the portrait by Joseph Whiting Stock (cat. 19), tracing the provenances and prices of a large number of objects, and uncovering Nadelman's active role in restoring some of his folk art objects. Nine catalogue entries consider the relationship of a selection of Nadelman's sculptures to his folk art collection.

Making It Modern breaks new ground not only in studies of the Nadelmans and folk art, but also in the history of American art and taste during the fast-paced cultural revolutions of the early twentieth century.

Roberta J.M. Olson
Curator of Drawings

Margaret K. Hofer
Curator of Decorative Arts
The New-York Historical Society

ACKNOWLEDGMENTS

This project, in its sheer scale and five-year gestation, required the assistance of many colleagues. We are delighted to have this opportunity to voice our hearty appreciation to all of them. First and foremost, we owe deep gratitude to Cynthia Nadelman for embracing the project from its infancy, sharing the astonishing trove of documentation in the Nadelman Papers, and freely offering her own research and personal insights into her grandparents' lives and collecting endeavor. She has been an enthusiastic collaborator throughout the process and her knowledge and perceptive observations have deeply enriched this volume.

Making It Modern: The Folk Art Collection of Elie and Viola Nadelman could not have been realized without the leadership of N-YHS President Louise Mirrer. We are also grateful to Linda S. Ferber, Museum Director Emerita, for her encouragement from the project's inception, as well as to Brian T. Allen, former Museum Director, and Jennifer Schantz, General Counsel and Chief Administrative Officer. Alexandra Mazzitelli deserves special thanks for providing crucial support through all stages of the undertaking, particularly image management. We are also indebted to Maeve M. Hogan, Sophie Lynford, and Rebecca Klassen for providing welcome research assistance and organizational skills. N-YHS research staff and interns contributed invaluable new findings on Nadelman objects and analysis of the MFPA records, including Margot Danielle Bernstein, Caroline Gillaspie, Timothy O'Connor, Jeffrey Richmond-Moll, Susie Silbert, Sarah Snook, Laura Speers, and Mike Thornton. Volunteer Natalie Brody doggedly pursued data on the Nadelmans' dealers, and Marilyn Lutzker investigated archival holdings in various repositories. We also thank our N-YHS colleagues Miguel Colon, Joseph Ditta, Kira Hwang, Marybeth Kavanagh, Susan Kriete, Alexandra Krueger, Victoria Manning, Richard Miller, Cheryl Morgan, Edward O'Reilly, Daniel Santiago, Dottie Teraberry, Mariam Touba, Heidi Wirth, and Scott Wixon.

We are grateful to N-YHS conservators Stephen Kornhauser and Heidi Nakashima for their sensitive treatments of paintings and works on paper. We also appreciate the magical touch of conservators Linda Nieuwenhuizen, Kathy Francis, and Sarah Nunberg. A special word of thanks to Glenn Castellano for bringing the folk art to life with his beautiful photography, and to Eleanor Gillers for coordinating the images. We are also indebted to Anne Hoy's incisive editorial pen.

Many professional colleagues outside the N-YHS generously provided assistance. Among them we thank the following individuals and institutions: Sybe Wartena, Bayerisches Nationalmuseum, Munich; Diane Hassan, Danbury (CT) Museum & Historical Society; Barbara Luck, Colonial Williamsburg; Paul D'Ambrosio and Erin Richardson, Fenimore Art Museum; Leslie Herzberg, Hancock Shaker Village; Valerie Fletcher, Hirshhorn Museum and Sculpture Garden; Jeanne Willoz-Egnor, Mariners' Museum; Michael Carter, Cloisters Library, and Ken Soehner and the staff at the Thomas J. Watson Library, Metropolitan Museum of Art; Charles Ritchie and Melanie Lukas, National Gallery of Art; Rupert Gerrittsen, National Library of Australia, Canberra; Damon Campagna, New York City Fire Museum; Danielle Castronovo, Jerome Robbins Dance Division, New York Public Library for the Performing Arts; Jessica Pigza, Rare Book Division, New York Public Library; Tutti Jackson, Ohio Historical Society; Alison Isenberg, Princeton University; Frank Sypher, St. Nicholas Society; Jean Burks, Shelburne Museum; Anita Duquette and Sarah Humphreyville, Whitney Museum of American Art; and Linda Eaton, Leslie Grigsby, and Ann Wagner, Winterthur Museum. We are also grateful to independent scholars Avis Berman, Adrienne Meyer, Mary Cheek Mills, and Kimberly L. Sorensen and collectors Dr. J.E. Jelinek and Catherine Tinker.

Dealers at home and abroad graciously fielded our inquiries and offered their insights. We thank Patrick Bell of Olde Hope Antiques; Alice Duncan of Gerald Peters Gallery; Fred Giampetro of Giampetro Gallery; Allan Katz of Allan Katz Americana; Bruce Livie of Gallery Arnoldi-Livie; Ralph Sessions of DC Moore Gallery; Diana and Gary Stradling of The Stradlings; David & Constance Yates; and Robert Young of Robert Young Antiques. We are also grateful to Nancy Druckman and Erik Gronning of Sotheby's and Deirdre Pook Magarelli of Pook & Pook.

Last but not least, we extend our sincere gratitude to the museums and private collectors whose loans have greatly enhanced the exhibition: Addison Gallery of American Art, Andover, MA; Amon Carter Museum, Fort Worth, TX; Colby College Museum of Art, Waterville, ME; Fenimore Art Museum, Cooperstown, NY; Harvard Art Museums / Fogg Museum, Cambridge, MA; Hirshhorn Museum and Sculpture Garden, Smithsonian Institution, Washington, DC; The Jewish Museum, New York, NY; Museum of Fine Arts, Boston, MA; and Wadsworth Atheneum Museum of Art, Hartford, CT.

Margaret K. Hofer
Curator of Decorative Arts

Roberta J.M. Olson
Curator of Drawings

NOTES TO THE READER

Accession numbers of N-YHS objects

Unless otherwise noted, Nadelman collection objects at the N-YHS were purchased from Elie Nadelman in 1937. Nadelman also donated items in 1938 and 1939. Objects from the 1937 purchase that were not catalogued during Nadelman's brief stint as curator for the N-YHS were subsequently assigned numbers with INV. or Z. prefixes or given simple numerical designations.

An asterisk following the accession number indicates that the object's acquisition by the Nadelmans is documented in the MFPA cards.

Authors' initials following entries

MKH Margaret K. Hofer
RJMO Roberta J.M. Olson

Frequently cited sources

Sources used multiple times are abbreviated with the author's last name and publication date; full citations of those publications appear in Frequently Cited Sources.

Life dates

Life dates for individuals mentioned in the text are provided in the index.

Media and measurements

Media are listed in order of dominance. Dimensions are given as height, width, and depth (if applicable), unless otherwise specified.

Provenance

Provenance is based on information in the MFPA cards and correspondence found in the NP. The omission of provenance indicates it is unknown.

Abbreviations

AAA
Archive of American Art, Smithsonian Institution, Washington, DC

AARFAM
Abby Aldrich Rockefeller Folk Art Museum, Williamsburg, VA

AFAM
American Folk Art Museum, New York, NY

MFPA
Museum of Folk and Peasant Arts (also Museum of Folk Arts), Riverdale, NY

NP
Nadelman Papers, Private collection, New York, NY

N-YHS
New-York Historical Society, New York, NY

NYPL
New York Public Library, New York, NY

NYSHA
New York State Historical Association, Fenimore Art Museum, Cooperstown, NY

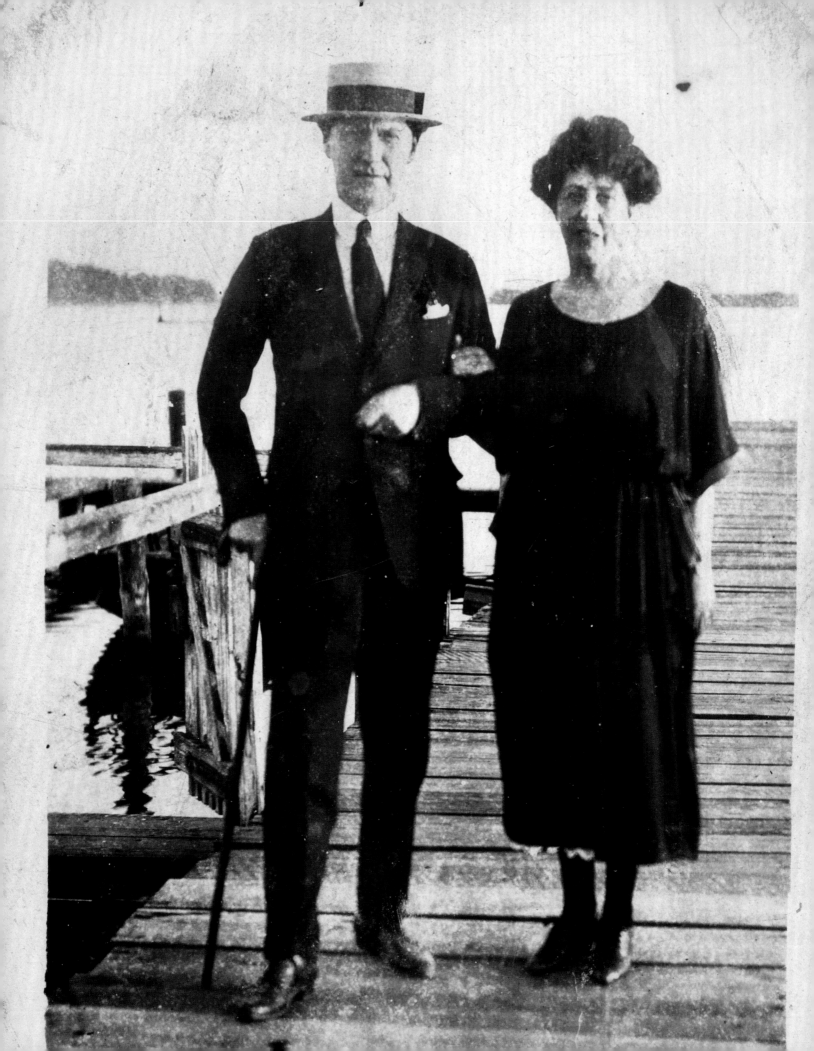

THE HISTORY OF THE NADELMAN FOLK ART COLLECTION

Roberta J.M. Olson and Margaret K. Hofer

In 1937 the New-York Historical Society (N-YHS) made the single largest acquisition in its two-hundred-year history: nearly fifteen thousand objects amassed by the pioneering folk art collectors Elie and Viola Nadelman (fig. 1). Exhibited by the couple from 1926 to 1937 in their Museum of Folk and Peasant Arts (MFPA) in Riverdale, New York, the works came from a collection spanning six centuries, thirteen countries of origin, and a wide range of media.[1] The sculptor and his wife assembled the extraordinary trove during the culturally nationalistic interwar period, when artists and critics sought to identify and champion native artistic traditions; nevertheless, they embraced an international scope and championed the notion that American folk art derived from European antecedents.

This volume examines the Nadelmans' collection through the nucleus purchased by the N-YHS, coupled with new archival evidence at the Historical Society and in the rich cache of the Nadelman Papers. It focuses on 216 folk art objects, considered in 87 entries, that seem most representative of the Nadelmans' collecting tastes and the far-sighted mission of the MFPA. In the catalogue, these folk art objects are followed by a sampling of Elie Nadelman's own sculpture to consider the possible interchanges between the sculptor's collecting and his avant-garde art.

Whereas scholars have devoted significant attention to the modernist sculpture of Elie Nadelman in recent years,[2] the couple's collecting enterprise has not received the in-depth analysis it deserves. Christine Oaklander and Elizabeth Stillinger published formative articles on it in the 1990s, and Stillinger recently expanded upon her earlier research, placing the Nadelmans in the context of other folk art collectors.[3] As the couple's biographical outlines have been traced by earlier historians, our overview starts with the inception of the Nadelmans' collecting venture following their engagement and marriage in late 1919.[4]

The Nadelmans Start Collecting: The Golden Age

These progressive collectors came from cosmopolitan but different backgrounds and shared a love of objects. Viola Spiess was born to New Yorkers of German Jewish descent and enjoyed a materially comfortable childhood that included trips to Europe and education in Germany and possibly Switzerland. In 1897, Viola married Joseph A. Flannery and subsequently had two daughters, Viola and Aileen. At age forty Flannery died, leaving an estate worth around $1.5 million, enabling Viola (fig. 2) and her daughters to become fixtures on the social circuit (see Cynthia Nadelman essay, pp. 95–96). By contrast, Elie Nadelman (fig. 3) was born to Jewish parents in Poland, where a folk culture flourished until World War II. While residing in Munich for six months (1904) and in Paris for ten years (1904–14), he developed a keen interest in sculpture from many periods, including his own day, and began making his own modernist art reflecting twentieth-century aesthetics. At the same time, he and other avant-garde artists looked to various forms of "primitive" and folk art in search of a contemporary idiom.

Fig. 1
Elie and Viola Nadelman near Berlin, Germany, ca. 1921. NP

Fig. 2
Viola Spiess Flannery at the Flannery
residence, 45 East Fiftieth Street, New
York City, ca. 1911. NP

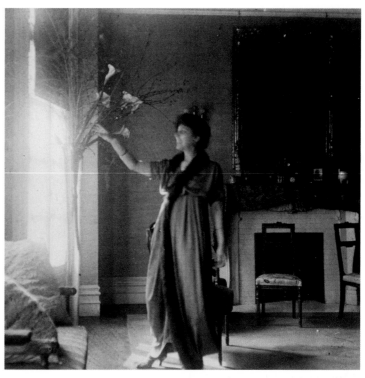

Fig. 3
Elie Nadelman, ca. 1920. NP

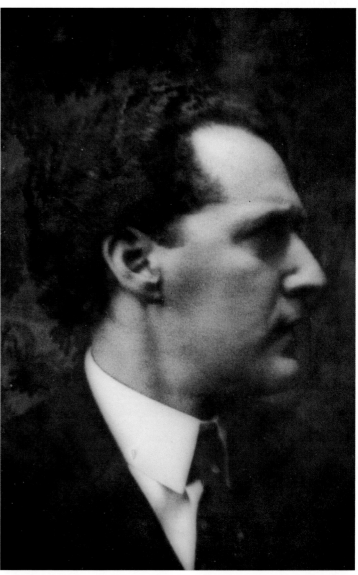

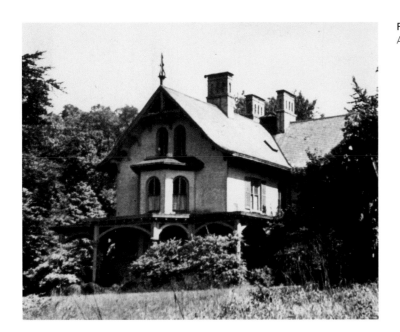

Fig. 4
Alderbrook, Riverdale, NY, ca. 1921. NP

Both Nadelmans were international in their cultural outlook. Each was fluent in several European languages, and they also shared an eye for craftsmanship and a fascination with how objects functioned. Elie was perhaps influenced by his father's work as a jeweler.[5] These interests underlay the couple's omnivorous collecting activities, which began by 1920 with ancient to Renaissance objects (see Hofer essay, pp. 57–59).[6] Both Nadelmans referred to their collection as "folk art" from the beginning, although the term did not become popular in America until the 1930s. They were, however, aware of folk studies that began in mid-nineteenth-century Germany.[7] Their collecting may have been sparked during their honeymoon trip to Norway, home of the Norsk Folkemuseum in Oslo (see fig. 38).[8] From that point on, their joint enterprise—documented in bills, correspondence, and the MFPA cards indexing their collection—continued non-stop for over a decade to encompass thousands of American and European objects.

The newlyweds commenced married life in the Savoy Hotel at Fifty-ninth Street and Fifth Avenue, since one of Viola's daughters occupied her mother's house at 612 Fifth Avenue. During the summer of 1920, they rented Beauport, the evocatively decorated home of the designer and antiques collector Henry Davis Sleeper in Gloucester, Massachusetts, an experience that may have stimulated their collecting.[9] Although much of their time was spent socializing, Elie participated in an exhibition in Gloucester and produced a clutch of drawings.[10] As the painter Marsden Hartley wrote to photographer and art impresario Alfred Stieglitz that summer: "The world was at the Nadelman's [*sic*] to lunch yesterday."[11] In the fall, the Nadelmans traveled to Paris, where Elie exhibited at Galerie Bernheim-Jeune.

In early 1921, the couple rented the Delafield estate in Riverdale-on-Hudson, north of Manhattan, which provided a vantage point from which to search for a country house. That same year, flush with money and promise, they purchased the picturesque Alderbrook, a villa overlooking the Hudson River (figs. 4, 72).[12] Nadelman also constructed a studio on the property where he worked with his four assistants, including Arthur Boni, his *praticien* from Paris who roughed out his sculptures.

Around the same time, the couple bought in quick succession two residences at 4 and 6 East Ninety-third Street, which the architectural firm of Walker & Gillette united into a four-bay townhouse in 1921–22 (fig. 5), installing an elevator and a top-floor, sixty- by forty-foot studio with a huge skylight.[13] They painted most of its walls a modernist white,

Fig. 5
Nadelman residence at 4 and 6 East
Ninety-third Street, New York City, in
1936 and in 2014

leaving space for a few colorful murals, and furnished it sparsely with
Italian Renaissance furniture on the model of Gertrude and Leo Stein's
apartment, which Elie visited during his early years in Paris. Inset glass
shelves in the dining room displayed their collection of glass animals
(figs. 6, 29). Additional ancient glass and marbles acquired from the
eminent dealer Joseph Brummer enriched the décor (see Hofer essay,
pp. 57–59).[14] The acquisition of their houses came none too soon as
July 29, 1922, marked the birth of the Nadelmans' son, Elie Jagiello,
named after Polish royalty but later called Jan. With little delay, the
couple continued their whirlwind social life, hosting regular "Sundays
at Home" parties in their townhouse. At the end of January 1923 they
opened the mansion with a now-legendary banquet in the studio for
one hundred guests, composed of New York's cultural elite, in which
Viola was seated between the painter John Sloan and the sculptor
George Grey Barnard.[15]

Elie joined New York social and professional clubs, which he
would frequent during the twenties, although he always remained an
independent figure as both an artist and collector.[16] When he served
as the president of the Modern Artists of America in 1923, his fellow
board members included other noted folk art collectors and modernists:
Samuel Halpert, chair; Yasuo Kuniyoshi, secretary; and Bernard Karfiol,
treasurer.[17] Nadelman was also a board member of the National
Committee on Folk Arts of the United States, which was started in
1928 in conjunction with the League of Nations International Folk
Art Commission; its international scope paralleled that of the MFPA.[18]
Despite Nadelman's professional association with some artist-collectors
who were part of the Ogunquit (Maine) colony and the Whitney
Studio Club circles, however, the couple did not socialize regularly with
these fellow folk art enthusiasts, who were drawn to the simplicity
and spare aesthetic of American folk art. Rather, the Nadelmans'
marriage confirmed their internationalism, and they adopted a more
cosmopolitan lifestyle with frequent travel that was supported by Viola's
inheritance and Elie's sculpture commissions.[19]

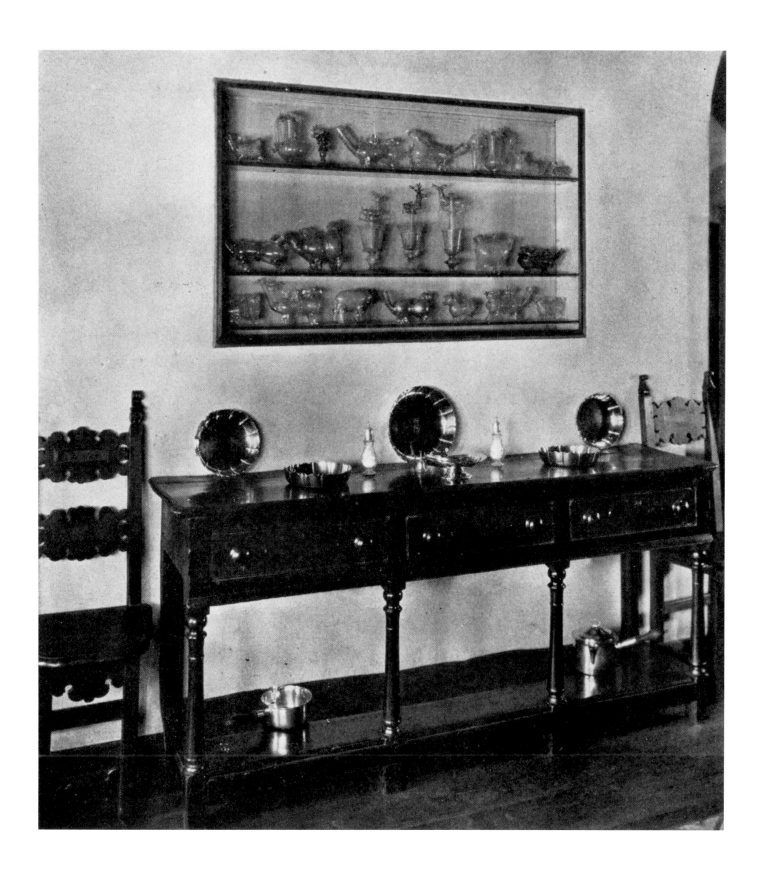

Fig. 6
Dining room of East Ninety-third Street
townhouse with glass objects, from
Antiquarian 3:6 (January 1925), 7

Fig. 7
Museum of Folk and Peasant Arts
(MFPA), Riverdale, NY, 1926–35. NP

Conversant with European art and literature, the couple moved easily in cultured circles. According to Lincoln Kirstein, after the official opening of the townhouse in 1923, Nadelman became friendly with many celebrated New York artists, among them Cecilia Beaux, Louis Bouché, Hunt Diederich, and Anna Vaughan Hyatt Huntington. He was invited to show at the National Academy, and for the annual Beaux-Arts Charity Ball of 1923, whose theme was "Le Cirque d'Hiver," Nadelman designed a processional float with a band of playing musicians.[20] For the next seven years the couple continued to live the high life and to spend extravagantly on their collection and themselves. In 1924 they embarked on a two-month Mediterranean cruise, while the summers of 1925 and 1926 found them in Europe, traveling with servants and a chauffeur, a practice they maintained through the decade. Elie also sent substantial sums of money to his parents in Poland. In 1927 the couple traveled with Polish passports and later set up a summer studio in the Hotel Trianon Palace in Versailles. Nadelman became an American citizen that same year.[21]

The Birth of the Museum of Folk and Peasant Arts

Since both Viola and Elie Nadelman came of age when folk art was still visible in the European countryside and figured importantly in each country's national cultural heritage, the couple understood its significance in a way that most Americans did not.[22] They visited and studied some of the pioneering folk museums in Europe, including Skansen and the Nordiska Museet in Stockholm, both founded by Artur Hazelius in the late nineteenth century.[23] From their investigations, they were undoubtedly exposed to the concept of "peasant art," a politically and culturally charged term frequently used in Europe for folk art.[24] It included the production of household and agricultural implements from rural areas, such as whetstone holders (cat. 74), as well as other genres, like embroidered textiles, one of the focal points of Viola's collecting.[25] Like other artist-collectors, the couple began acquiring at a time when folk art was just beginning to emerge from the broader category of antiques. In fact, the exhibition *Early American Art*, curated by the painter Henry Schnakenberg and spearheaded by Juliana Force at the Whitney Studio Club in 1924, was the first exhibition of American folk art, marking its public "discovery."[26] Asked by Force to plan an exhibition on a theme of his choice, Schnakenberg borrowed objects from artist-friends and later recalled, "As earlier American folk art had begun to interest some of my painter friends I selected this as my subject."[27]

The Nadelmans began by purchasing antiques to furnish their houses, but soon thereafter shifted to vernacular objects, and within a few years they had amassed the nation's largest and most significant collection of folk art. Their burgeoning collection soon outgrew their two houses. Rather than moving, the Nadelmans decided instead to establish the Museum of Folk and Peasant Arts to enshrine their holdings. Its founding marked a double milestone: the MFPA was not only the first museum in the United States devoted exclusively to folk art, but also the first in the world to demonstrate the European influences on American folk art.[28]

In 1924 the Nadelmans engaged Arthur T. Sutcliffe to design the museum building on their Alderbrook property. They would underwrite both the building and the museum's operating expenses. The rough-hewn stone structure (fig. 7) was under construction by early 1925, although by March of that year the couple realized that it would not accommodate their mushrooming collection and launched plans for an additional story.[29] The architectural blueprints, which bear Viola's name as commissioner, reveal its general layout (figs. 8, 9). The MFPA opened on November 28, 1926, offering free admission and tours by appointment. Viola was not only its director but also its managerial powerhouse. Her daily duties included greeting visitors and giving tours, bookkeeping, correspondence, and publicity.[30]

The MFPA holdings grew to approximately fifteen thousand objects, although the museum's press release inflated the number to thirty thousand.[31] In the foreword to the museum guide produced in 1935, the Nadelmans stated their collecting credo:

Fig. 8
Arthur T. Sutcliffe, Eastern elevation of
the MFPA, 1924–25. NP

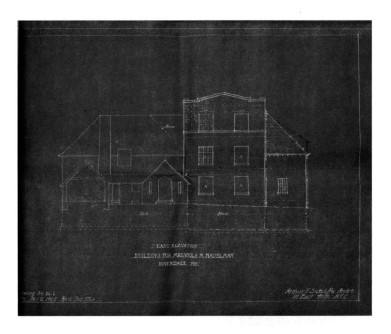

It is the only Museum in existence which shows examples of both European and American Folk Arts. Among the countries represented are: The United States, England, France, Italy, Germany, Spain, Switzerland, Hungary, Austria, Yugoslavia and the Scandinavian Countries. The range of these collections makes it possible for visitors to appreciate the universal scope and importance of Folk Arts. Nowhere else can there be found such a wealth of material for comparative study. The chief interest, however, of these collections lies in their aesthetic significance, and every one of these exhibits has been chosen with this object in view. It is this Museum which has first shown American primitive paintings and sculpture because of their intrinsic artistic significance and of their importance in any total view of American Art.[32]

The Arrangement of the MFPA Galleries
Although the building was demolished soon after the sale of the collection in 1937, we can reconstruct the MFPA's four-story layout from its architectural blueprints (see figs. 8, 9).[33] Several other sources in the Nadelman Papers allow us to identify the arrangement of the galleries and their contents: the draft for the 1935 press release, written by René d'Harnoncourt; the official press release; and the 1937 MFPA inventory.[34] The museum had fourteen galleries as well as some overflow collections noted in the inventory. Because the 1924 plans show twelve rooms—five on the ground floor/basement; three on each of the first and second floors; and one on the top floor—the Nadelmans clearly subdivided two rooms for the additional galleries. Installation photographs suggest that they occasionally moved objects as well.

The ground floor, which included Galleries I through VI, was

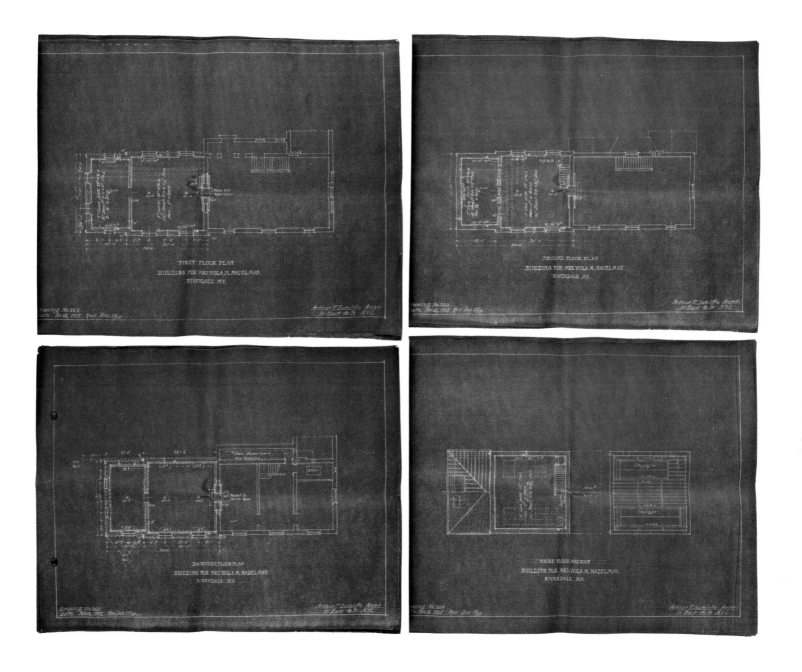

Fig. 9
Arthur T. Sutcliffe, Floor plans of the
MFPA (clockwise from lower left:
basement, first floor, second floor,
third floor), 1924–25. NP

Fig. 10
Gallery I, detail: American Drugstore,
MFPA, 1926–35. NP

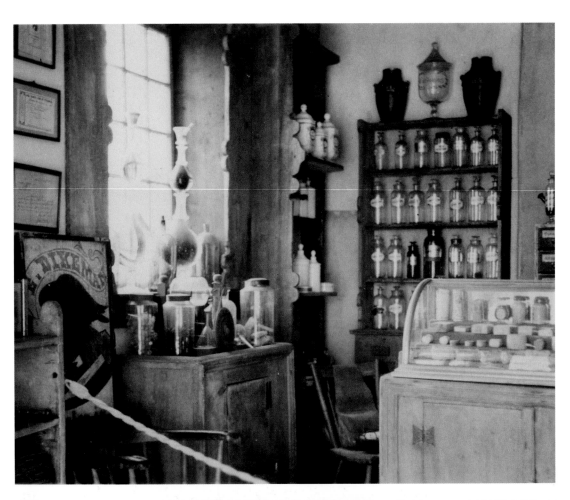

Fig. 11
Gallery II: American Collections, MFPA,
1926–35. NP

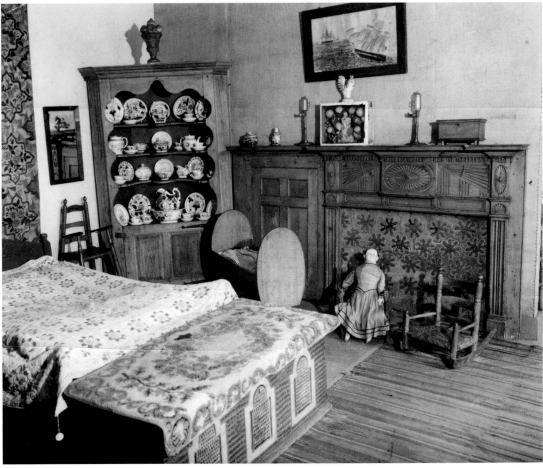

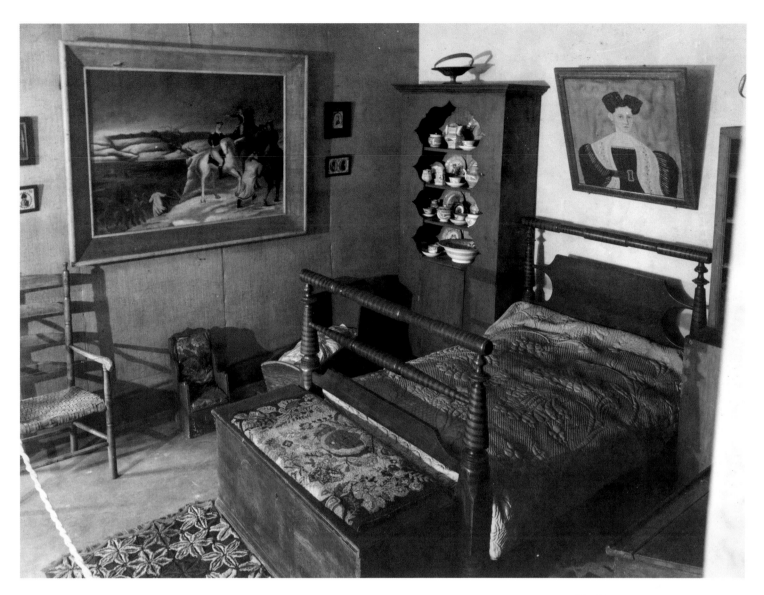

Fig. 12
Gallery III: American Collections,
MFPA, 1926–35. NP

primarily dedicated to American collections or what the Nadelmans
considered American-made objects (figs. 10–12,19, 35). Among the
installations in Gallery I was a complete early American drugstore,
cited in the inventory as "18th Century American Drug Store with 820
pieces" (fig. 10). Galleries II and III (figs. 11, 12), installed as quasi-period
rooms, shared a single large space. Gallery IV combined American and
European furniture and wooden household implements, from a French
carved wardrobe to mangle boards, whetstone holders, cake molds,
and apple parers (see figs. 35, 104). Gallery V, which further underlined
Elie Nadelman's love of wooden objects, displayed works on paper,
broadsides, and posters, as well as printing blocks, some for fabric.
This ground-level suite of galleries also held early portraits, landscapes,
decorative paintings, "Pennsylvania German chalkware," furniture, and
hooked rugs.

The MFPA entrance was on the first floor, where the visitor
entered Gallery VII, the largest room, punctuated by a staircase. In
this commanding space, the Nadelmans installed European peasant
furniture, painted beds, wardrobes, chests, and ship figureheads
(fig. 13, shows the figurehead "Maria Spatz"; fig. 88 shows "Rosa
Isabella"). From there visitors proceeded to Gallery VIII, packed with over
one thousand examples of American and European pottery (figs. 14,
100, 101). The Pottery Room featured a special display of the work of
eighteenth-century New York stoneware potters, among them a pitcher

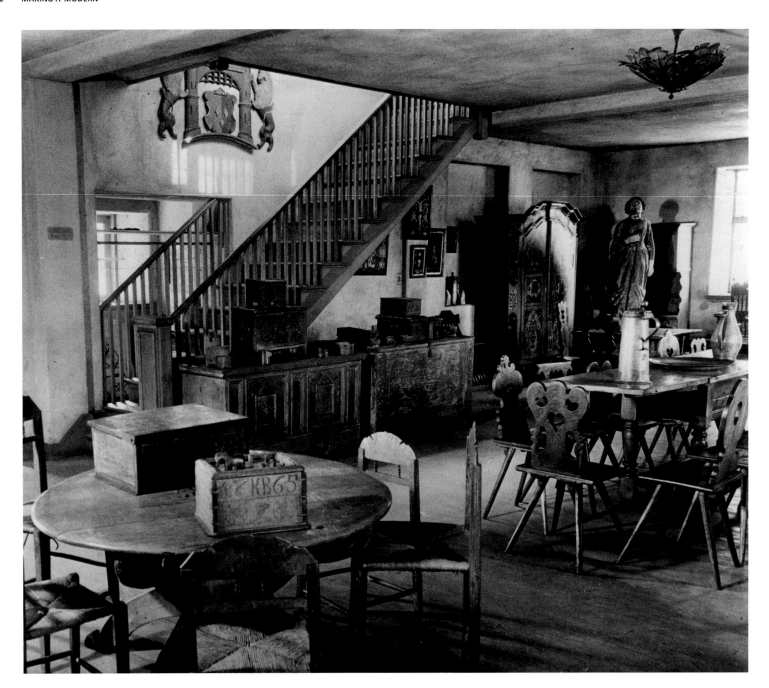

Fig. 13
Gallery VII: European peasant
furniture, MFPA, 1935. NP

signed by Clarkson Crolius (cats. 36, 37). It also contained a broad
spectrum of American and European pottery (Italian, Dutch, German,
Spanish, Hungarian, Czechoslovakian, French, Swiss, and English).
Nearby was the Toy Room, Gallery IX (fig. 15), packed chock-a-block
with a treasure of toys the press release called "the most important and
representative in America."

The second floor housed four galleries. Galleries X and XI displayed
a potpourri of objects in one large subdivided space, showcasing
needlework and other textiles. Among the highlights in Gallery X were
the "French Apothecary with 159 pots and bottles" (fig. 16) and a
French enclosed bed, while Gallery XI contained a Hungarian Baroque
bed with embroidered accoutrements and items related to sewing and
lacemaking, as well as a birdcage and many Christian religious objects.
According to the press releases, the main attractions on the second
floor were in Galleries XII and XIII: "beautifully wrought tools of every
trade and period" and examples of "the art of the blacksmith . . . ,"
ranging from padlocks and ornamental railings to an elaborate portrait

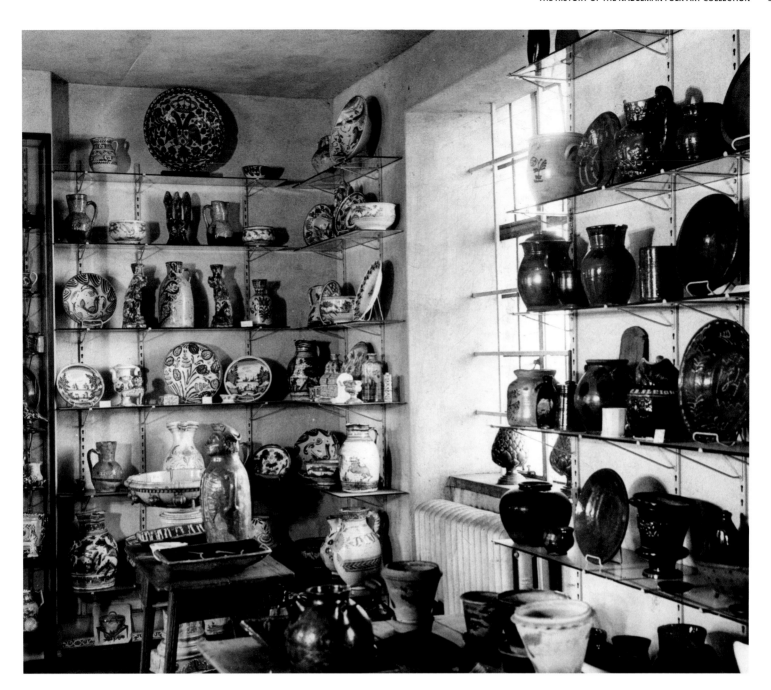

Fig. 14
Gallery VIII: Pottery Room, MFPA, 1935. NP

bust made of armorer's steel (fig. 17). Gallery XIII contained a bootery sign and at least seventeen weathervanes (cat. 6) that were "among the most sought after examples of the folk sculptor's art."[35]

On the top floor was the apogee of the Nadelmans' treasures, Gallery XIV, whose contents spanned the thirteenth to the nineteenth centuries. There the Nadelmans installed their array of anonymous European sculptures in stone and wood, including Christian sculptures from wayside shrines and provincial churches (fig. 18). The draft press release notes that the religious works were collected more for their artistry than their subject matter: "in many cases they were but skilled carpenters and stonecutters who applied their talent to a religious subject." Among the offerings were dramatic figures of Christ on the Cross, chests, ten Italian Renaissance chairs, and Norwegian wall hangings. In addition, the 1935 guide lists a frieze with a wedding celebration "painted in the characteristic style of the Swedish folk painters, 18th century."[36]

Although far from systematic, the MFPA's galleries were animated by the couple's commitment to comparing and contrasting American folk art

Fig. 15
Gallery IX: Toy Room, MFPA, 1935. NP

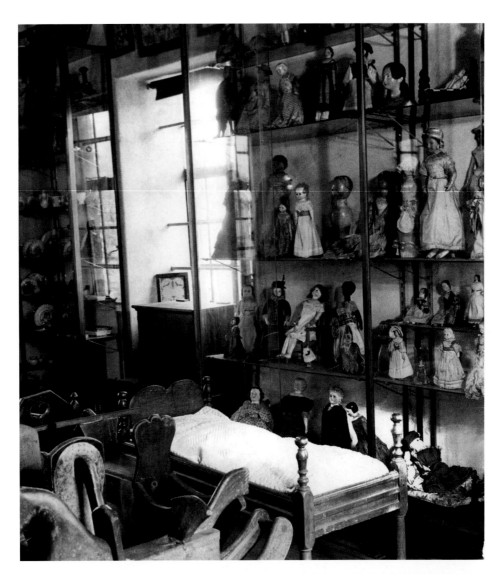

Fig. 16
Gallery X, detail: French Apothecary, MFPA, 1926–35. NP

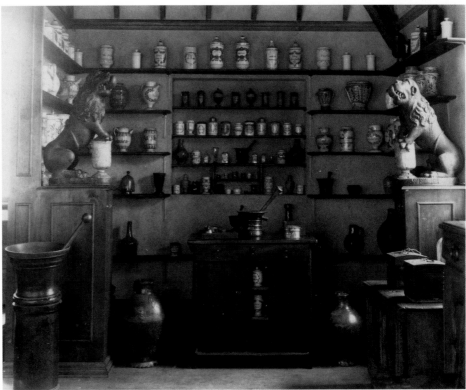

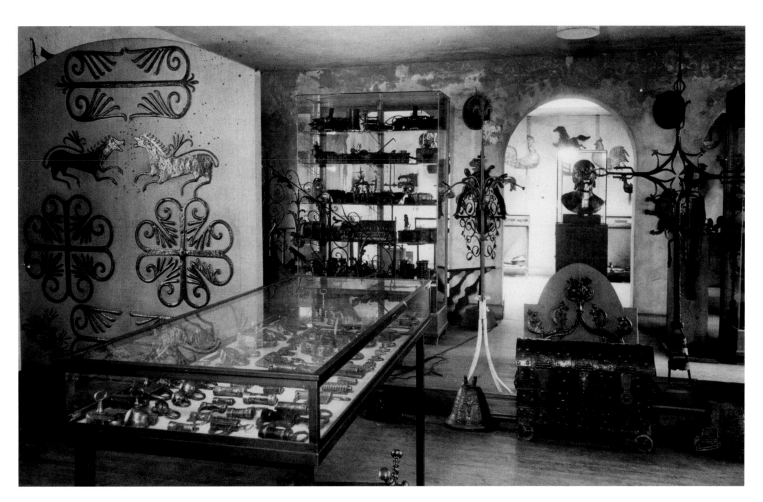

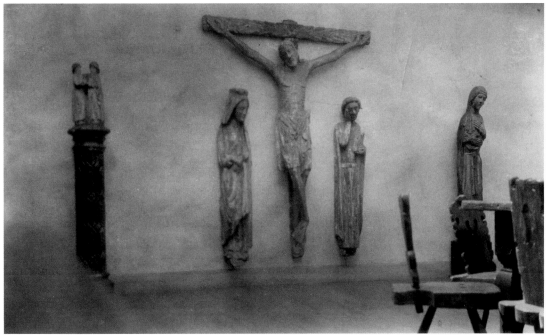

Fig. 17
Galleries XII and XIII: American and European wrought iron and weathervanes, MFPA, 1935. NP

Fig. 18
Gallery XIV: European sculpture and decorative arts, MFPA, 1926–35. NP

Fig. 19
Gallery VI: Wagon, sleighs,
implements, MFPA, 1926–35. NP

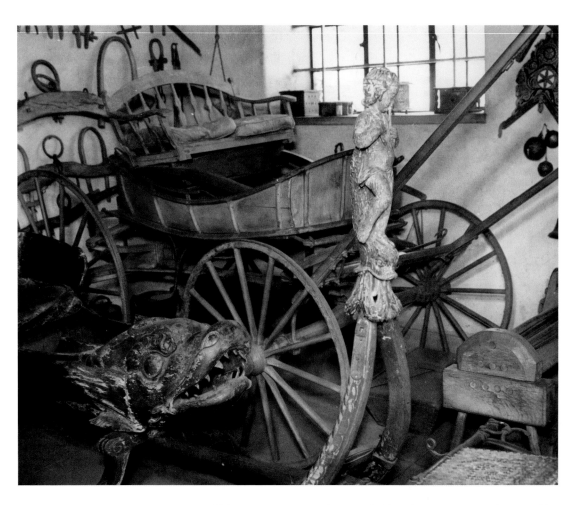

with its European antecedents and giving the museum an ethnographic dimension. Stillinger suggests that folk art displays in European museums provided the Nadelmans with models for their installation designs (Stillinger essay, pp. 50–53). The fourteen MFPA galleries were arranged to juxtapose related objects from different countries. The early American pharmacy in Gallery I (see fig. 10), for example, had its European prototype in the fully equipped French pharmacy in the second-floor Gallery X (see fig. 16). In some cases, the installations focused on how objects were used or made. Gallery VI housed a Connecticut-made Conestoga wagon, Dutch and Norwegian sleighs, American wagon seats, and American farm implements (see fig. 19), one of the Nadelmans' more unusual groupings of utilitarian objects. To demonstrate the development of a form or type over time, the museum guide indicated the range of centuries covered in various galleries.[37] Some objects illustrated processes outmoded by industrialization, such as butter prints (cat. 72) and candle-making, the latter demonstrated in Gallery IV (see fig. 35).

A private venture gone public, the MFPA became the focus of the Nadelmans' lives. As Stillinger has noted, "It symbolized all they knew

and believed in—it was, in a very real sense, their masterpiece."[38] According to the press release, it aimed to "show the artistic production of craftsmen . . . [enabling] the visitor to appreciate the universal scope and importance of Folk-Art." Elie Nadelman also stressed to the press that the museum would benefit public schoolchildren as well as artists and craftsmen, due to the superior quality of earlier craftsmanship.[39] Years later, Edith Gregor Halpert recalled:

> [T]he Nadelman Museum . . . was fantastic! It was a great museum, but it did not reach a public. It was known to very few people. . . . [Nadelman was] simply crazy about folk art. He had folk art around his studio. . . . He had the absolute cream because he got there long before anybody else, and he was an artist, and after all, an artist's eye is absolutely superior to anybody else's eye.[40]

In the later years of its operation, the MFPA participated in professional activities germane to museums. It was among the lenders to the first museum exhibition of folk painting and sculpture, organized by Holger Cahill in 1930 at the Newark Museum, providing objects selected by Viola and Cahill. In the catalogue, Cahill singled out the Nadelmans' portrait by Joseph Whiting Stock (cat. 19), comparing its style to that of Édouard Manet's canvases.[41] Among the other institutions that secured loans from the Nadelmans were the Brooklyn Museum, the New York Public Library, and the Museum of the City of New York, as well as Edith Halpert's American Folk Art Gallery.[42]

The MFPA in Crisis

The stock market crash of October 1929, and the subsequent Great Depression, was a turning point in the Nadelmans' fortunes and the fate of the MFPA. The devastating plunge did not have an immediate effect on the Nadelmans' collecting or the activities of their museum: the MFPA cards indicate that they purchased more objects in 1930 (227) than in 1929 (202). However, the financial reality must have set in shortly thereafter, as they recorded only thirty-four purchases in 1931 and even fewer in subsequent years.[43] By 1930, the couple had also downsized by moving their permanent residence from East Ninety-third Street to Alderbrook and renting out the Manhattan townhouse.[44] In 1933 they sold Alderbrook to a corporation that subdivided the property, remaining as renters until they could regain title to the house.[45] By 1934, the Nadelmans reached a state of crisis when they realized that they no longer had the means to support the operations of the MFPA, whose annual tax bill alone was more than $1,000, not to mention the costs for heat, building maintenance, and security. In the spring of 1934, Viola approached the president of the Carnegie Corporation, Frederick P. Keppel, about supporting the MFPA, confessing, "I am most anxious about the future of our Museum."[46] In December, the foundation voted to support the operations of the MFPA for one year with a grant of $4,000, administered through the School

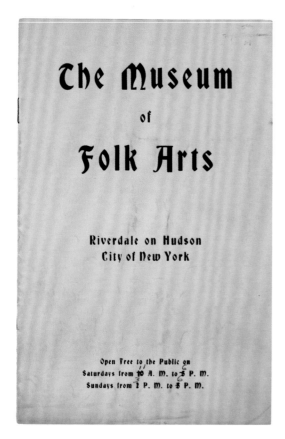

Fig. 20
Cover, Museum of Folk Arts guide,
1935. N-YHS Library

Art League. Florence N. Levy, a seasoned arts administrator who served as volunteer secretary of the League, forwarded monthly payments of $240 to cover Viola's curatorial salary of $100, $50 for coal, $50 for the watchman, $15 for the furnaceman, and $25 for a cleaner.[47]

The cash infusion from the Carnegie Corporation brought with it several major changes to the MFPA. Though admission had always been free, the museum kept regular hours for the first time in its nearly decade-long existence (Saturdays from 10 a.m. to 5 p.m. and Sundays from 2 p.m. to 5 p.m., with tours for school groups by appointment). It also operated under the guidance of a newly formed advisory committee, which in addition to Viola included Alfred H. Barr, Jr., director of the Museum of Modern Art (MoMA); René d'Harnoncourt, a curator, expert on Mexican folk art, and future director of MoMA; Holger Cahill, a champion of folk art who would soon lead the Works Progress Administration's Federal Art Project; and the arts administrator Florence N. Levy. Their names were printed in the museum's guide (fig. 20, Appendix II), another sign of its increasing professionalism.[48] In addition, the MFPA was rechristened the Museum of Folk Arts with its rejuvenation in 1935, likely at the behest of one or more of the advisory committee members. The advisors, all of whom had significant experience working at or consulting for major American museums, may have found the unwittingly pejorative connotations of the term "peasant art" problematic and recommended the new, simplified museum name.

The Museum of Folk Arts was unveiled to the public with several days of press previews followed by a formal reception on Saturday, April 27, 1935. The press list included a who's who of contemporary art and literary critics, including Henry McBride of the *Sun*, Forbes Watson of the *American Magazine of Art*, Lewis Mumford of the *New Yorker*, and Homer Eaton Keyes, founder and editor of *The Magazine Antiques*.[49] A surge of press attention brought thousands of visitors to Dodge Lane in Riverdale. McBride noted in the *Sun* on opening day that the Nadelman collection, already respected among the cognoscenti, "had much to do with promoting the interest in folk art, which is now taken more seriously than it used to be." He predicted that "visitors will be amazed" by the extensive displays and that the new museum would be "destined to enjoy popularity."[50] The *New York World-Telegram* announced the same day, "There is undoubtedly much to engage the mind in the exhibition at the Museum of Folk Arts. . . . Nowhere else probably can one find such a wealth of material for comparative study as in the museum's fourteen galleries."[51] The *Christian Science Monitor* noted that "in no other place . . . have there been brought together such a broadly inclusive representation from many lands as in this museum on the banks of the Hudson, permitting comparison of the activities of the people of America and widely separate countries."[52]

By all measures, the Museum of Folk Arts was a great success during its first year of operation under the Carnegie Corporation's aegis. From February to June 1935, the museum welcomed 3,422 visitors, including groups of students studying design. The museum was also

able to make long-overdue upgrades, including new casework, signage, object labeling, and repairs to the furnace and roof. But despite a glowing report summarizing a renaissance for the Museum of Folk Arts, the Carnegie Corporation decided not to extend funding for the following year. Viola rallied her advisory committee to appeal to Keppel for reconsideration. Alfred Barr complied, arguing that the Museum of Folk Arts "is a unique and valuable institution" and describing it as "the foremost private collection of international folk art in America . . . the only one of its kind in our country."[53] The Carnegie came through with an extension that allowed the museum to remain open through October 31, 1936. A highlight of that season was the ceremony held at the MFPA to honor Mayor Fiorello La Guardia, who was awarded a silver medal by the School Art League for his devotion to art education.[54] In his remarks, the mayor credited the Museum of Folk Arts and the School Art League for helping to establish an appreciation for art among the city's 1.2 million students.[55] Another achievement was the museum's participation in the Index of American Design, a division of the Federal Art Project directed by MFPA board member Holger Cahill. In 1936 and 1937, twenty-five unemployed artists hired as part of the federal work-relief program photographed and sketched a total of 207 objects at the MFPA under the supervision of "master artist" Elie Nadelman.[56] The precise watercolor renderings (see fig. 99) were part of an ambitious effort to chronicle the development of American design, capture the unique spirit of the nation's vernacular artifacts, and inspire a truly American modern art.[57] Ironically, the Index's mission to demonstrate that folk art produced in the United States was quintessentially American rather than an outgrowth of European traditions ran counter to the goals of the MFPA.

By October 1936, the museum's situation again grew dire when the Carnegie Corporation denied further funding, stating that it was against their policy to provide annual support for museums.[58] The Nadelmans cast about for alternatives that would preserve the collection at another public site. In May 1937, Elie approached Nelson A. Rockefeller to suggest that the Museum of Folk Arts relocate to Rockefeller Center, greatly increasing its accessibility. He proposed that proceeds from admission fees be used for gradual purchase of the collection, along with its upkeep: "Thus a Museum which in its character is unique in the world, would be offered to the public for its incalculable benefit and enjoyment."[59] After Rockefeller turned down the proposal, Elie renewed his appeal, offering the collection at no cost.[60]

Even before their attempts to salvage the MFPA by securing the support of the Carnegie Corporation and offering to display it at Rockefeller Center, the Nadelmans had begun to discreetly sell select objects from the MFPA in order to shore up their dwindling bank account. In October 1931, at the couple's invitation, Americana collector Henry Francis du Pont visited the museum to scout out potential purchases. Elie followed up with prices and additional information about a portrait of George Washington, a Hudson River Valley kas, and a weathervane depicting a Native American.[61] Du Pont ultimately decided to buy the kas, two boxes with "American subjects" (presumably

painted), a child's dress, a child's Windsor armchair, and a "historic watercolor" for a total of $2,025. He complimented the sculptor, telling him how inspiring it was to see the collection, and praised Viola's artistic arrangement of the objects. The collector also commiserated, "I hate to think that you have to dispose of some of these lovely things, as they do make such an interesting collection assembled as they are."[62] Despite further offers, du Pont does not appear to have purchased additional objects from the MFPA.

The Nadelmans also reached out to art dealer Edith G. Halpert, engaging her in June 1932 to place selected items by private sale. Parting with their prized collection was clearly painful. Viola explained candidly to Halpert, "There are some other things which we will dispose of, not because we wish to, but because we are forced to."[63] Luckily, at a time when dealers and collectors alike were struggling to collect debts and make payments, Halpert had just begun advising Abby Aldrich Rockefeller, a new collector of American folk art with seemingly limitless financial resources.[64] Decades later, Halpert recalled driving to Riverdale in her Hupmobile, loading the back of the car with paintings and sculpture, and continuing up the Hudson River to the Rockefeller mansion in Pocantico Hills to show her offerings to Mrs. Rockefeller.[65] The collector acquired at least eight items in 1932, including two weathervanes, three paintings on velvet, the major paintings *Outing on the Hudson* and the *Yellow Coach*, and the commanding ship's figurehead of Minnehaha by Boston carver William B. Gleason.[66] The following year she purchased an oil portrait of George Washington, probably the one passed over by du Pont.[67] Some of these objects would become touchstones in the Abby Aldrich Rockefeller Folk Art Collection, which the collector donated to Colonial Williamsburg in 1939. Halpert no doubt steered additional Nadelman objects into the hands of other folk art collectors. Electra Havemeyer Webb, who would form the Shelburne Museum in 1947, acquired several ex-Nadelman items that had passed through Halpert's gallery (see fig. 39).[68]

The same year that the Nadelmans engaged Halpert to sell some of their American folk art, they identified European items to return to dealer Joseph Brummer. In February 1932, they sold back fourteen objects, some likely from the East Ninety-third Street townhouse and others clearly from the MFPA galleries.[69] Three additional items, identified as belonging to Viola, were placed on consignment.[70] Brummer also took twenty-nine items "in exchange" in December 1933, perhaps against outstanding debts owed for earlier purchases.[71] A number of returns found eventual homes in museums, including the Brooklyn Museum, the Metropolitan Museum of Art, the Rhode Island School of Design, the Mead Art Museum, the Saint Louis Art Museum, and the Textile Museum.[72]

The Collection Goes to the New-York Historical Society

By fall 1936, the Nadelmans realized that deaccessioning individual objects would not generate enough cash to sustain the museum, and they resolved to sell the remaining collection in its entirety. On October

8, they authorized Edith Halpert to sell the contents of the Museum of Folk Arts for $400,000 (subsequently lowered to $350,000).[73] The couple remained optimistic, at least outwardly: Viola confided to Halpert that she had "complete faith in your capacity & in your desire to give the museum a fair chance for its existence," and acknowledged that if successful, the dealer would be given credit for "having saved & aided this Museum to become an important chapter in the history of the folk arts."[74] Halpert struggled to find a taker and found that potential buyers were deterred by the museum's European holdings. Elie's lament to Halpert is perhaps his clearest statement of the MFPA's mission: "It is regrettable that there is objection to the international scope. Every one [*sic*] in America interested in folk art would be very much puzzled what the European folk arts are like, for without that knowledge he could hardly have a real appreciation and understanding of his own. This is the only Museum which provides him with that knowledge."[75] Once the Nadelmans entered into discussions with the New-York Historical Society in November 1937, they terminated their contract with Halpert.[76]

The Nadelmans' introduction to the N-YHS was not made through their New York dealer, but instead brokered by collecting colleagues in rural Massachusetts. Edward Deming Andrews and his wife, Faith, noted collectors and scholars of Shaker furniture and artifacts, arranged a meeting with Americana collector Edna Greenwood and her friend, the Historical Society's president Alexander J. Wall (fig. 21), at Greenwood's Time Stone Farm in Marlborough, Massachusetts (fig. 36).[77] Wall was a regular visitor to Greenwood's restored home, where he and his wife, attired in costumes and wigs provided by their hosts, enjoyed hearth-cooked meals at a long board table set with eighteenth-century pewter plates, glassware, and utensils.[78] In an article on Greenwood's 1702 house and period furnishings for the New-York Historical Society's *Quarterly*, Wall praised the unparalleled collection of household objects and utensils of daily living, noting their great educational value.[79] The affable and energetic Wall, who played an important role in professionalizing the Historical Society and widening its audience from a small pool of scholars to the general public, recognized enormous potential in the Nadelman collection, as its acquisition would further his vision of a more open and inclusive institution with popular exhibitions. The timing of the meeting was propitious, as the Historical Society had recently received a bequest of over $4 million, allowing completion of a long-dreamed of expansion to the Central Park West building. Construction was underway, and Wall was already formulating ideas about how to entice visitors with new museum installations.[80]

On November 16, 1937, the New-York Historical Society's board of trustees voted unanimously to purchase the Nadelman collection for $50,000, to be paid in five annual installments. The board minutes elucidate Nadelman's reasons for parting with the trove:

Mr. Elie Nadelman, during the past twenty-five or thirty years, had collected a museum of Folk Art, which included practically every industry of American origin together with its European

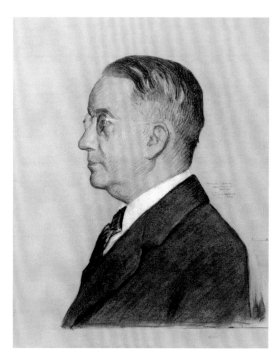

Fig. 21
Albert Rosenthal, *Alexander James Wall (1884–1944)*, 1936. Charcoal and black and white chalk on mauve paper, laid on board; 24½ × 19⅝ in. (62.2 × 49.8 cm). N-YHS, Gift of Albert Rosenthal, 1936.796

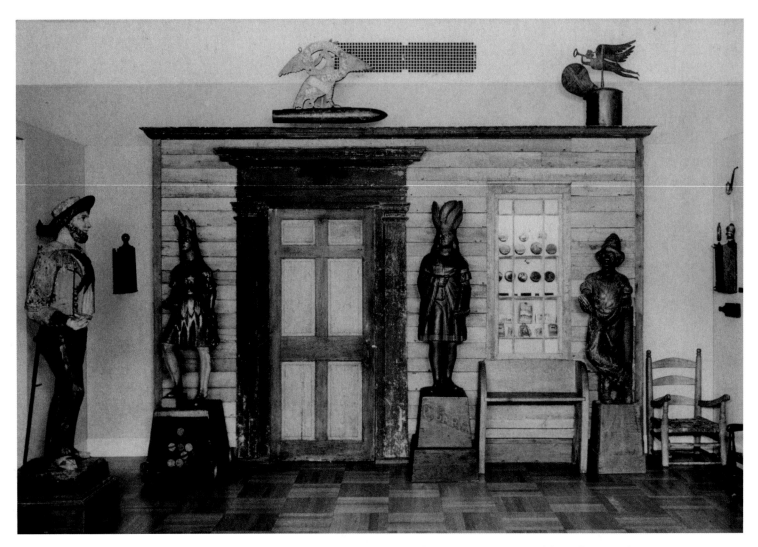

Fig. 22
Postcard showing the New-York
Historical Society folk art galleries,
ca. 1939. N-YHS Archives

background. He had housed the collection in his private museum
at . . . Riverdale-on-Hudson. The cost of gathering and housing
the 15,000 or more items now on display there was about
$300,000—and before the Depression Mr. Nadelman possessed
a fortune which he since has lost, retaining only his home and
the half acre on which his museum stands. That taxation was
bringing his place nearer a foreclosure sale and . . . he desired to
preserve his life work in the collection of this Folk Art Museum
and therefore offered it to the New-York Historical Society.[81]

The omission of any reference to Viola is curious, although the
Nadelmans may have decided that naming Elie as the collection's owner
provided financial protection. Indeed, in 1939, a creditor of Viola's made
a claim on a portion of the purchase amount not yet paid by the Society,
which was dismissed only after Viola signed a deposition stating that
the collection had been the sole property of her husband and that she
had no right, title, or interest in it.[82] Renouncing the collection that she
had dedicated herself to assembling, curating, and preserving must have
been a bitter pill for Viola. Though driven solely by financial concerns,
the distancing of Viola from the MFPA in 1937 had lasting implications,
as the Historical Society termed the trove "The Elie Nadelman Folk Art
Collection," and press surrounding the purchase minimized her role in
its formation.

The Historical Society moved swiftly to transfer the contents of the
MFPA, with Alexander Wall spending Sundays in the unheated Riverdale
museum to oversee the complicated logistics of the move.[83] A team

of three packed the thousands of objects in just one month, and on December 20, 1937, they deposited the final van-load of folk art at the Society's storage warehouse on the Upper East Side of Manhattan. Although installation in the newly renovated building would not begin until October 1938, the N-YHS trumpeted its transformative acquisition in the press. The *New York Times*, *Art News*, the *Art Digest*, and *The Magazine Antiques* announced the purchase in early 1938.[84] The editor of *Antiques* declared that the United States "can boast no other [comparable] accumulation of folk art in range and completeness."[85]

Nadelman threw himself into the task of organizing the installation of the folk art collection, but he clashed with Wall and the board over the location of its display. He insisted the collection be exhibited in Dexter Hall, the grand second-floor gallery with twenty-two foot ceilings. He was ultimately overruled, and the collection was installed in a new wing on the north end of the second floor, which Wall felt was more suitably scaled for folk art.[86] Nadelman was intimately involved in all aspects of the installation, from space allocation to ordering pedestals, ropes, and standards from local suppliers. Photographs of the gallery (figs. 22–25, 52) show Nadelman folk art objects alongside those acquired from other donors, including some that Nadelman himself solicited to amplify the display. One of his targeted donors,

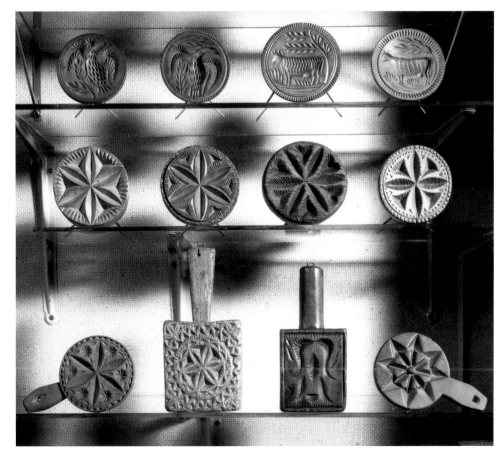

Fig. 23
Installation of butter prints in the New-York Historical Society folk art galleries, 1939. N-YHS Archives

Fig. 24
Folk art galleries at the New-York
Historical Society, 1939. N-YHS
Archives

Fig. 25
Installation of toys in the New-York
Historical Society folk art galleries,
1939. N-YHS Archives

Natalie Knowlton Blair, donated sixty-two items in January 1938, including needlework, printed textiles, glass, household tools, and, in a particularly nice complement to an MFPA object (cat. 6), a weathervane depicting the angel Gabriel.[87] Nadelman himself donated sixty-three items in December 1938, primarily tobacco-related objects that he had purchased specifically to flesh out the installation of a tobacconist's shop, followed by six quilts and coverlets in early 1939. When the gallery opened on April 1, 1939, its displays included the MFPA's American apothecary shop; a loom "with an unfinished rug still on its threads"; the façade of a tobacconist's shop, punctuated by cigar store trade figures; as well as displays of toys, pottery, glass, wood carving, and textiles.[88]

As part of the purchase agreement with the N-YHS, Elie Nadelman was hired as curator to catalogue the vast collection. The artist joined the Society's growing professional staff, recently expanded to include museum curators H. Maxson Holloway (objects) and Donald A. Shelley (paintings), as well as assistants for handling details such as numbering newly acquired objects (fig. 26). The task of cataloguing thousands of items would have been daunting for the most seasoned curator, but maintaining a nine-to-five schedule proved particularly challenging for Elie, who was accustomed to working independently and managing his own time. In April 1939, Wall complained to board chairman George Zabriskie about Nadelman's inability to commit to a schedule and dedicate himself to cataloguing the collection.[89] Five days later, he sent the sculptor a letter dismissing him from the position. Of the 14,492 individual objects purchased by the Society,[90] only about 1,475 were formally accessioned during Nadelman's sixteen-month tenure as

Fig. 26
N-YHS staff member Joseph Rapport
accessioning objects, 1939. N-YHS
Archives

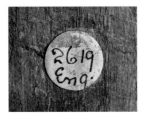

Fig. 27
MFPA collection label on carved
wooden spoon (N-YHS Z.106),
½ in. (1.3 cm) diameter.

curator, creating a record-keeping disaster that would take decades to untangle.[91] Luckily, the Nadelmans placed collection labels (fig. 27) on a large number of objects, which have proven a useful tool for identifying unaccessioned Nadelman objects within the N-YHS collection. These distinctive circular tags, attached to objects with wax, were typically annotated in ink with the object's MFPA number and an abbreviation of the alleged country of origin.

Largely absent from the Historical Society's folk art installation were the vast holdings of European material that had once been central to the mission of the MFPA. Wall felt it necessary to retain only a subset of the European objects in order to demonstrate the antecedents of American folk art. In 1943, the board concluded, "we wish to retain only such items as would be a connecting link between American material and European and thereby release for sale other items of this collection."[92] In July of that year, curator Shelley identified ironwork for deaccession, explaining to Wall, "there is a great deal of duplication here as elsewhere in the Nadelman collection and a little thinning out would actually improve the collection."[93] The Society consigned sixty-two lots (totaling approximately 156 individual objects) to Parke-Bernet Galleries, including a large number of locks, for an auction held on October 14, 1943.[94] Two months later, the N-YHS went significantly further in winnowing the Nadelman collection, consigning 235 lots (one thousand objects) to Parke-Bernet for a single owner sale of "Mid-European Folk Art," including English, Continental, and American blown and cut glass; chalkware; American and English stoneware and pottery; Continental faience and stoneware; devotional objects; Continental and American household and farm tools; carved wood, alabaster, and ivory sculptures; French, Swiss, and Danubian *coffrets*, furniture, and doors; Continental headdresses, costumes, and embroideries; and domestic and miscellaneous decorative objects.[95] The Nadelmans were devastated that the mission of their museum had been all but invalidated by the N-YHS sales.

Despite their ongoing financial troubles, the Nadelmans continued to collect, their passion undimmed by the dismantling of the MFPA. According to Kirstein, on the very day the sale to the N-YHS was finalized, Elie drove to New Jersey with his chauffeur to examine some nineteenth-century carved wooden circus figures.[96] After 1937 the couple narrowed their collecting to American folk art. Viola explained to Henry Francis du Pont in 1948, "After the New York Historical Society acquired the Museum, my husband starting collecting again, American objects only, and he left a very large collection, foremost a collection of Pennsylvania fracturs [*sic*], probably the most important in the country . . . paintings, furniture, hooked rugs, pottery and so on."[97] The Nadelmans' extravagant European collecting trips were replaced by jaunts within the United States. Alexander Wall complained to Zabriskie that instead of focusing on cataloguing his collection, Elie had been traveling around "gathering a new collection of folk art things," according to reports "from several of the dealer sources."[98] Indeed, Nadelman mailed Wall a cheery souvenir postcard from Charleston,

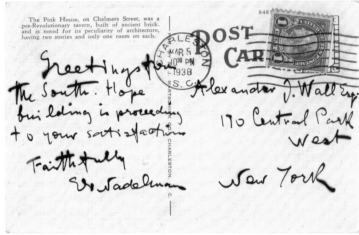

South Carolina, in March 1938: "Hope building is proceeding to your satisfaction. Faithfully, Elie Nadelman" (fig. 28). Sadly, after a period of poor health, Elie died in 1946, less than a decade after the sale of the collection. After her husband's death, Viola shifted her focus to dispersing their American acquisitions. In 1948, she sold thirteen objects to Stephen C. Clark and Louis C. Jones for the New York State Historical Association (cats. 12, 15, 16) and forty-one fraktur paintings to collector Maxim Karolik, who donated them to the Museum of Fine Arts, Boston (cat. 23).

By the early 1960s the New-York Historical Society shifted its emphasis away from folk art but has continued to display and interpret Nadelman collection objects in ways that Elie and Viola could never have anticipated. In 2001, within days of the terrorist attacks on the World Trade Center, the commanding statue of fire chief Harry Howard (cat. 1) was placed in the Society's Great Hall before a backdrop of an American flag as a tribute to the firefighters, rescue workers, and civilians who lost their lives on September 11. The Nadelmans' tobacco trade figure of an African American (see fig. 22, far right[99]) was featured in artist Fred Wilson's installation *Liberty/Liberté* (2011), a provocative meditation on the meaning of freedom as conceived by our nation's founding fathers and as experienced by enslaved Americans. In addition, three watercolors (cats. 20–22) were published in a scholarly catalogue devoted to the N-YHS collection of drawings and watercolors and included in the companion traveling exhibition; the Nadelmans' South Carolina face jugs (cat. 38) were analyzed, visually, historically, and scientifically, as part of a detailed study of African American face vessels from the Edgefield District; and a selection of toys from the MFPA traveled to Paris and Helsinki as part of a major traveling exhibition on the history of toys.[100] Now, after nearly nine decades, the Nadelman folk art collection is receiving its first major exhibition and comprehensive scholarly analysis, a development the Nadelmans would surely have applauded.

Fig. 28
Postcard from Elie Nadelman to Alexander Wall, 1938. N-YHS Archives

1 The name was changed to the Museum of Folk Arts in 1935, after it received support from the Carnegie Corporation.

2 The most thorough studies of Nadelman's sculpture to date are Ramljak 2001a; Haskell 2003. As Elie Nadelman's first biographer and champion, Lincoln Kirstein remains influential on Nadelman scholarship, especially Kirstein 1973.

3 Oaklander 1992; Stillinger 1994; Stillinger 2011. The collection is also discussed in Berman 2001, 74–76; Lampe 2010.

4 The *New York Times* announced the engagement and impending marriages of Mrs. Viola Flannery to Elie Nadelman and her daughter Miss Viola Flannery to Charles Wright Gutteridge (December 25, 1919, and January 3, 1920, respectively); the *New York Times*, January 7, 1920, recorded the Nadelman-Flannery marriage on December 27, 1919, at Lakehurst, NJ.

5 Stillinger essay, pp. 42–45, notes that Elie's associations with painter Hamilton Easter Field and his collections in the late 1910s were important in developing his taste, especially in the mixing of styles, periods, and "simplicity of form and color and the whimsy that such commingling could provide."

6 Stillinger 2011, 181, notes that neither of the Nadelmans discussed the genesis of their folk art collection.

7 Idem Stillinger essay, pp. 50–51.

8 Idem 2011, 184. The outdoor Norsk Folkemuseum opened in 1894.

9 See Stillinger 2011, 34–36, 256–66; see also idem, Stillinger essay, pp. 41–42.

10 Cynthia Nadelman, "Elie Nadelman's Beauport Drawings," *Drawing* 7:4 (November–December 1985): 75–78.

11 Nadelman 2001, 117 (quoting from the Alfred Stieglitz Papers, Beinecke Rare Book and Manuscript Library, Yale University, New Haven, CT).

12 In June 2010 the Landmarks Preservation Commission granted it landmark status; Michael D. Caratzas, "Alderbrook House (LP-2399)," Landmarks Preservation Commission report, 2009, 5; http://www.nyc.gov/html/lpc/downloads/pdf/reports/2399.pdf. This rare surviving mid-nineteenth-century Hudson River villa was probably built around 1858–59 by Oscar C. and Ada Woodworth Ferris. From 1864 until the 1890s, it was the country house of the industrialist and banker Percy R. Pyne. The gabled "bracketed mansion" was influenced by Italianate and Gothic Revival designs published by Andrew Jackson Downing

and Calvert Vaux.

13 Viola Nadelman purchased both townhouses on June 1, 1921: No. 4 from Fernando Wood and his wife; No. 6 from Harold and Martha Turner. The two were conveyed as one property to Elie in 1923 for $1; deeds, NP. See also Kirstein 1973, 218, who notes that 6 East Ninety-third Street was formerly owned by Jacob Ruppert, founder of the Knickerbocker Brewery. The structures were originally built as two brownstone-fronted row houses in a group of three designed by A.B. Ogden & Son (1888–89); see http://www.nyc.gov/html/lpc/downloads/pdf/reports/CarnegieHill_Expanded_HD.pdf.

14 Master blacksmith Samuel Yellin supplied a stair rail, brackets, and hardware in 1922, according to documents in the archives of Samuel Yellin Metalworkers. Thanks to Joseph Cunningham for the information. The townhouse has recently been refurbished and, sadly, few of the architectural details from the Nadelman renovation remain.

15 Kirstein 1973, 218.

16 Among the former were the City Club, the Knickerbocker Whist Club (he was an expert bridge player), and the Cavendish Club; among the latter, the Penguin Club, the Salons of America, the Modern Artists of America, The New Society of Artists, the Society of Independent Artists, and the Architectural League (serving as president, chairman, and board member). Nadelman 2001, 117, which cites additional memberships.

17 Ibid.

18 See Ruth Wolfe, "Nina Fletcher Little: Bridging the Worlds of Antiques and Folk Art," *Folk Art* 22:2 (Summer 1997): 34; "Out-of-Town," *New York Times*, January 19, 1936, mentions that Viola Nadelman was on the board of the National Committee.

19 Stillinger 2011, 180–81.

20 Kirstein 1973, 218–19, noting that "few men since Saint-Gaudens or Sargent occupied a place which was at once that of preëminent professional, taste-maker, patron."

21 Nadelman 2001, 118–19.

22 Stillinger 1994, 518; idem 2011, 180–81.

23 Holger Cahill recounted meeting Elie Nadelman and telling him about visiting several European folk museums in 1922, including Skansen, the Nordiska Museet, and other Swedish and Norwegian collections: "This interested him very much, because he had done the same thing. He had studied all the collections." Reminiscences of Holger Cahill,

1957, Columbia Oral History Project, Columbia University, New York, 189–92. Thanks to Wendy Jeffers for the reference.

24 The interest in peasant art paralleled the Arts and Crafts movement and National Romanticism. See Paul Stirton and Juliet Kinchin, "The Hungarian Folk Arts Debate in the British Press," in *Britain and Hungary: Contacts in Architecture and Design*, ed. Gyula Ernyey (Budapest: Hungarian University of Craft and Design, 1999), 30–46; Lou Taylor, "Displays of European Peasant Dress and Textiles in the Paris International Exhibition 1862–1900," in *The Lost Arts of Europe: The Haslemere Museum Collection of European Peasant Art*, ed. David Crowley and Lou Taylor (Haslemere, Eng.: Haslemere Educational System, 2000), 30–43; Bjarne Rogan, "Folk Art and Politics in Inter-War Europe: An Early Debate on Applied Ethnology," *Folk Life* 45 (2007): 7–23; Daniel DeGroff, "Ethnographic Display and Political Narrative: The Salle de France of the Musée d'ethnographie du Trocadéro," in *Folklore and Nationalism in Europe During the Long Nineteenth Century*, eds. Timothy Baycroft and David Hopkin (Leiden and Boston: Brill, 2012), 113–35.

25 Stillinger 2011, 183.

26 Lipman and Armstrong 1980, 221. For Force and the Whitney Studio Club, see Avis Berman, *Rebels on Eighth Street: Juliana Force and the Whitney Museum of American Art* (New York: Atheneum, 1990); Stillinger 2011, 175–78.

27 Stillinger 2011, 151.

28 Oaklander 1992, 50; Stillinger 2011, 190.

29 Sutcliffe in his diary, March 27, 1925, Arthur T. Sutcliffe Papers, Columbia University Libraries, Avery Drawings & Archives, New York.

30 Oaklander 1992, 54 n. 11, relates that in addition to press coverage, there were advertisements on city buses.

31 Oaklander 1992, 48, estimates 70,000; Nadelman 2001, 118, 10,000; Stillinger 2011, 189, estimates nearly 15,000. When the collection was sold to the N-YHS in 1937, the bill of sale cited a total of 14,492 individual items (see n. 89). Based on documented sales before 1937, the total probably never exceeded 15,000.

32 MFPA 1935.

33 NP.

34 This draft is appended to a letter from d'Harnoncourt to Viola Nadelman, April 30, 1935, NP. The official press release uses similar language, NP. The MFPA inventory details the types of

objects in each gallery while the guide provides only superficial descriptions of the contents. These sources do not always agree.

35 MFPA inventory, NP: "Weathervanes; 11 roosters, 1 arrow; 2 houses (*sic* horses?); 2 indians and a very elaborate vane . . . flying wooden angel / flying wooden angel." MFPA 1935 adds various smoking tools to the contents displayed in Gallery XIII.

36 See Parke-Bernet 1943b, probably lot 205, ill. (three panels representing wedding festivals).

37 Stillinger 2011, 186.

38 Ibid., 187.

39 Ibid.; "Riverdale School Children Benefit by Folk Art Museum," *Yonkers Statesman*, August 11, 1936.

40 Oral history interview with Edith Gregor Halpert, conducted by Harlan Phillips, 1962–63, AAA.

41 Holger Cahill, *American Primitives*, exh. cat. (Newark, NJ: Newark Museum Association, 1930), 14.

42 Oaklander 1992, 50.

43 Their spending confirms Jan Nadelman's recollection that his parents, whose investments were primarily in real estate, were not immediately affected by the financial downturn. Elizabeth Stillinger interview with Jan Nadelman, April 3, 1984.

44 The 1930 Federal Census records Alderbrook as the Nadelmans' primary residence. The census accounting of household members also reflects their dwindling assets: in 1925, the Nadelmans were assisted at East Ninety-third Street by six servants (two caretakers, a butler, a personal maid, a cook, and a waitress) and in 1930, a staff of five helped them at Alderbrook (two servants, a cook, a domestic, and a governess). By 1940, only a maid and a handyman lived with them.

45 Caratzas, "Alderbrook House," 5.

46 Viola Nadelman to Frederick Keppel, draft letter, n.d. [April 1934], NP.

47 Florence N. Levy to Viola Nadelman, January 30, 1936, NP.

48 MFPA 1935. Twelve hundred copies were printed and offered for sale at the museum. In April and May 1935, the museum received $18.10 in income from guide sales. Undated handwritten summary of museum finances, n.d. [June 1935], NP.

49 Press List for Folk Arts Museum, NP.

50 [Henry McBride], "Attractions in the Galleries," *Sun*, April 27, 1935.

51 "Museum of Folk Arts Exhibits: 30,000 Objects Comprise a Wealth of Material for Comparative Study," *New York World-Telegram*, April 27, 1935.

52 Carl Greenleaf Beede, "A Folk Arts Museum of Many Nations," *Christian*

Science Monitor, June 1, 1935.

53 Alfred Barr, Jr., to Frederick Keppel, October 30, 1935, NP.

54 "Mayor to Receive School Art Medal," *New York Times*, July 19, 1936; "Mayor Foresees U.S. Leading in Art," *New York Times*, July 22, 1936.

55 "Mayor Foresees U.S. Leading in Art."

56 List compiled by Charles Ritchie, National Gallery of Art, Washington, DC, February 14, 2011. Nadelman's employment as master artist beginning May 22, 1936, is documented in the Phyllis Crawford papers concerning the Index of American Design, reel NDA 3, AAA.

57 Clayton 2002, 1–6, 19–32.

58 Frederick Keppel to Viola Nadelman, October 8, 1936, NP.

59 Elie Nadelman to Nelson A. Rockefeller, May 27, 1937, NP.

60 Idem, July 3, 1937, NP.

61 Elie Nadelman to Henry Francis du Pont, October 19, 1931, Henry Francis du Pont papers, box 361, Winterthur Library, Winterthur, DE. For the kas, see Wallace Nutting, *Furniture of the Pilgrim Century, 1620–1720* (Boston: Marshall Jones, 1921), 148, ill.

62 Henry Francis du Pont to Elie Nadelman, October 21, 1931, Henry Francis du Pont papers, box 361, Winterthur Library, Winterthur, DE. Du Pont ultimately returned the Windsor armchair, claiming he was unable to find the right place for it.

63 Viola Nadelman to Edith Halpert, June 20, 1932, Downtown Gallery papers, AAA.

64 Stillinger 2011, 236–53.

65 Oral history interview with Halpert by Harlan Phillips, AAA.

66 Rumford 1988, 68–69, 96, 258–59, nos. 41, 61, 211, ills.

67 Beatrix T. Rumford, ed., *American Folk Portraits: Paintings and Drawings from the Abby Aldrich Rockefeller Folk Art Center* (Boston: New York Graphic Society in association with the Colonial Williamsburg Foundation, 1981), 278–79, no. 282, ill.

68 For instance, Webb purchased several ex-Nadelman weathervanes (Shelburne Museum, Shelburne, VT, FW-5, FW-6, FW-26) from John Kenneth Byard, a Norwalk, CT, dealer, in the late 1940s.

69 The Brummer Gallery Records, The Metropolitan Museum of Art Libraries & The Cloisters Library, N790, N2980–2993ab. Among the returns was an ancient Egyptian stone lion, which the Brooklyn Museum acquired in 1933 (Brooklyn Museum, New York, 33.382a-b), as well as a wrought-iron balcony and *aumônière* (alms purse) purchased by master blacksmith Samuel Yellin the same year.

70 Ibid., X631, X637, X638. She consigned a seventeenth-century English embroidered bonnet; an ancient Egyptian wooden statue of a winemaker, purchased in October 1932 by the Buffalo Museum of Science; and a Byzantine bronze lamp.

71 Ibid., N3078–3086, N3087a–h, N3088–3091, N3093, N3097–3100, N3147–3152.

72 See nn. 68, 69. In addition, a Roman mosaic of a bird (N3903) was sold to the Rhode Island School of Design, Providence, RI, 38.058.21; an Egyptian bas-relief (N2982) to Mead Art Museum, Amherst College, 1942.77; an iron lock (N3098) and box (N3099) to the Metropolitan Museum of Art; and two marble columns (N2983, N2984) to the City Art Museum (today the Saint Louis Art Museum), Saint Louis, MO. Several pieces of Coptic material (N3087c, N3087d, N3087e) were sold to George H. Myers, who founded the Textile Museum, Washington, DC, 71.59, 71.52, 71.53.

73 Elie Nadelman to Edith Halpert, October 8, 1936; Edith Halpert to Elie Nadelman, February 9, 1937, Downtown Gallery papers, AAA. Halpert's original commission was set at 10 percent but was negotiated up to 12½ percent.

74 Viola Nadelman to Edith Halpert, November 2, 1936, Downtown Gallery papers, AAA.

75 Elie Nadelman to Edith Halpert, January 9, 1937, Downtown Gallery papers, AAA.

76 Edith Halpert to Elie Nadelman, November 27, 1937, Downtown Gallery papers, AAA.

77 Faith Andrews to Viola Nadelman, October 6, 1937, NP.

78 Lillian B. Wall, *Entre Nous: An Intimate Portrait of Alexander J. Wall* (New York: New-York Historical Society, 1949), 145.

79 Alexander J. Wall, "Time Stone Farm, 1702–1936," *New-York Historical Society Quarterly Bulletin* 20:2 (April 1936): 35–53.

80 Wall, *Entre Nous*, 163–75. Coincidentally, the Historical Society's wings were designed by Walker & Gillette, the firm that undertook the renovation of the Nadelmans' home on East Ninety-third Street and in 1929 designed the Fuller Building at 41 East Fifty-seventh Street, featuring Nadelman sculptures on its façade.

81 Minutes of the New-York Historical Society, November 16, 1937, N-YHS Archives.

82 Viola M. Nadelman deposition, State of New York, County of Bronx, January 4, 1940, N-YHS Archives. The

creditor was the Manhattan Financial Corporation.

83 Wall, *Entre Nous*, 166.

84 "Folk Art Bought For Display Here," *New York Times*, January 24, 1938; "New York: Folk Art Purchased by the New York Historical Society," *Art News* 36:19 (February 5, 1938): 17; "Nadelman's [*sic*] Folk Art," *Art Digest* 12:11 (March 1, 1938): 15; [Homer Eaton Keyes], "The Nadelman Folk Art Collection," *The Magazine Antiques* 33:3 (March 1938): 152.

85 [Keyes], "The Nadelman Folk Art Collection," 152.

86 Alexander J. Wall to Elie Nadelman, September 17, 1938; George Zabriskie to Elie Nadelman, September 19, 1938, N-YHS Archives. Nadelman apologized to Zabriskie for his "lack of restraint" in discussing the issue with the Museum committee and thanked him for his "magnanimity." Elie Nadelman to George Zabriskie, September 20, 1938, N-YHS Archives.

87 N-YHS 1938.61.

88 Robert W. Brown, "City's Newest Museum," *New York Times*, March 26, 1939; "Historical Society to Reopen Museum," *New York Times*, March 30, 1939.

89 Alexander J. Wall to George Zabriskie, April 12, 1939, N-YHS Archives.

90 The bill of sale conveying the collection, signed by Elie Nadelman on January 18, 1938, includes an itemized list of 14,492 "pieces" grouped by collection category; N-YHS Archives. Curiously, a tally of the collection organized by country of origin done by Elie a year earlier totaled only 5,360. Elie Nadelman to Edith Halpert, January 9, 1937, Downtown Gallery papers, AAA.

91 Objects not accessioned in 1937 were assigned inventory numbers during a comprehensive inventory of the N-YHS collection made in the late 1980s. Many objects have been retroactively assigned a Nadelman provenance based on the distinctive MFPA label found on them. Currently, just over 1,700 N-YHS objects are identified with a Nadelman provenance, although that number continues to grow as links are made between N-YHS objects and MFPA records.

92 Minutes of the New-York Historical Society, October 19, 1943, N-YHS Archives.

93 Memorandum, Donald A. Shelley to Alexander J. Wall, July 30, 1943, N-YHS Archives.

94 Parke-Bernet 1943a, lots 184–246. The consignor of the lots was identified as "a N.Y. State educational institution." Dealer Joseph Brummer purchased

four lots—200, 211, 217, 246—that he had originally sold to Elie Nadelman.

95 Parke-Bernet 1943b, lots 1–235. The consignor of the single owner sale was identified as "an Eastern educational institution." Additional Nadelman objects were later sold at Parke-Bernet Galleries, New York, December 8–9, 1961, lots 1–5, 33–62, 308–10, 312–13; Parke-Bernet Galleries, New York, December 15–16, 1961, lots 14–65, 105, 107, 115; Parke-Bernet Galleries, New York, "French, English & Other Decorative Furniture," March 17, 1962, lots 92–94, 128, 131, 134, 138, 140, 149, 160, 168, 173, 175; William Doyle Galleries, New York, "Americana," April 16, 1986, lots 132, 144A, 147, 149, 151, 155, 158, 163, 195, 198, 201, 227, 232, 241, 242, 283, 596, 600, 617; William Doyle Galleries, New York, "Important 17th & 18th Century English & Continental Furniture and Decorations," May 7, 1986, lots 93, 104; Sotheby's, New York, "Americana and Decorative Arts: The Property of the New-York Historical Society," January 29, 1995, lots 248–52, 255–56, 258, 292–95, 297–300, 302–3, 313, 324–34, 336, 343. Altogether, 1,840 Nadelman items were deaccessioned.

96 Notes for Elie Nadelman chronology, Lincoln Kirstein papers, box 28, folder 275, Jerome Robbins Dance Division, The New York Public Library for the Performing Arts.

97 Viola Nadelman to Henry Francis du Pont, June 21, 1948, Henry Francis du Pont papers, box 361, Winterthur Library, Winterthur, DE.

98 Alexander J. Wall to George Zabriskie, April 12, 1939, N-YHS Archives.

99 N-YHS 1937.1401.

100 Olson 2008, 169–71, 140–41, 345–47; Claudia Mooney et al., "African-American Face Vessels: History and Ritual in 19th-Century Edgefield," *Ceramics in America*, ed. Robert Hunter (Hanover, NH: Chipstone Foundation distributed by University Press of New England, 2013), 2–37; Bruno Girveau and Dorothée Charles, *Des jouets et des hommes*, exh. cat. (Paris: Éditions de la RMN-Grand Palais, 2011), 106, 144, 221, 292, cats. 41, 161, 220, 298, 510, 577.

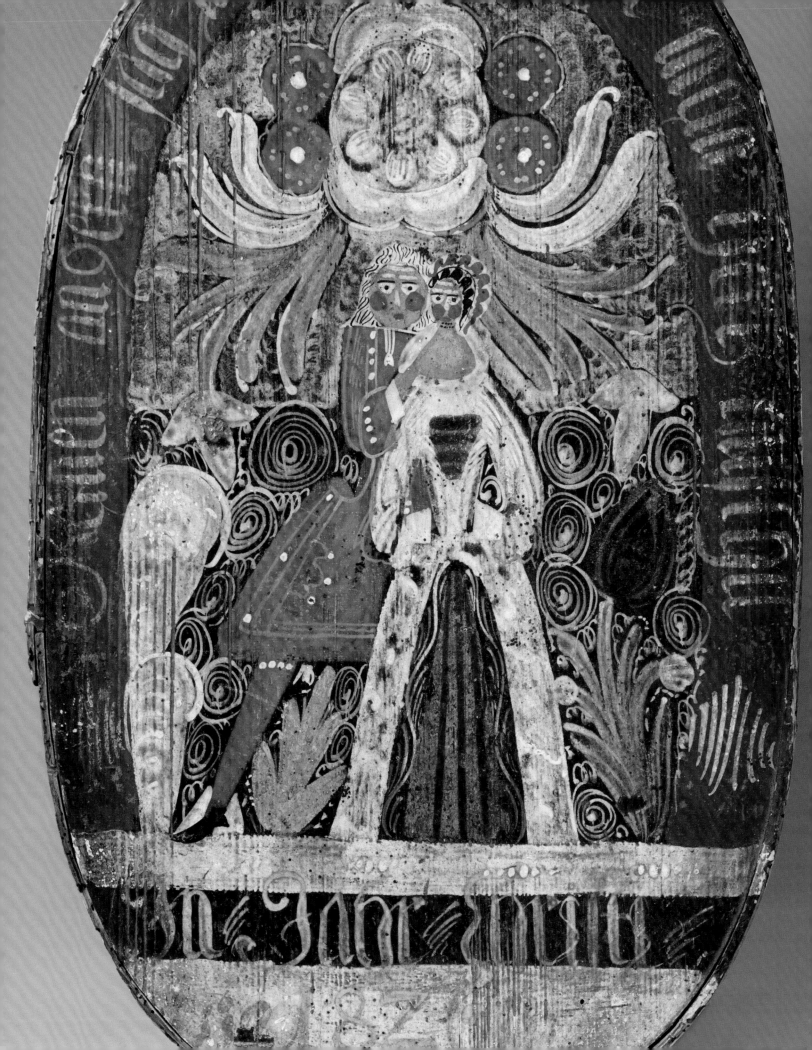

THE NADELMANS IN CONTEXT: EARLY COLLECTORS OF FOLK ART IN AMERICA

Elizabeth Stillinger

It seems that when he arrived in the United States in 1914 Elie Nadelman had not yet begun to collect.[1] He was occupied entirely with his art and it was not until his 1919 marriage to Viola Spiess Flannery that he took up collecting. It would become an obsession. Viola had been gathering antique laces and textiles since her youth, and her enthusiasm no doubt encouraged her husband to join her in collecting antique furnishings and decorations for their two homes, bought in 1921—the townhouse at 4–6 East Ninety-third Street in New York City and the Victorian mansion situated on a rise above the Hudson River in Riverdale, New York.

There were few collectors' clubs in New York when the Nadelmans began their pursuit, but it is doubtful that Elie would have been an active participant even if more clubs had existed, for he seems to have been a loner with respect to creating both his art and his and Viola's collection. "Even in his youth," wrote his granddaughter, "Nadelman never required or wanted much feedback from fellow artists . . . and in the end he kept his own counsel."[2] This was apparently true as well of Nadelman the collector, for although he belonged to numerous artists' organizations and in 1923 was on the board of the Modern Artists of America with folk art collectors Yasuo Kuniyoshi and Bernard Karfiol, there is no evidence that he went on collecting excursions either with them or with other artist-collectors. Nor does it appear that Nadelman had social contacts with fellow collectors based on shared collecting interests.[3]

Viola may have been the one who shared the collecting habit with others. She was a founding member in 1916 of New York's Needle and Bobbin Club, whose membership was, according to the *New York Times*, "composed chiefly of prominent New York women, collectors of fine old laces."[4] Some years later the *Times* expanded on this description, stating that club members expressed "a most sophisticated interest that leads [them] into fascinating bypaths of art, history, geography, and folklore."[5] Viola's attraction to antiques is also indicated by her participation in the "antique department" of the Red Cross Shop, which was set up in 1918 to raise money for the care of wounded soldiers and sailors in New York hospitals.[6] In 1936, Viola was described as "one of the most active in the assembling and installation" of an exhibition of Nantucket folk art at the headquarters of the National Committee on Folk Arts of the United States.[7] And it was she who assumed the responsibility of arranging and caring for the objects in the Nadelman museum and greeting visitors when the collection outgrew the couple's two houses and required space of its own.[8]

Perhaps the first of the Nadelmans' joint collecting ventures was that of colored glass animals, birds, and other glass forms. The dates of these objects ranged over several thousand years, and they came from all the European countries and the United States, according to an account of 1925. The collection, stated the account, was "beautifully arranged in glass cases built in the wall of the handsome dining room" of the Nadelmans' townhouse (figs. 6, 29).[9] It is not known whether the newly married couple was inspired to collect antique glass by displays at

Detail of cat. 31

Fig. 29
Glass shelves displaying glass objects in the dining room of the Nadelmans' New York townhouse, 1925. From *Antiquarian* 3:6 (January 1925), frontispiece

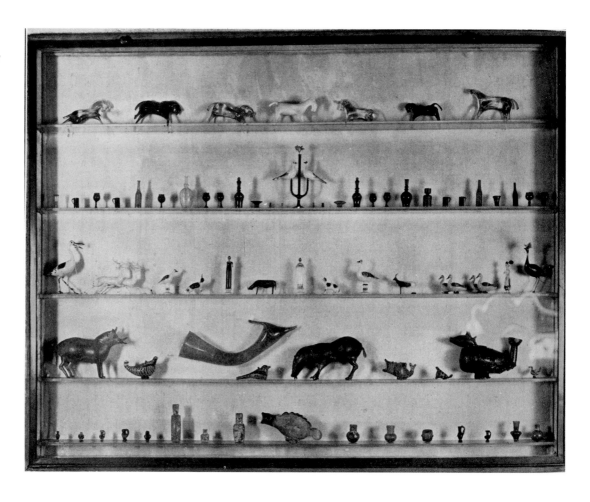

Beauport, Henry Davis Sleeper's atmospheric summer home beside the harbor in Gloucester, Massachusetts, where they spent the summer of 1920. But among the captivating arrangements of folk and decorative art at the collector and interior designer's home were old mullioned windows containing glass shelves full of venerable colored glass articles (fig. 30).[10]

After he arrived in New York, Elie attended Sunday at-home parties given by Hamilton Easter Field and his mother at their Brooklyn residence on Columbia Heights overlooking the East River and lower Manhattan.[11] Field was a painter, critic, teacher, patron and supporter of younger painters, particularly after founding his Ogunquit [Maine] School of Painting and Sculpture with his adopted son Robert Laurent in 1911. At Field's gatherings, Nadelman would have met most, if not all, of the artist-collectors who joined Field and Laurent at their summer school, many of whom were enthusiastic collectors of folk art. Field himself was a passionate acquisitor of a wide range of objects. When he returned in 1902 from almost a decade in Europe, he brought with him a large group of Japanese prints, Chinese stone rubbings, other Asian works including paintings on silk, bronzes, pottery and porcelain,

"and, indeed, anything that took his fancy and did not cost too much money."[12] Field's mother was sometimes skeptical of the value of the things he spent money on, and a reporter recalled that "After a new find he would return, if possible, after dark. One night he was trying to enter unseen by way of the basement steps, with a Chinese plate he had found somewhere for $10, when he stumbled and fell. His hat was ruined, but the plate was intact. The first thing he said when the noise caused him to be discovered was, 'Don't tell my mother about the plate.'"[13]

We know from auction catalogues, and a few written descriptions, that in his Columbia Heights home Field displayed folk and vernacular pieces such as ladder-back and Windsor chairs, schoolgirl samplers, folk pottery, and the hooked rugs to which he was particularly partial. After his untimely death of pneumonia at the age of forty-nine, in 1922, his estate auctioned antique American mahogany furniture in a variety of styles along with Windsor chairs; antique French and Italian furniture; sixteenth- and seventeenth-century Flemish and Aubusson tapestries; twenty-one "Early American" hooked rugs (fig. 31); English, American, Japanese, and Chinese pottery and porcelain; and a small group of antique French and Italian carved wood picture frames. His hundreds

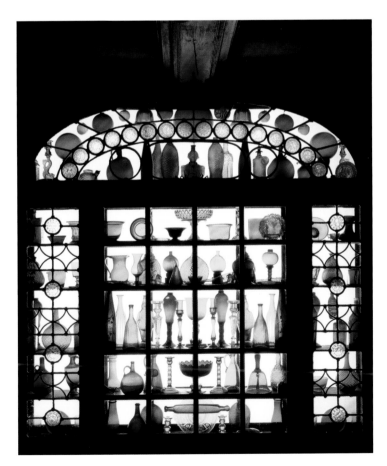

Fig. 30
Old Connecticut Valley doorway fitted with glass shelves to display glass objects at Henry Davis Sleeper's Beauport, Gloucester, MA, before 1934

Fig. 31
Unknown maker, hooked rug displaying the name "Jⁿ Tapley," 19th century; 59 × 24 in. (149.9 × 70 cm). From American Art Association, New York, "Antique Furniture, Rugs, Tapestries, and other Art Property, Collected by the Late Hamilton Easter Field," December 5, 1922, lot 192

of Japanese and Chinese colored prints, "rare Japanese paintings and screens," and paintings by Field himself were offered at other sales later the same week in December 1922.[14]

The mixture of art of diverse styles and origins that characterized Hamilton Field's house would not have seemed foreign to Elie Nadelman, for during his years in Paris he had seen a similar blending of furnishings and art of different kinds at the salons of Gertrude and Leo Stein (fig. 57). The Steins combined European Renaissance-style furniture with pieces of African sculpture, Japanese prints, and the modern art being produced by friends such as Henri Matisse, Pablo Picasso, and Nadelman himself. However, the Steins did not intersperse folk art among their solid, rectilinear chairs and tables as Field did. Therefore, Nadelman may have first seen, in Field's interiors, the notes of simplicity of form and color and the whimsy that such commingling could provide.

It is likely that Nadelman was influenced by Field for they had similar ideas about art, formed by study and work in Europe. Nadelman left his native Poland in 1904 for Munich, where he studied for six months before moving on to live and work in Paris from 1904 until 1914, when he emigrated to America. Field moved from Brooklyn to Paris in 1894 and lived there until 1902, traveling widely on the continent. After 1902, he frequently went back and forth between Europe and the United States. "There is no interest which so enriches a people as art," he wrote in the introduction to the first number of the *Arts*, the magazine he founded in 1920. "It brings into the lives of men happiness, peace, sanity. An interest in art running through all ranks of life and all nations would be more efficacious in preventing war than the pledges of a thousand diplomats."[15] Nadelman agreed and his belief in art as something everyone should enjoy is evident in the choice he made to collect folk art—the art of everyone—and in the little plaster, clay, and papier-mâché figures he created at the end of his life with the idea of making them available, if not to everyone, at least to all people of moderate means.

Field also held that art should not be viewed as a national phenomenon: "I believe that few love this country more than I do," he wrote. "Yet I would consider myself untrue to the principles for which my ancestors sought refuge in America if I should praise a work of art more than I would otherwise have done because it was made in this country of ours."[16] Field's point would have resonated especially loudly

with Nadelman, for he and Viola, alone among the collectors of their generation, chose to collect both European and American folk art so that the European could be studied as background for the American pieces and could be compared and contrasted. "The whole purpose of our Museum," wrote Viola in 1949, was "the showing of the derivation of the American folk arts from the European."[17]

The Nadelmans' decision to focus on folk art set them apart from acquisitors like Field and other encyclopedic collectors such as Alexander W. Drake of New York, art editor of the *Century* and *St. Nicholas* magazines, who counted among his many holdings some objects that fall into the formal category and others that fall into the folk (fig. 32). Among the latter were schoolgirl samplers, wallpaper-decorated hatboxes and bandboxes, birdcages, and decorative brass and copper vessels from North America, Europe, and the Near East. The tribute a friend paid Drake after his death stands as an evocative description of the educated, wide-ranging, well-traveled collectors of the late nineteenth and early twentieth centuries who included folk art objects among their possessions:

> Some tint or grace of line in the commonest article of daily use made it for him a treasure. A bit of cheap fabric he recognized as a picture; an old band box in an attic he found to be precious, not only for its breath of romance but often for some refinement of color or quaintness of design; a crude, faded signboard was to him a rare decoration, discarded bottles in an ash-heap were as jewels in a matrix—he could not pass them by. Furbished and skilfully placed in his beautiful home, visitors likewise were led to appreciate the super-value of these things—to see in a case of variegated glass shapes, with the light shining through, a glory of hue, and tint, and form hitherto undreamed.[18]

Another set of New York interiors, those of the Stettheimer sisters, Carrie, Florine, and Ettie, very likely influenced Elie—and possibly Viola as well. The sisters and their mother, Rosetta, presided over an avant-garde salon that drew a dazzling assortment of artists, writers, and musicians, both European and American, but all of the modernist persuasion. Although they did not collect folk art—the Stettheimers' taste was for formal European antiques—they did collect works by their modernist artist friends, some of whom were influenced by folk and tribal art. Their apartment at 102 West Seventy-sixth Street was also hung with paintings by Florine, whose work shared a number of characteristics with folk art—brilliant undiluted colors, simplified shapes, and indifference to consistent perspective (fig. 33).[19]

Among the guests were a few who would, like the Nadelmans, become antiques and folk art collectors—Louis Bouché, Charles Demuth, Gaston Lachaise and his wife, Isabel, and Marguerite and William Zorach. When the Zorachs came into a little money in 1923, Isabel and Gaston Lachaise told them of a sea captain's house on Georgetown Island, Maine, where they lived. The Zorachs bought the

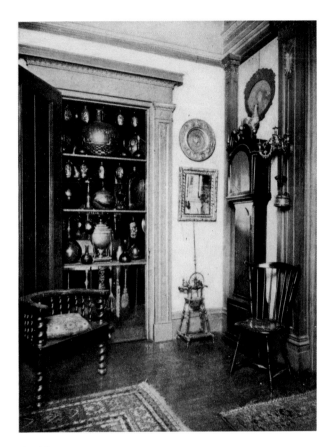

Fig. 32
"A Doorway Bottle-Cabinet" in the home of Alexander W. Drake, before 1916. From Alexander W. Drake, *Three Midnight Stories* (New York: Century, 1916), opp. p. 70

house and Marguerite and Isabel became rivals at local antiques sales and auctions. Marguerite was an enthusiastic collector of, among other things, simple country furniture, hooked rugs, and bright, cheerful spatterware pottery.

What Field, the Stettheimers, the Zorachs, and the Nadelmans had in common was the desire to use the objects they collected to express their views of art and life. For omnivorous collectors like Field and Drake, blending folk and vernacular pieces with high-style works made the point that beauty can be found in the simplest, most unpretentious objects and does not depend on academic training or skills or the possession of wealth. For the Zorachs, hand-made folk and vernacular objects were much cheaper than new furnishings and more colorful and decorative as well. Marguerite spoke of returning from Paris in 1912 "full of enthusiasm over the world of lively color the Fauves had discovered for me," and she found woolen yarns much more brilliantly hued than paint. She began to create tapestry pictures with vividly colored yarns and to make hooked rugs, and as well to collect the old rugs she found all about her in Maine.[20]

The artists who gathered around Field at his and Robert Laurent's summer school were motivated to collect folk art, as the Zorachs were,

because it was readily available in the neighborhood and because it was attractive and cheap. But they were further motivated by a desire to establish a connection with earlier American artists and by a feeling of kinship with those artists' sensibilities and techniques. However, the Ogunquit artists who collected what we would today describe as folk art did not at first use the term for their simple furniture, hooked rugs, decoys, weathervanes, and anonymous portraits. The first exhibition of American folk art objects came from the collections of several Ogunquit artists who were also associated with the Whitney Studio Club in New York. Curated by artist Henry Schnakenberg and held at the club in February of 1924, the exhibit was entitled *Early American Art*. Among the artists who lent to it were Yasuo Kuniyoshi and his first wife, Katherine Schmidt; Alexander Brook and his first wife, Peggy Bacon; and Dorothy Varian, of the Ogunquit group; Charles Sheeler, who was a regular at the Whitney Studio Club; and Juliana Force, who was the club's director. Unlike the Nadelmans who, with their European backgrounds, referred to the objects in their collection as "folk art" from the beginning, the Ogunquit artists and their friends did not do so until the early 1930s.[21]

Sheeler began to acquire simple furniture, hooked and rag rugs, and other objects that may be considered folk art when he rented an old stone house near the collector Dr. Henry Mercer in Doylestown, Pennsylvania, in the 1910s. The artist later discovered and collected Shaker furnishings, which appear in his photographs and paintings of interiors, such as *American Interior* of 1934.[22] Juliana Force started her collection of folk art for Barley Sheaf Farm, her old stone farmhouse in Holicong, Pennsylvania, after she and her husband bought it in 1914. As her biographer Avis Berman writes, she furnished it with "Portraits by self-taught limners, theorem paintings on velvet copied by schoolgirls, fanciful etchings of historical incidents, vernacular furniture fashioned by a local artisan or whittled by a tramp who happened to be passing through, quilts, whirligigs, cigar-store Indians, hand-carved toys, the odd article of homely whimsy—Juliana had an eye for them all."[23] Like Field and many of the Ogunquit artists, Force took some folk art with her when she returned to the city. Her apartment above the Whitney Studio Club was furnished with an artful blend of Victorian, modern, and folk art pieces. Mrs. Force took passé nineteenth-century Rococo Revival furniture, reupholstered it in red and pink satin, and combined it with paintings by, among others, Picasso, Sheeler, and J.A.D. Ingres, plus an assortment of anonymous American folk painters. Here was a tour de force of interior design, and it proclaimed its creator's imagination, humor, and progressivism. Force elevated folk art to the level of the fine arts by hanging it together with serious nineteenth-century and modern works.

In deciding to focus their collecting energies on folk art, Elie and Viola's motives were much closer to those of Juliana Force than to those of most of Elie's fellow artists. Whereas the Ogunquit artists and their friends were looking for an American artistic tradition to tap into and to join, Elie had no such need. According to interviews the couple gave

Fig. 34
Unidentified French maker, cupboard
in Gallery IV of the MFPA, sixteenth or
seventeenth century. Oak; 52 × 49½
in. (132.1 × 125.7 cm). NP

Fig. 35
Corner of Gallery IV of the MFPA
containing American and European
equipment for drying candles and
paring apples. NP

from 1926 on, after the Museum of Folk and Peasant Arts opened, their collection was important for its aesthetic qualities. "Every one of these thousands of articles," they told a reporter, "has been selected with [aesthetic value] in view."[24]

Another vitally important reason for the Nadelmans' collecting was to show the European origins of American folk art (fig. 34), a point so significant to Viola that she had it included in her obituary.[25] This also distinguished the Nadelmans from many of their artist contemporaries, who were looking for what was *American* about American folk art rather than what was universal, or related to the Old World. It is important to note, however, that ethnologically oriented collectors like Henry Mercer of Doylestown and Edwin AtLee Barber of Philadelphia, were more likely to acknowledge European antecedents and connections than such artists as Sheeler, Kuniyoshi, and many of their contemporaries.[26]

Showing the original uses of functional but now outmoded objects was another goal of the Nadelmans in their museum exhibits (fig. 35). They displayed cake prints, for example, along with dough that had been pressed into the mold and then released so that viewers would understand the process (see cat. 71). Their two pharmacies—one American, one French—were set up with a similar goal in mind: to show the differences between such early facilities and presentday models, and to compare American and European versions (see figs. 10, 16). Others contemporary with the Nadelmans who were concerned with the original uses of the objects they collected include Drs. Mercer and Barber and Dr. Barber's collecting colleague at the Pennsylvania Museum, Sarah Sagehorn Frishmuth; the Landis brothers (Henry Kinzer Landis and George Diller Landis), who founded the Landis Valley Museum, a few miles outside Lancaster, Pennsylvania; Nina and Bertram K. Little of Boston and Essex, Massachusetts; Faith and Edward Deming Andrews of Pittsfield, Massachusetts; and Edna Greenwood of Marlborough, Massachusetts. So far as I am aware, the Nadelmans knew none of these collectors, with the exception of Faith and Edward Andrews and Edna and her husband, Dr. Arthur Greenwood, whom they did not meet until 1935 or 1936. In 1935, a grant from the Carnegie Corporation reopened the museum, which the Nadelmans had been forced to close as a result of their losses in the stock market crash. The grant garnered wide publicity and the Andrews and Greenwood couples presumably visited after reading about the museum's reopening.[27]

Edna Greenwood was a collector whose love of her objects and the environment she created with them perhaps came closest to the feelings the Nadelmans had for their museum and its contents. A friend wrote of her, "Edna loved with a deep fierce love each item in her collection almost as a mother loves a child."[28] She began collecting while she was a student at Smith College, venturing out into the countryside around Northampton, Massachusetts, to visit with the "old folks," as she called them, on the farms there. After her graduation and marriage in 1911, she continued to collect for the farmhouses that she and her growing family occupied, focusing on simple early furnishings and the tools and

implements of the pre-industrial age (fig. 36). She frequented local antiques shops and house sales and was drawn particularly to "things no one could identify. These intrigued me. I bought them to find out what they were."[29]

Greenwood was clearly delighted with the Nadelmans and considered them kindred spirits: correspondence in the Nadelman Papers indicates that she thought of them with affection and valued her connection with them. She wrote in December of 1938, "what is happening to the darling things[?] Meanwhile our affectionate greetings to you both. Tho' we've only seen you once and a half we have known you a long time."[30] When the Carnegie Corporation refused to renew its grant in 1937, Edna became crucially important to Elie and Viola by connecting them with her friend Alexander Wall, director of the New-York Historical Society, who bought the Nadelman collection for the N-YHS late that year.[31]

In the report of the board of trustees for the year 1937 the Historical Society declared that the Nadelmans' "outstanding museum of 14,492 objects is undoubtedly America's leading collection of folk arts, and the first to be shown publicly in New York, if not in America," pointing out that it contained twenty-six different types of objects made of wood, metal, glass, ceramics, stone, and fabric.[32] The size of the collection, to say nothing of the broad range of objects contained in it, sets it apart from any other folk art collection of its period—or of any other period. No one before or since has attempted this sort of sweeping survey of the folk art of Europe and North America.

To accomplish their extraordinary task, the Nadelmans devoted nearly all their energy to collecting and to caring for the collection from the early 1920s until they parted with their treasures in late 1937. They visited antiques shops near and far, took numerous road trips, corresponded with dealers at home and abroad, and traveled to Europe on several occasions. Although dealers frequently wrote to offer them antiques, the Nadelmans seem to have had only one scout out looking on their behalf: Florence Ballin Cramer, an artist married to Konrad Cramer, who was also a progressive artist. The Cramers lived in Woodstock, New York, and during the 1920s Florence scoured the neighborhood for antiques and folk art. She apparently sent the best of her finds to Viola Nadelman, who purchased most of them.[33]

The Nadelmans' European trips were accomplished in great style. They booked three staterooms for their passage over and back and took their son, Jan, his nurse, and a maid, staying for months at a time. The itineraries for these trips must be pieced together from auction and antiques shop receipts, dealers' business cards, and Viola's detailed expense accounts, as there are no other records of them. In Europe, as in America, they traveled in a chauffeured car.[34]

Folk art had been of particular interest in northern Europe since the second half of the nineteenth century, so there were many museums displaying it and many dealers from whom it could be purchased. The best-known folk museum was named Skansen, an outdoor institution founded in Stockholm in 1891 by Artur Hazelius. The outdoor Norsk

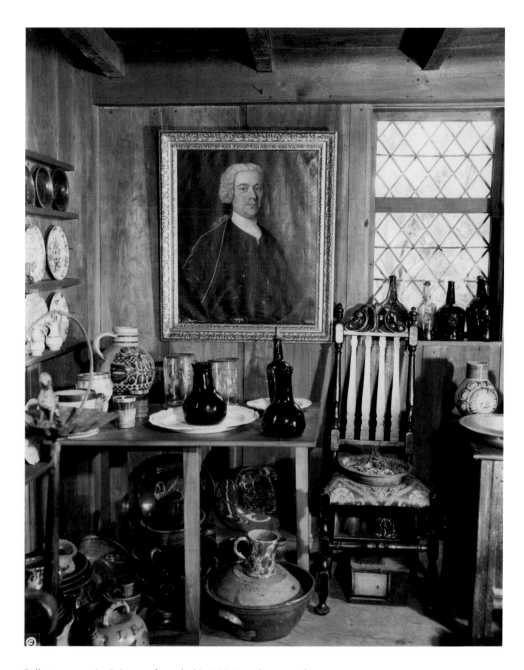

Fig. 36
Great Room, Time Stone Farm, home
of Edna and Arthur Greenwood,
Marlborough, MA, ca. 1965

Folkemuseum in Oslo was founded in 1894, and many other museums
containing folk material were scattered throughout the Continent. Both
Elie and Viola had occasion to visit museums when they lived in Europe
during their youths, but their trips during the 1920s enabled them to
travel to places they had not visited before and to focus particularly
on folk art. They told a reporter that "more than sixteen countries are
represented" in their folk art museum and a publicity release found
among the Nadelman Papers lists the collection's sources in the United
States, England, France, Italy, Germany, Spain, Switzerland, Hungary,
Poland, Czechoslovakia, Romania, Yugoslavia, and the Scandinavian
countries. "Nowhere else," states the release, "can there be found such
a wealth of material for comparative study."

It seems likely that folk art displays in European museums provided
models for the MFPA because a comparison of early twentieth-century
photographs of galleries there and in the Bayerisches Nationalmuseum
and the Norsk Folkemuseum indicate similar approaches to display
design (figs. 37, 38). [35] That the Nadelmans were successful in arranging
their exhibits is proved by the tribute they received from Henry Francis
du Pont, perhaps the greatest American collector-connoisseur of the

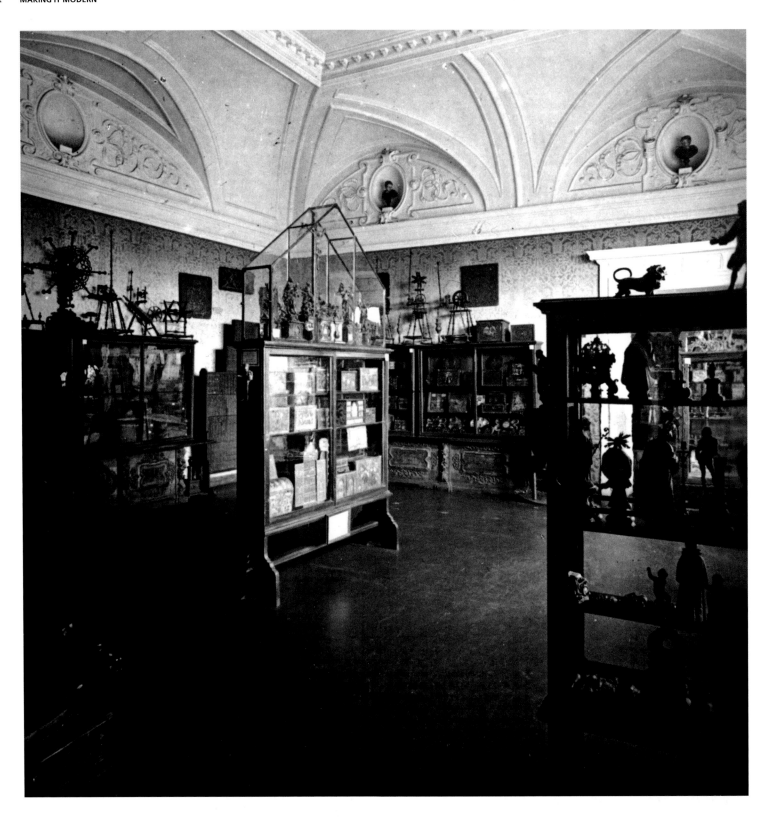

Fig. 37
Gallery containing spinning
equipment at upper left and wax
figures and their molds in right
foreground, early twentieth century,
Bayerisches Nationalmuseum, Munich

twentieth century: "I cannot begin to tell you what an inspiration it was to see your collection. The way Mrs. Nadelman has arranged it was so artistic. I hate to think that you have to dispose of some of these lovely things, as they do make such an interesting collection assembled as they are."[36]

Parting with their collection was probably the hardest thing Elie and Viola ever did, for it had become the center of their lives, and it represented the embodiment of all their ideas about art and life. As with all collections, it ceased to be theirs and fully to represent their ideas after it left their premises. Elie, who was appointed curator of the collection as part of the sale agreement with the N-YHS, struggled with the administration over many details concerning his hours of work and the placement of the collection in the Historical Society's new building, but he could not come to a satisfactory arrangement and therefore was eventually let go (see Olson Hofer essay, p. 35).

Nadelman continued to work on his small sculptures and to collect, confining himself, according to his wife, "to the assembling of American antiques exclusively, and he has left a considerable collection . . . of Penna [Pennsylvania] fracturs and birth certificates, about 110 . . . [and] a collection of Penna pottery and many other objects."[37] After their sale to the Historical Society, the Nadelmans accepted the fact that they had to sell things occasionally in order to buy others. With Elie's death in 1946, Viola's enthusiasm for collecting waned and she began to deaccession objects from the second collection rather than adding to it. The couple had been selling to Edith Halpert for the American Folk Art

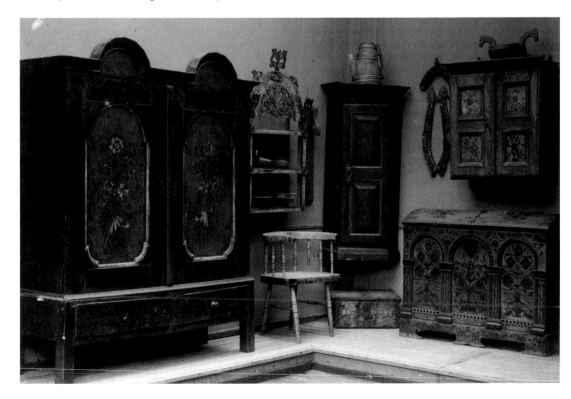

Fig. 38
Furniture gallery, 1927, Norsk Folkemuseum, Oslo

Gallery as well as buying from her since the early 1930s and Halpert had passed many things with a Nadelman provenance along to Abby Aldrich Rockefeller, whose folk art collection may now be seen in Williamsburg, Virginia. But the Nadelmans also did business with collectors who came to them directly—most significantly, Stephen Clark and Louis Jones for the New York State Historical Association in Cooperstown (NYSHA) (cats. 12, 15, 16). Maxim Karolik, collecting for the Museum of Fine Arts, Boston (cat. 23), and Electra Webb, for the Shelburne Museum in Vermont (fig. 39), may also fall into this category.[38] So in the end, although they were deprived of the pleasure of presenting and sharing their collection in their own museum, Elie and Viola *have* shared their collection—with the New-York Historical Society and with museums from Vermont to Virginia. Although it is not the legacy they hoped to leave, it remains a legacy for which we will all be forever grateful.[39]

Fig. 39
Unknown maker, Indian Archer weathervane, 1810–60. Sheet iron, copper, paint; 60 in. (152.4 cm) high. Shelburne Museum, Shelburne, VT, 27.FW-5, 1950-290.1, ex coll. Elie and Viola Nadelman

1 For a fuller discussion of the development of Elie and Viola Nadelman's folk art collecting, see Oaklander, 1992; Stillinger 1994; Stillinger 2011 as well as Olson Hofer essay, pp. 11–39.

2 Cynthia Nadelman, "The Shocking Blue Hair of Elie Nadelman," *American Heritage* 40:2 (March 1989): 91.

3 For more on Kuniyoshi and Karfiol as folk art collectors, see Stillinger 2011, 159–69.

4 *New York Times*, November 30, 1919.

5 Ibid., January 26, 1936.

6 Ibid., December 8, 1918.

7 Ibid., January 19, 1936.

8 For a description of the museum's operation and Viola Nadelman's role there, see the Olson Hofer essay, pp. 17–30, and Cynthia Nadelman essay, pp. 100–2.

9 "Fantasies in Glass: Nadelman Collection of Animals and Birds," *Antiquarian* 3:6 (January 1925): frontispiece, 5–7.

10 For more on Sleeper, see Samuel Chamberlain and Paul Hollister, *Beauport at Gloucester, the Most Fascinating House in America* (New York: Hastings House, 1951); David Bohl et al., *Beauport: The Sleeper-McCann House* (Boston: David R. Godine in association with the Society for the Preservation of New England Antiquities, 1990); Stillinger 2011, 256–66.

11 Field's mother was Lydia Seaman Haviland Field; information about Field is from Doreen Bolger, "Hamilton Easter Field and His Contribution to American Modernism," *American Art Journal* 20:2 (1988): 79–97; Wendy Jeffers, "Hamilton Easter Field: The Benefactor from Brooklyn," *Archives of American Art Journal* 50:1–2 (Spring 2011): 26–37; Stillinger 2011, 159–69.

12 Laurie Eglington, "Current Exhibit Revives Memory of Noted Figure: Art Foundation Vividly Recalls the Many-Sided Personality of Mr. Hamilton Easter Field, Artist, Critic and Patron," *Art News*, October 13, 1934, 5.

13 Ibid.

14 American Art Association, New York, "Catalogue of the Antique Furniture, Rugs, Tapestries, Curios, Antiquities, and Studio Effects Collected by the Well-Known Artist, Art Critic, and Editor of 'The Arts,' the Late Hamilton Easter Field," December 5, 1922. The sales of the prints, screens, and paintings were held at the American Art Galleries on December 6–8, 1922.

15 Eglington, "Current Exhibit," 10.

16 Ibid., 13.

17 Viola Nadelman to Mr. Jaeger, January 31, 1949, NP.

18 Alexander W. Drake, "A Memory," *Three Midnight Stories* (New York: Century, 1916), xii–xiii. The author might have been talking about the Nadelmans' multi-hued glass figures displayed on glass shelves in the dining room of their New York townhouse or Henry Sleeper's colored glass bottles exhibited on glass shelves fitted into mullioned windows at Beauport.

19 Florine's 1918 painting *Picnic at Bedford Hills* shows Elie Nadelman lying on the grass on the upper right as he chats with Ettie Stettheimer. Florine has depicted herself with a parasol sitting alone, while her sister Carrie and Marcel Duchamp prepare the picnic. For more on Florine's paintings, see Elisabeth Sussman et al., *Florine Stettheimer: Manhattan Fantastica*, exh. cat. (New York: Whitney Museum of American Art, 1995). The Stettheimers lived on Seventy-sixth Street until 1926, when they moved to an apartment in Alwyn Court on West Fifty-eighth Street. Because Viola and Ettie were in school together in Stuttgart, Germany (according to Nadelman 2001, 116), and would therefore have known one another, I suggest that perhaps Viola Nadelman attended the Stettheimer salons.

20 Stillinger 2011, 171.

21 See ibid., 159–68, for more about all these artists, and 10–12 for a discussion of the artists' switching terms from "early American" or "primitive" to "folk art."

22 For more on Sheeler, see Susan Fillin-Yeh, *Charles Sheeler: American Interiors*, exh. cat. (New Haven: Yale University Art Gallery, 1987); Stillinger 2011, 190–95.

23 Avis Berman, *Rebels on Eighth Street: Juliana Force and the Whitney Museum of American Art* (New York: Atheneum, 1990), 145; for more on what Berman calls Force's "enduring love affair—the seeking out and collecting of American folk art," see 145–48.

24 *Riverdale News*, March 1935, NP.

25 See Viola Nadelman's obituary in the *Riverdale Press*, March 8, 1962, which she wrote herself, NP. The European cupboard illustrated in fig. 34 falls most definitely into the folk, rather than the formal, category. Perhaps the Nadelmans placed the simply carved American duck decoy on top of the more richly ornamented cupboard to make a broad point about the difference between the Old World and the New.

26 See Stillinger 2011, 56–65 and 69–77 for more on Mercer and Barber.

27 One of the notices, in *The Magazine Antiques* 28:6 (June 1935): 232,

announced that "the Museum of Folk Arts in Riverdale-on-Hudson, containing the remarkable collection assembled by Mr. and Mrs. Elie Nadelman, is now open to the public."

28 See Elizabeth Stillinger, "Edna Greenwood and Everyday Life in Early New England," *The Magazine Antiques* 162:2 (August 2002): 64.

29 Ibid., 65; for more on Greenwood, see this article and Stillinger 2011, 123–32.

30 Edna Greenwood to the Nadelmans, December 20, 1938, NP.

31 For comments on the Historical Society's 1937 acquisition of the collection, see the Olson Hofer essay, pp. 30–37.

32 *Report of the Board of Trustees of the New-York Historical Society for the Year 1937* (New York: New-York Historical Society), n.p.

33 For more on the Nadelmans' collecting methods, see Oaklander 1992; Stillinger 1994, 516–25; Stillinger 2011, 178–90. Information about Florence Cramer is from correspondence in the NP; from Florence Cramer's diaries, which I read through the kindness of her daughter Aileen Cramer; and from an interview with Aileen Cramer, December 17, 1993, Woodstock, NY. I am indebted to Cynthia Nadelman for putting me in touch with Aileen Cramer.

34 Since the Nadelmans did not keep a diary or other record of their European trips, I have relied on Cynthia Nadelman's "Chronology" (Nadelman 2001), which indicates that the couple went to Europe during the summers of 1920, 1924–28, and 1933.

35 Renate Eikelmann et al., *Das Bayerisches Nationalmuseum 1855–2005: 150 Jahre Sammeln, Forschen, Ausstellen* (Munich: Hirmer, 2006), 411, 427, 452, 505, 581, 589, 627, and Xeroxes very kindly supplied by Dr. Sybe Wartena, Curator, Folklore Collection, Bayerisches Nationalmuseum, August 13, 2013; I am indebted to Margaret Hofer and Michael Buhrs for my introduction to Dr. Wartena. I am indebted as well to Stine Hoel, Photo Archivist, Norsk Folkemuseum, for sending me a link to photographs taken from 1920 to 1930 in the Folkemuseum's Digitalt Museum.

36 Henry Francis du Pont to Elie Nadelman, October 21, 1931, NP.

37 Draft of a letter by Viola Nadelman, December 20, 1947, NP. Viola also said, in a letter of January 14, 1949, to Jean Lipman, that she and Elie had started to collect again after the sale to the N-YHS "and had planned again a Museum, though much smaller." After her husband's death, she apparently

gave up the idea, however, as she was offering Lipman her choice of objects from the collection. Box 1 of 3, correspondence 1948–1949, Howard W. and Jean Lipman papers, 1848, 1916–2000, AAA.

38 It is possible that Karolik and Webb bought through Halpert, rather than directly from Viola Nadelman.

39 Stillinger 2011, 189.

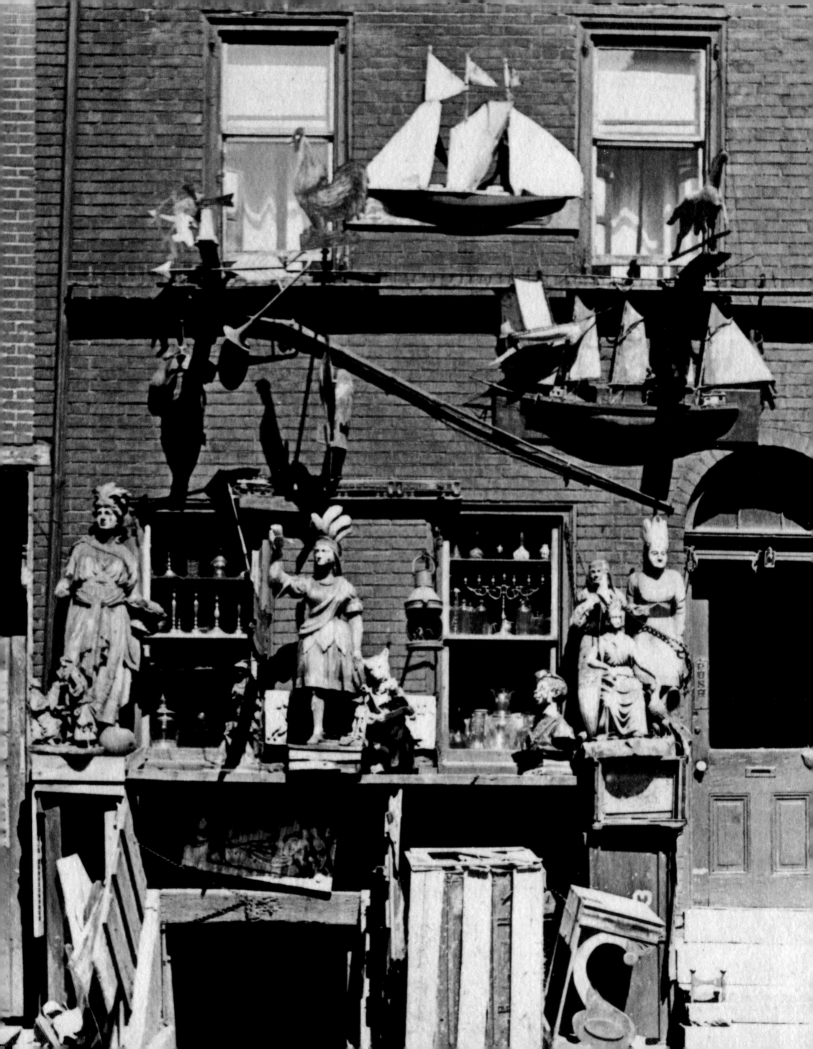

MANHATTAN TO MUNICH:
THE NADELMANS' SOURCES FOR FOLK ART

Margaret K. Hofer

Until recently, little was known about the Nadelmans' sources for their collection of folk art, save for the gleanings from scattered correspondence in the family papers and scant citations of provenance in the New-York Historical Society's accession records. Articles about the Museum of Folk and Peasant Arts (MFPA) as well as its own press materials generalized about the couple's collecting and suggested they built their museum from purchases made during frequent travels abroad.[1] One writer related how the Nadelmans "traveled about Europe for a number of years before and after 1920, buying whatever objects of handicraft seemed to them of aesthetic significance," adding, "nearly all the peoples of Europe saw them buying from shops and homes whatever pleased their very particular tastes."[2] Thanks to recently discovered collecting data, however, we now have a clearer and more nuanced understanding of where, when, and from whom the Nadelmans were purchasing objects and can amend the romantic perception that they amassed their holdings during buying sprees in far-flung European villages.

In June 2012, six oak card catalogue boxes packed with three-by-five index cards were retrieved from a trove of Nadelman memorabilia held in a Bronx, New York, warehouse. The cards, meticulously typed or handwritten and occasionally annotated, contain descriptions of objects in the MFPA, along with assigned museum number, name of the dealer or auction house that supplied the object, date of transaction, and purchase price (fig. 40).[3] The bounty of information contained on these curatorial cards, analyzed along with surviving Nadelman correspondence and dealer records in other repositories, has enabled a comprehensive investigation of the couple's collecting patterns: the chronology of their acquisitions; the relative prices paid for objects; their preferred dealers and auction houses locally, nationally, and abroad; and the breakdown of their acquisitions by country of origin. Unfortunately, the card system does not seem to have been maintained consistently, and significant gaps, evident when compared against the MFPA inventory of 1937, suggest that additional boxes may be missing.[4] Nevertheless, taken as a cross-section of the MFPA, the cards—which document the purchase of 4,628 objects from 202 dealers (see Appendix I) and several auction houses—provide fresh and intriguing insights into the patterns and preferences of Elie and Viola Nadelman, two voracious collectors.

The cards document only scattered purchases before 1924, the year that the Nadelmans began collecting folk art in earnest, but other sources shed light on the couple's earlier acquisitions. The records of the Hungarian-born art dealer Joseph Brummer reveal that Elie Nadelman was an active client during the early 1920s and suggest that Brummer himself may have played a role in stoking Elie's collecting passion. Like Nadelman, Brummer had left his native country to study art in Paris, and soon after arriving in 1904 he befriended Elie, a fellow student of sculpture.[5] Brummer and his brother Ernest established their Paris gallery in 1906, quickly earning a reputation as leading dealers in "primitive" art and antiquities. With the outbreak of World War I, Joseph moved

Fig. 40
Sample curatorial cards from the
Museum of Folk and Peasant Arts
(MFPA), 1924–36. N-YHS Library,
promised gift of Cynthia Nadelman

to New York City to open a second shop (fig. 41). Brummer Gallery
records indicate that in May 1920, within five months of his financially
advantageous marriage, Nadelman spent $1,000 on an Italian
Romanesque stone column and an Italian Renaissance twisted column.[6]
Purchases in 1921 included a classical marble head of a woman wearing
a pointed hat, a sixteenth-century Flemish wooden relief, and two
"antique" chairs.[7] That same year, Brummer presented his friend with a
fragmented bronze ring and limestone ox's head as gifts.[8]

None of the numerous acquisitions made from Brummer before
1927 are recorded in the MFPA cards; presumably the Nadelmans
purchased many works for their newly acquired homes in Manhattan
and Riverdale, particularly the East Ninety-third Street townhouse, which
had been completely renovated. According to Lincoln Kirstein, the
home's spare interior featured stark white walls punctuated by classical
marbles purchased from Brummer.[9] Despite Elie's initial focus on classical
to Renaissance *objets*, a trend toward the vernacular is evident in the
types of objects the sculptor purchased or sought prices for, including
a pastry roller and coffee grinder in 1925, a coal shovel in 1928, and
an Italian spinning wheel in 1929.[10] It is interesting that Brummer,

arguably Nadelman's most influential early source, straddled the worlds of avant-garde and traditional art. In New York, the Brummer Gallery focused on selling works from classical antiquity, the Middle Ages, and the Renaissance and Baroque periods along with Pre-Columbian objects, while mounting exhibitions of contemporary artists including Constantin Brancusi, Henri Matisse, Man Ray, and Pablo Picasso. Elie's art collecting and sales of his own work also overlapped at the Brummer Gallery: records indicate that in June 1923, Brummer sold five Nadelman drawings for $125.[11]

While Elie was admiring the antiquities at Brummer's Fifty-seventh Street Gallery, he was also being indoctrinated into the world of Americana by veteran dealer Charles Woolsey Lyon, whose shop was located on Madison Avenue near Forty-ninth Street. On February 18, 1921, Lyon followed up on the sculptor's visit to the gallery with a letter providing detailed information about objects he had expressed interest in, including a portrait by Joseph Whiting Stock (cat. 19) and several other paintings, a pewter and glass candle reflector, three seventeenth-century leaded glass windows, and a collection of glass animals and figures. Lyon noted provenance and assiduously documented issues of rarity and condition; he may also have stirred a competitive instinct by mentioning his previous sale of related items to the noted collector Mrs. J. Insley Blair. Nadelman purchased every item that Lyon mentioned in his letter for $640 in cash—presumably with the intention of displaying the trove at Alderbrook, the couple's Hudson River villa—and he continued to patronize the dealer until at least 1930.[12]

The MFPA cards document a trickle of purchases during the early 1920s and an explosion of them in 1924, with 928 acquisitions recorded that year and 974 the following (fig. 42). The numbers may be misleading, as the card system appears to have been initiated in 1924 and the retrospective record keeping is most certainly incomplete. Nevertheless, 1924 marks the beginning of the Nadelmans' systematic collecting of European and American folk art and the birth of their Museum of Folk and Peasant Arts.

During the period documented by the MFPA cards, the Nadelmans were active bidders at many New York City auctions, especially during their first years of feverish buying. Their preferred auction houses included the American Art Galleries and Walpole Galleries, each accounting for 30 percent of the recorded auction purchases; Anderson Galleries (10 percent); and Clarke Art Galleries (10 percent). They attended a number of high-profile sales of collections gathered by notable connoisseurs, including the property of Mrs. J. Kilbourne Hayward at the Walpole Galleries in February 1924 (they purchased European bronze mortars and bells, silver mounted pipes, and carved snuff boxes); the collection of Alexander Arzouyan at the Anderson Galleries in April of that year (Greek religious paintings and icons); and treasures gathered by Spanish collector Raimondo Ruiz at the Clarke Art Galleries the following month (Spanish carvings).

In June 1924, the Nadelmans boosted their holdings of American folk art in one fell swoop at the public sale of the George F. Ives

Fig. 41
Brummer Gallery at 27 East Fifty-seventh Street, 1924–28.
The Brummer Gallery Records,
The Metropolitan Museum of Art
Libraries & The Cloisters Library

Fig. 42
Graph of Nadelman purchases

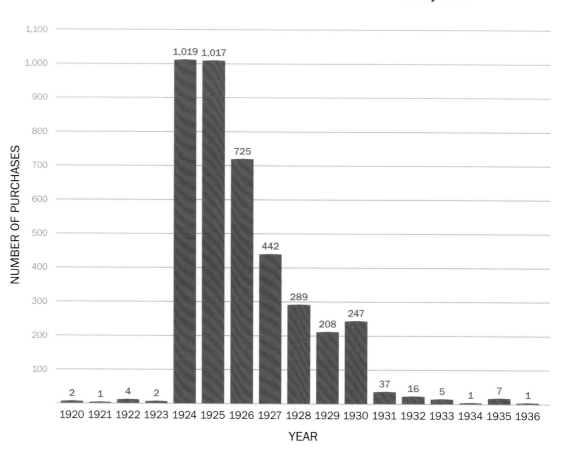

Museum of Folk and Peasant Arts Purchases by Year

collection. Held under a tent at the Ives Tavern & Colonial Museum in Danbury, Connecticut, the four-day sale comprised over eight hundred lots of American antiques, ranging from furniture and hooked rugs to lighting devices and kitchen implements.[13] Described in the contemporary press as "one of the foremost of American antiquarians," Ives had painstakingly assembled his unparalleled collection and installed it in an eighteenth-century tavern, which he had purchased in 1918 and moved to his Danbury estate.[14] Elie bid successfully on forty-six items, including a Lafayette cake print, a chalkware garniture, and an angel weathervane (see cats. 71, 10, 6). The *Danbury Evening News* profiled some of the collectors attending the auction, including the free-spending Nadelman: "Monsieur Nadelman (his card reads 'Monsieur et Madame Elie Nadelman') was one of the most interested buyers Saturday afternoon. He acquired a Windsor cradle for $125, the old Dutch wagon or pung for $70, a corner cupboard of natural pine for $270, a kitchen cabinet with trestle feet for $300, a 'Constitution and Guerriere' watercolor for $45, and a flax winder for $7."[15] Also present was collector Henry Francis du Pont, who spent $2,673 on sixteen items.[16] While Nadelman and du Pont may have competed against each other for some lots, they joined forces on at least one, the "two carved cake moulds" in lot 527. Nadelman recorded paying $22.50 for his Lafayette cake print, while du Pont purchased the second cake print for $70.

Although the Nadelmans frequently attended auctions during the 1920s, their main source for MFPA objects was a network of private dealers in New York City, across the northeastern United States, and in Europe. Not surprisingly, Manhattan dealers supplied the bulk of their purchases. By the 1920s, New York City had supplanted New England as the center of the nation's antiques trade. Most important

Fig. 43
Map of the Nadelmans' New York City
dealers

Dealers Patronized by the Nadelmans Clustered in Manhattan's East Fifties, ca. 1925

DEALERS

1. Alaquah (Alaquah Flood) 730 Lexington Ave.
2. Art Alliance of America 65 E. 56th St.
3. William Baumgarten and Company, Inc.
 715 Fifth Ave.
4. M. Dawod Benzaria 561 Madison Ave.
5. Mrs. Helen Bruce 532 Madison Ave.
6. Joseph Brummer 27 E. 57th St.
7. Carvalho Brothers of Portugal 520 Madison Ave.
8. Childhood Incorporated 108 E. 57th St.
9. Children's Book Shop 108 E. 57th St.
10. Gilman Collamore 15 E 56th St.
11. Rose Cumming 551 Madison Ave.
12. E.P. Dutton 681 Fifth Ave.
13. Ehrich Galleries 701 Fifth Ave.
14. Ann Elsey (French Provincial Antiques)
 163 E. 54th St. (by 1926)

15. English Antique Shop 579 Madison Ave.
16. P.W. French & Co. 6 E. 56th St.
17. Miss Gheen Inc. (Gertrude Gheen Robinson)
 441 Park Ave.
18. Sumner Healey 686 Lexington Ave.
19. Home of Childhood 108 E. 57th St.
20. C[larence] Vandevere Howard
 141 E. 57th St. (by 1926)
21. Renwick C. Hurry 7 E. 54th St.
22. Kirkham & Hall 31 E. 57th St.
23. Louis XIV Antique Co. 9 E. 55th St.
24. Nancy McClelland 753 Fifth Ave.
25. Elinor Merrell 50 E. 57th St. (by 1927)
26. Frans Middelkoop 507 Madison Ave.
27. Charles R. Morson 106 E. 57th St.
28. J. W. Needham's Antiques
 137 1/2 E. 56th St. (by 1927)

29. North Node Book Shop (Malcolm Schloss)
 114 E. 57th St.
30. Florian Papp 684 Lexington Ave.
31. Frank Partridge 6 W. 56th St.
32. Fred J. Peters 52 E. 56th St.
33. Schmitt Brothers 523 Madison Ave.
34. S. Serota 685 Lexington Ave.
35. Stair & Andrew 45 E. 57th St.
36. Henry Symons & Co. 730 Fifth Ave.
37. S[tanley] N. Thompson
 680 Lexington Ave. (by 1932)
38. Max Williams 538 Madison Ave.

AUCTION HOUSES

39. American Art Galleries 30 E 57th St.
40. Anderson Galleries 489 Park Ave.
41. Clarke Art Galleries 42 E 58th St.

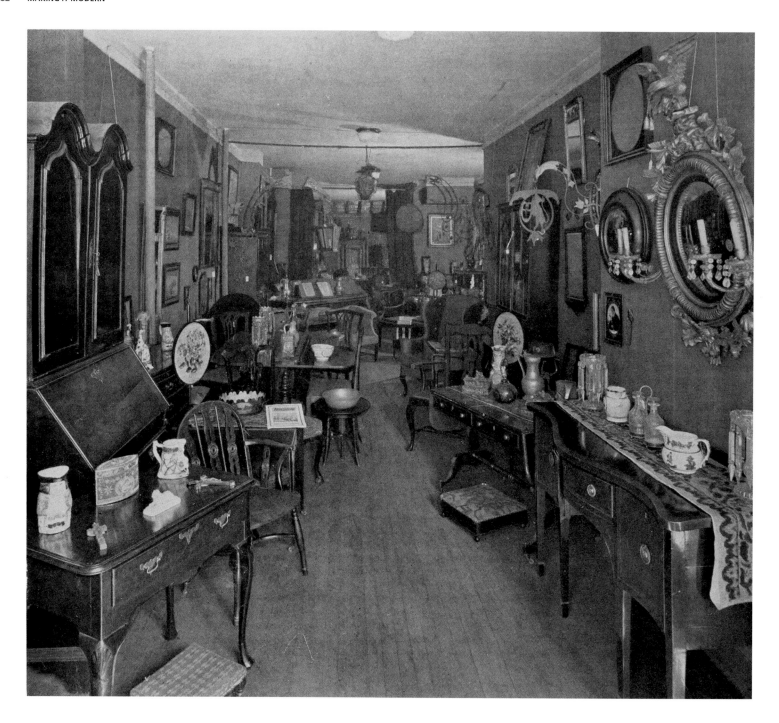

Fig. 44
C. Vandevere Howard store interior,
from *Antiquarian* 8:3 (April 1927): 52

auctions of American antiques took place in New York, and influential
dealers operated their retail establishments in midtown Manhattan.[17]
A mapping of dealers cited in the MFPA cards reveals at least forty
shops and auction houses clustered in the East Fifties between Fifth and
Lexington Avenues (fig. 43). C. Vandevere Howard, the Nadelmans'
top dealer, kept shop at 141 East Fifty-seventh Street, near Lexington
Avenue (fig. 44). The showrooms of other favored sources were located
just blocks away, including Joseph Brummer (see fig. 41), Childhood
Incorporated, Ann Elsey's French Provincial Antiques, Sumner Healey,
Renwick C. Hurry, Elinor Merrell, Nancy McClelland, and Fred J. Peters.
More preferred dealers just outside this nucleus—including Teina
Baumstone, the Czechoslovak Art Shop, Charles Woolsey Lyon, the
Spanish Antique Shop, Philip Suval, and Stephen Van Rensselaer—
dotted Madison Avenue as far north as Seventy-second Street and south
to Forty-seventh Street.

Elie and Viola's local purchases were not restricted to American antiques; in fact, they built their European collections largely from imported objects sold by Manhattan dealers. Howard supplied nearly three-quarters of the MFPA's Swiss objects, or 422 items, while Healey sold them at least 129 French objects. The couple purchased English items locally from Suval, Peters, Lehne, Howard, Todhunter, and Ginsburg & Levy. Some dealers specialized in objects from certain European regions, such as Carvalho Brothers of Portugal, the Czechoslovak Art Shop, the English Antique Shop, and the Spanish Antique Shop.

Judging from their concentration of activity with certain dealers, the Nadelmans built relationships with a small number of local and international vendors, who were probably scouting for objects to add to the mushrooming MFPA. In New York, they relied heavily on imported objects procured by C. Vandevere Howard (cats. 27, 68, 80, 81) and Sumner Healey (cat. 66) and American antiques from Renwick C. Hurry (cat. 48). Clarence Vandevere Howard, a native of New Bedford, Massachusetts, entered the antiques importing business by 1925.[18] A photograph of Howard's wholesale establishment at 141 East Fifty-seventh Street shows a preponderance of high-style English furniture and decorative objects, which his advertisements also emphasized (fig. 44). Howard's ads, however, also noted his "painted and unpainted peasant furniture," which was clearly of greater interest to the Nadelmans.[19] In March 1927, the *New Yorker* mentioned the availability in Howard's shop of "some unusual and genuine hand-painted wooden boxes of the fourteenth and fifteenth centuries, incredibly low in price," precisely the kind of objects that attracted the Nadelmans.[20] The MFPA cards record an astonishing 473 objects purchased at Howard's shop in the five-year period between 1925 and 1930; in December 1925 alone, the couple purchased 197 objects.

Howard likely relied heavily on buyers to secure merchandise for his shop, and he clearly had dependable pickers in Switzerland rounding up objects by the hundreds. One key source for him was the Swiss-born buyer Charles Strub, who had moved to New York in 1908. He was residing with Howard at the time of his petition for naturalization in 1926, and in 1932 was cited as a business partner.[21] Strub's frequent Atlantic crossings, documented by ship passenger lists, suggest that he may have been a primary supplier of Howard's European merchandise. The Nadelmans had patronized Strub directly in 1924 and early 1925, buying predominantly Swiss objects from Strub & Morgan, his partnership with James T. Morgan at 608 Amsterdam Avenue (cats. 25, 32).[22]

Like Howard, Sumner Healey handled huge quantities of European antiques. The son of a prominent New York carriage maker, Healey was educated primarily in France and became a decorated member of the Foreign Legion. He started his antiques business around 1920, and the Nadelmans began purchasing French and other European objects from him by 1923. Healey, who maintained a second shop in Bordeaux, France, developed a reputation as a connoisseur, particularly of armor, weapons, and ship models, and counted major museums among his

Fig. 45
Door with iron mountings from St.-
Léonard-de-Noblat (Haute-Vienne),
French, 11th–12th century. The
Metropolitan Museum of Art, The
Cloisters Collection

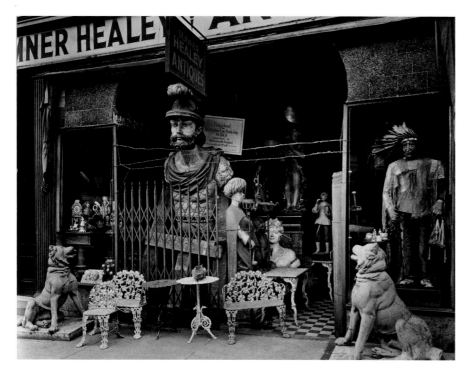

Fig. 46
Berenice Abbott, *Sumner Healey
Antique Shop, 942 Third Avenue and
Fifty-seventh Street, October 8, 1936*.
Museum of the City of New York

clients.[23] According to his obituary, Healey made 168 visits to Europe over the course of his career.[24] One of the Nadelmans' most spectacular Healey purchases was a set of French medieval iron door mountings, featuring a pair of panthers with foliate clusters blossoming from their mouths, which today are in the collection of The Cloisters (fig. 45).[25]

In 1936, photographer Berenice Abbott captured the exterior of Healey's shop at the corner of Third Avenue and Fifty-seventh Street (fig. 46). The storefront is bursting with objects: a cigar store Indian and a figurehead from the British ship of the line HMS *Mars* spill out onto the sidewalk. The somewhat chaotic array of vernacular sculpture, garden furniture, and knick-knacks is at odds with the elaborate medieval and Renaissance artifacts printed on Healey's formal letterhead (fig. 47). Flanking the shop's entrance is a pair of cast metal seated dogs, modeled on an ancient Roman prototype, which the Nadelmans purchased sometime between 1936 and 1939 and placed in the garden at Alderbrook, in Riverdale (see fig. 72). Healey's son wrote to Viola in 1939, three years after the dealer's death, to remind her that a balance of $50 was due on the canine sentries.[26]

Another important midtown dealer was Renwick C. Hurry, who entered the business around 1918 after a successful career in real estate.[27] Hurry's advertisements promote his specialty as early American paintings, prints, and pottery. He was also an expert in early American glass, and obtained rare examples from descendants of glass blowers at early manufactories in southern New Jersey and Pennsylvania.[28] The Nadelmans patronized his shops, first at 6 West Twenty-eighth Street and after April 1925 at 7 East Fifty-fourth Street, numerous times between 1924 and 1932 and they recorded 103 purchases of pottery, glass, toys, and other objects. Highlights included a dark green glass child's chamber pot attributed to the Wistarburgh Glass Works, purchased for $150, and a chalkware bust of a woman (cat. 11).[29]

The American dealers patronized by the Nadelmans almost invariably advertised their stock in trade as "antiques" and almost never employed the term "folk art."[30] As Kenneth L. Ames points out, folk art is not an empirical category of objects, but rather a cultural construct dependent on collectors and dealers who extract objects from the marketplace and label them as "folk" (see Ames essay, p. 78). The Nadelmans transformed their purchases from "antiques" into "folk art," giving them renewed potency. An émigré married to an internationally minded New Yorker, the couple may have associated themselves with "folk" in part because of its early recognition in Europe. Collectors motivated by different impulses, whether decorative, antiquarian, or patriotic, competed for the same merchandise, yet commonly used terms like "decorative arts" or "Americana" to describe their acquisitions.[31] Henry Francis du Pont, Francis P. Garvan, and Mrs. J. Insley Blair were just a few of the prominent collectors of the 1920s who patronized the same dealers yet framed their acquisitions in different terms than the Nadelmans.[32]

While male dealers may have supplied more objects to the MFPA, the Nadelmans actually patronized more female than male vendors (fifty-

Fig. 47
Sumner Healey letterhead, from letter dated February 23, 1923. NP

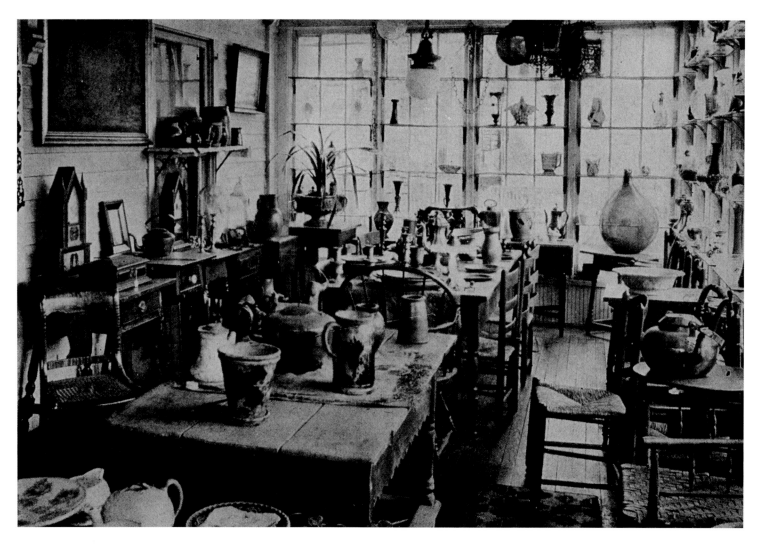

Fig. 48
Katharine Willis shop interior, from
an advertisement in *Antiquarian* 12:3
(April 1929): 95

seven versus fifty-four). Unlike the prominent Manhattan dealers who ran large retail establishments with grand showrooms, many successful female antiques dealers were located outside New York City and ran shops out of their homes, some for reasons of economic exigency. Estelle Berkstresser of York, Pennsylvania, operated a shop in her home between about 1925 and 1935, supplementing the income that her husband, Marshall, earned as a machinist.[33] Between 1925 and 1930, the Nadelmans purchased ninety-eight items from her, many of them identified as of Pennsylvania origin. Their acquisitions included fraktur, painted boxes (cat. 31), chalkware figures (cat. 10), butter prints (cat. 72), clay pipes, and bandboxes. Berkstresser's inventory was moderately priced; the Nadelmans' purchases typically cost a few dollars, and were never more than $35 for a single item. Despite the modest sums paid by the Nadelmans, they may have been among Berkstresser's top clients. In December 1925, she presented them with the gift of a painted chalkware plaque depicting the Last Supper.[34]

Similarly, Sara M. Sanders ran a shop from her home in Closter, New Jersey, and supplemented the earnings of her husband, a stationery salesman.[35] As with Berkstresser, the Nadelmans purchased moderately priced American antiques, including mechanical banks (cat. 87) and stoneware and earthenware pottery. Sanders presented them a gift of a carved butter mold in May 1924, perhaps in appreciation for their purchase of nine other items that month.[36] Many other women across the Northeast supplied the MFPA with objects, including Alice L. Curtis and her daughter Dorothy of A.L. Curtis American Antiques in Harrington Park, New Jersey; Mary D. Walker, who sold Americana from

her Four Corners Inn and Tea Room in Marion, Massachusetts (cats. 77, 86);[37] Mabel I. Renner, wife of an automobile repairman in York, Pennsylvania (cat. 10);[38] and Ruth D. Knox of Niagara Falls, New York.

Closer to Manhattan, the widow Katharine Willis kept a shop in Jamaica, Queens, and advertised aggressively in antiques journals (fig. 48). In a 1922 ad, she touted her establishment as "a veritable museum" and "Long Island's famous antique shop."[39] The following year, she described it as "a storehouse of old, filled to the topmost bin with treasures more precious than gold."[40] Willis also promoted herself by publishing articles on antiques; in 1928, for instance, she wrote on New York stoneware, illustrated entirely with pieces from the Nadelman collection.[41] Willis and Viola kept up a steady correspondence during 1927–28, and the savvy antiques dealer enticed her customer with quality merchandise (cats. 33, 40, 44, 54, 84). Willis worked closely with Canadian-born dealer Matthew Holden, who, according to the 1930 census, boarded with her and served as her business partner. Holden supplied some of the Nadelmans' most significant pieces of American pottery, including the Crolius spouted pitcher (cat. 36) and the Troxel *sgraffito* dish (cat. 39).

While many female antiques dealers worked out of necessity, others were clearly driven by a passion for preserving America's material past. The influential and well-connected antiquarian Jane Teller, for instance, had opened a shop in 1919 in the Smith mansion at 421 East Sixty-first Street (today the Mount Vernon Hotel Museum & Garden), and, as secretary of the Society for the Revival of Household Industries and Domestic Arts, she recruited women to learn hand-spinning and -weaving.[42] Caught up in Colonial Revival fervor, Teller collected and sold thousands of pieces of early American glass, pottery, metalwork, furniture, and hooked rugs and devoted herself to educating others about Colonial culture. The Nadelmans purchased at least fifty items from Teller in 1924 and 1925 including household implements and wooden dolls, and received a rolling pin as a gift.[43]

The Nadelmans patronized at least one African American dealer: Virginia-born James Eham of Philadelphia, who ran a well-known shop at 1237 Pine Street. In an advertisement in the 1910 *Philadelphia Colored Directory*, Eham noted that he bought and sold "antiques of all kinds" and added, "If you want anything in the line of Antiques I HAVE IT."[44] A surviving photograph of the storefront shows a lively display of objects across the entire façade of the building, including ship models, cigar store figures, a rooster weathervane, and a large ship's wheel (fig. 49). The Nadelmans recorded only two purchases from Eham's shop, one of them being the top of a cast-iron hitching post featuring a caricatured head of a black man.[45]

In addition to their network of American dealers, the Nadelmans cultivated relationships with a select number of European vendors. The trade in *Volkskunst* or *art populaire* was more developed in Europe, where displays of peasant ethnography at international world's fairs during the nineteenth century had played an important role in constructing and defining national identity.[46] During the tumultuous

Fig. 49
George Mark Wilson, *Antique Store, Pine Street East of Thirteenth Street, "The Old Curiosity Shop" of James Eham*, ca. 1923. Library Company of Philadelphia

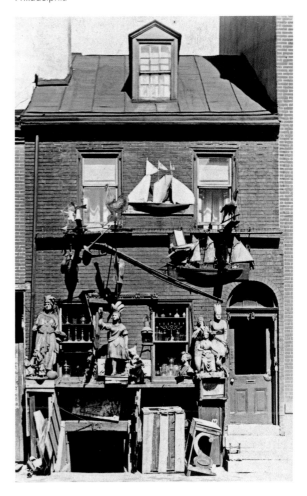

interwar period, political leaders viewed folk art as a useful means for identifying regional or national cultures and for countering the negative consequences of industrialization and modernization. It is noteworthy that just as the Museum of Folk and Peasant Arts was opening its doors, the first international congress on folk art was being organized by an arm of the League of Nations.[47]

The Nadelmans' frequent travels abroad and fluency in multiple languages facilitated relationships with European dealers, most of which were probably initiated by shop visits and then sustained through written correspondence. Surviving letters, together with recorded purchases, help to flesh out some of these interactions. The Budapest dealer Vilmos Szilárd supplied close to two hundred objects for the MFPA between 1925 and 1931, including the carved bobbins in cat. 57. All of the acquisitions were of Hungarian origin and included pottery, carved wooden cake prints, and painted furniture. The Nadelmans were clearly not fazed by shipping large objects across the Atlantic, as they purchased seventeen wardrobes from Szilárd in 1925. As an authority on Hungarian peasant art and a dealer with access to quality merchandise, Szilárd commanded the Nadelmans' respect. However, it is clear from correspondence that Viola had no qualms about returning items that she discovered were inappropriate for the MFPA or about attempting to negotiate more advantageous prices.[48]

The couple also relied on several dealers in Munich, including Siegfried Laemmle and Moritz Wallach. They first patronized Laemmle's Brienner Straße shop in September 1929, buying German toys and carved wooden objects. What began as a business transaction evolved into an enduring friendship, strengthened by Laemmle's visit to Riverdale. Writing to Viola in 1931, the dealer reminisced: "In my mind I often dwell in your cozy home next to the Hudson in the shadow of your giant trees and in your instructive folk art collection."[49] During the early 1930s, Siegfried and Viola exchanged letters about potential objects for the MFPA, from wax sculpture and carved wooden religious figures to pottery and needlecases (cat. 60).[50] They also commiserated about the severe economic crises in their respective countries and its grave effects on their professional and personal lives. In July 1931, Laemmle wrote to "Frau Professor," reminding her of his difficult financial situation. He politely requested she pay the balance of the credit he had extended, if her circumstances would permit.[51] They apparently did not, as he reiterated his request five months later.[52] In January 1932, Viola wrote that she expected "to be in a position to pay something on account very shortly," but apparently was unable to follow through.[53] By August, Laemmle's pleas for payment had grown desperate, exacerbated by his wife's stroke and resulting paralysis and depression.[54] Viola managed to send a payment of $25 in October but also informed him that the MFPA collections were in jeopardy. "With all my heart and also for idealistic reasons, I wish that it was possible for you to sustain your beautiful and interesting collections," replied Laemmle.[55] The dealer had an even more severe ordeal to contend with: the Nazi-controlled German government confiscated his Munich shop and its contents in 1938. Laemmle and his

immediate family fled to the United States, eventually settling in Los Angeles.[56]

A similar fate befell Moritz Wallach, whose Munich shop displayed "handicrafts of remote towns and provinces . . . collected as if in a museum."[57] Moritz and his brother Julius, sensing the increasing disengagement of the German people from their cultural traditions, dedicated themselves to revitalizing the folk costume and craft of their native Bavaria and other European regions. Their "Volkskunsthaus Wallach," which displayed and sold peasant art, was a Munich tourist attraction (fig. 50).[58] In 1937, the Third Reich notified the Jewish dealer—who had striven for more than three decades to bring recognition to traditional costume and craft—that he was unfit to promote German culture and ordered the sale of the cultural property in his possession.[59] Moritz fled Germany for the United States in March 1938, but less fortunate family members did not survive the Nazi terror. It is likely that the Nadelmans, who had purchased nineteen items from the Wallach shop in 1924, including the mangle board in cat. 62, stayed in contact with the dealer after his move to New York City and eventually to northwestern Connecticut.

Fittingly, a number of the dealers patronized by the Nadelmans sold folk art while also exhibiting and promoting the work of avant-garde artists. For instance, Florence Ballin Cramer, who was married to the pioneering modernist Konrad Cramer, opened the Florence Gallery on Fifty-seventh Street in 1919—with encouragement from Elie Nadelman—to exhibit and sell the work of living artists.[60] The gallery proved short-lived, but Cramer went on to collect and sell folk art from her home in Woodstock, New York, during the mid-1920s and she scouted for acquisitions for the MFPA. The cards record eighteen purchases between 1925 and 1927, including a portrait of a "rosy child" painted in Ulster County, New York, for $50 and a "primitive" landscape of the Hudson River with figures for $500 (today known as *Outing on the Hudson*), as well as chalkware figures, dolls, and a foot warmer (cat. 69).[61] Viola proudly updated Florence on the growth of the museum's collection and requested she keep an eye out for certain types of objects, such as early stoneware vessels with inscriptions.[62]

Like Cramer, Marie Sterner operated a Fifty-seventh Street gallery and exhibited the work of modern American and European artists, including Paul Cézanne, George Bellows, and Nadelman.[63] Although little is known about her sales of folk art, the MFPA cards record the purchase of a French "bonnet stand" or milliner's head (cat. 9) in August 1926.[64]

The Viennese immigrant Paul T. Frankl, an architect, furniture designer, and crusader for modern design, opened the Frankl Galleries at 4 East Forty-eighth Street in 1923, offering modern and handmade objects imported from Europe, including pottery, glass, and linens.[65] The Nadelmans discovered a pair of Italian Baroque polychromed wooden angels there in April 1924.[66] The couple must have been intrigued by Frankl's Peasant Furniture line made by local cabinetmakers, which recalled colonial models yet embodied the simplicity of the modernist vision he wanted to promote.[67]

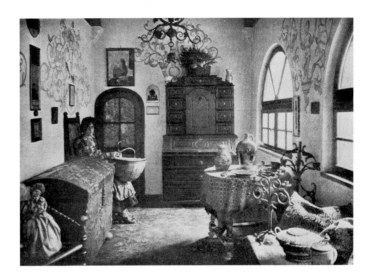

Fig. 50
"Detail of the Peasant Art Room of Wallach at Munich," from *Good Furniture Magazine* 12:9 (February 1929): 76

Fig. 51
Edith Halpert's Downtown Gallery,
with display of folk art and Elie
Nadelman's *Seated Woman*, 1926.
Downtown Gallery Records, AAA

The dealer who truly merged modernism with folk art was Edith Gregor Halpert, a Russian Jewish immigrant who opened the Downtown Gallery in Greenwich Village in 1926. Halpert, a generation younger than the Nadelmans, was aware of the couple's pioneering collection and inspired by their endeavor.[68] If the Nadelmans were among the first to "discover" American folk art, Halpert, as her biographer Lindsay Pollock points out, is significant for her role in developing the market for it.[69] When Halpert opened her West Thirteenth Street gallery in 1926, she combined sleek, modern works of art with folk objects, including glass, pottery, decoys, and furniture. A 1926 photograph of the gallery shows a painted chest—quite similar to examples held by the Museum of Folk and Peasant Arts—with Nadelman's *Seated Woman* displayed on top (fig. 51, cat. III), an apt juxtaposition for displaying the sculptor-collector's work. Sadly, Halpert had little opportunity to sell folk art to the MFPA: by the time she began buying in earnest in 1931, the Nadelmans were in the unfortunate position of having to divest themselves of their beloved collection. They used her instead to sell pieces to other collectors.[70]

Ironically, the Nadelmans had to begin winding down their great collecting venture just as folk art was gaining wider exposure and recognition in the art world. The objects they had discovered in antiques shops and codified as folk art were given market cachet by younger dealers such as Halpert, curators such as Holger Cahill, and collectors such as Abby Aldrich Rockefeller.[71] Some of the Nadelmans' objects returned to an invigorated marketplace to satisfy a new audience of collectors, while the bulk remains at the New-York Historical Society, a tribute to Elie and Viola Nadelman's pioneering enterprise.

1 Museum of Folk Arts flyer with map showing museum location, 1935, NP.

2 Carl Greenleaf Beede, "A Folk Arts Museum of Many Nations," *Christian Science Monitor*, June 1, 1935, 7.

3 Museum of Folk and Peasant Art curatorial cards, N-YHS Library, gift of Cynthia Nadelman. We are deeply indebted to Cynthia Nadelman for discovering the MFPA cards and making them available for study. The amount of data on each card is uneven: some lack dealer, price, or date of transaction.

4 For instance, the cards include 746 objects identified in the category of pottery, whereas the inventory tallies over one thousand pieces of pottery displayed in Gallery VIII.

5 Kirstein 1973, 29, 171.

6 The Brummer Gallery Records, The Metropolitan Museum of Art Libraries & The Cloisters Library, N334 and N335. Brummer and his brother Ernest maintained galleries in Paris (1906–40) and New York (1914–49). During the 1920s, the New York gallery was located at various numbers on East Fifty-seventh Street.

7 Ibid., N134, N424, N509–510.

8 Ibid., N207c, N341.

9 Kirstein 1973, 218.

10 The Brummer Gallery Records, The Metropolitan Museum of Art Libraries & The Cloisters Library, noted on Elie Nadelman client card.

11 Ibid., noted on client card, June 22, 1923.

12 Charles Woolsey Lyon to Elie Nadelman, February 18, 1921, NP.

13 City National Bank of Danbury, Danbury, CT, "The George F. Ives Collection of Antiques," June 18–21, 1924.

14 *The Magazine Antiques* 4:2 (August 1923): 55; http://www.oldbrookfieldtavern.com/history.html.

15 "Old Coach Brings $800," *Danbury Evening News*, June 23, 1924. I thank Diane Hassan at the Danbury Museum & Historical Society for bringing the article to my attention.

16 Henry Francis du Pont papers, box 194, Winterthur Library, Winterthur, DE.

17 Elizabeth Stillinger, *The Antiquers* (New York: Alfred A. Knopf, 1980), 197. Stillinger also points out that both *The Magazine Antiques* and the influential dealer Israel Sack had relocated from Boston to New York by 1930.

18 Howard moved to New York City by 1918 and, according to city directories, was employed as a manager of the New York Credit Men's Association until 1923.

19 For instance, *Arts & Decoration* 24:4 (April 1926): 17.

20 *New Yorker*, March 5, 1927, 62.

21 Charles Strub, Petition for Naturalization, April 20, 1926, available at Ancestry.com; *New York Times*, August 22, 1932. Howard and Strub leased the entire building at 684 Lexington Avenue for the sale of antiques.

22 Strub & Morgan, also known as the Amsterdam Art Gallery, was in business by 1915 and appears to have folded sometime after April 1925.

23 "Sumner Healey Dies; Antique Dealer Here," *New York Times*, October 18, 1936.

24 Ibid.

25 A bill in the Nadelman Papers dated February 23, 1923, indicates that the ironwork was purchased for $400. The mountings were acquired by the N-YHS in 1937, sold at Parke-Bernet in 1943 (Parke-Bernet 1943a, lots 200, 211, 217), acquired by Joseph Brummer, and sold to the Metropolitan Museum of Art in 1947 (47.101.81–86, 50.65.1, 2). See Helmut Nickel, "The Iron Door Mountings from St.-Léonard-de-Noblat," *Metropolitan Museum of Art Bulletin* 23 (1988): 83–87.

26 Roger Healey to Viola Nadelman, April 10, 1939, NP.

27 Renwick Clifton Hurry, World War I Draft Registration Card, 1918, available on Ancestry.com. New York City directories before 1917 list Hurry's business as real estate; thereafter his business is listed as antiques.

28 "Renwick C. Hurry, 79, Expert on Antiques," *New York Times*, January 25, 1954.

29 The chamber pot, purchased in September 1928, is N-YHS 1937.997 (no MFPA number was assigned).

30 The Nadelmans' European dealers occasionally employed terms like "peasant art" and "*Volkskunst*" for the same classes of objects. Vilmos Szilárd to Viola Nadelman, January 2, 1928, NP; Siegfried Laemmle to Viola Nadelman, February 3, 1931, NP.

31 See Stillinger 2011 for discussion of the various motivations driving collectors of folk art during the early twentieth century.

32 Henry Francis du Pont, Antique Dealers papers, Winterthur Library, Winterthur, DE; Francis Patrick Garvan papers, AAA; Mrs. J. Insley Blair collecting records, copies held by Department of American Decorative Arts, Metropolitan Museum of Art.

33 1930 Federal Census, available through Ancestry.com.

34 MFPA 1723.

35 1930 Federal Census, available through Ancestry.com.

36 MFPA 314.

37 *Cape Cod Magazine* (January 1922): 30; *Antiquarian* 4:6 (July 1925): 36; *The Magazine Antiques* 2:2 (August 1922): 100.

38 1930 Federal Census, available through Ancestry.com.

39 *The Magazine Antiques* 2:3 (September 1922): 137.

40 Ibid. 4:2 (August 1923): 59.

41 Katharine Willis, "Early New York Pottery," *Country Life* 54:5 (September 1928): 72, 77–78. Willis acknowledged in a letter to Viola that articles were good for business. Katharine Willis to Viola Nadelman, March 30, 1928, NP.

42 Christopher Gray, "The Unsung Queen of the Colonial Revival," *New York Times*, June 16, 2011; "Tallow Dips and Distaffs," *Edison Monthly* 13:7 (July 1921): 121–23.

43 MFPA 150, received in March 1924.

44 *Philadelphia Colored Directory* (Philadelphia: Philadelphia Colored Directory, 1910), n.p.

45 MFPA Iron 2377. The other item was a walking stick with the carved head of a dog, MFPA Misc. 2376. Both items were purchased in 1927.

46 Daniel DeGroff, "Ethnographic Display and Political Narrative: The Salle de France of the Musée d'Ethnographie du Trocadéro," in *Folklore and Nationalism in Europe during the Long Nineteenth Century*, eds. Timothy Baycroft and David Hopkin (Leiden and Boston: Brill, 2012), 113–35.

47 Bjarne Rogan, "Folk Art and Politics in Inter-War Europe: An Early Debate on Applied Ethnology," *Folk Life* 45 (2007): 7–23. The congress took place in Prague in 1928.

48 Vilmos Szilárd to Viola Nadelman, January 2, 1928, NP. The dealer mentions a chair "not of sufficient interest" being returned by Viola.

49 Siegfried Laemmle to Viola Nadelman, July 7, 1931, NP (original in German).

50 Idem, February 3, 1931 and March 7, 1931, NP.

51 Idem, July 7, 1931, NP.

52 Idem, December 8, 1931, NP.

53 Idem, August 25, 1932, NP.

54 Ibid.

55 Siegfried Laemmle to Viola Nadelman, November 9, 1932, NP.

56 Siegfried and his family were aided by his brother, Carl Laemmle, a founder of Universal Pictures, who committed himself to aiding Jews fleeing Nazi Germany. See Neal Gabler, "Laemmle's List: A Mogul's Heroism," *New York Times*, April 13, 2014. By 1939, they had reestablished an antiques business at 8708 Sunset Boulevard in Los Angeles.

57 "Peasant Art to the Fore," *Good Furniture Magazine* 12:9 (February 1929): 77.

58 Moritz Wallach, "Das Volkskunsthaus Wallach in Muenchen," unpublished typescript, 1961, Center for Jewish History, New York.

59 Ibid., 23.

60 Biographical information, Konrad and Florence Ballin Cramer papers, 1897–1968, AAA; http://www.aaa.si.edu/collections/konrad-and-florence-ballin-cramer-papers-9413/more#biohist.

61 MFPA 1255, purchased in April 1925, and MFPA 2258, purchased in March 1927. The latter is currently in the AARFAM, 32.101.4; see Rumford 1988, 68–69, no. 41.

62 Viola Nadelman to Florence Cramer, undated letter, series 2, microfilm reel 2752, Konrad and Florence Ballin Cramer papers, 1897–1968, AAA.

63 "Mrs. E.B. Lintott, Art Dealer Here," *New York Times*, July 2, 1953.

64 MFPA 2084, purchased for $45.

65 Elie had known Frankl since at least 1915, when he introduced the architect to cosmetics entrepreneur Helena Rubinstein and collaborated on the design of her first *salon de beauté* (see cat. I). See Christopher Long, *Paul T. Frankl and Modern American Design* (New Haven, CT: Yale University Press, 2007), 38.

66 MFPA 286, purchased April 17, 1924, for $25.

67 Long, *Paul T. Frankl*, 51–57. Frankl introduced his "Peasant Furniture" around 1925.

68 Lindsay Pollock, *The Girl with the Gallery: Edith Gregor Halpert and the Making of the Modern Art Market* (New York: Public Affairs Books, 2006), 132.

69 Ibid., 133.

70 Halpert sold individual pieces to Abby Aldrich Rockefeller and others during the early 1930s. In October 1936, the Nadelmans retained her to sell the entire collection but rescinded the contract in November 1937 (see Olson Hofer essay, pp. 30–31).

71 Stillinger 2011, 218–53.

THE TERM "FOLK ART" ONCE AGAIN

Kenneth L. Ames

In 1937, when the Nadelman collection came to the New-York Historical Society, the idea of folk art was relatively new and publications dealing with it were comparatively scarce (fig. 52). Forty years later, when I first wrote about the subject, the literature on American folk art had become considerable.[1] In the decades since, publications on folk art have continued to proliferate, some focusing on types of artifacts long considered folk art, others extending the idea to additional classes of the material world such as decoys and face jugs and objects and environments by so-called Outsider artists. The most important recent contribution to the literature may well be Elizabeth Stillinger's monumental and authoritative tome of 2011, *A Kind of Archeology: Collecting American Folk Art, 1876–1976*.[2] In a sweeping narrative of nearly four hundred pages, Stillinger chronicles the long history of the folk art movement in the United States in all its human and artifactual complexity. But since 1976, when her account ends, the nature of collecting has evolved, as has study of the phenomenon. This essay suggests two supplementary ways of framing the subject of folk art, first, as an invented cultural category and, second, as a by-product of the last two centuries of material abundance. Both, I hope, may in different ways expand and enrich our understanding of the folk art phenomenon.

To begin with, consider folk art an exemplary demonstration of the dynamics of culture, of the changing strategies people use to make meaning of the world. The governing concept here is that our species actively constructs its culture. Most people recognize that chairs, pots, and paintings are artifacts. They may be less aware that culture is also an artifact or, more exactly, a constellation of artifacts. Rather than being fabricated from tangible materials, however, cultural concepts and categories are cobbled together from ideas, ideals, assumptions, preferences, prejudices, past practices, and yet more, and they typically shape thinking and behavior. Stillinger and others have identified major cultural strands woven into the fabric of folk art. This discussion examines some of the same strands but from different ideational perspectives. For help in the process, I enlist the assistance of several observers who have made the sometimes covert workings of culture more apparent. Over the last few decades they have taught us, among other things, to be alert to the stealthy cultural work that common words may perform. Consider here four familiar words: *tradition*, *art*, *folk*, and *craft*.

Thirty years ago Eric Hobsbawm and Terence Ranger's edited volume, *The Invention of Tradition* (1984), jolted the historical profession by telling simple truths about familiar traditions.[3] It turned out that many traditions presumed ancient were often of quite recent invention. Some were purposefully constructed to serve social or political ends; at least one arose primarily to increase retail profits. The essays in the volume also demonstrated that, contrary to widespread assumptions that they persisted from one age to the next more or less unaltered, traditions typically changed over time, sometimes quite rapidly. Furthermore, vigorous traditions had the demonstrable capacity

Fig. 52
View of the folk art galleries with dining room at the New-York Historical Society, 1938. N-YHS Archives

Detail of cat. 83

to assimilate or accommodate sometimes jarringly incongruous features. The American Christmas celebration is one familiar example, a cultural crazy quilt of sun worship and solstice, Christian legend, evergreen trees, a gift-bearing elf, piety, family, rampant consumerism, a red-nosed reindeer, *Silent Night* and *Rockin' around the Christmas Tree*, and other bits of cultural debris. What one understands as essential to a tradition, of course, depends on where one enters its stream.

The idea of tradition operates in at least two ways in connection with folk art. First, considerations of whether or not an object is traditional, be it in form, material, or means of fabrication, has sometimes been invoked to determine if that object should be recognized as folk art. Second, the concept of folk art can itself be understood as a tradition. Like Christmas, folk art is similarly constructed of disparate components and has accommodated complexity, contradiction, and change. It is common today to see the Nadelman collection and others of that era referred to as "traditional" folk art. Some would maintain that, with the passage of time, the Herbert Waide Hemphill and Michael and Julie Hall collections, innovative when assembled in the third quarter of the twentieth century, have also become traditional, now fully integrated into the reigning paradigm for folk art.[4] The goods in those collections remain the same, but their position in the cultural sequence has changed and thus their designation.

Beyond its value in complicating the idea of tradition and by extension of all things thought traditional, Hobsbawm and Ranger's book opened a path of inquiry that led to critical thinking about other familiar terms. Consider Larry Shiner's *The Invention of Art* (2001).[5] In this provocative study, Shiner charts the historical ascent of the conception of art dominant today in the Western and Westernized worlds. Shiner leads us through three centuries of theorizing about classifying and ranking aspects of the material world, tracing the emergence and subsequent institutionalizing of art as a separate category of artifacts and of experience. Throughout the later eighteenth century and into the nineteenth, the designation "art" served increasingly to mark the transformation of once purposeful objects into objects without purpose. In this process of metamorphosis, the new institution of the art museum provided a neutral setting for decontextualizing and homogenizing diverse forms of cultural production, forms that had originally served highly divergent and charged economic, social, religious, or political ends. In the process of losing socio-technic purpose, art simultaneously gained a new spiritual significance, becoming for some a substitute or replacement for conventional religion. This shift in evaluation increasingly led, as Shiner notes, to "viewing art as the revelation of a superior truth with the power to redeem."[6] In the twentieth century, this function was joined by increasing emphasis on aesthetics, creating an autonomous and largely self-referential cultural domain. Like other areas of culture, conceptions of art continue to change. Indeed, philosopher and historian Leon Rosenstein claims that much of today's art isn't even art; it is only *about* art.[7]

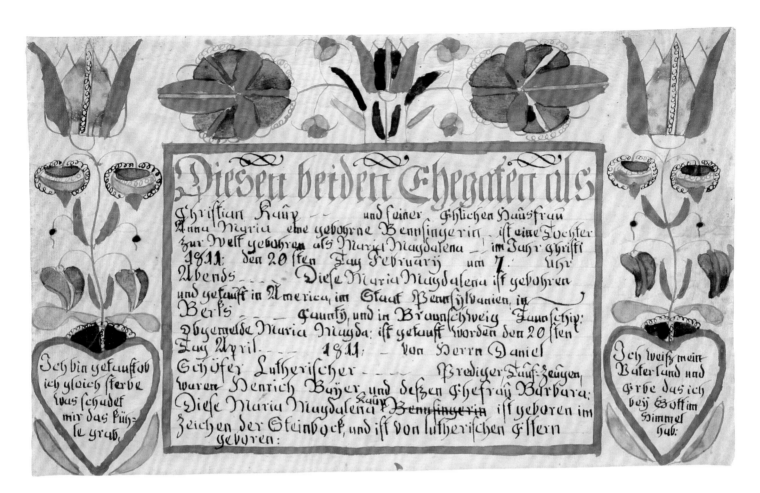

Fig. 53
Unidentified American fraktur artist,
Certificate of the Birth and Baptism
of Maria Magdalena Kaup of Berks
County, Pennsylvania, 1811. Gouache,
brown ink, and watercolor on beige
paper; 7⅞ × 13 in. (20 × 33 cm).
N-YHS, 1937.1813

Shiner's explication of the invention of art as we now know it is far more subtle and nuanced than I can indicate here. Compelling in its own right, his argument gains even greater force when juxtaposed with anthropological definitions of art. Anthropologists would argue that art in some form is probably a human universal. Most societies—possibly all—have some version or versions of it, even if they have no name for it. In these societies, art—whether named as such or unnamed—functions to elevate objects, events, or experiences, whatever they may be, above the ordinary. It makes things special and gives them greater meaning and heightened significance, typically through intensified attention to form. The critical point is that artful objects remain useful objects but differ from the everyday by evoking fuller affective or emotional responses.[8] From this perspective, a Pennsylvania-German birth and baptism fraktur, for example (fig. 53; cats. 23, 24), is both a valuable document and wonderfully artful calligraphy. The latter enhances the import of the former.

Twenty years before Shiner's *The Invention of Art*, Alan Gowans argued in *Learning to See* (1981) that the prevailing concept of art was retroactively injurious, inhibiting full understanding of the roles that artful objects had played in the past and distorting their value as historical documents.[9] More recently, Briann Greenfield's *Out of the Attic* (2009) explored the paradigm shift in standards for evaluating American antiques that emerged over the course of the last century.[10] Initially valued primarily for their explicit linkages to worthy people and memorable events, American antiques were prized as secular relics of sorts, deeply meaningful to early collectors with a romantic reverence for the past. During the first half of the twentieth century, however, the importance of historical context gradually declined, increasingly replaced by an aesthetic reading of objects. The most apparent evidence of this

Fig. 54
Unidentified American maker
(probably Massachusetts), Secretary
desk and bookcase, ca. 1770–80.
Maple, pine, paint; 84 × 37½ × 18½
in. (213.4 × 95.3 × 47 cm). N-YHS,
1937.1278

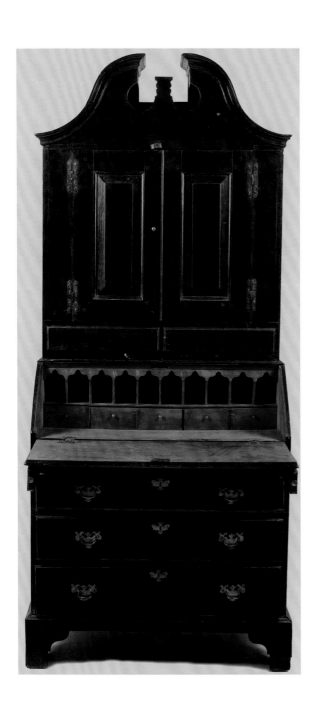

transformation may be in the field of American furniture. There the key document is surely Albert Sack's *Fine Points of Furniture* (1950), which proposed a system of aesthetic evaluation, ranking objects on the now-familiar scale of good, better, or best.[11]

The evaluative system Sack introduced was notable for privileging aesthetics to the near-total (but never entire) exclusion of historical factors. Today, an object's historical associations or provenance can still play an important part in ranking its desirability, but the appeal of the aesthetic framework is powerful, a perhaps sobering reminder that, at least in the current economic marketplace, art generally trumps history.

In the realm of folk art, privileging the aesthetic has sometimes contributed to a cavalier attitude toward origins and historical context. Peter Lord, a historian of Welsh material culture, has observed that in the American folk art world, middle-class goods, portraits among them, are rarely acknowledged as such but more often associated with a classless "folk."[12] More problematically, Welsh middle-class portraits of the nineteenth century, many of which bear a strong resemblance to American cognates, have appeared on the American folk art market, where they are sold as American goods. These pictures attract little attention in Wales and sell cheaply there, but they bring a great deal in this country once reinvented as American folk portraits.

Then there is that eternally troubling word *folk*. Not surprisingly, like tradition and art, *folk* is also a socially constructed category. In a short essay written more than twenty years ago, historian Robin Kelley maintained that use of the term *folk* was tied to "the reproduction of race, class, and gender hierarchies and the policing of the boundaries of modernism."[13] In other words, whoever and whatever were defined as *folk* typically ranked lower than those doing the defining. Kelley also maintained that it is important to recognize that, no matter how or where invoked, the concept of *folk* had no meaning without *modern*, to which it generally stood in opposition. The word conventionally signified either an imagined pre-industrial survival and/or the Other. No matter how innocently applied, *folk* remains a hegemonic category imposed on others. It is therefore hardly surprising that few people define themselves as folk.

Or as peasants either, for that matter. The Nadelmans had initially used the term *peasant arts* in conjunction with their collection. This made sense, considering Elie's European origins and the couple's extensive holdings of European objects. The concept of the peasant is as complex an artifact as that of the folk,[14] but in the United States the word *peasant* carried strongly negative associations and was largely ignored by American collectors. In fact, the Nadelmans later dropped it from the name of their museum. In the rhetoric of American democracy, the peasant and the aristocrat were both creatures of rigidly hierarchical and discredited social orders, and the terms were equally inappropriate within this new political experiment. Indeed, some saw the absence of a visible peasant class as a noteworthy feature of nineteenth-century America. As Alexis de Tocqueville noted in 1835, "Among the new objects that attracted my attention during my stay in the United States,

none struck me with greater force than the equality of conditions."[15] So, no peasants here in democratic America, but lots of folk.

The concept of craft need only be briefly mentioned here. In *The Invention of Craft* (2013), Glenn Adamson shows how this key word is yet another relatively recent invention, created in response to the trauma of modernity and industrialization.[16] Ways of working materials familiar to centuries of artisans only became crafts in retrospect, after they had been superseded by the waves of mechanized processes that transformed nineteenth-century industry. Like folk art, craft has sometimes been seen as a fragile and endangered vestige of the past, albeit a past that was largely imaginary. Even when modern or contemporary in origin, most objects designated as folk art are typically products of uncomplicated or pre-industrial technologies, closer to what is understood as craft than to industry.

The commingled histories of the four words *tradition*, *art*, *folk*, and *craft*, and the webs of culture adhering to them force acknowledgment that folk art is indeed an invented cultural category. But if it is invented, who are its inventors? The most likely suspects, perhaps not surprisingly, are collectors. Collecting is one of the grand enterprises spawned by modernization, reaching its fullest extent during the long nineteenth century and still a prominent activity today. At its peak, collecting embraced nearly the whole of both the natural and artifactual worlds. Consider the near-parallel establishment of the American Museum of Natural History in 1869 and the Metropolitan Museum of Art in 1870. In the nineteenth century, collecting was both product of and strategy for gaining intellectual control over the vast amounts of natural and cultural matter newly encountered through exploration and territorial expansion.

Anthropologist Daniel Miller has written about the specificity of goods, reminding us that understanding the properties and uses of one category of things does not necessarily help us understand the properties and uses of another.[17] So too with practices of collecting. Collecting is not a single homogeneous phenomenon. Superficial similarities may mask fundamental distinctions. It may be instructive to compare folk art collecting to some of the other forms of collecting that have coexisted with it. There is, for instance, a significant difference between collecting folk art and collecting furniture or ceramics, whether the latter are classified as antiques, Americana, or decorative arts (figs. 54, 55). Writing about furniture in 1891, Irving Lyon made it clear that he was part of a community of collectors of early New England furniture.[18] In the realm of ceramics, one of the earliest American publications was by a member of the China Hunters Club,[19] a group of collectors. Yet collection-based histories of furniture or ceramics used in America—pick any volume at random—typically build narratives explicating continuities and changes in design, production, or consumption of the objects. The collectors themselves are infrequently mentioned. Even in more recent publications focusing on prominent named collections—the Kaufman collection of American furniture or the Teitelman collection of Liverpool jugs—the objects dominate

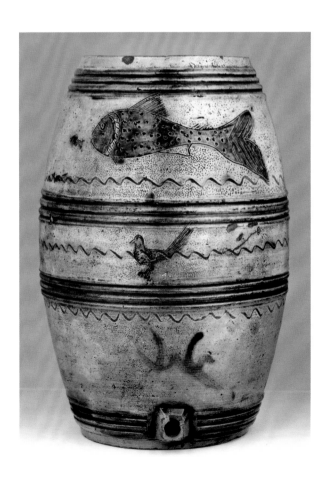

Fig. 55
Oliver Dubois (ca. 1790–1860), Keg, Zanesville, OH, 1821. Salt-glazed stoneware; 18 × 11½ in. (45.7 × 29.2 cm). N-YHS, 1937.910

the foreground, while the collectors themselves largely remain in the background.[20]

The reason for this hinges on a critical distinction. Chairs and tables, platters and jugs are empirical categories. They exist, with or without collectors. Folk art, on the other hand, is not an empirical category and it does not exist without collectors. Put in other words, chairs and platters, whether rare or commonplace, are objective realities, facts. Folk art is not fact but opinion. The objects indisputably exist, but their identity as "folk art" is a point of view. It might be helpful to think of folk art collectors as working with an evolving and never wholly verbalized system of artifactural classification that guides them in locating "folk art" within the near infinite universe of material culture. Unlike a chair or platter, an object is not folk art until designated as such. What sets folk art apart as a distinctive category of engagement with the material world, then, is the fact that the namers are every bit as important as the named. Perhaps even more so. Stillinger's *magnum opus* is not a history of material culture, not a history of objects, nor could it be. It is appropriately—and necessarily—a chronicle of the efforts, sympathies, and aesthetic sensibilities of those within the loose confederation of collectors propelling the folk art movement to 1976.

Subsequent publications demonstrate that the primacy of collectors as designators (and therefore creators) did not end in the 1970s. *Made with Passion*, published in 1990, celebrates the collecting acumen of Herbert Waide Hemphill, a prominent figure in folk art circles and a founder and trustee of the Museum of American Folk Art.[21] Hemphill's collection is now in the National Museum of American Art in Washington, DC. Curator Lynda Hartigan's seventy-page essay provides a detailed history of Hemphill's collecting as it unfolded within the broader context of evolving art and folk art worlds. The times were later, the characters and goods sometimes different, but the general contours of Hemphill's story would have been familiar to earlier participants in the folk art movement.

At first, most of Hemphill's collecting conformed to categories of antiques and Americana established earlier in the century. Only after meeting Michael and Julie Hall did Hemphill begin seeking objects made by living artisans. The year 1993 saw the publication of *Common Ground/Uncommon Vision*, a handsome volume celebrating the accession of the Michael and Julie Hall collection by the Milwaukee Art Museum.[22] The objects the Halls had collected consciously reified both continuities and changes in the governing idea of folk art. While a fair percentage of the collection fell into familiar categories for antiques, the Halls also embraced the perspectives of contemporary art collectors, acquiring several objects by living makers and in the process expanding the "traditional" understanding of folk art to include so-called Outsider art. Michael Hall later co-edited a volume on Outsider art, a cultural construct combining celebration of the idiosyncratic artist with the hierarchical distinctions embedded in the concept of folk art.[23]

In addition to conventional catalogue entries for each of the objects in the Hall collection, *Common Ground/Uncommon Vision* included

extensive—and separate—interviews with Michael and Julie Hall conducted by Russell Bowman, then director of the museum. Reflective and articulate people, the Halls provided their own insights into the complicated and absorbing business of collecting, which had been, for them, a near-obsession for many years. Both were familiar with criticism from academic folklorists and material culture scholars that folk art collecting was both anti-intellectual and even anti-factual,[24] but they consciously chose to follow their own visual orientation.

For Michael Hall in particular, collecting folk art was always but never only about aesthetics. In the Bowman interview and elsewhere, Hall reveals strong commitment to a democratic, inclusive definition of art and a profound respect for people who make expressive objects, particularly people from the margins of society. He describes his own approach to objects as intuitive rather than intellectual or historical, although close attention to his words reveals the workings of an exceptional intellect with ample attentiveness to historical context and considerable awareness of the politics of culture.

The Halls describe how collecting folk art became a consuming passion around which their lives revolved. Julie Hall recalls times when a day-long trip covered a mere twenty miles or so, as the couple stopped at every place that might conceivably hold what they sought. In scouring the landscape in search of the artifactual Other, the Halls were joining a long line of folk art collectors stretching back to the Nadelmans and before, all engaged in a kind of material tourism.[25] Like more conventional tourists, folk art material tourists were seeking alternatives to the everyday, the commonplace. For them, the everyday meant industrially produced, mass-market goods; what they sought was the rare, the authentic, the "primitive," the opposite, the Other.

It is remarkable how prominently the road trip figures in sagas of collecting. Whether roaming through the back roads of New England, sparsely populated regions of the Deep South, or ghost towns of the Old West, the search seems much the same. Even if collectors go no farther than the flea markets of Manhattan or Adamstown, Pennsylvania, the process of sifting through the flotsam and jetsam of commonplace goods in search of the glorious unfound remains a constant and key component of their activity, an activity that provides purpose and often profound meaning to their lives. It is also, variously, a commentary on, accommodation with, or critique of the material culture of the modern age.

Yet folk art collectors' quest for the "anti-modern" has been facilitated by distinctly modern conditions, the most important of which is the extraordinary material abundance of these United States. As Michael Hall noted, back when he and Julie were collecting, folk art objects were plentiful and not prohibitively expensive.[26] The same could be said more generally of American material culture past and present. David M. Potter's now-classic exploration of the American character, *People of Plenty* (1954),[27] should be required reading for those who wish to understand the material conditions enabling the invention and collecting of folk art. In the nineteenth century, rapid technological

development, industrial production of vast and previously unimaginable quantities and categories of consumer goods, and rising standards of living made the United States the envy of much of the world. More to the point, it created the abundance that was a precondition for subsequent decades of collecting.

Collecting is a complicated activity. It is, among other things, a form of shopping. That comparison may strike some as derogatory. Shopping is sometimes denigrated or trivialized, perhaps because typically associated with women. Collecting tends to be valorized, by contrast, perhaps because more frequently associated with men.

Shopping is the quintessential activity of modern consumer society, the profoundly materialistic enterprise of a profoundly materialistic culture. Collecting folk art has been for many a thoroughly absorbing, highly creative, and deeply rewarding activity, but it is a variation on the far larger theme of shopping. The goods around which the idea of folk art was constructed may evoke romantically imagined Others—but the underlying desire for acquisition, accumulation, and display is fully our own. Collecting folk art is yet another verse in the Great American anthem to finding meaning through material things. And so the study of the folk art phenomenon teaches us far more about our own society than about the world of the alleged folk.

Folk art is now a familiar part of America's cultural landscape, thanks to those many players chronicled in Stillinger's book, among them Elie and Viola Nadelman, later collectors like Herbert Hemphill and Michael and Julie Hall, and others as yet unchronicled but now involved in the game. What will happen to the idea of folk art in the future is difficult to predict. Will it endure as a separate category? Will folk art materials be integrated more fully into conventional art museums? For that matter, will new forms of museums with more inclusive visions upstage old-guard art museums? (And what of the reigning idea of art? It is changing—but into what?)

Embedded in the American idea of folk art from the start, albeit often obscured by muddled thinking and too frequently compromised by pecuniary considerations, lies an inclusivist impulse, an idea that remarkable things can come from anywhere. No race, no class, no gender, no ethnicity has a monopoly on creating affecting expression. There is a noble democratic ideal lurking within the idea of folk art, but continuing use of the term will not set it free. I have no investment in the concept of folk art and can happily live without it. In the end, as I have tried to suggest here and elsewhere, it only misidentifies. But others may be less willing to let it go.

1 Kenneth L. Ames, *Beyond Necessity: Art in the Folk Tradition*, exh. cat. (Winterthur, DE: Winterthur Museum, 1977).

2 Stillinger 2011.

3 Eric Hobsbawm and Terence Ranger, eds., *The Invention of Tradition* (New York: Cambridge University Press, 1984).

4 For the Hemphill collection, see Lynda Roscoe Hartigan et al., *Made with Passion* (Washington, DC: Smithsonian Institution Press, 1990). For the Hall collection, see Jeffrey Hayes et al., *Common Ground/Uncommon Vision: The Michael and Julie Hall Collection of American Folk Art* (Milwaukee: Milwaukee Art Museum, 1993).

5 Larry Shiner, *The Invention of Art: A Cultural History* (Chicago: University of Chicago Press, 2001).

6 Ibid., 194.

7 Leon Rosenstein, *Antiques: The History of an Idea* (Ithaca, NY: Cornell University Press, 2009), 10–15.

8 For one anthropologist's perspective, see Ellen Dissanayake, *What Is Art For?* (Seattle: University of Washington Press, 1988); idem, *Homo Aestheticus: Where Art Comes from and Why* (Seattle: University of Washington Press, 2000).

9 Alan Gowans, *Learning to See: Historical Perspectives on Modern Popular/Commercial Arts* (Bowling Green, OH: Bowling Green University Popular Press, 1981).

10 Briann Greenfield, *Out of the Attic: Inventing Antiques in Twentieth-Century New England* (Amherst, MA: University of Massachusetts Press, 2009).

11 Albert Sack, *Fine Points of Furniture: Early American* (New York: Crown, 1950).

12 Lord prefers to call these objects "artisan paintings." Peter Lord, *The Meaning of Pictures: Images of Personal, Social and National Identity* (Cardiff: University of Wales Press, 2009), 10–67; idem, *Relationships with Pictures* (Cardigan: Parthian, 2013), 109–66; written and oral communication with the author.

13 Robin D.G. Kelley, "Notes on Deconstructing 'The Folk,'" *American Historical Review* 97:5 (December 1992): 1402.

14 See, for example, Henri Mendras, "The Invention of the Peasantry: A Moment in the History of Post-World War II French Sociology," *Revue française de sociologie* 43 (2002): supplement, 151–71.

15 Quoted in Rob Dietz and Dan O'Neill, *Enough is Enough: Building a Sustainable Economy in a World of Finite Resources* (San Francisco: Berrett-Koehler, 2013), 87. More recently, critics of increasing economic inequality in this country see the creation of a permanent American peasant class as a likely outcome.

16 Glenn Adamson, *The Invention of Craft* (London: Bloomsbury, 2013).

17 Daniel Miller, ed., *Material Cultures: Why Some Things Matter* (Chicago: University of Chicago Press, 1998).

18 Irving Whitall Lyon, *The Colonial Furniture of New England* (Boston: Houghton Mifflin, 1891).

19 Annie Slosson Trumbull, *The China Hunters Club, by the Youngest Member* (New York: Harper and Brothers, 1878).

20 Michael J. Flanigan et al., *American Furniture from the Kaufman Collection* (Washington, DC: National Gallery of Art, 1986); S. Robert Teitelman et al., *Success to America: Creamware for the American Market Featuring the S. Robert Teitelman Collection at Winterthur* (Woodbridge, Suffolk, Eng.: Antique Collectors' Club, 2010).

21 Hartigan et al., *Made with Passion*.

22 Hayes et al., *Common Ground/Uncommon Vision*.

23 Michael D. Hall and Eugene W. Metcalf, Jr., *The Artist Outsider: Creativity and the Boundaries of Culture* (Washington, DC: Smithsonian Institution Press, 1994).

24 Ames, *Beyond Necessity*; John Michael Vlach, "American Folk Art: Questions and Quandaries," *Winterthur Portfolio* 15:4 (Winter 1980), 345–55.

25 The seminal text for tourism is Dean MacCannell, *The Tourist: A New Theory of the Leisure Class* (New York: Schocken, 1976).

26 Russell Bowman, "Interview with Michael D. Hall," in Hayes, *Common Ground/Uncommon Vision*, 29.

27 David M. Potter, *People of Plenty: Economic Abundance and the American Character* (Chicago: University of Chicago Press, 1954).

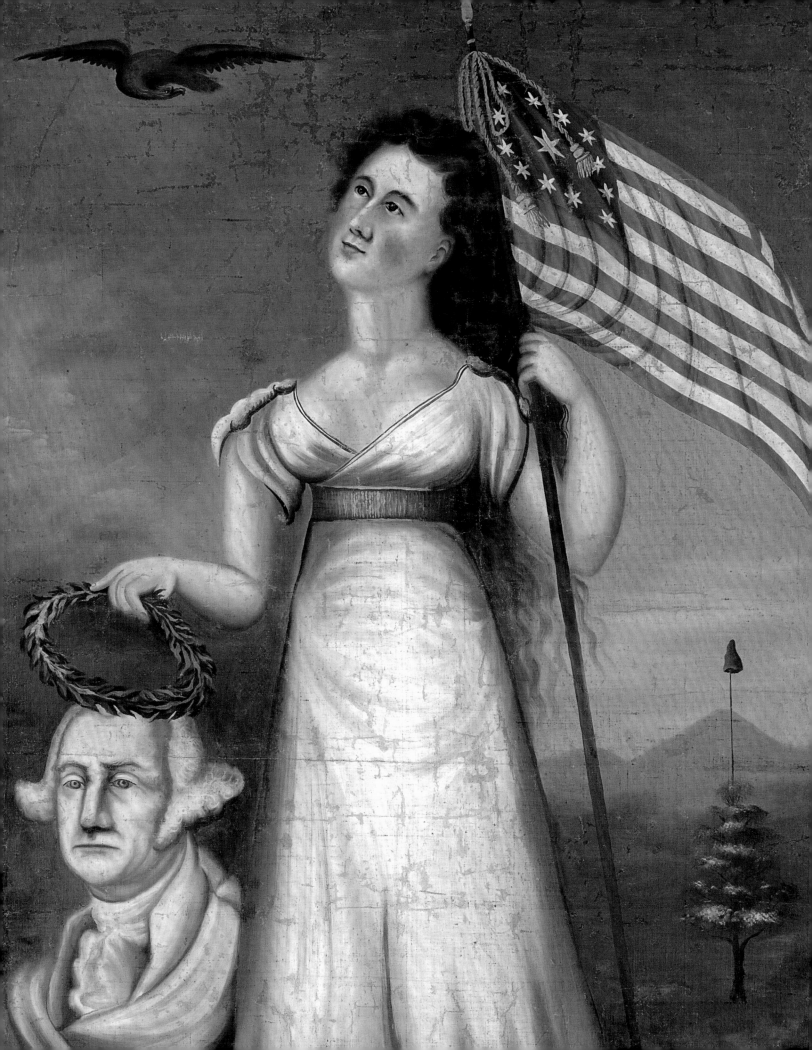

CLASSICAL ECHOES IN THE NADELMANS' FOLK ART COLLECTION

Roberta J.M. Olson

According to Elie Nadelman's fervent early champion, Lincoln Kirstein—writer, critic, impresario, and esteemed New York cultural figure—the sculptor was a true classicist. Kirstein wrote that Nadelman went straight to the fountain of ancient art for inspiration rather than to Neoclassical sculptors like Antonio Canova.[1] The models for his early sculptures were the icons of the Greek classical canon, whose greatest hits were known in multiple versions since Greco-Roman times. Among them were: the sculptures of Praxiteles, the *Spinario* (Thorn Puller), the *Doryphoros* (Spear Bearer) of Polykleitos, figures of Aphrodite/Venus as well as bathers, and Late Classical and Hellenistic Tanagra figurines. These Tanagra figurines represented the democratization of the Praxitelean ideal, which would inspire Nadelman's *Four Seasons* (cat. I) and the later figurines in plaster and terracotta that he mass-produced (see fig. 86). Ironically, Nadelman never exhibited these figurines during his lifetime although they were his ultimate egalitarian expression. Nadelman's immense debt to classical antiquity was already apparent in his early work, exhibited in 1909 at Galerie E. Druet in Paris (fig. 56). Thereafter, references to classical prototypes continued to run throughout his oeuvre, openly at first, and then later like an underground river that constantly refreshed his increasingly eclectic blend of sources.[2]

Sources in Munich and Paris

During his seminal trip to Munich in 1904, the Polish-born and -educated Nadelman visited two museums that would forever affect his aesthetic: the Bayerisches Nationalmuseum, with its vernacular collections that included regional Thuringian wood sculptures, and the Glyptothek, with its unrivaled holdings of classical Greek marbles. Notable among them were the pedimental groups from the fifth-century B.C. Temple of Aphaia at Aegina (see fig. 76), which embody the transition from the Archaic to Early Classical style.[3] The distinct trends represented by these twin early lodestars—classical sculpture and vernacular carving—would animate Nadelman's sculptures throughout his career.[4]

At the dawn of the twentieth century, when the simplified abstraction of *Jugendstil* was in vogue, Munich was an important intellectual center not only for archaeology but also for contemporary aesthetics. Among the influential intellectuals at the time were the philosopher Friedrich Nietzsche, heavily influenced by Arthur Schopenhauer, and the physicist Max Planck. The reigning contemporary sculptor was Adolf von Hildebrand, who worked counter to both the pedestrian and patriotic academicians and the growing influence of the French Romantic sculptor Auguste Rodin. Although there is no evidence that Nadelman and Hildebrand met, the ideas and aesthetics of the older sculptor nevertheless exerted a lasting influence on the young Pole. A copy of Hildebrand's 1893 treatise, *Das Problem der Form in der bildenden Kunst* (*The Problem of Form in Painting and Sculpture*), was found in Nadelman's Riverdale library.[5] Its prophetic emphasis on formal properties made a lasting impression on Nadelman and influenced

Detail of cat. 12

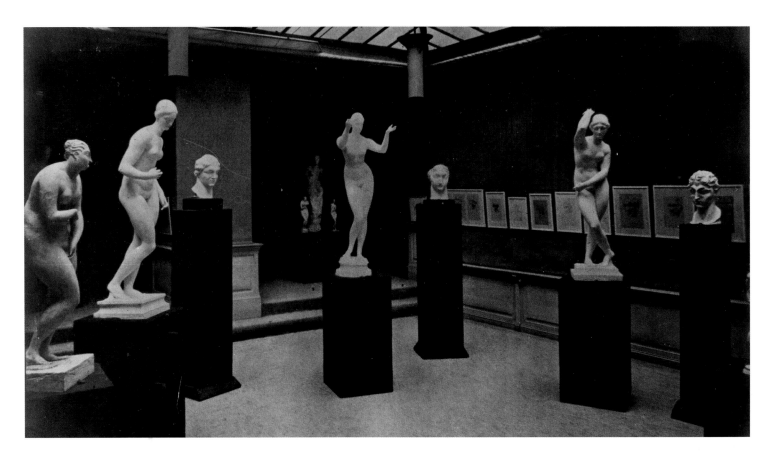

Fig. 56
Installation of Elie Nadelman's
exhibition at Galerie E. Druet in Paris,
April–May 1909. Lincoln Kirstein
Photograph Collection, Jerome
Robbins Dance Division, New York
Public Library for the Performing Arts,
Box 4, Nadelman 2, no. 2

his sculpture and collecting.[6] Nadelman also owned iconic books by
pioneering art historians of the early twentieth century, among them
Heinrich Wölfflin. A Swiss writer on aesthetics who espoused a formalist
approach, Wölfflin was the most important art historian of his period
writing in German.[7] Among the multitude of other publications in the
uncatalogued but extensive Nadelman library were archaeological
studies, monographs, and scholarly articles on a wide-ranging array of
objects from many cultures. All of these works shed light on Nadelman's
eclectic taste.[8]

While Elie Nadelman was basically self-taught, his art was heavily
influenced by the works belonging to the classical Western tradition
that he saw while he was in Paris (1904–14). Among them were
Michelangelo's two *Slaves* for the Tomb of Pope Julius II in the Musée
du Louvre, as well as the paintings of the Post-Impressionist Georges
Seurat, who enjoyed a large retrospective in March 1905 at the Salon
des Indépendants.[9] The Polish poet-critic Guillaume Apollinaire, who
heralded Paris as headquarters for a world revolution in verbal and visual
imagery, nicknamed Nadelman "Pheidia*sohn*" and "Praxitel*mann*" to
indicate his debt to Greco-Roman ideas and Aegean and Mediterranean
sources (in contrast to Pablo Picasso, who looked for inspiration to
Africa or Pacific cultures).[10] Leo Stein, the art collector and Gertrude
Stein's brother, brought their friend Picasso to Nadelman's studio in

the late summer of 1908, a critical year for the analytical stage of Cubism, the movement that Apollinaire would christen. Stein purchased a considerable number of Nadelman's early drawings, as well as his small plaster essay on Praxiteles' *Aphrodite of Knidos* (fig. 57), a larger version of which he exhibited at Druet (see fig. 56).[11] It was on this visit to Nadelman's studio that Picasso saw *Head of a Man* (now destroyed), which Nadelman claimed the French sculptor "cannibalized" in his own sculpture soon thereafter; he added that based on his plaster head he, not Picasso, had invented Cubism.[12] Nadelman later exhibited his plaster head at Druet in 1909 (see fig. 56, far right), and reportedly at the influential Armory Show in New York in 1913, after Walter Pach and Arthur B. Davies, two of the show's organizers, had selected it during their scouting trip to Paris.[13]

Sources in New York: Classical and Patriotic

Above all, Nadelman sought to create ideal forms, which he infused with a contemporary liveliness. Nevertheless, his art retained vestiges of Pythagorean ideas and geometric principles. According to Barbara Haskell, he strove for a timeless, universal art based on modernism's emphasis on formal values and its license to ignore subject matter, thereby avoiding reminders of ethnic, religious, and social distinctions. At the core of Nadelman's enterprise, however, remained the simplified forms of classical art, even though in much of his later works he strove to subvert the distinctions between high and low culture and to bridge the gulf between historical and contemporary styles.[14] In an article he published in *Camera Work* (1910), the sculptor noted: "It is form in itself, not resemblance to nature, which gives us pleasure in a work of art. But what is this true form of art? It is significant and abstract, i.e., composed of geometrical elements."[15] The Nadelmans' son, Jan, believed that his father first expressed his intrinsic bias toward abstraction and simplicity of form in his sculpture and later in his collection of folk art.[16] Certainly many of the same formal elements Nadelman sought in folk art were found in classical sculpture. In addition, American folk art included many classical motifs whose iconography accorded with the nation's democratic origins, a history that the Polish émigré applauded.

During Nadelman's New York years, which began in 1914, the sculptor's aesthetic search led to a broadening vision. His early American plaster figures with their vernacular insouciance represent a turning point and a departure from classical models. He exhibited a few of them in 1917 at the Ritz-Carlton Hotel benefit show (see cats. II, III), followed by an exhibition of a larger group at M. Knoedler & Co. in 1919 (see cats. II–IV). Nadelman's appreciation of populist materials, like plaster, and popular decorative subjects, such as dancers and musicians, found a parallel expression in the folk art objects that he and his wife, Viola, started collecting after their marriage in 1919 (see Hofer essay, pp. 57–59). Perhaps it was his growing interest in working with vernacular subjects and materials in his own sculpture that predisposed Nadelman to collecting folk art.

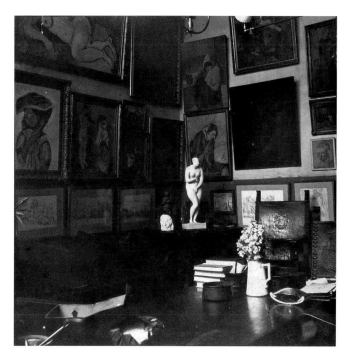

Fig. 57
Gertrude and Leo Stein's apartment (27, rue de Fleurus, Paris), ca. 1912. Beineke Rare Book and Manuscript Library, Yale University, New Haven, CT

By 1920 Nadelman was buying from the Brummer Gallery, run by his artist friend from Paris, Joseph Brummer.[17] Among the first objects that Elie and Viola collected were several hundred glass animals, which they displayed in custom-made glass cases in the couple's East Ninety-third Street townhouse (see figs. 6, 29).[18] The most valuable of these animals were ancient Greek, Roman, Persian, and Egyptian examples. The acquisition of the sometimes whimsical glass menagerie marked Nadelman's shift from a creator to a collector. This menagerie embodied a view that Nadelman had perhaps adopted from the writings of the Polish anarchist Mécislas Golberg, who held that objects across the spectrum of history shared formal characteristics. Golberg's view furnished the theoretical basis for Nadelman's interest in objects made by anonymous skilled craftsmen and encouraged the sculptor to become as engaged as Viola in collecting vernacular art.[19] According to Kirstein's much later appraisal, "Nadelman's own collection of folk-art, Shaker furniture, whaling pictures, and Pennsylvania *fraktur* hung alongside Roman glass and medieval forged iron, recognizing a continuity in traditions of intrinsic beauty sprung from necessity and inextricably linking America to Europe."[20] Sale records and other documents suggest that Elie was the leading force behind the purchases of ancient objects,[21] and they also demonstrate that the couple, while collecting folk art, continued to acquire objects from assorted cultures and periods, including classical Greece.[22]

As an émigré in 1914 Nadelman was at first repulsed by American culture. But he gradually became drawn to it, no doubt intrigued by the echoes of classicism he encountered in America's material culture and art. Like other immigrants and first-generation Americans who were active in modernist culture, Nadelman may have adopted attitudes and artistic practices he associated with folk art as a means of bringing himself closer to the traditional culture of the United States at a moment of extreme political tension over immigration. Kevin Murphy believes these American pioneers of modernism engaged in "international folkfashioning," a term derived from Kirstein.[23] But this practice was not without irony. Kenneth Ames points out that folk art by its very nature is predominantly conservative and traditional, characterized by a repetition of forms, patterns, symbols, and types.[24] By faithfully replicating their sources, in fact, folk artists affirmed them and their traditions.[25] According to David Park Curry, folk art objects also provided precedents for artists of this era, bolstering their progress toward abstraction.[26] For his part, Nadelman was clearly interested in replication in both his art and his collecting.

Since the United States was a democracy based at least in theory on Greek and Roman republican prototypes, it was natural that its national symbolism embraced classical elements and, therefore, that American folk art contained blatant patriotic motifs.[27] Forced to invent its own symbols in the late eighteenth century, the new heterogeneous nation also forged its mythology from motifs evoking patriotism and tradition, drawing on other cultures to sculpt its self-image and collective memory from the rich intellectual offerings available.[28] True to Enlightenment

ideas, at a time when the concept of the divine right of kings was questioned, Americans looked to the republics of antiquity for new models of statecraft and morality. During this formative period for America, archaeologists continued to excavate the remains of antiquity in Pompeii and Herculaneum, while the idealistic world of Johann Joachim Winckelman, with its "noble simplicity" and "calm grandeur," haunted the imaginations of the nation's founders. A case in point is the personification of America, who was transformed from a dusky Indian maiden into Columbia, and then into a Neoclassical Liberty (cat. 12).[29] In the increasingly pluralistic nation, the symbolism drawn from these ancient models formed connections among America's various cultures. Like other contemporaneous collectors of folk art, such as Maxim Karolik, the Nadelmans may have responded with increased enthusiasm to works suffused with patriotic elements because of the reverence for traditional American values that followed World War I and continued during the Colonial Revival through World War II.[30] By the interwar period both Elie and Viola were patriotic Americans.[31]

Classical Elements in the Nadelman Collection

Among the most overtly classical objects once in the Nadelmans' collection is a pair of polychromed wooden togate busts depicting Ceres, goddess of agriculture and abundance, and Apollo, god of the Sun and prophecy (figs. 58, 59). These busts were made by carvers John Skillin and Simeon Skillin, Jr., of Boston, both of whom helped embellish that city with symbols of the new Republic.[32] Like the bust of George Washington on a pedesta—based on a Roman sacrificial altar—in the Lady Liberty and Washington window shade (cat. 12), the Skillin busts are dressed in garments reminiscent of Roman togas; however, unlike the bust of Washington with its round socle base, they rest on flat bases. Classical in subject and format, the Ceres and Apollo busts embody the ideals of the fledgling but still agrarian American Republic, which looked to classical prototypes for national symbols at the close of the Federal period. While they symbolize prosperity and enlightenment, respectively, both are eclectic pastiches of elements culled from classical sources. For example, the ornate fibula on Apollo's toga and his laurel crown may derive from one source (fig. 60), although his cuirass, decorated with the face of the Sun (Sun-in-Splendor), finds its prototype in another, such as the bust whose cuirass is emblazoned with the head of Medusa (fig. 61). Whereas the pair's iconography has classical roots, its carving, by some of the finest New England artisans, is folky. It renders them less classical than the bewigged, shirt-wearing, faux-marble bust of the American hero Washington on the Liberty window shade, which owes more to the austere simplicity of Roman busts.

Another prize that the couple acquired (in 1936) is the monumental wooden sculpture of Harry Howard (cat. 1). Like many of the statues carved by workshops engaged in the production of ships' figureheads and shop figures (cats. 2–4), Harry Howard has a distinguished classical antecedent. Calling firefighters to action with his horn, he is modeled on a Roman type, which in turn was based on an Etruscan precedent

Fig. 58
Skillin Workshop, *Bust of Ceres*,
1790s. Painted wood; 23¾ × 19 × 9
in. (60.3 × 48.3 × 22.9 cm). Fenimore
Art Museum, Cooperstown, NY, Gift
of Stephen C. Clark, N0540.1948

Fig. 59
Skillin Workshop, *Bust of Apollo*,
1790s. Painted wood; 25 × 16½ × 9½
in. (64.5 × 41.9 × 24.1 cm). Fenimore
Art Museum, Cooperstown, NY, Gift
of Stephen C. Clark, N00539.48

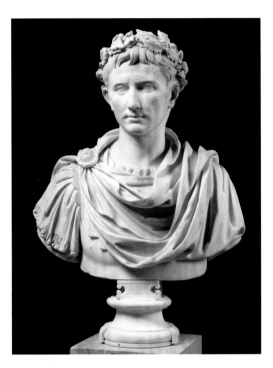

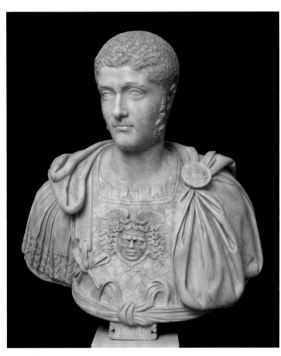

Fig. 60
Unknown Roman sculptor, *Augustus with the Corona Civica*, first century B.C. Marble; 32⅞ in. (83.5 cm) high. Musée du Louvre, Paris, 1247

Fig. 61
Unknown Roman sculptor, *Bust of a Young Man*. Marble, mid-third century A.D. Marble; 26 in. (66 cm) high. Museo Archeologico Nazionale, Venice, X: 12; inv. 148 (1887 inv.)

representing a rhetorician addressing a crowd, as exemplified by the Etruscan bronze *Aulus Metellus* ("The Orator").[33] The most famous example of this widespread type adopted by Roman emperors is the *Augustus of Prima Porta*, which assumes the same *ad locutio* pose, addressing his troops before going into battle (fig. 62). Given that Harry Howard's stance is a reversal of the ancient prototype, its unidentified carver may have consulted a print source with a reversed image.

The windswept drapery of "Rosa Isabella" (cat. 3) also traces its lineage to ancient prototypes, specifically to the figure of Nike, the winged Greek goddess of Victory most vividly represented by Paionios of Mende (fig. 63).[34] The goddess's "wet drapery," created by the wind blowing her chiton against her body, and her dancer's stance as she alights from flight are two features adopted from classical models. There were many similar representations of Nike on Greek vases, but more important were the three-dimensional sculptures that circulated via plaster casts in museums and institutions of learning throughout the Western world. These sculptures would have been available to wood-carvers in the nineteenth century through printed sources. It is also notable that among Nadelman's photographs of ancient Greek female figures were two of terracotta statuettes of Nike from Myrina whose alighting postures are similar to those of the *Nike* by Paionios and "Rosa Isabella."[35]

Surely it is no coincidence that one finds more echoes of ancient precedents in folk art sculpture than in other media, although these classically inspired works are not always on the same monumental scale. An example is the wonderfully decorative but diminutive chalkware pinecone (cat. 10), which the Nadelmans called a "pineapple." Its

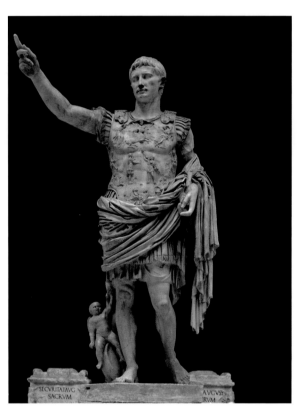

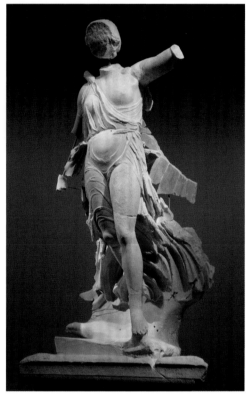

Roman prototype is the colossal bronze pinecone, a symbol of fertility, that once decorated a fountain next to the Temple of Isis in ancient Rome (fig. 64). Another example from the Nadelmans' trove is the European blanket chest dated 1678 (cat. 25). Its pillared arcade is a well-established classical motif drawn from Roman sarcophagi (fig. 65), which is echoed in other European furniture beginning in the Romanesque period.[36]

A myriad of classical references appear in paintings from the Nadelman collection, although only some have direct sources in classical sculpture. Notably, the portrait of a child and a toy horse by Joseph Whiting Stock (cat. 19) recalls the most famous horse tamers from antiquity, the *Dioscuri of Monte Cavallo* (fig. 66), and suggests an emblematic meaning for the portrait. The aforementioned Lady Liberty and Washington window shade (cat. 12) features a classicizing bust and pedestal that are complemented by other patriotic classical symbols, including a Phrygian cap and an eagle reminiscent of its Roman prototype.[37] Three of the half-cylindrical, painted wooden condenser cases collected by the Nadelmans have emblematic subjects descending from the antique, with motifs based on classical prototypes (for two, see cat. 13).[38] Moreover, the Clinton Company No. 41 condenser case, like many others, has an elaborate architectural frame composed of motifs drawn from the classical vocabulary. Its arch springs from the capitals of pilasters, and its prominent keystone is crowned by a large palmette

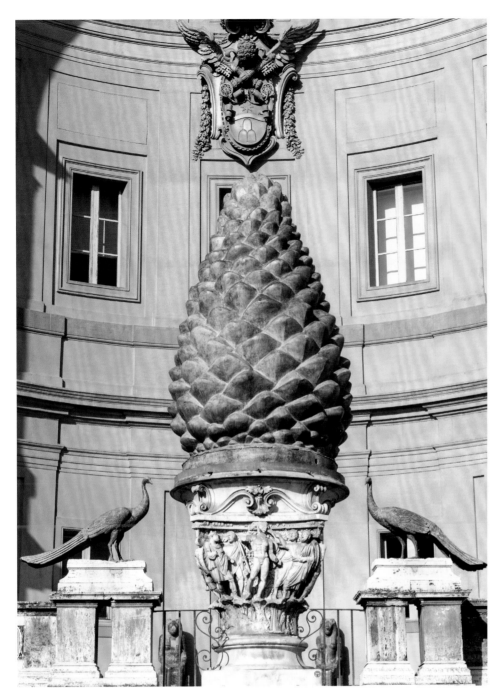

Fig. 64
Pigna (Pinecone), 25 B.C.–A.D. 25.
Bronze; 11 feet 8 in. (3.56 m) high.
Exedra, Cortile del Belvedere, Musei
Vaticani, Rome, 5118

Fig. 65
Roman Dionysian sarcophagus, fourth
quarter of second century. Marble;
27³⁄₁₆ × 78³⁄₈–80⁵⁄₁₆ × 28 in.
(69 × 199–204 × 71 cm). Staatliche
Museen zu Berlin, Sk 1938

Fig. 66
Dioscuri (Horse Tamers of Monte Cavallo), Roman copies of fourth-century B.C. Greek originals. Marble. Piazza del Quirinale, Rome

leaf, while its florid gilded decoration includes intricate foliate swags in its spandrels reminiscent of those in the Ara Pacis in Rome. Joseph H. Davis's appropriation of symbols from ancient sources in his portrayal of the Tuttles (cat. 20) includes the swags surrounding the painting on the wall and the faux-painted chairs, which resemble the Greek *klismos* model.[39] In addition, the cherubs found in some of the Nadelmans' fraktur (cat. 24) ultimately derive from the rampant *erotes* and cupids of classical art.

Eagles, including the enduring American symbol of the Bald Eagle, are a nearly ubiquitous motif in folk art (cats. 5, 39), whose roots lie in the ancient Roman symbol of power and authority.[40] An *Aquila* or eagle crowned the standard of a Roman legion (the legionnaire who carried this standard was called an *aquilifer*). Over thirty Nadelman objects in the N-YHS and fifty-five listed in the MFPA cards harken back to this ancient prototype. Among this group are the eagles carved by Wilhelm Schimmel (cat. 7), as well as multiple examples incised, painted, or stenciled on stoneware,[41] and others molded into glass.[42]

The Nadelmans' collecting impulses ran somewhat parallel to Elie's artistic credo: "To interpret the charm of life, often at its most fragile and shifting,—by inflexible and solid physical laws,—here is the definition of art."[43] Ultimately, it was the mix of classical, popular, and folk idioms, combined with craftsmanship and unpretentious charm, that attracted the Nadelmans to the objects they so passionately acquired and placed within their unique framing of folk art in the MFPA.

1 Kirstein 1973, 24.
2 Berman 2001, 47, observes that Nadelman never lost his passion for the values of the classical past and instead expanded, modernized, and Americanized them in his own work.
3 Between 1815 and 1817 the Danish Neoclassical sculptor Bertel Thorvaldsen had "restored" these fragments to fully reconstituted figures, albeit without their original polychromy, and arranged them to fit the shape of the two pediments.
4 Kirstein 1973, 161, notes that antiquities from the Mediterranean and Aegean areas, as well as folk art from Western Europe and America, revolve around a similar approach that Nadelman himself embraced: "the reduction of human or animal forms to irreducible profiles." Stillinger 2011, 181, discusses the preoccupation with folk art, ethnological studies, and ethnological museums throughout Europe at the time Nadelman was a young man.
5 Adolf von Hildebrand, *Das Problem der Form in der bildenden Kunst* (Strassburg, Germany: J.H.E. Heitz, 1893). It was translated and revised soon thereafter: *The Problem of Form in Painting and Sculpture*, trans. Max Meyer and Robert Morris Ogden (New York: G.E. Stechert, 1907). Cynthia Nadelman, e-mail message to Roberta J.M. Olson, October 23, 2013, believes that Nadelman owned the German edition.
6 Kirstein 1973, 165–67.
7 Heinrich Wölfflin, *Die klassische Kunst: Eine Einführung in die italienische Renaissance* (Munich: Bruckmann, 1904), published first in German and then in English.
8 The unusual combination of sources that informed his art and taste was characterized by one critic thus: "You may have never eaten anchovies with rice pudding but I assure you that you would find the combination quite as piquant as Nadelman's sculpture"; Hamilton Easter Field, "Modern Art Shown at Knoedler Gallery," *Brooklyn Daily Eagle*, December 2, 1919.
9 Paris, Salon des Artistes Indépendants—Rétrospective incorporée au Salon, Grandes serres de la Ville de Paris, XXI, March 24–April 30, 1905. See also cat. V, for a discussion of the influence of Seurat on Nadelman's high-kicking chorines.
10 Kirstein 1973, 172.
11 Haskell 2003, 38, states that Leo Stein purchased more than sixty-five of Nadelman's drawings from Druet; see also Janet Bishop, Cécile Debray, and Rebecca Rabinow, eds., *The Steins*

Collect: Matisse, Picasso, and the Parisian Avant-Garde, exh. cat. (San Francisco: San Francisco Museum of Modern Art in association with Yale University Press, 2011), 110–11, pl. 351. Ramljak 2001b, 11, observes that the sculpture conjoins the *Venus pudica* pose of Praxiteles' *Aphrodite of Knidos* with the face of Gertrude Stein, the literal figurehead of twentieth-century modernism (first suggested in Kirstein 1973, 177); Bishop, Debray, and Rabinow, *The Steins Collect*, 110, disagrees. Later, Stein wrote a prose portrait of the sculptor; see Gertrude Stein, "Nadelman," *Larus* 1:4 (July 1927): 19–20 (reprinted in Kirstein 1973, 274–75).
12 Kirstein 1973, 183–85. The Picasso sculpture in question is *Head of a Woman (Fernande)*, 1909; the plaster is in the Raymond and Patsy Nasher Collection, Nasher Sculpture Center, Dallas, while the bronze is in the Tate, London, 101712.
13 Galerie E. Druet, *Exposition Elie Nadelman*, exh. cat. (Paris, 1909), no. 14; Roberta J.M. Olson, "Drawings at the Armory: The Currency of Change and Modernism," *The Armory Show at 100: Modernism and Revolution*, eds. Marilyn Satin Kushner and Kimberly Orcutt (New York: New-York Historical Society in association with D Giles, London), 303, 309, 453.
14 Haskell 2003, 9; see also Haskell essay, pp. 105–13.
15 Elie Nadelman, "Notes for a Catalogue," *Camera Work* 32 (October 1910): 41 (reprinted in Kirstein 1973, 265).
16 Stillinger 1994, 518.
17 The Brummer Gallery Records, The Metropolitan Museum of Art Libraries & The Cloisters Library, N334 and N335.
18 "Fantasies in Glass: Nadelman Collection of Animals and Birds," *Antiquarian* 3:6 (January 1925): 5–7. For an example, see the receipt for one reportedly found "near Nazareth in Palestine" from Azeez Khayat (366 Fifth Avenue, New York City), April 8, 1922, for $25, NP.
19 Haskell 2003, 151; Haskell essay, p. 110.
20 Kirstein 1973, 215.
21 For example, on July 15, 1921, Nadelman purchased a Cypriot vase for $50 and a Hellenistic figure for $100; receipt from Kirkor Minassian (18 Fifty-seventh Street, New York), NP.
22 The NP, together with The Brummer Gallery Records, The Metropolitan Museum of Art Libraries & The Cloisters Library, N334 and N335, reveal that the Nadelmans acquired objects from the Brummer gallery (see Hofer essay,

pp. 57–59): for example, they purchased a Greek or Roman marble head of a woman with a pointed hat on June 13, 1921, for $500; a Roman head on March 22, 1923, for $45; and they inquired about a Tanagra figurine on February 24, 1928 (its quoted price was $340).
23 Kevin D. Murphy, "International Folkfashioning: Modern Sculptors and American Folk Art," *The Magazine Antiques* 177:1 (January/February 2010): 199.
24 Kenneth L. Ames, *Beyond Necessity: Art in the Folk Tradition*, exh. cat. (Winterthur, DE: Winterthur Museum, 1977), 24–25, 41, 66.
25 Henry Glassie, "Folk Art," in *Material Culture Studies in America*, ed. Thomas J. Schlereth (Nashville: American Association for State and Local History, 1982), 130.
26 See David Park Curry, "Slouching towards Abstraction," *Smithsonian Studies in American Art* 3:1 (Winter 1989): 48–71.
27 For this complicated topic, see New York State Historical Association, *Outward Signs of Inner Beliefs: Symbols of American Patriotism*, exh. cat. (Cooperstown, NY: New York State Historical Association, 1975); Patrick L. Stewart, "The American Empire Style: Its Historical Background," *American Art Journal* 10:2 (November 1978): 97–105; Nancy Jo Fox, *Liberties with Liberty: The Fascinating History of America's Proudest Symbol* (New York: E.P. Dutton in association with the Museum of American Folk Art, 1986); John Higham, "American in Person: The Evolution of National Symbols," *Amerikastudien / American Studies* 36:4 (1991): 473–93; Fischer 2005.
28 Wendell D. Garrett, "The Rising Glory of America," in S. Robert Teitelman et al., *Success to America: Creamware for the American Market Featuring the S. Robert Teitelman Collection at Winterthur* (Woodbridge, Suffolk, Eng.: Antique Collectors' Club, 2010), 15.
29 Ibid., 22.
30 See Carol Troyen, "The Incomparable Max: Maxim Karolik and the Taste for American Art," *American Art* 7:3 (Summer 1993): 72–73.
31 The NP provide documentation of their patriotism. For example, Nadelman acquired material related to Lincoln and wrote a four-page essay on George Washington and firefighting and collected objects related to Washington—such as his Masonic apron and a metal togate figure of Washington that graced the garden at Alderbrook (along with two metal casts after the second-century Roman copy

of the Hellenistic bronze known as "The Dog of Alcibiades" [see fig. 72]). It was important to the family that Elie served as an air warden in Riverdale during World War II, and that the Nadelmans' son, Jan, served in the Army during the war and later had a career in the State Department. Elie also worked in the Bronx Veterans Hospital, teaching wounded soldiers to work with clay to regain the use of their hands. Cynthia Nadelman, e-mail message to the author, April 9, 2014.
32 The Nadelmans acquired them after selling much of their collection to the New-York Historical Society in 1937, and Viola retained the pair until 1948 when Stephen C. Clark, Sr., purchased the busts after his scouting trip to Riverdale with Lincoln Kirstein; see Paul S. D'Ambrosio and Charlotte M. Emans, *Folk Art's Many Faces: Portraits in the New York State Historical Association* (Cooperstown, NY: New York State Historical Association, 1987), 10 (which attributes them to Samuel Skillin or a kinsman); Sylvia Leistyna Lahvis, "The Skillin Workshop," *The Magazine Antiques* 155:3 (March 1999): 449 (which attributes them to John and Simeon Skillin, Jr.).
33 Museo Archeologico, Florence, 3.
34 The sculpture was excavated at Olympia in 1875 by a German archaeological team.
35 NP; the versi of both are inscribed as in the Museum of Fine Arts, Boston, but only one remains in that collection (01.7692). Thanks to Cynthia Nadelman for bringing this to our attention.
36 For example, a bed from Holstein, Germany, dated to 1797; see H.J. Hansen, ed., *European Folk Art in Europe and the Americas* (New York and Toronto: McGraw-Hill, 1968), 53b, ill.
37 See Higham, "American in Person: The Evolution of National Symbols."
38 The third, N-YHS 1937.1632, features a classicizing bust of Andrew Jackson standing on a pedestal below patriotic bunting of the American flag and an eagle.
39 Priddy 2004, xxii.
40 Norton 2011, 26–27C. See also Frank H. Sommer, "Emblem and Device: The Origin of the Great Seal of the United States," *Art Quarterly* 24:1 (Spring 1961): 57–66.
41 Pottery examples with eagles include N-YHS 1937.577, .859, .909ab, .912.
42 For example, N-YHS 1937.961.
43 From a proposed foreword by Nadelman of ca. 1912 for a projected publication "Quarante dessins," or for another proposed portfolio, "Vers l'unité plastique" (Paris, 1914); quoted and incompletely cited in Kirstein 1973, 267.

G H I J K L M N O P Q R S T

h i k k l m n o p q r s t

H I K L M N O P Q R S T

f f g g h h i i k l M N N O P P Q R

L M M N O P Q R S T

b b l ll m n o p q r s

F. Meijer.

S. Meyer

J. V.

A. Winter. J. W

A. Mann.

Amalie. Julie. Auguste. Henriette.

Weibliche Unterrichts Anstalt.

Dresden 1810.

D. Pohlin

g h j k l m n o p q r s t u v w x y

h i k l m n o p q r s t

VIOLA NADELMAN AS A COLLECTOR

Cynthia Nadelman

As children, my brother and I would often receive a simply wrapped package at Christmas, to be shared, from our grandmother Viola—somewhat the worse for wear, since it would have come through the U.S. Embassy pouch.[1] Inside would be a variety of dime-store toys—a game of jacks, small wooden racquets with rubber balls attached by an elastic, marbles, playing cards, dice, or dominoes—thrifty but enduring classics. These fit with our image of our grandmother—small, simply dressed, with round tortoiseshell glasses, a bit formal with us, and to be respected. Far from merely representing octogenarian Viola Nadelman's circumstances at the time, there was something fitting about her gift-giving gesture—even if we probably moved on quickly to playing with new battery-powered toys.

Little did we know then about the giant trove of toys that had filled an entire gallery in the Nadelmans' Museum of Folk and Peasant Arts (MFPA) in the 1920s and 1930s (see fig. 15)—in particular, hundreds of dollhouse-size items (cats. 45, 79, 80) representing every possible feature of a real house, which seem to have been a particular area of interest for Viola. Elie's taste could be seen in mechanical coin banks and trapeze toys and even the large antique doll collection, so related to the job of a sculptor who embraced the figure. The timeless appeal of the toys Viola sent us in their way mirrored the goals of the Nadelmans' museum—namely, to show affinities among different types of craft and handiwork, and to display examples of ingenuity shared by broad segments of society.

It has been Viola Nadelman's fate to be known mainly as the "wealthy widow" or "socialite" who came into Elie Nadelman's life and changed it when they married in late 1919. While that is true up to a point, there is much more to Viola Spiess Flannery Nadelman than the epithets suggest. For his part, Elie Nadelman was already privy to the ways of high society, as he simultaneously catered to and formed their tastes through his exhibitions and commissions. He earned a respectable living from his art in the years leading up to meeting his wife and through the 1920s. But he was certainly not in Viola's league.

Viola Spiess was born into a life of privilege. Her father, Louis Spiess, junior partner in the New York tobacco and cigar manufacturing firm of Kerbs and Spiess (fig. 67), died at age thirty-five in the year of her birth, 1878. He left her twenty-three-year-old mother, the former Amelia Hess, with three children—Claribel, Arthur, and Viola—under the age of four. Both the Spiess and Hess families were prosperous New Yorkers of German Jewish descent. They were active in New York real estate and also in city politics. Amelia's father, Loeb Hess, who emigrated from Darmstadt in 1849, owned a successful wholesale beef and provisions business at Washington Market; her brother Jacob was variously fire commissioner and commissioner of subways, and another brother, Charles, was a prominent lawyer.[2] Amelia Hess cut quite a wide swath through Gilded Age society over the next few decades. After her husband's death, she sailed with her three young children and two nurses to Europe,[3] where she eventually married another New Yorker, Charles Einstein, who owned racehorses and was engaged in appointed

Fig. 67
Kerbs & Spiess cigar advertisement.
New York Public Library, George
Arents Collection, Arents 3245

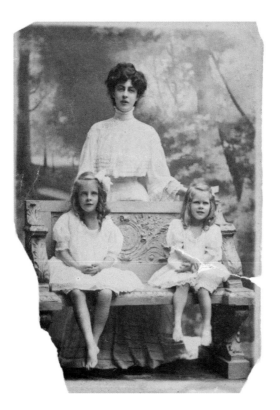

consular work for the State Department. Viola and her siblings attended schools in Germany and possibly Switzerland.[4] It appears that their mother and Einstein did not have children together, and in 1891 they were divorced.[5] A few years later, Amelia married the Italian count Girolamo Naselli, who was active in the Italian diplomatic corps in the United States. Amelia remained involved in real estate in New York throughout her life, relying on Viola to handle transactions for her after she settled in Rome.

In 1897, Viola married Joseph A. Flannery, a New York real estate attorney born in Montgomery, Alabama. She probably converted to Catholicism around that time. Joseph and Viola had two daughters, Viola and Aileen (who, following in her grandmother's steps, would marry an Italian count in the 1920s). In 1915, Joseph Flannery died at age forty, leaving an estate said to be worth around $1.5 million.[6]

Following Flannery's death, Viola and her two daughters (fig. 68) became especially active on the social circuit. Newspaper articles described her giving a "sailing party" on her yacht, the *Osceola*, in Newport in the summer of 1918,[7] and renting the "picturesque estate" of painter Albert Herter in East Hampton the next summer, where she hosted a benefit for the housing of destitute children in France.[8] Viola's elder daughter was in the ambulance corps in France during World War I, through the auspices of the American Field Service, which was run by her mother's friend from Gloucester, Massachusetts, Henry Davis Sleeper, an important figure in American collecting.[9]

Viola's involvement in the art world before her marriage to Elie Nadelman had been somewhat peripheral, but not insignificant. In 1912, she served on the exhibition committee for a show of George Inness paintings at the New York School of Applied Design for Women.[10] In 1915, she was a sustaining member of the Metropolitan Museum of Art.[11] A colored etched portrait of her (fig. 69) and a probably later double portrait of her daughters as girls were commissioned from the Belle Époque artist Paul-César Helleu.[12] Her lifesize portrait of 1910 by the German born, society painter Wilhelm Funk (figs. 70, 71) was widely shown: for example, in a 1911 group exhibition that opened at the National Arts Club and traveled to the Detroit Museum of Art (as it was then called) and other museums.[13] When the painting was shown at Funk's solo exhibition at the Reinhardt Gallery in New York in 1912,[14] it was favorably remarked upon by a reviewer.[15] It went to Europe with a traveling exhibition of Funk's work; on the return trip in 1915 all the exhibition's paintings were seized and held in Great Britain, since they were cargo on a German ship during wartime.[16] Eventually, Viola's portrait returned, and it was displayed in her home in Riverdale for many years.

Around 1917, Viola became a founding member of the Needle and Bobbin Club in New York. She began by specializing in acquisitions of

Fig. 70
Wilhelm Funk, *Mrs. Joseph Flannery*, 1910. Oil on canvas; 52½ × 38 in. (133.3 × 96.52 cm). Collection of Cynthia Nadelman

Fig. 71
Viola Spiess Flannery at 45 East Fiftieth Street, ca. 1913. NP

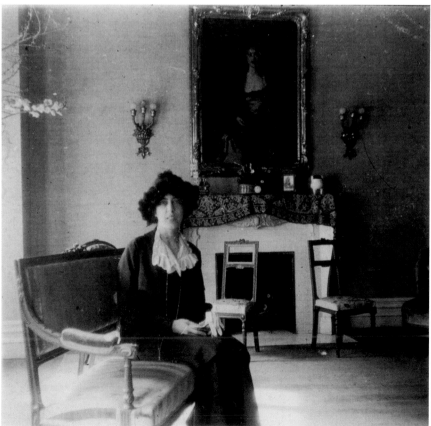

lace, but the Club's bulletin reveals that its members explored a wide range of subjects in the textile field.[17] Viola's collecting of textiles grew to include embroideries, costumes, and accessories, including a group of "headdresses," such as those worn in central and Eastern Europe for weddings and other occasions. She also purchased quilts, jacquard coverlets, weavings, and hooked rugs (cat. 54). Once she and Elie started collecting, she bought the tools and implements used in textile making, including such gadgets as flax brakes and swingling sticks, which she lent to a 1936 exhibition on American textiles at the Brooklyn Museum.[18]

After the Nadelmans married in 1919, they may have begun buying primarily for the houses they would occupy, including the limestone townhouses they combined at 4 and 6 East Ninety-third Street (see fig. 5)[19] and at Alderbrook, on the Hudson River (figs. 4, 72), the 1860s house and estate that Viola bought as a summer retreat in Riverdale, just north of Manhattan, in 1921. In a 1920 account of an auction at Augustus W. Clarke, "Mrs. Ely [sic] Nadelman" was mentioned, second only in order of purchasers after William Randolph Hearst.[20] According to Lincoln Kirstein, whom Viola must have informed, the Nadelmans were underbidders for the Unicorn Tapestries,[21] secured by John D. Rockefeller, Jr., in 1922 for over $1 million and later given to the Metropolitan Museum of Art's Cloisters. Medieval ironwork from the Nadelman museum would also one day hold pride of place at The Cloisters (fig. 45).[22]

In addition to the classical art that had always interested Elie, the Nadelmans seemed to show a marked interest in medieval material from Europe. Much of the religious work they collected—ranging from fifteenth-century English alabaster reliefs of biblical scenes,[23] and Spanish and Catalan Gothic Crucifixions and statuettes of apostles in wood, to eighteenth-century Scandinavian Nativity narratives painted on linen—may have reflected Viola's interests (see fig. 18), while the formal qualities of the polychrome sculptures supported Elie's artistic practice of the time. The European material illustrated the connections that the MFPA would stress, of anonymous and vernacular European crafts as a precursor to American efforts, made largely by immigrant populations influenced by objects from their early surroundings.[24] As an immigrant himself, who combined influences in his art, Elie may have been the earlier enthusiast for things American, with Viola following suit. Indeed, Viola at times seemed to prefer being identified as European, and was often referred to as Madame Nadelman.[25]

For their home at East Ninety-third Street, the Nadelmans commissioned "decorations" from the modernist painter Bernard Gussow in the mid-1920s. The work was not done directly on the wall, and unfortunately there seems to be no visual record of the results, but the artist worried that the colors might be too "strong," and had to be assured by Elie that Viola did not think so.[26] (In fact, the Nadelmans were not daunted by color: in their folk art collecting, they leaned toward colorful objects, and their Riverdale home had bright tile decorations in many of the rooms.) The furniture in their houses was generally eclectic

Fig. 72
Konrad Cramer, Alderbrook,
ca. 1947. NP

European—French Provincial, Louis XV, Italian Baroque tables and wood stools, worn Aubusson carpets, and Biedermeier pieces. Rattan outdoor chairs were eventually put to use in the favored upstairs "green room," where Elie and Viola wrote their daily correspondence and read the newspaper at a round George III table. Here Elie sometimes modeled his small late sculptures. In later years, Viola, who with Elie had been an avid bridge player, would use the table for playing solitaire, which she taught me one summer.[27] During the summer, the expansive columned porch overlooking the Hudson was another favorite spot, and in early days one could view the path that led down the hill to the MFPA, with trees to the left and a meadow straight ahead.

In various ways, each of the two brought a measure of stability to the other (figs. 73, 74)—perhaps Elie in particular to Viola, in a reversal of the usual truism about artists and their mates. Elie's strong sense of self-direction may have acted as a counterweight to the dramatic ups and downs of Viola's earlier family life. On the other hand, their extravagance in living and collecting seems almost to have been a *folie à deux*—fine as long as it could be sustained, encouraged, and facilitated by what they must have felt was the boundless capacity of her fortune and his earnings. The energy of their partnership was monumental, both while building their collection and while winding it down.

Although Viola had not attended college, she had a classic European education and was literate, if not bookish, in at least English, German, and French languages and cultures. She had a large collection of books,

Fig. 73
Arnold Genthe, Mr. and Mrs. Elie
Nadelman, with baby and cat,
1923. Library of Congress, Prints &
Photographs Division, Arnold Genthe
Collection

from French literature to texts on her collecting interests. A large group
of volumes on lace in various languages was auctioned in 1932 at
Anderson Galleries, probably when the family was forced by foreclosure
to move permanently from Manhattan to Riverdale.

Most important, Viola seems to have been the organizational
head of the couple's collecting enterprise. It was her name that
appeared on the architectural blueprints of 1924–25 for the stone
building that would house their museum (see figs. 8, 9).[28] Much of the
Nadelmans' voluminous correspondence is addressed to her, and it is
in her hand that most of the drafts of letters are written.[29] She fielded
correspondence in various languages, usually answering in English. Viola
was the one with mastery of English spelling and grammar and she had
a formal, yet warm, style, although Elie's colorful or poetic turns
of phrase are often discernible, as they worked on many of these letters
together. And sometimes another hand is evident on the reverse of
correspondence: messages scrawled by their son, Jan, such as, "I took
a nickel from your pocket," or "Buy leads, bring the pup upstairs,
buy candy."

In 1935, when the Carnegie Corporation gave the MFPA a grant,
through the School Art League, to continue the operations of the
museum, Viola was named director. All along, she had enlisted group

visitors—whether from New York University's Fine Arts Graduate Center (later the Institute of Fine Arts), the local high school, or the Bronx-based Colored Orphans Asylum—as well as assorted curators and fellow collectors. While assiduously clicking people off with an attendance counter, Viola also assumed the responsibility for displays, cataloguing, and other administrative tasks.[30] She answered questions about recommended reading on subjects ranging from Finnish textiles to Spanish pottery, wrote for information to museums in Poland and Wales, and scheduled appointments for specialists, such as the professor from NYU's Fine Arts Graduate Center who wrote about the Nadelmans' group of wood statuettes depicting Christ and the Apostles.[31]

When Homer Keyes, editor of *The Magazine Antiques*, expressed interest in having the Nadelmans' cake prints photographed,[32] Viola and family—none of them cooks—took it upon themselves to fill one of the many giant cake prints in the museum (cat. 71) with a concoction of plaster so that photographs would show the positive results of cake printing, rather than the mold's negative space. A few years later, the mold was acquired by the N-YHS, and the cake print appeared on the magazine's cover with credit given to Viola for creating the relief.[33] There were other practical matters: for instance, in 1944, years after the museum was dismantled, Viola sold a group of museum cases to

Fig. 74
Elie Nadelman, *Viola Nadelman*, ca. 1927. Brown ink on paper; 9 × 5½ in. (22.9 × 14 cm) (sight). Collection of Cynthia Nadelman

Fig. 75
Page from Viola's memorandum
book from trip to Charleston, South
Carolina, 1938. NP

the Sons of the Revolution for use at the Fraunces Tavern Museum in downtown Manhattan.[34]

Before and after Elie's death in 1946, Viola arranged loans, sales, and gifts with curators from the Metropolitan Museum of Art, the Newark Museum, the Brooklyn Museum, the Chicago Art Institute, the Museum of the City of New York, and the New York Public Library, among other institutions. In 1948, the speedy acquisition by philanthropist Stephen Clark of a number of folk objects for the New York State Historical Association in Cooperstown was cordially achieved by Viola and Clark through visits and letters.[35] She also corresponded with Electra Havemeyer Webb, resulting in some sales and gifts that entered the Shelburne Museum collection.[36]

Brought up with servants, Viola once admitted she had never coiffed her own hair until she was past middle age.[37] But in 1935 she proposed a budget to the Carnegie Corporation that included her salary of $100 a month as director of her museum. She was diplomatic, but something of a stickler: after the WPA's Index of American Design designated her the "supervising artist" for the artist-illustrators who would draw items in the collection, that soon changed, and Elie became the supervising artist. For this he was paid $115 a month, since Viola insisted that her skills did not fit the job description.[38] In 1927, when Elie had an exhibition at Galerie Bernheim-Jeune in Paris, the Nadelman entourage, complete with chauffeur, maids, and a nurse for young Jan, took over rooms at the Trianon Palace Hotel in Versailles for the entire summer.[39] They also made shopping forays from there for their museum. In contrast, a 1938 car trip to the Southeast ending in Charleston, South Carolina, was punctuated by $1.55 lunches, 70¢ trips to the movies, and $1.08 gas purchases. Typical lodgings were Miss Hatch's Motel in Wilmington, North Carolina, when motels were a new phenomenon (fig. 75). Viola kept a record of each expense in a little memorandum pad, including the prices of a painting on velvet ($10) and four pottery cups ($3).[40] During World War II, this needlework expert knit socks to send Allied soldiers, a testimony to her practical sense of the changed world.

Viola inspired friendships. Alfred Barr, Jr., the director of the Museum of Modern Art and a member of the Nadelmans' museum advisory committee, hand-wrote an oddly double-edged note to her on a copy of an endorsement of her museum's mission that he had written to the Carnegie Corporation in 1935: ". . . May I say something—personal—? It's not because of your museum I've written this letter but because I like and admire you so much B."[41] By 1946, Viola was a widow again. At age sixty-eight she had much work ahead as an advocate for her husband's sculpture and for their folk art collection. She may no longer have been wealthy in the monetary sense, but she was rich in memories, people, art, and tasks still to accomplish.

For their assistance, I owe a debt of gratitude to art historian and researcher Ronny Cohen, as well as to Catherine Tinker.

1 Jan Nadelman, Elie and Viola's son and my father, was a career U.S. Foreign Service officer, who was often posted abroad. We saw my grandmother sporadically, on visits made to Alderbrook, her home in Riverdale.
2 Loeb Hess obituaries, in *New York Daily Tribune*, October 3, 1895; *New York Herald*, October 4, 1895.
3 Passport application for Amelia Spiess, May 24, 1879: Ancestry.com.
4 One of Viola's schoolmates in Stuttgart was Ettie Stettheimer, who was romantically linked with Elie Nadelman during the mid-1910s.
5 Charles Einstein, according to newspaper accounts, was "living a gay life in Paris" with another woman. A few years after the divorce, Amelia received a settlement of more than $60,000 in lieu of alimony, which Einstein had neglected to pay. "Mr. Hess's Sister Secures a Divorce," *New York Tribune*, March 28, 1891, and Loeb Hess obituary, *New York Herald*, October 4, 1895.
6 Joseph Flannery ran afoul of the legal establishment for engaging in insider real-estate deals while he was pursuing condemnation proceedings for the City. "Disbarred Lawyer Died a Millionaire," *New York Times*, October 17, 1915.
7 "Fishing Contest for Norrie Cup To-Day," *Sun*, September 18, 1918.
8 "Seek $10,000 From Southampton Fete," *Sun*, August 13, 1919. The Herter estate is a well-known landmark known as "The Creeks" on Georgica Pond in East Hampton.
9 For an account of the Nadelmans' 1920 stay at Beauport, Henry Sleeper's home, see Cynthia Nadelman, "Elie Nadelman's Beauport Drawings," *Drawing* 7:4 (November–December 1985): 75–78.
10 *Exhibition of Thirty-Eight Paintings by the Late George Inness, N.A., from the Ainslie Collection and Others*, exh. cat. (New York: New York School of Applied Design for Women, 1912).
11 Metropolitan Museum of Art, *Forty-sixth Annual Report of the Trustees of the Metropolitan* (1916): 119.
12 Helleu's portrait of Viola is dated variously; it may depict her around the time of her first marriage.
13 *Circuit Exhibition of Contemporary Art of the National Arts Club*, exh. cat. (Detroit: Detroit Museum of Art, 1911), n.p. (first page of checklist).
14 *Exhibition by Mr. Wilhelm Funk*, exh.

cat. (New York: Reinhardt Gallery, 1912).
15 "The lips are slightly parted revealing pearly teeth. . . . there is a winsomeness in the expression which has impressed itself upon many visitors. These stand in rows before the canvas, often blocking the passage." Contemporary newspaper clipping with unknown date, NP. I thank Christine Oaklander for first bringing information on Wilhelm Funk to the family's attention.
16 "British Hold Up Funk's Paintings," *New York Times*, April 29, 1915. See also entry for Wilhelm Funk in Barbara Dayer Gallati, ed., *Beauty's Legacy: Gilded Age Portraits in America*, exh. cat. (New York: New-York Historical Society in association with D Giles, London, 2013), 118.
17 *Bulletin of the Needle and Bobbin Club* 10:2 (1926); 13:1–2 (1929); among others. I thank Margi Hofer for providing these references.
18 Letter from Philip Youtz, Director of the Brooklyn Museum, about an exhibition on "the making of textiles as carried on in the American home," with an actual "demonstration of the preparation of the natural fibers and the spinning and weaving of flax, wool and cotton," November 23, 1936, NP.
19 The architect of the renovation was A. Stewart Walker, husband of Viola's friend Sybil Walker. She was instrumental in securing a number of clients and portrait commissions for Elie Nadelman. Walker was the architect of the Fuller Building, 41 East 57th Street, for which Nadelman sculpted a tableau over the entrance, and he was the architect for additions to the New-York Historical Society in the late 1930s.
20 "209 Ancient Spanish Art Items Sold for $18,637," *New York Tribune*, November 19, 1920. She "paid $1,650 for two carved walnut doors, late sixteenth century, German."
21 Kirstein 1973, 219. Founder of the New York City Ballet, Kirstein had not known Elie personally, but he contacted Viola soon after the artist's death hoping to work on the artist as biographer and curator. Kirstein became a friend to Viola, frequently bringing people from the art and cultural worlds to visit her at Alderbrook.
22 The ironwork was acquired by the N-YHS in 1937 and is now in the collection of The Cloisters.

23 The independent scholar Augusta Tavender researched the two fifteenth-century reliefs belonging to the Nadelmans for an article on British alabasters in American collections, but the reliefs depicting the Trinity and the Betrayal of Judas were not mentioned in her *Speculum* articles of January 1955 and July 1959. Their fate since the 1943 N-YHS auction is unknown.
24 MFPA 1935; mission statement/press release 1935; "Folk Art Bought for Display Here," *New York Times*, January 24, 1938.
25 After her marriage to Elie, she briefly had a Polish passport as the wife of a Polish national, until he became a naturalized U.S. citizen in 1927.
26 NP.
27 Viola lived at the house in Riverdale until her death in 1962. Her son, Jan, and his family moved there in 1972, and it remained with them, housing Elie Nadelman's art, until 2009, when it was sold. It has been designated a New York City Landmark.
28 NP. The architect was Arthur Sutcliffe.
29 Ibid.
30 At one point, Viola had the temerity to ask Holger Cahill, former director of the Newark Museum and, during the 1930s, variously director of the WPA and the Federal Art Project, to "put some life into" a press release that had been written for the public opening of her museum by René d'Harnoncourt, future director of the Museum of Modern Art: both Cahill and d'Harnoncourt were members of the advisory committee for the Nadelmans' Museum of Folk Arts.
31 Walter W.S. Cook, "A Catalan Wooden Altar Frontal from Farrera," *Medieval Studies in Memory of A. Kingsley Porter*, ed. Wilhelm R.W. Koehler (Cambridge, MA: Harvard University, 1939) 1: 293–300, figs. 2–4, 6–10, 12. The essay is cited in the Parke-Bernet auction catalogue of December 1943, where the statuette group is listed for sale. Three other figures, in addition to the Nadelmans' group of nine, had been identified at that time: at the Museum of Fine Arts, Boston; the Fogg Art Museum, Cambridge, MA; and the collection of Juan Cabrejo. It is uncertain where the Nadelman group currently resides.
32 Correspondence with Homer Eaton Keyes, 1935–37, NP.
33 *The Magazine Antiques* 40: 4 (October 1941): cover.
34 NP.

35 Stephen Clark also bought a small marble by Nadelman at this time. Stephen's brother, Sterling Clark, founder of the Sterling and Francine Clark Art Institute in Williamstown, MA, had commissioned portrait busts of himself (marble and bronze) and his wife (marble) from Nadelman in 1933; today they are in that institution, 1955.1011, 1955.1008, 1955.975.
36 NP.
37 She confided this to her friend Florence Cramer, who entered her account of a 1948 visit to Viola in her diary. Florence's daughter Aileen sent the diary to the author in 1992. Subsequently, Elizabeth Stillinger provided her notes from her visit to Aileen.
38 NP.
39 Ibid.
40 Ibid.
41 Ibid.

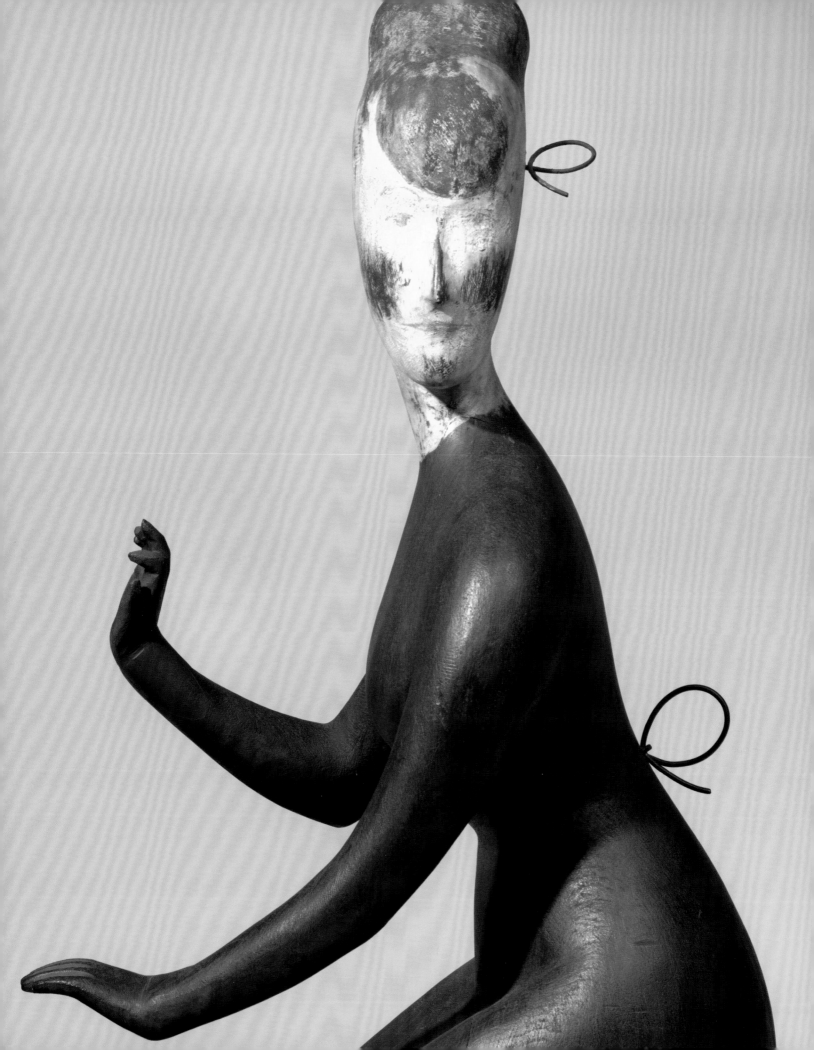

NADELMAN AND FOLK ART:
THE QUESTION OF INFLUENCE

Barbara Haskell

Between 1920 and 1936, Elie Nadelman and his wife, Viola, amassed a collection of close to fifteen thousand pieces of folk and utilitarian art from Europe and the United States. Installed in a freestanding building on their estate in Riverdale and opened to the public by appointment in 1926 as the Museum of Folk and Peasant Arts, the collection was a focal point of their years together. Nadelman's obsession with the collection, combined with the quotidian subject matter and seeming naïveté of the genre sculptures he created while assembling it, has led to the widespread assumption that folk art was a singular influence in shaping his aesthetic vocabulary. The trajectory of Nadelman's career, however, suggests that his attraction to folk art was perhaps more ideological than visual and that a true appreciation of his genius lies in recognizing his ability to unite folk art's emphasis on the subjects of contemporary life with the geometric simplicity of classical art.

Without a doubt, folk art exerted a formative influence on Nadelman. Growing up in Poland, the artist was sensitized to the importance of folk themes early in his life by the country's unusual symbiosis between art and nationalism. Poland had ceased to exist as a nation in 1795, when Russia, Austria, and Prussia divided its land among themselves. These powers abolished Polish schools and institutions, banned Polish language from public use, and suppressed all social, cultural, and economic links between the three occupied zones, but they were unable to suppress Polish nationalism and the dream of Polish reunification. Until 1918, when Poland again became an independent state, visual art was one of the prime conduits through which national consciousness was covertly expressed. Polish artists valorized folk culture and folk artifacts and focused their work on themes that revolved around Poland—its peasants, history, and countryside.[1] Nadelman began his career as an artist against the backdrop of this interconnection between folk themes and national identity, and he retained a deep respect for vernacular archetypes even after he left Poland in 1904.

Yet it would be the formal purity and grandeur of classicism that ultimately would have an arguably greater weight as Nadelman developed his art. His introduction to this visual language occurred in Munich, his first stop after leaving Poland in 1904. The city's most prominent sculptor and aesthetic theoretician was Adolf von Hildebrand, who practiced a late nineteenth-century version of early Greek classicism. Hildebrand's severe, volumetric style was a modern counterpart to the pedimental sculptures from the fifth-century B.C. Greek Temple of Aphaia on the island of Aegina, which were the crowning glory of Munich's antiquities museum, the Glyptothek (fig. 76). The city's pride in these classical figures, combined with Hildebrand's exhortations to artists to use them as guides for overcoming the "poverty of sculptural art to-day,"[2] could not have failed to exert a strong impression on Nadelman, who would later adopt their compact, geometric simplicity and freezing of gestures in climactic "stop" positions as key elements in his aesthetic.

Nadelman's appreciation for classicism accelerated following his relocation to Paris and his entrance into the city's close-knit community

Detail of cat. IV

Fig. 76
Unidentified artist, West pedimental
sculpture from the Temple of Aphaia,
Aegina, ca. 490 B.C. Marble;
50 in. (127 cm) long. Staatliche
Antikensammlungen und Glyptothek,
Munich

of Polish artists and intellectuals, who were embracing Greek art as
an antidote to what they viewed as the melodramatic themes and
vocabulary of Symbolism. Their aim was not to create a Neoclassical
revival but to use classical language to describe the modern world. As
explained by Guillaume Apollinaire, an important critic and member
of this Polish colony, "It was not a question of competing with models
of classical antiquity, but of renewing subjects and forms by bringing
artistic observation to the first principles of great art."[3] In 1909, five
years after Nadelman's arrival in Paris, his success at fashioning a
personal style rooted in Greek art was rewarded with a solo exhibition
at Paris's prestigious Galerie E. Druet, followed two years later by a
show in London at William B. Paterson's Gallery. The languid grace and
dreamy sensuality of the ten marble heads that constituted his London
exhibition caught the attention of Helena Rubinstein, the cosmetics
magnate and a fellow Pole, who purchased the show's entire contents
and commissioned Nadelman to decorate her London beauty salon with
a quartet of freestanding female figures engaged in the daily activities
of bathing, combing their hair, and dressing. Until then, Nadelman's
sculptures had been modeled after the idealized heads and nudes of the
fourth-century B.C. Greek sculptor Praxiteles, known for his sensuous
mythological subjects. Obliged by the Rubinstein commission to depict
activities associated with everyday life, Nadelman turned from Praxiteles
to the miniature Hellenistic terracotta figurines known as "Tanagras,"
after the site in Boeotia where they were first found. The majority of
Tanagra figurines depict fashionable women sitting close together on
couches or standing in casual poses, adorned with accessories like hats,
wreaths, or fans, and wearing the layered, body-concealing costume
of the fourth century B.C. (fig. 77). Small in size and mass-produced
by anonymous craftsmen using sectional molds, these inexpensive
terracotta figurines exhibit the stylistic features of Hellenistic sculpture
in their emphasis on fluid drapery and the suppleness of poses. What
attracted Nadelman to them as source material was their depiction of
the intimate world of urban, fashionable women, which seemed ideally
suited to a commission intended for a beauty salon. The *Four Seasons*
(cat. I), as his resulting quartet was later called, was Nadelman's first
foray into addressing the nobility of quotidian gestures and activities.

Nadelman's engagement with genre subjects renewed his interest
in the writings of Charles Baudelaire, whose 1863 essay "The Painter
of Modern Life" enjoyed wide acclaim within the Polish community
in Paris. Cautioning artists not to neglect the charm of everyday
circumstances and contemporary manners, Baudelaire proposed that
true beauty consisted of the union of the eternal and the transitory. The
fugitive and ephemeral must "on no account be disposed or dispensed
with," he argued; art that did so was destined to fall into an abyss
of indeterminacy.[4] "The true painter we're looking for," Baudelaire
wrote, "will be the one who can snatch from the life of today its epic
quality and make us feel how great and poetic we are in our cravats
and our patent-leather boots."[5] For Baudelaire, nothing epitomized
the ephemeral and the contingent more than fashion, which changed

with each season. The idea led Nadelman to wonder if depicting figures wearing modern-day clothing would render them unambiguously contemporary even if their formal vocabulary was classical. If true, it would be a way to answer Baudelaire's call to make art that was both classical *and* contemporary—art that portrayed the ephemerality of present-day life as epic and timeless. Nadelman tested the hypothesis by creating two idealized heads, one wearing a bowler hat that resembled Mercury's helmet and the other wearing an unequivocally modern top hat (fig. 78). Exhibited in the 1914 Salon des Indépendants, the heads were praised by Apollinaire, who called them the "first works in which a piece of modern clothing had been treated in an artistic manner."[6] Nadelman pushed his fusion of modern clothing and classical form further after relocating to New York in August 1914, following the onset of World War I.

The sculptor announced his new direction at Alfred Stieglitz's "291" gallery in December 1915. Along with a streamlined plaster horse and a sampling of earlier pieces, the show included drawings of fashionably attired men and women and a plaster of a young man wearing a bowler hat and a string tie, casually leaning against a tree (fig. 79). While compositionally based on Praxiteles' various depictions of Apollo resting against a tree, *Young Man in Hat*, as the plaster was titled, depicted a quintessential dandy, the hero Baudelaire had called the last "representative of what is finest in human pride."[7] Radiating a mixture of confidence and insouciance, the work was the first of what would be the artist's many portrayals of archetypes of American popular culture.

Two years later, after having established himself as an artist of idealized heads and lyrically stylized animals, Nadelman returned to the theme of American popular culture. The catalyst was his entrance into the circle surrounding the wealthy, unmarried Stettheimer sisters—Florine, Ettie, and Carrie—and his exposure to a sensibility that simultaneously celebrated and satirized American manners and habits. The Stettheimers' self-mocking assessment of the pomposity of upper-class society and the artifices and excesses of popular culture reinforced Nadelman's own view of the United States. He had been thirty-two when he arrived in America. Unaccustomed to speaking English and with few friends, he had initially disliked the country, which struck him as materialistic and lacking refinement. Although he had not lost his belief in the superiority of European over American culture, it had merged with an appreciation of the nation's naïveté and egalitarian, unpretentious directness. Attuned as an outsider to issues of national identity, he set out to depict what he felt was the essential American character, using figures from upper-class society and popular entertainment. The result was a series of thirty-inch-high plaster figures of circus performers and society archetypes whose facial details and attire he delineated with blue paint (fig. 80). Wearing dresses or trousers, and posed as if frozen while performing a casual gesture, these figures reflected Nadelman's attempt to come to terms with the nation that was now his home. Although likely inspired by the naturalistic poses and fashionable clothing of Tanagra statuettes, Nadelman's

Fig. 77
Unidentified artist, Female statuette from Tanagra, Boeotia, ca. 320 B.C. Terracotta; 11⅜ in. (29 cm) high. Musée du Louvre, Paris, MNB585

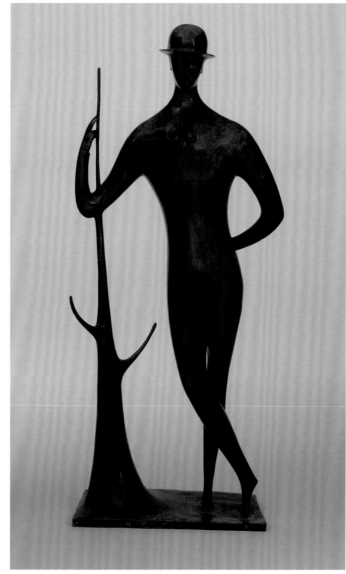

Fig. 78
Elie Nadelman, *Le boulevardier*, 1914.
Plaster; 18½ × 9 × 13½ in. (47 ×
22.7 × 34.3 cm). Los Angeles County
Museum of Art, Gift of Mr. and Mrs.
Nathan Smooke

Fig. 79
Elie Nadelman, *Man in the Open Air*
(original plaster titled *Young Man in
Hat*; cast initially titled *Le promeneur*),
ca. 1915. Bronze; 54½ × 11¾ × 21½
in. (138.4 × 29.8 × 54.6 cm). The
Museum of Modern Art, New York,
Gift of William S. Paley (by exchange)

plasters seemed "primitive" and unsophisticated to contemporary
audiences—more like caricatures than fine art. Their exhibition in 1919
at M. Knoedler & Company was a critical and financial failure.

The Knoedler Gallery had offered Nadelman's plasters for sale
both as self-sufficient objects and as models for works that clients
could order in wood or bronze. Undaunted by the public's rejection
of them, Nadelman went ahead with their production in these two
materials. Over the next five years, he cast a few in bronze and arranged
for the majority to be constructed from pieces of cherry wood glued
together and given with a reddish brown stain over which he applied
gesso and Prussian blue and red-orange paint to demarcate clothing,
facial features, and hair (fig. 81, cats. II–VI). In their tubular volumes
and elemental gestures, they were a sculptural counterpart to the
contemporary figures that populated Georges Seurat's paintings, which
Nadelman had known in Paris. What distinguished Nadelman's work
from that of Seurat and others who use idealized forms to describe the
modern world was the seeming naïveté of his figures' gestures and
painted facial features. Nadelman's aim had been to endow American
archetypes with the immutability of classical art; contemporary
observers, however, saw only the formal simplicity and subject matter of
his figures, which they associated with folk art.

Nadelman's use of wood as a medium furthered the perception that his work was influenced by folk art. Yet to Nadelman, having matured as an artist in Europe, wood was a commonplace material for all fine art. Xawery Dunikowski, Poland's most important early twentieth-century sculptor and Nadelman's former classmate at Kraków's Academy of Fine Arts, had made his sculpture out of wood, as had the German artists of Die Brücke. So, too, had German Gothic artists. Among Poland's national treasures, Nadelman had admired Veit Stoss's late fifteenth-century polychrome altarpiece in Saint Mary's Church, Kraków, and he had spent countless hours studying Tilman Riemenschneider's Late Gothic limewood sculptures in Munich's Bayerisches Nationalmuseum (fig. 82). In his first years in New York, he commissioned wood craftsmen to render several of his idealized bronze and marble sculptures in the material (fig. 83). His decision to construct the majority of his genre

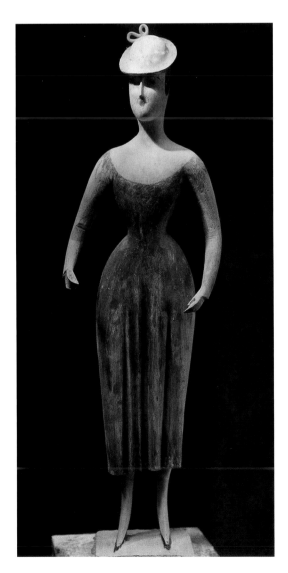

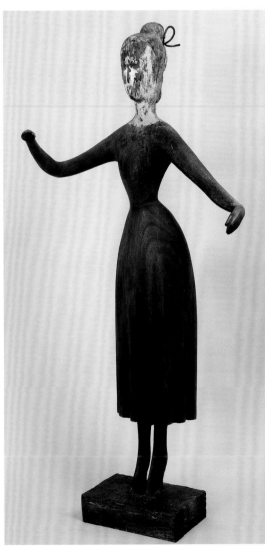

Fig. 80
Elie Nadelman, *Standing Woman in Hat*, 1918–19 (destroyed, preserved in this photograph by Mattie E. Hewitt). Painted plaster; 30 in. (76.2 cm) high. Lincoln Kirstein Photograph Collection, Jerome Robbins Dance Division, New York Public Library for the Performing Arts

Fig. 81
Elie Nadelman, *Chanteuse*, ca. 1920–24. Stained, gessoed, and painted cherry; 36¾ in. (93.3 cm) high. Private collection

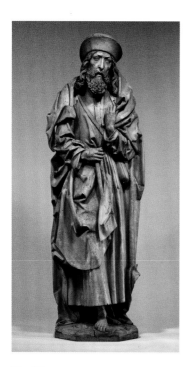

Fig. 82
Tilman Riemenschneider, *Saint James the Greater*, ca. 1505. Limewood; 58¼ × 20½ × 9 in. (148 × 52 × 23 cm). Bayerisches Nationalmuseum, Munich

figures out of wood did not owe to the influence of folk art, but to the material's suitability to depicting the citizens of the democratic, egalitarian nation.

Just as Nadelman was beginning his bronze and wood genre figures, he married Viola Spiess Flannery, a wealthy widow four years his senior. At the time of their marriage in 1919, Viola was already an ardent collector of laces, embroideries, and fabrics from ancient times to the present and from countries around the world. Soon after their marriage, the couple assembled a collection of glass animals (figs. 6, 29), whose recurrence of similar shapes from a wide spectrum of places and epochs would have reminded Nadelman of Mécislas Golberg, an esteemed member of the Polish community of expatriates in Paris, whose aesthetic theories had exerted a profound impact on the young artist.[8] Unlike the contemporaneous art historian Wilhelm Worringer, who postulated that art styles oscillate between abstraction and representation, Golberg believed in the steady reappearance of formal characteristics and motifs throughout disparate eras and genres. In Golberg's view, no inherent quality difference existed between art of distinct styles and epochs or between art made by trained and untrained craftsmen. Not surprisingly, given Nadelman's free amalgamation throughout his career of aesthetic motifs from diverse cultures and eras, the thesis likely resonated with him. After his marriage to Viola, their acquisitions gave him a way to demonstrate it. Guided by their mutual instinct for pedagogy, the couple began to collect chronologically diverse folk art from Europe and the United States whose shared forms demonstrated the theory that the whole sweep of art history was one seamless continuum of repeating, formal correspondences. Notwithstanding the collection's scope, however, its constituent objects bore little formal relationship to Nadelman's fine art, with the exception of the chalkware that he began purchasing in 1924 (cats. 10, 11), a year before making his painted electroplated busts of 1925–26 (fig. 84). In general, however, Nadelman's sculpture differed from the folk art he collected—whether chalkware busts, shop figures (cat. 2), carousel horses, or milliner's heads (cat. 9)—in its simplified classical vocabulary, which endowed everyday figures with an epic monumentality.

Nadelman completed the last of his wood and bronze genre figures in 1925; a year later, he and Viola opened their Museum of Folk and Peasant Arts. By 1931, the stock market crash and the couple's attendant financial reversals forced them to begin selling some of its contents. At the very moment that Nadelman began a desperate attempt to keep as much of the collection intact as he could, his production of sculpture did indeed move closer to the spirit and techniques of folk art. Before, he had often made duplicates of his classical heads and figures in different materials and sizes and with dissimilar surface treatments. With the installation of a kiln in a specially built annex to his studio in 1930, he began to make multiple, small-scale ceramic casts of single and paired female figures, identical in form to his larger, classical figures, differentiating each figure produced from the same mold by painting the hair and clothing distinctively (cat. IX,

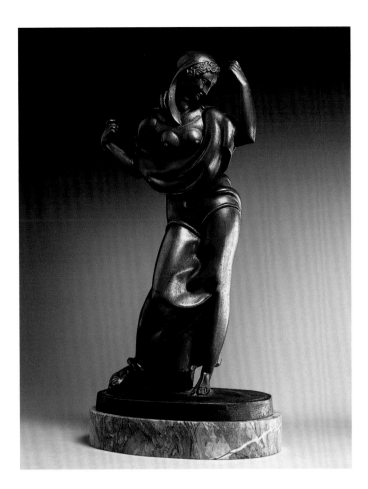

Fig. 83
Elie Nadelman, *Draped Standing Female Figure*, 1912–13, carved ca. 1915. Cherry; 23 in. (58.4 cm) high. Private collection

fig. 85). His production methods were similar to those used by ceramic folk artists to mass-produce identical pieces sharing a common shape but possessing unique features. While bearing witness to his fascination with familial groupings of related but different objects, Nadelman's brightly colored figurines seem almost to have been created to fill the void left by the gradual loss of his collection. Following the final sale of the contents of the couple's Museum of Folk Art to the New-York Historical Society in 1937, the mood and style of Nadelman's art shifted dramatically, with the modest pleasures and cheerful grace of everyday experiences yielding to intimations of flux, uncertainty, and anxiety in the wake of the rise of Fascism and the onset of World War II. For six years, however, Nadelman had created a body of brightly painted ceramics whose scale and relative affordability were intentionally populist and closer to the spirit of mass-produced folk objects than anything he had made previously. Paradoxically, the middle-class audience who might have purchased the work never saw it. By the time Nadelman began making his ceramics, he had exited from the art world; when he died, multiples of his ceramic figurines were found in his storeroom, most unfinished, having never been seen by anyone outside of his family (fig. 86).

Decades after Nadelman's death, the correspondences between folk art and his fine art seemed to be conclusive evidence that his decisions as an artist were primarily influenced by folk objects. The truth is more nuanced. Nadelman had successfully invested his sculpture with the unpretentious naïveté, and simple charm of folk art, but he had neither imitated it nor abandoned his commitment to the refined clarity and monumentality of classicism. By depicting the ephemeral pleasures of everyday life with the formal discipline and architectonic clarity of Greek classical art, he had taken the Baudelaire-inspired quest for the integration of the elusive and the timeless to a new plateau.

Fig. 84
Elie Nadelman, *Girl's Half-Length Torso*, 1925–27. Painted galvano-plastique; 30 in. (76.2 cm) high. Lincoln Kirstein Papers, Jerome Robbins Dance Division, New York Public Library for the Performing Arts, Box 4, Nadelman 1, no. 7

Fig. 85
Elie Nadelman, *Two Circus Women*, ca. 1928–29. Papier-mâché; 59¼ × 38 × 21 in. (150.5 × 96.5 × 53.3 cm). Collection of Cynthia Nadelman

Fig. 86
Nadelman's figures in the attic of Alderbrook, 1948, after the artist's death.

1 For a discussion of the relationship between Polish art and nationalism, see Jan Cavanaugh's *Out Looking In: Early Modern Polish Art, 1890–1918* (Berkeley, Los Angeles, and London: University of California Press, 2000).

2 Adolf von Hildebrand, *The Problem of Form in Painting and Sculpture*, trans. Max Meyer and Robert Morris Ogden (New York: Garland, 1978), 116.

3 Guillaume Apollinaire, "African and Oceanic Sculptures," in *Apollinaire on Art: Essays and Reviews, 1902–1918*, ed. Leroy C. Breunig, trans. Susan Suleiman (New York: Viking, 1972), 470. Apollinaire was born Apolinary Kostrowicki in Rome, the illegitimate son of Angelica Kostrowicka, who was the daughter of a Polish papal chamberlain. Though Apollinaire did not speak Polish and kept his Polish ancestry secret, it must have contributed to his close involvement with the Polish community in Paris.

4 Charles Baudelaire, quoted in Stephen F. Eisenman et al., *Nineteenth-Century Art: A Critical History* (London: Thames and Hudson, 1994), 304.

5 Ibid.

6 Guillaume Apollinaire, "March 5, 1914," in *Apollinaire on Art: Essays and Reviews, 1902–1918*, 358.

7 Charles Baudelaire, "The Painter of Modern Life," in *The Painter of Modern Life and Other Essays*, ed. and trans. Jonathan Mayne (London and New York: Phaidon, 1965), 28.

8 Mécislas Golberg's numerous contributions to vanguard Parisian art journals, including *Cahiers de Mécislas Golberg* (1900–07), and the extensive quotation of his commentaries by Polish critics made it impossible for anyone in the Polish community to be unaware of his theories. After his death in 1908, familiarity with the ideas in his posthumously published collection of essays, *The Morality of the Line* (1908), was essential for participation in café conversation.

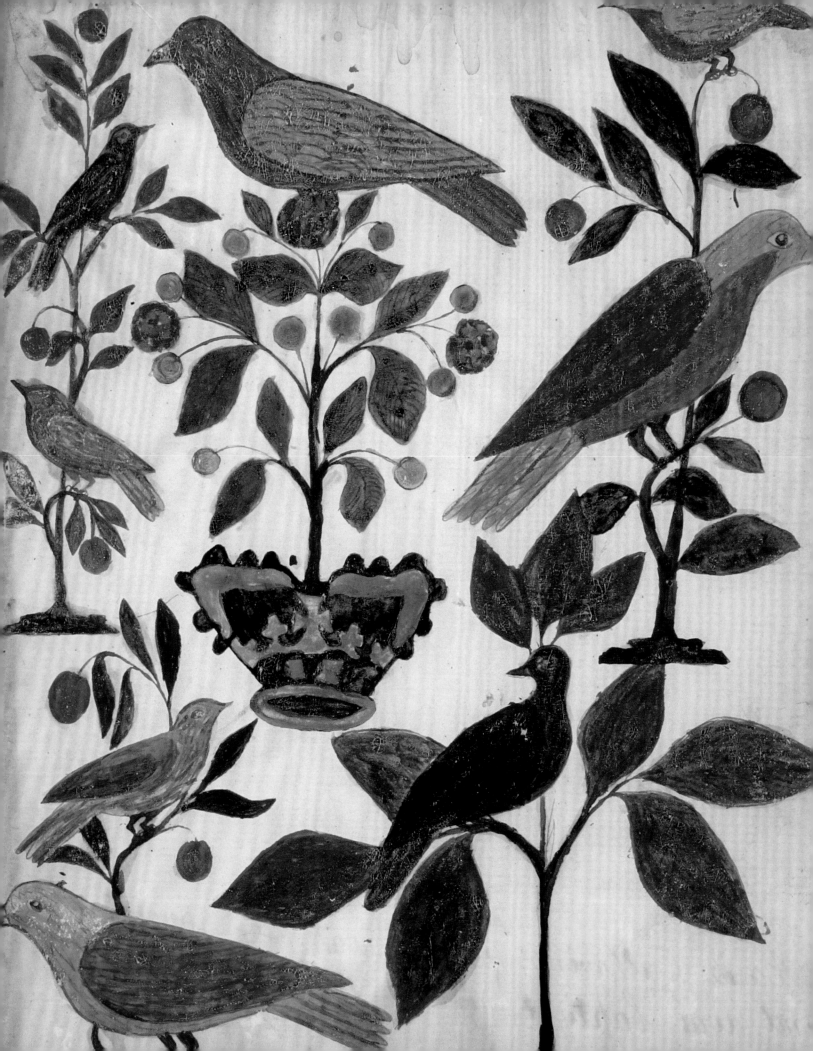

CATALOGUE

THE NADELMAN FOLK ART COLLECTION

1

Unidentified American maker
Fire Chief Harry Howard (1822–1896),
ca. 1855
New York City
Painted wood; 100 × 66 × 44 in.
(254 × 167.6 × 111.8 cm)
Provenance: Harry Howard Hose Company, 115
Christopher Street, ca. 1853–65; Neptune Engine
Company No. 2, Paterson, NJ, ca. 1865–75;
Protection Engine Company No. 5, Paterson,
1875–90; Paterson Exempt Firemen's Association,
Paterson, 1890–1936
1937.328

This icon of American folk art—a highlight of the Nadelman collection[1]—celebrates one of the most famous figures in New York City's firefighting history. Harry Howard was humbly born, but by 1857 had risen to chief engineer, the highest rank in the city's all-volunteer force. Of sterling integrity and legendary for his bravery in saving many lives,[2] he gained a national reputation. In this monumental statue, the man of "herculean frame" was represented, probably by a New York City ship carver, at nearly nine feet tall and in dramatic command: he brandishes a speaking trumpet and gestures to his company to lead them into action. The carved and painted figure of the hero once crowned the three-story headquarters of the Harry Howard Hose Company No. 55 at 115 Christopher Street, named in his honor.[3]

For its first eight decades, Harry Howard led a peripatetic existence, ornamenting four different fire headquarters in two states. Around 1865, men from the Harry Howard Hose Company in collaboration with firefighters from Neptune Engine Company No. 2 of Paterson, New Jersey, spirited the statue from the roof of 115 Christopher Street and hid it under a pile of hay in a Paterson barn until the search parties scouring the town had given up hope of finding it.[4] The plundered statue was then mounted on the roof of Neptune No. 2's house until the company's disbandment in 1875, subsequently moved to Protection No. 5's house, and finally donated to Paterson's Exempt Firemen's Association in 1890 when the town changed from volunteer to paid fire service. An undated photograph documents the position of the strapping hero on the roof of the Association's portico, where it stood sentry over a house overflowing with firefighting relics.[5]

The Nadelmans' curatorial records do not document the acquisition of Harry Howard, a very late addition to the Museum of Folk Arts. In July 1936, the *Sun* reported that the Nadelmans had recently discovered the statue "in the cockloft of an old volunteer fire house in Paterson, N.J." According to the *Sun*, the couple "bought it, dusted it off and shipped it in a crate to their studio, where it is now undergoing slight rehabilitation."[6] The extent of the Nadelmans' "rehabilitation" is unclear. Although its surface is quite weathered and covered with many layers of paint, the major carved elements have remained intact. The pedestal was probably pieced together in Elie Nadelman's studio from recycled furniture parts.[7]

The monumental figure clearly intrigued the Nadelmans, as they made a special trip to the New York Fire College in Long Island City to view a life-size oil portrait of Howard, commissioned in 1860 to hang in City Hall, in which he strikes a similar heroic pose.[8] The 1937 inventory of the Nadelmans' museum indicates that they displayed Harry Howard in the entry gallery (Gallery VII) alongside firefighting equipment such as parade shields and engine lanterns.
MKH

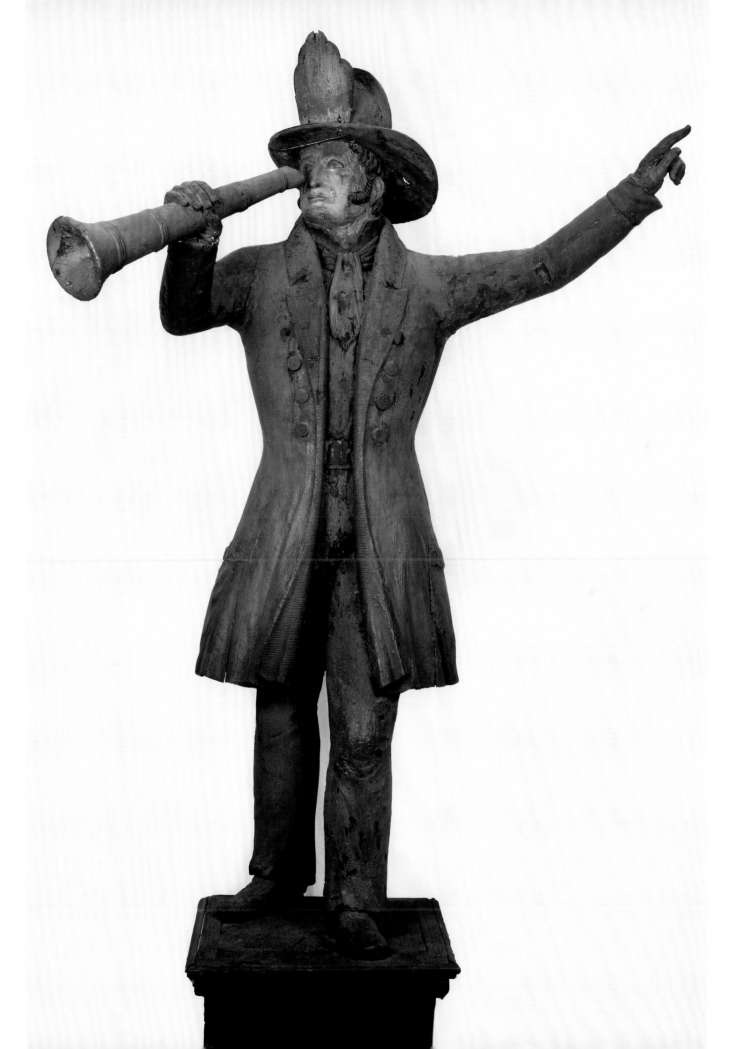

1 Harry Howard has been widely published. See, for example, Tom Armstrong, et al., *200 Years of American Sculpture*, exh. cat. (New York: Whitney Museum of American Art; Boston: D.R. Godine, 1976), 84–85; Stillinger 1994, cover; N-YHS 2000, 58–59; Sessions 2005, 140, 176, 179.

2 Augustine E. Costello, *Our Firemen: A History of the New York Fire Departments, Volunteer and Paid* (New York: Augustine E. Costello, 1887), 405; "Harry Howard is Dead," *New York Times*, February 7, 1896.

3 Costello, *Our Firemen*, 675. Scholars long believed that Harry Howard once topped Firemen's Hall on Mercer Street. However, that figure, as reproduced in period engravings, held a speaking horn in his left hand and gestured downwards with the right. Period references do not identify the figure as a portrait of Harry Howard. See "Firemen's Hall, Mercer Street, New York," *Frank Leslie's Illustrated Newspaper*, June 7, 1856; "New Firemen's Hall," *New York Times*, August 22, 1854. According to New York City directories, the Harry Howard Hose Company was first located at 52 Amos Street (now West Tenth Street) from 1855 to 1857. The company relocated by late 1857, when *Frank Leslie's* noted that their firehouse at 115 Christopher Street had just been furnished. See "The Harry Howard Hose Company No. 55," *Frank Leslie's Illustrated Newspaper*, October 17, 1857. It is unclear whether Harry Howard can be dated to the era of the company at Amos Street or to a commission for the new firehouse.

4 William Buckridge, ed., *The History of the Association of Exempt Firemen and Fire Department of Paterson New Jersey* (Paterson, NJ: Association of Exempt Firemen, 1905), n.p. I thank Damon Campagna, director and curator of the New York City Fire Museum, for bringing this source to my attention. The men of the Harry Howard Hose Company may have colluded with the Paterson firefighters because the New York firehouse was ordered closed as part of the city's mandated shift from volunteer service to a paid professional force in 1865.

5 Glenn P. Corbett, *The Great Paterson Fire of 1902: The Story of New Jersey's Biggest Blaze* (Waldwick, NJ: Privately printed, 2002), 50.

6 "Find Statue of a Great Fire Fighter," *Sun*, July 2, 1936. See also "The Antique Maple Bed Comes Back," *New York Times*, July 5, 1936.

7 When it was photographed on the roof of the Paterson Exempt Firemen's Association around 1890, the statue had a different base. The top of the current pedestal is made from several mismatched boards decorated with geometric carving and pierced with unexplained nail holes.

8 "Find Statue of a Great Fire Fighter." See also "City and County Affairs," *New York Times*, November 20, 1860. The portrait, by Joseph H. Johnson, is now at the New York City Fire Museum, 10.161.

2

W. Allan (English, active early nineteenth century)
Highlander tobacco shop figure, 1824
Wood, paint, metallic pigment; 46¾ × 13 × 10¼ in.
(119 × 33 × 26 cm)
Gift of Elie Nadelman, 1938.323

Probably workshop of Thomas V. Brooks (American,
1828–1895)
Sailor tobacco shop figure, ca. 1850–60
New York City
Wood, paint, tin, metallic pigment, iron;
74¼ × 27 × 23⅜ in. (188.5 × 68.5 × 59.5 cm)
1937.1400

Unidentified American maker, possibly workshop of
Samuel A. Robb (1851–1928)
Indian maiden tobacco shop figure,
ca. 1865–75
New York City
Wood, paint, metallic pigment, iron; 67½ × 15 ×
19¾ in. (171.5 × 38 × 50 cm)
1937.1766

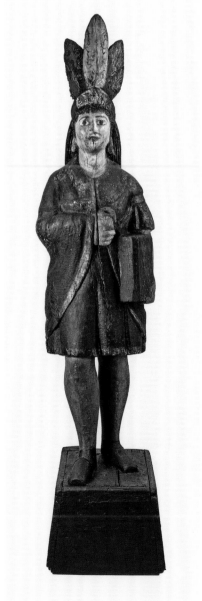

All three of these shop figures, which are unrecorded in the MFPA cards, were associated with the sale of products derived from the tobacco plant native to America. Elie Nadelman, himself a smoker, and his wife, whose father was in the cigar manufacturing business,[1] collected assorted smoking paraphernalia (see cats. 66, 67) of which these figures are the largest.[2] This juxtaposition of an early tobacconist shop figure from Europe with two from America illustrates one of the founding themes of the MFPA: to demonstrate the influence of European folk arts on their American counterparts. The American shop figures display a roughness, boldness, and simplicity of execution that certainly appealed to the couple, and, like African sculpture for Picasso, they were in tune with Nadelman's own wooden sculpture.

Polychromed shop figures like this belong to the genre of trade symbols and signs—like the apothecary's mortar and pestle, the jeweler's clock, and the barber's pole—that were used to advertise products and attract customers. When the Nadelmans started their quest, these figures were still common in New York City, serving its many non-English-speaking immigrant communities,

and they were beginning to be collectible.[3] Nonetheless during the Depression many were subsequently destroyed.

A black man wearing a tobacco leaf kilt was probably the first type, used as a tobacconist's trade sign in London during the time of Queen Anne (reigned 1702–14). The Highlander and Dutchman types followed. In America, where these figures were especially popular between 1850 and 1880. The native Indian dominated the other types, although all of them were stereotypes with elements of caricature. Sometimes carvers designed the figures themselves but more frequently copied them from illustrations or riffed on existing patterns, some after classical sculptures (see Olson essay, pp. 86–87), as they carved the log.[4] During the mid-nineteenth century, these wooden figures lined the sidewalks of American cities and functioned as sentries both inside and outside shops (fig. 87).[5]

With the decline of American shipping, many ship carvers turned to making shop figures full-time.[6] Among them were Thomas V. Brooks and Samuel A. Robb, New York City's leading carvers of shop figures, show figures, and circus wagons. Robb, in fact, had a veritable assembly line in his workshop.[7] Around 1919 Nadelman began working again in wood and may have emulated certain qualities he observed in the shop figures on New York streets, using professional carvers to work from his plaster models (cats. II–VI). Receipts confirm that some of Nadelman's wood sculptures were roughed out and assembled by outside sources who delivered them to the artist for finishing; two of the makers were named Robb. Moreover, Samuel Robb, who had closed his shop in 1903, worked in smaller shops for the next decades until he retired to Riverdale in 1921, the very year that the Nadelmans purchased Alderbrook, their estate on the Hudson River.[8]

The Nadelmans' Scottish Highlander is inscribed at the lower left on a rock "W. Allan / Sculp / 1824" and advertised snuff,

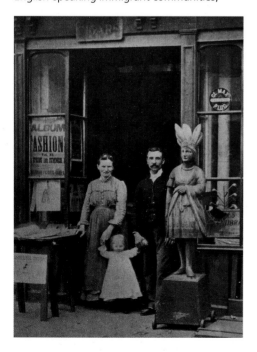

Fig. 87. Photograph of Indian tobacco shop figure. Culver Pictures, Inc.

dovetailing neatly with the snuffboxes collected by the couple (cat. 66).[9] Its scale and good condition indicate that it sat on a counter inside a tobacconist's shop.[10] More refined in its execution than American examples, the figure wears the typical Highlander regimental costume, including a Buchanan tartan kilt, intricate sporran (for shot and money), a feathered bonnet, and several weapons (two pistols, a dagger, and a dirk). The figure stands on a rocky base, symbolic of the rugged Highlands and holds a snuff mull, a handsized grinder used to prepare the powdered mixture. After 1720, as snuff became more popular, the number of Highlanders (and, less frequently, "lassies") grew.[11]

Sailor trade figures advertised nautical instrument makers, ship's chandlers, or tobacconists, or like the Nadelmans' jaunty lifesize sailor, tobacconists.[12] Dressed in garments with real weight—such as the white blouson shirt, blue jacket with three-dimensional gold buttons, bell bottom pants (originally painted blue), and a black tie—this "Jack Tar" also sports an unusual tin hat that resembles the tenth-anniversary tin wedding gifts of the folk tradition.[13] Striking a relaxed classical contrapposto pose, he offers two packages of tobacco with his right hand, while the holes in his right palm suggest that he also once carried a pipe or another smoking implement. He is supported by an iron rod and has a hook for attachment to the wall of the tobacconist's shop for stability and security.

The Indian maiden or "squaw" and her male counterpart were known as "Cigar Store Indians" as early as 1882 and constituted the most popular American type.[14] In her right hand she holds part of her cloak and an unidentified object, perhaps a tobacco pouch, while clutching a box of cut tobacco with her right arm and supporting a box of cigars with her left. The maiden wears large disk earrings and a feather headdress that once displayed five feathers. Typical of the type, she stands on a box that would have had iron wheels to roll her in and out of the tobacconist's shop. Her many distressed layers of repaint may make it impossible to discern the quality of the carving

below and to attempt an attribution. Her face and headdress have been heavily repainted in tonalities that Nadelman used for many of his wood figures (cats. II–VI), and her features now have more in common with an Archaic Greek *kore* than an Indian maiden, perhaps the result of the sculptor's "restoration" efforts.[15] Nevertheless, it is evident that a New York maker carved her, as she is related to a legion of similar figures by or attributed to Robb and his workshop.[16] **RJMO**

1 Louis Spiess and his firm, Kerbs & Spiess, had one of the largest cigar manufactories in New York City during the 1870s and 1880s (see fig. 67).

2 The MFPA cards note 251 examples: pipes and stands and cases for them; snuffboxes, tobacco jars, boxes, cutters, grinders, scrapers, pouches, and cigar molds.

3 Electra Havermeyer Webb was earlier than the Nadelmans, purchasing a cigar store figure in 1907, which is in the Shelburne Museum, VT, 2000.24.1; see Henry Joyce and Sloane Stephens, *American Folk Art at the Shelburne Museum* (Shelburne, VT: Shelburne Museum, 2001), 2, ill. The trend to collect them dates to the first decade of the twentieth century: see Kate Sanborn, *Hunting Indians in a Taxi-Cab* (Boston: R.G. Badger, 1911). In 1931 Robert Cahill organized an exhibition of America folk sculpture at the Newark Museum, which gave further impetus to the collecting of wooden figures. For an anthropological view, see Eleanor Gross, "Containing the Indian Threat: Cigar-Store Indians in Nineteenth-Century America" (master's thesis, University of Washington, 2011).

4 See Frederick Fried, *Artists in Wood: American Carvers of Cigar-Store Indians, Show Figures, and Circus Wagons* (New York: Clarkson N. Potter, 1970); Sessions 2005.

5 Later, mass-produced metal versions joined their ranks. From around 1910, however, such trade figures began to disappear given sidewalk obstruction laws, electric signs introducing new forms of advertising, and city ordinances addressing street crowding.

6 "Lo, The Wooden Indian," *New York Times*, August 3, 1890.

7 Fried, *Artists in Wood*, figs. 170 (a photograph of ca. 1879 shows the interior of Robb's shop with at least seven Indian maidens, some with their original bright paint), 201, 202.

8 Fletcher 2001, 89–90; 95 n. 21, discusses the shops and subcontractors, including J. & W. Robb, that worked on these Nadelman wooden sculptures in 1920–21. The 1920–21 New York City Directory (p. 1523) lists them as: John M. and William Robb, carpenters at 245 West Twenty-eighth Street.

9 According to Robert Young, personal communication with Roberta J.M. Olson, January 29, 2013, it is typical of the work of ship carvers in the north of England near the River Tyne; he observed that American carvers would never have added "Sculpt" to the inscription. Christensen 1950, 66, notes that American Highlanders usually present a package of cigars. For the type, see Sessions 2005, 30–31.

10 Charles Dickens described one in his novel *Little Dorrit* (1855–57).

11 Sessions 2005, 30–32, 151.

12 For the N-YHS sailor, see ibid., 32–33, 36, ill., 75, 78, pl. 35, which assigns it to a New York carver ca. 1860. See also Fried, *Artists in Wood*, fig. 161, as "probably carved by Thomas V. Brooks." Also reproduced in Lipman 1948, pl. 77.

13 For example, American Folk Art Museum, New York, 1988.25.1, 2, 6, 9, 12; Hollander and Anderson 2001, pl. 135a–e. Also reproduced in Lipman, Warren, and Bishop 1986, 180–81, fig. 10.24.

14 As noted in "Carving Wooden Figures," *New York Times*, May 30, 1882: "The greatest demand is now and always has been for Indian figures."

15 One wonders whether this was Nadelman's own attempt at trying to restore the power of the sculpture's original gaze and polychromy. The front parts of both feet are probably also replacements.

16 Allan Katz, personal communication with author, January 29, 2013, assigns her to Samuel A. Robb. She certainly could have been produced by his workshop, which might help explain the misunderstood object in her right hand (after Robb's wife died he sometimes carved his figures holding a rose). Robb operated the most successful workshop during the last quarter of the century. One of the many carvers working with him was Thomas White, but the business was constantly evolving. An article in the *New York Times* (August 3, 1890) reported that of the many carved Indians in New York, "[n]early all of these figures came from Robb's shop, and many of them are Thomas White's handiwork." After about 1870, William Demuth, a New York tobacco products distributor, offered a full line of figures through catalogue sales; both Robb and White were among the carvers who supplied Demuth with figures.

3

Unidentified German maker for H.C. Stülcken Sohn
(Hamburg, Germany)
"Rosa Isabella" ship figurehead, 1865
Red pine, oil paint, iron; 74 × 29 × 21 in.
(188 × 74 × 53 cm)
Provenance: Julius Bahr, Hamburg, 1865–67;
Reederei F. Laeisz Company ("Rosa y Isabel"),
Hamburg, 1867–84; August Burchard, Rostock,
1884–87; Louis M. Monsanto, Krum Bay, St.
Thomas, West Indies, 1888; Max Williams, New York
City, 1923 or 1924
1937.330*

"Rosa Isabella" dates from the mature age of the clipper ship, a vessel designed for speed. Her stance and windblown look evoke those streamlined vessels, as well as the conventions and poses of classical sculpture (see Olson essay, p. 89). With one foot forward and raised, she and legions of similar striding figures seem ideally suited for the bows of clipper ships. There she was supported on a scroll that in profile seemed to emerge from the concave curve of the ship's cutwater stem.[1] A figurehead was thought to embody the "soul" of the ship and served as its identifying insignia in a partly illiterate society. Ornamenting the bowsprit, it was believed to function as the "eyes" of the vessel, guiding it through rough waters and bringing it good luck (see cat. 4).

At the time of her creation "Rosa Isabella" was a racy image that would have appealed to seafaring men. Her revealing costume is characteristic of dancers of the time, classical ballet dancers among them. The lace-decorated bodice, full short skirt, and wide, flowing sash, however, identify her as

a Spanish dancer, a type then at the height of its European vogue.[2] Her luxuriant, cascading black hair and the red rose tucked behind her pierced right ear support that identification and disqualify her as a ballet dancer or a "proper" woman. She once wore an earring secured by a nail, a remnant of which survives, as well as a much showier carved and once-gilded necklace. Its settings were filled with glass or metal gems to create a sparkling spectacle as her barque sliced through the waves.

It is not known whether "Rosa Isabella" was modeled after a historical figure by that name or based on a print representing another dancer. Among the mid-century Iberian performers celebrated in Europe was the famous flamenco dancer Pepita de Oliva (stage name Josefa Durán y Ortega), who starred with the National Dance Company of Spain and traveled to Germany during 1852–53.[3] Her exotic image, with flowing locks and wide-belted costume, was reproduced in many media and may have inspired the carver of "Rosa Isabella."[4] Similarly, the Spanish dancer Lola de Valence was immortalized by Édouard Manet and others as the toast of Paris around 1862–64.[5] "Rosa Isabella" also belongs to a well-established tradition of figureheads that represent actresses in historical roles or divas, such as Jenny Lind, who captured the imagination of sailors.[6]

The Nadelmans acquired "Rosa Isabella" in 1923 or 1924 for $300 from the maritime dealer Max Williams.[7] According to the MFPA inventory, she was one of seven ship's figures (only five were definitely figureheads).[8] It identifies her as "Figure of dancing girl, Rosa Isabella/Spanish early 19 cent." One of the others, "Maria Spatz," was acquired simultaneously from the same dealer for the identical price and is held by the N-YHS.[9] Both were exhibited in Gallery VII with other American and European seventeenth- to early nineteenth-century objects (see fig. 13). Another interior photograph of the MFPA, reproduced in a 1929 article, shows "Rosa Isabella" without forearms and with part of her proper right foot missing (fig.

Fig. 88. "Rosa Isabella" in Gallery VII, MFPA. NP

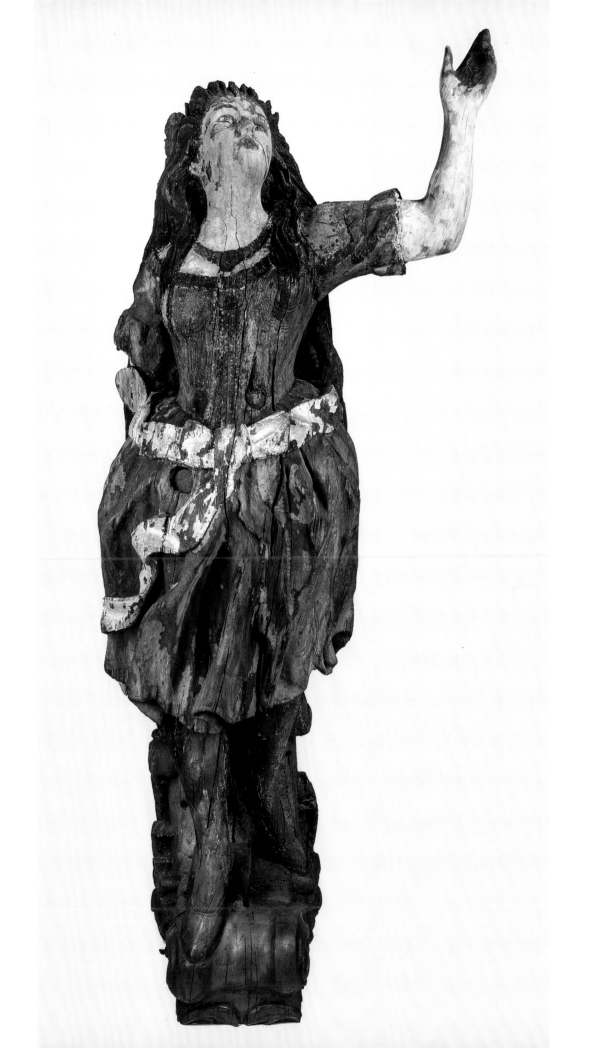

Fig. 89. Unknown photographer, "Rosa Isabella" in the Monsanto shipyard, Krum Bay. From *Rudder* (September 1948): 35

88).[10] By 1946, when the figurehead was illustrated in the *N-YHS Quarterly*, her proper left forearm and the tip of her right foot had been replaced.[11] Unlike the rest of the figure, which is red pine, those replacements are in cherry, Nadelman's favorite wood for his own sculptures (cats. II–VI). The morphological similarities between the replaced arm and hand and similar limbs in Nadelman's own sculptures strongly suggest that he was her restorer. He also added a cherry section to the front of the scroll cutwater mount of the billet head that includes the front of her proper right foot.[12]

New research makes it possible to reconstruct a provenance for "Rosa Isabella" before the dealer Max Williams. An undated photograph of a shipyard for scrapped sailing vessels in Krum Bay, St. Thomas, shows at the far left a heavily polychromed "Rosa Isabella" wearing a dark dress with a light sash, minus her forearms, and at the far right "Maria Spatz" from the barque *Marie Spatz*.[13] Another photograph, dated after the October 1916 hurricane, documents the devastation wrought on that same location, a ship graveyard,[14] a "marine Madame Tussaud's," run by the wrecker Louis M. Monsanto.[15] Of the three figureheads the one in the right lower corner is "Maria Spatz." Monsanto, who bought crippled ships for junk and dismantled them, repainted his figureheads annually, as seen in another undated photograph with a repainted "Rosa Isabella" in a light bodice

(fig. 89).[16] He also created a unique walkway to his residence with a row of some twenty figureheads.[17] Eventually, he sold at least ten to Max Williams who mounted an exhibition of them at his gallery, on Madison Avenue at Forty-sixth Street, sometime around 1920.[18]

In one of the articles describing Monsanto's establishment, the figurehead is referred to as "Rosa Y Isabella."[19] This name can be linked to the wooden barque, a nitrate clipper, named *Rosa y Isabel* in a fleet list of the F. Laeisz Company of Hamburg, Germany (1867–84), which was renowned for her voyage around Cape Horn in record time.[20] She was built by H.C. Stülcken Sohn in Hamburg for the company of Julius Bahr. After nearly two decades, the Laeisz company sold her to the Burchard firm of Rostock, which she served from 1884 to 1887. While transporting asphalt from Trinidad to Bremen, she began taking on water and was deemed unseaworthy on February 21, 1888, and sold for scrap to Monsanto on St. Thomas.[21]

RJMO

1 Originally used by French ship carvers, this stance was adopted by American, and now we can add German, carvers; Linda Bannel et al., *William Rush: American Sculptor* (Philadelphia: Pennsylvania Academy of the Fine Arts, 1982), 17.

2 In addition to earlier paintings of the subject there was a late eighteenth-century seafaring song "Spanish Ladies," which has associations with safe navigation and is featured in *The Oxford Book of Sea Songs*. See Lisa Royse, "Fashionable Ladies: A Closer Look at Figurehead Costumes and Styles," *The Mariners' Museum Journal* 15:4–16:1 (Winter/Spring 1989): 6–10.

3 A very colorful figure, Pepita became the lover of Lionel Sackville-West and was the grandmother of Vita Sackville-West.

4 Adolf Menzel captured her magnetism in a rare pastel in the State Hermitage Museum, St. Petersburg, 131-17910. See also Narciso Diaz de Escovar, "El baile y las bailerinas," *Blanco y negro* 37:2 (1927): n.p. (p. 81), which notes she captivated audiences in Hamburg, Vienna, Berlin, Dresden, and Munich; 78, ill.

5 See Françoise Cachin et al., *Manet 1832–1883*, exh. cat. (New York: Metropolitan Museum of Art and Harry N. Abrams, 1983), 144–56.

6 For the figurehead, possibly of Jenny Lind, in the Mariners' Museum, Newport News, VA, 1934.01.00.000001, see Tony Lewis, "Her Effigy in Wood: Figureheads with Feminine Subjects," *The Magazine Antiques* 130:6 (December 1996): 836, pl. VII. Lewis notes that female figureheads did not appear until the late eighteenth century, as before that time women were considered ill omens and not allowed on board.

7 MFPA card (unnumbered) as "18th Century"; MFPA inventory, Gallery VII, no. 28.

8 Five were reproduced in Mr. and Mrs. G. Glen Gould, "The Nadelman Ship Figureheads," *International Studio* 94:388 (September 1929): 51–53. "Rosa Isabella," "Maria Spatz," and "Figure of Eagle" (cat. 4) are held by N-YHS; "Lady Edmonton" is in the Mariners' Museum, Newport News, VA, 1934.0528.000001AI; "Minnehaha" is in AARFAM, 1932.704.1.

9 MFPA card (unnumbered) as "18th Century"; MFPA inventory, Gallery VII, no. 2; N-YHS 1937.329.

10 Gould and Gould, "The Nadelman Ship Figureheads," fig. 3.

11 George A. Zabriskie, "Ships' Figureheads in and about New York," *N-YHS Quarterly* 30:1 (January 1946): 10, ill.

12 Nadelman also painted faux weathering with a dry brush that is similar to that on his now-destroyed plaster figures and wood pieces, such as cats. II–VI and *Tango* (fig. 109). "Rosa Isabella" was conserved and stabilized in 2013 by Linda Nieuwenhuizen, Give Me A Break Conservation Services, thanks to a generous grant from the Greater Hudson Heritage Network.

13 Illustrated in "The Graveyard of Ships that Passed in the Night," *Popular Science Monthly* 91:4 (October 1917): 520. Thanks to Maeve Hogan for finding this article.

14 Theodoor de Booy and John T. Paris, "Figureheads of Old Sailing Vessels in Krum Bay Shipyard, St. Thomas," in *The Virgin Islands: Our New Possessions and British Islands* (Philadelphia and London: J.B. Lippincott, 1918), opp. p. 117.

15 So-called in the *Virgin Islands Daily News*, August 1, 1975, which mentions figureheads of Marie Antoinette and Minnehaha. See also Theodoor de Booy, "The Virgin Islands and the United States," *Geographical Review* 4:5 (November 1917): 365, which refers to Krum Bay as "the graveyard of ships"; De Booy and Paris, "Figure-heads of Old Sailing Vessels," 118–20, which terms Monsanto's "a small museum of curiosities"; Frederic A. Fenger, *The Cruise of the Diablesse* (New York: Yachting, 1926), 121–23; ill. opp. p. 123.

16 Gershom Bradford, "In the Wake of the Hurricanes," *Rudder* 64:9 (September 1948): 35, 61. Thanks to Mike Thornton for finding this article and his early research on the topic.

17 De Booy and Paris, "Figure-heads," 120. By 1948 Monsanto had sold all his figureheads in New York, "where the demand for maritime antiques of this character was too strong for Mr. Monsanto to resist."

18 According to the inside back cover of an undated pamphlet privately printed for Max Williams in the N-YHS Library (*Ship Models: Suggestions as to Their Use for Interior Decoration*), there was a "Unique Exhibition: Ten Old Ships' Figureheads: The Collection of Mr. L.M. Monsanto of Krum Bay . . . from the ships, Lady Edmonton, Marie Antoinette, Minnehaha, Rosa Isabella, Maria Spatz, Jeanne d'Arc, Evelyn, Eagle, Don Carlos and Varnum H.V. Hull." The Nadelmans acquired the first and third through the fifth figureheads.

19 Fenger, *The Cruise of the Diablesse*, 122.

20 See: http://www.bruzelius.info/Nautica/Ships/Owners/Fleet_lists/Laeisz.html. *Annalen der Hydrographie und Maritimen Meteorologie* 9 (Berlin: Ernst Siegfried Mittler & Sohn, 1884), 494–96.

21 Thanks to Alex Mazzitelli for reconstructing her early history. For a painting listed in the collection of Dr. Jürgen Meyer showing the *Rosa y Isabel* on the high seas, see Peter Klingbeil, *Die "Flying P-Liner." Die Segelschiffe der Reederei F. Laeisz* (Bremerhaven: Deutschen Schiffahrtsmuseum, 1998), 10, ill. For her history, see H.C. Rohrbach et al., *A Century and a Quarter of Reederei F. Laeisz* (Flagstaff, AZ: J.F. Colton, 1957), 37; Kaiserlichen Statistischen Amt, *Statistik der Seeschiffahrt für das Jahre 1888 bezw. den 1. Januar 1889. Schiffsunfälle an der Deutschen Küste* (Berlin: Buttlammer & Rühlbrecht, 1889), 72–73.

4

Unidentified American maker
Eagle ship figurehead, ca. 1850
White pine, small traces of ground, paint, gilding;
25½ × 13 × 23 in. (65 × 33 × 58.5 cm)
Provenance: Jonathan Bowers, Willow Dale, MA,
ca. 1861; Carleton T. Chapman, New York City;
Anderson Galleries, New York, Chapman sale, 1924[1]
1937.753*

Beginning in ancient times ships' bows were animated with protective ornaments—from real animals to the guiding, apotropaic eyes painted on Egyptian and Greco-Roman galleys and the strange heads that decorated Viking ships. Figureheads per se made their debut in the sixteenth century when a change in ship design introduced a stem head structure on which to place them. Like the decoration on the stern, a figurehead indicated the vessel's name to the illiterate; on military ships it also communicated power and/ or wealth. Figureheads evolved with the design and purpose of ships and with fashion. After the Napoleonic wars, they frequently took the form of a waist-length or bust-length image rather than a full figure, but with the advent of clipper ships in the 1850s and 1860s, full-figures, albeit smaller and lighter, returned to vogue until new ship design eliminated them.[2]

The Eagle, one of seven carvings identified as ships' figureheads in the Nadelman inventory,[3] was once owned by Carlton T. Chapman, the naval and marine painter. It belongs to the figurehead type for small vessels, which also includes bust-length human figures set on a substantial base.[4] The elaborate and beautifully carved foliate scroll on which the eagle perches is characteristic of scrolled billet heads, which fit into the stem head of the bow under the bowsprit.[5] Although the eagle's attitude and posture reflect the forward motion of a ship facing into the wind, the bird turns its head and body slightly to its left in a contrapposto pose, enlivening the patriotic guardian and symbol of good luck.[6]

The Nadelmans purchased this pieced construction—the two wings are separate attachments—for $160 in the 1924 Chapman sale.[7] At that time, the bird still had at least one of its inlaid eyes,[8] and also retained more of its original gilding and paint over a white ground. A 1931 newspaper article, which projected that the Nadelman collection would one day belong in New York City, preserves a rare quotation from the sculptor: "Prominent in the collection was an American eagle carved in wood, with ancient gold paint still glinting

in his wing feathers. But it was the lines of the gallant bird, not the gold, of course, which moved the sculptor to admiration as he pointed out his treasures. 'It was not just a sailor who carved this but an artist,' said he. 'Notice the really monumental quality of this eagle.'"[9] At the time the Nadelmans displayed it in Gallery VII of the MFPA on the newel post at the base of the stairs. A graphite drawing of it was included in the Index of American Design.[10]

The carver of the Eagle had some knowledge of the bird's anatomy, endowing it with weight, presence, and a great naturalism, despite the overall texture created by the incised feathers, with their vanes and barbs. One cannot help but associate its posture and potential to soar with the well-known image of the Golden Eagle by John James Audubon in *The Birds of America*, which by the mid-nineteenth century enjoyed a wide circulation in many editions. Because the sculpture no longer has its original pigment, it is impossible to determine whether the carver used as his model a Golden Eagle or a Bald Eagle, whose mature individuals have white heads, although he likely intended the latter because it is the national bird.[11]

Carved below the scroll on the front of its base is the inscription "J BOWERS / 1861." In the past, this inscription has been interpreted as a signature leading to an attribution to a J. or Joseph Bowers. There is no evidence, however, of a wood-carver by that name in the New York City directories or elsewhere on the East Coast.[12] Two nearly identical hand-carved inscriptions appear on the back of two other figureheads. The first is a bust of an Indian with a feather headdress mounted on a similar scroll (fig. 90), which appeared on the market in 1925 and was known by the Nadelmans.[13] The second is a bust of Secretary of State William H. Seward, whose maker signed it on the back of the collar ("W.H. GERRISH"), which argues that the "J BOWERS" does not refer to the maker.[14] Rather than signatures, these three inscriptions are collectors' marks, identifying their nineteenth-century owner: Jonathan Bowers, an entrepreneur

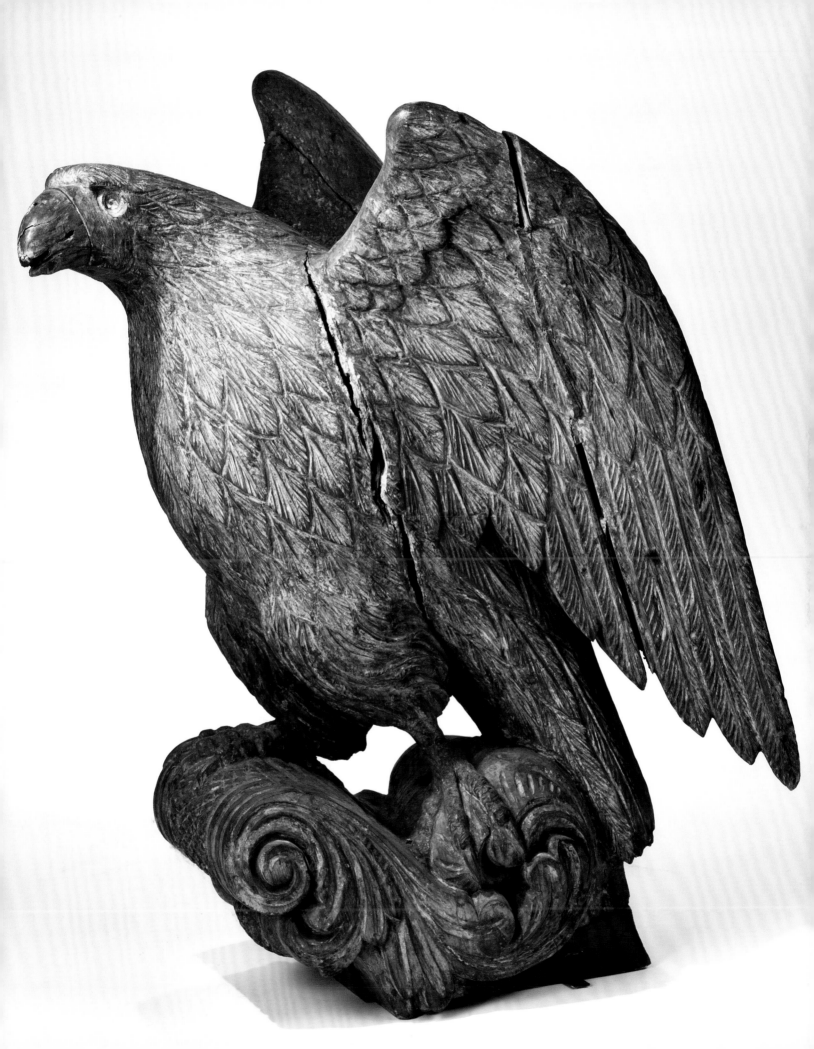

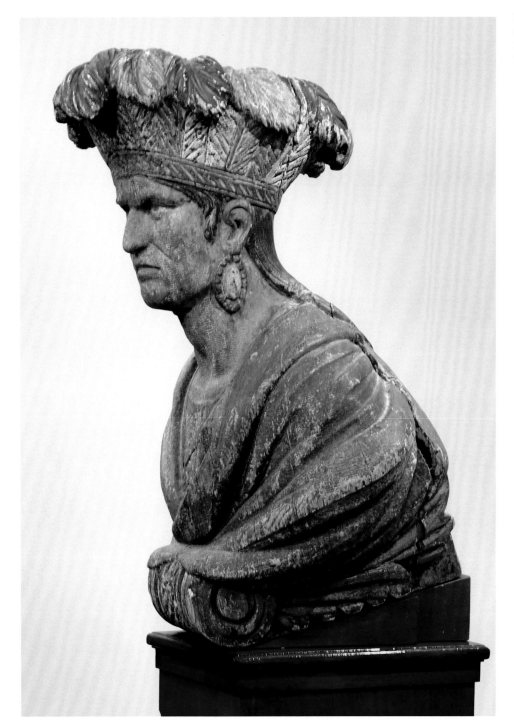

Fig. 90. Unidentified American maker, Figurehead of an American Indian. Wood, paint, gilding, 29 × 22 × 24 in. (73.7 × 55.9 × 61 cm). Private collection, formerly Hyland Grandby Antiques, Hyannis Port, MA

and mechanic with an artistic bent who had inherited a large fortune from his parents. In 1857 Bowers purchased a property at Willow Dale, six miles from Lowell, Massachusetts, converting it into a picnic ground, which became a popular summer resort. A unique feature of the park was its remarkable collection of statuary or "relics," including ships' figureheads.[15] Among them was the celebrated figurehead of Andrew Jackson from the USS *Constitution*, which was purchased by the New York dealer Max Williams at the Bowers estate sale.[16] Since Bowers had exhibited the Andrew Jackson at his resort

from 1861, the inscriptions with that year on the Eagle and the two other figureheads may record the date of their acquisition or display by Bowers.

RJMO

1 It was offered by Sumner Healey to Henry Francis du Pont, July 13, 1932, Henry Francis du Pont Antique Dealer papers, box 26, Winterthur Library, Winterthur, DE. The asking price was $400 and Du Pont turned it down; presumably the Nadelmans acquired it soon thereafter.

2 For the topic, see Pauline A. Pinckney, *American Figureheads and Their Carvers* (New York: W.W. Norton, 1940); M.V. Brewington, *Shipcarvers of North America* (Barre, MA: Barre Publishing, 1962); Sessions 2005; Michael Stammers, *Figureheads and Ship Carving* (London: Chatham, 2005).

3 Handwritten (by Viola Nadelman), a page of the MFPA inventory lists one "stern piece over entrance door" (a coat of arms of Denmark) and seven figureheads: Minnehaha, Lady Edmonton, "dancing girl, Rosa Isabella" (cat. 3), Maria Spatz, Columbia [in the Shelburne Museum, VT, FW.104], the head of Daniel Boone, and "Figure of Eagle," all with additional notations. See also cat. 3, n. 8.

4 See examples in Pinckney, *American Figureheads*, pls. VI, XII, XV–XVII, XXI, fig. 6.

5 For similar billet heads, see ibid., pl. XXVII; Brewington, *Shipcarvers*, figs. 115–16. Mr. and Mrs. G. Glen Gould, "The Nadelman Ship Figureheads," *International Studio* 94:388 (September 1929): 51–53, fig. 1, considers the Eagle a figurehead. A similar but more frontal eagle is in the Mariners' Museum, Newport News, VA, 1934.0498.000001; it was formerly identified as a pilot house decoration but because of its billet head scroll, it is currently considered a figurehead from a small vessel; see Robert L. Polley, ed., *America's Folk Art: Treasures of American Folk Arts and Crafts in Distinguished Museums and Collections* (New York: G.P. Putnam's Sons, 1968), pl. 1. Other eagle figureheads on billet heads include examples from the USS *Lancaster* (1880–81) in the Mariners' Museum, 1934.0037.000001A, and *The Wanderer* (1878), a whaler from New Bedford, MA (Pinckney, *American Figureheads*, pls. XXVII–XXVIII); and *Seaman's Bride* (1851) (Brewington, *Shipcarvers*, fig. 53). Hornung 1972, 1: 44, no. 89, mistakenly identifies the Nadelman Eagle as a "pilothouse eagle with its wings spread from Hudson River steamboat 'Mary Powell.'" The introduction of steam hastened the disappearance of figureheads; around 1882, eagles, often smaller, began adorning pilot houses; see "Carved Wooden Figures," *New*

York Times, May 30, 1882; Pinckney, *American Figureheads*, 151–58, pl. XXIX; Brewington, *Shipcarvers*, fig. 113.

6 For nineteenth-century bird figureheads, made for lighter ships, see David Pulvertaft, *Figureheads of the Royal Navy* (Barnsley, South Yorkshire, Eng.: Seaforth Publishing, 2011), 77–85, especially figs. 7.1, for HMS *Buzzard* (1849), and 7.3, for HMS *Falcon* (1854), whose posture is nearly identical to that of the Nadelman Eagle.

7 MFPA 103; Anderson Galleries, New York City, March 26, 1924, lot 82, whose catalogue states: "Carved in East Boston, but never in use on shipboard." Pasted on the reverse of the MFPA card is a sale catalogue entry (see n. 13 for the sale), lot 72: "Carved Ship's Figurehead by J. Bowers, 1861. Carved bust of an American Indian Chief with Eagle-plume headdress. Painted in colors and set on scrolled bow piece."

8 George A. Zabriskie, "Ships' Figureheads in and about New York," *N-YHS Quarterly* 30:1 (January 1946): 12, ill. (an article fraught with errors).

9 "City to Receive Rare Collection of Primitive Art," *New York Herald Tribune*, October 30, 1931.

10 National Gallery of Art, Washington, DC, 1943.8.9817 (by Bernard Westmacott).

11 For the bird, see Norton 2011.

12 Pinckney, *American Figureheads*, 155–56, mentions "Joe Bowers"; Zabriskie, "Ships' Figureheads," 10, made the problematic comment that "Joe Bowers was really a New Yorker!" Brewington (*Shipcarvers*, 162) later identified him as "Joseph Bowers, active 1860."

13 Sold at the Anderson Galleries, New York City, William Bell Chambers sale, November 12, 1925, lot 72, for $100. See also n. 7 above, revealing that the Nadelmans continued to study their acquisitions. Pinckney, *American Figureheads*, 155–56, cites only the Indian and the Eagle as works by Bowers.

14 In the Giampietro Gallery, New Haven, CT.

15 William Richard Cutter, *Historic Homes and Places and Genealogical and Personal Memoirs Relating to the Families of Middlesex County, Massachusetts* (New York: Lewis Historical, 1908), 1: 389; W.H. Goodfellow, *The Industrial Advantages of Lowell, Mass. And Environs . . .* (Lowell: W.H. Goodfellow, 1895), 44–45.

16 Museum of the City of New York, M52.11; see "Wealthy Unknown, Outbidding Henry Ford, Gets Jackson Figurehead of Old Constitution," *New York Times*, November 9, 1925; Anderson Galleries, New York City, Max Williams sale, April 17–18, 1928, lot 231, which notes that it was displayed at Willow Dale from July 2, 1861, through the 1925 estate sale; Sessions 2005, fig. 24.

5

Unidentified American maker
Eagle architectural ornament, 1800–50
Iron, paint; 28¾ × 32 × 2 in. (73 × 81 × 5 cm)
1937.588

This majestic sheet iron eagle—its chest embossed in low relief, wings spread, and feet planted on a cloud while grasping lightning bolts and arrows—ostensibly embodies the American patriotic spirit. Elie and Viola Nadelman would have been attracted not only to its potentially nationalistic imagery but also to its bold design. Of trimmed sheet iron, the work resembles a metallic silhouette, an effect amplified by its cut-out eye. Horizontal iron strips affixed to its reverse are attached to two vertical strips visible from the front; they facilitated its insertion into an architectural setting, perhaps as a crowning element that in its silhouetted form resembles a stationary weathervane (cat. 6).[1] The couple may have displayed it in Gallery XIII of MFPA with their wooden angel and other weathervanes, in which case it may be the "Small eagle" listed with those works in the MFPA inventory.

The Bald Eagle, symbol of America, was and is a highly prized and collectable folk art icon. The bird, which lives only on the North American continent, has become a metaphor for freedom. However, there are many variations on this theme, and the bird's accoutrements help to determine its nature and date. The eagle's first public appearance as a national symbol was in 1782 on the seal of the United States, which was officially adopted in 1787. In this context the bird held thirteen arrows representative of the thirteen states in its left talon, and an olive branch in its right; it looked to the right (the direction of honor). There were many subsequent variations; for example, the American Eagle sometimes holds flags, bunting, or a shield with the stars and stripes.[2]

By contrast, the Nadelman eagle grasps lightning bolts that issue from a horizontal cloud. Since ancient times, both lightning bolts and an eagle (not the North American Bald Eagle, however) were symbolic of Zeus/Jupiter, king of the Greco-Roman gods. In the Nadelman sculpture, the lightning bolts merge with the more customary arrows of the American symbol and help blur the piece's origin and symbolism. The lack of any American patriotic attributes or species identification places this powerful piece in a kind of iconographic limbo that emphasizes its more bellicose aspects.
RJMO

1 The bird is composed of four pieces of metal, three of which form the top of its head and wings.
2 See Norton 2011.

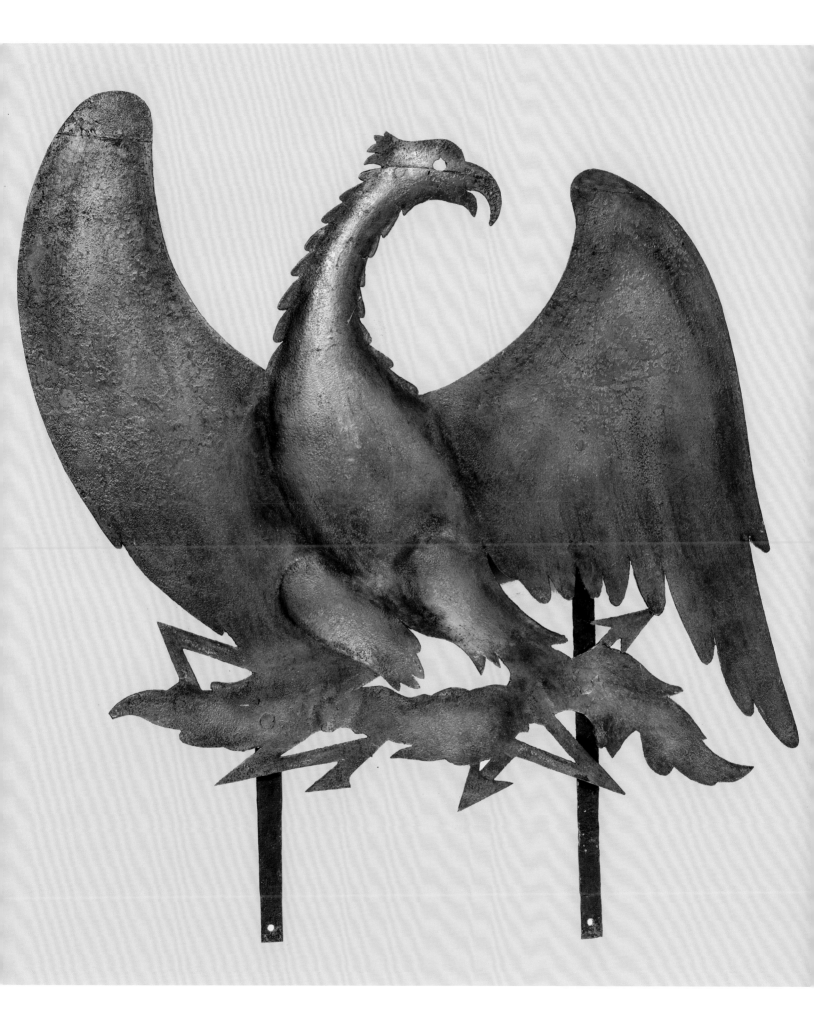

6

6a
Unidentified English maker
Rooster weathervane, ca. 1800
Sheet iron, copper, steel; 30 × 18½ × 1 in.
(76.2 × 47 × 2.5 cm)
Provenance: Anderson Galleries, New York, Karl
Freund sale, 1928
1937.1161*

6b
Jonathan Howard & Company (active 1850–1868)
West Bridgewater, MA
Rooster weathervane, ca. 1860
Zinc, copper, brass, gilding; 27 × 25½ × 3 in.
(68.6 × 64.8 × 7.6 cm)
Provenance: Anderson Galleries, New York, William
Whiting Nolen sale, 1924
1937.1165*

6c
Unidentified American maker
Rooster weathervane, ca. 1800–50
Wood, metal; 39 × 19 × 1 in. (99.1 × 48.3 × 2.5 cm)
1937.1157

6d
Unidentified American maker
Gabriel (Herald Angel) weathervane,
ca. 1850–1900
Wood; 13 × 48¾ × 1 in. (33 × 123.8 × 2.5 cm)
Provenance: George F. Ives estate sale, Danbury, CT,
1924
1937.929*

6e
Unidentified American maker
Horse weathervane, 1880–1900
Copper, gilding; 17¾ × 21½ × 2 in.
(45.1 × 54.6 × 5.1 cm)
1937.1163

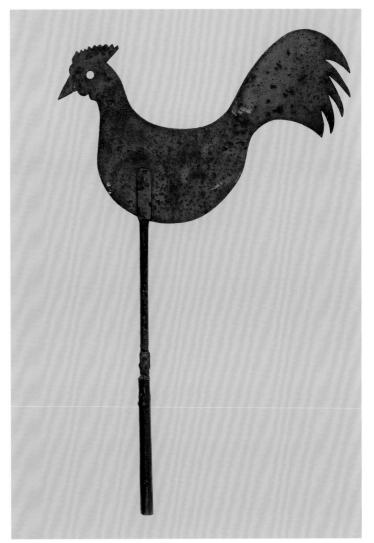

6a

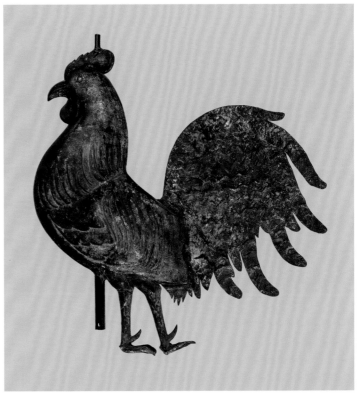

6b

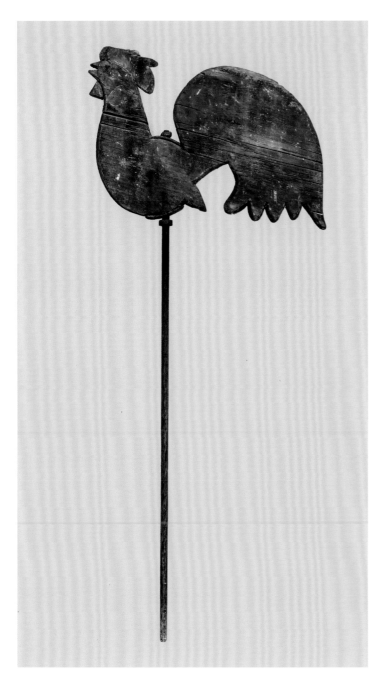

6c

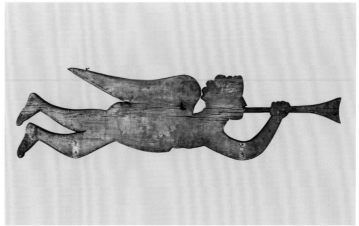

6d

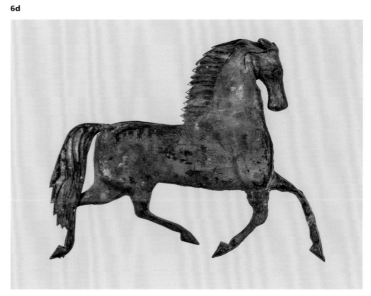

6e

Classic icons of Americana, weathervanes have functioned for hundreds of years as wind direction indicators and rooftop decorations. They are the earliest known meteorological instruments, first appearing in the ancient world on ships as small banners and only later as figurative forms. Throughout the Middle Ages, the weathercock, a symbol of vigilance and changeability as well as an emblem of St. Peter, topped the bell towers of many European churches. English kings granted nobles the right to fly related fanes, metal flags bearing the family coat of arms, over their castles. Later, the weathercock and the fane merged to form the generic term "weathervane." Dutch and English settlers brought the tradition to America, where weathervanes moved from public buildings to barn roofs.[1] Weather was a basic factor of rural life, and the weathervane was an accessory of major importance for growing crops. As a source of information about weather conditions, these silhouettes in the sky needed to be seen from a distance and thus had to be readable as outlines. Therefore, whether conceived as flat silhouettes or modeled more three-dimensionally, illusionistic realism was not their goal.

Since the beginning of the twentieth century, folk art collectors have sought out weathervanes as examples of good design and craftsmanship. The Nadelmans collected at least twenty-five examples. The MFPA cards record eleven weathercocks, one of which the Nadelmans thought was an early English example (cat. 6a).[2] The MFPA inventory lists two large weathervanes in Gallery XII, the Iron Room, while period photographs show the installation of one of the three weathercocks illustrated here (cat. 6b, see fig. 17),[3] together with other weathervanes that were not acquired by the NYHS. (All the Nadelmans' examples that can be traced lack their directionals.) Although other barnyard animals, such as cows, horses, pigs, sheep, and dogs, entered the American repertoire, roosters and horses (cats. 6b, 6c, 6e) remained the favorites. Many animated examples indicate that their makers were keen observers of animals. The

MFPA inventory also twice notes a "flying wooden angel" in Gallery XIII, one of which may be cat. 6d.[4] While Christian in inspiration, angels belongs to the legion of fantastic figures, such as mermaids and centaurs, as well as allegorical personifications, like Lady Liberty, that also functioned as weathervanes.

Before 1850 few professional artisans are known to have made weathervanes; most were handmade by homesteaders and thus unique examples exhibiting a great flair

for design. Like whirligigs, weathervanes offered the pioneer farmer one of the few opportunities for personal expression. Eventually, they took on the mantle of a trade symbol for farmers.[5] Weathervanes were constructed of a variety of materials. Many were carved out of wood or cast in iron and other metals. Some were fashioned from sheet metal, and some were embossed, such as cats. 6b, 6e.[6] As American manufacturing and marketing matured, Alvin L. Jewell, of

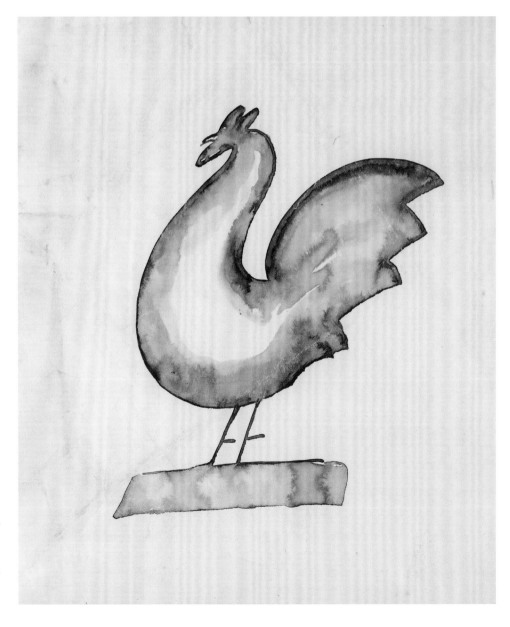

Waltham, Massachusetts, became the first full-time weathervane manufacturer, opening a shop near Boston in 1852.[7] Many other firms followed, such as Jonathan Howard & Company (cat. 6b), some of which issued catalogues.

Jean Lipman summarizes the power of these pre-industrial designs, which can be regarded as early American sculpture: "The effect achieved through a flair for functional design and a natural vitality of execution . . . would be hard to surpass. . . ." She emphasizes that it is "rather those simpler pieces that one feels could stand up as pure design in comparison with any sculpture, native or foreign, primitive or academic, that will retain the most lasting value as American folk art."[8] Certainly the Nadelmans would have agreed. Pablo Picasso, Elie Nadelman's contemporary, realized their power as well: "Cocks have always been seen, but never as well as in American weathervanes."[9] Nadelman exaggerated their captivating proud stance in a drawing (fig. 91).

RJMO

Fig. 91. Elie Nadelman, *Rooster*, ca. 1922. Blue ink with blue wash on paper; 7¾ × 6¾ in. (19.7 × 17.1 cm). Collection of Cynthia Nadelman

1 One of the first known weathervanes in America was the copper cockerel (1656) for the Dutch Reformed Church at Albany, which was brought from Holland; Charles Klamkin, *Weather Vanes: The History, Design, and Manufacture of an American Folk Art* (New York: Hawthorn Books, 1973), 75, ill. Erwin O. Christensen, "Weathervanes," *The Magazine Antiques* 59:3 (March 1951): 199, fig. 4, reproduces the cock made for New York's first City Hall, which is owned by the St. Nicholas Society, New York City, and has directionals. See also Francis J. Sypher, "Speculations on Our Antique Weathercock," *Weathercock* 66 (Fall 2006): 6–7.

2 N-YHS 1937.1161 is MFPA Misc. 2494, purchased for $35 at the Freund sale on December 13, 1928, lot 137, as "English 17th century, Made in a most simplified and archaic manner." See Klamkin, *Weather Vanes*, 72–85, for weathercocks.

3 N-YHS 1937.1165 is MFPA 145, purchased for $52.50 on March 6, 1924, lot 260 (information from sale catalogue). See also Robert Bishop and Patricia Coblentz, *A Gallery of American Weathervanes and Whirligigs* (New York: E.P. Dutton, 1981), fig. 44; Steve Miller, *The Art of the Weathervane* (Exton, PA: Schiffer, 1984), 37, ill.

4 N-YHS 1937.929 is MFPA 487, purchased for $16 in June 1924, cat. 3254. For a less elongated wooden Gabriel weathervane from ca. 1800, found in Ridgefield, CT, see *An American Sampler: Folk Art from the Shelburne Museum*, exh. cat. (Washington, DC: National Gallery of Art, 1987), no. 63, ill. For the Gabriel type, see Klamkin, *Weather Vanes*, 156–61.

5 Hornung 1972, 2: 456.

6 For other similar horses, see Klamkin, *Weather Vanes*, 95–113.

7 For additional information about the history of weathervanes, see Lipman 1948, 49–55; Erwin O. Christensen, *The Index of American Design* (New York: MacMillan; Washington, DC: National Gallery of Art, Smithsonian Institution, 1950), 79–201; idem, "Weathervanes," 198–200; Hornung 1972, 2: 455–67; Klamkin, *Weather Vanes*, 4–8; Bishop and Coblentz, *A Gallery of American Weathervanes*, 7–21; Hollander and Anderson 2001, 537–41, nos. 300–10; 553, no. 318; 555, no. 341.

8 Lipman 1948, 51–55.

9 Picasso quoted in ibid., 54–55.

7

Wilhelm Schimmel (American, 1817–1890,
b. Germany)
Cumberland County, PA

Eagle, ca. 1865–70
Wood, paint, primer; 12½ × 17⅛ × 10 in.
(31.8 × 43.5 × 25.4 cm)
INV.7954

Eagle, ca. 1865–70
Wood, paint, primer; 13¾ × 24 × 14 in.
(34.9 × 61 × 35.6 cm)
Provenance: McKearin's, New York City and Hoosick
Falls, NY, 1929
1937.1124*

Eagle, ca. 1865–70
Wood, paint, primer; 5½ × 7¾ × 4⅝ in.
(14 × 19.7 × 11.7 cm)
Provenance: McKearin's, New York City and Hoosick
Falls, NY, 1929
1937.1117*

Eagle, ca. 1865–70
Wood, paint, primer, varnish; 4½ × 7 × 3½ in.
(11.4 × 17.8 × 8.9 cm)
INV.7955*

Wilhelm Schimmel remains one of the most prolific and recognized traditional folk carvers of the region around Carlisle, Pennsylvania. Born in Germany, near Hessian Darmstadt, he emigrated to Pennsylvania around 1860 and did itinerant farm work in the Pennsylvania-German and Anglo-Irish agrarian communities along the Conodoguinet Creek in rural Cumberland County. Carving animals from soft pine, indigenous pear, or tulip poplar and selling them for a few pennies apiece seems to have been his only consistent occupation. He was a tramp of sorts, sleeping in barns and occasionally doing chores or watching children of the German families who housed and fed him or the barkeeps who kept him in alcohol. Despite drunken behavior that often landed him in jail, local families supported him and gave him wood for whittling his animal figures, which delighted their children. By some accounts he was valued for his useful woodworking skills as a repairman and carver. By all accounts unpredictable in temperament, Schimmel was also remembered as gentle and often nurturing to children. He died in the Cumberland County Almshouse and was buried in an unmarked grave in the potter's field.[1] His obituary noted that "Old Schimmel," though of "surly disposition," was known by everyone in the county.[2]

An untrained, expressive carver in the wood-carving tradition of Bavaria, the Black Forest, and Alpine countries, Schimmel may have made nearly five hundred figures.[3] His carvings were frequently covered in a gesso-like ground or primer and then painted with bold patterns. Among his favorite animals were eagles, which tend to show more intricate, if irregular, carving patterns than his other figures (see cat. 8). For these raptors, Schimmel first shaped the body, creating a crosshatch pattern with his folding penknife, and then carved (sometimes chip-carved) and articulated their separate wings. He inserted these into the body with mortise and tenon joints in such animated positions that they seem poised for flight. While he also may have burnished his carvings with a piece of glass before painting them, most of his eagles retain their original rough, angular cuts suggesting the texture of ruffled feathers. Since he did not sign his works, animals are attributed to him on the basis of their technique and their often fierce, imposing appearance.[4]

While all four of the Schimmel eagles collected by the Nadelmans perch on a mound, Schimmel decorated each in a different manner.[5] The largest of these national birds is the most magnificent and powerful. The couple purchased it for the high price of $100 in 1929, the first year they are known to have acquired works by the artist. This same year they procured two other Schimmel carvings from McKearin's, including another eagle. Coincidentally, this was the very year that McKearin's advertised and illustrated similar examples in *The Magazine Antiques*.[6] According to the MFPA inventory, the Nadelmans displayed eight Schimmels in the Toy Room, Gallery IX.
RJMO

1 For a recent consideration of his life and carvings, see Amanda C. Burdan, "Wilhelm Schimmel: A Bold Piece of Work," *Antiques Show 2014* (Chadds Ford, PA: Brandywine River Museum of Art, 2014), 5–13.

2 *Carlisle (PA) Evening Sentinel*, August 7, 1890.

3 Clayton et al. 2002, 79; see also Flower 1986, 14. There is no scientific accounting but he was prolific.

4 Milton E. Flower, "Schimmel the Woodcarver," *The Magazine Antiques* 44:4 (October 1943): 164–66; idem 1965; idem 1986; Judith A. Barter and Monica Obniski, *For Kith and Kin: The Folk Art Collection at the Art Institute of Chicago* (Chicago: Art Institute of Chicago, 2012), 114–15.

5 N-YHS 1937.1117 (MFPA Toys 521), acquired in January 1929 for $30; N-YHS 1937.1124 (MFPA Toys 520), purchased at the same time for $100 (with a MFPA label inscribed "520/Amer"); N-YHS INV.7955 (MFPA 525).

6 See *The Magazine Antiques*, 15:1 (January 1929): 65; *The Magazine Antiques*, 15:4 (April 1929): 337. Ads also appeared in the *Antiquarian* 12:3 (April 1929): 94; *Antiquarian* 12:5 (June 1929): 24.

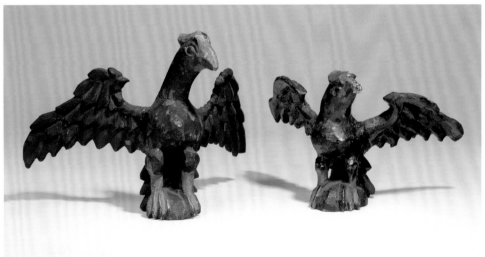

8

Wilhelm Schimmel (American, 1817–1890,
b. Germany)
Cumberland County, PA

Parrot, ca. 1865–70
Wood, paint, primer; 5½ × 2⅞ × 2⅜ in.
(14 × 7.3 × 6 cm)
Provenance: Madge Farquhar Holstein, Great Neck,
NY, 1929
1937.1116*

Poodle, ca. 1865–70
Wood, paint, primer; 3⅛ × 5⅜ × 1⅛ in.
(7.9 × 13.7 × 2.9 cm)
Provenance: Renwick Hurry, New York City, 1932
1937.1112*

Parrot on basket of flowers, ca. 1865–70
Wood, paint, primer; 4⅜ × 3⅜ × 2½ in.
(11.1 × 8.6 × 6.4 cm)
Provenance: Madge Farquhar Holstein, Great Neck,
NY, 1929
1937.1113*

Rooster, ca. 1865–70
Wood, paint, primer; 5¼ × 4 × 2¼ in.
(13.3 × 10.2 × 5.7 cm)
Provenance: McKearin's, New York City and Hoosick
Falls, NY, 1929
1937.1115*

The MFPA cards identify three carvings in this quartet (all but the poodle) as by Wilhelm Schimmel (see cat. 7). For the twelve carvings by Schimmel in the N-YHS with a Nadelman provenance, there are ten relevant MFPA cards, nine of which the couple assign to Schimmel.[1] According to the MFPA inventory, the couple displayed eight works by the carver in the Toy Room, Gallery IX. Schimmel's favorite subjects were fanciful eagles, parrots, roosters, dogs, and squirrels. Among the sources for all his animals, save the eagles, one influence stands out: the small chalkware figures that circulated widely in nineteenth-century America (see cat. 10).[2]

The prolific Schimmel shaped his figures with a folding penknife directly from scavenged pieces of wood. Like the wings of his eagles, he carved some parts of his compositions separately and inserted them, as he did in the flowers in the "basket" with the parrot. Whereas Schimmel's eagles (cat. 7) are articulated and detailed more by carving than by paint, his smaller figures tend to have smoother surfaces and depend on paint to establish their character and charm. One exception is the poodle, whose textured fur the artist rendered in his characteristic chip-carved crosshatching. To ornament all his figures, Schimmel applied pigments—usually greens, reds, whites, yellows, and black—over a thin ground of gesso-like material. Frequently, he used common household paints, leftover colors that he was probably given by his sympathetic neighbors and hosts.

Although birds and other animals were his favorite subjects, he also depicted more narrative tableaux.[3] One of his most intricate represents Adam and Eve in a fenced-in Garden of Eden, which is known in several versions,[4] and which was reproduced in the Index of American Design.[5]
RJMO

1 The Nadelmans paid the following amounts for objects now in the N-YHS: (1) $2 for 1937.1112 (MFPA Toys 575) in November 1932; (2) $20 for 1937.1113 (MFPA Toys 524) in February 1929, which they identified as "Bird on a basket," although similar structures in Schimmel carvings are sometimes called pedestals; (3) $20 for 1937.1115 (MFPA Toys 519) in January 1929; (4) $20 for 1937.1116 (MFPA Toys 525) in February 1929. Three dealers supplied the Nadelmans with nine Schimmels: Holstein (4); McKearin's (4); and Hurry (1, although the couple did not attribute it to Schimmel).

2 Flower 1986, 20, illustrates a chalkware rooster, squirrel, and dog with similar subjects carved by Schimmel.

3 See Flower 1965, 18–21, nos. 27, 28, 44, 79, 83; Flower 1986, figs. 4, 6.

4 Philadelphia Museum of Art, Philadelphia, PA, 1955-94-2 (Flower 1986, fig. 6); AARFAM (Flower 1965, 10, 21, no. 79, ill.). Flower 1986, 8–9, mentions several versions and notes that Schimmel submitted one to the Cumberland County Fair, where it failed to win a prize, making him angry.

5 The watercolor by Yolande Delasser for the Index of American Design is in the National Gallery of Art, Washington, DC, 1943.8.8096; Clayton 2002, 75; http://www.nga.gov/content/ngaweb/Collection/art-object-page.20294.html.

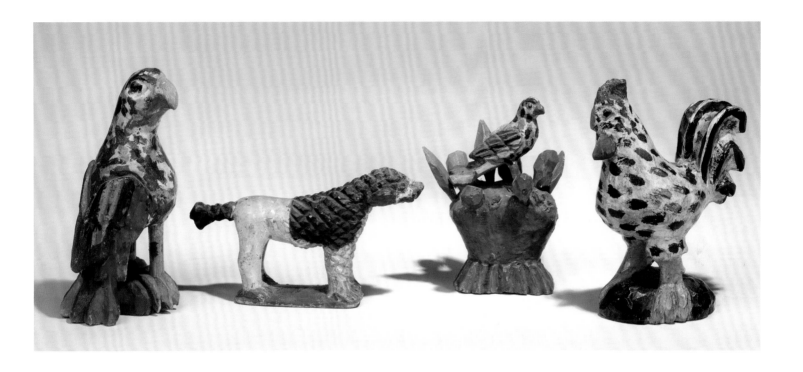

9

Unidentified French makers

Milliner's head, 1820–70
Red pine; 13½ × 8¼ × 8½ in. (34.3 × 21 × 21.6 cm)
Provenance: Marie Sterner, New York City, 1926
INV.8708*

Milliner's head, 1820–70
Papier-mâché, paint, gesso; 17 × 6½ × 8¼ in.
(43.2 × 16.5 × 21 cm)
INV.8709

Milliner's head, 1820–70
Wood; 15 × 7 × 9 in. (38.1 × 17.8 × 22.9 cm)
Provenance: Ann Elsey, New York City, 1928
INV.8707*

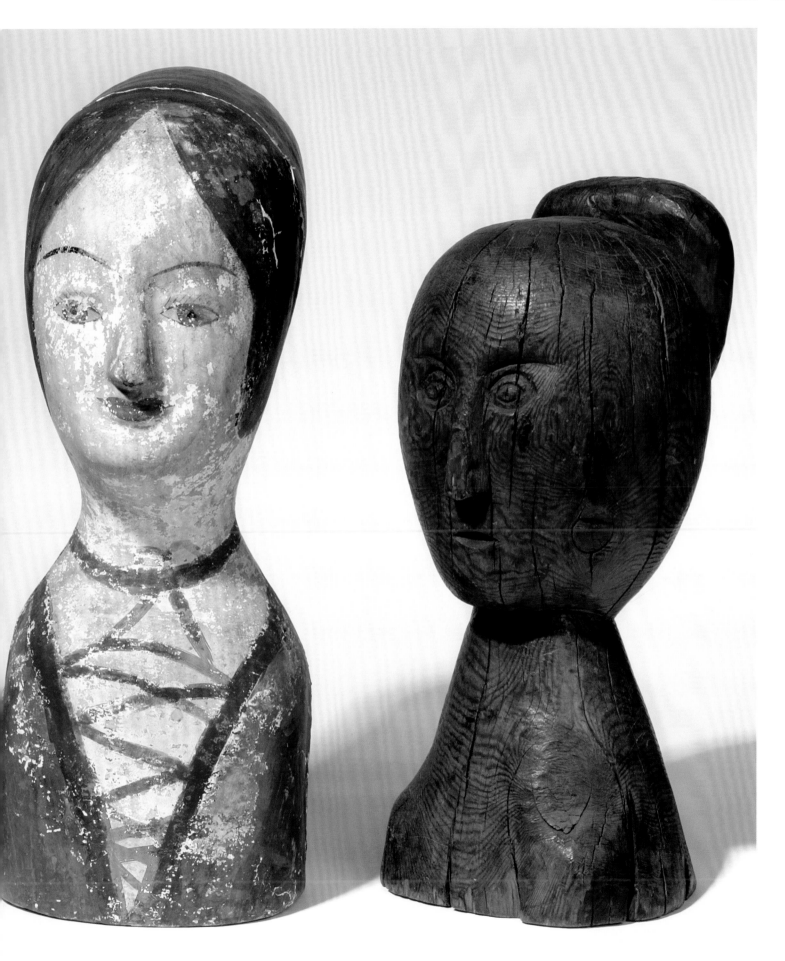

Millinery—the designing, making, trimming, and selling of hats—was traditionally a woman's profession.[1] Like dressmaking, the trade enabled women to transform culturally gendered skills into a lucrative vocation.[2] In many cases women became shop owners when they were widowed, and millinery was one of the main avenues to financial independence. Since shops specializing in hats also sold a wide variety of ornamental accessories, fabrics, and other notions,[3] it is no wonder that Viola Nadelman, a long-time lace collector, was interested in these accoutrements of the trade.

Hats were fabricated on a form or "milliner's head" (fig. 92) and the finished product could be displayed on one in the shop or shop window. Usually made of soft wood or papier-mâché, milliner's heads sometimes had padded cloth or animal skin on top to facilitate attaching the hat. Early examples for display were hand-painted, but by the 1850s some had printed features pasted in place.[4] The majority of extant milliner's heads date from the heyday of the bonnet during the first three-quarters of the nineteenth century.

According to the inscription on the MFPA card for the first (left) example, at least one of these lifesize heads was displayed, together with belts and other accessories, in the "Bonnet room" of the museum, perhaps Gallery X.[5] On their MFPA cards, the Nadelmans identified both of the wood examples as French eighteenth-century objects—probably bolstered by their dealers (including Ann Elsey, who specialized in French provincial antiques). The couple thought that INV.8708, which they called a "bonnet stand," dated from the early part of that century.[6] They simply classified the less detailed, cruder one (INV.8707) as "Wooden head."[7]

The two wooden milliner's heads are unusual and relate to the featureless hat forms used for fabricating men's headgear. Both were carved with similar conventions, suggesting a common geographic origin. Their facial features are incised, but only the one on the left sports diamond-shaped, intaglio earrings. Both carvers exploited the natural grain of the wood to model and lend volume to the faces, a trait beautifully evident in the cheeks, eyes, and bosom of the more refined example on the left. Each head is made of two pieces of wood: the main unit and the appendage, consisting of a heart-shaped bun or chignon and the back of the head, attached to the main unit by three large wooden pegs. This three-dimensional hairstyle proves that both heads are props for hats rather than wig stands. Only the right one (INV.8707) has pinholes (around sixteen). Of the two, the left example (INV.8708) is more ambitious and with its shoulders resembles a bust. Its high level of detail, including a bodice with scalloped, tongue pattern trim echoed in the neck choker, raises the question of whether it was once painted.

The papier-mâché milliner's head represents the more typical type with painted or printed features. Nevertheless, the back of its cranium is unusual because it is conically shaped like the crown and tip bonnet and painted black. Many similar examples have hair painted only at the front of the head.[8] Characteristic of papier-mâché examples, it is hollow and has a rectangular opening in its base at the back to facilitate drying and for the insertion of ballast or ribbons, pins, and millinery tools, which could have been conveniently stored there.

The simplified, abstract forms of all three heads, as well as the bright colors of the papier-mâché example, attracted Elie Nadelman, whose own wood sculptures from the 1920s share formal characteristics with them (cats. II–VI). Other pioneers of modernism, such as Picasso and Brancusi, also sought inspiration in pure forms outside of traditional Western art. Even more pertinent is Giorgio de Chirico, whose years in Paris overlapped those of Nadelman. De Chirico employed tailors' mannequins and their heads as prominent motifs in his paintings during his Metaphysical period (1909–19), where they evoked classical art and forecast his later adoption by the Surrealists. Nadelman himself fashioned a featureless plaster head

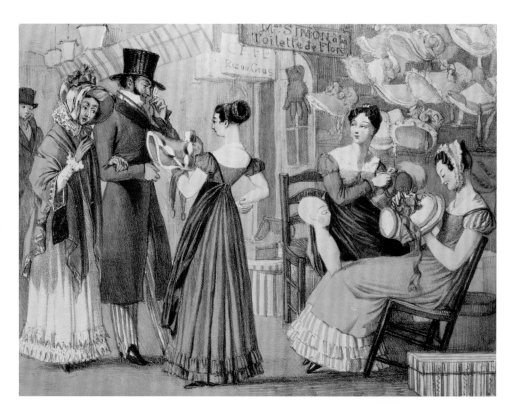

in 1908, now preserved only in a photograph, which looks just like a dressmaker's dummy.[9] Together with his classicizing heads from the 1910s and 1920s, it reveals that the sculptor's taste was primed for the acquisition of the milliners' heads.

In the 1920s the Nadelmans were in the vanguard of collecting milliner's heads. A. Stewart Walker of the architectural firm of Walker & Gillette—which designed an extension of the New-York Historical Society building—and his wife owned a papier-mâché milliner's head. Not aficionados of folk art, they collected Nadelman sculptures as well as Old Master paintings and French furniture.[10] It is tempting to speculate that the Nadelmans played a role in the Walkers' acquisition of their one piece of folk art.[11]

RJMO

1 See Wendy Gamber, *The Female Economy: The Millinery and Dressmaking Trades, 1860–1930* (Urbana and Chicago: University of Illinois Press, 1997). For a history of hats in general, see Madeleine Ginsburg, *The Hat: Trends and Traditions* (Hauppauge, NY: Barron's, 1990).

2 Christina Bates, "Women's Hats and the Millinery Trade, 1840–1940. An Annotated Bibliography," *Dress: The Annual Journal of the Costume Society of America* 27 (2000): 49.

3 Jacqueline Barbara Carr, "Marketing Gentility: Boston's Businesswomen, 1780–1830," *New England Quarterly* 82 (March 2009): 31.

4 See François Theimer, *The Encyclopedia of French Dolls, 1800–1925* (Annapolis, MD: Gold Horse Publishing, 2003), 168–69, for Louis Danjard, a manufacturer of papier-mâché milliner's heads (1860–82). In 1860 he took out a series of patents for the decoration of heads with printed patterns for appliqué on papier-mâché forms. He also made one with a torso.

5 There is no "Bonnet room" listed in the MFPA inventory, although the MFPA cards list it as the location for other objects; it may be Gallery X, which had six cases with embroideries, costume accessories, etc.

6 MFPA card 2084, purchased from Marie Sterner in August 1926 for $45. Marie Sterner (later Lintott) was a dealer who exhibited works by modern artists, Elie Nadelman among them. The Nadelmans noted that it was also called a wig stand, a common misconception. It has a MFPA collection label on the underside of its base inscribed "208/Fr."

7 MFPA unnumbered card, classified as "Cost. and Acc." (costumes and accessories), purchased from Ann Elsey in 1928 for $37.50. There is also an unnumbered MFPA card for a third wooden head, whereabouts unknown, which is described as having a base and a coat of light cream paint, also classified as "Cost. and Acc." and purchased from Ann Elsey in February 1928 for $37.50.

8 For example, Pitt Rivers Museum, Oxford University, Eng., 1932.70.1, terms it a "wig block." The back of the hair and the area under the chin are covered with white leather, suggesting that it was for displaying bonnets with ribbons that tied under the chin.

9 Ramljak 2001b, fig. 6.

10 It was also Walker who commissioned from Nadelman the monumental relief for the Art Deco Fuller Building on 57 Fifty-seventh Street (1929); see ibid., fig. 13.

11 For the Walkers' milliner's head, see http://bofferdingnewyork.com/2012/11/15/recent-acquisitions/. The dealer questions why the Walkers possessed such an out-of-character piece, speculating: "They could have bought it on their own, but . . . they exchanged gifts with the Nadelmans over the years. Or they could have acquired it when the Nadelmans were forced to sell off the collection during the Depression."

Fig. 92. John James Chalon, *At the Milliners (La marchande de modes)*, 1822. Hand-colored lithograph. Private collection

10

Unidentified American makers

Chalkware urn with fruit and pair of lovebirds, 1850–90
Plaster of Paris, paint; 15½ × 8¼ in. (39.4 × 21 cm)
Provenance: Estelle Berkstresser, York, PA, 1925
1937.1132*

Chalkware seated boy, 1850–90
Plaster of Paris, paint; 11½ × 5½ × 5 in.
(29.2 × 14 × 12.7 cm)
Provenance: Elsa Rogo, New York City, 1925
INV.630*

Chalkware watch stand, 1850–90
Plaster of Paris, paint; 8¼ × 5½ × 3¼ in.
(21 × 14 × 8.3 cm)
Provenance: Estelle Berkstresser, York, PA, 1925, or
Mable I. Renner, York, PA, 1927
1937.1142a*

Chalkware garniture with spray of fruit and leaves, 1850–90
Plaster of Paris, paint; 14 × 10 × 4½ in.
(35.6 × 25.4 × 11.4 cm)
Provenance: George F. Ives estate sale, Danbury, CT,
1924
1937.1129*

Chalkware pinecone on stand, 1850–90
Plaster of Paris, paint; 9¼ × 4⅜ in. (23.5 × 11.1 cm)
Provenance: Mable I. Renner, York, PA, 1927
1937.1137*

Chalkware plaque with a seated woman,
1840–60
Plaster of Paris, paint; 4¾ × 5¾ in. (12.1 × 14.6 cm)
Provenance: Renwick Hurry, New York City, 1925
1937.1135*

Chalkware lovebirds, 1850–90
Plaster of Paris, paint; 4¾ × 3¾ × 3¼ in.
(12.1 × 9.5 × 8.3 cm)
1937.1134a**

Chalkware dog, 1850–90
Plaster of Paris, paint; 8¾ × 4 × 5¾ in.
(22.2 × 10.2 × 14.6 cm)
Provenance: Charles Woolsey Lyon, New York City,
1924
1937.1150*

Chalkware cat, 1850–90
Plaster of Paris, paint; 5⅜ × 3¼ × 2⅜ in.
(13.7 × 8.3 × 6 cm)
1937.1146

Chalkware rooster, 1850–90
Plaster of Paris, paint; 10 × 7 × 4¼ in.
(25.4 × 17.8 × 10.8 cm)
Provenance: William A. Davis, Albany, NY, 1926
1937.1144*

Chalkware squirrel with nut, 1850–90
Plaster of Paris, paint; 5⅝ × 3⅜ × 2⅝ in.
(14.3 × 8.6 × 6.7 cm)
Provenance: Early American Antiques, 1925
INV.631*

Chalkware bird on pedestal, 1850–90
Plaster of Paris, paint; 6 × 2⅛ × 4 in.
(15.2 × 5.4 × 10.2 cm)
Provenance: Sara M. Sanders, Closter Antique
Shop, Closter, NJ, 1927?
1937.1153*

Chalkware, often called the poor man's Staffordshire, first appeared in Europe in the early eighteenth century and later in that century was being advertised in New York and Boston newspapers as locally made.[1] As early as 1768, a Colonial stonecutter advertised his own pieces including busts and a menagerie of parrots, cats, dogs, lions, and sheep.[2] Cast in molds, these hollow figurines were made of plaster of Paris: calcinated gypsum ground into a powder and mixed with water. They were individually hand-colored in watercolor, tempera, or oil to compensate for their lack of detailed modeling. The most popular figures were roosters and domesticated animals. The more ornamental pieces for household decoration were urns and vases, or miniature churches with glazed windows and an interior space for candle illumination. Portrait busts were less frequently produced (see cat. 11). The Nadelmans collected all these types.

In the 1800s chalkware became an affordable solution to the demand for decorative objects created by the urbanizing middle class in America and Europe. Evidence suggests that chalkware was frequently made by Italian immigrants, probably plaster craftsmen from Tuscany, and pieces were often sold on the streets by itinerant vendors, known as "image peddlers" (see fig. 93).[3] They remained popular household decorations through the nineteenth century, as witness Huckleberry Finn's comments about "chalk figures." On the mantel of a Missouri parlor he describes "a big outlandish parrot on each side of the clock, made out of something like chalk, and painted up gaudy" (Mark Twain confuses them with squeak toys on the same page of his novel).[4]

The MFPA inventory records eighty-nine pieces of "Pennsylvania plaster" in Gallery II in the "plaster case," although the MFPA cards list ninety-eight objects, thirty-five of which are held by the N-YHS today. Many of these objects have graphite inscriptions inside with their MFPA numbers. The Nadelmans appear to have been in the vanguard of collecting chalkware, and their dealers had a ready supply.[5] No doubt the couple was attracted by the decorative charm, vivid colors, and generalized, almost abstract, pre-industrialized forms, as well as the "shabby chic" aesthetic of chalkware. (With reuse the molds produced casts with less and less detail, so that some figures are difficult even to identify.)[6] The MFPA cards reveal that the Nadelmans made the majority of their purchases between 1924 and 1927, tapering off by 1929, and they paid prices according to the rarity and size of the objects.

Four handsome examples stand out among the large mantel ornaments in the N-YHS. The first (1937.1129) is a spray of brown leaves and yellow and red fruit, which the Nadelmans purchased for $11.50 from the estate auction of the antiques dealer George F. Ives.[7] The other is an "urn" with fruit and lovebirds (1937.1132), which they acquired from Berkstresser.[8] They displayed a similar urn without lovebirds in Gallery II of the MFPA perched on top of a corner cabinet. The couple had a penchant for these engaging "doves," because the simple pair of billing lovebirds (1937.1134a) is one of a trio recorded in MFPA cards, two of which are in the N-YHS.[9] The third mantel ornament is a watch stand (1937.1142a), one of a pair from the same mold, which dovetails with the Nadelmans' collection of watch accessories.[10] For the last in this quartet, the fetching seated boy wearing a hat and holding an apple (INV.630), the Nadelmans paid Rogo only $3, which seems relatively inexpensive for its size.[11]

Several other pieces collected by the Nadelmans are rare survivals. Among them is the plaque with a neoclassical relief of a seated woman (1937.1135) and "1785" scratched onto its reverse, which they purchased for $25 from Hurry.[12] Another is the "Plaster Tree . . . shaped like a pineapple" (1937.1137) for which they paid Renner $4.75.[13] Rather than that symbol of hospitality, the object replicates the famous ancient sculpture of a pinecone, symbolic of fertility, on a pedestal in the Vatican (see fig. 64).

Certainly the whimsical charm of the menagerie of animals appealed to the couple, a taste also reflected in their collection of bellows toys (see cat. 77). One of the largest chalkware animals is a rooster (1937.1144), which they probably acquired from Davis for $15.[14] They had paid the same amount to Lyon for the dapper dog (1937.1150), which is amusingly lettered "BOW WOW."[15] For lesser sums, the couple purchased the bird, probably a canary, on a pedestal (1937.1153) from Sanders for $5.40,[16] and the squirrel holding a nut (INV.631) from Early American Antiques for $1.50.[17] Not all their purchases, however, are recorded in MFPA cards, for example, the droll, more common cat (1937.1146), for which they paid $1.50, according to the graphite inscription on its base. Evidence that their collection of chalkware was important is underlined by a 1929 article about it in *House and Garden*, which reproduces some of the works discussed here.[18]

RJMO

1 See Jerry Oberwager, *Chalkware Tools and Methods, Prepared as a Complement for a Talk by Jerry Oberwager before the Early Trades and Crafts Society* (n.p.: Early Trades and Crafts Society, 1981), a copy of which is on deposit in the Winterthur Museum Library, according to Priddy 2004, 245, n. 37; Suzanne Feldman and Rowenna Pounds, "The Chalk Menagerie," *Clarion* (Spring 1982): 30–35; Amanda E. Lange and Julie A. Reilly, "Chalkware," *The Magazine Antiques* 146:4 (October 1994): 496–505, which points out (p. 503) that the early misconceptions about the Pennsylvania-German origins of chalkware served to make it more appealing to the first collectors of folk art.

2 Feldman and Pounds, "The Chalk Menagerie," 32; Lange and Reilly, "Chalkware," 498; Hollander and Anderson 2001, pl. 119a–o, for a similar selection.

3 It was formerly believed that Pennsylvania Germans produced most chalkware because so many examples survived in eastern Pennsylvania.

4 Mark Twain, *Adventures of Huckleberry Finn* (New York: Charles L. Webster and Company, 1885), 137.

5 Ralph and Terry Kovel, "Know Your Antiques: German Chalkware," *Sun*, January 26, 1964, estimates that "About 30 years ago the crude painted plaster figures were 'discovered.' Experts claimed chalkware was an example of early folk art." Lange and Reilly, "Chalkware," 496, notes other collectors of folk art who also collected chalkware during the 1920s and 1930s.

6 Lange and Reilly, "Chalkware," 500.

7 MFPA 506; City National Bank of Danbury, CT, "The George F. Ives Collection of Antiques," June 18, 1924, lot 3274 (group), ill. p. 278 on upper shelf, second from left (sale of the Ives Tavern and Colonial Museum).

8 MFPA 1724; acquired from Berkstresser (with no price) in December 1925.

9 MFPA 1084 (inscribed in graphite on the inside); two MFPA cards (505 and 506) record multiple chalkware pieces, including three "doves" (nos. 1084–86).

10 Although there are cards for three watchstands, it is most likely MFPA 1602, which they purchased from Berkstresser for $15.50 in September 1925. Its pendant (1927.1142b), which from its inscription is MFPA 2263, is described on its card: "Hollow white stand on base with four feet. Corrugated front with round hole, raised border colored yellow with red spots. Raised flowers and an oval decorationd [*sic*] painted yellow red and green. On top a white dog with black ears and tail, dashe [*sic*] of red and green. Height over all 11". Dog has been repaired. Hole over watch opening." They acquired it from Renner for $15 in April 1927, and the dog is now missing but the opening on top of the other watch stand may have once had a similar animal. The third watch stand, MFPA Misc. 2375, which they purchased from Renner in 1927 for $9.50, is not in the N-YHS.

11 MFPA 1236; purchased in April 1925.

12 MFPA 1320; purchased in June 1925. The "1785" could be interpreted as a date but may have been added at any time.

13 MFPA 2369; purchased in 1927.

14 MFPA 2040; purchased in September 1926.

15 MFPA 691; purchased in October 1924.

16 Probably MFPA 2350; purchased in 1927.

17 MFPA 1423; purchased in August 1925.

18 Mr. and Mrs. G. Glen Gould, "Plaster Ornaments for Collectors: A Little Known Americana is Found in These Fragile Cottage Decorations," *House and Garden* 56:2 (August 1929): 84–85, 122.

11

Unidentified American maker
Chalkware bust of a woman, ca. 1800–50
Plaster of Paris, paint; 13½ × 7 × 4¼ in.
(34.5 × 18 × 11 cm)
Provenance: Renwick Hurry, New York City, 1925
1937.1138*

Fig. 93. "Images. / 'Images; very fine, very pretty,'" woodcut from *The Cries of New-York* (New York: Printed and Sold by S. Wood, 1812), 34, ill. N-YHS Library

In 1925 the Nadelmans paid Renwick Hurry the high price of $100 for this rare, unusually large object. It was more than they paid for any other chalkware piece (see also cat. 10).[1]

Chalkware was produced in the United States as early as the mid-eighteenth century, although ornamental plaster busts were less numerous than other mantel ornaments and the ubiquitous animals.[2] By 1768 a Bostonian stonecutter advertised native chalkware pieces, including busts (among them Homer, Milton, and Mathew Prior),[3] while a later source notes that plaster busts of glorious American heroes were marketed in 1851.[4]

Chalkware figures were sold by peddlers, as depicted in a woodblock print of 1812 (fig. 93). It shows a chalkware vendor holding a vase with flowers and carrying a tray on his head of his other wares; from the left: two busts, a seated figure, three standing nude Neoclassical figures, a dog, and a bird. The accompanying text relates, "This man, although his business is not so useful or necessary as some others, yet strives to please, by presenting a variety of images, or representations of animals, which he carries round to sell. This is his way to get a living."[5]

The Nadelman chalkware female bust is one-quarter lifesize and approximates the measurements of the bust second to the left carried on the peddler's tray in figure 93, as

well as the larger busts produced by various Staffordshire potters in England, some of which have similar socles. Her costume, jewelry, and hairstyle with its hair ornament were fashionable around the period when Dolley Madison was First Lady.[6] This evidence suggests that the handsome bust dates to the early decades of the nineteenth century.
RJMO

1 MFPA 1147; they purchased it from Hurry in April 1925. Reproduced in Mr. and Mrs. G. Glen Gould, "Plaster Ornaments for Collectors: A Little Known Americana is Found in These Fragile Cottage Decorations," *House and Garden* 56:2 (August 1929): 84.

2 Suzanne Feldman and Rowenna Pounds, "The Chalk Menagerie," *Clarion* (Spring 1982): 32, cites *New York Gazette and Weekly Mercury*, October 3, 1768; see also Amanda E. Lange and Julie A. Reilly, "Chalkware," *The Magazine Antiques* 146:4 (October 1994): 496–505.

3 Feldman and Pounds, "The Chalk Menagerie," cites the *Massachusetts Gazette. And Boston News-Letter* for 1768 and 1770; see also Lange and Reilly, "Chalkware," 498.

4 Priddy 2004, 186–87; two examples are reproduced in Hollander and Anderson 2001, pl. 119a–o.

5 *The Cries of New-York* (New York: Printed and Sold by S. Wood, 1812), 35, continues:

 They are made of plaster of paris, which is a kind of stone that abounds at Nova-Scotia. It is brought in vast quantities from thence, and is a valuable article of commerce. It finds employ for many people, vessels, and mills. It is brought to New-York in stones of various sizes, from one pound to an hundred or two hundred weight, and sold by the ton, at from five, to ten dollars per ton. It is then taken to the mills; first broken by large hammers, to about the size of walnuts: then it is ground to powder, like flour, in which state it is sold, by the bushel, at from fifty cents to one dollar. . . .

6 See the 1804 portrait of Dolley Madison by Gilbert Stuart in the collection of the White House Historical Association. Gould and Gould, "Plaster Ornaments for Collectors," 122, identifies the bust in the Nadelman collection as representing Mrs. Andrew Jackson (ill. on p. 84).

IMAGES.

"*Images; very fine, very pretty.*"

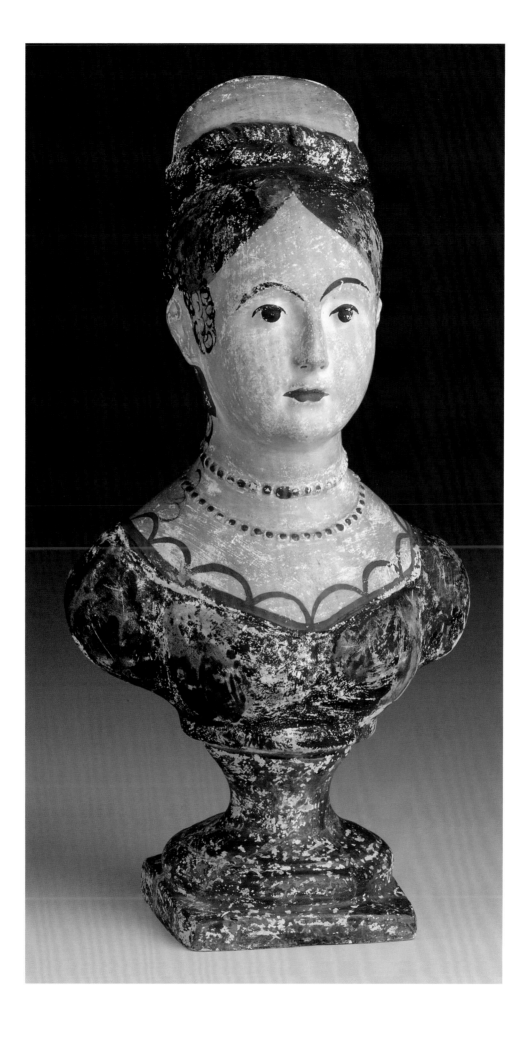

12

Unidentified American artist
**Window shade with Lady Liberty and
Washington**, 1800–10
Oil on canvas; 73 × 43⅞ × 1½ in.
(185.5 × 111.5 × 4 cm)
Provenance: Frederick William Fuessenich sale,
Litchfield, CT, 1928;[1] Nadelman Collection;
purchased by Stephen C. Clark for the New York
State Historical Association, 1948
Fenimore Art Museum, Cooperstown, NY
N0535.1948

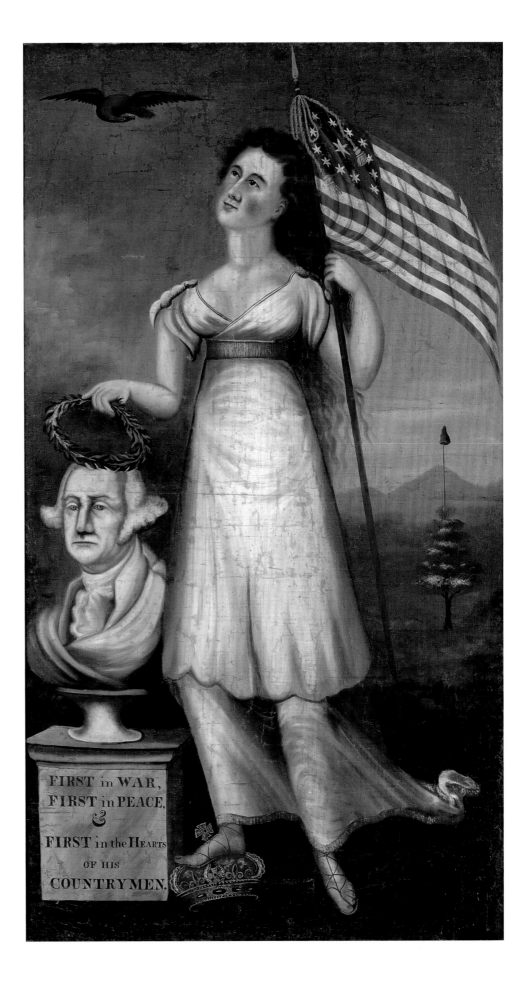

In late 1928 the Nadelmans acquired this wonderfully patriotic work, with Lady Liberty placing a laurel wreath on a bust of George Washington, directly from the home of the collector and dealer Frederick William Fuessenich.[2] Reportedly he had purchased the large painted window shade from a Connecticut inn, where it had graced the interior of the building, perhaps in a ballroom, as one of a set of six. Five were destroyed in a fire and their subjects remain unknown, as does the location of the inn and the painter's name.[3]

The work is filled with symbols appropriate to the young republic of the United States. Not only does the multi-tasking Liberty trample the crown of English rule in a classical Victor-over-the-Vanquished pose, but she also holds the American flag emblazoned with a circular constellation of thirteen stars (one in the center) and thirteen stripes symbolizing the colonies.[4] While looking at the American eagle flying above, Liberty bestows a laurel crown, a classical sign of honor, on a sculptured bust of Washington.[5] In the background, like a footnote to this nationalistic imagery, grows a Liberty tree topped by a Phrygian or Liberty cap on a Liberty pole (see Olson essay, p. 90).[6] The bust of Washington rests on a pedestal inscribed with a quotation from his funeral eulogy delivered by Henry Lee III on December 26, 1799: "FIRST IN WAR, / FIRST IN PEACE, / & / FIRST IN THE HEARTS / OF HIS / COUNTRYMEN." Since numerous likenesses of Washington were in circulation at the time, it is difficult to pinpoint the painter's source of the bust-length sculpture, which was more than likely a print. Washington's effigy resembles a Roman Republican portrait bust, wherein the sitter is draped in a toga, but it is a pastiche since he also wears a shirt. Nevertheless, the bust and the other symbols in the depiction allude to the democratic principles of America and its founding fathers (see Olson essay, pp. 85–92).

Beginning in the eighteenth century with the Enlightenment, a new genre of "transparent" goods emerged that featured painted light-conducting fabrics. Among the earliest examples were stage sets lit from behind, followed by candlelit parade banners for nocturnal marches and celebrations. Charles Willson Peale incorporated transparent painting into a magnificent outdoor triumphal arch that he built in Philadelphia to celebrate the Treaty of Paris in 1784.[7] Transparencies became part of the Neoclassical vocabulary and also reflected a contemporary interest in lighting technology and special-effects phantasmagoria.[8]

By the start of the nineteenth century, transparent shades for windows emerged as one of the more imaginative modes of domestic ornamentation. According to Sumpter Priddy, few of these shades survive, yet they epitomize the American love affair with the Fancy style, a decorative style popular in the United States between 1790 and 1840. He dates the first painted American shades to 1792, when Baltimore merchants advertised "transparent Blinds for Windows," a half century after the first documented British examples. Four years later, a Philadelphia firm of "House, Sign, and Ship-Painters" offered to execute "transparencies, silks for windows." By the 1820s and 1830s painted shades were common in many fashionable households.[9]

RJMO

1. The shade may never have been in the MFPA; Fenimore Art Museum records reveal that Clark purchased it from Viola Nadelman (Elie Nadelman's estate) in 1948.
2. For the sale see "Fuessenich Richly Stores Old Inn and Schoolhouse . . . ," *Hartford Courant*, October 7, 1928, which mentions the shade; "New Wing of Boston Museum . . . Frederick W. Fuessenich Put on Market Antiques . . . ," *Hartford Courant*, November 11, 1928.
3. According to the object file in the Fenimore Art Museum, this information was reported by Fuessenich.
4. For Lady Liberty, see Louis C. Jones, "Liberty and Considerable License," *The Magazine Antiques* 74:1 (July 1958): 40–43, fig. 11; E. McClung Fleming, "From Indian Princess to Greek Goddess: The American Image, 1783–1815," *Winterthur Portfolio* 3 (1967): 37–66, fig. 24, which first identifies the Fenimore personification as Columbia, later admitting that the two were interchangeable and that American Liberty became predominant; Nancy Jo Fox, *Liberties with Liberty: The Fascinating History of America's Proudest Symbol* (New York: E.P. Dutton in association with the Museum of American Folk Art, 1986), fig. 8; John Higham, "American in Person: The Evolution of National Symbols," *Amerikastudien / American Studies* 36:4 (1991): 473–93; Fischer 2005, 233–42.
5. Fox, *Liberties with Liberty*, 17, notes that the Fenimore Liberty is based on Edward Savage's engraving of 1798, *Liberty in the Form of the Goddess of Youth Giving Support to the Bald Eagle* (ibid., fig. 4), which inspired many folk art representations of Liberty; it had been based on Sir William Hamilton's watercolor of 1791, *Hebe Offering a Cup to the Eagle (Jove)*.
6. See Fischer 2005, 19–36 (Liberty tree); 37–49 (Liberty pole).
7. Charles Coleman Sellers, *Charles Willson Peale* (New York: Charles Scribner's Sons, 1969), 194. It was to be "exactly in the stile of the triumphal arches *among* the Romans," and it was Peale's second such construction, as a year earlier he had made one for Congress.
8. See Barbara Jean Stafford, *Artful Science: Enlightenment, Entertainment, and the Eclipse of Visual Education* (Cambridge, MA: MIT Press, 1994).
9. Priddy 2004, 128–29, 240 n. 42; see also fig. 223 ("Ball & Price, Plain and Fancy Blind-Factory," trade card, ca. 1830, N-YHS, Prints, Photographs, and Architectural Collections, Bella C. Landauer Collection).

13

Unidentified American makers

Fire engine condenser case, possibly of Hudson Engine Company No. 1, New York City, 1830
Wood, oil paint, primer, metal; 30 × 19 × 12½ in.
(76.2 × 48.3 × 31.8 cm)
1937.1630

Fire engine condenser case of Clinton Engine Company No. 41, New York City,
ca. 1832–42
Wood, oil paint, primer, gilding; 32 × 30¼ × 15 in.
(81.3 × 76.8 × 38.1 cm)
1937.1631

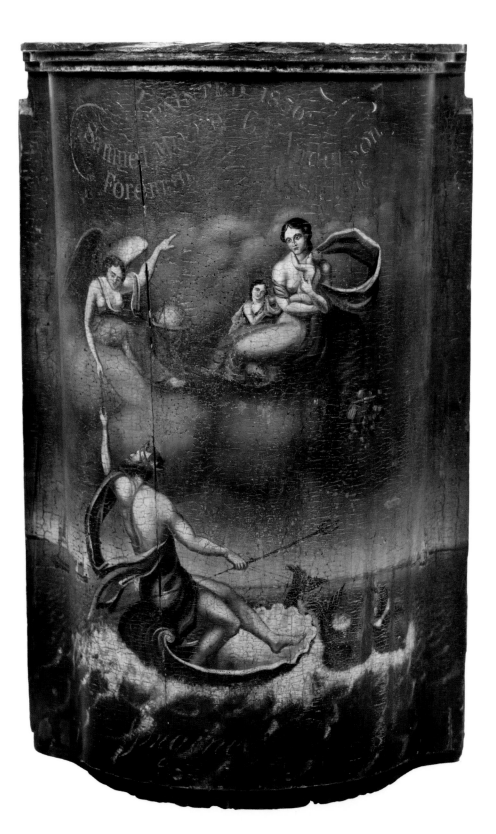

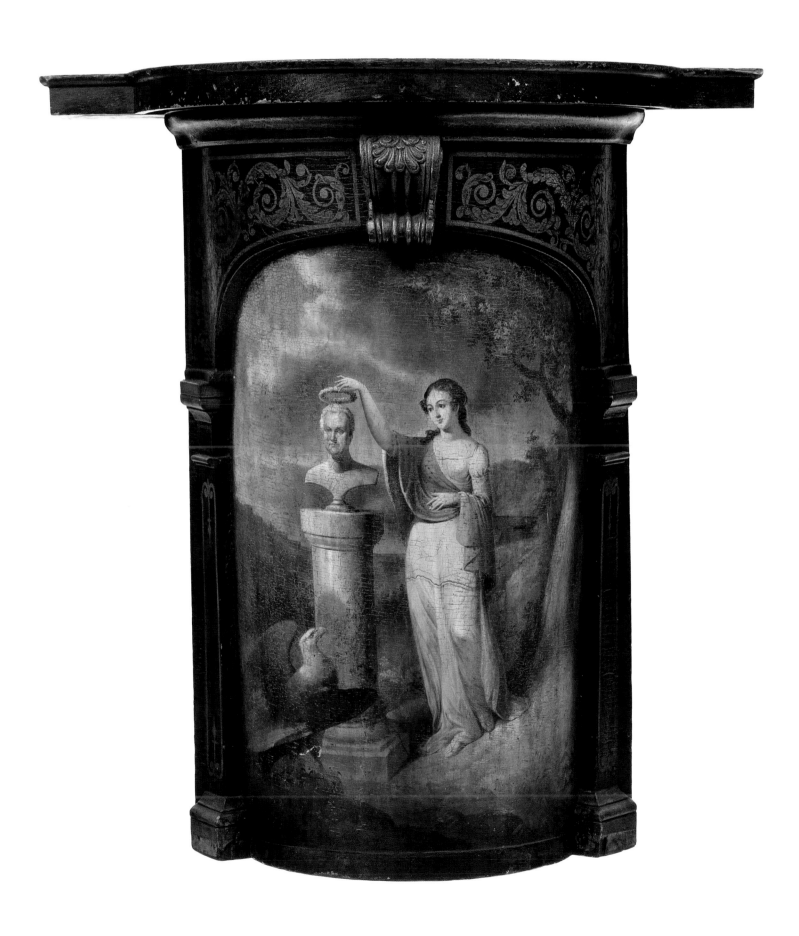

During the early nineteenth century the pressure chambers on hand-pumped fire engines were covered with plain condenser cases. After raising funds for their decoration, the volunteer fire companies replaced the spartan covers on their engines with elaborately painted ones. The cases had dual functions: to conceal the apparatus and to bear the company's emblem, which frequently included allegorical, civic, or patriotic figures in a demonstration of esprit de corps. The companies, which were like fraternal social clubs, commissioned artists or sign painters to embellish these detachable cases with painted scenes that could be rendered in the studio, a practice that may date to the late 1790s in New York City. While elaborate condenser cases are described in parades and ceremonial occasions, it is clear from other reports that once a company had a fancy condenser case, it usually became a permanent feature of its engine, even when responding to a fire (fig. 94).[1]

Two of the four condenser cases from the MFPA are considered in this entry. Since none is listed in the MFPA inventory or cards, they may have been later acquisitions.[2] All four were made for the New York style "gooseneck" type of engine used until around 1840.[3] No doubt the robust forms of these cases, their civic function, and, above all, their festive embellishment attracted the Nadelmans. The couple also collected other firefighting objects, including Harry Howard (cat. 1), which they exhibited in Gallery VII of the MFPA, as noted in the inventory.[4] Framing their painted scenes, these half-cylindrical wooden structures typically had elaborate architectural surrounds in a Neoclassical style. Whereas the condenser case on the left lacks its frame, that of Clinton Company No. 41 features a classicizing arcade with gilded detail, spandrels with intricately painted foliate scrolls, and a prominent, carved keystone crowned by a large palmette.

A partial entablature of three fasciae suggests that the frame of the condenser case on the left, possibly of Hudson No. 1, did not include an arch.[5] The panel is inscribed in red paint at the top in block letters: "PAINTED 1830. / Samuel Moore. / Foreman. / C. V.

Anderson. / Assistant"; and below in cursive: "Engine [?]" (number effaced). Since Cornelius V. Anderson became the foreman of Hudson No. 1 in 1830, the inscription strongly suggests that this case belonged to Hudson No. 1, the first fire company of New York City.[6] Because of the role water played in fighting fires, Poseidon / Neptune, the Greco-Roman god of the sea, was a popular mascot of fire companies. On the Nadelman condenser case he wears a crown, holds a trident, and sits in a scallop shell barque, drawn by two dolphins or hippocamps from antique and Renaissance models. This iconography is nearly identical to that on a certificate printed by the newly formed New York Nautical Institution in commemoration of the Erie Canal opening in 1825.[7] Although the certificate's caption identifies the seascape as located outside of Sandy Hook, with Staten Island on the right, the view on the condenser case seems more generic. Because the number of the engine company in the inscription, formerly at the lower center, has disappeared, it is difficult to clinch the identity of its engine company.[8]

Fig. 94. T.W. Strong, *The Fireman: The Nobleman of Our Republic*, ca. 1850. Hand-colored lithograph; 10 × 14 in. (25.4 × 35.6 cm). New York City Fire Museum, 00.1701

The condenser case at the right belonged to New York City's Clinton Engine Company No. 41, whose namesake was DeWitt Clinton, governor of New York and a founder and president of the N-YHS.[9] Made for a new engine purchased in 1829, it replaced an earlier case described in 1825.[10] Commissioned by the committee for the fire department to find a better water source for the City, Clinton championed importing a new supply from the Croton River in Westchester and became one of the driving forces during the construction of the Erie Canal. The beautifully painted scene on the case depicts the Genius of Agriculture crowning a bust of Clinton (on a pedestal) with a laurel wreath,[11] while an eagle (emblematic of the American Republic) looks on at the lower left. The two background landscapes represent the Erie Canal (Clinton was known as the father of the Erie Canal) and Albany (seat of the state government). The first description of this later case is in the account of a parade celebrating the opening of the Croton Aqueduct on October 14, 1842,[12] which has been called "New York's paean for fire protection."[13] This very scene was described as "on the back" of the engine, which was painted yellow with red and gilt stripes.[14] Since DeWitt Clinton was also termed the father of the Croton Aqueduct and the Croton Distributing Reservoir, this celebration was a tremendous opportunity for the company to display its might and finery. Its members would have devoted enormous effort to their display, perhaps even commissioning a new condenser case.

RJMO

1 Thanks to Damon Campagna of the New York City Fire Museum for this information. In this lithograph, which was third in a series of four, the condenser case serves as a podium for the foreman with his speaking trumpet; see Kenneth Holcomb Dunshee, *As You Pass By* (New York: Hastings House, 1952), pl. II.

2 The two others not exhibited are: N-YHS 1937.1629 (Washington Fire Company) and 1937.1632 (Jackson Fire Company).

3 Jerome Irving Smith, "Painted Fire Engine Panels," *The Magazine Antiques* 32:5 (November 1937): 245–47, fig. 2, shows the elaborately painted condenser case as an integral part of the engine.

4 A charming four-page essay written by Elie Nadelman on George Washington as a volunteer fireman also attests to his interest in the historic, patriotic, and civic aspects of firefighting; NP.

5 Another example from the period with a straight entablature is in the New York City Fire Museum, 09.060.

6 Anderson was assistant foreman before he was made foreman in 1830, after Samuel Moore, according to Jerome Irving Smith (Registrar of the Henry Ford Museum and Greenfield Village, Dearborn, MI), letter to N-YHS, April 2, 1956. Smith believes that the inscriptions are later, perhaps after 1846, when Hudson No. 1 was reorganized from Engine Company 9. See also Augustine E. Costello, *Our Firemen: A History of the New York Fire Departments, Volunteer and Paid* (New York: Knickerbocker, 1890), 399–400, 560. For the locations/dates of the company, see http://www.nyfd.com/history/manvolfd.pdf. ("A History of the Volunteer Fire Companies of Manhattan [1731–1865]").

7 Cadwallader D. Colden, *Memoir, Prepared at the Request of a Committee of the Common Council of the City of New York . . .* (New York: W.A. Davis, 1825), 203–4, unnumbered pl. between pp. 202 and 203. The caption reads (ibid., 375): "This device is emblematic of Science, Skill, and Benevolence; Science is characterised as an angel, with appropriate instruments, and bending from a cloud she delivers to Neptune a sextant, as the emblem of Naval Skill: Benevolence like a nursing mother, with her attendant circumstances, is seated on a cornucopiae, upon the same cloud with Science. This scene is represented as taking place outside of Sandy Hook; on the right of Neptune, who is seated on his naval car, and drawn by dolphins, are the highlands of Neversink, and on the left of the picture, is Staten Island; in the distant horizon is Sandy Hook Lighthouse; pilot-boats, ships outward and inward bound are placed under their appropriate positions."

8 The N-YHS accession record notes the above inscription and also "Engine, 9." Today, the numeral is illegible and nearly totally effaced. The combination of the case's imagery and its date could link it to at least two different fire companies: Hudson No. 1 and Neptune Engine Company No. 6, whose banner in the 1842 Croton Celebration is described summarily as "Neptune drawn by sea-horses"; see George W. Sheldon, *The Story of the Volunteer Fire Department of the City of New York* (New York: Harper & Brothers, 1882), 500.

9 For locations and dates of the company, see http://www.nyfd.com/history/manvolfd.pdf.

10 See Colden, *Memoir*, 244–45; Costello, *Our Firemen*, 617. Jerome Irving Smith, letter to N-YHS, April 24, 1946, suggests that the case was painted by Thomas Grenell, who had painted the earlier engine for that company and later may have been a partner in Thorp & Grenell, a firm that executed decorations for other companies in the 1840s.

11 The most likely source for the sculptural likeness of Clinton, who was frequently represented from 1816 through the 1830s, lies in paintings and prints. John Wesley Jarvis painted a portrait of a younger Clinton with a similar tilt to his head, which is known in several versions; the original is in the National Portrait Gallery, Washington, DC (NPG.65.53), with two versions in the N-YHS (1940.958; 1854.1). Albert Newsam's (1809–1864) lithographic portrait of 1830 is another possible source (NPG.81.62).

12 Charles King, *A Memoir of the Construction, Cost, and Capacity of the Croton Aqueduct, Compiled from Official Documents: Together with an Account of the Civic Celebration of the Fourteenth October 1842* (New-York: Printed by author, 1843), 284.

13 Stephen F. Ginsberg, "The History of Fire Protection in New York City, 1800–1842" (Ph.D. diss., New York University, 1968), 117.

14 Sheldon, *Fire Department*, 505. It remained in use, for example, in an annual ball ticket of ca. 1846 for the company that features a version of this scene; see ibid., 299, ill.

14

George Washington Mark (American, 1795–1879)
Washington Crossing the Delaware,
before 1850
Oil on canvas; 38½ × 53½ in. (98 × 135 cm)
1937.451

The Nadelmans owned at least three paintings by the self-taught artist George Washington Mark.[1] They hung *Washington Crossing the Delaware* with American works in Gallery III of the MFPA (fig. 12), as recorded in the inventory. As their three Mark paintings are among the few works reproduced in the 1935 MFPA guide (see p. 363), it is clear they regarded them highly.

After quitting the life of a sailor, Mark began advertising himself as a house, sign, and Fancy chair painter in 1818, later adding trompe-l'oeil wood and stone painting, portraits, and landscapes, as well as framing to his repertoire. In 1848 the artist opened an art gallery devoted exclusively to his paintings in his Connecticut River Valley town of Greenfield, Massachusetts. Charging an admission of twenty-five cents, he exhibited twenty-six works. The following year he issued a catalogue listing thirty-three paintings (a second of 1850 lists seventy).[2] Landscapes composed the largest category, followed by history paintings, many after prints.

Mark copied in oil this storied scene depicting George Washington Crossing the Delaware from one of at least two engravings that reproduce a painting by Thomas Sully.[3] In 1818 the legislature of North Carolina had requested that Sully paint two full-length portraits of Washington, but the artist suggested instead a historical picture involving the founding father. The subject selected was the crossing of the Delaware River by the Continental Army at McConkey's Ferry (now Washington's Crossing, Pennsylvania) on the night of December 25–26, 1776, for its surprise attack on the Hessian troops at Trenton. Unable to verify the dimensions of the space for which the painting was intended, Sully executed a huge canvas, which was rejected because of its size. This painting of 1819 (*Washington's Passage of the Delaware*) is now in the Museum of Fine Arts, Boston.[4]

Mark exhibited his copy of Sully's composition in his gallery and described it in his 1850 catalogue (no. 17):

WASHINGTON CROSSING THE DELAWARE: The passage of the Delaware, Dec. 25, 1776, is the most important event of the Revolution in point of Military daring and enterprise. This is the first successful blow struck upon the enemy after the commencement of the Revolution. On the right sits the noble [General Nathaniel] Green [*sic*], in the rear the thundering [General Henry] Knox, pointing with his sword to the place of embarkation, in front is the brave [General John] Sullivan in the act of mounting his horse, and Him that was first in the hearts of his countrymen! anxiously surveying the scene! forming the most interesting group that mortal eye ever rested upon. It was night, and we see the smoke curling from the watch-fires of Trenton over the angry Delaware. And, truly has the noble Sully more than immortalized himself by giving to Americans on canvass one of their noblest Monuments (54 × 38).[5]

Most of Mark's paintings, like those owned by the Nadelmans, have bizarre, unsettling qualities that result from a distorted perspective and an arbitrary scale for the figures based on his estimation of their importance. These features, coupled with Mark's imaginative abilities as a storyteller, result in unintentional humor and add to the naïve elements in his art that verge on the surreal. All these characteristics would have appealed to the Nadelmans, as would the patriotic subject of this painting (see Olson essay, pp. 86–87).
RJMO

1 The other two are: *Marion Feasting the British Officer on Sweet Potatoes* (N-YHS 1937.453) and *Old Church, Jamestown, Virginia* (N-YHS 1937.455); for all three, see Koke 1982, 2: 309–11, ills.

2 For more information about Mark, see Deborah Chotner, *American Naïve Paintings* (Washington, DC: National Gallery of Art; Cambridge, Eng.: Cambridge University Press, 1992), 251–52.

3 According to Koke 1982, 2: 310, there are at least two engravings of the Sully painting, the best-known one of 1825 by George S. Lang. Edward Hicks painted at least ten copies of the composition; see Dorothy Canning Mather and Eleanore Price Mather, *Edward Hicks: His Peaceable Kingdoms and Other Paintings* (Newark: University of Delaware Press; New York: Cornwall Books, 1983), 154–62; Carolyn J. Weekley, *The Kingdoms of Edward Hicks* (Williamsburg: The Colonial Williamsburg Foundation in association with Harry N. Abrams, 1999), 77–79, 156, figs. 59–62, 150–52.

4 Museum of Fine Arts, Boston, 03.1079.

5 An art critic from *Knickerbocker Magazine*, who traveled from New York City to Greenfield to see the 1850 exhibition, made such scathing remarks about the artist's incompetence that Mark destroyed some of his works and closed his gallery; see "Editor's Table," *Knickerbocker Magazine* 41 (February 1853): 191–93.

15

Unidentified American maker
"Bear and Pears" fireboard, ca. 1825–35
Oil on wood; 33 × 45 in. (83.8 × 114.3 cm)
Provenance: Viola and Elie Nadelman, New York
City; Edwin Hewitt, New York City, Jean and Howard
Lipman, Wilton, CT, 1940s;[1] Stephen C. Clark,
Cooperstown, NY
Fenimore Art Museum, Cooperstown, NY
N0044.1961

This hand-painted board and batten construction once graced a parlor, covering its fireplace opening during the summer months. Chimney (or fire) boards embellished by itinerant ornamental painters were an integral part of room decoration during the eighteenth and first half of the nineteenth centuries. Custom-made for each fireplace, they fitted exactly inside the surrounding woodwork, with several methods for holding them in place. Sometimes a painted overmantel also crowned the fireplace ensemble. Many fireboards feature a basket or pot of flowers, which is occasionally painted against a trompe-l'oeil space simulating the fireplace chamber and continues the pre-existing custom of placing a flower arrangement on the hearth when a fireplace was not in use. Other popular subjects include exotic or local topographical landscapes, which resembled overmantel scenes or wallpaper imported from France, and animal pieces related to contemporary images produced by sign painters.[2]

Among the most fanciful and imaginative of scenes with animals is the fabulously stylized "Bear and Pears," which its unidentified artist painted with a rag, a sponge, and stencils. He was influenced by the work and/or the instructional writings of the prolific muralist and inventor Rufus Porter, who wrote a popular book for amateurs on how to execute mural paintings and decorate domestic interiors—*A Select Collection of Valuable and Curious Arts* . . . , published in four editions in 1825–26.[3] Nina Fletcher Little posited a New Hampshire origin for "Bear and Pears" by allying it to a painted floorboard from the Thomas Dodge House in Lisbon, New Hampshire.[4] The same artist also decorated several homes, including one in Norridge, Maine, and a mural in distemper from the Boyce House in Thornton, New Hampshire.[5]

Many of the charming but naïve qualities of the "Bear and Pears" fireboard, which also occur in early twentieth-century art, made it highly appealing to the Nadelmans. One of these traits is the lack of naturalistic scale, as seen in the oversized decorative pears,

which can be found in needlework of the mid-eighteenth century and earlier English embroideries.[6] The red of the huge pears completes the complementary color scheme to make the work inherently pleasing. The three tall pear trees dwarf the house and the pine trees that dot the horizon as well as the silhouetted animals: the bear sniffing at the base of the central pear tree, a stag with antlers, and another mammal, probably a beaver, upon the black groundline. The work's fantastic lack of scale and the artist's inventive powers lend it the humorous, mysterious dimension present in much folk art and in the canvases of the self-taught French painter Henri Rousseau. No wonder that the Nadelmans were drawn to collect this whimsical yet haunting work.
RJMO

1 The final entry on the last page of the Lipman's inventory reads: "Fireboard. Bears in an orchard, from the Nadelman Collection. Purchased through Edwin Hewitt, 18 E. 69 St, N.Y.C. after several trips to Mrs. Nadelman of Riverdale, N.Y., the owner, from whom the previous year we had been unable to buy it. Checks 2151, 2-21-50, $300, JL check 2-1-50, $700. $1000." Howard and Jean Lipman Papers, Box 15, "Inventory, n.d.," AAA.

2 See Nina Fletcher Little, *American Decorative Wall Painting, 1700–1850* (New York: E.P. Dutton, 1972), 66–79.

3 See Jean Lipman, *Rufus Porter Rediscovered: Artist, Inventor, Journalist, 1792–1884*, exh. cat. (New York: Clarkson N. Potter, 1980), 77–88; Linda Carter Lefko, *Folk Art Murals of the Rufus Porter School: New England Landscapes, 1825–1845* (Atglen, PA: Schiffer, 2011).

4 Lipman, *Rufus Porter Rediscovered*, 78, fig. 84.

5 American Folk Art Museum, New York City, 1988.10.1, which attributes it to the "Bear and Pears Artist"; see http://www.folkartmuseum.org/?p=folk&t=images&id=4132.

6 For example, those on a late sixteenth- or early seventeenth-century coif, Cooper Hewitt, Smithsonian Design Museum, New York, 1962-53-2; see http://collection.cooperhewitt.org/objects/18445163/.

16

Unidentified American artist
"Briant Hall" boot and shoemaker trade sign, 1845–55
Wood, metal, paint; 26 × 37 × 1¾ in.
(66 × 94 × 4.5 cm)
Provenance: Purchased from Viola Nadelman by Stephen C. Clark for the New York State Historical Association, 1948
Fenimore Art Museum, Cooperstown, NY, Gift of Stephen C. Clark, Sr.
N0529.1948

Trade signs are emblematic advertisements or finding aids for goods or services offered for sale. They usually employ the fewest possible words, much like modern international signage, where a picture can replace a thousand words. Tracing their history back to Egyptian and Greco-Roman times, many signs, such as the three balls of pawnbrokers, became identified with specific trades. This is the case with boots and shoes. Signs with a maker's name and representations of footwear were conventional signage for a cobbler, such as Briant Hall, whose name is featured on this trade sign, and Josiah Turner, whose comparable sign was probably painted in Massachusetts around 1810.[1]

At the top of the Briant Hall trade sign is a black banner, outlined in white against the blue background, with V-shaped terminations; it is lettered "BRIANT * HALL." There is evidence of pentimenti below the inscriptions, suggesting that the board was repurposed and that the letters underneath survive from an earlier incarnation. The composition is centered on the oval framing a boot in profile and the sole and heel of another boot or shoe, bristling with nails. On either side of the oval, shoes in profile and pairs of them showing their undersides advertise the cobbler's careful craftsmanship. A small area at the lower right has been repainted and replaced. To date, no shop or individual named Briant Hall who worked as a shoemaker or cobbler has been identified.[2]

The Nadelmans probably displayed this trade sign, which in the MFPA inventory they may have called a "bootery sign," in Gallery XIII, together with weathervanes, other signs, and ironwork.[3] The couple also purchased a three-dimensional, eighteenth-century trade sign in a shape of a boot by a German maker, which they identified as a "Guild sign."[4] Among their trove of artisans' tools they also had a "shoemaker's collection," which was kept in a cupboard at the MFPA, demonstrating their fascination with how objects were made and their desire to preserve these disappearing skills in the industrialized world.
RJMO

1 AARFAM, 58.707.1; Beatrix T. Rumford and Carolyn J. Weekley, *Treasures of American Folk Art: The Abby Aldrich Rockefeller Folk Art Center* (Boston: Little, Brown, Bulfinch Press in association with the Colonial Williamsburg Foundation, 1989), fig. 64.

2 The closest is a Bryant Hall (1806–1887), who lived in Clyde, New York, in Wayne County, and was a carpenter, hotel keeper, and farmer. See *Clyde Times*, September 8, 1887; George W. Cowles, *Landmarks of Wayne County, New York* (Syracuse, NY: D. Mason, 1895), 258. In 1856 the town of Clyde had four shoe shops.

3 The Fenimore Art Museum records reveal that Clark purchased it from Viola Nadelman (Elie Nadelman's estate) in 1948.

4 MFPA Misc. 2586; N-YHS INV.7928. They acquired it for $100 in September 1929 from the dealer Laemmle in Munich.

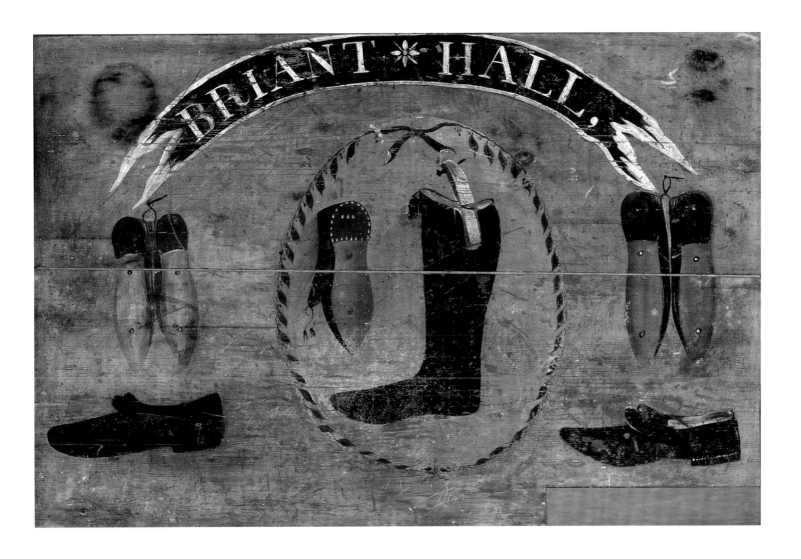

17

Herbert Eugene Covill (American, 1854–after 1930)
"Ye Boston Baked Beans" trade sign, 1886
Oil on canvas; 28¼ × 36 in. (72 × 91.5 cm)
1937.459

This amusing advertisement, painted in the format of a trade sign, is signed and dated in red paint at the lower right: "H.E. Covill. 86" (above the red and blue lettered slogan on the slanting near curb: "YE. BOSTON.BAKED.BEANS."). Its maker can be identified as Herbert Eugene Covill, who was born in Sandwich, Massachusetts. He is further identified in the 1883 New Bedford, Massachusetts, directory as a carriage trimmer, residing at 29 Walnut. In the 1930 United States Census he was seventy-five years old, a widower, and owned his own shop.[1]

Covill's scene takes place on a commercial street where a fancifully huge white pig pulls a buckboard driven by the American folk figure Uncle Sam, represented as a peddler ringing a bell highlighted in metallic pigment.[2] Their cargo is a huge steaming bean pot. Behind them the left-hand building is inscribed: "FISH MARKET" and "OYSTERS," and the middle store is identified as selling "FLOUR" and "GRAI[N]." The right-hand structure is a "DRY GOODS" store owned by "P.H. MILLER." While the representation is highly imaginative, its receding perspective is fairly accurate and it may also contain topical references. According to the 1883 New Bedford directory, a Peter H. Miller, a rope maker at the New Bedford Cordage Company, resided at 66 Arnold. That company was founded in 1842 and manufactured whale line and other marine cordage.[3]

The recipe for Boston baked beans consists of navy or pea beans cooked with molasses, salt pork, and seasonings. It traces its origin to the Indian practice of baking beans in pots with maple syrup, one that the Pilgrims and Puritans adopted. In the eighteenth century the Triangular Trade made Boston a supplier of rum, whose distillation process used molasses. Readily available as a cheap sweetener, molasses was added to local baked bean recipes to create Boston Baked Beans, and hence gave rise to Boston's nickname "Bean Town." In Colonial New England, baked meals were traditionally cooked on Saturdays and left in brick ovens overnight, allowing people to consume a hot meal on Sundays and still comply with Sabbath restrictions. Baked beans and brown bread was a popular meal on Saturdays and Sundays in Massachusetts until the early 1900s.[4] The archaizing "YE" in the advertisement's title was meant to connote the antiquity of this traditional dish as well as to underscore the humor of the scene.

The charm of this work, together with its patriotic elements (among them its palette), simplified style, and comical nature would have piqued the Nadelmans' collecting instincts. According to the inscription on its stretcher, the work was hung in Gallery V of the MFPA.

RJMO

1 The late Thomas Kugelman located information about the painter that allowed us to identify this previously unknown figure; see Koke 1982, 1: 220–21; Stillinger 1994, pl. IX.
2 For Uncle Sam, see Fischer 2005, 228–32.
3 See http://library.mysticseaport.org/manuscripts/coll/coll075.cfm. In 1964 it merged with Phillips Petroleum Co.
4 See http://www.celebrateboston.com/culture/bean-town-origin.htm.

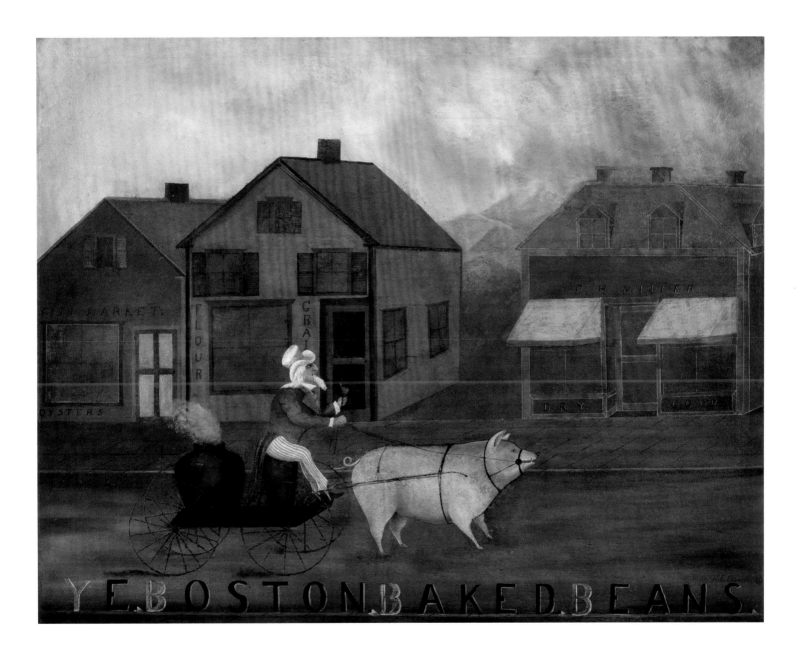

18

Attributed to Dr. Samuel Addison Shute (American, 1803–1836) and/or Ruth Whittier Shute (American, 1803–1882)

Portrait of a Woman, ca. 1830–33
Oil, graphite, and gold foil on canvas; 29 × 29 in. (73.5 × 73.5 cm)
Provenance: Philip Suval, New York City or Southampton, NY
1937.456

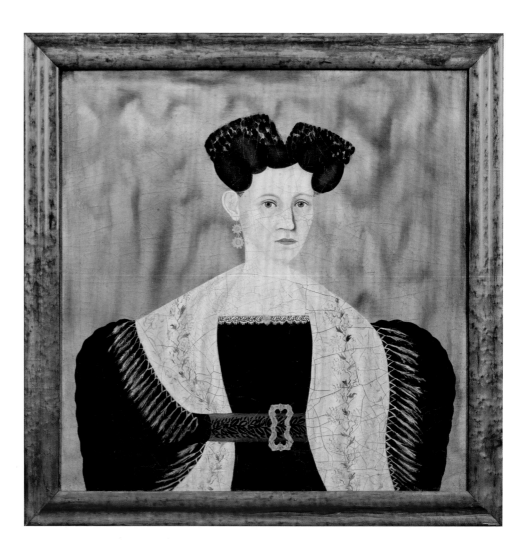

The Nadelmans displayed this striking portrait in its original maple frame over a bed in Gallery III of the MFPA (fig. 12).[1] While they knew neither its sitter nor its maker, they regarded it highly as evident in its reproduction in the 1935 MFPA guide (see p. 365). The name of the portraitists can now be suggested: Dr. Samuel Shute and/or his wife Ruth.[2] The Shutes usually worked collaboratively, and although the great majority of their portraits are unsigned, some are inscribed on the reverse: "Painted by R.W. Shute and S.A. Shute." Their individual contributions in their collaborations are more specifically documented on a few watercolors: "Drawn by R.W. Shute / and / Painted by S.A.

Shute." Nevertheless, their oeuvre calls for further study to establish a chronology and core groups of works.

It was the pioneering Edith Halpert (see Hofer essay, p. 70), one of the dealers associated with the Nadelmans, who first noticed in 1937 that a group of similar portraits were signed with two sets of initials. Although she hypothesized they might represent brothers, subsequent scholarship has established them as belonging to the prolific and enterprising Shutes who were married in Somersworth, New Hampshire, on October 16, 1827. After his marriage, Dr. Shute shifted away from medicine and joined his wife in an artistic partnership that took

them to the towns and small cities of northern New England and New York State as itinerant portrait painters.[3] Their efforts met with considerable success until Samuel's untimely death at age forty-two. He probably suffered a lingering illness, because by September of 1833 Ruth alone signed the paintings and a newspaper solicitation for portrait commissions mentions her name only. For four more years, Ruth, who may have been the stronger creative force, continued to travel and paint. Then, in 1840, she remarried and moved to Lexington, Kentucky. Her later portraits reveal that she experimented with different styles, but this too needs study.

Among the most numerous of the Shutes' clients were young women who had recently left their family farms to work in the mills of prosperous river towns in Massachusetts and New Hampshire. The jewelry worn by the sitter in the Nadelman portrait—an elegant parure of bicolor gold earrings and a brooch— suggests, however, that she was the spouse of a man of means.[4] From her fashionable finery and hairstyle, this portrait can be dated around 1830–33, when large tortoiseshell combs, whose mottled pattern the artist rendered with a technique reminiscent of sponge painting, seem to have been popular with the Shutes' clientele.[5] With graphite the artist gave vitality to the painterly fringe and latticework of the sitter's flower-embroidered fichu, an accessory characteristic of a more mature woman. It is tucked into a floral-decorated belt whose gold-toned, embellished buckle has a raised pattern in gold foil to underline the sitter's status. The non-traditional material demonstrates that the Shutes, as so often the case with artists lacking formal training, experimented with a diverse and unorthodox mixture of media.

The bold design and linear abstraction of this portrait foreshadow early twentieth-century taste. Like other portraits by the couple or Ruth Shute working alone, its exaggerated stylistic conventions—among them huge shoulders and a wasp waist—add to the compelling likeness. It is telling that the Nadelmans hung another unattributed and unidentified female portrait, in watercolor and pastel, in the same gallery of the MFPA (fig. 95), which is primarily if not entirely the work of Ruth Shute.[6]

RJMO

1 Heretofore, the painting has been reproduced as by an unidentified artist, for example, Lipman 1942 (1972 ed.), pl. 19. An old label on the stretcher records it with the dealer Philip Suval, 823 Madison Avenue (between Sixty-eighth and Sixty-ninth streets), summer shop, Southampton.

2 See Helen Kellogg, "Found: Two Lost American Painters," *Antiques World* 1:2 (December 1978): 36–47; idem, "Ruth W. and Samuel A. Shute," in *American Folk Painters of Three Centuries*, exh. cat., ed. Jean Lipman and Tom Armstrong (New York: Hudson Hills in association with the Whitney Museum of American Art, 1980), 165–70; Hollander 2001, 387–91, pls. 20–26.

3 An advertisement they placed in the *New Hampshire Argus and Spectator* (April 15, 1833) shows one method of attracting clients: "PORTRAIT / PAINTING! / MR. AND MRS. SHUTE / Would inform the Ladies and Gentlemen of Newport, N.H. that they / have taken a room at Nettleton's Hotel, where they will remain for a short / time. / All who may employ them may rest assured that a correct likeness of / the original will be obtained. If not the work may remain on our hands. / Prices will be regulated, according to the size of the portrait. / CALL AND EXAMINE THE PAINTINGS / Price from 5 to 10 dollars. / April 15, 1833." Hollander 2001, 387.

4 There is another portrait of a woman, measuring around 30 × 20 inches, with a similar costume and nearly identical earrings and pin in a private collection; Patrick Bell, e-mail to Roberta J.M. Olson, January 3, 2014.

5 See Kellogg, "Found," 41, 43, 44, ills.; idem, "Ruth W. and Samuel A. Shute," 164, 167, 168, 169, ills.; Hollander 2001, 52, 55, 389, 391.

6 MFPA 1254; N-YHS 1937.450; see Kellogg, "Found," 36, ill., 43, no. 51. It was purchased for $200 from Dudensing in New York City in January 1925 and was also hung in the hall at the Nadelman townhouse on East Ninety-third Street.

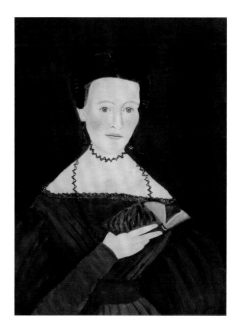

Fig. 95. Ruth Whittier Shute and possibly Dr. Samuel Addison Shute, *Portrait of a Woman*, ca. 1830–33. Watercolor, graphite, pastel, and black ink on paper, laid on board; 28⅛ × 20⅞ in. (71.4 × 53 cm). N-YHS, 1937.450

19

Joseph Whiting Stock (American, 1815–1855)
Willard T. Sears (1837–1920) with a Horse Pull Toy, ca. 1843
Oil on canvas; 50½ × 40 in. (128.5 × 101.5 cm)
Provenance: New Bedford, MA, before 1920[1];
Charles Woolsey Lyon, New York City, 1920–21
1937.452*

With their purchase of this portrait in 1921, the Nadelmans entered into the vanguard of the growing taste for folk art.[2] The portrait is cited in the MFPA cards (1566 crossed out) without an artist's name as "Very large painting of boy . . . holding a black hobby horse." According to an inscription on its stretcher, this portrait was hung in Gallery III of the MFPA.[3] Nearly two decades later Joseph Whiting Stock became one of the first popular folk portraitists, resulting in the 1939 show devoted exclusively to nine works by him at the Morton Galleries (New York City). It followed on the heels of two seminal folk art exhibitions in 1932 that had included paintings by Stock: at the Downtown Gallery and the Museum of Modern Art.[4]

Although Stock's short life was plagued with illness and adversity, he managed to sustain a successful career as a portraitist in New England and New York State during the 1840s and 1850s. Remarkably, he is one of the most thoroughly documented folk painters, with his activities known through advertisements, a will with the appraisers' inventory of his possessions (including books on art and phrenology, as well as periodicals), and his seventy-three-page journal, which covers the first fourteen years of his career as a prolific, sometimes itinerant, artist. His journal cites around 923 works painted between 1832 and 1846, with an additional eighty-five to ninety-five works listed among his effects.[5]

After an accident with an oxcart left him paralyzed below the waist from age eleven, Stock spent his adolescence as an invalid. Although he was primarily an autodidact, he studied painting briefly with Franklin White, a pupil of Chester Harding. In 1835 Dr. James Swan designed a customized wheelchair that enabled him to sit upright, allowing him to establish a studio in his native Springfield, Massachusetts. His portraits of children, which are generally his most developed and sensitive, often include toys that he made as studio props. Perhaps the pull toy in the Nadelman portrait was one of them; it resembles the elephant pull toy noted in the inventory of the Museum of Folk and Peasant Art (fig. 96).

Not limiting himself to portraits of the living and dead, Stock also painted Fancy pieces, landscapes, transparent window shades, copies, and miniatures, as well as creating shell work and anatomical illustrations, cleaning and varnishing canvases, and selling artists' supplies. When Samuel F.B. Morse introduced the daguerreotype to America in 1839, in direct competition with folk portraitists, Stock and his brother set up a short-lived partnership in portraits and daguerreotypes.

Less than one-tenth of the portraits Stock catalogued in his journal have been identified and very few of those listed are as large as the Nadelman portrait. In fact, the artist only listed two with the dimensions 50 × 40 inches that depict young boys, both six years old: (1) Willard T. Sears of New Bedford (1842–43), together with smaller portraits of his four older sisters (each 30 × 25 inches) for the price of $55;[6] and (2) Henry D. Whitcomb of Providence (1843) for $7, a lesser sum possibly because he was a cousin of the painter.[7] The Nadelman portrait's provenance from New Bedford proves the Sears identity. Mr. and Mrs. Willard Sears, who also commissioned Stock to paint their portraits in a 30 × 25 format at a cost of $12 each, probably requested the larger format for their heir apparent for dynastic reasons.[8] Buttressing the tentative identification of the Nadelman portrait as depicting the younger Willard Sears is a dated entry in Stock's journal (May 30, 1843), where he corrects the age of Willard T. (born November 5, 1837) to five years: "[O]ne job for Willard Sears, of 5 portraits—his children—begun the boy about five years old full statue."[9] The portrait's iconography also supports this identification.

In this likeness Stock, whose talent lay in his fine decorative sense, has portrayed a serious young man who holds the reins of his wooden horse pull toy in his left hand, while he seems to rest his right affectionately around the animal's neck but wields a whip. Underlying this deceptively childlike image is a tradition of equestrian portraits, some of children, whose theme concerns latent control and mastery—emblematic of success,

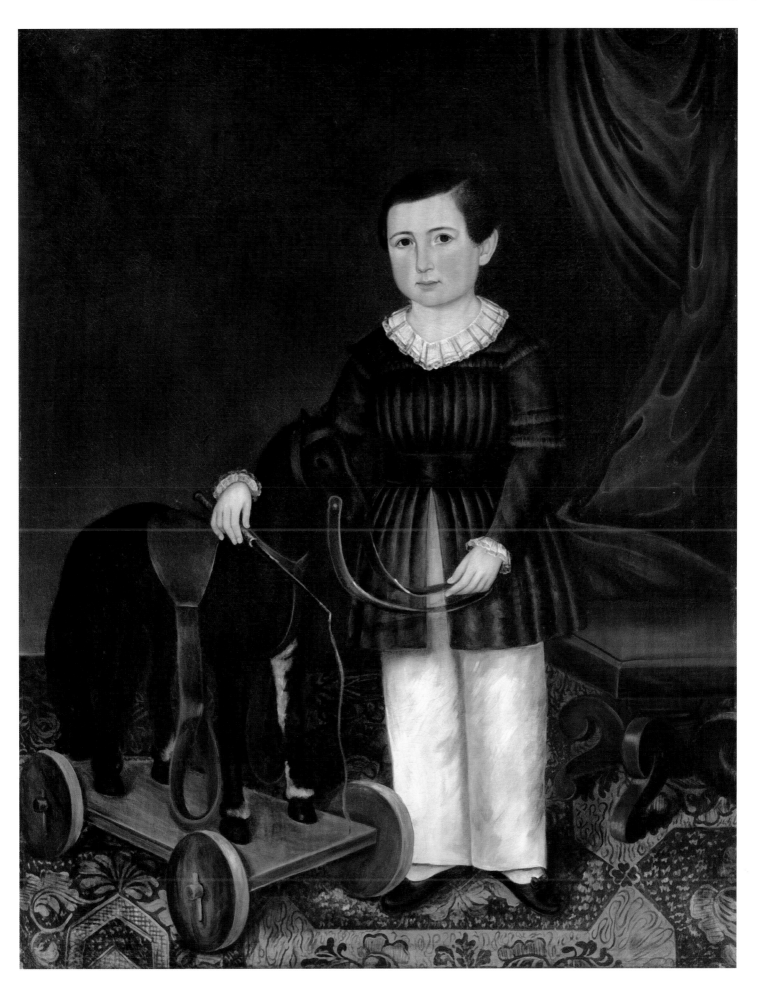

Fig. 96. Unidentified American maker, Elephant pull toy, 1830–80. Wood, paint, oilcloth; 17¾ × 24 × 10¼ in. (45.1 × 61 × 26 cm), N-YHS, 1937.486

power, and freedom. This youth's pose also contains distant echoes of the horse tamers of ancient art (see fig. 66) and the conventional symbolism of formal portraiture, such as the elegant red drapery. Stock's representation clearly embodies the wishful thinking of the sitter's parents and the dictum that "it becometh a prince best of any man to be a fair and good horseman."[10] Sears, who owned a tannery and was a prominent New Bedford businessman, had grand plans for his son's future, hoping that he would grasp the "reins of power" of his family. Willard T. Sears became a prominent New England architect, however, who worked primarily in the Gothic Revival and Renaissance Revival styles, designing among other buildings, Fenway Court, the home of Isabella Stewart Gardner (later the Gardner Museum), and with Charles Amos Cummings, the Stone Chapel of Phillips Academy in Andover and the Old South Church on Copley Square in Boston.
RJMO

1 Charles Woolsey Lyon to Elie Nadelman, February 18, 1921, NP.

2 The Nadelmans' portrait has been published many times, including in Lipman 1942 (1972 ed.), pl. 11; Juliette Tomlinson, ed., *The Paintings and the Journal of Joseph Whiting Stock* (Middletown, CT: Wesleyan University Press, 1976), 72, pl. II: 12; *Joseph Whiting Stock, 1815–1855*, exh. cat. (Northampton, MA: Smith College Museum of Art, 1977), 34, 56, fig. 30.

3 The verso of the canvas is inscribed at the upper left in black paint: "RESTORED / BY / PAULINE M. COLYAR / 1908 / NEW BEDFORD." Colyar was also a painter.

4 *Joseph Whiting Stock*, exh. cat., 3.

5 Ibid. Stock's journal—a combination diary and account book (based on ledgers)—is now in the collection of the Connecticut Valley Historical Museum, Springfield, MA.

6 Tomlinson, *The Paintings . . . Stock*, 38, cites p. 57 of Stock's journal. Misreading the document, she thought that $55 was the price for the portrait of the boy, when instead it was the amount for the five portraits, and speculated erroneously that the high price was charged for repainting it (ibid., xiv).

7 Ibid., 40, cites p. 59 of Stock's journal.

8 The closest dimensions of portraits of boys of four and five years measure 50 × 38 inches and 48 × 38 inches. See ibid., 28, 38, although Stock does not always give the ages of his sitters.

9 Ibid., 35, citing p. 51 of Stock's journal, which also notes that he finished all the Sears portraits on July 22, 1843 (ibid., 37, citing p. 54 of Stock's journal).

10 James I of England, when he was James VI of Scotland, to his eldest son and heir apparent in the essay "On the Education of a Prince," in *Basilikon Doron or His Majesties Instrvctions To His Dearest Sonne, Henry the Prince* (Edinburgh, 1599); see Charles Howard McIlwain, ed., *Political Works of James I* (Cambridge, MA: Harvard University Press, 1918), 3–52.

20

Joseph H. Davis (American, 1811–1865)
James (1777–1852) and Sarah Clark Tuttle (1779–1840), 1836
Gouache, watercolor, graphite, and black ink with selective glazing on ivory paper; 9¾ × 14¾ in. (24.7 × 37.4 cm), irregular
1937.1715

According to the MFPA inventory, the Nadelmans exhibited three portraits of Tuttle family members in Gallery III. Today all three of these watercolors by Joseph H. Davis are in the New-York Historical Society. In addition to this double portrait of James and Sarah Clark Tuttle, who were married on June 30, 1799, there is a pair of full-length profile portrayals of daughters Esther (1815–1892) and Betsy (1817–1905), two of their twelve children.[1]

Joseph H. Davis was an itinerant portraitist who worked in rural New Hampshire and Maine between 1832 and 1837. He painted over 150 likenesses in his distinctively vivid style and signed a few "Joseph Davis / Left Hand Painter." He may have also been the legendary "Pine Hill Joe" of Newfield, Maine, a farmer who earned $1.50 per portrait. Davis specialized in portraying upstanding New Englanders and their families in domestic settings whose decoration is delightfully unrestrained. His formulaic compositions, which are indebted to silhouettes, usually feature single standing sitters or seated groups in profile, but Davis is best known for his portraits of married couples. His sitters dress in their most fashionable finery, surrounded by colorful furnishings in the exuberant Fancy style of the early nineteenth century. The style is exhilarating in its ornamental patterns and indicative of his sitters' status. Among his favorite motifs are boldly patterned, kaleidoscopic floor cloths or carpets. The Fancy-style chairs seem to be the artist's own design, albeit in the classical *klismos* shape, while other decorative accessories, which are frequently symbolic, derive from the standard vocabulary of mid-century drawing books, English prints, textiles, and wallpapers. Davis laid in his charming compositions with graphite, adding bold areas of color in watercolor and gouache, enhanced by black ink outlines. Rather than modeling his sitters' faces, he identified them, together with their ages and dates, in his ingenious, decorative calligraphy, usually in a border at the bottom of the sheet, as here.[2]

Davis executed this iconic portrait of the Tuttles seated in their parlor on January 25, 1836, in Strafford, New Hampshire.[3] Little is known about their lives, although town records of 1823–24 report that Tuttle was voted Surveyor of Lumber for both years. Among other documents is a deed (1833) noting a grant to him for the land on which he lived, in addition to an ironworks, tools, and a saw. Another deed of the same year records Tuttle's part-interest in a sawmill erected on the property.[4] This enterprise led to the family's prosperity, which Davis commemorated in the customized picture hung above the table and draped with celebratory swags.

Davis's portrayal provides additional information about the Tuttles, although many elements in his composition are generic.[5] While a central pet cat or dog was nearly *de rigueur* in his groups,[6] the Tuttles' feline functions not only as domestic filler but also completes the family unit in a household suffering from empty nest syndrome. The couple faces each other, heraldically flanking the trompe-l'oeil grained table on which rest a top hat and bowl of fruit, both of which underline the themes of material prosperity and abundance. The elaborate interior appointments contrast with the dignified expressions and stiff poses of the sitters. Tuttle points to an open Holy Bible, while his wife holds a small book (probably for devotions) to stress their piety and literacy for all posterity.
RJMO

1 N-YHS 1937.1717 and 1937.1716; see Koke
 1982, 1: 260–61, ills., who notes that the Tuttles
 had thirteen children, although current ancestry
 sources list twelve. For the three watercolors, see
 also Gail and Norbert H. Savage and Esther Sparks,
 Three New England Watercolor Painters, exh. cat.
 (Chicago: Art Institute of Chicago, 1974), 63.
 The inscribed dates on the portraits of the two
 daughters indicate that Davis executed them on the
 same visit.

2 For the artist, see Savage, Savage, and Sparks, *Three
 New England Watercolor Painters*, 22–41, 62–65;
 Beatrix T. Rumford, ed., *American Folk Portraits:
 Paintings and Drawings from the Abby Aldrich*

Rockefeller Folk Art Center (Boston: New York
Graphic Society in association with The Colonial
Williamsburg Foundation, 1981), 83–87; Arthur B.
Kern and Sybil B. Kern, "Joseph H. Davis: Identity
Established," *Clarion* 14:3 (Summer 1989): 45–52.

3 It is inscribed at lower left in black ink: "James
 Tuttle. Aged 58. September 15th 1835"; at lower
 center: "Painted AT Strafford / Jany 25th. 1836.";
 at lower right: "Sarah Tuttle. Aged 56. Octbr. 25.
 1835." It is reproduced in Frank O. Spinney, "Joseph
 H. Davis, New Hampshire Artist of the 1830's," *The
 Magazine Antiques* 44:4 (October 1943): 177–80,
 fig. 3; Black and Lipman 1966, 102, fig. 114; Koke
 1982, 1: 259–60; *Geriatric Nursing: American*

Journal of Care for the Aging 6:1 (1985): cover;
Olson 2008, 240–41.

4 Koke 1982, 1: 261.

5 For example, Davis also represented a similar hat, a
 Holy Bible pointed out by the male, a swag around a
 painting over the central table, a still life of fruit, and
 a bold floor cloth in a portrait of John and Abigail
 Montgomery (1836) in the National Gallery of Art,
 Washington, DC, 1967.20.8; Savage, Savage, and
 Sparks, *Three New England Painters*, 30, no. 14, ill.

6 Rumford, *American Folk Portraits*, 85, no. 54, ill.,
 reproduces a similar composition used by Davis
 for a portrait of the Tilton family in the AARFAM,
 36.300.6.

21

James Sutes? (American, active mid-nineteenth century)
Calligraphic Horse, ca. 1850
Brown and black ink and watercolor on paper;
18¼ × 17⅞ in. (46.5 × 45.5 cm)
Provenance: Renwick Hurry, New York City, 1924
1937.1723*

A young male student performed this charming calligraphic exercise to demonstrate proficiency in pen work.[1] The word *calligraphy* derives from a Greek word meaning "beautiful writing." During the nineteenth century schoolchildren executed penmanship exercises, Fancy pieces, and theorem still-life paintings routinely as part of their education. Many were no doubt given to proud parents as evidence of classroom achievements. Student art was readily inspired by prints in magazines, illustrated Bibles or popular novels. Girls cleverly utilized elements from these same sources in their fancy pieces and mourning pictures, while schoolboys appropriated some of the motifs in their copies with steel pens from penmanship sample books or teachers' models. More than one version of the same composition frequently exists, usually with variations. Animals were customary subjects, as children found them appealing. Horses, leaping deer, and patriotic eagles are among the most common, because the natural curves of these animals' bodies suited the repetitive, rhythmic flourishes necessary to developing a confident calligraphic style.

Both students and their instructors often produced works of exceptional quality, but most lack any history save what their inscriptions record. Teachers exerted control over the type of work that was created and prepared exemplars to copy. In cases where the work is excellent, it can be difficult to ascertain whether it was a teacher's model or a superior student copy. According to its inscription (*Drawn by James T Sutes* [?] *under the tuition of JG Trego*), the Nadelman sheet is definitely the work of a male student, whose surname is only partially legible and thus can only be identified tentatively as James T. Sutes [?].[2] The name of his calligraphy instructor is more clearly written.[3]

The Nadelman example contains conventions typical of decorative calligraphic horses drawn at mid-century, such as the animal's less linear mane and tail simulating the texture of the horsehair. Its young draftsman also used the customary stylized

parallel flourishes within the horse's body, perhaps to indicate a dappled coat but surely to suggest volume. Each of these exercises also contains highly individualized traits that customize it, for example, the more animated and interconnected lines in the Nadelman sheet that vary in width. Its horse, ready for its rider to mount, wears proper tack—bridle, martingale, saddle blanket, and saddle with dropped stirrups—instead of the more customary stylized and abbreviated trappings. Moreover, Sutes's painterly ground, consisting of brush-applied layers of black and green for soil and grass, adds a realistic touch to his image as opposed to the more common practice of filling the paper's margins around the horse with additional calligraphic flourishes.

At least three very similar sheets depicting calligraphic horses, two with the caparisoned horse walking left with its head facing right, as well as a fourth, more distant variation, prove that young Sutes and his peers drew after a readily available model whose source has not been identified.[4] The evidence underlines the popularity of this equine composition for young male students and suggests there may have been two models in circulation: one for right-handed calligraphers, and another for left-handed ones, both of which were modified as they were circulated.

Its MFPA card identifies the work as a "Picture of Horse, Factor piece" which the Nadelmans purchased for $1.00 from Renwick Hurry on March 25, 1924.[5] The brief comments also mention the black and red colors of the equestrian composition, which no doubt had attracted them, together with its vernacular origin.

RJMO

1 For the variety of these exercises, see Rumford 1988, 346–57. See also Alvin R. Dunton, *The Original Duntonian System of Rapid Writing* (Boston: Lee & Shepard; New York: Lee, Shepard & Dillingham, 1873); Bruce A. Johnson, *Calligraphy: "Why Not Learn to Write,"* exh. cat. (New York: Museum of American Folk Art, 1975).

2 Koke 1982, 3: 362, 363, ill., transcribes the

surname as *Jules*. Rumford 1988, 355–56,
transcribes the inscription as "Drawn by James G.
Sales under the tuition of J.G. Gray."

3 A William T. Trego, who exhibited at the 1893
World's Columbian Exposition in Chicago, was
taught by his father, Jonathan K. Trego of Bucks
County and Philadelphia; see Carolyn Kinder Carr
and George Gurney, *Revisiting the White City:*

American Art at the 1893 World's Fair, exh. cat.
(Washington, DC: National Museum of American
Art and National Portrait Gallery, Smithsonian
Institution, 1993), 327. Perhaps this Jonathan
Trego or a relative may have instructed our young
calligrapher, and the middle initial is a mistake.

4 AARFAM, 31.312.1 (the most like N-YHS
1937.1723 in the pose of the horse and treatment

of the ground) and 64.312.3 (Rumford 1988,
355–56, 348, ills.); collection of Joseph and Janet
Wolyniec (Johnson, *Calligraphy*, 17, no. 182);
Museum of Fine Arts, Boston, 56.416 (Rossiter
1962, 2: 310–11, ill.). For a more extensive
discussion of their relationship, see Olson 2008,
345–47, ill.

5 MFPA 49, purchased March 25, 1924.

22

Henry Young (American, 1792–1861)

Betrothal Celebration of Miss Frances Taylor and Her Fiancé, 1831
Watercolor and black ink with areas of glaze on beige paper; 12 × 7⅞ in. (30.5 × 20 cm), irregular
1937.1721

Celebrating Couple: General Jackson and his Lady, ca. 1831
Watercolor and black ink on brown paper; 10³⁄₁₆ × 7⁹⁄₁₆ in. (25.9 × 19.2 cm)
Provenance: Nadelman Collection; Maxim Karolik, 1948
Museum of Fine Arts, Boston, Karolik Collection, 56.751

It is understandable why the works of the parochial schoolteacher Henry Young would have appealed to the Nadelmans. An untrained artist who emigrated from Saxony and settled in Union County, Pennsylvania in 1817, Young created drawings to supplement his teaching income from about 1823 until his death. He specialized in certificates of birth, baptism, and marriage executed in the fraktur tradition and formulaic scenes of celebration, among them courtship, a frequently revisited theme in folk art.[1] Young never painted the actual likenesses of his subjects, but rather produced generic characters that he identified in inscriptions.[2]

The Nadelmans owned at least two of the many versions of the scene Young delineated, like a theme with variations, usually to celebrate a betrothal or the birth of a child. The prominent inscription at the upper center in brown ink on the left sheet identifies the occasion (although the word "betrothal" has been omitted) and its date: "Miss Frances Taylor's / Picture Bought / A.D. 1831." Similar watercolors by Young suggest that this composition was a stock item in his repertoire that he inscribed according to a patron's request.[3] Young's nearly identical domestic toasting ceremony, formerly in the Nadelman collection, has an unusual twist since its commemorative inscription witnesses the popularity of Andrew Jackson, who with his wife may be interpreted as toasting the nation.[4] This version may have been purchased from the artist during Jackson's unsuccessful first run for president in 1825 or, more likely, during his two-term presidency (1829–37). Its inscription elevates Young's formulaic composition from a provincial theme to the arena of national politics.

While not a fraktur per se, the Nadelmans' charming sheet on the left records a formal engagement, a significant family event, for posterity. In the spirit of the fraktur tradition, the artist makes effective use of color and pattern to display his sense of design (see cats. 23, 24). In this frequently reproduced work, Miss Frances Taylor, attired in a flower-patterned muslin dress with lace trim, is toasted by an unidentified gentleman, presumably her fiancé.[5] Like many of Young's celebratory scenes, this one features not only a pair of eight-pointed stars or radial motifs, suggesting celestially destined lovers, but also a tripod table holding a decanter with red wine, and a tiny, stylized plant at the lower right that functions as the artist's hallmark. RJMO

1 See E. Bryding Adams, "The Fraktur Artist Henry Young," *Quarterly of the Pennsylvania German Society: Der Reggeboge* 11:3–4 (Fall 1977): 1–24, notes that the artist produced thirteen types of illustrations; cat. 22 belongs to "Man and Woman with Wineglass"; Earnest and Earnest 1997, 2: 826–34, lists 22 examples of the type.
2 See Mary Black and Jean Lipman, *American Folk Painting* (New York: Clarkson N. Potter, 1966), 193, fig. 180; Weiser and Heaney 1976, 1: figs. 48–49; 2: figs. 388, 390, Index (n.p.); Lipman, Warren, and Bishop 1986, 132, 136, fig. 8.8; Olson 2008, 169–71.
3 For example, see Weiser and Heaney 1976, 1: fig. 49; 2: fig. 388. A few watercolors lacking inscriptions suggest that the artist drew his watercolors beforehand and completed the identifications when he received a commission; Lipman, Warren, and Bishop 1986, 132.
4 It is inscribed at the upper center in brown ink: "Generall Jackson and his / Lady." Rossiter 1962, 2: 281, no. 1341, fig. 360; Black and Lipman 1966, 161, fig. 152; Stillinger 1994, 522, pl. VIII.
5 Lipman 1942, pl. 32; Black and Lipman, *American Folk Painting*, 201, fig. 180; Lipman, Warren, and Bishop 1986, fig. 8.8; Olson 2008, 170, ill.

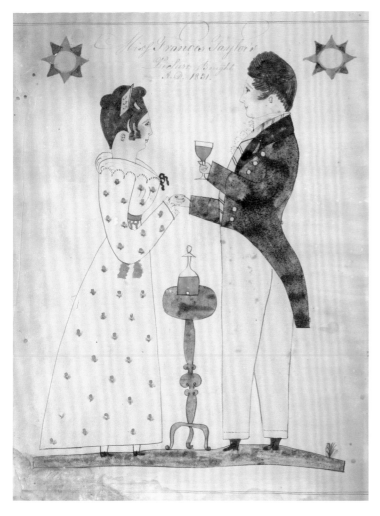

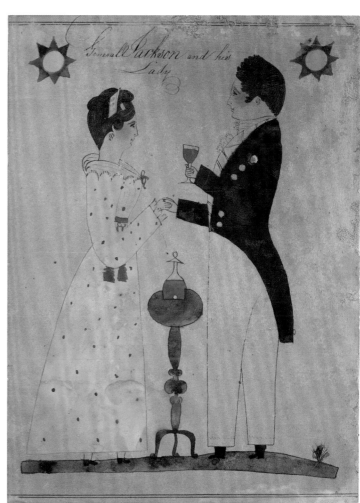

23

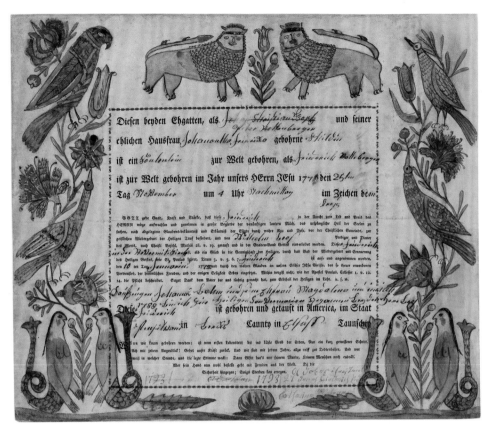

23a

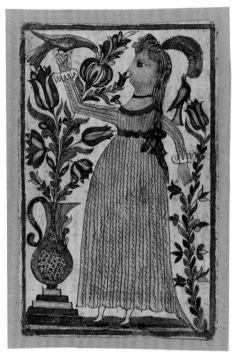

23b

23a

[Georg] Friederich Speyer (American, active ca. 1774–1801)

Birth and baptism certificate of Friederich Rottenberger of Berks County, PA, 1788

Watercolor and brown ink on printed paper; 13⁹/₁₆ × 16³/₁₆ in. (34.5 × 41 cm)

Provenance: Nadelman Collection; Maxim Karolik, 1948

Museum of Fine Arts, Boston, Karolik Collection 56.769

23b

Unidentified American fraktur artist

Girl in Yellow Dress, nineteenth century

Watercolor and brown ink on paper; 5⅝ × 3⅝ in. (14.5 × 9 cm)

Provenance: Nadelman Collection; Maxim Karolik, 1948

Museum of Fine Arts, Boston, Karolik Collection 56.747

23c

Unidentified American fraktur artist

Marriage certificate of Johannes Lein and Margretha Leinin, ca. 1800

Brown ink, watercolor, gouache, and graphite on cut paper; laid on paper; 15⅞ × 12⅝ in. (40.5 × 32 cm)

Provenance: Anthony Wayne Shop, 1925

1937.1724*

23d

Unidentified American fraktur artist

The First of May (Den Ersten Maÿ), 1822

Watercolor, black ink, and collage on paper; 6⅛ × 6⅛ in. (15.5 × 15.5 cm)

Provenance: Nadelman Collection; Maxim Karolik, 1948

Museum of Fine Arts, Boston, Karolik Collection 56.758

23e

Unidentified American fraktur artist

Birds Perched on Fruit-bearing Plants with Crown; birth and baptism record of Maria Catharine Ziegenfus, ca. 1855

Gouache over graphite with glazing on paper; 9¼ × 7½ in. (23.5 × 19 cm)

1937.1806

"Fraktur" refers both to a style of angular lettering related to a sixteenth-century typeface, that became associated with penmanship, and a category of elaborate illuminated folk art created by Pennsylvania Germans. Of the many varieties of American fraktur produced largely between 1740 and 1860, the most common were birth and baptismal certificates (*Geburts- und Taufscheine* or simply *Taufscheine*). Most were drawn by ministers or schoolmasters, who had the education and materials needed to produce them. While some were hand-lettered and colored, printed examples with customized lettering by scriveners became increasingly popular as the nineteenth century went on (cat. 24). Fraktur, which might include texts in German, English, or both languages, recorded an individual's rites of passage, his or her family, community, and faith. They were personal keepsakes treasured by the Pennsylvania Germans. Fraktur decorative forms also relate to furniture and other objects produced by these societies.[1]

The Pennsylvania-German fraktur evolved from old German laws requiring formal certificates of birth, baptism, and marriage to be registered with the state. The beautifully

23c

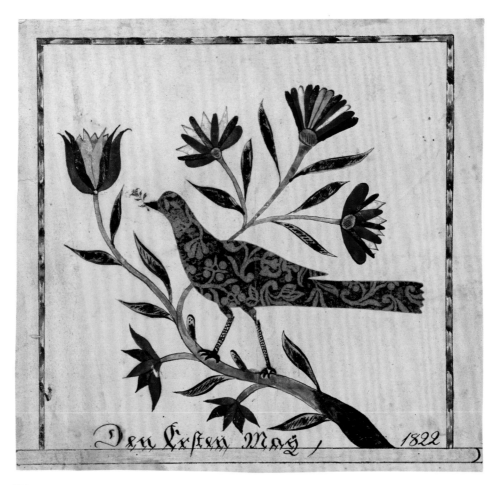

23d

inscribed and embellished certificates became symbols of social status for German-speaking families, including those who continued the tradition in America where they were no longer mandated by law.[2] "Pennsylvania-German" is the correct term for German-speaking Protestants who emigrated to America beginning in 1683. They were colloquially referred to as the "Pennsylvania-Dutch," a corruption of the word "Deutsch," meaning German. Fraktur have connections with other European peasant practices; for example, in eastern France and some Swiss cantons, baptismal sponsors or godparents gave the child a medal or coin wrapped in a greeting called a *goetteilbriefe*.[3]

Hand-drawn fraktur embellished with watercolor are found in a variety of forms: writing samples (*Vorschriften*); birth and baptismal certificates (*Taufscheine*); marriage and house blessings; book plates, songbooks and hymnals; and floral and figurative scenes.

Common artistic motifs include birds, hearts, and tulips and other flowers, as well as calligraphy. The popular birth and baptismal records name the parents, the place of baptism, the clergyman, the sponsors, and sometimes the sign of the zodiac for the day. (German settlers in Pennsylvania used a lunar zodiac that changed signs almost daily.) In most fraktur secular and religious images are combined in an eclectic manner that enshrines piety, in addition to a love of color, symmetry, and whimsical design. Most were stored away and few were displayed, ensuring that many survive, despite vermin, fire, disintegration, and the widespread tradition of burying them with their owner.

The Nadelmans acquired both hand-drawn and printed examples of fraktur.[4] Judging by advertisements in *The Magazine Antiques*, fraktur had already become collectible by 1925. In 1948 Viola Nadelman sold a group of forty-one, both watercolors and prints, to

the art collector Maxim Karolik, whose wife, Martha Codman, had died in April of that year.[5] Using Mrs. Karolik's wealth, the couple had amassed a trilogy of collections, the third of which was mostly of works on paper, including fraktur. Mr. Karolik later donated these collections to the Museum of Fine Arts, Boston.[6] It has been said that: "the greatest strength of this last collection is its folk art" and that "Karolik had become entranced by the expressive power of these pictures and eagerly bought up works on paper that fell outside the mainstream . . . [like] frakturs."[7] In his insistence that the distinction between folk and academic art was artificial, Karolik was ahead of his time.

Three works from the Karolik group that were not part of the MFPA nucleus are featured with the watercolors in this sampling of fraktur. The earliest is a *Taufschein* of 1771 by Friederich Speyer, who worked in Lancaster, Dauphin, and Berks counties in Pennsylvania

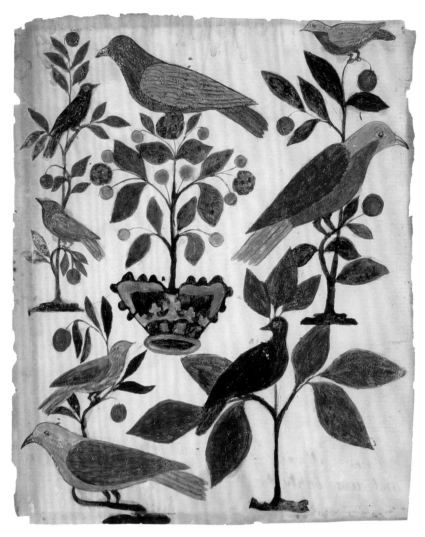

23e

and sometimes depicted mermaids in his borders.[8] One of two examples by Speyer in the Karolik Collection, both are a hybrid mode of fraktur because they incorporate printed sections in a primarily hand-drawn work.[9] Two entirely hand-drawn fraktur from the Karolik trove may have been presentation drawings; they are: *Girl in Yellow Dress*, which may have been a bookplate,[10] and *The First of May*, celebrating spring, which preserves an early example of collage.[11] Its maker cut the dove from printed paper and pasted it onto the support, a collage technique that the Cubists claimed they invented in the years when Nadelman was in Paris. Another hand-drawn work the Karoliks acquired with a Nadelman provenance—the stylized *Pelican Feeding Her Young*, symbolic of the Passion of Christ and the Eucharist—may have been a bookmark (fig. 97).[12]

One of the fraktur that entered the N-YHS collection from the MFPA features seven birds perched on fruit-bearing trees (cat. 23e). It may have been intended as a presentation drawing, but it functions as a birth and baptism record, because its verso is inscribed in brown ink: "Maria Catharine Ziegenfus was born August 31st 1855 / and was baptized November 11th 1855 by Reverend Rath." Its unfinished state raises the spectre that the babe may have died in infancy. Although this example appears to be secular, it contains Christian symbolism that was palatable to Protestants. The crown to the left of center alludes to the Christian crown of life, from which sprouts the tree of life laden with the fruits of Paradise. They are feasted on by birds, emblematic of souls.

Another fraktur from the MFPA in the N-YHS is the highly intricate example commemorating the union of Johannes Lein and Margretha Leinin on September 27, 1776 (cat. 23c). Though its iron gall ink has damaged the delicately drawn and cut-out work, the Nadelmans paid the high price of $35 for it.[13] Its composition pivots around circular forms—symbolic of Heaven and suggestive of eternity—and, appropriately, hearts. It also includes more overt religious symbolism, such as the four seraphim or cherubim at its four corners, which underline divine approval of the earthly marriage.[14] Its intricate inscriptions also testify to the importance of this occasion.[15] Among other things, they admonish the couple to be faithful to each other and to "let the mouth and the heart be one and the same." Others invoke correct conduct and warn about falling from the true path (Matthew 3:10): "The ax is already at the root of the trees."
RJMO

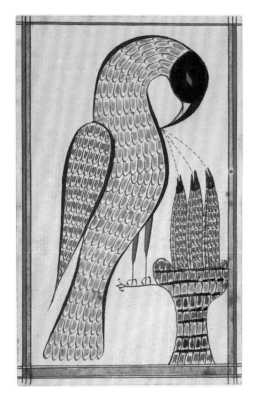

Fig. 97. Unidentified American fraktur artist, *Pelican Feeding Her Young*, nineteenth century. Watercolor and brown ink on paper; 4⅝ × 2¹⁵⁄₁₆ in. (12 × 7.5 cm). Karolik Collection, Museum of Fine Arts, Boston, 56.760

1 See Lisa Minardi, "From Millbach to Mahantongo: Fraktur and Furniture of the Pennsylvania Germans," in *American Furniture 2011*, ed. Luke Beckerdite (Hanover, NH: Chipstone Foundation distributed by University Press of New England, 2012), 3–119.

2 See Henry S. Bornemen, *Pennsylvania German Illuminated Manuscripts: A Classification of Fraktur-Schriften and an Inquiry into Their History and Art* (Norristown, PA: Pennsylvania German Society, 1937); Donald A. Shelley, "Illuminated Birth Certificates: Regional Examples of an Early American Folk Art," *N-YHS Quarterly* 29:2 (April 1945): 93–104; idem, *The Pennsylvania German Style of Illumination* (Allentown, PA: Pennsylvania German Folklore Society, 1961); Lipman, Warren, and Bishop 1986, 138–45; Frederick S. Weiser, "Fraktur," in Wertkin 2004, 171–73.

3 Cuisenier 1977, 40.

4 Thirteen MFPA cards refer to fraktur, but they are not comprehensive and some reveal a confusion between drawn and printed examples. The N-YHS holds twenty-two hand-drawn and forty-two printed fraktur with a Nadelman provenance.

5 Stillinger 2011, 189. For the Karoliks, see also pp. 344–51. It seems that Lincoln Kirstein may have been involved as a broker in the sale of fraktur; see Lincoln Kirstein Papers, Jerome Robbins Dance Division, New York Library for the Performing Arts, Nadelman Files, folder 259. Letter from Karolik to Kirstein, September 30, 1948: "Please tell Mrs. Nadelman that, as a collector, I will treat her fairly and gently. . . . We already have six Pennsylvania Dutch watercolors and drawings of fine quality. Mr agrees with me that it would be desirable to make a comprehensive and representative group. . . ."

6 Carol Troyen, "The Incomparable Max: Maxim Karolik and the Taste for American Art," *American Art* 7:3 (Summer 1993): 64–87. See also Rossiter 1962.

7 Troyen, "The Incomparable Max," 81. For Karolik's own spin on this collection, see Maxim Karolik, "Summarizing the Trilogy," in Rossiter 1962, 1: 15.

8 Rossiter 1962, 2: 295, no. 1358; for Speyer, see Earnest and Earnest 1997, 2: 722–25.

9 The other is the Birth and Baptism Certificate of Johannes Seybert, 1770, Karolik Collection, Museum of Fine Arts, Boston, 56.770; Rossiter 1962, 2: 291, no. 1357.

10 Ibid., 257, no. 1313.

11 Ibid., 265, no. 1325, notes that Friedrich von Hagedorn wrote the German inscription.

12 Rossiter 1962, 2: 257, no. 1317; for variants, see Weiser and Heaney 1976, 1: nos. 149–50.

13 MFPA 1271; purchased in April.

14 For the symbolism of the heavenly circle in the earthly square/rectangle, see Roberta J.M. Olson, *The Florentine Tondo* (Oxford: Oxford University Press, 2000), 34–57.

15 For all the inscriptions, consult individual object records available through the N-YHS emuseum website: http://emuseum.nyhistory.org:8080/emuseum/.

24

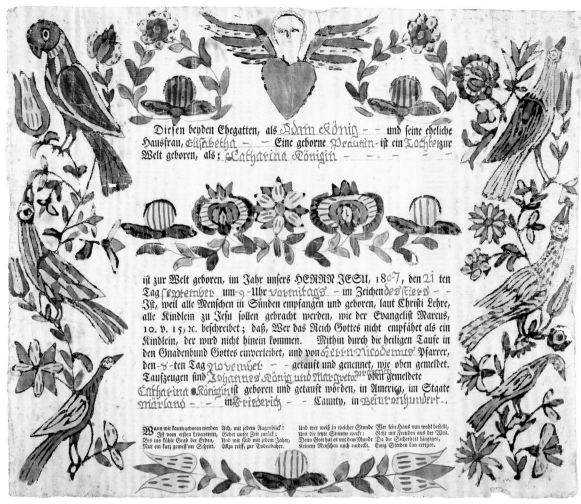

24a

24a
Salomon Mayer (American, active 1792–1811)
for the Pseudo-Otto Artist (American, active ca.
1773–1809)
**Birth and baptism certificate of Catharina
König**, 1807
York, PA
Hand-colored woodcut with handwork in watercolor
and black and red ink; 13¼ × 16⅛ in.
(33.7 × 31 cm), irregular
N-YHS, Prints, Photographs, and Architectural
Collections

24b
Johan Starck (American, active early nineteenth
century) and Daniel Lange (American, b. Germany
1783) (partnership 1807–15)
**Birth and baptism certificate of Joseph
Flor**, 1811
Hanover, PA
Hand-drawn in watercolor and brown and red ink on
woodcut printed paper; 13¼ × 16⅛ in.
(33.7 × 31 cm), irregular
N-YHS, Prints, Photographs, and Architectural
Collections

24c
Johann Ritter (American, 1779–1851)
**Birth and baptism certificate of Chonerath
Jost**, 1834
Reading, PA
Hand-colored woodcut with handwork in watercolor
and brown ink; 16⅜ × 13¼ in. (41.6 × 33.7 cm),
irregular
Provenance: Norah Churchman, Philadelphia, 1930
N-YHS, Prints, Photographs, and Architectural
Collections*

24d
G.S. [Gustav Samuel] Peters (American, b. Germany
1793)
***Paths to Heaven and Hell**, ca. 1830–40
Harrisburg, PA
Hand-colored woodcut; 11¹¹⁄₁₆ × 25⅝ in.
(29.7 × 39.7 cm), irregular
N-YHS, Prints, Photographs, and Architectural
Collections

24e
R. & W.S. (American, nineteenth century)
***The Eall [sic Fall] of Man**, ca. 1815
Hand-colored woodcut; 10¾ × 6¾ in.
(27.3 × 17.2 cm), irregular
N-YHS, Prints, Photographs, and Architectural
Collections

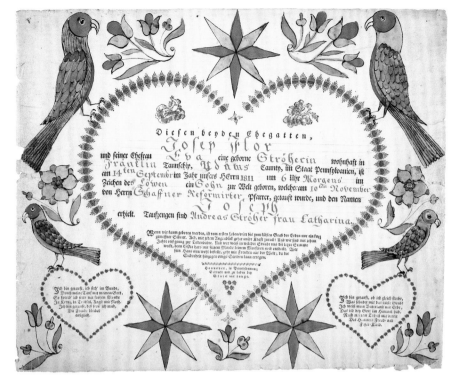

24b

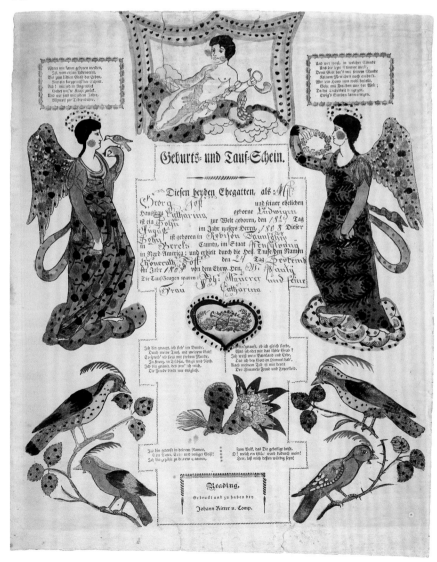

24c

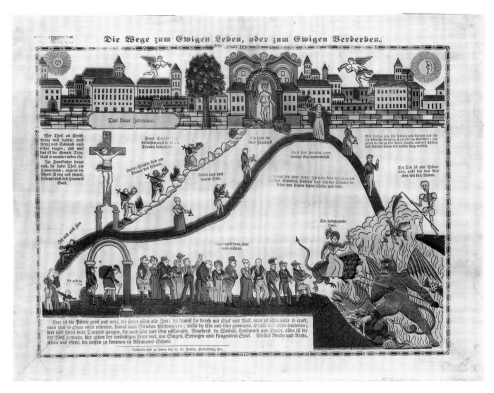

24d

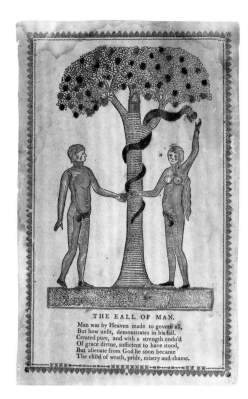

24e

Pennsylvania Germans made decorative documents called fraktur to serve as records of important life events. The most popular type commemorated birth and baptism (called *Geburts- und Taufscheine*). Some of the many other types of fraktur include writing samples, rewards of merit, house blessings, book plates, hymns, New Year's greetings, and love letters (see cat. 23).

Pennsylvania-German fraktur can be traced to the German-speaking regions of Europe where, from the sixteenth century, official church and government documents were printed with elaborate calligraphic lettering also called fraktur. "Fraktur" comes from the Latin word *fractura*, which means to break or to fracture. The bold, ornate fraktur typeface, which survived in Germany until the 1940s, was used in America by German-speaking immigrants. During the 1740s members of the Ephrata Cloister—a religious community in Lancaster County, Pennsylvania—produced

some of the earliest American fraktur. In order to meet a demand for more fraktur, the Ephrata Cloister started employing a printing press in the 1780s, a practice that nearby cities soon adopted. The role of the printer and printed fraktur became increasingly important in the 1800s. A printer set the typeface and selected the woodcuts or metal cuts, tailpieces, or other stamped embellishments and printed them for these mass-produced documents. Professional scriveners and decorators then enhanced the printed fraktur.

The first of the three printed birth and baptismal certificates, for Catharina König, is close to those printed in the Ephrata Cloister printshop for the unidentified Pseudo-Otto Artist, but it is by the printer Salomon Mayer who learned the craft there.[1] The Pseudo-Otto Artist completed the fraktur with handwork and was more than likely the scrivener who filled in the blanks in red ink to personalize the document.[2] While many

of its motifs are secular, such as the winged anthropomorphized heart, the printed text makes the religious underpinnings of baptism apparent: "This Catharina König was born into the world in the year of our LORD JESUS, 1807, the twenty-first day of September at 9 o'clock in the morning in the sign of Taurus. Because all people are conceived and born in sin, according to Christ's teachings. . . ." Even in this happy context many of the inscriptions concern the temporality of life, underlining the major role fraktur played in enabling the community to confront the high infant mortality rate and the reality of death.

The birth and baptism certificate of Joseph Flor, printed by Starck and Lange, features three hearts framing its text: a large central heart flanked by a pair of smaller ones.[3] It is a hybrid fraktur because its printed sections form its core with the dominant hand-drawn elements placed in the margins: birds, stars, and flowers. In Ephrata, Reading, and Hanover,

Pennsylvania, the triple heart was one of the standard layouts for both hand-drawn and printed *taufscheine*. The heart represented the seat of human emotions, which in this instance welcomed the birth of Joseph on "14ᵗʰ of September in the year of our Lord 1811 at 6 o'clock in the morning, in the sign of Leo."

The printer of the third certificate was the prolific Johann Ritter, who began a printing dynasty and specialized in these formulaic certificates and house blessings published only in German. Chonerath Jost from Berks County used his birth and baptism certificate, which was produced when he was an adult, like a family register to record family events: his marriage and the births of his four children on its verso in brown ink.[4] The Nadelmans had at least ten examples of similar fraktur featuring different combinations of stamps and tailpieces, each with highly individual coloring.[5] The flamboyant hand-colored patterns of the angels' costumes, the prominent canopy over the putto at the top, and the central heart in this fraktur are among the most folky of those impressions in the Nadelmans' collection.[6]

G.S. Peters's "Paths to Heaven and Hell," a popular broadside topic, is one of around eight frakturs by this printer with a Nadelman provenance in the N-YHS. Dating from the 1830s and 1840s, their earlier inscriptions are in German and the later in English. The text of this grim house blessing expounds on the right path to take for achieving eternal life in Heaven (three saved souls above the Crucifixion, including an African American, climb past the Crucifixion) and it warns of the fire and brimstone path to damnation and Hell, represented at the lower right, in the wake of the Whore of Babylon from the Book of Revelation.[7] No doubt members of the household would have followed a strict path of righteousness to avoid being warmed by those fires.

Adam and Eve in the Garden of Eden (or Paradise, depending on the text) and the Temptation and Fall of Man were also subjects found in hand-drawn fraktur and broadsides. The Nadelmans collected at least three examples of the scene. Whereas the others feature long texts in German, this stylized variant, whose bold forms resemble those found in German Expressionist prints of the early 1930s, is more like a broadside and has only six lines of English text, with the title revealing unfamiliarity with the English language.[8] They quote "On the Fall of Man" from *A New Guide to the English Tongue* by Thomas Dilworth (d. 1780).[9] This theme was resonant in American folk art.

RJMO

1 See Klaus Stopp, *The Printed Birth and Baptismal Certificates of the German Americans* (Mainz, Germany and East Berlin, PA: Published by the author, 1997–98), 2: 182–85, nos. 255.2–257; 5: 24–31, nos. 794.1–796A, cites the N-YHS fraktur (no. 796); for the Pseudo-Otto Artist, see Earnest and Earnest 1997, 2: 628–30.

2 For the stamps of the Pseudo-Otto Artist, see Stopp, *Printed Birth and Baptismal Certificates*, 2: 178–81.

3 Ibid., 2: 234–35, no. 290, cites this fraktur and illustrates another example with variant marginal designs.

4 MFPA Misc. 2710. The Nadelmans purchased it for $10 from Norah Churchman, Philadelphia, in March 1930. Stopp, *Birth and Baptismal Certificates*, 4: 201, no. 687, cites this N-YHS fraktur as in a private collection and identifies the child mistakenly as a daughter.

5 For some of the variants by Ritter and other printers, see ibid., 2: 23–33; 3: 42–83; 4: 164–276; 281–93.

6 See Weiser and Heaney 1976, 2: nos. 482–84, 487, for impressions without additions; Russell D. and Corinne P. Earnest, *Flying Leaves and One-Sheets: Pennsylvania German Broadsides, Fraktur, and Their Printers* (New Castle, DE: Oak Knoll Books, 2005), 294–95, fig. 123, reproduces another impression in a private collection with additions colored by the same artist.

7 See Earnest and Earnest, *Flying Leaves and One-Sheets*, 258–59, fig. 105, for another impression.

8 For a variant woodcut, see ibid., 200–1, fig. 78, which states it may be the earliest English-language "Adam and Eve" printed for the Pennsylvania Germans.

9 Thomas Dilworth, *A New Guide to the English Tongue* (London: Richard & Henry Causton, 1793), 136.

25

Unidentified Swiss maker
Chest, 1678
White pine; 15½ × 32½ × 15 in.
(39.4 × 82.6 × 38.1 cm)
Provenance: Strub & Morgan [Charles E. Strub and
James T. Morgan], New York City, 1924
1937.1300*

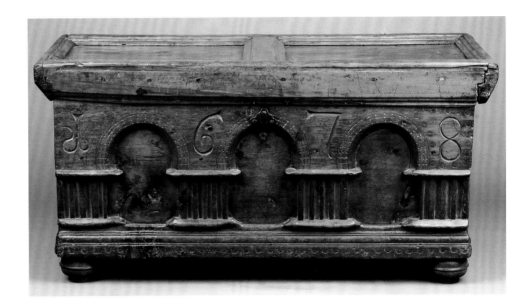

The Nadelmans' buying habits suggest that they had a passion for Swiss folk art, particularly carved or painted chests of all sizes. This vigorously carved chest with a hinged lid is one of many Swiss furnishings displayed in the MFPA. Its lively arcaded façade is punctuated by three deep arches supported by wide fluted columns and bold projecting lintels. Each arch is accentuated by an outline of deeply scribed lines. The chest is further ornamented with punchwork pinwheels stamped between the arches and along the base molding, and the date "1678" is exuberantly carved in large ornamental numerals across the front.[1]

The chest is not clearly itemized in the MFPA inventory, but it may be one of the three "carved wooden chests" cited in Gallery VII, which, according to the museum's brochure, displayed Swiss, Spanish, German, and Italian furniture.

The Nadelmans purchased the chest in December 1924 from the firm of Strub & Morgan, one of several carved or painted examples identified as Swiss that the couple acquired from the firm.[2] Also known as the Amsterdam Art Gallery and located at 608 Amsterdam Avenue, Strub & Morgan may have specialized in Swiss folk art. Charles (Americanized from Karl) Strub, a Swiss German who emigrated to New York in 1908,

probably had ready access to Swiss folk art for the gallery. Ship passenger lists indicate that he traveled nearly annually to Europe, probably in search of stock for eager customers like the Nadelmans. It is likely that Strub also supplied Swiss objects to the couple's primary source of Swiss artifacts, the East Fifty-seventh Street dealer C. Vandevere Howard. Strub's 1926 Petition for Naturalization, which lists his occupation as "buyer," gives his place of residence as "c/o Howard" and is witnessed by Howard himself.[3]

MKH

1 The inside of the lid is inscribed in chalk: "Fässler Jr / № 2 / 70-". The name may refer to an earlier dealer or a restorer, perhaps Hermann Fässler of Appenzell, Switzerland. (The same name is inscribed in ink on the underside of the box in cat. 32). The bun feet are later additions and the lid of the till is replaced.

2 MFPA 924, no sale price recorded. Other purchases from Strub & Morgan include a small painted Swiss chest with two doors, acquired for $18 in 1924 (MFPA 180), and a large carved chest "Gothic ? Swiss ?" purchased for $60 in April 1924 (MFPA 198).

3 Charles Strub, Petition for Naturalization, April 20, 1926. The document is available on ancestry.com.

26

Unidentified American maker
Chest, 1775–1800
Probably Lebanon County, PA
Pine, iron, paint; 19¾ × 49½ × 23½ in.
(50.2 × 125.7 × 59.7 cm)
Provenance: Anderson Galleries, New York, Mrs.
Laurie E. Post sale, 1925
1937.1286*

During the eighteenth and nineteenth centuries, large storage chests played an important role in the lives of Pennsylvania Germans. Typically, they were given to a bride as a gift from her parents and used to hold the precious textiles—such as tablecloths, bedding, and clothing—that the new couple would use in their home. Made by local craftsmen, these chests often featured vivid painted decoration and sometimes incorporated the bride's name or initials. Owners often pasted important documents such as birth and marriage certificates (frequently called "fraktur"; see cats. 23, 24) inside the lid. As cherished possessions and repositories of family valuables, these chests were often passed down through generations.[1]

Three tombstone-shaped panels punctuate the front of this boldly designed chest, each one carefully ornamented with neat rows of stippling executed by applying a mixture of Prussian blue pigment and vinegar with a fingertip.[2] A white outline silhouettes and accentuates each panel. The background is sponge-painted in brown, probably using a rolled rag or crumpled piece of paper dabbed across the surface.[3] A single panel, similarly decorated, ornaments each end of the chest, and the lid is covered with the same brown sponge painting. While many Pennsylvania chests were raised on bracket feet, this example always rested directly on the floor.[4] Although the chest retains its original iron strap hinges, its original crab lock (the hasp of which is still intact) was replaced in the nineteenth century with a box lock.[5]

The Nadelmans purchased the chest for $57.50 at the Anderson Galleries auction of the Laurie E. Post collection.[6] They were undoubtedly attracted by its vivid painted surface and not deterred by the "as is" condition noted in the catalogue. In addition, the chest helped fulfill the Nadelmans' mission of demonstrating the influence of European folk art on American expression, as the chest derived from a long tradition of European painted chests well represented by examples in the MFPA. Photographs of the MFPA's Gallery II indicate that this piece occupied a prominent position among the American furniture and decorative objects (see fig. 11). The Nadelmans placed the chest—draped with a hooked rug—at the foot of a low bedstead covered with a vibrant stenciled quilt, in decorative conversation with the gallery's other painted furniture, patterned textiles, decorated pottery, and folk pictures.
MKH

1 For more information on Pennsylvania-German chests, see Wendy A. Cooper and Lisa Minardi, *Paint, Pattern & People: Furniture of Southeastern Pennsylvania, 1725–1850*, exh. cat. (Winterthur, DE: Henry Francis du Pont Winterthur Museum in association with University of Pennsylvania Press, 2011), 89–92, 144–49; Monroe H. Fabian, *The Pennsylvania-German Decorated Chest* (New York: Universe Books, 1978), 28–35.

2 MFPA 1022.

3 For decorative painting techniques, see Cynthia V.A. Schaffner and Susan Klein, *American Painted Furniture* (New York: Clarkson Potter, 1997), 109–18, 139–46.

4 Close examination of the underside, back, and base molding confirms that the chest is in its original configuration and never had feet.

5 In a photograph of the chest in Gallery II of the MFPA, it has yet another later locking mechanism to the left of the current keyhole (probably removed by the N-YHS).

6 Anderson Galleries, New York, "Early American Furniture . . . the Collection of Mrs. Laurie E. Post," February 12–13, 1925, lot 437. They also purchased a brass flatiron (lot 26) at the sale.

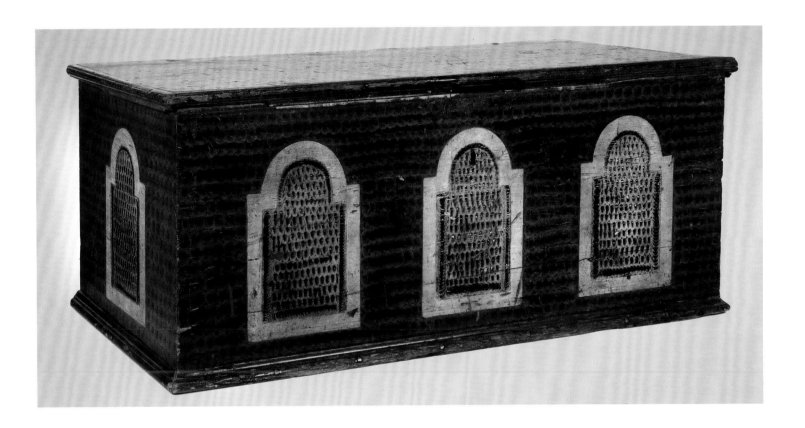

27

Unidentified European maker
Baby walker, 1700–50
Probably the Netherlands, possibly northern
Germany
Cherry; 15 × 25¾ × 25¾ in. (38.1 × 65.4 × 65.4 cm)
Provenance: C. Vandevere Howard, New York City,
1927
INV.14959*

Eighteenth-century baby walkers are remarkably similar to their modern counterparts in molded plastic. These walking aids can be traced back as far as the fifteenth century, when they appear in illuminated manuscripts, such as the Dutch *Hours of Catherine of Cleves* (ca. 1440), which depicts the young Jesus in a rolling baby walker.[1] Although the devices had their critics—as they do today—they were apparently popular in northern Europe, particularly the Netherlands, during the seventeenth and eighteenth centuries.[2] They helped babies learn to walk, encouraged erect posture (which carried moral overtones of upright character), and, more important, prevented dangerous tumbles into hot stoves and fireplaces. Images of babies toddling in these contraptions appear in paintings and prints during the period and were even created as silver miniatures.[3] With regular usage, wooden baby walkers suffered considerable wear and tear. The Nadelman collection baby walker is thus a rare survival.

The Nadelmans purchased this piece for $24 in February 1927 from the East Fifty-seventh Street shop of C. Vandevere Howard, an importer of English and Continental antiques who also advertised "painted and unpainted peasant furniture" (see fig. 44).[4] They catalogued the walker as Swiss, although its overall form and decorative turnings point to a Dutch origin. A very similar walker at the Columbia County (New York) Historical Society invites close comparison: its survival in New York's Hudson River Valley, an area dominated by Dutch settlers, strengthens the attribution to the Netherlands.[5] Curiously, the Nadelmans purchased a great deal of folk art identified as Swiss from Vandevere Howard, raising the question of whether objects so attributed were more desirable in the marketplace during the interwar period than those from other European countries.

The baby walker was displayed in the Toy Room (Gallery IX) of the MFPA and is listed in the 1937 inventory as "chair for teaching child to walk." Related juvenile furniture, including high chairs, cradles, and a "painted chair on wheels," was exhibited nearby. The walker was in poor condition when it arrived at N-YHS in 1937 and remained in storage until it was put on display in the Luce Center in 2000.[6] Elie Nadelman failed to catalogue it during his brief curatorial stint at N-YHS. Luckily, the distinctive Nadelman Museum adhesive label on the underside of the lower frame, inscribed with the MFPA number 247, allowed successful cross-referencing with the MFPA curatorial records and the reclamation of this delightful object as part of the Nadelmans' legacy.
MKH

1 The manuscript is in the Morgan Library and Museum, New York, MS M.917, fols. 146–49.

2 Critics included Swiss surgeon Felix Würtz, who argued in *An Experimental Treatise of Surgerie* that learning to walk should be left to nature. See Mary Spaulding and Penny Welch, *Nurturing Yesterday's Child: A Portrayal of the Drake Collection of Paediatric History* (Toronto: Natural Heritage / Natural History, 1994), 271.

3 See, for example, the etching *Vrouw met Kind in Loopwagen* by Johan Antoni Kauclitz Colizza, ca. 1774–1808 (Rijksmuseum, RP-P-1878-A-763) and http://www.bexfield.co.uk/12/n029.htm for a miniature baby walker by Amsterdam silversmith Arnoldus Van Geffin, ca. 1740.

4 MFPA Toys 247. Howard advertised frequently in the *Antiquarian*, *The Magazine Antiques*, and the *Sun*. See, for example, *Antiquarian* 7:6 (January 1927): 10. Also see Hofer essay, pp. 62–63, for more on Howard.

5 Blackburn and Piwonka 1988, 193, fig. 227.

6 Conservation treatment in 2000 included replacing one missing wheel and rebuilding one corner of the lower frame. See Baggot Frank Conservation treatment report dated March 7, 2000, in the object file. The walker was first published in N-YHS 2000, 70.

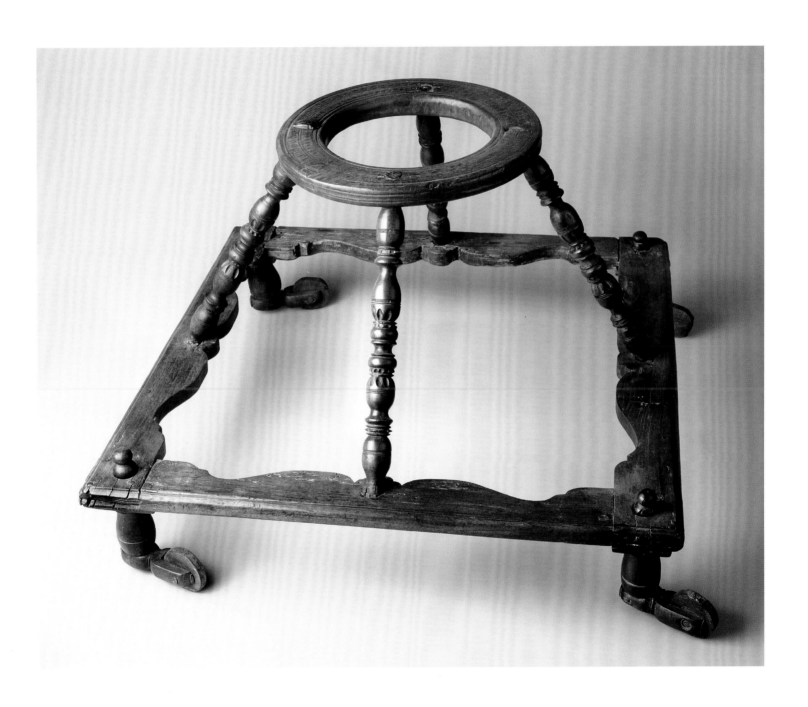

28

Unidentified American maker
Slat-back high chair, 1770–1810
Probably Delaware River Valley
Maple, oak, pine, paint; 37½ × 14½ × 16 in.
(95.3 × 36.8 × 40.6 cm)
Provenance: Anderson Galleries, New York,
F.W. Fuessenich sale, 1925
1937.1297*

This charming high chair was displayed in Gallery II, one of two rooms at the MFPA dedicated solely to American folk art (see fig. 11). By 1937 the gallery displayed five high chairs interspersed among a rather chaotic assemblage of painted and carved furniture, hooked rugs, folk paintings, and smaller objects such as pewter and pottery. The Nadelmans were probably attracted to the pleasing proportions of this chair, which features slightly splayed legs for added stability. The gentle arch of the slats and the type of decorative turnings link this example to the distinctive slat-back chairs made in the Delaware River Valley during the eighteenth and nineteenth centuries.[1] The chair retains an old, possibly original, oak splint seat as well as an old painted finish burnished with the patina of heavy use. Remnants of iron oxide pigment on the seat frame and bottom slat suggest that it was originally painted red. The footrest and its supports are later additions, probably made during the nineteenth century to increase the comfort of the chair's young occupant.

This slat-back high chair is one of three purchased by the Nadelmans at the Anderson Galleries Fuessenich sale in October 1925.[2] The sale featured the impressive collection of American antiques amassed by Frederick W. Fuessenich for his home, Toll-Gate Hill Tavern, in Torrington, Connecticut. The 317 lots offered at Anderson's Park Avenue galleries attracted major collectors and garnered impressive prices.[3] The Nadelmans, then at the peak of their collecting frenzy, purchased at least sixteen items, primarily vernacular furniture such as a pine dresser (lot 110), a painted pine wall cupboard (lot 262), and a paneled chest (lot 304). Their purchases ranged from $12.50 to $240, with the "rare" and "all original" high chair costing them $32.50.
MKH

1 John Mark Bacon, "Delaware Valley Slatback Chairs: A Formal and Analytical Survey" (master's thesis, University of Delaware, 1991).

2 MFPA 1645. Anderson Galleries, New York, "Part of the Noted Collection of Rare American Antiques Formed by F.W. Fuessenich," October 23–24, 1925, lot 82.

3 "Fuessenich Antiques Will Be Sold Here," *New York Times*, October 18, 1925; "Antiques Bring $12,414," *New York Times*, October 25, 1925.

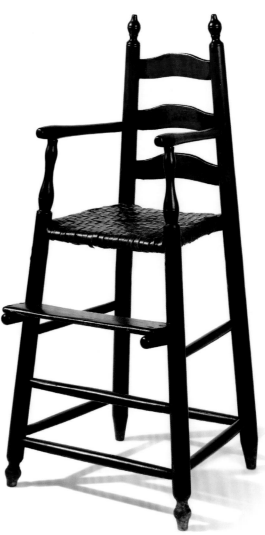

29

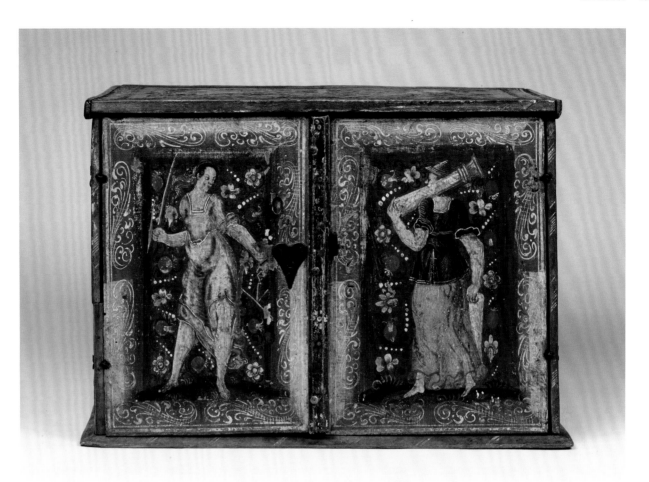

Unidentified European makers

Betrothal coffer, 1580–1660
Wood, gesso, paint, silver pigment?, iron;
10¼ × 15¼ × 10 in. (26 × 38.5 × 25.5 cm)
INV.8523

Chest with drawers (trinket box), 1700–1800
Wood, gesso, paint, découpaged etchings, metallic pigment; 9¾ × 9 × 5 in. (24.8 × 22.9 × 12.7 cm)
1937.1382*

Betrothal coffer, 1800–50
Wood, gesso, paint, silver pigment?, iron;
6 × 7¾ × 6 in. (15.2 × 19.7 × 15.2 cm)
INV.8524[1]

These delightful boxes reflect the Nadelmans' love of painted, decorated objects. The MFPA documents reveal that the couple amassed a sizeable number of various types of boxes (cats. 30–35), some of which are only generically mentioned in the MFPA inventory.[2] The second of the trio has an MFPA card, which indicates that the couple considered it a toy:[3] it was exhibited in Gallery IX, the Toy Room, where the MFPA inventory records that various boxes and a doll's chest were displayed.

Most likely, however, all three boxes were associated with marriage and were among the love-gifts given upon betrothal or upon marriage. Sometimes they were filled with small presents or trinkets and were meant to hold the personal possessions of the new wife.[4] This function is reinforced by the floral symbolism on all three, which is appropriate to marriage and alludes to fecundity and love (roses). The heart on the lid of the smaller chest with drawers and the female personifications of virtues on the largest, most elaborate chest are also symbolic of marriage. Since boxes such as these are often miniature reflections of the prevailing furniture trends of a particular period and geographic region, both their forms and painting suggest a

European taste and a place of origin spanning southern France, Switzerland, or southern Germany-Austria.[5] The two smaller objects are the most representative of "peasant," country art, although the earlier of the pair—with its bun feet, turned wooden finials, and découpaged flowers—imitates finer furniture prototypes.

The oldest, largest, and most highly embellished of the trio was also the most ambitious and was meant to secure valuables, such as jewelry and documents. It has two locks: a larger one, in the form of a heart, on the left door, and a second one, visible when the two doors are opened, in the center of a false top drawer. It releases the lid to reveal a shallow, two-inch-deep compartment within the box. The locked box carried symbolic meaning, as a medieval knight told his beloved: "Lady, you carry the key / and have the casket in which my happiness / is kept."[6] The background color of the chest, which is now a dark green, may contain silver pigment (now tarnished), reinforcing the precious nature of this treasure chest.

This intricately decorated chest also has the most complex symbolism, which is tied to older religious and secular traditions. Like the larger cassone given to new wives

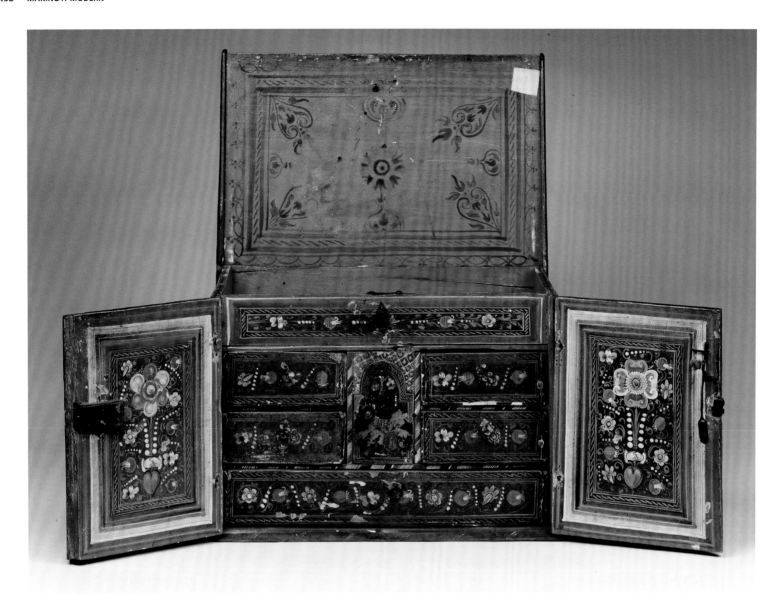

during the Italian Renaissance,[7] or to a lesser extent the betrothal or courtship boxes of Alsace and Germany (*coffrets de courtoisie* or *Minnekästchen*),[8] its decorative imagery contains *exempla* for the bride, with an implied admonishment to follow their examples, together with the heraldic devices of the two conjoined families. Embellishing three sides are the four Cardinal Virtues holding their attributes: Prudence on the left, Justice and Fortitude on the front doors, and Temperance on the right. Decorating the top of the chest are representations of the three Theological Virtues: Faith, Hope, and Charity. The back contains a depiction of a woman holding a large red cross. Although she does not wear a halo, she is probably St. Helen, mother of the Emperor Constantine and an empress herself, who is credited with discovering the True Cross on which Jesus was crucified. This

would explain the large cross, her traditional attribute, her classicizing drapery, and the ermine (a symbol of royalty) peeking out at the right from behind her robes.[9] St. Helen may also have been the name saint of the owner. All seven virtues also wear classicizing garments reminiscent of Italian sixteenth-century fashions. The interior of the chest features four short drawers, one long lower drawer that echoes the blind top drawer, and a taller central compartment whose painted arcuated door has a coffered vault with stars above, recalling Florentine fifteenth-century tabernacles for storing the Eucharist. The painted vault frames an intricate composition that includes the heraldries of the bride and groom, which conform to the conventions of heraldry in the Holy Roman Empire around 1605. The escutcheon on the left crowned by a helmet surmounted by a black bird (a raven)

is that of the Rabenstein family in Germany's Fränkische Schweiz region. Most likely that of the groom, it towers over and seems to encompass the abbreviated heraldry of the bride.[10] Reinforcing the matrimonial symbolism rampant on this chest are the conjoined hands above hearts painted on the interiors of both doors.

Adding to the emotional complexity of the object is a label in the top false drawer, which a later owner added when she was contemplating deaccessioning what was probably a family heirloom. It is inscribed: "My Hart / aches to part / with this wun- / derful Tresure." This expressive sentiment could only have been matched at the other end of the spectrum by the Nadelmans' joy at their acquisition.

RJMO

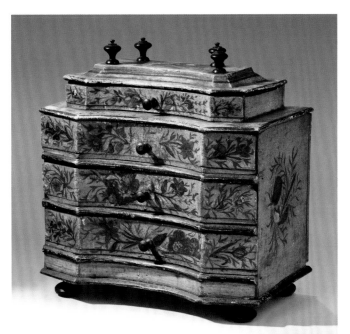
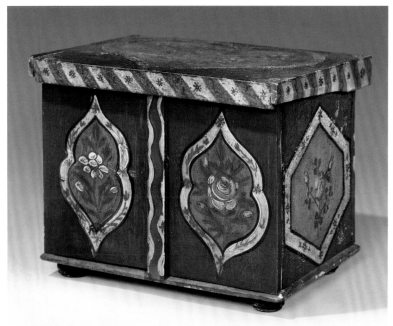

1　This box is heavily restored: its front doors may not be original and the blue paint is later; Linda Nieuwenhuizen conservation report, June 3, 2014.

2　Over a dozen of the couple's painted boxes and another dozen metal boxes are listed as French, Swiss, or "Danubian" in Parke-Bernet 1943b, lots 155–65.

3　1937.1382 is MFPA Toy 381. In addition to a MFPA card, it has an MFPA collection label inscribed "381" and another label, probably from a dealer, inside the second drawer inscribed "20- / 251L2L." For toy furniture, see Sandra Brant and Elissa Cullman, *Small Folk: A Celebration of Childhood in America* (New York: E.P. Dutton in association with the Museum of Folk Art, 1980), 131, 133, whose criteria for doll furniture, that it not be higher than four inches, disqualifies these objects.

4　See Andrea Bayer, ed., *Art and Love in Renaissance Italy*, exh. cat. (New York: Metropolitan Museum of Art; New Haven and London, Yale University Press, 2009), 107–11, nos. 38–41, for Renaissance examples. See also Jacqueline Marie Musacchio, *The Art and Ritual of Childbirth in Renaissance Italy* (New Haven and London: Yale University Press, 1999), 94; 192 n. 23.

5　There are five MFPA cards for chests of drawers with incomplete information, two of which were considered Swiss and acquired from C. Vandevere Howard, New York City, in 1927 and 1929. Only one was identified as American and all were considered toys.

6　From the medieval Chrétien de Troyes, *Yvain; or, The Knight with the Lion*, quoted in Michael Camille, *The Medieval Art of Love: Objects and Subjects of Desire* (New York: Harry N. Abrams, 1998), 68.

7　See Cristelle L. Baskins, *Cassone Painting, Humanism, and Gender in Early Modern Italy* (Cambridge, Eng., and New York: Cambridge University Press, 1998); Jacqueline Marie Musacchio, *Art, Marriage, and Family in the Florentine Renaissance Palace* (New Haven and London: Yale University Press, 2008).

8　See Musée Alsacien, Strasbourg, 66.006.0.7, for a seventeenth-century version with some of the same features and interior striped decoration, and Metropolitan Museum of Art, 50.141, a fifteenth-century example with coats of arms and personifications. The areas of Alsace and Franconia Schweiz are adjacent and have made stylistic exchanges for centuries.

9　Since a halo was usually *de rigueur* in Roman Catholic iconography, the owner may have had a Protestant affiliation.

10　The escutcheons may be canting arms, that is, they may represent the bearer's name in a visual pun. See Johann Siebmacher, *Johann Siebmachers Wappenbuch von 1605*, ed. Horst Appuhn (Dortmund: Harenberg, 1988), 1: pl. 105, for Rabenstein; 2: pl. 201, for the Zily coat of arms, a candidate for the bride's family.

30

Unidentified French maker
Marriage box (*Coffret de mariage*),
ca. 1800–50
Normandy, France
Beech, iron, paint; 6 × 8 × 4½ in.
(15.2 × 20.3 × 11.4 cm)
Provenance: Probably Nancy McClelland,
New York City, 1924
1937.1587*

Marriage boxes like this were traditional in Normandy, France, between 1750 and 1850. Painted with symbols alluding to love and prosperity, these trunk-shaped boxes were typically presented to the bride and used to store money, jewelry, and documents when she moved to her new husband's house after the wedding. Boxes varied in size from petite containers such as this one to trunks three feet wide, but the construction and decorative features are remarkably consistent. The dome-top boxes are simply assembled from beech wood with butt joints secured by small iron nails and fitted with a wire bail handle and iron lock with an off-center latch. The edges are outlined with white paint, while animated painted motifs of birds, flowers, and swags of fabric decorate the top, front, and sides.[1] This example also features a coin slot cut at the top of the lid. A number of *coffrets de mariage* survive with maker labels indicating they were crafted in the city of Rouen, which appears to have been a locus of manufacture. In fact, sixteen *coffretiers* are documented as working in Rouen in 1848, suggesting that a small cottage industry flourished there.[2]

The top of this box is vivaciously painted with a pair of lovebirds, alluding to the bond of marriage. The front and sides are ornamented with festoons of red and blue roses, emblematic of love, and swags of blue fabric with red and white fringe, which connote celebration, domestic comfort, and prosperity. The back, now faded, was painted solid blue. The vivid and spontaneous character of the painted decoration—not to mention its patriotic palette—must have caught the imagination of the Nadelmans.

This object is likely the "Box, Normandie" purchased for $20 from the East Fifty-seventh Street antiques dealer and interior decorator Nancy Vincent McClelland in 1924, although the MFPA card includes no further identifying details.[3] The Nadelmans must have particularly enjoyed the form, as they also purchased a Normandy "trunk" from McClelland that same year. That piece, probably a larger version, was described as "painted a light tan, decorated with yellow leaves, yellow and red blossoms,"

and it included the motifs of a basket of flowers and two birds.[4]
MKH

1 Cuisenier 1977, 85, 92, fig. 137; see also "*Coffret de mariage normand*," www.citedesarts.com/fr/Aff. php.
2 "*Coffret de mariage normand*," n.p.
3 MFPA 70.
4 MFPA 25.

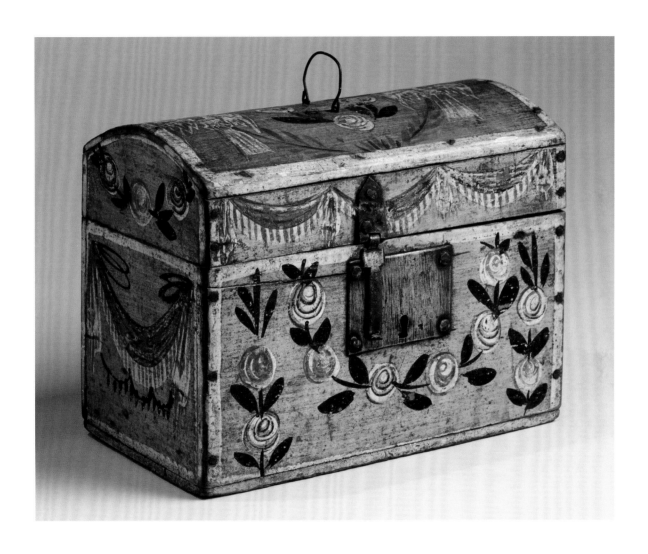

31

Unidentified German maker
Bride's box, 1826
Probably southeastern Germany
Wood, paint; 7⅝ × 19¼ × 11¾ in.
(19.4 × 48.9 × 29.8 cm)
Provenance: Estelle Berkstresser,
York, PA, 1929
1937.1109ab*

German craftsmen in thickly forested Bavaria and neighboring regions created painted oval boxes made from thin or shaved wood as early as the sixteenth century. Because these decorative boxes were popular bridal gifts, intended to hold trousseau items like lace, linens, ribbons, and traditional headgear known as *trachtenhauben*, collectors often refer to them as "bride's boxes."[1] Specialist craftsmen made the containers by soaking strips of birch, bass wood, limewood, or maple in hot water, placing the pliable strips around molds, and then forming the box sides by lapping the ends and stitching them together with split willow or reed. The separate base and lid top, made from thicker pine, were then secured to the sides with wooden pegs or small nails. The decoration was executed by a specialist box painter—sometimes a woman—who often came from a line of family decorators.[2]

In its construction—particularly the method used for lacing the sides—and its florid painted decoration, this example is consistent with boxes made in southeastern Germany. The sides are ornamented with stylized tulips, while the top features an elegantly attired bride and groom set against a striking background of swirls and stylized flowers. The inscription around the edge of the top, "Keinen andern sag ich zu daß er mir mein Herz aufthu," based on a German hymn, translates loosely as "To no other do I consent that he opens my heart."[3] Below the couple, "In Jahr Christi / 1826" dates the nuptials to 1826 "in the year of Christ."

Bride's boxes were already attracting collectors when the Nadelmans purchased this one from Pennsylvania dealer Estelle Berkstresser in April 1929.[4] Four years earlier, Esther Stevens Fraser had published an article on Pennsylvania bride's boxes in *The Magazine Antiques*, which the couple had probably read.[5] Although Fraser's article discussed and illustrated both Pennsylvania boxes and their German antecedents, dealers and collectors who found these boxes locally were inclined to identify them as American. Indeed, the Nadelmans catalogued this box

as Pennsylvania-made in the MFPA cards. However, they appear to have stayed abreast of scholarship on the subject and took note of the increasing evidence that many such boxes were in fact European.[6] When Elie Nadelman catalogued the box upon its arrival at the N-YHS in 1937, he designated its origin as south German.[7]

The figural painting on German bride's boxes had grown highly formulaic by the early nineteenth century, as this example demonstrates. Representations of the bride and groom were often reduced to simple flattened forms with little perspective.[8] The Nadelmans no doubt appreciated the abstract quality of this bridal couple.

MKH

1 Linda Carter Lefko, "German Decorated Boxes," *Early American Life* 35:3 (June 2004): 22–23.

2 Ibid., 23–24. See also Kurt Dröge and Lothar Pretzell, *Bemalte Spanschachteln: Geschichte, Herstellung, Bedeutung* (Munich: Callwey, 1986), 40–70.

3 The quotation is derived from the hymn "Jesu, komm doch selbst zu mir," first published in 1657 and reprinted in many later German collections. Thanks to Jeffrey Richmond-Moll for identifying this source.

4 MFPA 2530; they paid $20 for the box.

5 Esther Stevens Fraser, "Pennsylvania Bride Boxes and Dower Chests, Part I: Preliminaries," *The Magazine Antiques* 8:1 (July 1925): 20–23.

6 D.H. Landis, "Pennsylvania Decorated Boxes," *The Magazine Antiques* 27:5 (May 1935): 184–85. Landis concluded that "the most alluring of the Pennsylvania wooden boxes were brought to this country by early German immigrants, or were subsequently imported by enterprising merchants, or, . . . represent comparatively recent accumulations gathered in the antiques market of Europe."

7 N-YHS accession sheet 1937.1109ab.

8 For related examples, see Dröge and Pretzell, *Bemalte Spanschachteln*, 92–93, figs. 55, 57–60.

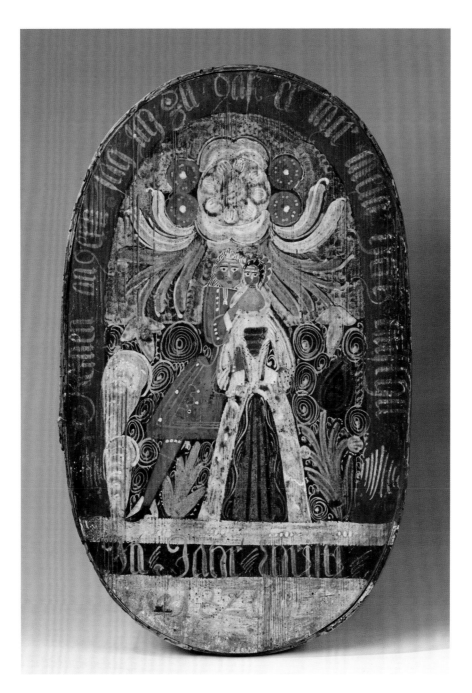

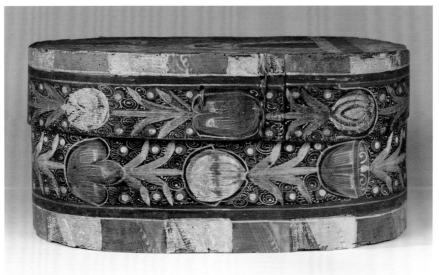

32

Unidentified European maker, probably Swiss
Slide lid box, 1806
Spruce, paint; 5⅜ × 10¾ × 13⅜ in.
(13.7 × 27.3 × 34 cm)
Provenance: Strub & Morgan [Charles E. Strub and James T. Morgan], New York City, 1924
INV.8548ab*

This charming box with a sliding lid was presented to Anna Elisabeth Schlowstein in 1806, probably at the time of her marriage.[1] Painted with a background of once-vivid Prussian blue, the box is decorated with sprays of flowers that symbolically allude to Anna's marriage. The white rose at the center symbolizes the bride's purity, as do the white lilies, while the red carnations suggest romantic love and passion. The ribbon tying the stems together also refers to the union of the bride and groom. The roses ornamenting the front end of the box, painted half white and half red, also make playful reference to marriage.

Like the German bride's box (cat. 31), Swiss carved chest (cat. 25), and Pennsylvania chest (cat. 26), this object is part of an enduring Germanic tradition of decorated storage boxes and chests that was amply represented in the Nadelmans' museum.[2] This type features a lid that slides in grooves cut into the top of the sides. Though less common than the hinged-lid chest or oval bentwood bride's box, the painted slide lid box is found in both European and American contexts.

The Nadelmans purchased this box from New York dealers Strub & Morgan, proprietors of the Amsterdam Art Gallery, for a modest $7.[3] The ink inscription "Fässler Jr" on the underside of the box—the same name written on the back of a Swiss chest (cat. 25)—suggests that the two objects, both purchased from Strub & Morgan, may have come from a common source abroad.
MKH

1 The family name is difficult to discern: it may possibly read "Schlowfein."
2 Monroe H. Fabian, *The Pennsylvania-German Decorated Chest* (New York: Universe Books, 1978), 15–18.
3 The Nadelmans mistakenly created duplicate cards for this box: one (MFPA 247) describes a Swiss box purchased from Strub & Morgan in 1924, "painted green with red trimmings and festoons of flowers" and inscribed "Ana Elizabeth [*sic*] Schlowstein 1806"; the other card (MFPA 175) simply identifies a Swiss painted box with sliding top dated 1806, purchased from Strub & Morgan for $7.

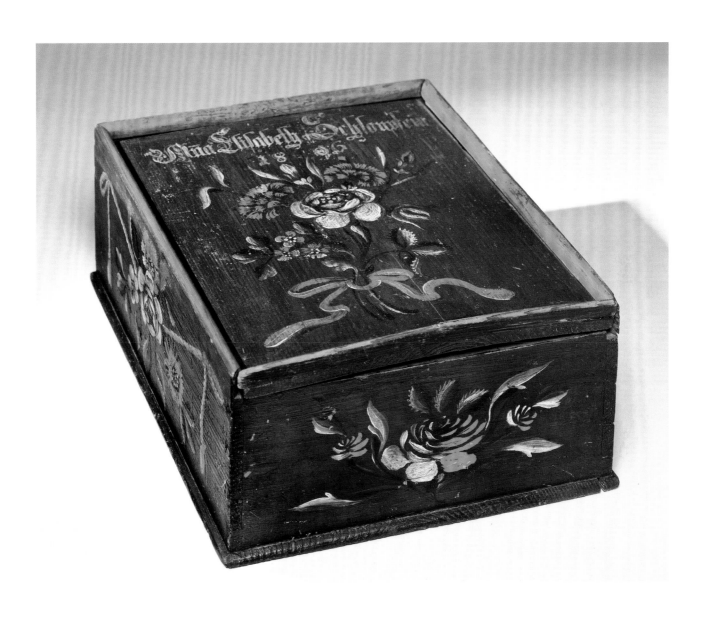

33

Unidentified American maker
Box, 1800–40
Lancaster County, PA
Tulip poplar, pine, tinned sheet iron, paint;
10⅝ × 13⅞ × 9⅝ in. (27 × 35.2 × 24.4 cm)
Provenance: Katharine Willis, Jamaica, NY, 1925
1937.1104*

The Nadelmans were among the earliest Americana collectors to purchase dome-top boxes made by the so-called "compass artist" of Lancaster County, Pennsylvania.[1] Although the couple may not have fully understood the use or origin of these engaging objects, they surely would have admired the stylized, vibrantly painted, compass-drawn designs. This example is one of two compass artist boxes they acquired from dealer Katharine Willis in April of 1925 (fig. 98).[2] The MFPA cards record their origin only as "American," suggesting that the couple was not aware of their Pennsylvania-German ties. A photograph of the MFPA's Gallery II shows the two boxes on top of a pine dresser that displayed pewter on its open shelves. The boxes are in dialogue with other painted and patterned objects in the room, particularly the quilt, stenciled with stylized flowers, vines, and leaves that echo the compass-work designs.[3]

The distinctive decoration of compass artist boxes was based on a technique commonly used in northern Europe as early as the seventeenth century.[4] Although the identity of the artist is unknown, the work from this hand (or shop) is much better understood today than when the Nadelmans collected their examples. More than sixty pieces of furniture—at least thirty-five of them dome-top boxes such as this—are now assigned to the group. Study of inscriptions found on some of the objects, and their family histories, link the compass artist conclusively to a geographic region near the border separating Lancaster and Lebanon counties.[5]

The Nadelman box, noteworthy for its large size and excellent condition, features a ground of Prussian blue, compass motifs filled with vermilion (red), and outlines of white lead suspended in linseed oil. The compass motifs ornamenting the front, top, and sides, and the pair of paisley motifs above and below the hasp, are stippled with red. The varnish layer has yellowed with age, giving the once-bright Prussian blue a dark green cast and turning the white lead yellow. However, traces of paint on the inside of the box reveal the brilliance of the colors when

they were applied.[6] The box retains its original fan-shaped escutcheon plate and trapezoidal hasp, both fashioned from tinned sheet iron and decorated with punched dots.
MKH

1 Other early collectors of the form included Henry Francis du Pont, Rhea Mansfield Knittle, Mrs. Robert de Forest, and Titus C. Geesey. See Wendy A. Cooper, Patricia Edmonson, and Lisa M. Minardi, "The Compass Artist of Lancaster County, Pennsylvania," in *American Furniture 2009*, ed. Luke Beckerdite (Hanover, NH: Chipstone Foundation distributed by the University Press of New England, 2009), 65–66.

2 MFPA 1197. The second example is N-YHS 1937.1767.

3 The stenciled quilt is N-YHS 1937.1387.

4 Cooper, Edmonson, and Minardi, "Compass Artist," 67–68.

5 Ibid., 63, 84.

6 The other compass artist box purchased by the Nadelmans (fig. 98) was painted with the same color scheme. Due to the later removal of the varnish layer, its colors better approximate the original, though they have lost their luster.

Fig. 98. Unidentified maker, Lancaster County, PA, Box, 1800–40. Tulip poplar, pine, tinned sheet iron; 6½ × 10 × 10 in. (16.5 × 25.4 × 25.4 cm). N-YHS, 1937.1767.

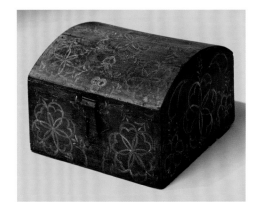

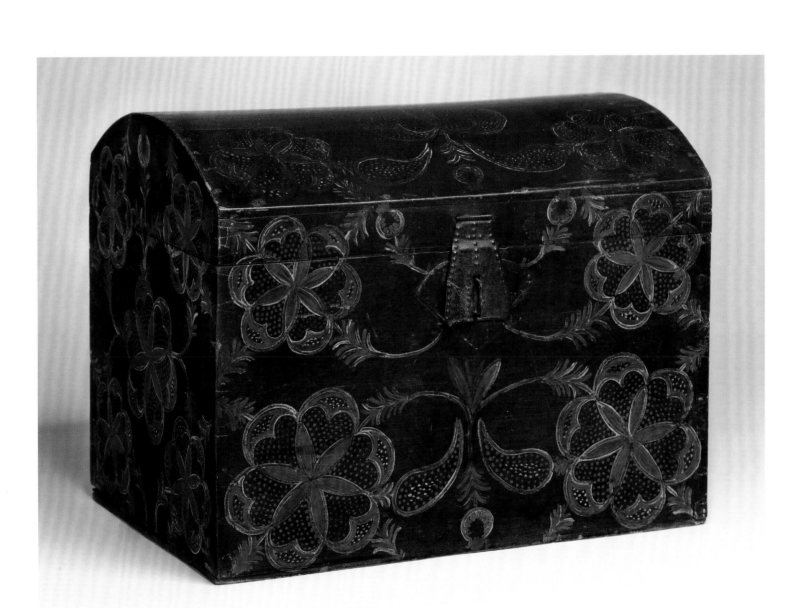

34

Unidentified American maker
Bandbox, ca. 1820–30
Pasteboard, wallpaper; 11 × 15¼ × 11¾ in.
(27.9 × 38.7 × 29.8 cm)
Provenance: W.P. Prentice, Elmira, NY, 1928
1937.1620ab*

Much like the shopping bags of today, lightweight pasteboard boxes covered with lively block-printed wallpaper were used by Americans during the second quarter of the nineteenth century to carry their belongings while traveling and to store hats and other valued items at home. The term "bandboxes" derives from their original use as storage containers for collar bands.[1] The colorful printed designs decorating these large oval or round boxes ranged from exotic beasts and romantic scenery to images of American heroes and landmarks. Transportation themes, including coaches, steamships, and canal boats, alluded to the boxes' frequent use on these conveyances.

This bandbox, with a vivid blue background, is trimmed with a three-color, block-printed scene of tropical foliage and parrots perched on branches. On the lid, a shepherdess with a crook is seated near a ram. A third design, a trim in a guilloche pattern, runs along the sides of the lid. Although the maker has not been identified, bandboxes embellished with this parrot wallpaper were probably produced in some quantity. The Nadelmans owned a second box block-printed with this design; the Cooper-Hewitt Museum has an example; and the Shelburne Museum holds two boxes with the parrot print on their lids.[2]

Bandboxes entered Americans' historical imagination by the end of the nineteenth century. The genre painter Edward Lamson Henry depicted a blue bandbox similar to this one atop a flat-top high chest in his romantic Colonial Revival scene, *Memories*, painted in 1873.[3] By the turn of the twentieth century, collectors had discovered the charm of bandboxes. Alexander W. Drake, who was intimately familiar with the art of woodblock printing through his experience as art director of *Scribner's Monthly* (later the *Century Magazine*), amassed a collection of nearly three hundred American bandboxes, many of which were sold at public auction in 1913 (see Stillinger essay, p. 45).[4] Bandbox collectors like Drake may have stimulated the Nadelmans and others to consider the containers as a form of American folk art. Elie and Viola purchased their first bandboxes—one with a firefighting scene and the other a coaching vignette—in 1924.[5] During the 1920s, Electra Havemeyer Webb filled two bedrooms of her Westbury, New York, home with bandboxes, using the lids to create a decorative frieze.[6]

The Nadelmans purchased this bandbox in November 1928 from the antiques dealer William P. Prentice, likely through Prentice's mail order business. They paid $7, a price that reflects the box's excellent condition. (Their other parrot bandbox, noted as being in "poor condition," cost only $4.[7]) Surviving mail order catalogues issued by Prentice in 1929 and 1930 provide a glimpse of his wide-ranging offerings. The twenty-page 1929 catalogue describes more than five hundred items ranging from a 40¢ fashion plate from *Peterson's Magazine* to a $300 Sheraton mahogany dining table.[8]

By 1937, the Nadelmans had amassed an impressive, if unwieldy, collection of bandboxes: the MFPA inventory notes twenty examples "not exhibited because of lack of space."

MKH

1 Catherine Lynn, *Wallpaper in America from the Seventeenth Century to World War I* (New York: W.W. Norton, 1980), 292–300.

2 The Nadelmans' second parrot box, purchased from the Jemima Wilkinson Antique Shop in 1929, is MFPA 2532 (N-YHS INV.8527). The Cooper-Hewitt's is 1913-17-10-a,b. Both boxes have a yellow ground and continue the parrot theme with a single large parrot on the box lid. The Shelburne lids, one with a blue and one with a yellow ground, are illustrated in Lilian Baker Carlisle, *Hat Boxes and Bandboxes at Shelburne Museum* (Shelburne, VT: Shelburne Museum, 1960), 53.

3 Yale University Art Gallery, TR2003.12925.2. See Amy Kurtz Lansing, *Historical Fictions: Edward Lamson Henry's Paintings of Past and Present*, exh. cat. (New Haven: Yale University Art Gallery, 2005), 38, fig. 30.

4 American Art Galleries, New York, "Mr. A.W. Drake's Famous Collections," March 10–17, 1913. See also Carlisle, *Hat Boxes*, vii–viii.

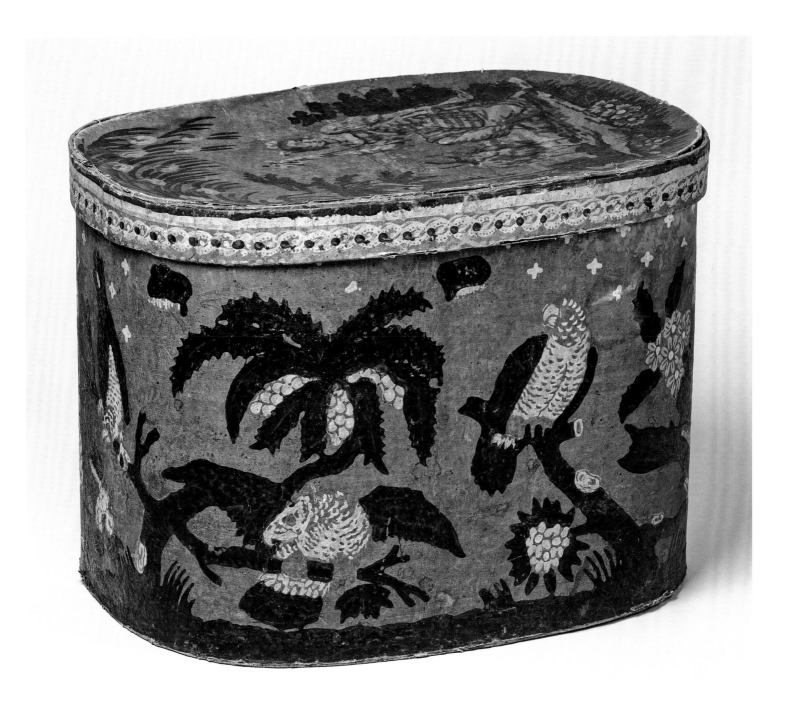

5 The first two boxes were purchased at the George F.
 Ives sale in Danbury, CT, in 1924 for $1 and $3.

6 Carlisle, *Hat Boxes*, viii–ix.

7 MFPA Misc. 2485.

8 A copy of Prentice's June 1929 catalogue,
 "Antiques," is in the Winterthur Library.

35

Unidentified American maker
Tramp art box, ca. 1885–90
Wood, probably cedar; 6⅜ × 12 × 6½ in.
(16.2 × 30.5 × 16.5 cm)
Gift of Elie Nadelman, 1938.374

In December 1938, a year after the New-York Historical Society purchased the Nadelman Folk Art Collection, Elie Nadelman donated an additional forty-two objects, nearly all of which were related to tobacco: cigar store shop figures (including cat. 2), tobacco jars, snuff bottles, pipes, and this object, fashioned from a reused cigar box. When accessioned, it was described simply as a "hobnail wooden box." (The term "hobnail," which referred to the box's appearance rather than a craft technique, was frequently used to describe the all-over pattern of raised dots popular on glassware during the 1930s.) Made in the idiom known today as tramp art, in which wood reused from cigar boxes is chip-carved in triangular notches and layered, the box probably appealed to Nadelman both for its tobacco reference and for its idiosyncratic design. Indeed, the sculptor indulged in cigars and cigarettes and may have formed this auxiliary collection through his smoking habit. Unwittingly, it seems, Elie Nadelman was in the vanguard of collecting tramp art. Though it is considered a quintessential form of folk art today, the term was not coined until the late 1960s, and the first major text on the subject appeared in 1975.[1]

Tramp art, which derived from the chip-carving tradition practiced in Northern Europe, flourished in America from the 1880s to the 1930s. Although collectors have romanticized the art as the work of hobos whittling and chip-carving cigar boxes into objects to be exchanged for food, drink, or lodging, the sizeable and technically ambitious pieces that survive indicate that at least some of the artists were not itinerant, but working in established shops.[2] Nevertheless, few pieces of tramp art are signed and little is known about the majority of artists who produced these eccentric creations.

This relatively simple example of tramp art uses a cigar box to form the container and eight graduated layers of notch-carved wood—probably also from cigar boxes—to embellish the top and sides.[3] Tiny nails are used to attach the layers to the box, and small brass hinges secure the lid. Red and green paint, once brilliant, decorate the carved layers. The stamped lid interior bears the mark of cigar manufacturers Lewyn & Martin, who were active in New York City during the mid-1880s.[4] An image of a hand with smoking cigar enlivens the inside of the box; the same image adorns the otherwise plain back. The prominence given to smoking imagery suggests that this reconstituted cigar box was still intended to fulfill its original function.
MKH

1 The earliest recognition of the craft was Frances W. Lichten's "Tramp Work: Penknife Plus Cigar Boxes," *Pennsylvania Folklife* 10:1 (Spring 1959): 2–7. The term "tramp art" came into use about a decade later. See "Year's Final Show Has Some Rarities for Antiques Fans," *New York Times*, December 2, 1969, in which the writer mentions a clock case made of cigar boxes in a dealer's booth at an antiques show: "'tramp art' the proprietors called it." The first comprehensive study of the genre was Helaine Fendelman, *Tramp Art: An Itinerant's Folk Art* (New York: E.P. Dutton, 1975), which accompanied an exhibition at the American Folk Art Museum.

2 Helaine Fendelman and Jonathan Taylor, *Tramp Art: A Folk Art Phenomenon* (New York: Stewart, Tabori & Chang, 1999), 42–45, 65–72; Clifford A. Wallach and Michael Cornish, *Tramp Art: One Notch at a Time* (New York: Wallach-Irons, 1998), 15–17.

3 Tramp art boxes are often more elaborate than this example. See Wallach and Cornish, *Tramp Art*, 96–109, ills.

4 In 1885, the factory was located on the Upper East Side of Manhattan, at 1228–1232 Second Avenue. City directories list the partnership beginning in 1881–82; by 1888–89 Adolph Lewyn and Max Martin were pursuing separate interests.

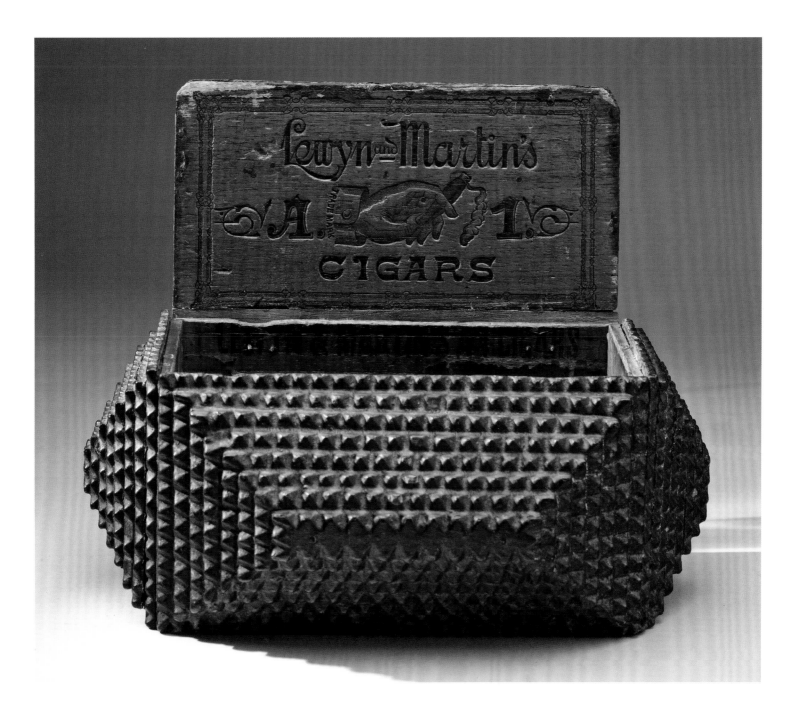

36

Clarkson Crolius, Sr. (American, 1773–1843)
Spouted pitcher, 1798
New York City
Salt-glazed stoneware with cobalt oxide; 11 × 8½ in.
(27.9 × 21.6 cm)
Provenance: Dodge family, Middletown, NY, early
nineteenth century; Mrs. L. B. Caswell, Jr. (Eliza
Moak), Fort Atkinson, WI, 1904; Matthew Holden,
Rye or Jamaica, NY, by 1927
1937.587

This decorated stoneware vessel was one of the Nadelmans' most prized objects. In 1931 Elie Nadelman explained its importance to his fellow Americana collector Henry Francis du Pont: "It is not only the outstanding piece of early New York pottery, but it is the only magnificent work of the early New York potters which is signed and dated. . . . [Crolius was] the most famous of the New York potters. . . . This piece . . . is a constant delight."[1] Scholars today concur with Nadelman's assessment. The pitcher is profusely and exuberantly ornamented with incised and punched flowers and vines, filled with cobalt oxide. A freehand inscription incised into the clay reads, "New York Feb[y] 17th, 1798," "Blue," and "Flowered by M[r]. Clarkson Crolius."[2] Crolius's grandfather, Johan Willem Crolius, had emigrated to New York from Germany in 1718, establishing the city's first stoneware pottery and founding an American stoneware dynasty that thrived until 1849.[3] The enterprising Clarkson greatly expanded the business, exporting wares as far as New England and the Carolinas.[4] By the early years of the nineteenth century he had also become a prominent citizen, serving as an

alderman and eventually state assemblyman.[5] Although numerous pieces of Crolius stoneware bear the pottery's stamp, this is the only vessel with Clarkson's signature.[6]

Because of its large cylindrical spout, the vessel has frequently been called a batter pitcher, but the tiny, rough piercings at the junction of the body and spout were clearly not intended for the passage of a thick liquid. The form may in fact be a "spout pitcher," one of the products cited in the 1809 price list issued by the Crolius pottery.[7]

This object is unusual among the Nadelman holdings in having an early history of ownership. The *Craftsman* published an article about the pitcher in 1904, when it was owned by Mrs. L.B. Caswell, Jr., of Fort Atkinson, Wisconsin. Mrs. Caswell recalled its early history in Middletown, New York, "in the early part of the nineteenth century":

> One hot summer's day, Grandma Dodge, who was then a young girl, drove into town with money to buy a print dress for herself. She saw this jug in a shop window and could not resist the temptation to buy it; for it was harvest time, and the jug was

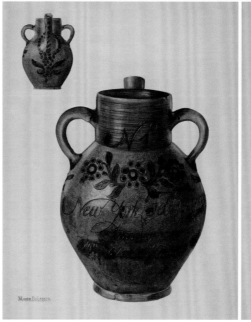
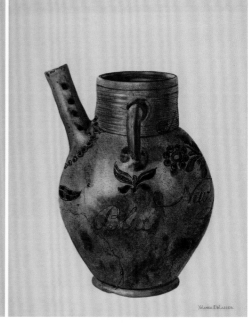

Fig. 99. Yolande Delasser, *Water jug [Spouted pitcher]*, ca. 1936. Watercolor with white heightening over graphite on paper, 11½ × 9 in. (29.2 × 22.8 cm) and 10⅞ × 9 in. (27.6 × 22.9 cm). National Gallery of Art, Washington, DC, 1943.8.6394, 1943.8.6395

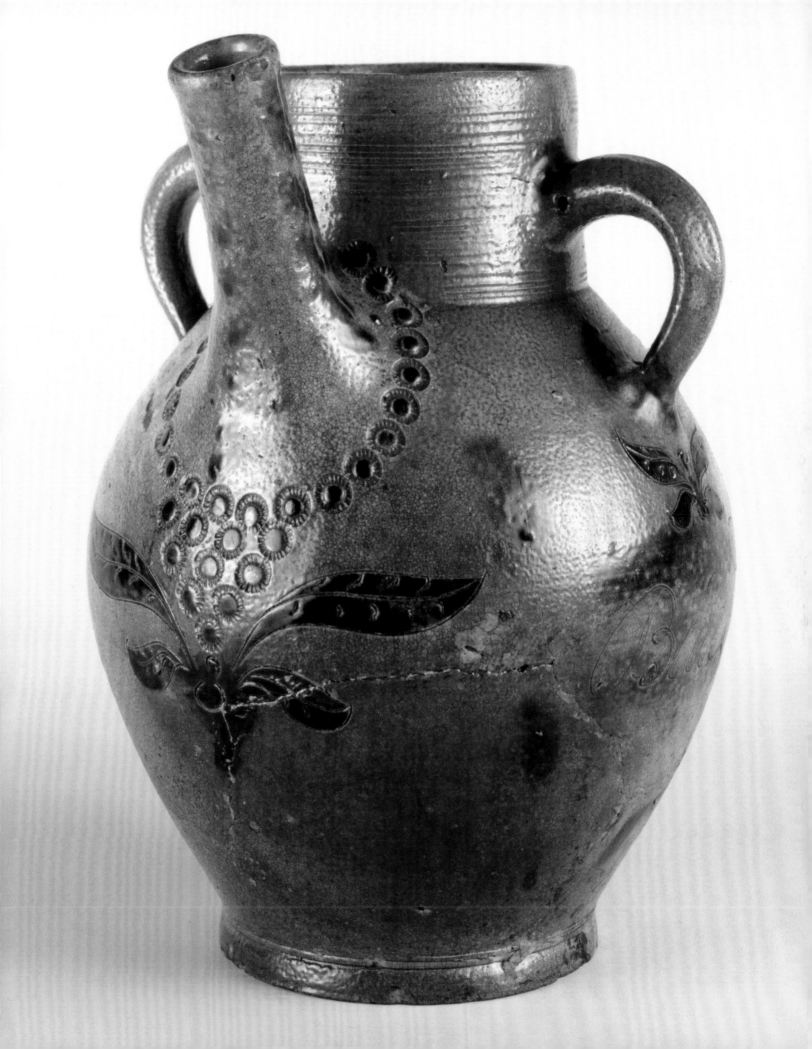

exactly what she needed. It was Grandma's task to carry a field lunch to the men every day at ten o'clock, and it was difficult to keep the coffee as hot as they liked it. See! There are the little holes where the wire bale was fitted; –for it had a handle and a pewter cover in those days.

Grandma never even looked at the "sprigged frocks," but carried home the jug instead. Good service it did, too, until the family came West, and even here in Wisconsin, as long as there were fields to harvest and lunches to carry, it continued its labors.[8]

Around the time it appeared in the *Craftsman*, the pitcher also began to attract the attention of pottery historians and collectors.[9] Collector-dealer Matthew Holden may have traveled out West to pry the pitcher loose from Mrs. Caswell, as dealer Katharine Willis noted in a letter to Viola Nadelman in 1927 that she was "so pleased that you got the important Crolius piece that Mr. Holden went out for."[10] Though it was clearly in the Nadelmans' museum by this date, there is no record of the purchase in the MFPA cards. However, the couple did purchase forty-three other pieces of pottery from Holden between 1926 and 1930.

The Crolius pitcher was exhibited at the center of a glass display case in Gallery VIII (see fig. 100), the MFPA's pottery gallery, which included at least twenty-one other pieces marked by Clarkson or his son, Clarkson, Jr. Also on view were many examples of German salt-glazed stoneware, a juxtaposition no doubt intended to demonstrate the important links between American stoneware and its European antecedents. In 1936, the piece was selected for inclusion in the Index of American Design (see Olson Hofer essay, p. 29). The stunning watercolors (fig. 99) executed by artist Yolande Delasser, working on site at the MFPA, depict the pitcher from three different angles.[11]

MKH

1 Elie Nadelman to Henry Francis du Pont, November 11, 1931, NP. Viola Nadelman also regarded the pitcher as "one of the gems of her collection." See Katharine Willis, "Early New York Pottery," *Country Life* 54:5 (September 1928): 78.

2 The neck is also incised "N 1."

3 Janine E. Skerry and Suzanne Findlen Hood, *Salt-Glazed Stoneware in Early America* (Williamsburg, VA: Colonial Williamsburg Foundation in association with the University Press of New England, 2009), 192–93.

4 William C. Ketchum, *Potters and Potteries of New York State, 1650–1900*, 2nd ed. (Syracuse: Syracuse University Press, 1987), 49.

5 New-York Historical Society, *Catalogue of American Portraits in The New-York Historical Society* (New York: New-York Historical Society; New Haven: Yale University Press, 1974), 2:177. The N-YHS's portrait of Crolius by Ezra Ames (1863.8), painted in 1825 when he was speaker of the state assembly, depicts a refined gentleman who clearly identified himself as a statesman rather than an artisan.

6 A covered pitcher held by the N-YHS (1926.16ab) is also incised with the name Crolius, but it may have been signed by his son, Clarkson Crolius, Jr. (1808–1887).

7 The price list, held by the American Antiquarian Society, is illustrated in John A. Burrison, *Roots of a Region: Southern Folk Culture* (Jackson: University Press of Mississippi, 2007), 118.

8 Elizabeth M. Short, "A Clarkson Crolius Jug," *Craftsman* 6:2 (May 1904): 180, 182.

9 Edwin AtLee Barber, *Marks of American Potters* (Philadelphia: Patterson & White, 1904), 73; idem, *Salt Glazed Stoneware* (New York: Doubleday, Page, 1907), 25 and fig. 41.

10 Katharine E. Willis to Viola Nadelman, November 17, 1927, NP.

11 Clayton 2002, 110–11.

37

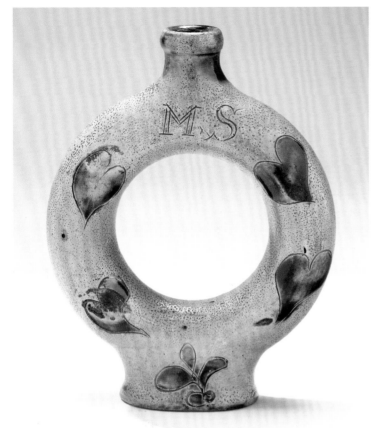

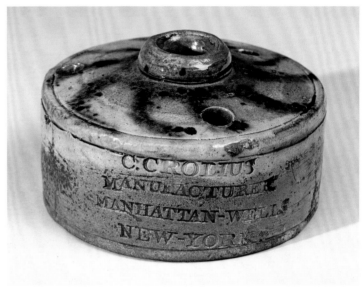

Unidentified American maker
Ring bottle, 1800–30
Probably New York City
Salt-glazed stoneware; 6½ × 5½ × 1¾ in.
(16.5 × 14 × 4.4 cm)
1937.579

Clarkson Crolius, Sr. (American, 1773–1843)
Inkwell, ca. 1800–14
New York City
Salt-glazed stoneware; 2 × 3¾ in. (5.1 × 9.5 cm)
1937.719

Thomas W. Commeraw (American, active
ca. 1796–1819)
Jug, 1796–1819
New York City
Salt-glazed stoneware; 12 × 7¾ in. (30.5 × 19.7 cm)
1937.820

William Howard (American, active 1806–09)
Jug, ca. 1806–09
New York City
Salt-glazed stoneware; 6¾ × 4½ × 4½ in.
(17.1 × 11.4 × 11.4 cm)
1937.824

Elie and Viola Nadelman had a passion for pottery, and their voluminous holdings suggest a particular fondness for New York stoneware. The MFPA inventory itemizes more than 130 examples of American stoneware, many of them produced in and around Manhattan during the first half of the nineteenth century. Photographs of Gallery VIII, which housed the MFPA's pottery, reveal a room bathed in natural light, packed floor to ceiling with vernacular wares (figs. 14, 100, 101). Most of the pottery was displayed on open glass shelves, while highlights of the collection, including some American and English pottery, were enclosed in glass cases with sliding doors. Rows of crocks and jugs lined the floor, some two deep, while overflow spilled onto small tables arranged around the room.[1]

Even though the MFPA inventory assigns unique numbers to hundreds of pieces of American pottery, including these examples, extant records do not document all the purchases. The absence of curatorial cards for most of the Nadelmans' American pottery suggests that they were created but

subsequently lost. The cards that do survive suggest some of the sources the couple turned to for American stoneware. A prize jar marked by Xerxes Price of South Amboy, New Jersey, for instance, was purchased from Matthew Holden in 1926 for an impressive $150.[2] Another possible source is Holden's business associate Katharine Willis of Jamaica, New York, who published an article on New York stoneware in *Country Life* in 1928 illustrated entirely with examples from the Nadelman collection, including the inkwell and Commeraw jug discussed here and the Crolius spouted pitcher in cat. 36.[3] Willis's assessment of the Nadelman collection of early New York pottery as "one of the finest ever assembled" intimates her own role in building it, and correspondence between Willis and Viola Nadelman confirms that she offered ceramics to the couple.[4]

The petite ring bottle, which is just visible near the bottom of the glass display cabinet in Gallery VIII (see fig. 100), is decorated with incised and cobalt-filled motifs suggestive of early nineteenth-century New York stoneware.[5] The incised initials "M S" framed by hearts

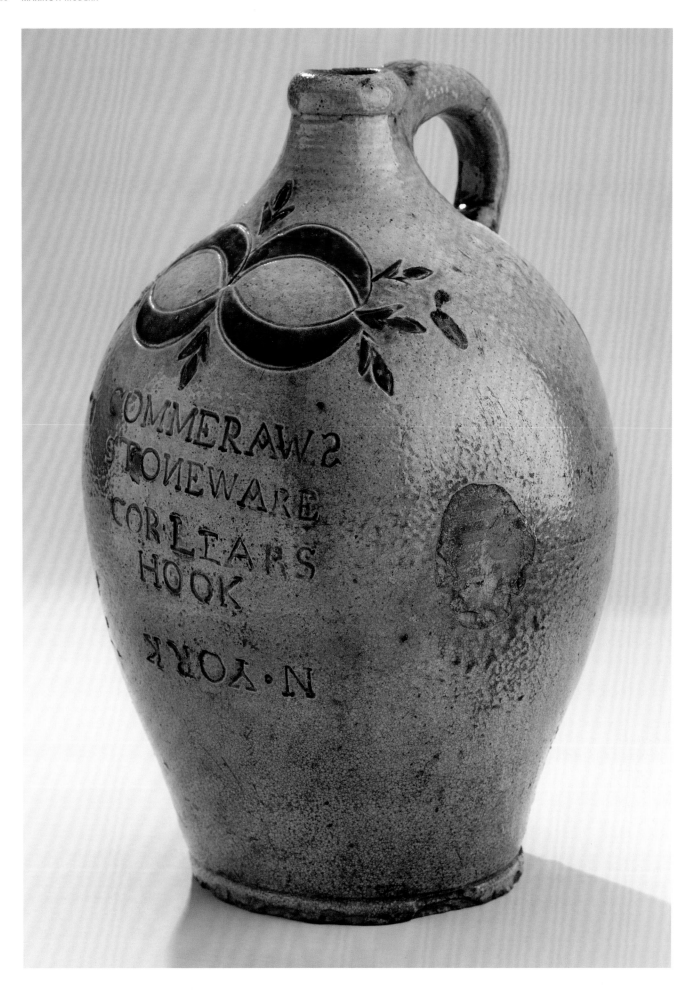

suggest that it was a gift for a loved one. A Germanic form identified with farm work, ring bottles were seldom produced by American stoneware potters; those that survive were likely special orders made for presentation.

The Crolius inkwell is barely visible in the same display cabinet, on a central shelf to the right of the Crolius spouted pitcher. Its mark, "C. CROLIUS / MANUFACTURERS / MANHATTAN-WELLS / NEW-YORK," refers to the pottery's location near the city's water supply. Although inkwells like this were produced in large quantity by the Crolius manufactory, this particular example is notable for the animated pinwheel motif painted in cobalt around the opening.

The taller jug bears the distinctive decorative swags and mark of Thomas W. Commeraw, whose pottery was located at Corlear's Hook on the East River, near today's Chinatown.[6] Like Crolius, Commeraw marked his wares boldly with his name and location. Several reversed letters as well as the upside-down "N·YORK" contribute to the jug's folky quality. Commeraw was long assumed to be a potter of European origin, like his local competitors Clarkson Crolius, Sr., and John Remmey III. New research has revealed that

Commeraw was in fact a free African American who not only ran a successful pottery but was active in the antislavery and colonization movements.[7]

The Nadelmans were probably drawn to the patriotic and whimsical imagery on the diminutive jug, which features not only incised and cobalt-filled decoration but also motifs filled with manganese oxide and wavy combed decoration on its upper third. The primary motifs include crossed flags flanking a Liberty pole surmounted by a Phrygian cap, above the inscription "N*York," as well as a dolphin or another fantastical sea creature with water erupting from its spout. The initials "R R" probably reference the person to whom the jug was presented. The piece is boldly signed "Made by Bill Howard," likely by the William Howard who appears in New York City directories between 1806 and 1809 living on Cross (now Park) Street. Howard was probably a worker in the pottery of either Clarkson Crolius, Sr., or John Remmey III. Willis singled out this jug in her article on the Nadelmans' pottery collection, noting that it "always attracts the attention of visitors to the Museum."[8]

MKH

1 The MFPA inventory tallies more than one thousand pieces of pottery in Gallery VIII. American pottery made up the lion's share with 473 items, followed in number by Swiss (143), Hungarian and Czechoslovakian (140), French (120), and English (106) examples. More modest displays of pottery from Spain (50), the Netherlands (16), Germany (14), and Italy (12) rounded out the collection.

2 N-YHS 1937.920. In addition to Holden, the Nadelmans purchased stoneware from dealers Armstrong of Norwich, CT; S.N. Thompson of Woodbury, CT; Sara M. Sanders of Closter, NJ; Stephen Van Rensselaer of New York City and Peterborough, NH; and Charles R. Morson and the firm of Ginsburg & Levy, New York City. See MFPA Pottery cards 1162, 1495, 870, 868, 884, and 1184, respectively.

3 Katharine Willis, "Early New York Pottery," *Country Life* 54:5 (September 1928): 72, 77–78.

4 Katharine Willis to Viola Nadelman, March 16, 1928, NP.

5 The bottle still bears its Nadelman sticker marked "1114 / Am" and can be linked via its MFPA number to the "Harvester's or field bottle" cited in the MFPA inventory.

6 Although the Nadelmans' source is unknown, the jug is quite similar to one advertised by McKearin's in 1928. See *The Magazine Antiques* 13:3 (March 1928): 180.

7 The discovery was made by Brandt Zipp of Crocker Farm auctioneers around 2003. See http://www. commeraw.com/. Commeraw worked as an advocate for the American Colonization Society, which promoted the "return" of free African Americans to Africa. The potter's account of his 1820 trip to Sierra Leone for the promotion of colonization appeared as a letter to the editor in several newspapers, including the *National Advocate* [New York], June 13, 1820.

8 Willis, "Early New York Pottery," 78. The article discusses the Howard jug and illustrates the Commeraw jug and Crolius inkwell shown here.

38

Unidentified American makers

Face jug, ca. 1860–80
Edgefield District, SC
Alkaline-glazed stoneware, kaolin; 7⅛ × 5¾ × 7 in.
(18.1 × 14.6 × 17.8 cm)
1937.1410

Face jug, ca. 1860–80
Edgefield District, SC
Alkaline-glazed stoneware, kaolin;
6⅞ × 6¼ × 5½ in. (17.5 × 15.9 × 14 cm)
1937.1409

During the mid-nineteenth century, African American potters working in the Edgefield District of South Carolina began producing peculiar stoneware vessels incorporating faces with bulging eyes and gaping mouths.[1] Long misunderstood as racist statements, or as novelties created by potters in their spare time, these intriguing objects are now believed to have functioned as ritual vessels among African Americans living in and around Edgefield.[2] New evidence suggests that face jugs relate to the Kongo ritual known as a "conjure," in which a diviner or shaman used a distinctive vessel known as a *nkisi* to hold magical materials and make contact with the spirit world.[3] The use of kaolin clay, a material traditionally considered magical in West Africa, to form the white eyes and teeth hints at a link to Kongo ritual.[4]

The Nadelmans may have been introduced to face jugs through Edwin AtLee Barber's discussion of the form in his influential study, *Pottery and Porcelain of the United States.*[5] Barber described them as "weird-looking water jugs, roughly modeled on the front in the form of a grotesque human face,— evidently intended to portray the African features." Interestingly, the Nadelmans used the nomenclature "monkey jug" when

itemizing at least two of these in the MFPA inventory, a term that Barber employed, explaining that it was used "not on account of their resemblance to the head of an ape, but because the porous vessels which were made for holding water and cooling it by evaporation were called by that name."[6] Barber's publication of Edgefield face jugs and efforts to secure examples for the Philadelphia Museum of Art, where he was a curator, effectively mainstreamed the form and encouraged other institutions and pottery collectors to acquire them.[7] Unfortunately, the Nadelmans' source for their four face jugs is undocumented, although their MFPA numbers suggest that they were purchased separately between 1927 and 1930.[8]

Two face jugs, including the larger one here, are visible in a glass display cabinet in Gallery VIII (fig. 100), where they are grouped with earthenware animals, including dogs, squirrels, and monkeys, as well as a fiddler with African American features (cat. 41). The four vessels are also prominent in a 1939 photograph showing N-YHS art handler Joseph Rapport applying accession numbers to the recently acquired Nadelman collection (fig. 26).[9]

MKH

Fig. 100. Detail of the Pottery Room, Gallery VIII of the MFPA, ca. 1935. NP

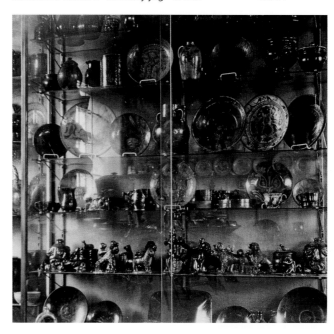

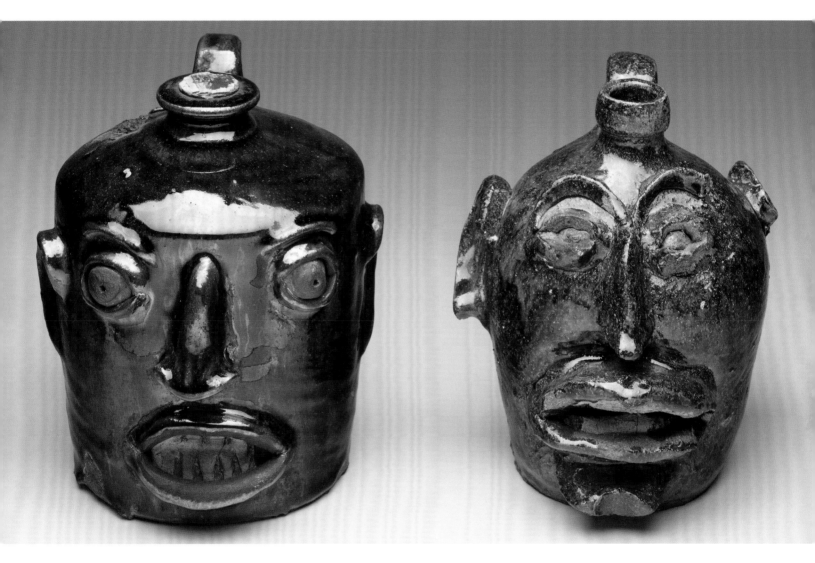

1 Located in west-central South Carolina, the
 Edgefield District comprised today's Edgefield,
 Aiken, and Greenwood counties.

2 Claudia Mooney et al., "African-American Face
 Vessels: History and Ritual in 19th-Century
 Edgefield," *Ceramics in America 2013*, ed. Robert
 Hunter (Hanover, NH: Chipstone Foundation
 distributed by the University Press of New England,
 2013), 2–37. See also Mark M. Newell with Peter
 Lenzo, "Making Faces: Archaeological Evidence of
 African-American Face Jug Production," *Ceramics
 in America 2006*, ed. Robert Hunter (Hanover,
 NH: Chipstone Foundation distributed by the
 University Press of New England, 2006), 123–38;
 John Michael Vlach, *The Afro-American Tradition in*

Decorative Arts (Athens, GA: University of Georgia
 Press, 1990), 81–94.

3 For an example of an African *nkisi*, see Vlach, *Afro-
 American Tradition*, 86, fig. 78.

4 Mooney et al., "African-American Face Vessels,"
 24.

5 The discussion of face jugs did not appear until
 the third edition, published in 1909. Edwin AtLee
 Barber, *The Pottery and Porcelain of the United
 States*, 3rd ed. (New York: G.P. Putnam's Sons,
 1909), 465–67.

6 Ibid., 466.

7 For example, Philadelphia Museum of Art, 1904-
 36, 1904-37, 1917-196. An Edgefield jug was
 purchased by the Metropolitan Museum of Art,

New York, in 1922 (22.26.4).

8 Three face jugs can be identified in the MFPA
 inventory: "1237 Grotesque jug," "1376
 Monkey jug (grotesque)," and "1185 Monkey
 jug (grotesque)." The fourth is identified by its
 Nadelman collection label marked "1097 / Am"
 (N-YHS 1937.1412). The estimated purchase dates
 are based on documented pottery acquisitions with
 contiguous MFPA numbers.

9 Two of the four Nadelman face jugs, 1937.1411
 and 1937.1412, were deaccesssioned. See
 Sotheby's, New York, "Americana and Decorative
 Arts: The Property of the New-York Historical
 Society," January 29, 1995, lot 297.

39

Samuel Troxel (American, 1803–1870)
Dish, 1828
Upper Hanover Township, Montgomery County, PA
Lead-glazed red earthenware, slip, copper oxide;
1⅞ × 11¼ in. diam. (4.8 × 28.6 cm)
Provenance: Alfred G. Rolfe, Pottstown, PA, 1903;
Matthew Holden, Rye or Jamaica, NY, 1926
1937.708*

This tour de force of Pennsylvania-German pottery held pride of place in Gallery VIII of the MFPA, which displayed a dizzying array of European and American ceramics. It stood front and center in a glass display case of American ceramics (fig. 100), accompanied by other fine examples of red earthenware made using the *sgraffito* technique, in which the potter incised decoration through a layer of creamy slip (liquid clay) that revealed the red clay body beneath.

Potter Samuel Troxel employed a captivating melange of Pennsylvania-German motifs, patriotic imagery, and political language in his bold design. A plant with striated leaves and pendulous tulip flowers grows from an undersized flowerpot. Perched precariously between its two stems is an American eagle with outspread wings and a striped shield at his breast. Above, in a banner-like reserve, is the inscription "LIBERTY FOR / J. A. JACKSOИ."[1] Accents of green glaze, achieved with copper oxide, enhance the dish's vivid design—and would also have increased its cost.

Troxel's showpiece is characteristically rich with text on both front and back. Pennsylvania-German *sgraffito* dishes often carried an inscription around the edge with a motto, proverb, biblical quotation, or humorous rhyme.[2] This dish is embellished with what would have been appreciated as an entertaining, if irreverent, verse: "Unser magd die sau, die ver alle tag gern eine frau," which translates loosely as "Our maidservant the sow, who would gladly be a lady any day."[3] Though Troxel confidently incised his name and the year of manufacture on the obverse, he felt compelled to scratch mostly redundant details into the clay on the underside: "Samuel Troxel / Potter october the / 6th A. D. 1828, / in the year of / our Lord." At the bottom, he added the price of his product: "12 1/2 cent [sic]." With Troxel's extensive verbiage, this piece must rank among the most loquacious and well-documented examples of American redware.

Based on his surviving output, Samuel Troxel held strong political views or served a clientele eager to publicize their political leanings. A dish dated 1833 includes similar iconography and the inscription "LIBERTY FOR GACKSON [sic]," while another example dated 1846 is inscribed "LIBERTY Fr POLK."[4] Other dishes incorporate the American eagle alone or with the Liberty banner, without specific reference to a president or presidential candidate.[5]

The owner of this dish was demonstrating support for presidential candidate Andrew Jackson, the Tennessee frontiersman and army general. Jackson earned the Democratic Party's nomination in a rematch with incumbent John Quincy Adams. Despite extensive mudslinging on the part of Republicans, including charges of bigamy against Jackson's wife Rachel, Jackson ultimately prevailed, handily defeating Adams in the 1828 general election. German immigrants were solidly in favor of Jackson's candidacy: one newspaper reported that ten of the twelve German newspapers in Pennsylvania supported the "Hero of New Orleans."[6]

The Nadelmans paid the astonishing price of $200 for this piece when they purchased it from Matthew Holden in September 1926.[7] The high price tag reflected the popularity of *sgraffito* ware, which had been "discovered" by Edwin AtLee Barber in 1891 after his purchase of a Troxel plate. Assuming that its German inscription was indicative of German manufacture, Barber investigated the plate's history, identifying its Pennsylvania origins as well as the rich tradition of incised redware among German immigrant potters.[8] Barber published his definitive work on the subject—doubtless familiar to the Nadelmans—in 1903 and included reference to this particular piece. At the time it was owned by Professor Alfred G. Rolfe, an instructor at the Hill School in Pottstown, Pennsylvania.[9]

MKH

1 Troxel appears to have begun incising Jackson's
 name incorrectly and simply started over rather
 than attempting a correction; as a result, he ran out
 of space and had to cramp letters toward the end
 of the presidential candidate's name.

2 Edwin AtLee Barber, *Tulip Ware of the Pennsylvania-German Potters* (Philadelphia: The Pennsylvania Museum and School of Industrial Art, 1903), 27–28.

3 Barber referred to the verse on this dish as a "doggerel couplet." It is unclear whether he had difficulty with its translation or was offended by the coarse humor. Ibid., 167.

4 Philadelphia Museum of Art, 60-120-1 (Garvan 1982, 205, no. 143); Metropolitan Museum of Art, New York, 34.100.126.

5 Pook & Pook, Downingtown, PA, January 11, 2008, lot 387; Philadelphia Museum of Art 1893-211; 1994-20-9.

6 Lydia Blackmore, "Objects for President: Campaign Material Culture and Populist Politics, 1828–1848" (master's thesis, University of Delaware, 2013), 70.

7 MFPA Pottery 781.

8 Barber, *Tulip Ware*, 3.

9 Ibid., 167.

40

J. Eberly & Co. (American, active 1874–1903)
Washbowl, ca. 1890
Strasburg, VA
Lead-glazed red earthenware, manganese and
copper oxides; 7¼ × 17¾ × 16 in.
(18.4 × 45.1 × 40.6 cm)
Provenance: Katharine Willis, Jamaica, NY, 1930
1937.1458*

Probably Asa E. Smith (American, 1798–1880)
Dish, ca. 1825–50
Norwalk, CT
Lead-glazed red earthenware, slip; 1½ × 10¼ in.
(3.8 × 26 cm)
Provenance: W.F. Cooper, New York City, 1927
1937.703*

Solomon Miller (American, 1832–1916)
Bowl, 1872
Adams County, PA
Lead-glazed red earthenware, iron oxide;
2⅞ × 5½ in. (7.3 × 14 cm)
1937.694

Unidentified American maker
Box, 1851
Probably Pennsylvania
Unglazed red earthenware; 4 × 4 × 4 in.
(10.2 × 10.2 × 10.2 cm)
Provenance: Claude W. Unger, Pottsville, PA, 1926
1937.1451ab*

Unidentified American maker
Roach trap, ca. 1840
Probably Pennsylvania
Lead-glazed red earthenware; 3⅝ × 5¼ in.
(9.2 × 13.3 cm)
Provenance: Matthew Holden, Rye or Jamaica, NY,
1927
1937.1729*

The Nadelmans packed the shelves of Gallery VIII in the MFPA with American earthenware. While Pennsylvania examples predominated, they collected pottery made as far afield as New England, Ohio, and South Carolina. They were drawn to quirky forms, expressive ornament, and unusual decorative techniques, some of which are seen in these examples.

The "Apple Pie" dish boldly announces its intended contents in an elegant script. With its drape-molded construction, coggled edge, and distinctive slip-trailed writing, the pie dish is typical of wares produced by the Asa E. Smith Pottery in Norwalk, Connecticut. In fact, much of the "slip-script" ware produced by the Smith pottery was decorated by the same hand, thought to be that of Henry Chichester.[1] The Nadelmans purchased this dish, one of several Norwalk "slip-script" examples in the MFPA, from the midtown Manhattan antiques dealer W.F. Cooper in 1927 for $10.[2] Other Smith pottery wares included dishes and platters inscribed "Cheap and Good," or "Mary's Dish," as well as politically themed examples inscribed "Lafayette" and "Hurrah for Cleveland President of the U.S."[3] The Nadelmans catalogued their Norwalk pieces as American earthenware, as scholars had not yet linked these distinctive dishes to the Smith pottery.

The couple must have been delighted with their earthenware roach trap, a triumph of ingenious design. One of three examples in the MFPA, it was purchased for $4.[4] Cockroaches were as much a nuisance in the nineteenth century as they are today; the ceramic "roach motel" was an inventive solution. The hole near the bottom edge of the hollow trap was corked, then a bait of sweet, sticky molasses was poured into the hole on top. Insects lured by the scent would climb the unglazed, ribbed outside wall to the funnel-shaped well, which was glazed and therefore slippery; then they would slide down into the hole and end up trapped inside. The Nadelman roach trap was considered significant enough for inclusion in the Index of American Design (see Olson Hofer essay, p. 29).[5]

The unglazed square box with pricked decoration is an anomalous example of American pottery that must have appealed to the Nadelmans because of its peculiar form and charming decoration of hearts and stars. The lid is incised "Nov 12 / 1851," but the object does not offer clues about its regional origin. Its purchase in Pennsylvania suggests possible manufacture in that state.[6] The function of the container, whose lid fits inside the walls of the box to compress its contents, is unclear. The Nadelmans called it a tobacco box in their curatorial records and inventory, although when it was catalogued at the N-YHS in 1937, presumably under Elie Nadelman's direction, it was identified as a cheese pot. Both the unglazed surface and simple slab construction are unusual in American redware, and suggest that it might have been made by an artisan, such as a brickmaker, not equipped with the typical tools and materials of a potter.

The simple redware bowl decorated with a wavy band of iron oxide is more clearly documented. The underside is incised "Solomon / Miller / Jan #22 / 1872," leaving little question about its maker. Miller, a third-generation potter who worked in Adams County, Pennsylvania, signed a number of finely thrown and glazed redware pieces, suggesting that he was a skilled potter.[7] According to historian Jeannette Lasansky, women of the family, particularly Miller's young niece Ameda, actually incised his name on his wares.[8] The bowl's spare, abstract ornament, which has the fluidity of traditional Chinese brush painting, would have had visceral appeal for a modernist artist of the 1920s.

The delightful redware washbowl with polychrome glaze was made in the Shenandoah Valley region, whose pottery industry thrived due to an abundance of natural clays and the creative spirit of its potters, many of them German immigrants. Based on similar marked examples, this wheel-thrown basin coated in cream-colored slip accented with streaks of green copper and brown manganese oxides was probably made by Jacob Jeremiah Eberly's pottery in

Strasburg, Virginia.[9] The basin has a pierced soap dish at the rear, crowned by coiled clay scrollwork flanked by balls of clay. When the Nadelmans purchased the washbowl from Katharine Willis in December 1930, it was en suite with a pitcher and it cost a hefty $90.[10] They identified it as a product of the Strasburg potter Solomon Bell, who was traditionally associated with these distinctive washbowl and pitcher sets.[11]

MKH

1 See Brian Cullity, *Slipped and Glazed: Regional American Redware*, exh. cat. (Sandwich, MA: Heritage Plantation, 1991), 40, 44, pl. III; William C. Ketchum, *American Redware* (New York: H. Holt, 1991), 64–65.

2 MFPA Pottery 1122.

3 MFPA Pottery 788 (N-YHS 1937.1464), purchased from Matthew Holden in 1926; MFPA Pottery 871, purchased from Sara M. Sanders in 1926; MFPA Pottery 1129 (N-YHS 1937.714); and N-YHS 1937.584.

4 MFPA Pottery 1073. The others are MFPA Pottery 234 (N-YHS INV.12643), purchased for $5 from Claude Unger, Pottsville, PA, in 1926; Sotheby's, New York, January 29, 1995, lot 299.

5 National Gallery of Art, Washington, DC, 1943.8.13373. The watercolor was executed by Yolande Delasser around 1936. See Harold F. Guilland, *Early American Folk Pottery* (Philadelphia: Chilton Books, 1971), 271, ill.

6 MFPA Pottery 236, purchased from Claude Unger in March 1926 for $12.

7 http://www.crockerfarm.com/Items/cpmx01.htm.

8 Jeannette Lasansky, *Central Pennsylvania Redware Pottery, 1780–1904* (University Park: Pennsylvania State University Press, 1979), 17.

9 A marked example is in the Metropolitan Museum of Art, 1983.206.8. See also Comstock 1994, 279–80.

10 MFPA Pottery 1420; the pitcher is N-YHS 1937.1428.

11 Comstock 1994, 279 n. 31.

41

Unidentified American maker
Lion, 1830–60
Southeastern Pennsylvania
Lead-glazed red earthenware; 5⅛ × 2¼ × 5⅝ in.
(13 × 5.7 × 14.3 cm)
1937.684

Unidentified American maker
Fiddler with dog, 1840–80
Southeastern Pennsylvania
Lead-glazed red earthenware; 7⅜ × 5½ × 3¼ in.
(18.7 × 14 × 8.3 cm)
Provenance: Claude W. Unger, Pottsville, PA, 1926
1937.670*

Unidentified American maker
Squirrel, 1840–80
Southeastern Pennsylvania
Lead-glazed red earthenware; 4⅛ × 3⅜ × 1¾ in.
(10.5 × 8.6 × 4.4 cm)
Matthew Holden, Rye or Jamaica, NY, 1927
1937.688*

Unidentified American or English maker
Monkey, 1860–90
Lead-glazed earthenware; 7⅜ × 3½ in.
(18.7 × 8.9 cm)
1937.671

Unidentified American maker
Bird whistle, 1830–60
Probably Pennsylvania or Ohio
Lead-glazed red earthenware; 3⅞ × 5½ × 2¾ in.
(9.8 × 14 × 7 cm)
Provenance: Ginsburg & Levy, New York City, 1929
INV.12620*

Figural toys and household decorations made from hand-modeled and colorfully glazed clay were popular gifts and tokens of affection in nineteenth-century America, particularly among German immigrants living in Pennsylvania. These fanciful creatures, which functioned as whistles, banks, or decorative statuettes, may have been influenced in part by earthenware figurines imported from the Staffordshire region of England and the inexpensive chalkware figures also popular among Pennsylvania Germans (cat. 10).[1] The Nadelmans collected a virtual barnyard of clay animals, some displayed in Gallery VIII of the MFPA along with pottery, and others included with the toys in Gallery IX. The pottery display included at least eleven dogs, as well as two monkeys, a lion, a duck, and a chicken, many of which were visible in a glass case (see fig. 100). According to the inventory, the Toy Room held fourteen pottery bird whistles, in addition to the four examples displayed in the English pottery section of Gallery VIII. No doubt the Nadelmans were cognizant of the debt that American craftsmen owed to Staffordshire potters for their inspiration.

The charming bird whistle features a broad body, small pointed head, and flat fan-shaped plumage, with a whistle pipe protruding from its end.[2] The potter molded the body by hand, formed the tail feathers by pinching the clay between his fingers, and incised a heart on the back. Two holes allow the blower to alter the pitch of the whistle. The Nadelmans purchased this light-hearted object for $8 from Ginsburg & Levy in October 1929—ironically, the same month the stock market crashed and ultimately put an end to their collecting.

Nadelman records describe the seated violinist, purchased for $30, as "Negro Fiddler."[3] Indeed, the potter fashioned the male musician as a caricature of an African American.[4] Such racist depictions were not uncommon in clay and in fact pervaded nineteenth-century American culture. As Hollander observes, "The monkey . . . frequently embodied prejudicial caricatures within the climate of slavery, abolition, and the conflict of the Civil War, as a minstrel or liveryman, part African slave and part animal."[5] The Nadelmans displayed the fiddler in a glass display case in Gallery VIII (see fig. 100) with other clay figures, mixing racially charged characters such as this with innocuous domestic or barnyard animals. Interestingly, they chose to flank the small figures with two face jugs made by African Americans, which they referred to as "monkey jugs" (see cat. 38).[6]

The endearing squirrel clutching a nut was displayed on the same shelf in Gallery VIII. Purchased for $15 despite its broken tail, the brown-glazed rodent sits on an oval base stamped with flowers and rings and incised on the bottom with the number "8."[7] The same incised number appears on a pair of dog figures in the Philadelphia Museum of Art, suggesting that they were made by the same hand.[8]

The lion, a symbol of nobility and courage, was a popular motif in Pennsylvania-German folk art. The Nadelmans' amiable king of beasts was hand-modeled, and his fur was delineated by scraping the damp clay with a fork-like instrument.[9] The potter stamped the base with a flowering plant motif and a perimeter of ovals; he used the same oval tool to create the beast's eyes. Like the fiddler and the monkey in this grouping, the lion toy rattles when shaken. The rattle was created by inserting a small ball of loam-dusted clay inside the hollow body before firing.[10]

Unlike the other toys in this group, the monkey figure is molded, not modeled, and its body is made from buff-colored rather than red earthenware. In subject matter, however, the tame primate relates to the fiddler and other figures of street performers. Crouching and wearing a decorative cap, the capuchin resembles the organ grinder monkeys that were a frequent sight on city streets in the nineteenth century. While the grinder cranked his organ, his droll companion attracted attention, performed tricks, and collected money in a tin cup. Such performances, deemed a form of begging, were banned in New York City in 1936.[11] This unusual figure

may have functioned as a hat pin holder: its back is pierced with rows of holes intended for the insertion of long pins.[12] Alternatively, the holes may have been intended to hold incense (or joss) sticks, which were popular during the late nineteenth-century craze for things Japanese.[13]

MKH

1 Hollander 2001, 449. See also Wendy Lavitt, *Animals in American Folk Art* (New York: Knopf, 1990), 77–79.

2 MFPA Toys 537.

3 MFPA Pottery 196.

4 A related figure of a fiddler and dog is at Colonial Williamsburg, 1979.900.6. The Nadelman example, incised "3 I." on the base in a manner similar to

the squirrel figure, was illustrated for the Index of American Design; see Harold F. Guilland, *Early American Folk Pottery* (Philadelphia: Chilton Book, 1971), 276, ill. A spot without glaze on the fiddler's head suggests he may have once had a cap.

5 Hollander 2001, 449. For related examples, see Hollander 2001, nos. 117–18; Garvan 1982, 224, no. 22.

6 Another racist figure visible in the photograph is N-YHS 1937.669, a fez-wearing musician seated on a stump.

7 MFPA Pottery 1068.

8 Garvan 1982, 223, no. 18. The Nadelman squirrel was illustrated for the Index of American Design with a watercolor by Yolande Delasser, National Gallery of Art, Washington, DC, 1943.8.8288.

9 For related examples, see Hollander 2001, no.

115a, 115b. With the stamped ovals and flowers on its base, the lion also relates to figures attributed to the Solomon Bell pottery of Strasburg, VA. See Comstock 1994, figs. 5.89, 5.91.

10 Comstock 1994, 233.

11 Sam Roberts, "Way Back Machine: If Not for Bias in Ariz., N.Y. Might Be Good for Organ Grinders," *New York Times*, August 2, 2010.

12 The large piercings run in regular rows, five across and eight down.

13 "Joss-Sticks," *Arthur's Home Magazine* 60 (May 1890): 455; "How to Make Some Pretty Trifles," *Godey's Lady's Book* 120:719 (May 1890): 430; Florence Pegg Taylor, "Some Oriental Ideas," *Ladies' Home Journal* 20:4 (March 1903): 36. Thanks to Rebecca Klassen for bringing these articles to my attention.

42

Unidentified Spanish maker
Tiles, 1750–1800
Talavera de la Reina, Spain
Tin-glazed earthenware; 8 × 8 × ⅝ in.
(20.3 × 20.3 × 1.6 cm)
Provenance: Anderson Galleries, New York, Francis
Wilson Mark sale, 1927
Z.758–760*

Gallery VIII of the MFPA displayed a smorgasbord of European pottery from the sixteenth through the nineteenth centuries in dialogue with mainly nineteenth-century American ceramics. The Nadelmans concentrated on Hungarian and Czechoslovakian, French, Swiss, and English pottery, while also representing Italian, Dutch, German, and Spanish ceramic traditions.[1] A photograph of Gallery VIII (fig. 14) shows a corner with a dynamic display of Spanish pottery, including these colorful Talavera tiles on the bottom row. The three tiles were purchased by the Nadelmans in a group of nine, all depicting household and table utensils.[2]

The city of Talavera de la Reina, located near Toledo, Spain, was a center of maiolica production from the sixteenth through the eighteenth centuries. Derived from Italian Renaissance maiolica and influenced by Moorish, Islamic, and Far Eastern designs, Talavera pottery became renowned for its polychrome decoration and vigorously painted tile pictures.[3] The Nadelmans may have appreciated the global reach of Talavera production: potters from the Spanish pottery center brought the craft of tin-enameled earthenware to Puebla, Mexico, in the seventeenth century and established an enduring tradition in the New World.[4]

In February 1927, the Nadelmans attended an auction of Hispano-Moresque pottery collected by Francis Wilson Mark, who was British Consul at Palma, Majorca (Spain), from 1884 to 1894. The three-day sale included over one hundred lots of Talavera maiolica tiles, including the nine tiles that the Nadelmans purchased for $75.[5] The couple also picked up two maiolica liqueur bottles from Castelli (Italy) for $17.[6]

It is not surprising that the couple passed over the many lots of tiles painted with figures, hunting scenes, or Baroque scrollwork in favor of these folky tiles featuring domestic implements: a bellows that seems to float in mid-air, primed to stoke a fire; a cauldron balanced on a trivet, licked by red hot flames; and a mortar and pestle set (curiously) on a grassy mound. The tools depicted on the tiles provided a playful link between the pottery in Gallery VIII and the actual implements displayed in the MFPA.
MKH

1 Scandinavian folk pottery is oddly absent from the display, although the Nadelmans collected other objects made in Sweden and Norway.

2 MFPA Pottery 949. According to the Nadelman curatorial cards, the other tiles depicted an oil lamp, knife, powder pouch, pitcher, pan, and jar; they were never accessioned by the N-YHS.

3 Gordon Campbell, ed., *The Grove Encyclopedia of Decorative Arts* (Oxford: Oxford University Press, 2006), 2: 415; Edwin AtLee Barber, *Tin Enameled Pottery: Maiolica, Delft and Other Stanniferous Faience* (Philadelphia: Pennsylvania Museum and School of Industrial Art, 1906), 12–13.

4 See Margaret Connors McQuade, *Talavera Poblana: Four Centuries of a Mexican Ceramic Tradition* (New York: Americas Society, 1999). The Nadelmans may have been familiar with the collection of tin-enameled Mexican earthenware collected by Emily Johnston de Forest and donated to the Metropolitan Museum of Art in 1911.

5 Anderson Galleries, New York, Francis Wilson Mark sale, February 10–12, 1927, lot 148.

6 Ibid., lot 124; MFPA Pottery 918, 919.

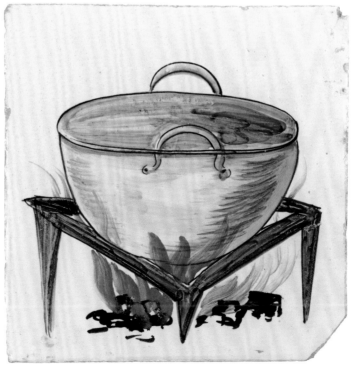

43

Unidentified English maker
Dish, ca. 1825
Staffordshire, England
Lead-glazed earthenware; 7⅛ in. (18.1 cm) diam.
1937.438

Since the 1930s, collectors have referred to vividly colored Staffordshire wares with freehand painted decoration of flowers and fruit as "Gaudy Dutch."[1] Made during the early nineteenth century for export to American consumers, who had a particular fondness for Fancy goods, Gaudy Dutch pottery was an inexpensive imitation of the fine Imari-type porcelains produced at Derby and Worcester. The distinctive palette features underglaze blue decoration with overglaze orange, yellow, green, and red enamels. Gaudy Dutch encompasses at least fifteen different patterns, including the folky "Urn" pattern decorating this dish.[2]

Although records of their purchases do not survive, the Nadelmans amassed at least thirty-four examples of Gaudy Dutch pottery now held by the New-York Historical Society.[3] They might have acquired them under the assumption that they were made in Pennsylvania, a common misconception among early collectors based on the large numbers found in that region. Sam Laidacker set the record straight by 1938,[4] but antique hunters continued to associate the ware with the Pennsylvania Germans and held fast to stereotypes about their taste in tablewares: "Gaudy Dutch pottery . . . was addressed to the spritely taste of a particular folk, the color-loving Pennsylvania-Germans of southeastern Pennsylvania. Here was a fat, smiling farmland that provided bountiful and famous tables; the German folk lived well. And who could imagine golden *Pannhas* (scrapple) on a plain plate, or *Lattwoerick* (apple butter) in anything but a flowered bowl?"[5] Although this characterization is exaggerated, there is no question that the central motif of this Gaudy Dutch pattern, an urn overflowing with flowers, was also a common motif in Pennsylvania-German folk art.

The Nadelmans were among the early collectors of Gaudy Dutch, which remained the purview of relatively few specialized collectors until the 1940s and 1950s. After the sale of the Mary Margaret Yeager collection at Parke-Bernet in 1943, and the first mentions of the ware in *The Magazine Antiques* that same year, prices began a steady climb.[6] Ironically, prices for these modest earthenware pieces rivaled or even surpassed the more refined porcelains that they were made to imitate. The Nadelmans must have been pleased to have acquired this Urn pattern dish in pristine condition. In 1954, Laidacker noted the popularity of the pattern and the high prices it commanded due to "keen competition between a number of collectors."[7]

MKH

1 For an early description of the pottery, see Sam Laidacker, ed., *The Standard Catalogue of Anglo-American China* (Scranton, PA: Privately printed, 1938), a collector's guide with prices. Edwin AtLee Barber used the term "gaudy painted ware" in his 1914 glossary of ceramic terms. See Edwin AtLee Barber, *The Ceramic Collectors' Glossary* (New York: Walpole Society, 1914), 46–47.

2 Other patterns classified by Laidacker include Butterfly, Carnation, Dahlia, Double Rose, Dove, Grape, Leaf, Oyster, Primrose, Single Rose, Strawflower, Sunflower, War Bonnet, and Zinnia.

3 They primarily collected plates and cups with saucers, along with several pieces of hollowware. Two examples in the Zinnia pattern (1937.447, 1937.448) are marked by John and Richard Riley of Burslem, Staffordshire.

4 Laidacker, *Standard Catalogue of Anglo-American China*, 82.

5 Helen Comstock, ed., *The Concise Encyclopedia of American Antiques* (New York: Hawthorn, 1965), 227.

6 Parke-Bernet Galleries, New York, "The Mary Margaret Yeager Collection of Old Staffordshire," March 17–20, 1943; *The Magazine Antiques* 43:3 (March 1943): 138, and 43:5 (May 1943): 230.

7 Sam Laidacker, comp., *Anglo-American China, Pt. 1* (Bristol, PA: Privately printed, 1954), 72.

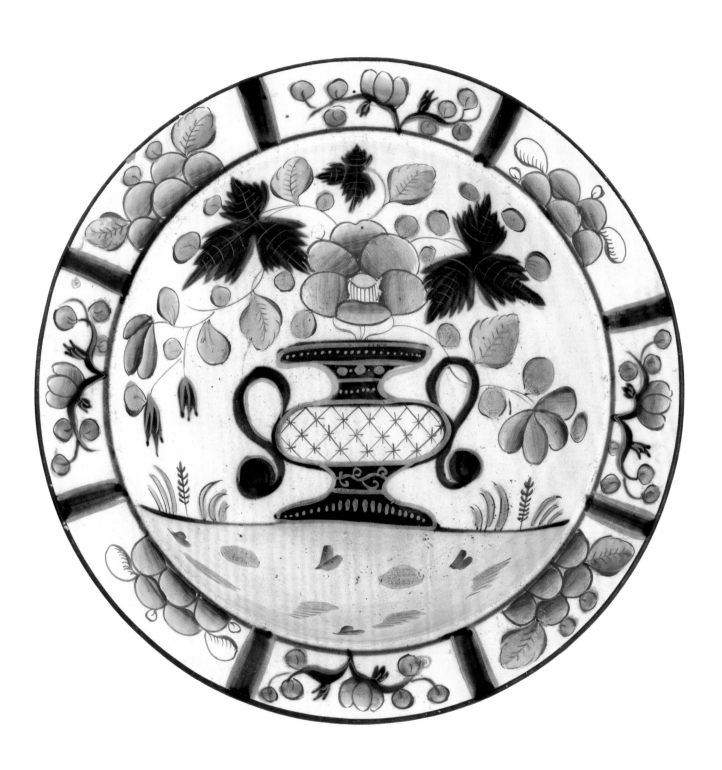

44

Unidentified English makers

Child's plate: "Amusement," 1815–40
Glazed earthenware; 6½ in. (16.5 cm) diam.
INV.9965

Child's plate, Franklin's maxim: "He that hath a trade," 1830–50
Glazed earthenware; 7⅛ in. (18.1 cm) diam.
Provenance: Katharine Willis, Jamaica, NY, 1926
INV.9973*

Child's plate, Franklin's maxim: "Industry needs not wish," 1830–50
Glazed earthenware; 7¼ in. (18.4 cm) diam.
Provenance: Katharine Willis, Jamaica, NY, 1926
INV.9974*

Child's plate, Franklin's maxim: "Keep thy shop," 1840–70
Glazed earthenware; 6¾ in. (17.1 cm) diam.
INV.13535

Charles Allerton & Sons (English, active ca. 1859–1942)
Child's plate: Punch and his dog Toby, 1865–80
Longton, Staffordshire, England
Glazed earthenware; 6⅞ in. (17.5 cm) diam.
INV.9972

Alphabet wares—plates and mugs with a molded or printed alphabet and/or a printed child-friendly scene—have been made since the late eighteenth century for moral and educational instruction and as a reward for good behavior and achievement. Particularly popular in the Victorian era, they were manufactured by as many as sixty different potteries throughout Britain.[1] Manufactories churned out edifying and entertaining children's wares in large quantity for an expanding middle-class market.[2]

The Nadelman records document the purchase of at least ten plates and mugs, but additional examples at the N-YHS with Nadelman collection labels suggest that the couple acquired around forty pieces of children's pottery.[3] The recorded acquisitions were all purchased from two dealers in September and October of 1926 for prices ranging from $4 to $12.[4] The inventory cites only seven "alphabet plates" in the Toy Room (Gallery IX), leaving a large number of plates and at least four mugs unaccounted for. It is possible that the Nadelmans displayed a selection of the children's wares at Alderbrook; the charming pieces would have certainly been appropriate decoration for the nursery of their son, Jan, who was four years old when they made their purchases.

The first child's plate, with a purple luster border and central transfer print with a scene of children flying a kite and playing with a hoop toy, predates those with molded borders and is more finely potted. Near mid-century, transfer prints became increasingly didactic, and illustrations of Benjamin Franklin's maxims emerged as one of the most popular subjects for children's wares. America's prototypical self-made man, Franklin rose from humble tradesman to revolutionary thinker and world leader through a combination of hard work and thrift (by his own account). In his *Poor Richard's Almanack*, published serially between 1732 and 1757, he printed a steady offering of aphorisms and proverbs counseling industry and frugality, which captured the attention of strivers bent on self-improvement. Beginning in the 1830s, Franklin's sayings were frequently

printed, and imaginatively illustrated, on plates and mugs for children. The illustrations on two of these plates—"He that hath a trade" and "Industry needs not wish"—are derived from a picture sheet/jigsaw puzzle illustrating Franklin's *Lessons for the Young and Old, on Industry, Temperance, Frugality & c*, published by Bowles and Carver in London in 1795.[5]

The last plate in this group, with a molded alphabet border, features a brightly colored humorous scene with characters from the popular Punch and Judy puppet show. Punch is shown with Joey the Clown and his dog Toby, who is biting Punch's nose. The image is taken directly from a print source that was disseminated through children's books.[6]

Like many alphabet wares, the Franklin's maxims and Punch and Judy plates are clumsily hand-colored. Ironically, the same potteries producing wares to instruct youngsters used child labor to execute this overpainting and to perform other tasks. According to Noël Riley, "several children, each wielding a brush loaded with a different colour, probably added their dashes and blobs as the plates passed along the line." Young laborers also lit fires, wedged clay, carried molds between craftsmen's benches and the stoves, and worked the plate-turning machines. Potteries routinely exploited children as young as six for cheap labor, jeopardizing their health and development.[7]

MKH

1 Noël Riley, *Gifts for Good Children: The History of Children's China, Pt. 1: 1790–1890* (Shepton Beauchamp, Somerset, Eng.: Richard Dennis, 1991), 9. American potters began manufacturing alphabet wares in the 1890s and continued well into the twentieth century. ABC wares were also made in metal, glass, and later plastic. See also Davida and Irving Shipkowitz, *The ABC's of ABC Ware* (Atglen, PA: Schiffer, 2002).

2 Riley, *Gifts for Good Children*, 7–12.

3 The plates in this entry bear Nadelman collection labels inscribed, respectively: "706/Eng," "713/Eng," "712/Eng," "732/Eng," and "705/Eng." The ABC wares were all assigned MFPA pottery numbers between 690 and 732.

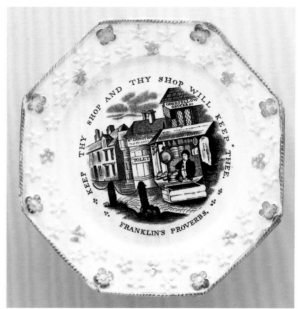

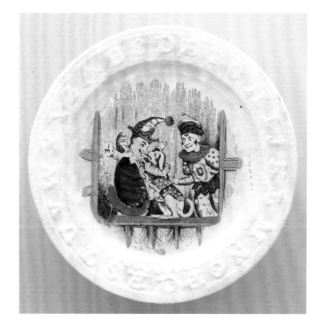

4 Katharine Willis and Louis Richmond of Freehold, NJ.

5 Riley, *Gifts for Good Children*, 309, ill.

6 The Victoria and Albert Museum, London, S.950-
 2010 is a copy of the undated source engraving.
 The same image appeared in *The National Nursery
 Book* (London: Frederic Warne, 1865–72).

7 Riley, *Gifts for Good Children*, 13, 16.

45

Unidentified English makers

Miniature tea and coffee set with tortoiseshell glaze, ca. 1760–85
Probably Staffordshire, possibly Leeds, Yorkshire, England
Lead-glazed earthenware; coffeepot, 2⅜ in. (6 cm) high
Provenance: Philip Suval, New York City, 1929
Z.278c–z*

Miniature tea and coffee set with Chinoiserie decoration, ca. 1775–1800
Probably Staffordshire, possibly Leeds, Yorkshire, England
Lead-glazed earthenware; teapot, 3 in. (7.6 cm) high
INV.9866a–b, d–n

For centuries, miniatures have captivated collectors for their craftsmanship and the sheer allure of their diminutive size. Tiny ceramics may have been fashioned from the time that humans first began baking clay; by the mid-sixteenth century they were manufactured in Germany for use in dollhouses. The vogue for dollhouses in Holland during the seventeenth century stimulated the production of miniature Dutch pottery as well as the importation of Chinese porcelain scaled to dollhouse use.[1]

Miniatures were made in at least three sizes: the smallest, sized for dollhouses; a medium size, such as these examples, often referred to as "toy" size by potters; and a larger size made specifically for children to use.[2] British potters produced miniature tea wares as early as the 1740s, and possibly earlier. Although called "toys" by manufacturers and merchants, these enchanting whimsies amused both children and adults alike.[3] Imported miniatures found a ready market in the American colonies: the Norfolk, Virginia, merchants Balfour and Barraud advertised "tortoise sets of childrens toys complete" in the *Virginia Gazette* in 1766, undoubtedly referring to examples like the tortoiseshell-glazed set shown here.[4]

The Nadelmans delighted in miniatures of all kinds. They displayed hundreds of tiny household items and animals in the Toy Room (Gallery IX) of the MFPA and showed a few notable examples in other galleries. The tortoiseshell-glazed tea set here was displayed in Gallery VIII along with full-sized examples of English pottery.

The couple began collecting tortoiseshell-glazed Staffordshire pottery, referred to by collectors as "Whieldon ware," in 1925, and over the next five years they purchased more than twenty-five examples.[5] They acquired their first miniature Whieldon piece, a Neoclassical teapot with beaded decoration, in October 1928 for $25. A few months later, they purchased another Whieldon teapot for their assemblage despite its cracked body.[6] They must have been thrilled to discover the complete tea and coffee set at Philip

Suval's high-end antiques shop, with six cups and saucers, teapot, coffeepot, cream jug, sugar bowl, tazza, and tea caddy (which they misidentified as a "jar for preserves").[7] Based on the tea set's daunting price—the couple purchased it for $280 in May 1929—it was among their most prized examples of English earthenware. Despite its pocket-sized stature, the set is the most expensive pottery acquisition itemized in the MFPA curatorial records.

Like the tortoiseshell-glazed set, the second example, documented only by an illegible MFPA collection label, is a rare survival. The ceramic body is pearlware, a refined white earthenware with clear lead glaze given a bluish tint by the addition of cobalt oxide.[8] Developed to emulate the whiteness and delicacy of Chinese porcelain, which was imported to England in great quantity, pearlware was sometimes also decorated in imitation of the highly fashionable Chinese wares. This tea set is hand-painted with a Chinoiserie scene featuring a house with peaked roof flanked by ornate fences and surrounded by lush vegetation and flying birds. Sets like this one may have been modeled after English porcelains hand-painted with Chinoiserie decoration, such as those from the Worcester, Liverpool, or Lowestoft factories, rather than actual Chinese porcelain.[9]

MKH

1 Nancy Akre, *Miniatures* (New York: Cooper-Hewitt Museum, 1983), 81–82.
2 Ibid., 82. See also Maurice and Evelyn Milbourn, *Understanding Miniature British Pottery and Porcelain, 1730–Present Day* (Woodbridge, Suffolk, Eng.: Antique Collectors' Club, 1983), 11–14.
3 Milbourn and Milbourn, *Miniature British Pottery*, 15–16.
4 *Virginia Gazette*, July 25, 1766. I thank Leslie Grigsby, Senior Curator of Ceramics & Glass at Winterthur, for bringing this advertisement to my attention.
5 The mottled glaze, created with the application of copper and manganese oxides to the surface of the creamware, was developed by Staffordshire potter Thomas Whieldon (1719–1795). The glaze was

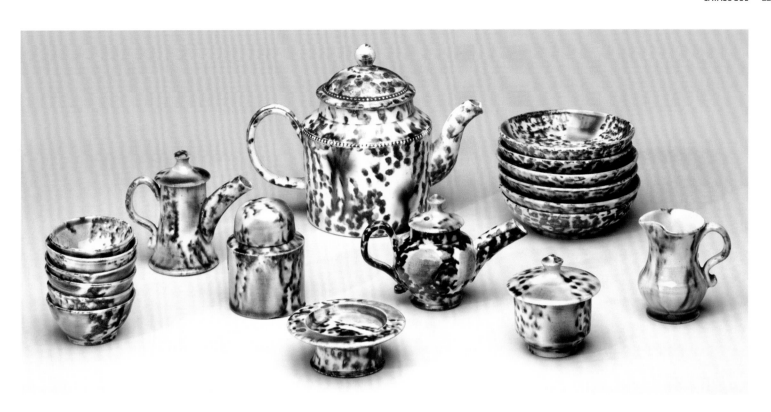

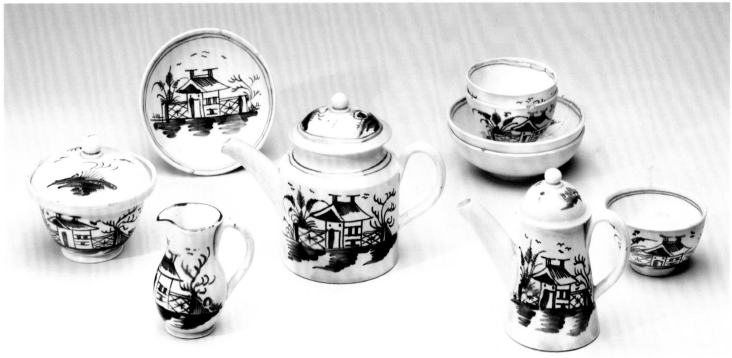

popular during the third quarter of the eighteenth century and was not restricted to Whieldon's pottery.

6 The first teapot, MFPA Pottery 1208, was purchased in October 1928 from Philadelphia dealer Martha de Haas Reeves (N-YHS Z.278ab); the second, MFPA Pottery 1218, was purchased for $15 from McKearin's in Hoosick Falls, NY, in either December 1928 or April 1929 (duplicate MFPA cards with the same object description and MFPA number suggest a cataloguing error).

7 MFPA Pottery 1240.

8 Josiah Wedgwood (1730–1795) has traditionally been credited with developing pearlware, or "Pearl White," in 1779, but other Staffordshire potters had been producing it as early as 1775 under the name "China glaze." See George L. Miller and Robert Hunter, "How Creamware Got the Blues: The Origin of China Glaze and Pearlware," in *Ceramics in America 2001*, ed. Robert Hunter (Hanover, NH: Chipstone Foundation distributed by the University Press of New England, 2001), 135–61.

9 See, for example, Bernard Watney, *English Blue & White Porcelain of the 18th Century* (New York: Thomas Yoseloff, 1963), pls. 28, 29, 47, 82.

46

Unidentified English maker
Cow creamer, ca. 1800–20
Lead-glazed earthenware; 5⅝ × 7¼ × 3½ in.
(14.3 × 18.4 × 8.9 cm)
Provenance: Philip Suval, New York City, 1930
INV.581ab*

In November 1930, one year after the stock market crash (which ultimately defeated their museum), the Nadelmans purchased this spirited English cow creamer for the impressive price of $100 at the Madison Avenue showroom of Philip Suval, a prominent ceramics dealer with an international reputation.[1] Suval's advertisements indicate that he had a large stock of the form; in the May 1929 issue of *Country Life* he illustrated a shelf with six underglaze-painted English cow creamers, several of them nearly identical to this example.[2] A similar advertisement may have drawn the Nadelmans into Suval's shop, which they had patronized steadily since 1926.[3]

The creamer belongs to a broad category of English earthenware known by dealers and collectors as Pratt ware, characterized by relief decoration and/or distinctively colored underglaze painted decoration.[4] The Pratts were a family of Staffordshire potters whose name appears on some marked wares, but in fact "Pratt ware" was made in many regions of England and in Scotland from the early 1780s to the late 1830s.[5] This whimsical hand-modeled cow with a doleful expression, fashioned with exaggerated curling horns and a dramatic upswept tail, was ostensibly manufactured for dispensing milk into one's tea, although it may have been enjoyed simply as a novelty. Its body is sponge-painted in brown, with the exception of the belly, which is decorated with deep yellow interlocking diamonds. The canted rectangular base has vivid blue circles with central dots in a crude imitation of guilloche ornament. A small, alert calf, highlighted with blotches of brown and yellow, lies beneath its mother. Although not attributable to a specific maker, the creamer is related to others manufactured in the same English pottery.[6]

Silver creamers in the form of a standing cow, popular in England during the third quarter of the eighteenth century, inspired myriad Pratt ware adaptations. London silversmith John Schuppe, believed to be a Dutch immigrant, produced the form in large numbers.[7] The Nadelmans must have been drawn to these delightful tea accessories, as they displayed at least two such bovines in the MFPA.[8] They may have simply been engaged by the charm, color, and pattern of this exceptional example, or perhaps they also sought to demonstrate English influence on later American versions (cat. 47). Their enthusiasm for cow creamers, however, was not universally held: British writer P.G. Wodehouse's fictional Bertie Wooster, a young Edwardian aristocrat, sniffed: "Why anyone should want such a revolting object had always been a mystery to me, it ranking high up on the list of things I would have been reluctant to be found dead in a ditch with. . . ."[9]
MKH

1 MFPA Pottery 1415. The Nadelmans noted in their records: "Perfect condition, excepting stopper replaced."

2 *Country Life* 56:1 (May 1929): 109.

3 According to the Nadelman records, the couple made at least thirteen purchases between January 1926 and February 1931, many of them English bird whistles. The miniature tea set (cat. 45) was also among their Suval acquisitions.

4 The term was probably coined in 1909. See John and Griselda Lewis, *Pratt Ware: English and Scottish Relief Decorated and Underglazed Coloured Earthenware, 1780–1840*, 2nd ed. (Woodbridge, Suffolk, Eng.: Antique Collectors' Club, 2006), 11.

5 Ibid., 11, 18.

6 For example, ibid., 281, ill. Some related examples feature a milkmaid rather than a calf.

7 Beth Carver Wees, *English, Irish & Scottish Silver at the Sterling and Francine Clark Art Institute* (New York: Hudson Hills, 1997), 370.

8 Gallery VIII displayed two cow creamers, this example and MFPA 277.

9 P.G. Wodehouse, *How Right You Are, Jeeves* (New York: Simon & Schuster, 1960), 71.

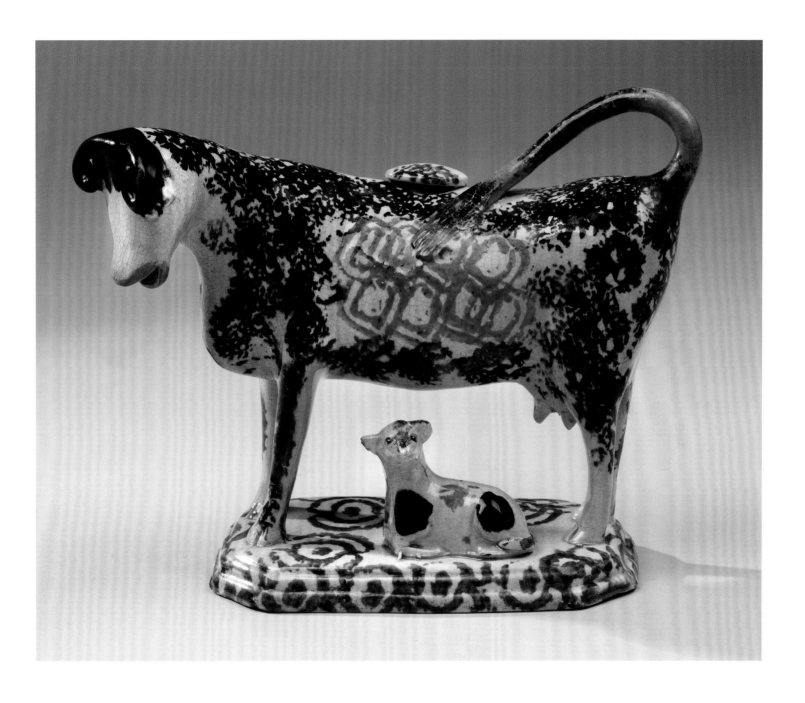

47

Unidentified American maker
Cow creamer, ca. 1850–60
Possibly New Jersey
Lead-glazed earthenware; 6 × 7½ × 3¼ in.
(15.2 × 19 × 8.3 cm)
1937.659ab

Unidentified English maker
Mermaid flask, ca. 1840–60
Derbyshire, England
Lead-glazed earthenware; 7 × 3½ × 2½ in.
(17.8 × 8.9 × 6.4 cm)
1937.678

Lyman, Fenton & Co. (American, active 1849–52)
Toby pitcher, 1849–58
Bennington, VT
Lead-glazed earthenware; 5⅞ × 4⅛ × 5 in.
(14.9 × 10.5 × 12.7 cm)
Provenance: Madelon H. Tomlinson, Hoosick, NY,
1927
1937.648*

The Nadelmans exhibited an impressive collection of Rockingham wares—pottery decorated with a rich brown glaze colored by the addition of manganese—in Gallery VIII of the MFPA. Also known in the United States as "Fancy ware" during its greatest popularity (mid-1840s through ca. 1900), the pottery was named for the tortoiseshell-like brown glaze developed at the Rockingham Pottery in Yorkshire, England, in the late eighteenth century.[1] Much of the Nadelmans' Rockingham ware came from potteries in Bennington, Vermont, leading producers of American Rockingham from about 1847 to 1858.[2]

All of the Rockingham purchases documented in the Nadelman records were acquired in 1926 and 1927.[3] John Spargo's *The Potters and Potteries of Bennington* of 1926 may have inspired the couple, as it did others.[4] Among their recorded purchases was this Toby pitcher, acquired for $30 from Madelon Tomlinson of Hoosick Falls, who maintained a large inventory of Rockingham wares.[5] Toby jugs or pitchers, typically depicting a seated man wearing a tricorn hat and holding a beer mug, originated in England around 1770, possibly inspired by the infamous drunkard Toby Fillpot, a character in Francis Fawkes's 1761 song "The Brown Jug."[6] The Nadelmans must have enjoyed these amusing vessels: they collected at least eight to display in Gallery VIII.[7] This distinctive example, one of several Toby designs made by the Bennington Pottery, has a handle in the form of a man's booted leg, bent at a right angle.[8] Its base is impressed with the mark of Lyman, Fenton & Co., which includes the firm name along with "Fenton's enamel patented 1849," a reference to the flint enamel glaze developed by Christopher Webber Fenton. The colorful glaze was achieved by sprinkling finely powdered metallic oxides—cobalt for blue, copper for green, and manganese for brown—on the surface of the pottery before the second firing.[9] Fenton applied his mark indiscriminately to his wares, even when they did not feature the multicolored flint enamel glaze. A case in point is this Toby; it has the typical monochromatic Rockingham glaze.

Green highlights created with copper oxide enliven the glaze on the engaging cow creamer. The plaster mold used to form the creamer was modeled with great skill: the cow's horns, haunches, udder, and even the lid's flowerbud finial boast fine detail. In addition, the rectangular base is incised to suggest a grassy pasture. American cow creamers closely imitated their English counterparts (cat. 46); the MFPA displayed examples of both.[10] Because many mold-makers in America began their careers in England, moved from pottery to pottery, and even adapted their designs so they could sell molds to multiple firms, it can be difficult to pinpoint the origin of unmarked Rockingham like this work.

The Nadelmans also collected English pottery with a tortoiseshell glaze, no doubt to underscore the British roots of the American Rockingham tradition. The delightful flask in the shape of a mermaid may have been an impractical container for spirits, but it was a beloved novelty during the mid-nineteenth century.[11]

MKH

1 Diana Stradling, *"Fancy Rockingham" Pottery: The Modeller and Ceramics in Nineteenth-Century America*, exh. cat. (Richmond, VA: University of Richmond Museum, 2005), 9–10. See also Richard Carter Barret, *Bennington Pottery and Porcelain* (New York: Crown, 1958), 18–19.

2 Lyman, Fenton & Co. was established in 1848 or 1849 and renamed United States Pottery Company shortly thereafter. It closed in 1858. See Lois Lehner, *Lehner's Encyclopedia of U.S. Marks on Pottery, Porcelain & Clay* (Paducah, KY: Collector Books, 1988), 481.

3 Thirteen Rockingham purchases are recorded, although the inventory and the number of objects

purchased by N-YHS suggest that the original number was much larger. The Nadelmans' sources included Matthew Holden, Renwick Hurry, and Sara M. Sanders.

4 John Spargo, *Potters and Potteries of Bennington* (Boston: Houghton Mifflin, 1926).

5 MFPA Pottery 1168. For an undated price list itemizing Madelon Tomlinson's available pottery, pewter, glass, and mirrors, see NP.

6 Francis Fawkes, *Original Poems and Translations* (London: James Beattie, 1761). See also John Bedford, *The Toby Jug* (Worthing, Eng.: Littlehampton Book Services, 1968).

7 Four American Tobys were assigned MFPA Pottery

nos. 204, 770, 1116, and 1168 (illustrated in this entry); four French examples were numbered 464, 465, 520, and 552.

8 Barret, *Bennington Pottery*, 319. Barret calls the design the "Ben Franklin" pattern.

9 Ibid., 19.

10 Two cow creamers are cited in the MFPA inventory: Pottery 277, which may be the Rockingham example, and Pottery 1415, the Pratt ware version in cat. 46.

11 A related example is in the Victoria and Albert Museum, London, C.42-1937.

48

Unidentified English makers

Bowl, 1810–30
Lead-glazed earthenware; 5 × 10 in.
(12.7 × 25.4 cm)
Provenance: Howards of York (Blue Spruce), York,
PA, 1926
Z.2014*

Mustard pot, 1810–30
Lead-glazed earthenware; 3⅜ × 3⅜ × 3 in.
(8.6 × 8.6 × 7.6 cm)
Provenance: American Art Galleries, New York City,
Mr. and Mrs. G.G. Ernst sale, 1926
INV.12855ab*

Coffee pot, 1800–20
Lead-glazed earthenware; 11¼ × 9 × 6 in.
(28.6 × 22.9 × 15.2 cm)
Provenance: Renwick Hurry, New York City, 1926
INV.12630ab*

Pitcher, 1800–20
Lead-glazed earthenware; 8 × 8¼ × 6½ in.
(20.3 × 21 × 16.5 cm)
INV.12633

Fig. 101. Detail of the Pottery Room, Gallery VIII of
the MFPA, ca. 1935. NP

"Mocha ware" is the popular term used today for factory-made British earthenwares decorated primarily by manipulating slip into bold abstract patterns.[1] Though inexpensively produced for a mass market, these everyday tablewares were individually embellished, making each a unique product. With the basic tools of a horizontal turning lathe and colored slip (clay mixed with water), together with a battery of ingenious techniques, individual potters created dramatic surface decorations prophetic of the evocative and kinesthetic paintings of Abstract Expressionism.

The large bowl exhibits a type of mocha decoration known as "common cable" or "earthworm." These sinuous patterns were created using a three-chambered slip cup that channeled the colors into a single tube. While the lathe turned, the potter would let drips from the cup fall onto the surface of the pot, producing a chain of overlapping drops.[2] The looping earthworm on the Nadelman bowl, composed of blue, brown, and white slip, has a bold, three-dimensional quality thanks to the high contrast of its colors.[3]

The term "mocha" was first applied to a specific pattern that imitated a semiprecious agate known as mocha stone.[4] Today, this subset of mocha ware is referred to as "dendritic" for its tree- or seaweed-like shapes. The latter pattern decorates the bulbous mustard pot here: dark tendril-like blotches punctuate its wide orange-brown band, offset by a green-glazed reeded band above.[5] The potter made this piece by first positioning the vessel on a lathe to spin the bands of slip onto the cream-colored body. With the lathe turning at a slow speed, he dipped a brush into an acidic solution known as "mocha tea" and allowed drops to fall onto the alkaline slip. The resulting effects, which had an almost magical randomness, occurred through chemical reaction.[6] Dendritic wares, first manufactured in British potteries in the 1790s, were exported in large quantity to America, where they were frequently used in taverns.[7]

The banded decoration on the majestic coffeepot has a more mechanized appearance than the abstract dendritic or marbled ornament. Its checkerboard bands were created with a special tool that cut through a layer of slip and incised the pattern on the surface of the pot while it rotated on the lathe. The Nadelmans catalogued this vessel, purchased in April 1926 for $15, as Leeds.[8] They were likely aware of *The New Teapot Drawing Book*, a pattern book used by the Leeds Pottery of Hartley, Greens & Co. in Yorkshire, which included renderings of wares with similar checkered bands.[9]

Another type of decoration found on mocha ware is "slip marbling," seen on the pitcher here. Also executed with a horizontal lathe, the decoration was achieved by first spinning a field of colored slip onto the body—in this case orange-brown—and then applying drops of different-colored slip—here cream and black—onto the wet slip field while the lathe was slowly turning.[10] A green-glazed rouletted band was added at the neck. While the skill of the turner and the speed of the lathe affected the decoration, chance was also important to the outcome. As slip is free-flowing and versatile, it gives the decorator some artistic freedom. However, slip dries quickly and captures human error irreversibly. The decorator of this pitcher let the wide band of brown slip dribble into the section below,

and mistakenly scraped the belly of the pitcher with a sharp tool, leaving minute lines.

These pieces and several other examples of mocha ware were displayed with English pottery in Gallery VIII of the MFPA: the coffee pot and flanking mustard pots are visible in a glass case (fig. 101). The Nadelmans may have been in the vanguard with their appreciation of the ware's dramatic, abstract decoration. Although Edwin AtLee Barber had described the pottery in a 1903 article, Katharine McClinton, writing in 1951, claimed that mocha ware had only "come into the collector's field during the last five years."[11]

MKH

1 For discussion of period and current usage of the term, see Jonathan Rickard, *Mocha and Related Dipped Wares, 1770–1939* (Hanover, NH: University Press of New England, 2006), ix–x; Robert Hunter, "Surfaces of Illusion: Mocha and Spatter Wares," in *Expressions of Innocence and Eloquence: Selections from the Jane Katcher Collection of Americana*, ed. Jane Katcher et al. (New Haven: Yale University Press, 2006), 207–29.

2 Hunter, "Surfaces of Illusion," 212; Rickard, *Mocha and Related Dipped Wares,"* 65–66.

3 MFPA Pottery 225. The bowl has a MFPA collection label inscribed "225/Eng."

4 Hunter, "Surfaces of Illusion," 207.

5 MFPA Pottery 213. This mustard pot, which bears a MFPA collection label inscribed "213/Eng," was one of a pair purchased at auction for $7.50. See American Art Galleries, New York, "The Early American Collection of Mr. and Mrs. G.G. Ernst," January 20–23, 1926, lot 441.

6 Rickard, *Mocha and Related Dipped Wares*, 46, 49.

7 Ibid., 52.

8 MFPA Pottery 275.

9 The pattern book was known by 1892 when it was described in Joseph R. Kidson and Frank Kidson, *Historical Notices of the Old Leeds Pottery* (Leeds, Eng.: J.R. Kidson, 1892), 30–46.

10 Ibid., 21, 24.

11 Edwin AtLee Barber, "Mocha Ware," *Old China* 2:4 (January 1903): 71–73; Katharine Morrison McClinton, *Antique Collecting for Everyone* (New York: McGraw-Hill, 1951), 1.

49

Unidentified European maker
Bottle, 1770–1830
Probably Northern Europe, possibly Portugal
Glass; 8½ × 3½ in. (21.6 × 8.9 cm)
1937.1041

The glass displayed in Gallery I of the MFPA was overwhelmingly American-made. Of the approximately two hundred glass purchases documented in the MFPA records, less than thirty were European, suggesting that the Nadelmans did not place a high priority on collecting Continental glassware. However, this spiral-ribbed pinch bottle, with its original pewter cap, is a fine example of a type that had lasting influence on American glass production.

Made from deep blue nonlead glass, the bottle was blown using the half-post method, typical of Continental production. The glassblower slightly inflated the initial gather of glass and then dipped it again into the pot of molten glass to apply a second gather. Because the second layer did not fully cover the first, it left a thickened ridge on the shoulder of the bottle.[1] The maker then dipped the double gather of glass into a pattern mold with sixteen ribs, then expanded, twisted, and pinched the body with tools. The shape and proportions of this example, and the use of a pewter cap, are associated with Northern European bottles made during the late eighteenth and early nineteenth centuries. According to George S. and Helen McKearin, who sold the Nadelmans a good deal of glass, this type was brought to America by settlers and imported as well.[2]

American pattern-molded glass was highly collectible when the Nadelmans were assembling the MFPA in the 1920s. Frederick William Hunter's 1914 publication *Stiegel Glass* had fueled interest in wares attributed to the German-born entrepreneur Henry William Stiegel, who operated a glassworks in Manheim, Pennsylvania, between 1764 and 1774. Hunter optimistically attributed a large body of work to "Baron" Stiegel, including pattern-molded pitchers, salts, and sugar bowls in blue, green, and amethyst.[3] The Nadelmans, familiar with the embryonic scholarship on American glass, were somewhat more cautious with their attributions, using terms such as "Stiegel type" or "supposedly Stiegel" in their cataloguing.[4] Their "Stiegels" were displayed in a single

case along with figured flasks and other blown three-mold glass, together comprising 166 pieces (fig. 102).[5] Visible on the second shelf from the bottom in the photograph are nine American pattern-molded pocket bottles whose half-post construction and swirled ribbing betray Continental influence. Though Stiegel can in fact be credited with the production of decorative pattern-molded pocket bottles, the Nadelmans' examples were probably made by various glasshouses in New England or the Midwest during the early nineteenth century.[6] This European bottle, though not visible in the photograph of the glass gallery, was likely displayed in close proximity to its American counterparts.
MKH

1 The half-post method, often referred to as the German half-post method, continued to be used in American glass production, particularly in "Pitkin"-style pocket bottles with fine swirled ribbing made in New England and the Midwest during the early nineteenth century. See Arlene Palmer, *Glass in Early America: Selections from the Henry Francis du Pont Winterthur Museum* (New York: W.W. Norton for the Winterthur Museum, 1993), 356, 369, nos. 367–68.

2 George S. and Helen McKearin, *American Glass* (New York: Crown, 1941), 448, pl. 239, no. 5. See also Charles Holme, ed., *Peasant Art in Austria and Hungary* (London: Studio, 1911), nos. 176–78.

3 Frederick William Hunter, *Stiegel Glass* (Boston: Houghton, Mifflin, 1914); see also Palmer, *Glass in Early America*, 14. Many of Hunter's speculative attributions were proved incorrect by later scholars.

4 For instance, the MFPA cards include an enameled bottle described as "Stiegel type," a glass funnel catalogued as "perhaps Stiegel," and a spiral perfume bottle described as "supposedly Stiegel" (no MFPA numbers were assigned).

5 The MFPA inventory describes case no. 2 in Gallery I as "166 pieces of Stiegel glass, three mould contact blown glass and Sandwich glass."

6 Palmer, *Glass in Early America*, 364. See also Kenneth M. Wilson, *American Glass 1760–1930* (New York: Hudson Hills in association with the Toledo Museum of Art, 1994), 1: nos. 10–15.

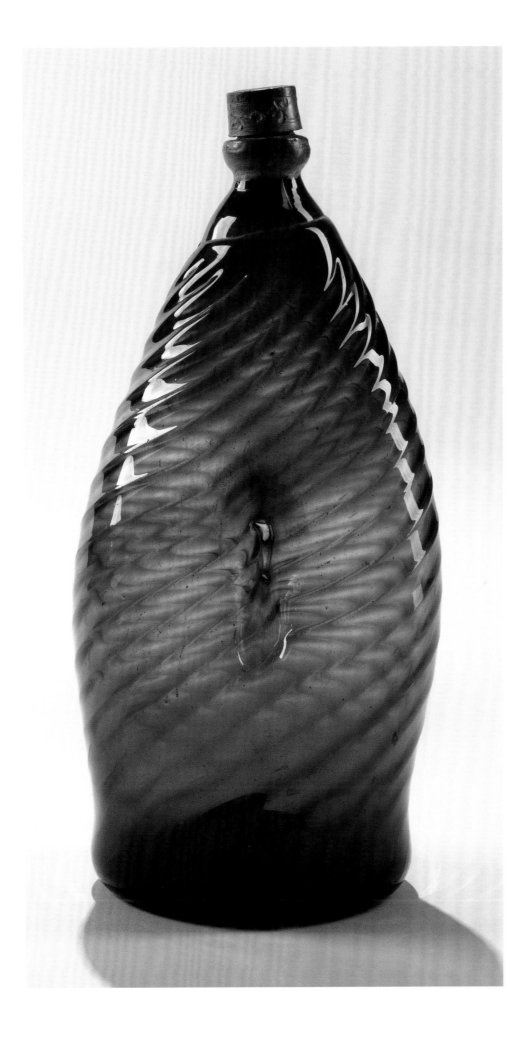

50

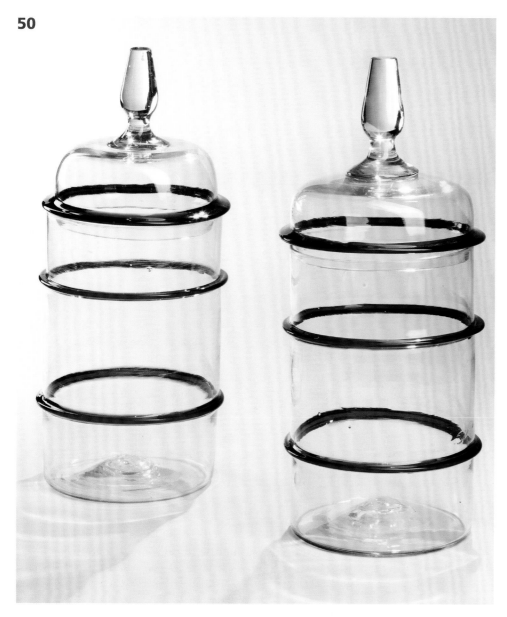

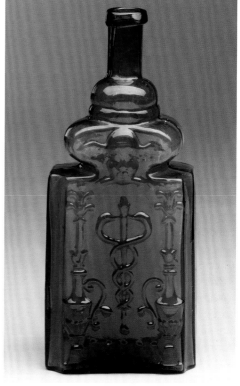

Bakewell, Pears & Co. (American, active 1842–82)
Show jars (pair), ca. 1875
Pittsburgh, PA
Glass; each 15 × 6 in. (38.1 × 15.2 cm)
Provenance: Probably Matthew Holden, Rye or
Jamaica, NY
INV.11855ab, INV.11856ab

Unidentified maker, probably American
Medicine bottle, 1830–60
Glass; 10 × 4¼ × 2¼ in (25.4 × 10.8 × 5.7 cm)
1937.1663

The Nadelmans installed two apothecary shops in the Museum of Folk and Peasant Arts: an American drugstore in Gallery I, adjacent to the display of glass, and a French shop in Gallery X, near their holdings of needlework and textiles (figs. 10, 16). By the late nineteenth century, pharmacy museums were popular in Europe and the United States, and the couple may have been influenced by installations they saw on their travels. They may have known the late eighteenth-century pharmacy at the Skansen open-air museum in Stockholm, which was installed by 1907; the apothecary window display at the Newport Historical Society, opened in 1884; or closer to home, Columbia University College of Pharmacy's restoration of an early New York drugstore.[1]

The discovery and acquisition of apothecary-related items may also have spurred the Nadelmans to develop their two shops, which were the only displays in the MFPA dedicated to a specific trade. The records document only a few apothecary-related purchases in the early years of the museum, including a set of eighteenth-century Swiss apothecary weights in 1924. Judging from the timing of purchases, a major impetus for the French drugstore may have been the Nadelmans' acquisition of a pair of magnificent eighteenth-century seated apothecary lions, each of which rested its front paws on a white and gold apothecary jar. The Nadelmans purchased the carved and painted beasts from dealer Sumner Healey in January 1930 for an imposing $225. Through 1930 and 1931, they bought numerous French drug bottles, Dutch apothecary jars, and other items to fill out their nascent European drugstore.

The American drugstore was similarly

anchored by a few significant purchases. MFPA records document the 1928 acquisition of a pair of blue glass apothecary jars on colorless pedestal bases from the Frederick, Maryland, pharmacy of Dr. Fairfax Schley, who had ordered the jars from the glass manufactory in Millville, New Jersey, to adorn his store window. According to the detailed history typed on the Nadelman object card, Schley was indignant upon receiving the eleven-inch-high vessels as they were much smaller than ordered.[2] Charmed by the tale, the Nadelmans spent an astonishing $350 on the Schley show jars.[3] In 1935, they made an even more significant purchase, from the Upper East Side antiques dealer S.N. Thompson: the contents of an unnamed, late nineteenth-century New York drugstore—including its mortar and pestle trade sign, display urns, scales, large iron mortar, eighty assorted bottles, and eleven medical signs.[4]

The pair of show jars and medicine bottle illustrated here were probably part of the American apothecary display. The six-quart covered jars of blown glass are decorated with cobalt blue bands: two applied to the body of the jar, and a third to the rim of the cover. The pair is nearly identical to a show jar illustrated in the ca. 1875 catalogue of Bakewell, Pears & Co., a leading American glass manufacturer located in Pittsburgh.[5] As the name in the catalogue suggests, the containers were intended primarily for show and were probably displayed prominently on a shelf or in a store window. Although the Nadelman cards do not record the acquisition of the jars, their source was probably the couple's favored pottery and glass dealer Matthew Holden, who illustrated a pair of identical jars in a 1920 article about his early American glass. Holden identified the containers as "druggists' jars for maple sugar cakes."[6]

The ten-inch-tall, cobalt blue medicine bottle, blown in a three-part mold, is ornamented with imagery relating to its function. At the center of each side is a caduceus—the staff carried by the Roman god Mercury—with two entwined snakes, elongated urns at each side, and the winged head of Mercury above. Derived from Greek mythology, the caduceus was a symbol of commerce and negotiation. Its erroneous association with medicine, which had developed by the sixteenth century, is believed to derive from the symbol's similarity to the Rod of Asclepius, a staff with a single entwined serpent wielded by the Greek god of that name, who was associated with healing and medicine.[7] While the molded imagery suggests medicinal use, the bottle's color offers additional clues to its intended contents. Certain chemicals, such as nitrate of silver, were customarily kept in blue glass bottles, as the colored glass was thought (incorrectly) to prevent light from penetrating the glass and acting upon the substance.[8] Blue was also the preferred color for bottles containing poisons; in fact, by the late nineteenth century New York City public hospitals used blue bottles exclusively to hold poisonous external medicines.

MKH

1 George B. Griffenhagen, *Pharmacy Museums* (Madison, WI: American Institute of the History of Pharmacy, 1956), 24, 44, 48. Artur Hazelius, *Guide to the Collections of the Northern Museum in Stockholm* (Stockholm: P.A. Norstedt, 1889), 51–52. The Skansen pharmacy, composed of objects collected by folklorist Artur Hazelius between 1873 and 1907, featured the equipment of Swedish chemist Carl Wilhelm Scheele and also included the shop fittings from the palace pharmacy at Drottningholm, outside Stockholm. The Columbia University pharmacy was installed by 1929. Also significant were the Stabler-Leadbeater Apothecary Shop in Alexandria, VA, a restoration of a 1792 shop installed by 1933; and the "Old World Apothecary Shop," representing European pharmacies from the fifteenth through nineteenth centuries, owned by E.R. Squibb and Sons and exhibited at the Chicago "Century of Progress" exhibition in 1933–34. Griffenhagen, *Pharmacy Museums*, 20, 23.

2 MFPA card, no number. The jars are N-YHS 1937.950ab. The history recounted on the card has some errors, as the Nadelmans confused the druggist with his famous cousin, Admiral Winfield Scott Schley. The supposed date of the jars, 1836, is probably too early given Fairfax Schley's dates and the style of the vessels.

3 They were purchased from Mamaroneck, New York, dealer Charles Burns in 1928.

4 The receipt from S.N. Thompson is in the Nadelman papers, inserted into the MFPA inventory. Although undated, it can be documented to around 1935 because Thompson's printed address, 680 Lexington Avenue, is crossed out and "927 ½ Third" is written in its place. Polk's New York City Directory documents Thompson at the former address in 1933–34, and the Manhattan New York City Telephone Directory places him at 927 ½ Third Avenue by summer 1935.

5 Bakewell, Pears & Co., *Glass Catalogue* (Pittsburgh, PA: Armor, Feurhake, n.d.), 30. A reproduction of the catalogue with an introduction by Lowell Innes was printed by Davis & Warde of Pittsburgh in 1977. The jar appears in the catalogue with a grouping of "Urns & Show Jars" described as a "6 Qt. H.M. [handmade] Squat Two Ring Jar."

6 M[atthew] Holden, "Early American Glass," *House & Garden* 38:2 (August 1920): 74, ill.

7 Bernice S. Engle, "The Use of Mercury's Caduceus as a Medical Emblem," *Classical Journal* 25:3 (December 1929): 204–8.

8 "Notes on Practical Pharmacy," *American Druggist* 13:12 (December 1884): 233.

51

Kensington Glass Works (American, active 1816–38)
Figured flask: General Washington,
1826–35
Kensington, PA
Glass; 7¼ × 5 × 2½ in. (18.4 × 12.7 × 6.4 cm)
1937.743

Unidentified American maker
Figured bottle (calabash): Kossuth, 1851–53
Probably Philadelphia, PA or New Jersey
Glass; 10¼ × 5½ × 4 in. (26 × 14 × 10.2 cm)
Provenance: Charles Burns, Mamaroneck, NY, 1928
1937.957*

Whitney Brothers Glass Works (American, active 1838–1918)
Figured flask: Flora Temple, 1859–65
Glassboro, NJ
Glass; 10¼ × 4¾ × 2¼ in. (26 × 12.1 × 5.7 cm)
Provenance: Frederick C. Bassick, Bridgeport, CT, 1928
1937.963*

Whitney Brothers Glass Works (American, active 1838–1918)
Bitters bottle: Indian Queen, 1868–75
Glassboro, NJ
Glass; 12½ × 3 in. (31.8 × 7.6 cm)
1937.1048

Fig. 102. Glass bottles displayed in Gallery I of the MFPA, ca. 1935. NP

Gallery I of the MFPA showcased a colorful and captivating array of more than five hundred pieces of glass. American examples predominated, although the Nadelmans also exhibited examples from England, Ireland, France, Switzerland, Spain, and Hungary. One case held ninety-three glass whimsies, primarily animals, which the couple had displayed in their East Ninety-third Street townhouse before they opened their museum (figs. 6, 29).[1] Another case held Stiegel-type and Sandwich glass, while a third grouped similar forms, such as glass lamps (twenty-one) and perfume bottles (fifty-three).

Figure 102, the only photograph that survives of glass displayed in Gallery I, shows a tall case with at least five glass shelves, set in front of a window. On the central shelf sit fifteen figured flasks and bottles, including three of the examples here. The Nadelmans deliberately placed their most coveted pieces of American glass in front of the window so that sunlight would shine through the colored vessels and set the display aglow. Their use of natural light and glass shelving may have been inspired by their visit to Beauport, the Gloucester, Massachusetts, summer house of Henry Davis Sleeper, an influential collector and interior decorator (fig. 30). During their three-month stay at Beauport during the summer of 1920, the newly married couple fell under the spell of Sleeper's dramatic arrangements, which highlighted the play of shapes, colors, and textures among his antiques.[2]

In their collecting, the Nadelmans, and probably Sleeper before them, benefitted from Edwin AtLee Barber's pioneering work on early American glass, which stimulated and guided the first generation of American glass collectors.[3] American bottles and flasks, with their engaging colors and patriotic themes, found a ready audience. Stephen Van Rensselaer expanded upon Barber's groundwork with his *Check List of Early American Bottles and Flasks*, published in 1921 and expanded in 1926.[4] The Nadelmans clearly relied on Van Rensselaer's work, as they cited his book on some of the MFPA cards for glass.

The four vessel designs discussed here were all included in the *Check List*.[5]

The emerald green pint flask depicting General George Washington in uniform on the obverse and an American eagle on the reverse is inscribed on one edge: "Adams & Jefferson July 4, A.D. 1776." Blown in a two-part mold, the flask commemorates the death of John Adams and Thomas Jefferson a few hours apart on July 4, 1826, the fiftieth anniversary of the signing of the Declaration of Independence. The name of the manufactory that produced the whiskey flask, Kensington Glass Works, is inscribed on another edge, while the initials of the glassmaking entrepreneur Thomas W. Dyott appear below the American eagle.[6]

A second flask with a patriotic theme is the light green quart-size calabash (a gourd-shaped bottle) featuring the profile bust of Lajos (Louis) Kossuth, the political leader who spearheaded Hungary's struggle for independence from Austria.[7] This bottle is one of numerous commemorative items produced during the hero's visit to the United States in 1851–52. The tall tree with foliage on the bottle's reverse may be a Liberty tree symbolically linking Kossuth's revolutionary struggle to the American fight for independence.[8]

The olive amber "Flora Temple" flask, blown in a two-part mold, has an applied scroll handle with exaggerated curves.[9] Like the preceding flasks, this example commemorates a specific event in American history: the record-breaking feat of the New York racehorse Flora Temple, who trotted a mile in two minutes, nineteen and three-quarter seconds on October 15, 1859, in Kalamazoo, Michigan. The famous horse, dubbed "Queen of the Turf" by the *New York Times*, inspired songs, Currier & Ives lithographs, and six different flask designs.[10] This example, which was produced in large numbers, features an image of the racehorse in a square panel on the obverse, with her race statistics, "HARNESS TROT 2.19 ¾ OCT. 15, 1859," on the reverse.[11]

A rarity among the Nadelmans' glass is the patented "Indian Queen" bottle, designed to

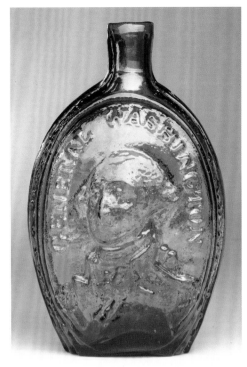

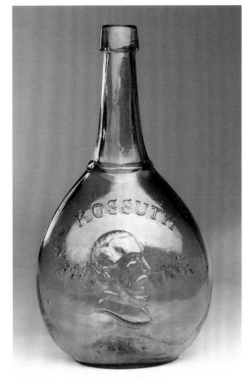

hold Brown's Celebrated Indian Herb Bitters, a concoction of alcohol, tree bark, and other ingredients sold as a remedy for a range of maladies. Patented on February 11, 1868, by Neal N. Brown of Philadelphia, the bottle was produced in numerous colors, including amber and olive green.[12] Examples in aquamarine, like this one, are particularly scarce. The pose of the majestic glass "queen" echoes that of the Nadelmans' Indian maiden tobacco shop figure (cat. 2)—just one of many visual and thematic dialogues that bridged the gallery walls of the MFPA.

MKH

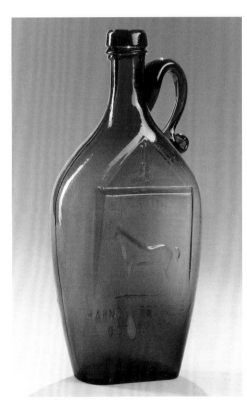

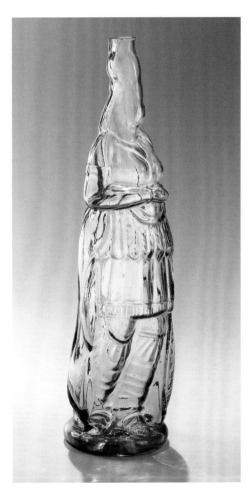

1 "Fantasies in Glass: Nadelman Collection of Animals and Birds," *Antiquarian* 3:6 (January 1925): 5–7. The collection was displayed in glass cases built into the wall of the dining room.

2 Stillinger 2011, 183–84, 256–66.

3 Edwin AtLee Barber, *American Glassware, Old and New* (Philadelphia: David McKay, 1900). The Nadelmans cited Barber on the MFPA cards for some of their glass, including the Kossuth bottle (1937.957).

4 Stephen Van Rensselaer, *Check List of Early American Bottles and Flasks* (New York: the author, 1921).

5 Ibid., 28–29 (Kossuth bottle); 36–37 (Flora Temple flask); 42–43 (bitters bottle); 104 (Washington flask).

6 George McKearin developed a classification system for figured flasks and bottles in 1941 that is still used today; this flask is GI-14. See Helen McKearin and Kenneth M. Wilson, *American Bottles and Flasks and Their Ancestry* (New York: Crown, 1978), 87, 451–52, 526; Kenneth M. Wilson, *American Glass, 1760–1930: The Toledo Museum of Art* (New York: Hudson Hills, 1995), 1:113, no. 45; Helen McKearin, *Bottles, Flasks, and Dr. Dyott* (New York: Crown, 1970), 95.

7 The bottle, which was never assigned a MFPA number, was purchased for $10 in April 1928.

8 McKearin GI-113. McKearin and Wilson, *American Bottles and Flasks*, 472, 552–53.

9 The flask, which was never assigned a MFPA number, was purchased for $10 in December 1928.

10 Kevin A. Sives, "A Horse is a Horse, of Course, of Course," http://www.glswrk-auction.com/039.htm.

11 McKearin GXIII-24. McKearin and Wilson, *American Bottles and Flasks*, 434–35, 495–96, 660.

12 McKearin and Wilson, *American Bottles and Flasks*, 305–6; Ferdinand Meyer V, "Looking Closer at Brown's Celebrated Indian Herb Bitters," http://www.peachridgeglass.com/2012/09/look-closer-at-the-browns-celebrated-indian-herb-bitters/.

52

Unidentified maker
Nursing bottle, 1825–50
Probably United States, possibly England
Glass; 9⅛ × 3⅜ in. (23.2 × 8.6 cm)
Provenance: Estelle Berkstresser, York, PA, 1926
Z.639*

During the nineteenth century, bottle feeding developed as a safe alternative to breastfeeding or wet-nursing infants. Clay feeding bottles were used as early as 2000 B.C., perforated cows' horns found favor during the Middle Ages, and silver and pewter feeders became popular during the eighteenth century.[1] These early devices were difficult to clean, however, and sometimes caused infant deaths. Not until the Industrial Revolution, with the development of the glass feeding bottle, did mothers have access to a hygienic alternative to breastfeeding. Until the end of the nineteenth century, these nursing bottles typically dispensed animal's milk, usually from cows but also from goats, sheep, donkeys, camels, pigs, or horses.[2]

The Nadelmans identified this free-blown, colorless lead glass nursing bottle as American, as indicated by the MFPA label on its underside. The MFPA card describes it further as Stiegel glass, an attribution that cannot be substantiated.[3] The elongated ovoid bottle has a glass nipple at the top and stands on a broad domed foot with a folded edge. Milk could be poured in through the hole at the center of the foot, which was then corked. This bottle's upright orientation is unusual, as is the generously sized foot. Before 1900, nursing bottles were more frequently designed to lie flat and be filled from a hole in the side.[4]

Records indicate that the Nadelmans displayed three nursing bottles in the MFPA, probably with their glass collection in Gallery I. This one, purchased from dealer Estelle Berkstresser for $5 in February 1926, joined two American examples already in the museum: one boat-shaped example made for use with a metal nipple, purchased for $8 from dealer Charles Burns of Mamaroneck, New York, in October 1924, and another, described only as "eighteenth century," purchased for $10 from New York City dealer Jane Teller in 1924.[5]

MKH

1 Emily E. Stevens et al., "A History of Infant Feeding," *Journal of Perinatal Education* 18:2 (Spring 2009): 35.
2 Ibid., 36.
3 MFPA Glass 1867. The object is described as "Stiegel glass nursing bottle. Flat oval inshaped. Wide flange." The bottle probably postdates the operation of Henry William Stiegel's Manheim, PA, glassworks (1774–84).
4 See, for instance, the boat-shaped nursing bottle at the Winterthur Museum, Winterthur, DE, 1957.0006. For an upright example with a side fill-hole and smaller foot, see the Corning Museum of Glass, Corning, NY, 1963-08-01. For a history of nursing bottles, see http://www.acif.org/past.html.
5 MFPA 700 and 76, respectively. The material of the latter is not specified but was probably glass.

53

Unidentified English maker
Rolling pin, ca. 1842
Probably Sunderland, England
Glass; 15½ × 1¾ in. (39.4 × 4.4 cm)
Provenance: Anderson Galleries, New York, William
Bell Chambers sale, 1925
1937.1484*

In the mid-nineteenth century, a number of English sheet and bottle glass factories maintained a sideline business in domestic wares, including rolling pins. Factories at Nailsea and Bristol, and in Gloucestershire, Shropshire, Yorkshire, Newcastle, and Sunderland produced rolling pins that were flecked with colored glass, festooned with Venetian-style *latticinio* decoration, or ornamented with transfer-printed, painted, or stippled imagery and inscriptions.[1] This rolling pin with stippled decoration, likely a love token from a sailor to his sweetheart, was probably made at a glass factory in Sunderland, a bustling port in northeast England.[2]

The rolling pin was blown from thick, dark amber glass and its cylindrical shaft and knob handles were tooled into shape. The stippled images and inscriptions, organized in four horizontal registers covering the length of the pin, provide important clues to the object's origins and use. Engraved in the uppermost register is "MICHELL·SMITHS / LEAP SEPTEMBER 15th / 1842," above an image of an arched bridge on two stone piers. At the center of the span stands a figure, presumably Smith, waving one hand while clutching an urn-shaped lamppost. A small boat with three figures floats below the bridge. The picture illustrates a memorable event in Sunderland history, when the twenty-three-year-old American sailor Michael Smith jumped from the center of the Wearmouth Bridge into the River Wear, a distance of over 110 feet. Built in 1796, the cast-iron bridge was a technological marvel whose 236-foot span made it the longest in the world.[3] Smith's feat, announced in advance by handbills, was planned for September 7, 1842, but the local constabulary foiled the stuntman's plans by arresting him. On September 15, Smith made a successful leap in front of thirty thousand spectators, escaping with minor bruises.[4] The following week, a local tailor in a drunken state tried to match Smith's exploit and was fished out of the river "quite dead."[5]

The image of Michael Smith's leap suggests that the rolling pin was made at one of several glasshouses operating in Sunderland during the 1840s.[6] Although the factories chiefly produced wine and beer bottles, they also built a trade in souvenirs for seafarers. Located just upriver from the North Sea, Sunderland was an important port whose quays teemed with ships loading cargo—mostly coal—for shipment to distant markets. Indeed, an image in the second register depicting a two-masted schooner with the name Ann below it may refer to a Sunderland vessel.[7] Other decorations include "MRS. MACKRELL," whose identity remains a mystery, and stock motifs including the farmer's arms and inscription "SPEED THE PLOUGH" in the third register; a Masonic shield in the fourth; and markings on the opposite side, including the popular biblical motto "THOU GOD SEEST ME," a heart, anchor with entwined rope, and beehive.

The rolling pin may have been manufactured as a blank at a local glasshouse and then decorated near the Sunderland docks by an enterprising engraver who personalized the souvenir with images and inscriptions.[8] Though heavy enough to be used for flattening dough, such rolling pins were likely intended for display, hung on a wall by a ribbon tied around the knobs. Early collectors of these objects proposed more fanciful functions—including use as containers for smuggling brandy, or as safeguards for sailors who, in case of shipwreck, would insert a message and launch it across the ocean—but scholars today agree that these decorative pins functioned primarily as love tokens.[9]

The Nadelmans purchased this sailor's rolling pin for $10 at the Anderson Galleries auction of the marine collection of William Bell Chambers, a former Royal Navy sailor who formed a major collection of nautical objects, including ship figureheads, ship models, and maritime portraits. The catalogue described the rolling pin as "Bristol blown glass," an attribution that the Nadelmans repeated when cataloguing it for their museum.[10] Only one other glass rolling pin, an undecorated example of aquamarine glass, is documented in the Nadelman collection.[11] The pins were most probably displayed with the glass collection in Gallery I.[12]

MKH

1 Jocelyn Lukins, "Glass Rolling Pins," *Antique Dealer and Collectors' Guide* 24:10 (May 1970): 65–66.

2 MFPA 1616.

3 The engraver of the rolling pin probably derived his image from a print source, such as *Sunderland, County of Durham*, engraved by William Le Petit after Thomas Allom; see Thomas Rose, Thomas Allom, and George Pickering, *Westmorland, Cumberland, Durham, and Northumberland, Illustrated* (London: H. Fisher, R. Fisher, & P. Jackson, 1832), opp. p. 46, ill.

4 T. Fordyce, *Local Records; or, Historical Register of Remarkable Events* (Newcastle-upon-Tyne, Eng.: T. Fordyce, 1867), 165–66.

5 Ibid., 166.

6 Sunderland Museum and Art Gallery, *The Glass Industry of Tyne and Wear. Pt. 1: Glassmaking on Wearside* (Sunderland, Eng.: Tyne and Wear County Council, 1979), 38–40. Images of the famous bridge can be found transfer-printed on pottery and engraved on glassware during the period; for instance, a lusterware pitcher (N-YHS INV.12741) made by Sunderland potters Dixon, Austin & Co. and printed with a similar view of the Iron Bridge at Sunderland.

7 Lukins, "Glass Rolling Pins," 66, mentions another rolling pin with a two-masted vessel named *Arun*, built at Sunderland in 1842.

8 Ibid., 66.

9 Ibid., 68; "Queries and Opinions," *The Magazine Antiques* 29:4 (April 1935): 155.

10 Anderson Galleries, New York, William Bell Chambers sale, November 12–13, 1925, lot 6.

11 N-YHS 1937.1332. The Nadelman records also include a wooden rolling pin with incised designs from Hungary (MFPA 2382), a French example of carved boxwood (MFPA 990), and an American example made of stoneware (MFPA 1495, N-YHS 1937.1483).

12 The rolling pins are not itemized in the MFPA inventory.

54

Unidentified American maker
Quilt: Seek No Further or Many Mansions
pattern, 1840–60
Probably Maryland or Pennsylvania
Cotton; 100¼ × 99 in. (254.6 × 251.5 cm)
Provenance: Katharine Willis, Jamaica, NY, 1929
Gift of Elie Nadelman, 1939.4

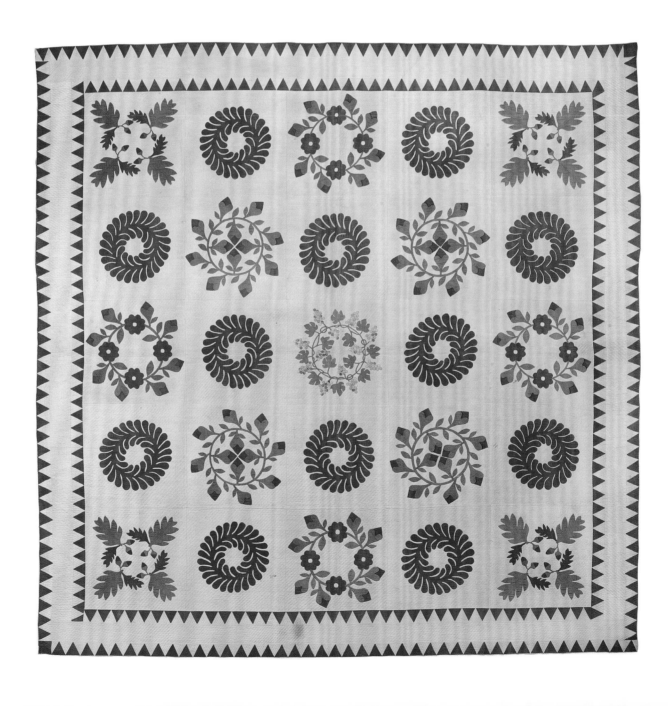

Unidentified American maker
Quilt: Sunburst pattern, 1825–50
Probably Mid-Atlantic or Southern New England
Cotton; 79½ × 80 in. (201.9 × 203.2 cm)
Gift of Elie Nadelman, 1939.5

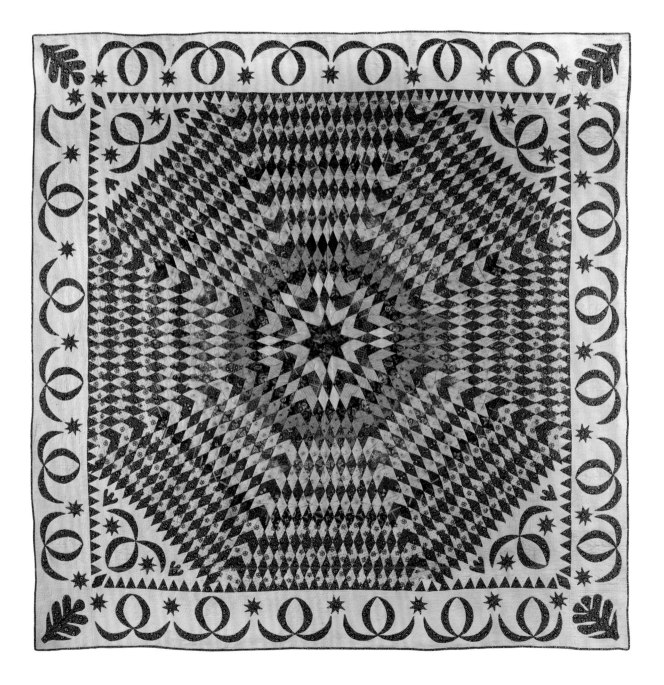

Under Viola Nadelman's direction, the MFPA acquired a broad selection of American bedcoverings, including appliquéd, pieced, and stenciled quilts as well as woven coverlets. The N-YHS collection includes eight quilts and nine coverlets from the Nadelmans, twelve of which the Society purchased in 1937 and five additional pieces—including these two quilts—that the couple donated two years later.[1] Most were probably kept folded and stored, but at least one—the rare stenciled quilt visible in fig. 11—was displayed on a bed in the American bedroom.[2] The MFPA cards record six bedcover purchases made between 1924 and 1930, revealing that the Nadelmans paid between $4 and $22 per item and acquired quilts both through antique dealers and at auction.[3] Their purchases ranged from basic woven coverlets to showy displays of needlework prowess like the two examples discussed here.[4]

The bold red and green quilt, which resembles album quilts made primarily in the Mid-Atlantic United States during the mid-nineteenth century, is composed of twenty-five appliquéd squares framed by a double sawtooth border.[5] A single wreath of grapes at the center is surrounded by four alternating patterns: tulip bud wreaths in the inner corners, oak leaves with acorns in the outer corners, and tulip wreaths with buds and red feather crown wreaths filling out the remaining blocks.[6] The apparent spinning motion of the wreaths lends the quilt its magnificent dynamism. The grapes in the central square, symbolic of fertility and good luck, are enlivened by the use of trapunto—design elements stuffed with batting—to give dimensionality to the fruit.

When the Nadelmans donated the bedcover in 1939, it was catalogued with two pattern names, Seek No Further and Many Mansions, referring to the designs used in the individual blocks. Both have biblical derivations: Many Mansions from John 14:2, "In my Father's house are many mansions," and Seek No Further possibly from Matthew 7:7, "Ask and it will be given to you; seek and you will find." By 1929, when the quilt was

published in Ruth E. Finley's *Old Patchwork Quilts and the Women Who Made Them*, it was in the hands of the Jamaica, New York, dealer Katharine Willis.[7] The Nadelmans probably purchased the quilt directly from Willis, a dealer who supplied them with a range of folk art.

The dazzling Sunburst pattern quilt is composed of thousands of pieced diamonds cut from various imported English printed cotton fabrics made between the late 1830s and the 1850s. The pattern, which was popular in the second quarter of the nineteenth century, found particular favor among quilters in the Mid-Atlantic and Southern New England. The maker of this example contained her sunburst within an appliqué sawtooth frame and a border of stylized swags and stars with a leaf at each corner. With its central eight-pointed star radiating outward into concentric circles and octagons, this quilt relates to several made by Rebecca Scattergood Savery, an affluent Quaker from Philadelphia.[8] Its kaleidoscopic effect reflects the craze for kaleidoscopes that followed the invention of the device by Scottish physicist Sir David Brewster in 1816.[9]
MKH

1 The quilts are N-YHS 1937.933, .937, .1200, .1321, .1322, .1387, and 1939.4, .5; the coverlets are 1937.934, .935, .1316, .1317, .1318, .1633, and 1939.1, .2, .3.

2 N-YHS 1937.1387.

3 The Nadelmans continued to acquire quilts and coverlets even after selling the contents of the MFPA to the N-YHS in 1937. In January 1939, for instance, they purchased eight coverlets, two quilts, and other textiles from Mrs. Lawrence J. Ullman of Tarrytown, NY. In February, they purchased seven more coverlets at Parke-Bernet. Mrs. Lawrence J. Ullman, receipt to Mr. and Mrs. Elie Nadelman, January 19, 1939, NP; Parke-Bernet Galleries, receipt to Mr. E. Nadelman, February 17–18, 1939, NP.

4 At least one quilt left the MFPA before the collection was sold to N-YHS. Mrs. John D. Rockefeller, Jr. purchased a Baltimore album quilt from the MFPA via Edith Halpert's Downtown Gallery, and later donated it to the Museum of Fine Arts, Houston. See Dena S. Katzenberg, *Baltimore Album Quilts*, exh. cat. (Baltimore: Baltimore Museum of Art, 1981), 56, 86; Corinne McNeir, Acting Curator, Museum of Fine Arts, Houston, to Mrs. Elie Nadelman, May 17, 1945, NP.

5 For related album quilts, see International Quilt Study Center & Museum, Lincoln, NE, 2008.040.0136, 2008.040.0087, 2005.039.0002, 1997.007.0890, and Art Institute of Chicago, 1919.535. See also Robert Shaw, *American Quilts: The Democratic Art, 1780–2007* (New York: Sterling, 2009), 44–46.

6 Ruth Finley identifies these patterns respectively as Fruitful Vine, Tulip Bud, Charter Oak, Garden Wreath, and Feather Crown. See Ruth E. Finley, *Old Patchwork Quilts and the Women Who Made Them* (Philadelphia: J.B. Lippincott, 1929), 125.

7 Ibid., pl. 62.

8 Winterthur Museum, Winterthur, DE, 1997.0022; Philadelphia Museum of Art, 1975-5-1; American Folk Art Museum, New York, 1979.26.2.

9 Priddy 2004, 81–97.

55

Henrietta Schnip (American, ca. 1828–1909)
Mourning picture, ca. 1835
New York City
Silk thread on linen ground; 22¼ × 20⅝ in.
(56.5 × 52.4 cm)
1937.343

Ana Asensio (Spanish, dates unknown)
Sampler, 1791
Silk floss on linen ground; 23⅛ × 25⅞ in.
(58.7 × 65.7 cm)
1937.340

Unidentified German maker
Sampler, 1810
Dresden, Germany
Cotton floss on cotton ground; 13⅛ × 22⅛ in.
(33.3 × 56.2 cm)
1937.341

Christiane Bauer (German, dates unknown)
Sampler, 1840
Saxony, Germany
Cotton floss on cotton ground; 12¼ × 19¾ in.
(31.1 × 50.2 cm)
1937.342

Viola Nadelman assembled an international sampling of schoolgirl needlework for the MFPA comprising at least seventeen samplers, embroidered pictures, and beadwork pictures made in the United States, France, Germany, England, and Spain.[1] The Nadelmans were no doubt aware of the close ties between the European samplers they acquired and their American counterparts.

Samplers probably originated during the early Renaissance, developing over time from a personal reference tool into a component of women's formal education.[2] Their making had become customary in both England and Spain by the time the Spanish princess Catherine of Aragon, a known devotee of needlework, arrived in England in 1501 to marry Prince Arthur.[3] By the seventeenth century the vocabulary of sampler motifs had become international, due in part to the popularity of pattern books that circulated throughout Europe and made their way to America.[4]

Henrietta Schnip, the daughter of German immigrants living in New York City, worked the mourning picture at a girl's school when she was around seven years old.[5] The picture, cross-stitched on a coarse linen ground, memorializes Susan Schnip, possibly a half-sister, who died in 1828 at age sixteen. Henrietta's composition follows the conventions of early nineteenth-century mourning pictures, which became popular in schoolgirl art following the death of George Washington in 1799. Her picture incorporates standard iconography for the genre: a tombstone topped by a classical urn, symbolic of death, and a weeping willow, suggesting both sorrow and regeneration.[6] Henrietta also stitched eight lines of verse, probably dictated by her teacher, expressing sorrow over Susan's death and hope for her everlasting life.[7] These personal expressions of grief were distinctly American, though needlework mourning pictures like Henrietta's were heavily indebted to classical symbols and European precedents memorializing heroic figures.[8]

The large square sampler, densely worked with geometric patterns and figurative motifs in various stitches, typifies eighteenth- and early nineteenth-century Spanish examples. Young Spanish girls were expected to learn the catechism of the Catholic Church as well as embroidery stitches, both typically taught by nuns. A sampler or *dechado* like this was usually completed by a girl at age seven or eight to demonstrate her mastery of different stitches.[9] Ana Asensio, who worked this sampler in 1791 in cross and satin stitches, included religious symbols and phrases (*Ave Maria Purisima*) as well as secular motifs such as an urn with flowers. Spanish sampler motifs reflect the country's Moorish past: here the dense geometric patterning and the repeated Persian stars. The Nadelmans were well acquainted with Spanish textile history, as their reference library included Mildred Stapley's 1924 study of Spanish weaving and embroidery.[10]

The two refined samplers stitched primarily with red cotton floss are typical of needlework created at girls' schools in Saxony, Germany, particularly Dresden. Worked by girls from well-to-do families, these samplers attested to each young woman's social status and helped her develop valued household skills. The unidentified maker of the Dresden sampler stitched eight alphabets in different styles, which served as practice for marking family linens. At the center of her composition is a blasted tree with a sign advertising "Weibliche Unterrichts Anstalt / Dresden 1810" (Institute for Woman's Education / Dresden 1810). The student also stitched the names or initials of twenty-six family members, each with a floral motif—all useful practice for identifying the fine linens in a woman's dowry.[11]

The equally accomplished needlewoman Christiane Bauer may have also worked her sampler in Dresden. It too includes multiple alphabets, the initials of family members, and selective use of white stitches to create a sense of depth, all worked in satin, back, running, and outline stitches. Christiane also stitched four different royal crowns, which then denoted levels of German aristocratic rank. With the three whitework floral sprays to the right of the alphabets and spot motifs, Christiane displayed her skills at cutwork and drawn threadwork, techniques used in decorative embroidery.

MKH

1 N-YHS 1937.340, .341, .342, .343, .344, .345, .346, .1335, INV.1079 (MFPA 437), .1080 (MFPA 2570), .1082, .1144, .1170, .1172, .1207, and .1214. The MFPA cards also record a 1791-dated sampler with a figure of an African American (MFPA 1091).

2 Gordon Campbell, ed. *The Grove Encyclopedia of Decorative Arts* (Oxford: Oxford University Press, 2006), 2:310–12; see also Clare Browne and Jennifer Wearden, *Samplers from the Victoria and Albert Museum* (London: V&A Publications, 1999).

3 Betty Ring, *Girlhood Embroidery: American Samplers & Pictorial Needlework 1650–1850* (New York: Knopf, 1993), 1: 5–9.

4 Ibid., 9, fig. 6; Wertkin 2004, 447–48.

5 The Nadelmans also collected an alphabet sampler by Henrietta Schnip dated 1834 (N-YHS INV.1207).

6 Blanche Linden-Ward, *Silent City on a Hill: Landscapes of Memory and Boston's Mount Auburn Cemetery* (Columbus: Ohio State University Press, 1989), 134–36; Anita Schorsch, "Mourning Art: A Neoclassical Reflection in America," *American Art Journal* 8:1 (May 1976): 4–15.

7 "On Susans grave we'll drop the tear Although she bade us not to weep / Over her mouldring relics here Which guardian angels safely keep / Angels have borne her far away Where now she shines in robes of white / Hynmning [*sic*] her everlasting lay [?] In worlds of uncreated light" and "No spot more sweet then [*sic*] susans grave / Can meet the sun [*sic*] refulgent beam / And now he glides the distant wave / And mildly decks the verdent [*sic*] scene".

8 Schorsch, "Mourning Art," 4–15.

9 Mildred Stapley, *Popular Weaving and Embroidery in Spain* (New York: William Helburn, 1924), 29–33.

10 Ibid.

11 *Mustertücher: Stickmuster aus drei Jahrhunderten* (Graz, Austria: Leopold Stocker, 2010), 87–89.

56

Unidentified French maker
Lacemaker's pillow (*Tambour de dentellière*), 1788
Queyras, France
Wood (probably white pine), wool, linen, iron;
4¾ × 11 in. (12.1 × 27.9 cm)
Provenance: Unspecified source, Paris, 1926
Z.18*

Known in its region of origin as a *tambour de dentellière* or *tambour à dentelle*, this lacemaker's pillow with carved wooden sides is part of the lively folk tradition of Queyras, a secluded valley high in the French Alps. This distinctive expression of local culture served multiple functions: women worked freehand bobbin lace—made to adorn caps, collars, and cuffs—on the fabric-covered padded surface, using pins to determine the pattern, and stored their sewing supplies in the interior compartment behind a hinged door. In addition, the large round sides provided a surface for carved ornament and personalization. This example, one of at least two Queyras lace pillows exhibited by the Nadelmans, bears the carved initials "W [or VV] / M F," the presentation date 1788, and the conjoined letters "AM" inside the compartment door.[1] The wooden sides are decorated with a central six-pointed rosette encircled by bands of geometric carving. The box's cylindrical rim, constructed with a series of vertical wooden staves, is padded, covered with coarse fabric, overlaid with green wool trimmed with white, and tacked with iron nails.

A second Queyras lace pillow acquired by the Nadelmans provides an instructive comparison (fig. 103).[2] Unlike the geometric ornament of the 1788 pillow, this example is decorated with naturalistic carving composed of scrollwork, leaves, and hearts. The top disc also includes four letters placed at cardinal points around the edge, carefully carved within the foliage: "A" opposite "M," and "V" opposite "V." "AM," also carved on the 1788 lace pillow door, likely refers to *Auspice Maria*, a monogram of the Virgin Mary and Latin for "under the protection of Mary." The meaning of "V V" is unclear, but rather than the owner's initials, it too probably has Christian symbolism.[3] This lace pillow still retains a sample of bobbin lace pinned to the work area.

When the Nadelmans acquired their lace pillows in the late 1920s, the folk art of the isolated and culturally homogeneous valley of Queyras had attracted a small group of scholars, particularly the ethnographer Hippolyte Müller.[4] Müller's 1931 article on Queyras summarized years of research on the material culture of the peasantry and illustrated over a dozen eighteenth- and nineteenth-century lacemaker's pillows, including one with the same carved design as this example.[5] Scholars took special note of these masterpieces of folk art, which peasants carved during the long winter months when they were free of the demands of herding and growing grain.[6] The pillows, typically carved from white pine (*Pinus cembra*) or larch (*Latrix decidua*), were often inscribed and presented as love tokens. Although extant examples date as early as 1650 and as late as 1830, the golden age of production was between 1720 and 1789.[7] This example was created on the eve of the French Revolution, which marked a seismic shift in the political and cultural life of the Queyras peasantry.[8]

The MFPA card notes that the lacemaker's pillow was acquired in Paris in June 1926 but does not specify a source. That same month, the Nadelmans recorded the purchase of eleven pieces of eighteenth-century French peasant art, including lace measures and handlooms, from the Musée d'ethnographie du Trocadéro, apparent deaccessions from the struggling institution. Though not specifically designated, this lacemaker's pillow may have been among the Trocadéro purchases.
MKH

1 Also inside the compartment door is a MFPA
 label inscribed "1953 / Fr." The MFPA card reads
 "Lace pillow maker, carved, French." When it was
 acquired by the MFPA, the pillow still contained
 bobbins and other implements.
2 N-YHS Z.413; MFPA 2633; Nadelman collection
 label "2633 / Germ." The Nadelmans identified the
 lacemaker's pillow as German in origin, probably
 because they purchased it in Munich from the
 dealer Siegfried Laemmle.
3 The initials "V V" also appear in portraits by the
 Italian Renaissance painter Giorgione and others.
 In these cases, the letters likely stand for *Vivus
 Vivo*, or "the living [made it] for the living." See
 Nancy Thomson de Grummond, "VV and Related
 Inscriptions in Giorgione, Titian, and Dürer," *Art
 Bulletin* 57:3 (September 1975): 346–56.
4 Marie-Pascale Mallé, *Queyras: Hautes-Alpes* (Aix-
 en-Provence: Association pour le patrimoine de
 Provence, 1994), 4, 15; see also H.[ippolyte] Müller,
 "Études d'art populaire dans le Queyras (Hautes-
 Alpes)," *L'Art populaire en France* 3 (1931): 7–20.
5 Müller, "Études d'art populaire dans le Queyras,"
 10, fig. 4 (lace pillow at the center).
6 Robert K. Burns, Jr., "The Circum-Alpine Culture
 Area: A Preliminary View," *Anthropological
 Quarterly* 36:3 (July 1963): 141–42; see also idem,
 "The Ecological Basis of French Alpine Peasant
 Communities in the Dauphiné," *Anthropological
 Quarterly* 34:1 (January 1961): 19–35.
7 "Tambour de dentellière," in *Objets d'hier—Site
 dédié aux arts populaires et objets de curiosité*:
 http://citedesarts.com/fr/Aff.php?select_nom=98
8 Mallé, *Queyras*, 5, 7.

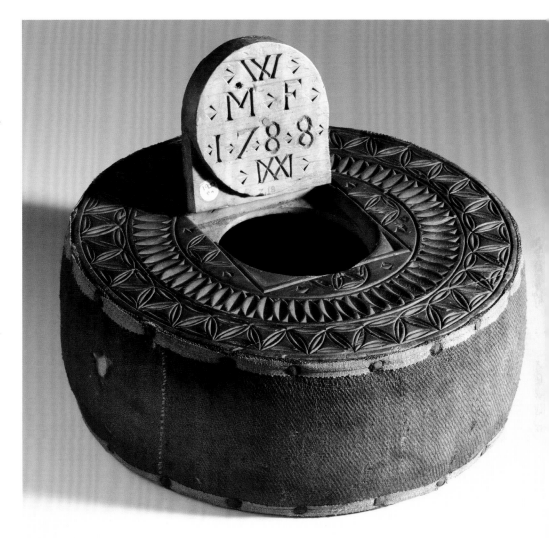

Fig. 103. Unidentified French maker, Lacemaker's
pillow (*Tambour de dentellière*), Queyras, France,
1730–80. Wood (probably white pine), wool, linen,
iron; 7 × 10¾ in. (17.8 × 27.3 cm). N-YHS, Z.413.

57

Unidentified Hungarian makers
Lace bobbins, 1800–50
Wood; 6⅜ × 1⅛ × 1⅛ in. (16.2 × 2.9 × 2.9 cm) (largest)
Provenance: Vilmos Szilárd, Budapest, Hungary, 1928
Z.1564.1, .4, .6, .7, .9, .12, .17, .20*

The Nadelmans had a deep interest in the folk art of Hungary, as witnessed by more than two hundred Hungarian-made objects in the MFPA and by their philanthropic support of the Hungarian Museum of Applied Art in Budapest.[1] Correspondence in the Nadelman papers documents Viola's purchase of a group of thirty-nine Hungarian lace bobbins from Budapest art dealer Vilmos Szilárd in early 1928. The letters reveal Viola as a discerning collector who demanded high quality and reasonable prices. Addressing concerns she raised about the bobbins, Szilárd wrote: "I beg to remark that not one of these is modern, and that I am unable to accept your limit of $20. The utmost I can do, is to reduce the price to $35."[2] The dealer went on to reproach her for attempting to negotiate a lower price: "I wish to emphasize that the prices I quote are always moderate and cannot be subjected to any reduction, what I beg you to note for the future."[3] Viola eventually relented and proceeded with the purchase, instructing her bankers to send a $35 check from her personal account to Szilárd in Budapest.[4]

Vilmos Szilárd was an important supplier of Hungarian folk art to the MFPA. Between 1925 and 1931, the Nadelmans made at least forty-five purchases from him of pottery, glass, iron, carved wooden artifacts, and weaving implements.[5] Szilárd was also connected to the Budapest shop Klasszis, which supplied the Nadelmans with at least 147 items in 1925 and 1926.[6] In addition to selling antiques, Szilárd edited a monthly journal on collecting, featuring articles on Hungarian peasant art, and had ready access to quality artifacts. He capitalized on his status as a scholar and insider to reassure Viola: "I now, by editing this Art Journal am in still closer touch with everybody and everything referring to Hungarian Peasant Art. Therefore if I say that these articles are getting scarce and that my prices are the possible lowest, I do not doubt that you will believe me."[7] Through his writing, collecting, and dealing, Szilárd played a significant role in preserving the fast-disappearing material culture of rural Hungary, and the MFPA helped to extend that mission.

Bobbin lace originated in Italy in the sixteenth century and was made throughout Europe, with regional variations. The traditional bobbin lace made by Austro-Hungarian peasants was characterized by a flowing tape design on net ground.[8] The lacemaker outlined a design by setting pins into a pillow or cushion, and then twisted and plaited lengths of thread around the pins. The ends of the threads were wound around bobbins, which the lacemaker used to manage the multiple threads.[9] Typically made of wood or bone, European bobbins were also produced in ivory, metal, and glass.[10]

These eight wooden bobbins flaunt the talents of the wood-carvers who made them. While most European bobbins were cylindrical and turned on a lathe, these examples are square in profile and heavily carved.[11] It is possible that the bobbins were created as part of a conscious revival of Hungarian folk craft, as the square, notch-carved implements are more closely related to the carving found on traditional Hungarian grave-posts (*kopjafák*) than they are to typical Hungarian bobbins.[12] Five of the Nadelman group include a looped end and attached pendant carved from a single piece of wood—a virtuosic display of wood carving.

MKH

1 The MFPA cards document the purchase of 229 objects identified as Hungarian. In 1925, the Nadelmans supported the museum's collections with a donation of $100. Ide Végh, Director, Hungarian Museum of Applied Art, to Elie Nadelman, June 9, 1925, NP.

2 Vilmos Szilárd to Mrs. Elie Nadelman, January 2, 1928, NP.

3 Ibid.

4 MFPA 2425. Viola M. Nadelman to Equitable Trust Co., undated, NP.

5 Twenty-three transactions were identified in the MFPA cards with both Szilárd's name and the name of the Klasszis shop.

6 See advertisements for Szilárd and Klasszis in *A Mügyütö* [Connoisseur], 1929, as reproduced in Györgyi Fajcsák, "Exhibition of Oriental Art, 1929," *Ars Decorativa* 23–24 (2004): 169. As the shop's address in the advertisement is the same as that on Szilárd's stationery, it is likely that Klasszis—which means "classic" or "unique" in Hungarian—was simply a name for his business.

7 Vilmos Szilárd to Mrs. Elie Nadelman, January 2, 1928, NP.

8 Phyllis G. Tortora and Ingrid Johnson, *The Fairchild Books Dictionary of Textiles*, 8th ed. (London: Bloomsbury Group, 2013), 31, 64, 296.

9 Molly G. Proctor, *Needlework Tools and Accessories: A Collector's Guide* (London: B.T. Batsford, 1991), 86; "Lace Bobbins," *Bulletin of the Needle and Bobbin Club* 1:1 (December 1916): 5–12.

10 Edward H. Pinto, *Treen and Other Wooden Bygones: An Encyclopedia and Social History* (London: G. Bell and Sons, 1969), 309–12.

11 For related Hungarian carvings, see Malonyay Dezsö, *A Magyar Nép Müvészete* (Budapest: Franklin-Társulat, 1912), 155, ill.

12 See Ernő Kunt, *Temetők népművészete* (Budapest: Corvina Kiadó, 1983), 44, pl. XII. Thanks to Rebecca Klassen for pointing out the relationship between the bobbin carvings and Hungarian grave-posts.

58

Unidentified European or American maker
Sewing bird, 1830–80
Steel; 3¾ × 1½ in. (9.5 × 3.8 cm)
Provenance: Unspecified source, Saint-Germain-en-
Laye, France, 1926
1937.1611*

Unidentified American maker
Sewing box, 1840–80
Pine, birch, bone, metal, textile; 6½ × 7⅛ × 5½ in.
(16.5 × 18.1 × 14 cm)
Provenance: Disosway, Staten Island, NY, 1926
INV.7572a-v*

Textiles and sewing implements were of particular interest to Viola Nadelman, who had formed a collection of antique textiles and lace even before the couple began their folk art odyssey.[1] Galleries X and XI of the MFPA displayed a plethora of hand-embroidered textiles as well as related sewing tools. According to the inventory, Gallery X included six cases with embroideries and costume accessories and Gallery XI had a case of "161 implements for making lace, weaving, sewing, knitting, etc." Five spinning wheels and other tools for processing fiber provided additional context for the textiles and needlework. "Madame Nadelman" gave a special tour of the MFPA to fellow members of the Needle and Bobbin Club in 1926, paying special attention to the peasant caps, headdresses, and embroideries.[2] While she herself may not have been skilled with a needle, Viola did enjoy knitting. A reporter who visited the museum in 1935 observed: "Over in a corner, at an old German table, sits Mrs. Nadelman, director of the Museum, knitting."[3]

This steel sewing bird, perched on its clamp as if alighting, was one of at least four such implements in the museum.[4] Unlike many of the examples produced in the United States and Europe during the late eighteenth and nineteenth centuries, this example is completely unornamented. Its sleek silhouette is, surprisingly, more in keeping with the streamlined design of the 1930s than the fussy decoration of the Victorian era. Sewing birds essentially served as an extra hand for seamstresses and tailors, holding fabric taut while they stitched. The clamp attaches firmly to a table by means of a thumbscrew-operated slip-vise; depressing the tail of the bird opens its beak; releasing it lets the beak grip the fabric placed within. Sewing birds, also made in iron, brass, and painted wood, were first developed in England in the early eighteenth century as a variation on the needlework clamp. Charles Waterman of Meriden, Connecticut, received the first American patent for a sewing bird in 1853; numerous manufacturers followed with an endless flock of decorative variations on the basic

form.[5] Many sewing birds did double duty by supporting a pincushion on their backs. This example, which bears an incuse maker's mark of "MC" on the clamp, may be the "sewing screw, bird" that Viola Nadelman bought for $1.50 in Saint-Germain-en-Laye, a suburb west of Paris, in June 1926.[6]

The tiered thread-dispensing sewing box was also useful to the nineteenth-century needlewoman. The top of the box lifts off, revealing eight metal prongs for holding spools of thread. The thread is guided through the bone eyelets—four at the front and two on each side—for easy, tangle-free access. The pincushion and storage drawer make the stand a multi-purpose tool. Viola acquired this object from a Staten Island dealer, identified only as "Disosway," for $4 in September 1926.[7] At the time of purchase, the drawer held two lengths of crocheted lace, an ivory-handled crochet hook, an ivory needle case, and thread wound on ivory thread winders—all of which remain inside.

Though this box is hand-crafted, with finely cut, locking rabbet joints joining the drawer sides to the front and back, the type

was apparently produced in quantity, with some variants: two or three tiers; three, four, or six eyelets on the front panel; and walnut, maple, or pine as the primary wood. The turned wooden or ivory drawer pull, turned pincushion support, and pointed Gothic finials are consistent among surviving examples.[8] Although its once-vibrant colors have dulled with time, this example features a red-stained pine drawer front and eyelet panel with contrasting birch pilasters and finials, set off by the prominent white eyelets. The box's simple geometry and spare ornamentation probably appealed to the Nadelmans. These same features may have prompted some dealers and auction houses to identify this type of sewing box as a Shaker product.[9] Although Brother Theodore E. Johnson of the Sabbathday Lake (Maine) Shaker Community identified these objects as Shaker-made, no documentation has been found to support the claim.[10]

MKH

1 Kirstein 1973, 218; Stillinger 2011, 181.
2 "Club Notes," *Needle and Bobbin Club Bulletin* 10:2 (1926): 25.
3 James Morgenthal, "'Junk' Says Old Boy, But Visitor to Folk Arts Museum Disagrees," *Riverdale News* (September 1935): 3.
4 MFPA 1996. Other examples included a brass sewing bird, purchased from Burgard in March 1930 (MFPA Misc. 2707); a sewing bird with painted box, purchased from [C.W.] Lyon in March 1925 (no MFPA number); and a "sewing screw for table," acquired from Mrs. S. Cohen (MFPA 1817).
5 Mary C. Beaudry, *Findings: The Material Culture of Needlework and Sewing* (New Haven: Yale University Press, 2006), 160–62; Molly G. Proctor, *Needlework Tools and Accessories: A Collector's Guide* (London: B.T. Batsford, 1990), 82–85; Nerylla Taunton, *Antique Needlework Tools and Embroideries* (Woodbridge, Suffolk, Eng.: Antique Collectors' Club, 1997), 151–55.
6 MFPA 1996. The card identifies the object as French and further describes it: "Bird which open[s] mouth. Metal."
7 MFPA 2151. Although the sewing box was not accessioned in 1937, the Nadelman collection adhesive label on its underside inscribed "2151/ Amer" links the object and the MFPA card.
8 For example, N-YHS INV.5470; Winterthur Museum, DE, 1966.1461; Skinner, Bolton, MA, "American Furniture & Decorative Arts," August 14, 2005, lot 405; Cowan's Auctions, Cincinnati, OH, "Americana and Decorative Arts," November 12–13, 2003, lot 973; Myers Auction Gallery, St. Petersburg, FL, "Fine American Antiques," February 19, 2012, lot 209; Case Antiques, Knoxville, TN, January 28, 2012, lot 609.
9 Skinner, Bolton, MA, "American Furniture & Decorative Arts," August 14, 2005, lot 405; Cowan's Auctions, Cincinnati, OH, "Americana and Decorative Arts," November 12–13, 2003, lot 973; Myers Auction Gallery, St. Petersburg, FL, "Fine American Antiques," February 19, 2012, lot 209; Case Antiques, Knoxville, TN, January 28, 2012, lot 609.
10 E-mail correspondence with Lesley Herzberg, Curator of Collections, Hancock Shaker Village, Pittsfield, MA, November 21, 2013. I would also like to thank Jerry Grant, Director of Collections and Research at Mount Lebanon Shaker Museum and Library, Old Chatham, NY.

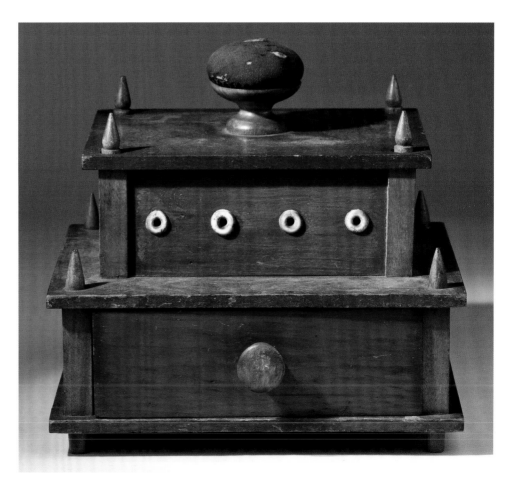

59

Unidentified English maker
Knitting sheath, 1785
Wood; 9¼ × ⅞ × ¾ in. (23.5 × 2.2 × 1.9 cm)
Provenance: James Falcke, London, 1928
2489*

Unidentified European maker, probably French
Knitting sheath, 1500–1650
Boxwood; 9⅛ × ½ × ½ in. (23.2 × 1.3 × 1.3 cm)
Z.1808

Unidentified French maker
Knitting sheath, 1500–1650
Boxwood; 9 × ¾ × ¾ in. (22.9 × 1.9 × 1.9 cm)
Provenance: American Art Galleries, New York,
Georges Spetz sale, 1925
Z.1809*

Knitting originated in the Middle East and spread to Europe during the Middle Ages through Mediterranean trade routes.[1] Knitted textiles were a luxury trade item during the medieval period, but by the 1600s, peasants throughout Europe had taken up hand-knitting to keep their families warm and supplement their incomes. Requiring no special equipment other than needles and yarn, knitting was practiced by family members at home as well as by sailors and shepherds. Knitting sheaths, in use by the sixteenth century, supported the right-hand needle and took the weight of the knitting. Wearing the implement on the right hip, tucked into a belt or apron strings, the knitter inserted his or her working needle into a hole bored in the top of the sheath. The sheath freed the fingers of the right hand, allowing the knitter to work more rapidly.[2]

The two more elaborately ornamented sheaths at the right are exquisite examples of boxwood carving, an art that flourished during the Renaissance alongside ivory carving. The materials are similarly fine-grained and suited for minutely detailed carving.[3] Both of these boxwood sheaths are expertly fashioned, with crisply executed decorative motifs and subtly curving shafts that follow the contour of the knitter's body. One sheath, featuring five graduated tiers of arcades reminiscent of the famous Leaning Tower of Pisa, is topped by a leafy crown and terminates in a heart-shaped foot. Once part of the private museum of connoisseur Georges Spetz in Alsace, France, the sheath was one of two arcaded examples purchased in a single lot for $7.50 at the American Art Galleries' Spetz sale in 1925.[4] The auction catalogue assigned their origin to the Upper Rhine region of Alsace and dated them to the early sixteenth century. The second boxwood sheath, which is carved with zigzag and other geometric motifs and features four narrow windows near the top, may also have originated in Alsace. Its purchase is not documented in the MFPA cards.

In contrast to the expertly carved boxwood examples, the English knitting sheath comes out of a lively folk tradition. Like many English sheaths, it appears to have been made as a love token. The shaft is engraved "WH," probably the recipient's initials, and the date 1785. The craftsman flaunted his skill by carving a hollowed-out window with a loose ball inside.[5] The five northern counties of England had a strong tradition of carved knitting sheaths, which, like corset-stiffening busks, lace bobbins, and love spoons, were typically made by young men as gifts for their sweethearts.[6] The Nadelmans purchased this sheath from London dealer James Falcke in November 1928 along with a second initialed and dated example.[7]

The Nadelmans had a particular appreciation for this form: they acquired more than twenty knitting sheaths between 1924 and 1930, including twelve English examples from Falcke.[8] They displayed the sheaths in Gallery XI of the MFPA along with a plethora of implements related to knitting, sewing, weaving, and lacemaking.
MKH

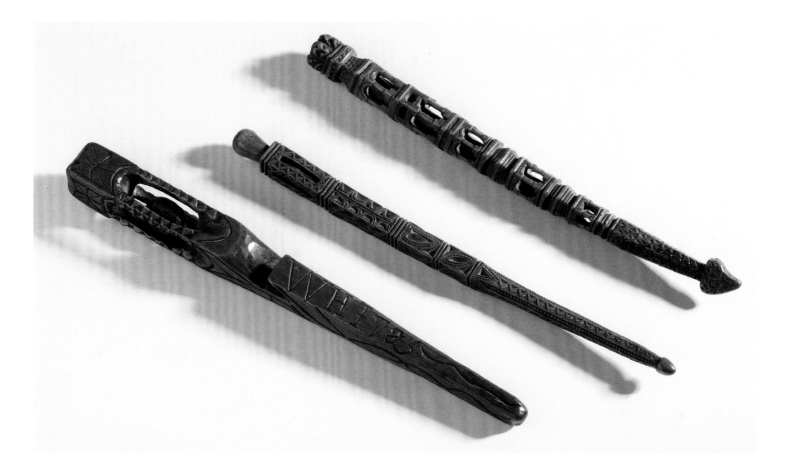

1 Irena Turnau, *History of Knitting Before Mass Production*, trans. Agnieszka Szonert (Warsaw: Institute of the History of Material Culture, Polish Academy of Sciences, 1991), 24–25; Sylvia Groves, *The History of Needlework Tools and Accessories* (New York: Arco, 1973), 70.

2 Groves, *History of Needlework Tools*, 73–74; Edward H. Pinto, *Treen and Other Wooden Bygones: An Encyclopedia and Social History* (London: G. Bell and Sons, 1969), 305–6; Kay Sullivan, *Needlework Tools and Accessories: A Dutch Tradition* (Woodbridge, Suffolk, Eng.:

Antique Collectors' Club, 2004), 155–56.

3 Johanna Hecht, "Ivory and Boxwood Carvings, 1450–1800," http://www.metmuseum.org/toah/hd/boxw/hd_boxw.htm.

4 MFPA 1004; American Art Galleries, New York, Georges Spetz sale, January 14–17, 1925, lot 461.

5 For related examples of "lantern-and-ball" carving, see Groves, *History of Needlework Tools*, figs. 111, 112; Pinto, *Treen and Other Wooden Bygones*, figs. 322–24; W. Ruskin Butterfield, "About Knitting Sheaths," *Connoisseur* 53 (January 1919): figs. 1–3.

6 Pinto, *Treen and Other Bygones*, 158–63; J.C. Varty-

Smith, "Knitting Sticks and Sheaths," *Connoisseur* 61 (September 1921): 25; Butterfield, "About Knitting Sheaths," 20.

7 MFPA 2489 (number and price crossed out on the MFPA card). The sheath still bears a Nadelman collection label inscribed "2489/Engl."

8 The MFPA cards documenting the Falcke purchases all have their category, museum number, and purchase price crossed out. Small photographs of the objects are glued to the cards.

60

Unidentified American and European makers

Straw marquetry needlecase, 1820–60
Straw, wood; 5⅜ × 1 in. (13.7 × 2.5 cm)
Provenance: Versailles, France, 1926
INV.9827ab*

Giraffe needlecase, 1825–75
Ivory, metal; 3⅜ × ¾ × ⅛ in. (8.6 × 1.9 × 0.3 cm)
Z.1499ab

Rolling pin needlecase, 1840–80
Ivory, paint; 3⅝ × ⅜ in. (9.2 × 1 cm)
INV.9798ab

Lovebirds needlecase, 1830–70
Bone, paint; 4¼ × ½ in. (10.8 × 1.3 cm)
INV.9784a-c

Boot needlecase, 1820–50
Wood; ⅝ × 1¼ × ½ in. (1.6 × 3.2 × 1.3 cm)
INV.9839ab

Beadwork needlecase, 1830–60
Wood, glass, linen; 4¼ × ⅞ in. (10.8 × 2.2 cm)
INV.9779ab

Since Paleolithic times, sewing needles have been essential to human civilization. From the earliest examples of bone to steel needles introduced in the sixteenth century, a good needle was a vital possession.[1] They traditionally belonged to the domestic sphere of women, and only later to that of commercial tailors. Needles were expensive, highly valued for their utilitarian function, and markers of their owners' social status. With the rise of a leisure class, women were encouraged to keep their hands busy with needlework projects, often done in the company of others.[2] Hence, for certain segments of society, etiquette governed how a needle was held. It revealed the accomplishments of the user as well as her gentility.

Since clothes lacked pockets until the late eighteenth century, needlecases—also known as needle sheaths or *étui*—were necessary accessories for most women to safeguard their needles. Although tubular bronze examples found with needles still in them are extant from the Viking period in Europe, few medieval needlecases have survived because they were made of organic materials. Later, ornate examples were sometimes suspended from chatelaines as a status symbol or sartorial ornament, while less elaborate examples hung from a girdle or chain. The earliest needlecase documented in America dates from 1677, although bone examples turn up regularly at Colonial and later North American archaeological sites.[3] The late eighteenth century marked an explosion of sewing accessories in bone and ivory, including needlecases. Many of these are lathe-turned (INV.9798ab and INV.9784ab), intricately carved, or decorated (Z.1499ab). Unlike embroidered needlebooks, needlecases could be tightly closed to keep the steel needles from rusting, leading to their great popularity.

Craftsmen made needlecases in a seemingly infinite variety of forms, including peasant figures, with countless types of embellishments.[4] French makers produced multi-colored beaded cases of bone or wood with the beads threaded on fine wire, silk, or linen as in the case of INV.9779ab. The finest bead work from France was known as sable work. "Sable," meaning sand, refers to the fact that glass beads are made from sand, as well as small in size and as smooth to the touch as fur.[5] From the late eighteenth century, straw marquetry was yet another form of ornamentation used for needlecases in France, Italy, and England, and notoriously practiced by prisoners in the Napoleonic wars.[6] The Nadelmans concluded that the marquetry sample they purchased in June of 1926 for 75¢ at Versailles—whose abstract forms look amazingly modern—was French (INV.9827ab).[7] Industrialization and a change in marketing sounded the death knell for needlecases. By the mid-nineteenth century manufacturers in England began selling their needles in small cardboard boxes decorated with images, and the garment industry began to replace home sewing. The close of the Victorian era coincided with the demise of the ornamental needlecase.[8]

Since Viola Nadelman belonged to the Needle and Bobbin Club of New York and had a profound interest in lace and sewing accoutrements, it is not surprising that the couple amassed elegant European and American needlecases, which were popular collectibles at the time (see note 3). The MFPA cards document that they owned at least 206 examples. Most of these came from the trove of 197 needlecases (in gold, tortoise, pearl, bone, ivory, enamel, agate, niello, silver, etc.) that the Nadelmans purchased from Siegfried Laemmle in Munich in 1930 for $300.[9] The couple believed that the majority were seventeenth-, eighteenth-, and nineteenth-century German examples, although they indicated that one was from Moscow.
RJMO

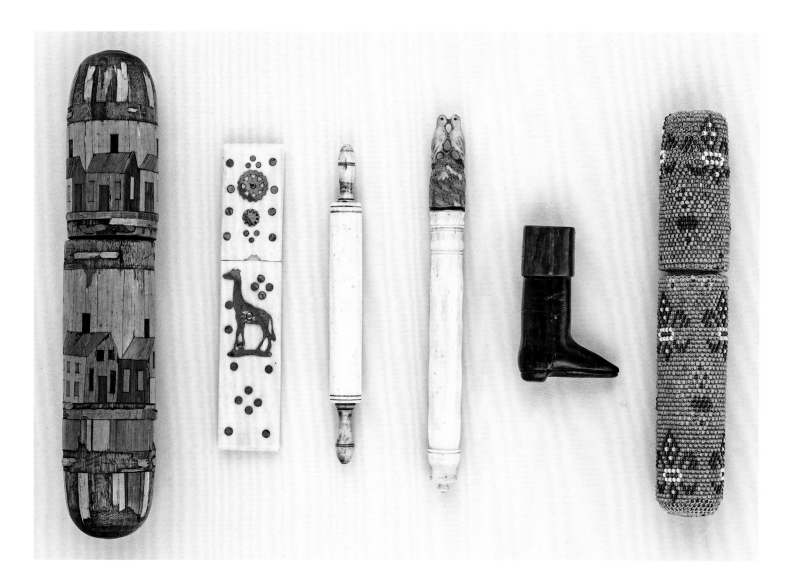

1 For the history of needles, see Mary C. Beaudry, *Findings. The Material Culture of Needlework and Sewing* (New Haven and London: Yale University Press, 2006), 44–85.

2 See E.J.W. Barber, *Women's Work: The First 20,000 Years: Women, Cloth, and Society in Early Times* (New York: W.W. Norton, 1994).

3 Ibid., 72–73. See also Gertrude Whiting, "On Needlebooks and Needlecases," *The Magazine Antiques* 8:6 (December 1925): 348–52.

4 N-YHS INV.9831ab, a wood example in the form of a hunter, may have belonged to the Nadelmans. Other needlecases produced in Austria and Germany took the form of peasants or fishermen, like the hunter, and echo the theme of "The Cries" (see fig. 93).

5 Bridget McConnel, *The Story of Antique Needlework Tools* (Atglen, PA: Schiffer, 1999), 113.

6 See Sylvia Groves, *The History of Needlework Tools and Accessories* (New York: Arco, 1973), 24. It is sometimes called "prisoner of war work," as French prisoners held by the British made them to sell or exchange for food and supplies.

7 MFPA 1965.

8 Groves, *The History of Needlework Tools and Accessories*, 27.

9 MFPA Misc. 2780. The MFPA card notes that the group was purchased for "Ap $284" from Siegfried Laemmle in January 1931. However, the dealer's invoice, dated February 2, 1931, states they were purchased for $300 on November 21, 1930, NP.

61

Unidentified European maker, possibly Hungarian
Box, 1730–80
Binder's board, watercolor, wood, linen, wool;
6 × 10¾ in. (15.2 × 27.3 cm)
Provenance: Clarke Art Galleries, New York City, 1924
INV.8520ab*

Principally attracted by the aesthetic qualities of folk art, the Nadelmans did not always clearly understand the function of the objects they acquired. This octagonal box, which was displayed in the MFPA with implements related to sewing, needlework, and lace making, is a case in point. The MFPA cards describe the curious container as a "needlepoint work box" of Hungarian origin, presumably for holding a woman's sewing notions.[1] Though covered with needlework, the box in fact had no functional link to sewing. Its construction and iconography suggest that it was a woman's keepsake used for devotional purposes.

The interior of the box is crafted from binder's board, a laminated board often used in bookbinding.[2] It is fitted with twenty-four small storage compartments: two tiers of eight drawers, each fitted with a silk drawer pull, and in between the drawers, triangular compartments with hinged covers and silk pulls. Each drawer stack is embellished on top in watercolor with stylized tulips—symbolic of love—alternating with bellflowers and other floral blossoms, while the triangular compartments each bear a single tulip.[3] The underside of the lid is decorated with complementary motifs including eight anthemions within heart-shaped enclosures, and, on the central octagonal panel, an unidentified coat of arms presumably representing the owner's family. The elaborate ornament conceals the box's dramatic focal point: within the lid's central hinged panel is a recessed octagonal frame enclosing a hand-colored engraving of Saint Catherine of Siena receiving the stigmata.[4] Catherine may well have been the namesake of the box's owner.

The box's top and sides are stitched with Florentine work—zigzag patterns created using flat vertical stiches. Also known as bargello, flame stitch, or Hungarian point, the style is thought to have originated in Hungary and it flourished in Florence during the fifteenth century.[5] The type of needlework may have prompted the Nadelmans to assign the box a Hungarian origin.[6] The box's precise function and origin remain a mystery: the storage compartments are too small,

fragile, and inaccessible to be practical, and the box does not seem to conform to an identifiable folk tradition. It may have been a one-of-a-kind creation by a craftsman with these particular materials at hand. It is tempting to speculate that the box was made by a bookbinder skilled in manipulating and decorating binder's board, particularly since bookbindings were often covered with embroidery.[7] Though the artisan cannot be identified, the intention is clear: the inclusion of a patron saint and coat of arms indicate that the box was created for a specific woman, and the iconography of tulips and hearts suggests that it was created for the object of the maker's or commissioner's affection.
MKH

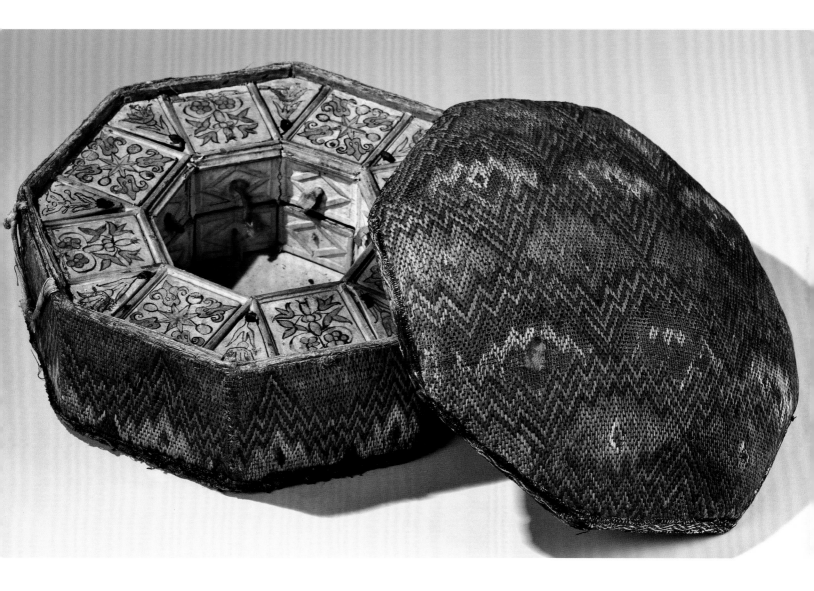

1 MFPA 332. A MFPA label on the underside of the box is inscribed "332 / Hungari / an."

2 Matt Roberts and Don Etherington, *Bookbinding and the Conservation of Books: A Dictionary of Descriptive Terminology* (Washington, DC: Library of Congress, 1982), http://cool.conservation-us.org/don/dt/dt0299.html.

3 One top of a triangular compartment is replaced and has a tulip executed later in black ink rather than watercolor.

4 Catherine can be identified by her Dominican habit and crown of thorns. At her side is a book, which may represent her *Dialogue* of 1377, and more generally her dialogue with God. See Fernando Lanzi and Gioia Lanzi, *Saints and Their Symbols: Recognizing Saints in Art and in Popular Images* (Collegeville, MN: Liturgical Press, 2004), 175–76.

5 Elsa S. Williams, *Bargello: Florentine Canvas Work* (New York: Van Nostrand Reinhold, 1967), 4–7; Pamela Warner, *Embroidery: A History* (London: B.T. Batsford, 1991), 101.

6 The box is described on MFPA card 332 as "needlepoint blue, green and tans—badly worn. Inside nests of boxes and drawers. Top decorated and opening shows picture of Christ." The Nadelmans purchased it at an unspecified Clarke Art Galleries sale in May 1924 for $11. The only extant catalogue from Clarke for May 1924 appears to be the May 6 Raimundo Ruiz sale of Spanish antiques and objets d'art. The box does not appear in the Ruiz catalogue.

7 Embroidered bookbindings flourished in England in the late sixteenth and early seventeenth centuries and were frequently used for bibles and books of psalms. See Cyril James Humphries Davenport, *English Embroidered Bookbindings* (London: Kegan Paul, Trench, Trübner, 1899).

62

Unidentified Northern European maker
Mangle board, 1791
Possibly Denmark
Carved birch; 5¼ × 4 ¼ × 26 in.
(13.3 × 10.8 × 66 cm)
Provenance: Probably Wallach, Munich, 1926
1937.1746*

Before the widespread use of flat irons, northern European housewives relied on mangle boards to smooth household linens. From the sixteenth through the nineteenth centuries, mangle boards were carved by young men as courtship gifts, often with their intended bride's initials. Handles were sometimes carved in the shape of animals, especially horses. Mangle boards were always paired with a roller, around which the damp textile was wrapped. The board was passed back and forth over the roller with heavy pressure and a smooth motion until the fabric was properly "ironed."[1]

This charming example features alternating rosettes—three carved in a stylized floral motif and two with pinwheels—surrounded by a chip-carved background. Carved under the handle is "ANO 1791 / END / ANO 1791," referring to the year of the couple's marriage and perhaps their surname. The three-piece handle with crosses carved into its supports is tenoned through the board. Signs of heavy usage are evident, especially on the smoothly worn handle. Although the Nadelmans

cataloged the mangle board as German, the style of carving suggests a Scandinavian origin, most likely Denmark.[2]

The Nadelmans purchased mangle boards both domestically and abroad. The present example may be the one noted as having "conventional rosette carvings," bought in October 1924 for $5 at Volkskunsthaus Wallach in Munich.[3] The brothers Moritz and Julius Wallach, passionate collectors of European peasant art, opened their popular shop in 1920 (see Hofer essay, p. 69). The Nadelmans purchased at least ten items from their museum-like retail establishment in August and October 1924.[4] They obtained other European mangle boards in the mid-1920s from New York City antique dealers C. Vandevere Howard, Ginsburg & Levy, Frans Middlekoop, a Budapest dealer cited only as "Muller," and an unidentified dealer in Nuremberg. Some, as here, were decorated with geometric carving, while others were considerably more elaborate. The example purchased in Budapest, for instance, was carved with four romantic scenes, a scroll and leaf border, and an image of Minerva on the handle. A photograph of the MFPA's Gallery IV reveals an eye-catching display of at least thirteen mangle boards surrounded by related carved household objects (fig. 104). The 1937 inventory confirms that the room included "17 Carved mangle boards, and wash beaters." This example, the only Nadelman mangle board at the N-YHS, is clearly visible in the lower row, adjacent to a spoon rack.

The tradition of carved mangle boards did not catch on in the American colonies, where irons fulfilled the need to press household linens. However, the style of carving used on such objects was carried to America by northern European settlers, particularly the Dutch, and is evident in the delightful spoon racks carved in New York and Bergen County, New Jersey.[5] Perhaps in an effort to link European and American traditions, the Nadelmans juxtaposed mangle boards and spoon racks in Gallery IV so that visitors could grasp the compelling visual relationship.[6]
MKH

Fig. 104. Gallery IV of the MFPA, 1935. NP

1 Ian McNeil, ed., *An Encyclopedia of the History of Technology* (New York: Routledge, 1990), 932.

2 For Scandinavian examples, see H.J. Hansen, ed., *European Folk Art in Europe and the Americas* (New York: McGraw-Hill, 1968), 88–89. A comparable Danish example can be found at http://www.artfact.com/auction-lot/a-danish-rococo-country-style-mangle-board,-year-106-c-8c0c564768. I thank Robert Young for his observations on the regional origin of this mangle board.

3 MFPA 725.

4 The MFPA curatorial records indicate that their purchases included painted boxes, woven baskets, wooden canteens, and a tin candle holder.

5 See, for example, Blackburn and Piwonka 1988, 159–61.

6 Two spoon racks are visible in the photograph of Gallery IV, but the inventory lists five. The MFPA curatorial records indicate that at least three of these were American.

63

Unidentified German makers

Ell rule, 1780–1820
Wood, ivory; 28¼ × ⅞ × 1 in. (72 × 2 × 2.5 cm)
Provenance: Hamburg, Germany, 1924
643*

Ell rule, 1780–1820
Wood, ivory; 32¾ × 1 × 1 in. (83 × 2.5 × 2.5 cm)
Provenance: Hamburg, Germany, 1924
Z.80*

Ell rule, 1780–1820
Wood, ivory; 34 × 1 × 1 in. (86.5 × 2.5 × 2.5 cm)
Provenance: Hamburg, Germany, 1924
Z.79*

Like many other textile-related utensils, these ell rules, or ell wands, were popular love tokens.[1] Artisans frequently lavished decorative motifs on them, as seen in these examples with rich dark and light wood and ivory inlay, elegantly turned handles, and tapering forms. The archaic term "ell," whose variants are found in many languages, derives from the Old High German word for the forearm (*elina* or *aliná*, the Latin *ulna*), which served as a unit of measure, similar to the cubit, approximating the length of a man's arm from the elbow or the shoulder to the middle finger or the wrist. Ell rules were primarily used by women for measuring home-woven fabric but were also employed by European textile merchants. The standard length varied country to country but in Germany, to which the ell rule traced its origins, nearly every town or region had its own standard length, ranging from twenty-four to thirty-two inches.[2] The Nadelmans were not aware of the technical term for these objects, as the MFPA cards for all three designate them as "YARD STICK, WOOD." The cards also record that they were purchased in Hamburg during August 1924 for $1 each.[3]

These implements reflect the couple's shared taste. They dovetailed with Viola Nadelman's collecting interests (lace, embroideries, and fabrics), which she had already developed before her marriage to Elie Nadelman in 1919. They also intersected with Elie Nadelman's interest in wood objects and modern, streamlined design. While these ell rules are not individually listed in the MFPA inventory, they were probably among the "161 implements for making lace, weaving, sewing, knitting, etc." and were displayed with them in Case 3 of Gallery XI of the MFPA, whose installation is unfortunately not preserved in a photograph.
RJMO

1 Thanks to Jeffrey Richmond-Moll for his early research on these objects.
2 See Ernst Schlee, *German Folk Art*, trans. Otto Ballin (Tokyo: Kodansha International, 1980), 130, 277, figs. 193–94; http://www.oed.com/viewdictionaryentry/Entry/60511; http://en.wikipedia.org/wiki/Ell. At some point in commercial use, a double ell superseded the original measure and became the normal length of ell measuring rods.
3 All three have inscribed MFPA collection labels (643: "643/German"; Z.79: "644/German"; Z.80: "625/German").

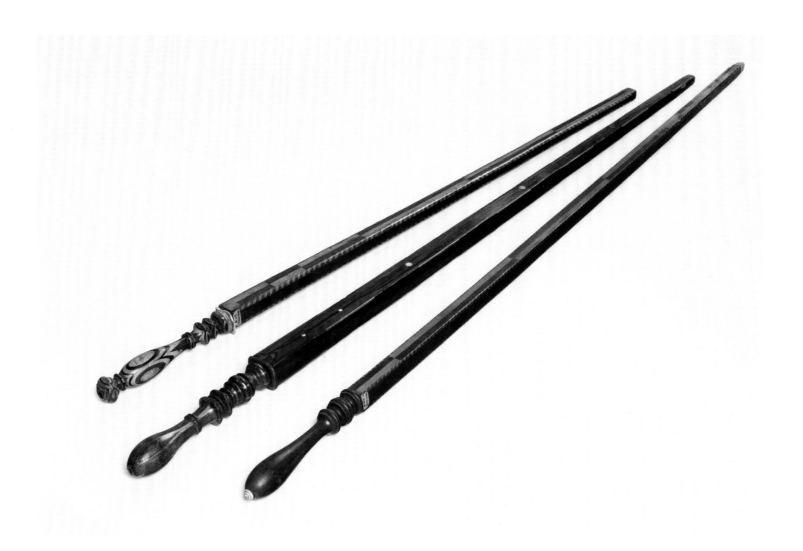

64

Unidentified makers
Clothespins, 1850–1900
Wood; 7¼ × 1¼ in. (18.4 × 3.2 cm)
INV.14896b-c

Clothespins, also known in England as clothes pegs, are wonderfully sculptural objects. They piqued the interest of both Nadelmans, who owned at least eight examples, all of which the couple considered American and hand cut.[1] Not only are they utilitarian household articles associated with clothing and textiles, and therefore aligned with Viola's interests, but also elegant wooden designs with decidedly simplified forms in sync with Elie's aesthetic.

The earliest clothespins were low-tech—probably straight, flat strips of wood with a slit up the middle. Later came cylindrical or spindle forms and tapered prongs. Users either carved the pins themselves or purchased them from traveling peddlers who had crafted them by hand. Frequently, children turned those featuring knobs into dolls. Samuel Pryor of Salem, New Jersey, received the first American patent for a mechanical clothespin with metal in 1832, but his model was lost in a fire that destroyed the U.S. Patent Office four years later. It was only in the 1840s that clothespins began to be mass-produced. From 1852 to 1887, the U.S. patent office issued 146 separate patents for clothespins that modified Smith's shape or hinge to improve performance or manufacture.[2] The first design that resembles the modern clothespin, a "spring-clamp for clotheslines," was patented in 1853 by David M. Smith, a prolific Vermont inventor; it featured two levers so that the wind could not detach the clothes from the line.

If the mid-nineteenth century was the hotbed of clothespin technology, the earlier history of the device is difficult to trace. Since the beginning of time, people dried their clothing and linens on the grass or bushes, and since at least the sixteenth century on outdoor drying frames. We can only speculate about where and when clothespins appeared, perhaps as early as the eighteenth century.[3] One theory posits that clothespins were an innovation brought home by fishermen who, while at sea, had hung their washing on rigging, fastened with wooden clips. Peddlers saw an opportunity and began to carve clothespins.[4] While early British colonists may have brought them to America, they also existed in Germany and other European countries.[5]

Turned wooden clothespins with ovoid or straight heads and forked fasteners were made on a lathe. They continued to be produced alongside the industrially manufactured variety.[6] Rarer are high-end clothespins made from whalebone and decorated with carvings, which are said to be love tokens.

RJMO

1 MFPA 182; one from Jane Teller, New York City, March 1924, for $3; MFPA 205, one from Morton; MFPA 2371, six of oak from Landis, York, PA, all for $1.50, which were rectangular in shape. The eight in the N-YHS (INV.14896a-e) are turned with rounded forms.

2 Hilary Greenbaum and Charles Wilson, "Who Made That Clothespin?" *New York Times*, May 11, 2012. In 1998 the Smithsonian Institution's National Museum of American History, Washington, DC, mounted an exhibition entitled "American Clothespins." See also Anita Lahey, "The Better Clothespin," *American Heritage of Invention and Technology* 22:2 (Fall 2006): 38–43. The theory that the Shakers invented the clothespin may not be historically correct and may simply derive from shared aesthetic qualities.

3 See "The History of Laundry; Clothes Horses and Airers; and Drying Outdoors," http://history-of-laundry.aspx.

4 Lahey, "The Better Clothespin," 41.

5 For Austrian examples in the Otto Berger Heimatmuseum, Bernhardsthal, see: http://www.seifen.at/museum/Fuehrung-5.htm.

6 Edith Minter, "When Treen Ware was 'The' Ware," *The Magazine Antiques* 18:6 (December 1930): 504–7, espec. fig. 12.

65

E. O'Brian (Australian, early nineteenth century)
Powder horn, 1810–20
Cow horn, wood, paint, felt; 16¼ × 6¾ in.
(41.3 × 17.1 cm)
1937.1407a

Unidentified Hungarian maker
Powder flask, ca. 1700
Staghorn (antler); 10¾ × 6¼ in. (27.3 × 15.9 cm)
1937.1486ab

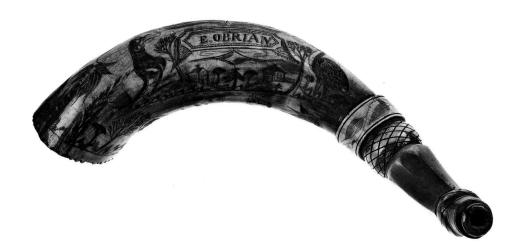

Records show that the Nadelmans owned just under a dozen powder horns or flasks, three of which are American examples recorded in the MFPA cards.[1] It is not surprising that the couple was drawn to these objects, as they were highly prized by collectors of Americana and folk art.[2]

Powder horns functioned as containers for gunpowder and were generally created from cow, ox, or buffalo horn. The horn was typically held by a long strap and slung over the shoulder. Although "powder horn" has been applied to any personal container for gunpowder, regardless of material or shape, "powder flask" is the more accurate term. The use of animal horn along with nonferrous metal parts ensured that sparks would not ignite the powder during storage and loading. Horn was also naturally waterproof. Its smooth, cream-colored surfaces, like blank canvases, invited personalization and decoration by their owners, mostly hunters, soldiers, and sportsmen. Powder horns were most often engraved in a technique resembling that of scrimshaw, which sometimes was supplemented with colored pigments and less frequently with carving.

Many decorated examples shed light on the lives of those individuals who used them, encouraging recent scholars to classify them retrospectively as folk art.[3]

The extremely rare powder horn on the left is inscribed with its owner's name inside a cartouche: "E. OBRIAN."[4] On the basis of its nationalistic imagery, a collector attributed it in 1952 to an Australian maker.[5] It features a kangaroo ("THE KANGAROO"), an emu ("THE EMU"), and the Bowman flag of 1806.[6] The powder horn is also inscribed "UNITY" above a rose intertwined with a thistle and shamrock (the floral emblem of Britain), which relate to the armorial bearings of the Commonwealth of Australia. The horn is also inscribed "THE NOT" near three imaginary birds (not knots), each with two plumes on their heads. The engraved lines are colored with red and black pigments.

The example on the right, probably a priming flask since it has only one opening, retains a single suspension ring and has the tantalizing remains of a Nadelman collection label. Characteristic of the Hungarian forked type, it was made from the antlers shed by a red deer (*Cervus elaphos L.*) common to

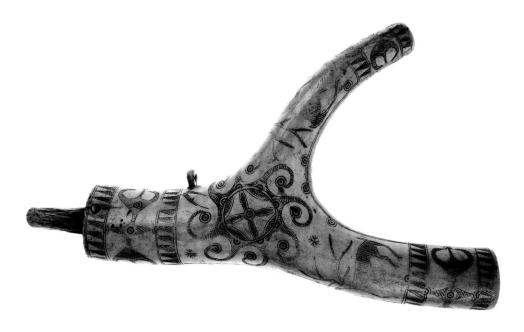

Hungary.[7] Its outer smooth side is engraved with a series of repeating folk motifs, including a dominant rotating rose, symbolic of the Sun and light, at the juncture of its three branches or "breast." Flanking the rose are two stags with lengthy antlers, invoking magical powers for the hunt, while cosmic concentric circles made with a compass and biomorphic forms complete the engraved ornamentation. These decorative motifs persisted in Hungarian stag horn flasks from the late sixteenth century to the mid-nineteenth century.[8] The flask's inner side, which was worn against the body, retains the grooves of the rough antler. Since Hungary is adjacent to Poland, Elie Nadelman may have been familiar with this type of engraved pattern and assuredly was attracted to the abstract, decorative motifs.

This pair of powder horns seems to embody the Nadelmans' mission statement for the MFPA: to reveal the connections between New World (in this case Australia) and Old World folk art, albeit via two objects with unusually exotic origins.

RJMO

1 They purchased the trio at the Walpole Galleries, Fred E. Hines sale, New York City, May 9, 1924, lots 29 (MFPA 381, N-YHS 1937.1405); 292 (MFPA 366, N-YHS 1937.1403); 543 (MFPA 364, N-YHS 1937.1404).

2 For additional material on powder horns, see John S. du Mont, *American Engraved Powder Horns: The Golden Age, 1755–1783* (Canaan, NH: Phoenix, 1978); Béla Borsos, *Staghorn Powder-flasks*, trans. Lili Halápy (Budapest: Corvina Kiadó, 1982); Jim Dresslar, *Folk Art of Early America: The Engraved Powder Horn* (Bargersville, IN: Dresslar, 1996). Rufus Alexander Grider, the amateur historian and draftsman, was obsessed with the genre and rendered well over a thousand powder horns in detailed watercolors, the majority of which are now in the New York State Library, Albany, and in the N-YHS; see Olson 2008, 276–79.

3 Robert F. Trent, "American Powder Horns and the Problem of Folk Art," in William Guthman, *Drums A'beating, Trumpets Sounding*, exh. cat. (Hartford: Connecticut Historical Society, 1993), 9–11. Like so many folk art objects, Trent suggests that powder horns only began to be regarded as folklike in retrospect. His observations on the various sources of decorated powder horns from elite to popular and folk cultures apply to folk art in general.

4 O'Brian was the owner and perhaps also the maker. The horn is one of a pair by the same maker owned by O'Brian and the Nadelmans; the other is N-YHS 1937.1407b, inscribed "E. O.BRIAN."

5 C. Stanley Jacob of Plainfield, NJ, in 1952 (according to Richard J. Koke, notes in the N-YHS object file).

6 Designed by John and Honor Bowman of New South Wales, the painted silk flag is in the Mitchell Library, State Library of New South Wales, Sydney. It represents the first recorded use of the kangaroo and emu as supporters of the shield in the national coat of arms. See http://www.sl.nsw.gov.au/ discover_collections/history_nation/terra_australis/ bowman/index.html. Thanks to Maeve M. Hogan for making this connection.

7 It is reproduced in Musée national d'histoire et d'art Luxembourg, *Drei Jahrhunderte Europäische Jagdpulverbehälter: 1550–1850* (Luxembourg: Le musée, 1995), n.p.

8 For Hungarian examples, see János Kalmár, *Régi Magyar fegyverek* (Budapest: Natura, 1971), 236, fig. 199; Borsos, *Staghorn Powder-flasks*, 40–50, pls. 1–4, 16–21, 40; Musée national d'histoire et d'art Luxembourg, *Drei Jahrhunderte . . . Jagdpulverbehälter*, n.p., one dated 1580–1850, the other 1700.

66

66a
Unidentified European maker, possibly French
Tobacco grinder, ca. 1700–50
Lignum vitae, pewter; 4¼ × 1½ in. (10.8 × 3.8 cm)
Provenance: Unspecified source, Versailles, France,
1926
INV.7587ab*

66b
Unidentified British maker, possibly Scottish
Snuff box, ca. 1730–80
Horn, silver; 4¼ × 1½ × 2⅜ in. (10.8 × 3.8 × 6 cm)
INV.7586

66c
Unidentified American maker
Snuff box, ca. 1800–50
Walnut; 1¾ × 2¾ × 2¾ in. (4.4 × 7 × 7 cm)
Provenance: Howe's House of Antiques (Elmer
C. Howe), Boston, 1926
INV.7659ab*

66d
Unidentified French maker
Snuff box, ca. 1800–30
Boxwood and other woods; 1⅝ × 3⅝ × 1½ in.
(4.1 × 9.2 × 3.8 cm)
Provenance: Sumner Healey, New York City, 1924
INV.7981*

66e
Unidentified French maker
Match safe, ca. 1840–80
Wood; 1 × 4⅝ × 2⅛ in. (2.5 × 11.7 × 5.4 cm)
Provenance: Unspecified source, Paris, France, 1926
INV.7652*

66a

66b

66c

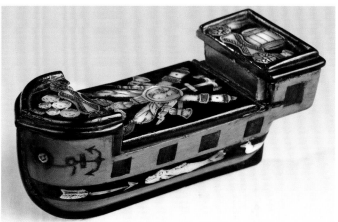

66d

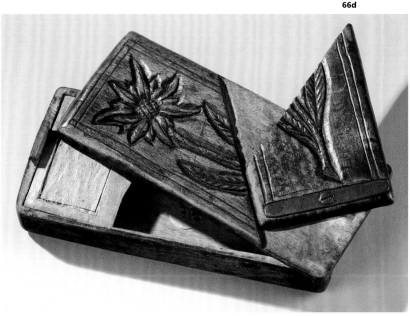

66e

The wealth of tobacco-related artifacts at the MFPA likely reflected Elie Nadelman's penchant for smoking: according to the family, he regularly indulged in both cigars and cigarettes.[1] It is also possible that Viola, the daughter of a successful cigar manufacturer, developed a special interest in tobacco paraphernalia.[2] Gallery XIII displayed one case of ninety-three pipes and another with 122 snuff boxes and related items.[3] The MFPA cards reveal a captivating variety of snuff boxes made from wood, horn, papier-mâché, bone, pewter, brass, and copper, taking the shape of boats, books, hats, shoes, firearms, and animals. This small grouping only hints at the delightful diversity of the Nadelmans' snuff and smoking equipment.

Tobacco, first observed in the West Indies in 1492 by two crewmen traveling with Christopher Columbus, became prized in Europe by the 1570s for its supposed curative powers. By the seventeenth century, the consumption of tobacco in both smoked and powdered forms spread throughout Europe, with the Catholic countries inclined toward snuff. During the early 1700s, snuffing surpassed smoking in popularity, and the taking of snuff developed into an elaborate social ritual.[4] As one scholar notes, "Everybody who was anybody snuffed; the French habit spread across Europe until even the English were separated from their beloved pipes in favour of perfumed powder and a snuff box."[5]

Snuff boxes were an essential accessory to the ritual of snuffing and functioned as symbols of refinement. Frequently presented as gifts to both gentlemen and ladies, the containers were made in a variety of materials, from wood and papier-mâché to jewel-encrusted gold. The spread of snuff to the lower classes after 1800 stimulated the production of snuff containers in simpler materials, reflecting the folk traditions of the regions in which they were made.[6]

The cylindrical container here was used to grind an individual portion of tobacco to a fine powder. Such tobacco grinders or snuff mills, which functioned like a miniature mortar and pestle, were common in the seventeenth century before commercially ground tobacco became widely available.[7] The Nadelmans purchased their example, made of lignum vitae and decorated with applied bands of roulette-patterned pewter, while visiting France in the summer of 1926.[8] The end of the plunger is studded with pewter teeth, laid in an X shape, for pulverizing the tobacco. The couple noted on the MFPA card that the grinder was "similar to those in Musée du Trocadéro" and assigned it the regional origin of the Auvergne, probably based on the attribution of the examples they viewed in the Paris museum.

Shoe- and boot-shaped snuff boxes, popular throughout the eighteenth and nineteenth centuries, were often presented as keepsakes to friends and sweethearts. The silver-mounted, boot-shaped snuff box has a silver disc on the lid engraved "W. Snell," likely the name of the recipient and owner. The boot is made of ram or goat horn, which was heated and then molded into shape.[9] The hinged lid retains its cork stopper, which ensured an airtight seal. The boot's exaggerated, playful proportions—particularly the elongated shaft and dainty shoe—invite comparison with the shapely lower legs of the Nadelmans' tobacco shop figure in the form of a Highlander (cat. 2).

The inlaid boxwood snuff box shaped as a galleon was a present from Manhattan dealer Sumner Healey in April 1924.[10] Healey was one of the Nadelmans' prime sources for antiques and no doubt appreciated their steady patronage (see Hofer essay, pp. 63–65). Just a month before they received the gift, the couple had purchased eleven French snuff boxes from Healey and seven months later they bought six more. Made of boxwood and other woods, the ship is exuberantly decorated with nautical- and military-themed mother-of-pearl and wood inlays, including cannon balls, an anchor, flags, compasses, barrels, and harpoons. A hinged lid along the top of the hull lifts to reveal the compartment within. Boat-shaped snuff boxes were particularly popular in early nineteenth-century France and may have been carried by sailors.[11]

The Nadelmans paid $5 for the charming heart-shaped walnut box, which they acquired from Boston dealer Elmer C. Howe.[12] Its tight-fitting lid suggests that the container may indeed have been intended to hold snuff, but it could have been used for a number of purposes. The maker carefully carved small cut-outs on either side of the lid to provide a gripping surface. No doubt this bold expression of affection was presented as a love token.

The Nadelmans catalogued the French box carved with a sunflower (and a rose on the reverse) as a snuff box, but the strike pad concealed within indicates that the container is a match safe.[13] Match safes, also known as Vesta cases, were developed after the invention of the friction match in 1826 and provided safe housing for combustible matches held in the pocket.[14] The "trick" or puzzle box requires several steps to open: the user must first pivot the lower half of the box to the side, then push the upper half down and rotate it to reveal the interior compartment. Most match safes were made of metal; a wood case such as this offered questionable protection from fire.
MKH

1 E-mail from Cynthia Nadelman, July 9, 2013.

2 Louis Spiess was a partner in the firm of Kerbs &
 Spiess, cigar manufacturers located at 35 Bowery
 during the 1870s and 1880s.

3 MFPA inventory.

4 Clare Le Corbeiller, *European and American Snuff
 Boxes, 1730–1830* (New York: Viking, 1966),
 1–17; Deborah Gage and Madeleine Marsh,
 *Tobacco Containers and Accessories: Their Place
 in Eighteenth Century European Social History*
 (London: Gage Bluett, 1988), 9–26; Lutz Libert,
 Tobacco, Snuff-Boxes and Pipes, trans. Sheila
 Marnie (London: Orbis, 1986), 5–16.

5 Gage and Marsh, *Tobacco Containers*, 18.

6 Libert, *Tobacco, Snuff-Boxes and Pipes*, 16.

7 Edward H. Pinto, *Wooden Bygones of Smoking and
 Snuff Taking* (London: Hutchinson, 1961), 57, pl.
 24; J. Seymour Lindsay, *Iron & Brass Implements of
 the English and American Home* (Boston: Medici
 Society, 1927), 171; Owen Evan-Thomas, *Domestic
 Utensils of Wood, XVIth to XIXth Century* (London:
 O. Evan-Thomas, 1932), 89; Pierre Faveton, *Autour
 du tabac: Tabatières, pipes, cigares, allumettes et
 briquets* (Paris: Charles Massin, 1988), 45, 47 ill.

8 MFPA 1967, purchased for $2. The Nadelmans
 catalogued this grinder and two others purchased
 from the same source (MFPA 1968, 1969) as
 originating in the Auvergne.

9 Snuff boxes made of horn were particularly popular
 in Scotland, where they were called "mulls." See
 Hugh McCausland, *Snuff and Snuff-Boxes* (London:
 Batchworth, 1951), 133–34.

10 MFPA 134. Instead of a date of purchase, the MFPA
 card notes "present." The date April 2 is cited
 without a year, but the MFPA number falls between
 those of snuff boxes purchased in March and
 October of 1924.

11 Pinto, *Wooden Bygones of Smoking and Snuff
 Taking*, 78–79, pl. 44.

12 MFPA 1883, purchased in March 1926 and
 catalogued as a snuff box on the MFPA card. The
 underside of the box bears a MFPA collection label
 inscribed "1883 / Amer."

13 MFPA 1950. They paid fifty cents for the "puzzle
 box." The box has a MFPA collection label inscribed
 "1950 / Fr."

14 Neil Shapiro, *A Brief History of Gorham Match
 Safes*, http://www.matchsafescholar.com/Brief_
 History.asp.

67

Gambier factory (French, active 1780–1926)
Figural pipes, ca. 1865–1914
Givet, France
White clay, enamel; 5¾ in. (14.6 cm) long
Provenance: Unspecified source, Paris, 1926
INV.8493*, INV.8550*

In June 1926, the Nadelmans purchased a group of tobacco pipes in Paris, including seven examples produced by the French factory Gambier, located in the town of Givet in the Ardennes.[1] The tobacco pipe originated in America and was introduced to Europe in the sixteenth century. England and Holland dominated pipe manufacturing until the second half of the nineteenth century, when the major French centers of Saint-Omer and Givet, with their natural resources of fine white clay and abundant firewood, took the lead. Gambier, the most famous firm, became virtually synonymous with ornamental clay pipes.[2] Their extant catalogues record over two thousand varieties, including both pipe heads intended for use with a cherry-wood stem and pipes with the stem and bowl molded in one piece, as in these examples.[3] Subjects ranged from biblical and mythological characters to literary heroes and contemporary politicians.[4] These two clay pipes are typical of the lively caricatures that drove the immense popularity of French figural pipes during the second half of the nineteenth century.

The pipe terminating in a head of a mustachioed man wearing a tasseled cap represents a Zouave soldier, a member of an elite corps of French infantry.[5] Zouaves wore distinctive uniforms, derived from the dress of the indigenous North African troops that gave them their name.[6] During the Second Empire, French Zouave units fought in numerous military engagements and gained renown for their dashing appearance. The Gambier firm capitalized on their celebrity, producing seven different pipes featuring the head or full figure of a Zouave.[7] In this example, the caricatured Zouave sports an extremely long mustache that divides in the center and extends behind his neck. He wears the corps' distinctive red cap, ornamented with a blue tassel.

The other pipe, called "Le chignon" in the Gambier catalogue, depicts a woman with her hair pulled high on her head and tied with a blue ribbon.[8] The ends of the ribbon extend partly down the pipe stem, where they join with the molded floral decoration. The figure's ornate pendant earrings complement her sumptuous hairstyle. Rather than representing a famous individual or group, as did many of the Gambier pipes, this example depicts a generic type and satirizes the large, elaborate hairstyles of the Second Empire.[9] The chignon, which can be traced back to ancient Greece, was popular in France throughout the nineteenth century and its placement moved up and down the head with the vicissitudes of fashion.[10]

Gambier's clay pipes were produced in two-part molds of bronze or cast iron, which were intricately engraved by skilled craftsmen. Each mold yielded thousands of identical pipes; in fact, near mid-century, Gambier produced approximately a hundred thousand pipes per day.[11] Even though these mass-produced objects hardly conform to a strict definition of folk art, the Nadelmans were perhaps drawn by the pipes' popular appeal.
MKH

1 These two pipes were originally assigned MFPA numbers 1942 (Zouave) and 1939, but their numbers were later struck. In addition, they purchased figural pipes representing a "Negro"; South African statesman Paul Krüger; the biblical Jacob; a curly-haired man; and a man wearing a fur cap. Each was purchased for fifty cents, although someone later struck out the purchase price on the MFPA cards.

2 Cuisenier 1977, 89; Benjamin Rapaport, *A Complete Guide to Collecting Antique Pipes*, rev. ed. (Atglen, PA: Schiffer, 1979), 15–23; Roger Fresco-Corbu, *European Pipes* (Guildford, Surrey, Eng.: Lutterworth, 1982), 19–26.

3 Rapaport, *Antique Pipes*, 22; Fresco-Corbu, *European Pipes*, 23.

4 The compiled Gambier catalogues offer a glimpse of the range of pipes produced by the firm. See Arthur van Esveld, *La catalogue digitale des pipes en terre Gambier, 1840–1926:* http://gambierpipes.com/flippingbook/1840-1926_NED/index.html.

5 Mold no. 1137, referred to as "Zouave, fantaisie," first appears in the 1868 Gambier catalogue.

6 Elizabeth C. Childs, *Daumier and Exoticism: Satirizing the French and the Foreign* (New York: Peter Lang, 2004), 82–83.

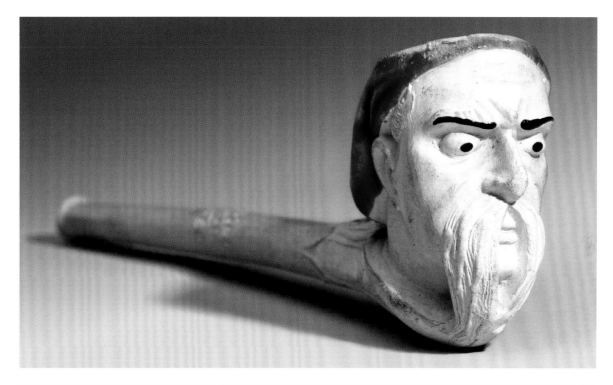

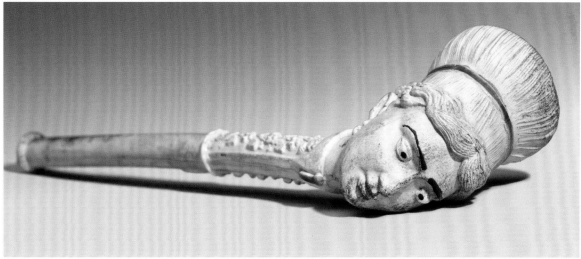

7 Mold nos. 671, 675, 684, 961, 1017, and 2037 also depicted Zouaves.

8 Mold no. 1281, "Le chignon, fantaisie." The model first appeared in the 1871 Gambier catalogue.

9 Carol Rifelj, *Coiffures: Hair in Nineteenth-Century French Literature and Culture* (Newark: University of Delaware Press, 2010), 59–60, 67–68.

10 Ibid., 59–60.

11 Jean-Léo, *Les pipes en terre françaises: Du 17me siècle à nos jours* (Brussels: Le grenier du collectionneur, 1971), 15.

68

Unidentified European maker, probably French
Trammel, 1750–1800
Wrought iron; 43 (adjustable to 65⅜) × 10½ × 2¾ in.
(109.2 to 166 × 26.7 × 7 cm)
Provenance: Paris de plage, France, 1926
INV.242*

Unidentified European maker, probably French
Broiler, 1750–1800
Wrought iron; 2¼ × 20 × 7 in.
(5.7 × 50.8 × 17.8 cm)
Provenance: Unspecified source, Versailles, France,
1926
INV.14867*

Unidentified American or European maker
Broiler, 1750–1830
Wrought iron; 3¼ × 19⅞ × 8¼ in.
(8.3 × 50.5 × 21 cm)
INV.14870

Unidentified European maker, possibly French or
Swiss
Wafer iron, 1717
Wrought iron; 33½ × 8¼ × 3½ in.
(85.1 × 21 × 8.9 cm)
Provenance: C. Vandevere Howard, New York City,
1925
1937.1181*

Unidentified American maker
Herb grinder, 1820–60
Possibly Pennsylvania
Cast iron, oak; trough, 3⅝ × 18½ × 4¼ in.
(9.2 × 47 × 10.8 cm); blade and handle,
12¼ × 7½ in. (31.1 × 19.1 cm)
1937.1553ab

Galleries XII and XIII of the MFPA were filled to bursting with ironwork: cast, wrought, and sheet iron spanning seven centuries and made for a multitude of purposes. In Gallery XII, for instance, the Nadelmans hung elaborate medieval wrought-iron door mountings in the form of panthers (fig. 45), which had come from a church near Limoges, France, in the company of cooking pots and griddles used in American hearths during the eighteenth and nineteenth centuries.[1] The sampling of tools here typifies the Nadelmans' holdings of domestic ironwork used in Europe and America during the eighteenth and nineteenth centuries.

The two sturdy broilers were used to cook meats or fish over a fire. Also known as gridirons, grilles, griddles, or roasters, these convenient cooking implements, once heated and oiled, allowed searing of meats over a bed of hot coals.[2] Both of these examples incorporate serpentine grillwork, which served both an aesthetic and functional purpose: the gently curving bars provided a decorative flourish while also preventing the meat from falling into the fire. The Nadelmans purchased the broiler on the left in Versailles during a tour of Europe in the summer of 1926.[3] The MFPA card identifies its origin as the Auvergne, a province in south-central France with a tradition of decorative church ironwork dating back to the twelfth century. The work of a master blacksmith, the broiler features charming decorative flourishes, including a heart-shaped scrolled handle terminus, whose shape is echoed in the rear foot. Its neck is ornamented with loosely coiled volutes as well as an upright scroll, which helped prevent the meat from sliding off the surface. The simpler example is composed of concentric squares divided by serpentine bars radiating diagonally from the center. Its handle, twisted near the roasting surface and flattened and hollow-wrapped near the end, terminates in a hook that allows it to be hung near the hearth.

The wrought-iron trammel was also purchased by the Nadelmans in France during their 1926 trip.[4] Suspended from a horizontal lug pole high in the chimney, these implements

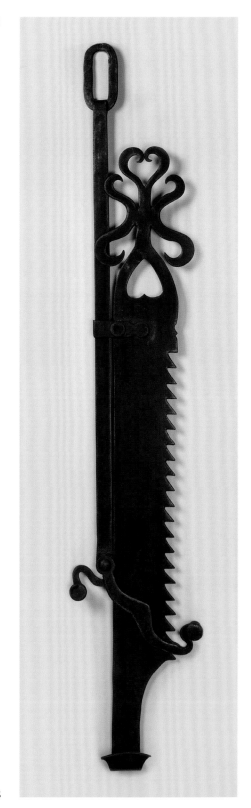

provided a hook for hanging a cooking pot and a mechanism for adjusting its height above the fire.[5] This sawtooth-type trammel is a tour de force of blacksmithing, combining a precisely forged ratchet catch mechanism with bold, sinuous ornament. An inverted heart cut-out at the head of the blade echoes the forged heart crowning the top.

The MFPA cards record the purchase of five wafer irons made in Italy, Switzerland, and the United States, including this one purchased from New York City dealer C. Vandevere Howard.[6] The Nadelmans identified it as Swiss, as they did most of the antiques they purchased from Howard's midtown shop. Wafer irons were used in Europe as early as the thirteenth century to form the consecrated wafer or host served in the Roman Catholic rite of Holy Communion.[7] Secular variants of wafers, known also as waffles, were popular in the Netherlands, Belgium, Germany, France, and Switzerland. The two plates of this iron are chased and stamped with a series of motifs: one has a central, house-like device enclosing three *fleurs de lis* and the date 1717, the other a roundel with the paschal lamb or Lamb of God and an illegible inscription (fig. 105). Both central images are flanked by squares with geometric ornament reminiscent of the cutwork lace known as *reticella*, surrounded by a border of stamped motifs composed of leaves and rosettes. The paschal lamb motif suggests that wafers from this iron were intended for Easter celebrations.[8]

The substantial herb grinder, a boat-shaped trough supported on trestle legs, is made of cast rather than wrought iron. Grasping the wood handle and rolling the sharpened wheel back and forth in the trough, a cook could grind herbs or other foods in the deep bowl and then pour the contents from the open end. Similar herb grinders are held in American museums; some have been cited as Pennsylvania German in origin, although no documentation has yet linked these implements with specific American foundries.[9] It is easy to imagine how the spare simplicity of this vernacular tool, which recalls the long, narrow canoes carved and painted by native

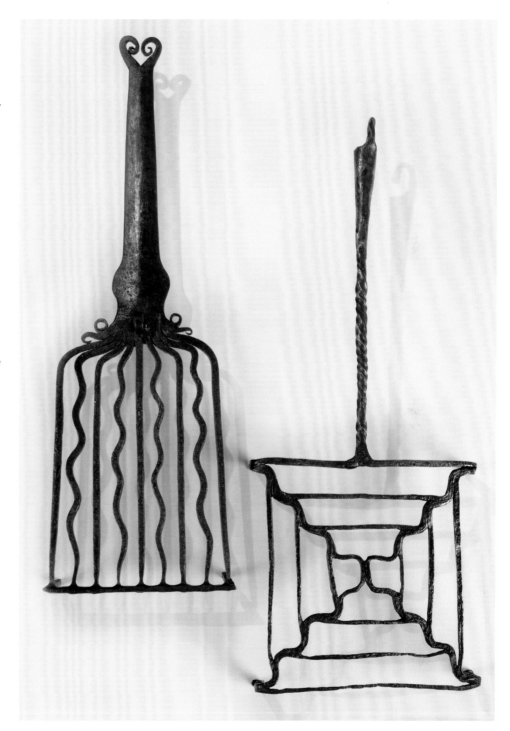

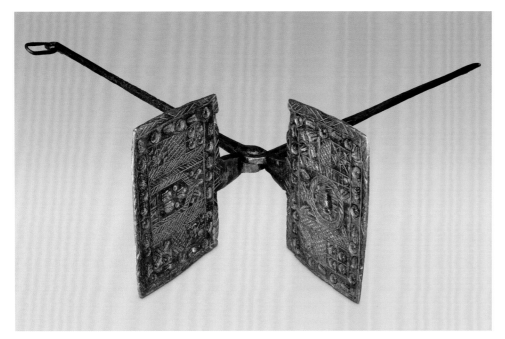

Fig. 105. Impressions from wafer iron. Plaster; 5¾ × 8⅛ in. (14.6 × 20.6 cm). N-YHS.

peoples of the Pacific Northwest, caught the Nadelmans' attention.
MKH

1 Helmut Nickel, "The Iron Door Mountings from St.-Léonard-de-Noblat," *Metropolitan Museum Journal* 23 (1988): 83–87.

2 Donald L. Fennimore, *Iron at Winterthur* (Hanover, NH: University Press of New England for the Winterthur Museum, 2004), 238; Don Plummer, *Colonial Wrought Iron: The Sorber Collection* (Ocean Pines, MD: Skipjack Press, 1999), 66–68.

3 MFPA Iron 2042, identified as a trivet. It was purchased for $2 in June 1926.

4 MFPA Iron 2083, identified as a fire crane. It was purchased for $1.50 in June 1926. The source, "Paris de plage," may be either a dealer name or a locale.

5 Plummer, *Colonial Wrought Iron,* 14–17; Herbert Schiffer et al., *Antique Iron: Survey of American and European Forms, Fifteenth through Nineteenth Centuries* (Atglen, PA: Schiffer, 1979), 230–31; Albert H. Sonn, *Early American Wrought Iron* (New York: Charles Scribner's Sons, 1928), 3:190–94, pls. 296–98.

6 This example is MFPA Iron 1776, purchased for $18 in December 1925. The others are MFPA Iron 586, 1165, 1166, and 1777, two of which were purchased in Milan in 1924, one from Vandevere Howard in 1925, and another from an unidentified source in 1924.

7 Janny de Moor, "The Wafer and Its Roots," in *Look and Feel: Studies in Texture, Appearance, and Incidental Characteristics of Food. Proceedings of the Oxford Symposium on Food and Cookery, 1993*, ed. Harlan Walker (Totnes, Eng.: Prospect Books, 1994), 119–27.

8 Deborah L. Krohn and Peter N. Miller, eds., *Dutch New York between East and West: The World of Margrieta van Varick*, exh. cat. (New Haven: Yale University Press, 2009), 303, fig. 149. For related wafer irons, see "The Editor's Attic," *The Magazine Antiques* 40:6 (December 1941): 374; Sonn, *Wrought Iron*, 210–11, pl. 306.

9 Garvan 1982, 136, fig. 78; Schiffer, *Antique Iron*, 205, fig. D; Rachael Feild, *Irons in the Fire: A History of Cooking Equipment* (Marlborough, Eng.: Crowood, 1984), 30–32, fig. 21.

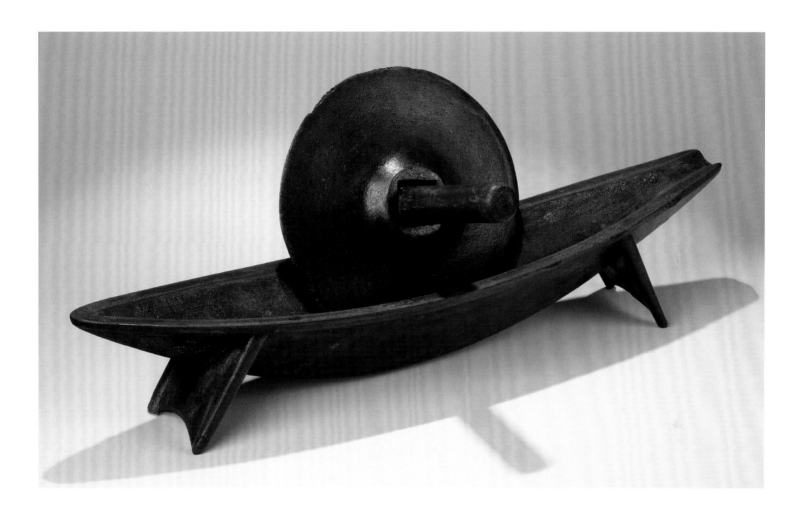

69

Unidentified American maker
Foot warmer, 1820–50
Possibly Pennsylvania
Tinned sheet iron, iron wire, wood; 6⅝ × 9 × 7½ in.
(16.8 × 22.9 × 19 cm)
Provenance: Florence Ballin Cramer, Woodstock, NY,
1925
1937.1769*

Unidentified American maker
Cheese strainer, 1800–50
Tinned sheet iron; 7 × 8 × 8 in.
(17.8 × 20.3 × 20.3 cm)
INV.14876

Unidentified English or American maker
Mold pan, 1780–1830
Tinned brass, copper; 8 × 14¼ in. (20.3 × 36.2 cm)
1937.1309

Though wrought iron dominated the metalwork on display in the MFPA, the Nadelmans also appreciated the craft of the tinsmith, who worked objects out of lightweight sheet iron coated with tin to protect the surface from the damaging effects of moisture. The couple collected sheet-iron objects cut into bold shapes, such as weathervanes (cat. 6), and were equally attracted to humble household tools decorated with paint, punchwork, and piercing.

The foot warmer, composed of a tinned sheet-iron box held within a wooden frame, is pierced on four sides with a heart enclosed in a circle. The tinsmith used an awl of small diameter to punch the decoration on the sides and a larger tool to punch the six rows of holes across the top. The box holds a removable interior pan for burning embers, whose heat escaped through the large punched holes. Churchgoers brought these heating devices to services during the winter months and warmed themselves by resting their feet on the wooden slats at the top.[1] The Nadelmans purchased this classic foot warmer—one of at least five American and European examples in the MFPA—from the artist and folk art dealer Florence Ballin Cramer in March 1925.[2] It is among several examples visible on a window sill in Gallery VI (see fig. 19).

When viewed in profile, the cheese strainer looks like a rather ordinary kitchen tool. Its interior, however, reveals an intricately pierced design of six concentric circles that echo the container's lobes. Enclosed within the circles is a roundel with the initials "VA"—or "AV" when rendered in the strained cheese—which likely refer to the implement's owner and user. Pierced tin lent itself to cheese making, as the holes allowed for drainage while the solidified cheese retained the shape and pierced design of the mold.[3] A recipe for "old Virginia cream cheese" instructed cooks to pour their thickened, drained cream "into a large heart-shaped tin mould to press" and further directed that the bottom of the mold "be pierced with round holes and . . . stand on little feet so that the cheese may drain while pressing."[4]

The circular two-handled pan with seven individual molds is made of tinned brass rather than sheet iron and stands on three gently curved copper feet (one missing). When the pan entered the N-YHS collection in 1937, it was catalogued, presumably by Elie Nadelman, as an eighteenth-century *poffertje* pan probably made in Holland.[5] A traditional Dutch food, *poffertjes* are small fluffy pancakes, the size of a silver dollar, made from a batter of yeast and buckwheat flour. However, *poffertjes* are typically made in special cast-iron or copper pans with shallow circular indentations rather than deep, shaped depressions.[6] This pan was more likely used to bake shaped sweet or savory puddings such as plum, potato, carrot, or marrow.[7] Once the pudding batter was poured into the pan, it was covered with a fitted lid so that hot coals could warm the top as well as the bottom of the pan.[8] Though the Nadelmans may have been confused about its function, they undoubtedly appreciated the pan's bold, folky motifs and hand-crafted metalwork.

MKH

1 Donald L. Fennimore, *Iron at Winterthur* (Hanover, NH: University Press of New England for the Winterthur Museum, 2004), 314–16, fig. 155; Earl F. Robacker, "Decorated Tinware East and West: In Pennsylvania," *The Magazine Antiques* 66:3 (September 1954): 211, ill.

2 MFPA 1089, purchased for $6.

3 Robacker, "Decorated Tinware," 210, 212.

4 "Old Virginia Cream Cheese. Mrs. Washington's Unrivalled Cook Book," *American Kitchen Magazine* 13:6 (September 1900): 230.

5 N-YHS accession record 1937.1309.

6 Peter G. Rose, *Food, Drink and Celebrations of the Hudson Valley Dutch* (Charleston, SC: History Press, 2009), 29, ill.; Janny de Moor, "The Flattest Meal—Pancakes in the Dutch Lowlands," in *The Meal. Proceedings of the Oxford Symposium on Food and Cookery, 2001*, ed. Harlan Walker (Totnes, Eng.: Prospect Books, 2002), 74.

7 For pudding recipes, see Charles Carter, *The Compleat City and Country Cook, or, Accomplish'd Housewife . . .* (London: Printed for A. Bettesworth et al., 1732), 52–53, 142–43. Mold pans are

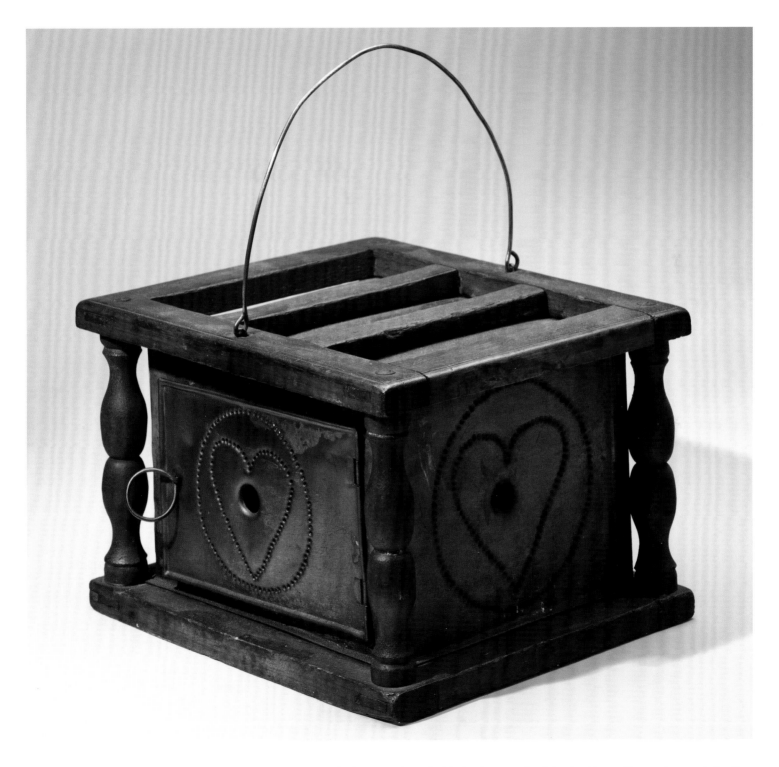

specifically cited in pudding recipes printed in B. Clermont, *The Professed Cook or, the Modern Art of Cookery* . . . (London: W. Davis, 1776), 160–61,

253–54. Thanks to Laura Speers for bringing these recipes to my attention.

8 Related mold pans of brass and copper, both with covers, are N-YHS 1928.69ab and Winterthur Museum, Winterthur, DE, 1965.1697A, B.

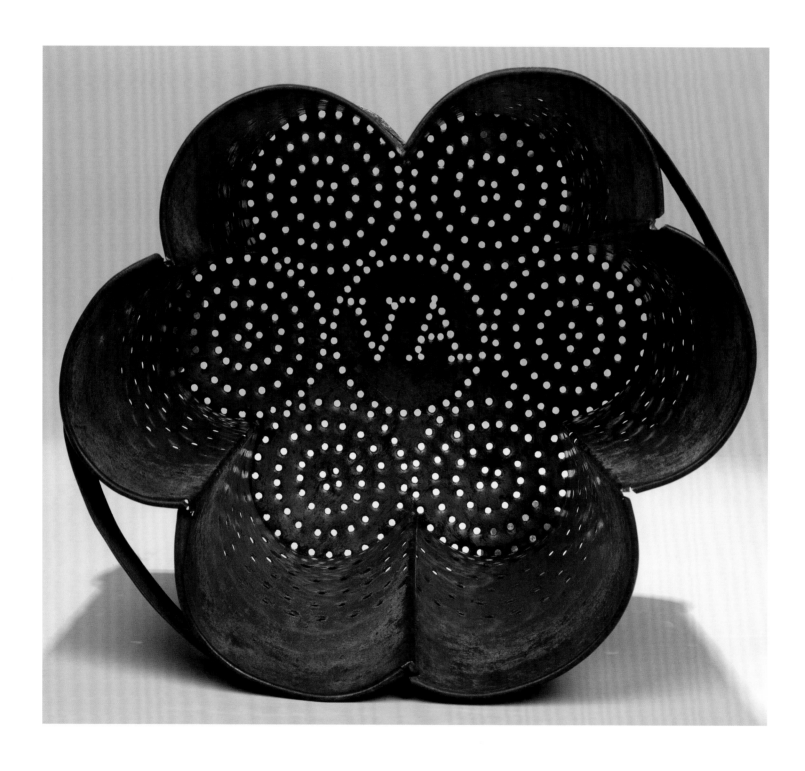

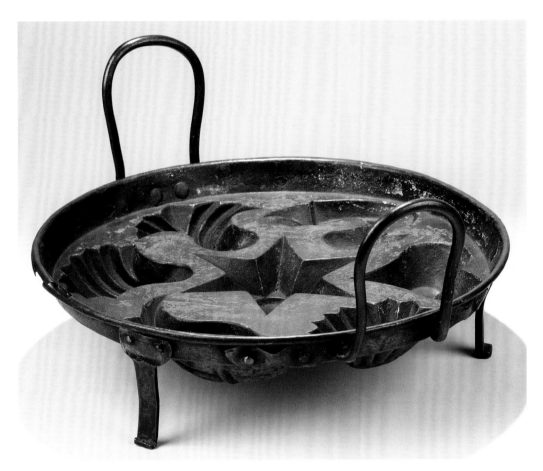

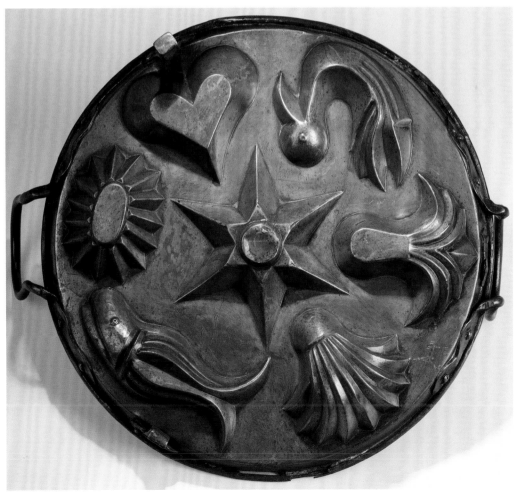

70

Unidentified European maker
Cookie mold, 1800–50
Wood, 13 × 5 × 1 in. (33 × 13 × 2.5 cm)
Provenance: G. Mouchel, Versailles, France, 1927
INV.1029*

Unidentified Swiss maker
***Tirggel* mold with circus and
entertainment scenes (double-sided)**,
1800–30
Wood; 13¼ × 7¼ × ¾ in. (33.5 × 18.5 × 2 cm)
Provenance: C. Vandevere Howard, New York City,
1928
INV.1030*

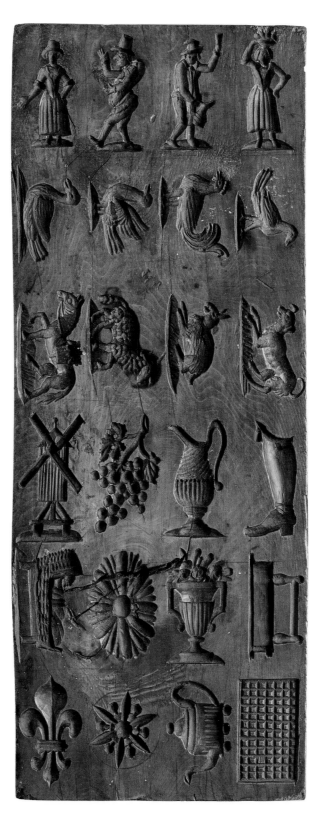

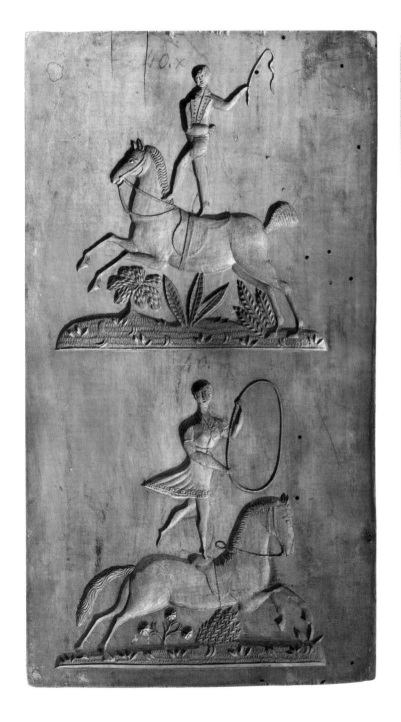

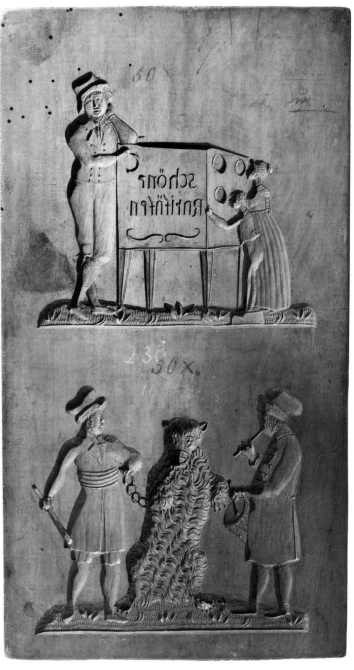

Both of these intaglio-cut boards for making sweets are recorded in the MFPA cards, where the first, considered French, is called a "candy mould" and the second is identified as a "cake mould."[1] While there is no shortage of information about northern European molds and print boards for different types of cookies, confections, and cakes,[2] there is no definitive study that differentiates among them.

The Nadelman boards and their vernacular imagery are related to molds for springerle, which usually have a rectangular gridding system.[3] Historians trace these cookies and related types back to the Julfest, a midwinter festival of pagan German tribes, celebrated to encourage an early spring. Instead of sacrificing animals to the gods, people gave token sacrifices in the form of animal-shaped or -stamped breads and cookies. Vestiges of them are found in a variety of cookies and sweetmeats, among them springerle, lebkuchen, *speculaas/spekulatius*, *Frankfurter brenten*, Würzburg/Nürnberg marzipan, and Swiss *tirggel*. Eventually, this culinary folk art form bore holiday images and scenes from everyday life. Sometimes the cookies were used to celebrate major life events, such as betrothals, weddings, births, and deaths, while exchanging springerle during the holidays was a common practice akin to sending cards today.[4] The geographic origins of springerle have been traced to Swabia in Bavaria, where these anise-flavored cookies, with stamped designs created with specially carved rolling pins or molds (presses or boards), were recorded in the fifteenth century.[5]

Among the legion of these molds are also alphabet boards and molds carved to print a cookie from each letter of the alphabet.[6] Animals and other motifs also had an instructional dimension, as many came from children's books or popular print sources that crossed regional boundaries.[7] These didactic culinary aids for children functioned much like reward plates (see cat. 44).

Related cookie and marzipan molds also share characteristics with their close cousins, gingerbread cookie and cake molds, produced from Scandinavia through Central Europe and the Balkans.[8] In the second half of the nineteenth century, all of these molds became collectible, and a number of museums, especially in Germany, France, and Switzerland, formed collections.[9]

Since the molds sometimes had multiple uses, it is not possible to identify all the types of sweets produced from the two Nadelman boards, whose image sources lie in the vernacular sphere. INV.1029 is carved with twenty-four images arranged like those for *speculaas* cookies or sugar paste sweets—including animals on bases that resemble chalkware figurines (see cat. 10), human figures of occupations resembling those in "The Cries," fruit, silver tableware, and a windmill, a traditional Dutch motif for *speculaas* sweets.

INV.1030, a finely carved double-sided board, presents four ambitious vignettes with suggestions of landscapes. The obverse features a whip-wielding male acrobat balancing on a rearing horse above a female acrobat in an arabesque pose holding a hoop on a prancing horse, both of which dovetail with Elie Nadelman's own sculptures of circus performers (cats. VI, VIII, IX). Each of the two carvings on the reverse contains three figures involved in the street entertainments that were popular throughout Europe in the early decades of the nineteenth century: the peep show (inscribed "*Schöne Raritäten*" or beautiful rarities) and a dancing bear with a musician playing a pipe and drum. They derive from print sources in circulation at the time.[10] The costumes of their figures also date the mold to this period. The board may have been used to press a design on a sweetmeat or a cake,[11] most likely on a thin Swiss honey cake called "*tirggel*." In fact, the Nadelman circus mold resembles a double-sided *tirggel* board in the Adomeit Mold Collection in the Shelburne Museum.[12]

RJMO

1 INV.1029 is MFPA 2216, purchased in January 1927 for $3.50; it has a MFPA collection label on its reverse inscribed "2216/Fr." INV.1030 is MFPA Misc. 2474, purchased for $16; it has a MFPA collection label on its side inscribed "2474/Swiss."

2 See Hornung 1972, 1: 505–11; Anneliese Harding, *The Edible Mass Medium: Traditional European Cookie Molds of the Seventeenth, Eighteenth, and Nineteenth Centuries*, exh. cat. (Cambridge, MA; Busch-Reisinger Museum, Harvard University, 1975); Edith Hörandner, *Model: Geschnitzte Formen für Lebkuchen, Spekulatius und Springerle* (Munich: Callwey, 1982); Sharon Hudgins, "Springerle Cookies," *Gastronomica: The Journal of Food and Culture* 4:4 (Fall 2004): 66–71; William Woys Weaver, "Cake Prints, Carved Molds, and the Tradition of Decorative Confections: The Adomeit Mold Collection," *The Magazine Antiques* 177: 4 (Summer 2010): 158–67, which provides excellent bibliography.

3 Some historians have connected springerle with the leaping horse of Wotan, the king of the Nordic gods in the pre-Christian era, because linguists translate from the Old German dialect the word "springerle," from the verb "springen," to mean "little knight," "little springer," or "little jumper." The word may also refer to the fact that springerle dough rises or springs up during baking.

4 Hornung 1972, 1: 505–11; Hudgins, "Springerle Cookies," 66.

5 Hudgins, "Springerle Cookies," 68, notes that in the late Middle Ages *formenstecher*, carvers of cake and cookie molds, had their own craftsmen's guilds. *Zuckerbäcker*, bakers of confections such as springerle, were often required to pass examinations on carving the molds before they were allowed to practice their trade. The related *speculaas* (Dutch) or *spekulatius* (German) are spice or ginger cookies, whose boards and molds lack the springerle framing grids and are usually more boldly carved with stylized, caricatured forms than those for springerle or *tirggel*. See J.J. Schilstra, *Prenten in hout: Speculaas-, taai- en dragantvormen in Nederland* (Lochem, Netherlands: De Tijdstroom, 1985); Weaver, "Cake Prints," 162–63, 165.

6 For both, see Weaver, "Cake Prints," fig. 8, in the Adomeit Mold Collection in the Shelburne Museum, VT.

7 Ibid., 162–63.

8 William Woys Weaver argues that "the molds themselves were artistic productions, their stock patterns and their commercial nature raise the question as to whether they are in fact folk art, or even part of folk cookery" (*America Eats: Forms of Edible Folk Art* [New York: Museum of American Folk Art, 1989], 117).

9 Among the museums with notable caches of historic cookie molds is the Bayerisches Nationalmuseum in Munich, which Nadelman visited in 1904; see Hudgins, "Springerle Cookies," 68.

10 They parallel the many popular hand-colored print and watercolor series by Bartolomeo Pinelli, like his *Raccolta di cinquanta costumi pittoreschi* (1809), which include scenes with a bear and a peep show; see Giovanni Incisa della Rocchetta, *Bartolomeo Pinelli*, exh. cat. (Rome: Museo di Roma, 1956); Maurizio Fagiolo and Maurizio Marini, *Bartolomeo Pinelli, 1781–1835, e il suo tempo*, exh. cat. (Rome: Centro iniziative culturali Pantheon: Edizioni Rondanini, 1983); Roberta J.M. Olson, "Are Two Better than One? The Collaboration of Franz Kaiserman and Bartolomeo Pinelli," *Master Drawings* 48:2 (2010): 195–226.

11 Among the types are Swiss baking molds for "devisen" (meaning currency or exchange), which were similar to "tragant" sweetmeats made of colored sugar dough distributed at children's parties as prizes or favors. See Kristin Bühler-Oppenheim, *Swiss Folk Art* (Basel: Amerbach, 1947), n.p., nos. 12, 13, ills. See also Margarete Pfister-Burkhalter, "Baking Molds in Lucerne," in *Swiss Folk Art: Celebrating America's Roots*, ed. Cynthia Elyce Rubin (New York: Museum of American Folk Art, 1991), n.p.

12 See Weaver, "Cake Prints," figs. 6a, b. See also Gotthard Schuh, *Tirggel: Ein altes Weihnachtsgebäck* (Zurich: Amstutz & Herdeg, 1941); Annemarie Zogg and Robert Hirt, *Zürcher Gebäckmodel* (Bern: Paul Haupt, 1970); Annemarie Zogg, *Züri-Tirggel: Bräuche, Bilder, Herstellung* (Zurich: Zürcher Kantonalbank, 1992).

71

Unidentified American makers

Cake print: Lafayette, 1824–25 or 1834
New York
Mahogany; 15 × 26 × ½ in. (38.1 × 66 × 1.3 cm)
Provenance: George F. Ives sale, Danbury, CT, 1924
1937.592*

Cake print: Allegory of Greek independence, 1823–32
New York
Mahogany; 15¾ × 26 × 1½ in.
(40 × 66 × 3.8 cm)
1937.591

Cake print: Fire engines (double-sided),
ca. 1825–35
New York
Mahogany; 8 × 14½ × 1 in. (20.3 × 36.8 × 2.5 cm)
1937.1562

When a reporter from the *New York Herald Tribune* visited the MFPA in 1931, Elie Nadelman guided him through the museum and pointed out highlights of American folk art. Among his selections was the cake print featuring Lafayette on horseback, which the sculptor speculated was "designed to decorate the icing of a festival cake."[1] Nadelman was so intrigued by the intricacy of the carving that he created a plaster impression from the board so that visitors could fully appreciate the lively design.[2] Among the earliest collectors of such prints, the Nadelmans assembled an extensive collection of what they generally termed "cake moulds" in the MFPA cards, including numerous examples from Switzerland and Hungary.[3] The couple exhibited their molds in Gallery IV of the MFPA, including thirteen in a glass case partially visible in a photograph (fig. 35). Though dominated by European examples, many with religious imagery, the display provided visual evidence of the influence of European cake molds on New York cake prints, which flourished during the nineteenth century.

Large cake prints such as these were used by professional bakers to impress a design into caraway-flecked New Year's cakes, which were traditionally served to visiting friends on New Year's Day. Once out of the oven, the delicacies were often ornamented with color and even gilding. The region's New Year's cake evolved from two Dutch traditions: New Year's Day wafers (*nieuwjaarskoeken*), which were formed in a wafer iron, and the spiced honey cakes made for St. Nicholas Day, formed in wooden molds.[4] Though indebted to these European antecedents, the New Year's cake enjoyed by New Yorkers was a true American innovation.[5] Many cake prints are marked by their carvers, including the leading New York City print cutter, John Conger.[6] None of the Nadelman examples bear a maker's name, and their carving styles suggest three separate hands.

The Lafayette cake print represents the young French aristocrat on horseback at Yorktown, where in 1781 he engaged British troops and helped to secure the ultimate surrender of Lord Cornwallis. The carver depicted the Marquis as a swashbuckling knight, brandishing an enormous sword and wearing showy plumed headgear.[7] The central roundel and smaller flanking reserves are all enclosed in a pointed oval, a shape characteristic of New York cake prints. The distinctive carving, with shallow cuts, rayed stars in the border, a cross-hatched band encircling the roundel, and stalks of grain, are found on other cake prints but as yet have not been linked to a named carver.[8] An important clue about the history of the object is the inscription "W. FARROW" below the horse, which ties the cake print to New York City baker William Farrow, who was active between 1815 and 1834.[9] The cake print was likely commissioned by Farrow either in 1824–25 to celebrate the Marquis de Lafayette's triumphal return to America or in 1834 to commemorate his death.[10]

The Nadelmans purchased the Lafayette cake print at auction for $22.50 in June 1924.[11] The first wooden cake mold acquired by the couple, it may have ignited their interest in this particular genre of folk art.[12] The Lafayette print also inspired a wider circle of collectors when the plaster impression of it, along with the Greek Independence print, appeared on the cover of *The Magazine Antiques* in October 1941. The illustration and accompanying commentary, which speculated that the boards were used in Pennsylvania for marzipan cakes, aroused interest and prompted commentary from several readers.[13]

Like the Lafayette example, the cake print carved with a detailed allegorical scene refers to a nation's struggle for independence. In this case, the imagery celebrates Greece's ultimately successful war against the Ottoman Empire. At center, a weeping figure of Greece leans on a broken column, facing a Turk poised to strike her with a sword. A massive eagle hovers above, ready to crown Greece with a laurel wreath. At left, a personification of America subdues the Turk by grabbing his weapon. A benevolent Britannia accompanied by a lion stands at the right, holding a banner

inscribed "Byron," an allusion to the famous English poet, who became a hero after joining the Greek fight for independence in 1823.[14] While the United States officially maintained a neutral stance, many Americans were sympathetic to the cause of Greek liberty. In 1824, New York philhellenes raised 6,600 sterling pounds to send to the Greek government.[15]

The double-sided cake print with a hand-drawn fire engine on each side is the least sophisticated of the trio and arguably the most folky.[16] Each side features a pointed oval enclosing an early engine pulled by three firefighters, the leader with his speaking trumpet raised as if directing his fellow volunteers to a fire. One side depicts an engine with the number "17" on the cylinder and the name "SUPERIOR" above; the other has the number "8" and the name "MANHATTAN" in the same locations.[17] With deep, crisp gouging, the carver rendered the engines with detail suggesting first-hand knowledge of fire vehicles, even delineating the decoration on the condenser cases at the rear (cat. 13).[18]

MKH

1 "City to Receive Rare Collection of Primitive Art," *New York Herald Tribune*, October 30, 1931.

2 Ibid.

3 The carved boards, usually of mahogany, were known as "cake prints" during the nineteenth century but are typically referred to as "cake boards" by today's collectors. "Cake print" is used here in deference to period usage.

4 Kimberly L. Sorensen, "Prints Charming: Nineteenth Century New York Cake Boards and New Year's Cake" (master's thesis, Bard Graduate Center for Studies in the Decorative Arts, Design, and Culture, 2011), 12–13, 26–27. See also Peter Rose, "Dutch Foodways: An American Connection" in *Matters of Taste: Food and Drink in Seventeenth-Century Dutch Art and Life*, exh. cat. (Syracuse, NY: Syracuse University Press, 2002), 24–25.

5 William Woys Weaver, "The New Year's Cake Print: A Distinctively American Art Form," *Clarion* 14:4 (Fall 1989): 58–63; Sorenson, "Prints Charming," 31.

6 For information on John Conger and other New York City carvers, see Sorensen, "Prints Charming," 42–52; Louise Belden, "Cake Boards," *The Magazine Antiques* 138:6 (December 1990): 1243–48; Weaver, "The New Year's Cake Print," 61–63.

7 A cake print depicting William Henry Harrison on horseback is modeled on the same source, although the carving style is quite different. Winterthur Museum, Winterthur, DE, 1964.01.32.

8 Belden, "Cake Boards," 1244.

9 Farrow is listed as a baker in the New York City directories between 1815–16 and 1833–34 at various lower Manhattan locations, including Mott, Oak, and Oliver streets.

10 Another cake print depicting Lafayette (also once owned by the Nadelmans) is dated 1834, Fenimore Art Museum, Cooperstown, NY, N0532.1948(01). A cotton banner with an ink impression from the N-YHS cake print survives at Lafayette College. See Stanley J. Idzerda et al., *Lafayette, Hero of Two Worlds*, exh. cat. (Hanover, NH: University Press of New England, 1989), 131, fig. 124.

11 MFPA 508. City National Bank of Danbury, CT, "The George F. Ives Collection of Antiques," June 18, 1924, lot 527. The lot included two cake prints, one of which was acquired by Henry Francis du Pont. See Henry Francis du Pont Antique Dealers Papers, Arc. 28, Winterthur Library, Winterthur, DE.

12 The MFPA cards record the subsequent purchase of over seventy carved cake molds, including American examples from Charles Woolsey Lyon in 1924 and Renwick Hurry in 1925, large numbers of Swiss molds from C. Vandevere Howard between 1925 and 1930, and several Hungarian examples from Vilmos Szilárd in 1926 and 1927.

13 "The Cover," *The Magazine Antiques* 40:4 (October 1941): 209; "Placing Those Celebrative Cake Molds," *The Magazine Antiques* 40:5 (November 1941): 280.

14 Richard Barons attributed the board to New York City carver Henry F. Cox, but its style of carving is sufficiently different from the one extant cake print signed by Cox to call the attribution into question. See Richard Barons, "The Cake Boards of New York State," *Clarion* 7 (Spring 1977): 10.

15 George C. Chryssis, "American Philhellenes and the Greek War for Independence," http://www.helleniccomserve.com/greek_war_for_independence.html.

16 Photographs of the cake print are held in the Index of American Design archives, although it was never rendered as a watercolor. E-mail from Charles Ritchie to Margaret K. Hofer, January 27, 2014; Lipman 1948, fig. 159; see also Jean Lipman and Alice Winchester, *The Flowering of American Folk Art 1776–1876*, exh. cat. (New York: Viking Press in cooperation with the Whitney Museum of American Art, 1974), fig. 363.

17 The company names and numbers cannot be linked to specific New York City fire companies.

18 A related cake print depicting a similar hand-drawn engine pulled by three firefighters was advertised in *The Magazine Antiques* 103:4 (April 1973): 669.

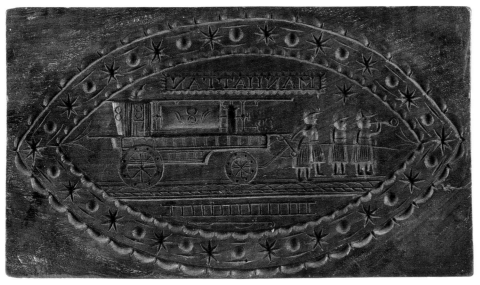

72

Unidentified American and European makers

Butter print with eagle, ca. 1825–75
Wood; 4¼ × 7 in. (10.8 × 17.8 cm)
Provenance: Martha de Haas Reeves, Philadelphia,
PA, 1926
1937.1352*

**Butter print with plant in urn and five
tulips (double-sided)**, ca. 1825–75
Wood; 3⅝ in. (9.2 cm)
Provenance: Martha de Haas Reeves, Philadelphia,
PA, 1926
INV.1042*

**Butter print with six-part radial and
inscription (double-sided)**, 1758
Wood; 9¼ × 4½ × 1 in. (23.5 × 11.4 × 2.5 cm)
Provenance: Early American Antiques, 1925
1937.1582*

**Butter print with six-part radial design
and eight flowers**, ca. 1825–75
Wood; 6½ × 4¼ in. (16.5 × 10.8 cm)
Provenance: Mary H. Dodge, Pawling, NY, 1925
1937.1574*

**Butter print with stylized palm tree and
initials**, ca. 1825–75
Wood; 5¾ × 3¾ in. (14.6 × 9.5 cm)
Provenance: Estelle Berkstresser, York, PA, 1928
INV.7581*

Butter print with heart and leaves, ca.
1800–25
Wood; 4¾ × 7 × 3½ in. (12.1 × 17.8 × 8.9 cm)
Provenance: Martha de Haas Reeves, Philadelphia,
PA, 1926
1937.1568*

Decorative butter prints, which were sometimes used in conjunction with molds, are familiar early American folk art objects with long histories. European examples from Scandinavia and Holland date to the seventeenth century. Butter prints were used so widely in England that a child was sometimes referred to as a "butter print" of its parent.[1] Immigrants transported the custom to this country of decorating butter with a design transferred from a carved wooden form, and the earliest American butter prints date from 1750.[2] "Print" butter was common in American farm homes and was a commodity in the markets of Philadelphia and smaller towns, where farmers also sold their printed butter for extra income. The designs pressed on butter pats or pounds served a dual purpose: they beautified a gracious table and like a hallmark or brand they carried the imprimatur of a maker of known quality. Several hundred different butter print and mold designs are extant and fall into subject categories, such as food, domesticated animals, and wildlife, which were understandably popular in agricultural communities. Women, who handled most dairy chores, also favored flowers and botanicals. Simpler designs, like INV.7581, are carved with names or initials.[3]

Straightforwardly attractive, butter prints were carved from wood (usually pear, poplar, or beech) and can be divided into several types depending on their overall shapes.[4] Round disks predominate and feature a design on one side or rarely on two (for example, INV.1042, which has a thick neck connecting two carved disks).[5] There are also rectangular or half-round butter prints. For convenience, a handle was usually added, either a knoblike form set at a right angle to the printing surface or a horizontal paddle added to one side, like the handle of a spoon (1937.1574).[6] Pressing the print with its intaglio design onto the top of a slab of butter left the decorative design in relief on its surface. These print devices were versatile and could also be used to decorate baked goods.

Butter molds, which are frequently confused with prints, consist of a case, which measures the amount of butter, and a plunger that prints the design and pushes the butter out of the case.[7] The MFPA cards use the term "Butter moulds" for both butter prints and molds and list around sixty-six objects; only one of these can be identified as a mold by its description as a four-sided box.[8] Perhaps some of the MFPA objects once belonged to two-part bell and plunger molds.[9] Square, hexagonal, or rectangular variations of the molds were also made.

Butter prints (see fig. 23), which generally feature the most appealing designs, fall into three categories determined by their manufacture: one-of-a-kind by a single maker; craftshop; and factory-made (in woodenware factories that produced treenware). While these categories represent an evolutionary development—from a unique carved print to eventual mass production with pressure-stamped designs—unique examples continued to be made, especially in remote areas.[10] The Nadelmans paid $15 for an early example, hand-carved from a single piece of wood with a six-part radial design (1937.1582),[11] whose large paddle format is characteristic of early examples. Its reverse (fig. 106) is dated and inscribed with a name: "1758 / M:MENT / IETH."[12] Examples of the craftshop type were generally lathed-turned and then carved with designs based on patterns. Butter prints by shop carvers collected by the Nadelmans include two half-round prints: one with an eagle (1937.1352),[13] whose pattern was also adapted to round prints,[14] and the other with a crosshatched heart (1937.1568).[15]
RJMO

Fig. 106. Reverse of butter print (double-sided) with six-part radial and inscription, 1758. Wood, 9¼ × 4½ × 1 in. (23.5 × 11.4 × 2.5 cm). N-YHS, 1937.1582

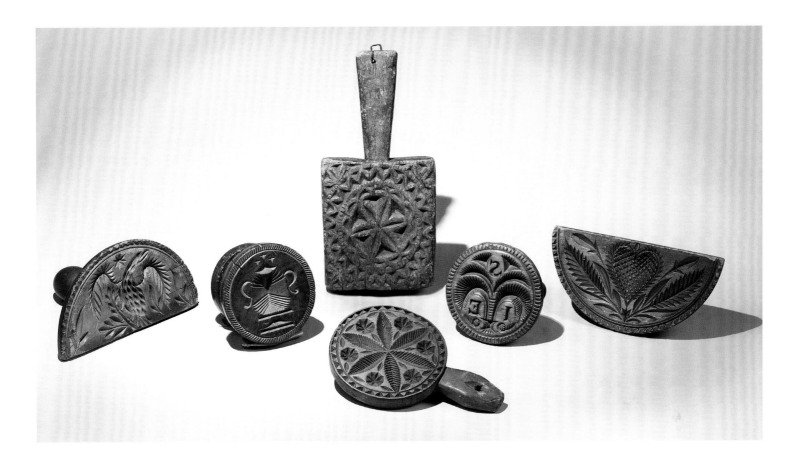

1 Paul E. Kindig, "Butter Molds and Prints: Miniature Sculpture from the Early American Home Dairy," *Clarion* (Fall 1982): 45.

2 Paul E. Kindig, *Butter Prints and Molds* (West Chester, PA: Schiffer, 1986), 89–90.

3 N-YHS INV.7581 is MFPA Misc. 2467; it was purchased in May 1928 for $2.50. It has a MFPA label inscribed "246 /Amer."

4 See Kindig, "Butter Molds and Prints," 45–51. The Museum of Michigan State University has over twelve hundred examples that have been inventoried in their Butter Print and Mold Project: http://museum.msu.edu/index.php?q=node/761.

5 N-YHS INV.1042 is MFPA 2116; purchased in August 1926.

6 MFPA 1663; purchased in April 1925 for $3.

7 Kindig, "Butter Molds and Prints," 46; idem, *Butter Prints and Molds*, 78–97.

8 MFPA 2246, described as a four-sided box with a square pusher. The majority of those listed are held by the N-YHS.

9 For example, N-YHS INV.1037, which has a MFPA collection label inscribed "314/Amer." See Kindig, "Butter Molds and Prints," 48; idem, *Butter Prints and Molds*, 78, 81, 180–87, 235.

10 Kindig, *Butter Prints and Molds*, 39–55.

11 MFPA 1626; purchased in October 1925 for $15.

12 "Menteith" is probably a surname, although Menteith/Monteith is a district within the Stirling council area in central Scotland.

13 MFPA 2118; purchased in August 1926.

14 For a closely related group in the Chester County Historical Society, West Chester, PA, see Kindig, *Butter Prints and Molds*, fig. IV–67; for half-round prints see pp. 61–63. The Nadelmans purchased over thirty butter prints from the Philadelphia dealer Martha de Haas Reeves in August 1926, although they acquired a number from other sources, including several purchased in Budapest, Hungary, from the Klasszis shop and the associated dealer Vilmos Szilárd in 1925 and 1926.

15 MFPA 2132; purchased in August 1926. A nearly identical one is in the Mercer Museum of the Bucks County Historical Society, Doylestown, PA; ibid., fig. V–92.

73

Probably David Mills Pease family (American, 1815–1890)
Container with lid, 1850–90
Cascade Valley, OH
Wood (probably maple), iron; 10¼ × 9¾ in. (26 × 24.8 cm)
Provenance: Dobbs Ferry Sales Rooms, Dobbs Ferry, NY, 1924
1937.1588ab*

Unidentified maker, probably English
Mortar grater, ca. 1700–50
Wood (probably sycamore), metal; 8½ × 4½ in. (21.6 × 11.4 cm)
1937.1755a-c

The Nadelmans collected wooden objects voraciously, particularly furniture and household tools with carved or painted decoration. The MFPA holdings also suggest that the couple appreciated the craft of wood turning. Turners produced objects such as these two skillfully executed vessels by manipulating a sharpened tool—either a gouge or chisel—against a block of wood while it rotated on a lathe.

The mortar grater was used for grinding and storing a range of materials, from herbs and spices to tobacco and snuff.[1] It is made up of three separable parts. The top, with a knob for ergonomic use and decoration, is a cylindrical pestle with a perforated metal plate attached to its bottom. The pestle fits into a sleeve with another perforated plate. When the user rotated the pestle, the friction between the jagged plates pulverized the contents, and the holes allowed the ground material to fall into the vessel below. The rotating central sleeve can be removed for easy access to the vessel's contents; locking "keys"—protrusions on the sleeve corresponding with cut-outs on the base—ensured a seal and prevented spillage.

The mortar grater may have been turned on a simple pole lathe, which was typically operated by a treadle on the floor and used reciprocal motion. The covered bowl, on the other hand, was executed on a powered lathe with continuous rotary motion. The bowl is characteristic of "Peaseware" produced by David Mills Pease and other family members in the Cascade Valley of Ohio during the second half of the nineteenth century. Born in New England, Pease had struck out for the Western Reserve by 1838. Around 1850, he constructed a mill on Big Creek and harnessed its natural energy by digging a channel and installing a large waterwheel to power five lathes of various sizes.[2] Nearby forests provided an ample supply of fresh-cut maple for turned products, which included spice containers, spool holders, and goblets. Perhaps most widely produced were practical lidded containers such as this, which protected foods such as maple sugar chunks from pests

and moisture. The Nadelmans owned two such containers and identified them as "pickle buckets" in the MFPA cards.[3] This expertly turned vessel, which includes an iron wire bail with wooden handle to facilitate carrying, is embellished with a large acorn-shaped finial. Traces of paint suggest that it was once painted mustard yellow.

MKH

1 Jonathan Levi, *Treen for the Table: Wooden Objects Relating to Eating and Drinking* (Woodbridge, Suffolk, Eng.: Antique Collectors' Club, 1998), 111.

2 Gene and Linda Kangas, "Peaseware: Fruit of the Garden of Eden," *Maine Antique Digest* 24:12 (December 1996). See also idem, "The Pease-Brown Connection," *Antique Review* 22:10 (October 1996). Both articles are accessible at http://creeksideartgallery.com/articles/peaseware.html.

3 This example is MFPA 582, purchased for $7.50 in May 1924. The second example, MFPA 583 (N-YHS INV.13811), was purchased at the same time.

74

Unidentified Swiss makers

Whetstone holder, ca. 1830–40
Wood, paint; 12 × 3¼ × 4 in. (30.5 × 8.5 × 10.2 cm)
Provenance: C. Vandevere Howard, New York City, 1930
INV.755[dup]*

Whetstone holder, 1834
Pine, paint, metal wire (added later);
12¼ × 3½ × 4½ in. (31.1 × 8.9 × 11.4 cm)
Provenance: C. Vandevere Howard, New York City, 1930
INV.754*

In their form, function, and decoration, this pair of whetstone holders, or flasks, embody the first name of the Nadelmans' Museum of Folk and Peasant Arts. The MFPA inventory lists "Nine whetstone holders," although the cards list eleven (nine of wood and one each of leather and brass). These two examples of European peasant art are among the trio photographed on the wall in Gallery IV of the MFPA (fig. 104).

Whetstones are finely grained stones used to sharpen cutting tools. Reapers filled these wooden flasks, which were usually carved, with water, strapped them onto their belts, and carried them into the fields in order to keep their whetstones moist in the event that they needed to sharpen their scythes.[1] The type—which was alternatively called a *Wetzsteinköcher* (whetstone quiver), *Wetzsteintasche* (whetstone pocket), or *Wetzsteinkümpf* (whetstone mate)—features a tapered point at the base that also allowed owners to stake the quiver upright into the ground without losing its water when they rested from their labors in the field. Found throughout northern Europe, the oblong shape with its flat back and decoration is more characteristic of the Swiss type. Those of Swiss origin also feature carved ornaments and rosettes or painted hearts, bull's eyes, and flowers, as in these examples. Both examples also have openings through which a belt was threaded, either along a groove on the front (INV.754) or the back (INV.755[dup]). Similar types appear in publications about European peasant art on both sides of the Atlantic as early as 1911, pointing to their collectability.[2] In one of these sources, the author states that "wood is *par excellence* the favourite material of the peasant worker," noting its accessibility and pliability.[3]

The Nadelmans recorded both of these whetstone holders in the MFPA cards (Misc. 2651 and Misc. 2646) as Swiss in origin and purchased from C. Vandevere Howard in February 1930 for $9.60 and $12, respectively.[4] The one on the right, which is painted green and incised with a tulip and a heart enclosing two six-pointed rosettes/

stars and a knot design, is dated and initialed below the lip in stylized lettering: "18 [initials?] 34." The one on the left has similar decorative motifs, except for the target-like or bull's eye forms in the lobe of the heart, painted in red, yellow, green, and black; it is initialed at the upper center in yellow paint: "[?]M." Indicating what was important for them, the Nadelmans described the right object as an "Oblong carved wooden holder to carry on a belt. All carved from one piece of wood. Carved with tulip, rosaces and running ornament." Their description of the left whetstone holder, which they noted was not in good condition, again reveals their priorities: they observed that it too was carved from a single piece of wood and "painted red, green, black and yellow with bull's eyes and two six petalled flowers." Its designs resemble the paintings of the French modernist Robert Delaunay, who was a founder of Orphism, a colorful offshoot of Cubism that around 1912 evolved into abstract art. Elie Nadelman, who had been in Paris when Delaunay's art flourished, could not have missed this coincidence, which illustrates a concrete formalist link between the aesthetics of folk and modern art.

RJMO

1 See Daniel Baud-Bovy, *Schweizer Bauernkunst* (Zurich: Orell Füssli, 1926), fig. 187, for an illustration of a man wearing a whetstone holder and carrying a scythe.

2 M. Haberlandt, "Austrian Peasant Art," in *Peasant Art in Austria and Hungary*, ed. Charles Holme (London, Paris, New York: Studio, 1911), 21, figs. 124–32; Baud-Bovy, *Schweizer Bauernkunst*, figs. 187, 194; Titus Burckhardt, *Schweizer Volkskunst . . . Art populaire suisse* (Basel: Urs Graf, 1941), fig. 13.

3 Haberlandt, "Austrian Peasant Art," 22.

4 Both have MFPA collection labels; INV.755[dup] is inscribed "2646/Swiss"; INV.754 is inscribed "2651/Swiss."

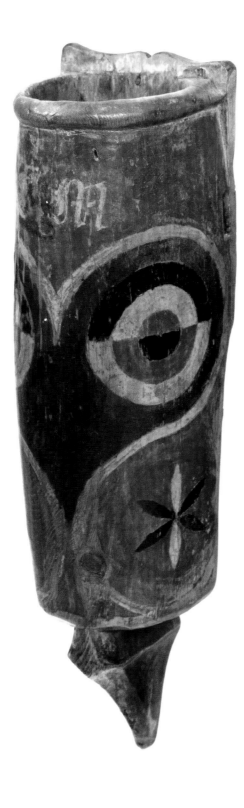
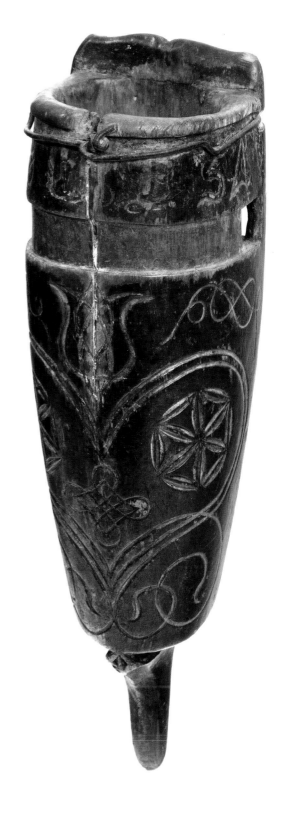

75

Unidentified European maker
Kakelorum, 1780–1810
Southern Germany, probably Oberammergau
Wood, paint, gesso, wire; 8¼ × 7⅜ × 9¾ in.
(21 × 18.7 × 24.8 cm)
Provenance: Siegfried Laemmle, Munich, Germany,
1929
INV.4539*

Intended for the amusement of adults rather than children, this carved and painted marble game, known as a *kakelorum*, is distinctive to upper Austria and southern Germany.[1] In this game of chance, players take turns dropping a marble into an opening at the back of a figure's head; after descending the spiral chute, the marble lands in one of the sixty-three numbered depressions in the tray below. Players garner points according to the spaces on which their marbles come to rest and win the game outright if their marble lands in the central spot, identified with a red spade. This *kakelorum* resembles examples made in the Bavarian town of Oberammergau, which had a long-established tradition of wood carving. The spiral tower takes the form of a well-dressed woman with an elaborate striped costume, feathered hat, facial features denoted in paint, and real earrings (one now missing) made of wire, wood, and gesso. Though fashioned entirely of wood, the game's faux painted surface imitates more exotic materials: the spiral chute resembles stone, possibly quartz, while the rim of the circular tray is marbleized. Other examples of the game feature turbaned Turks or shako-wearing hussars, with an opening in the top of the headdress or hat to receive marbles.[2]

The Nadelmans purchased the *kakelorum* from Munich dealer Siegfried Laemmle for the substantial price of $55.[3] Though Laemmle's gallery specialized in late medieval and early Renaissance sculpture, the Nadelmans purchased a range of folk art from his shop between 1924 and 1931, initially in person and later via mail. They probably spotted the game during a visit to the Brienner Straße shop in September 1929, as the MFPA records indicate that the couple purchased a large number of German folk art pieces at the same time, including seventeenth- and eighteenth-century pottery, ironwork, trade signs, and needlecases (cat. 60). The Jewish dealer and his son Walter Laemmle kept up friendly correspondence with Viola Nadelman after 1938, when they fled to Los Angeles following the confiscation of their shop and its contents by the German government (see Hofer essay, pp. 68–69).[4]
MKH

1 Hubert Kaut, *Alt-Wiener Spielzeugschachtel: Wiener Kinderspielzeug aus drei Jahrhunderten* (Vienna: Hans Deutsch, 1961), n.p.; Charlotte Angeletti, *Aus Münchner Kinderstuben, 1750–1930: Kinderspielzeug, Kinderbüchner, Kinderporträts, Kinderkleidung, Kindermöbel: Aus den Beständen des Münchner Stadtmuseums*, exh. cat. (Munich: Stadtmuseum, 1976), 174–75, fig. 542.
2 Angeletti, *Aus Münchner Kinderstuben*, 174, fig. 542; Bayerisches Nationalmuseum, Munich, Germany, acc. nos. 28/1920, 30/2009; see also http://www.antiquetoys.nl/kakelorum.large.gif.
3 MFPA Toys 535, purchased in September 1929. The MFPA card refers to it as a "marble spiral game."
4 http://research.frick.org/directoryweb/ browserecord2.php?-action=browse&-recid=6351; correspondence between Siegfried and Walter Laemmle and Viola Nadelman, NP.

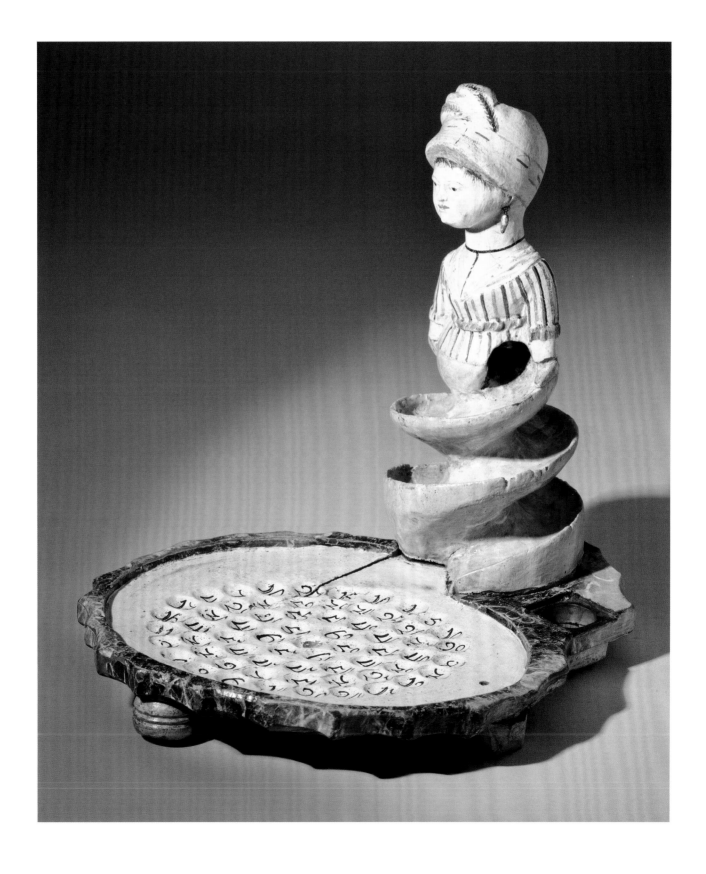

76

Unidentified Swiss maker
Rocking horse, 1800–50
Fir, paint; 23 × 36¾ × 14 in. (58.5 × 93.5 × 35.5 cm)
Provenance: Arden Galleries, New York City, 1928
1937.499*

Although the Nadelmans identified this object as a "Hobby Horse" on the MFPA card, it is instead a rocking horse toy with an unusually extended rectangular seat built for two. The couple considered it an example of eighteenth-century Swiss craftsmanship, probably due to its delicately painted decoration, but as a handmade object it is difficult to date precisely. They also noted that it was "much worn."[1] The Nadelmans exhibited it in the Toy Room, Gallery IX of the MFPA, together with two other Swiss rocking horses.

The horse has a carved head—painted in a dappled white and black pattern with a black mane and black halter, red lips, and teeth— and a carved tail, painted black. Its green runners have rests for two sets of feet. Each side is painted with red and white flowers with blue shading and a long swag of leaves with red cording, which is suspended by two long ribbons tied in bows.[2] Its maker also depicted the horse's legs with hooves on both the front and back panels, extending its child-friendly charm.

Early predecessors of the rocking horse include cradles, tilting seats used for jousting practice during the Middle Ages, and wheeled hobby horses featuring a painted horse's head that were employed in parades and ceremonies. The earliest extant rocking horses date from the seventeenth century, although they are rare. Made on the same construction principles as cradles and rocking chairs, they only slightly indicated equine features. This simple design and method of construction, which continued into the nineteenth century, avoided the problem of carving the horse's legs. Many of the early rocking horses were constructed of pine and brightly painted, sometimes with folk designs, like the Nadelman example. Mostly built by amateur woodworkers, they ranged from relatively crude to finely crafted and ornamented. During the nineteenth century, as society began emphasizing play and valuing childhood, rocking horses became more popular and diverse, although their soothing motion to calm the child during play

remained paramount. In middle-class houses, rocking horses, like all equine toys, also had a didactic function: to build character and provide early familiarity with an animal that would help males fulfill the role of a successful adult (see cat. 19). Later in that century, when the production of rocking horses became industrialized, the legs of the horse were usually articulated and sat either on narrow rockers or hovered above the ground while the horse itself was suspended on a rigid frame by iron straps.

The Nadelmans were drawn to this engaging horse with its pegged construction, because it was a handmade, one-of-a-kind object with eccentric but charming proportions and lyrical decorative painting. While it embodies a nostalgia for pre-industrial craftsmanship, it also exudes the qualities of movement, whimsy, and woodcraft that attracted Elie Nadelman in his collecting and animated his own sculpture.
RJMO

1 MFPA Toy 503; the couple paid $75 for it in October 1928. The MFPA cards record three other related examples: MFPA Toy 502, also identified as an eighteenth-century Swiss "Hobby Horse," purchased from Arden Galleries at the same time for the same price; two others, each correctly identified as "Rocking-horse": MFPA Toy 441 (N-YHS 1937.488), MFPA 710 (identified as American).

2 Ruth Bottomley, *Rocking Horses* (Princes Risborough, Buckinghamshire, Eng.: Shire Publications, 1994), 9, ill. reproduces on the right a smaller, German nineteenth-century example with a similar painted bridle, albeit with rider. See also Patricia Mullins, *The Rocking Horse: A History of Moving Toy Horses* (London: New Cavendish Books, 1992); McClintock and McClintock 1961, 45, 53.

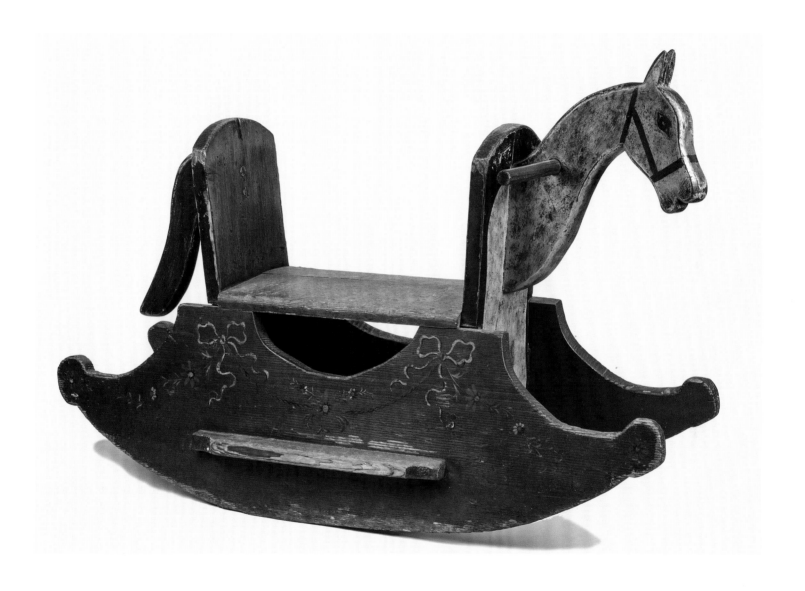

77

Unidentified German makers

Squeak toy: Caged bird on tree, 1820–50
Wood, wire, papier-mâché, cloth, paint, moss;
7⅜ × 2¾ × 2¾ in. (18.7 × 7 × 7 cm)
Provenance: McKearin's, New York City or Hoosick
Falls, NY
INV.7625*

Squeak toy: Baby in cradle, 1820–50
Cloth, wood, papier-mâché, leather, paint, paper,
lace; 2¾ × 2½ × 2½ in. (7 × 6.4 × 6.4 cm)
Provenance: Mary D. Walker, Marion, MA, 1925?
INV.11519*

Squeak toy: Baby in cradle, 1820–50
Cloth, wood, papier-mâché, leather, paint, paper;
2¾ × 2⅜ × 2⅝ in. (7 × 6 × 6.7 cm)
Provenance: Mary D. Walker, Marion, MA, 1925?
INV.11517*

Squeak toy: Cat and bird, 1820–50
Papier-mâché, wood, leather, fiber (flocking), paint,
wire (traces of whiskers); 3⅞ × 3¾ × 2⅜ in.
(9.8 × 9.5 × 6 cm)
INV.5306

Squeak toy: Rabbit, 1820–50
Papier-mâché, leather, wood, paint, fiber (flocking);
3⅛ × 2½ × 1⅝ in. (7.9 × 6.4 × 4.1 cm)
INV.4464

Squeak toy: Rooster, 1820–50
Papier-mâché, wood, paint, cloth, wire;
6⅞ × 3⅜ × 1⅝ in. (17.5 × 8.6 × 4.1 cm)
Provenance: Mable I. Renner, York, PA, 1927
INV.8127*

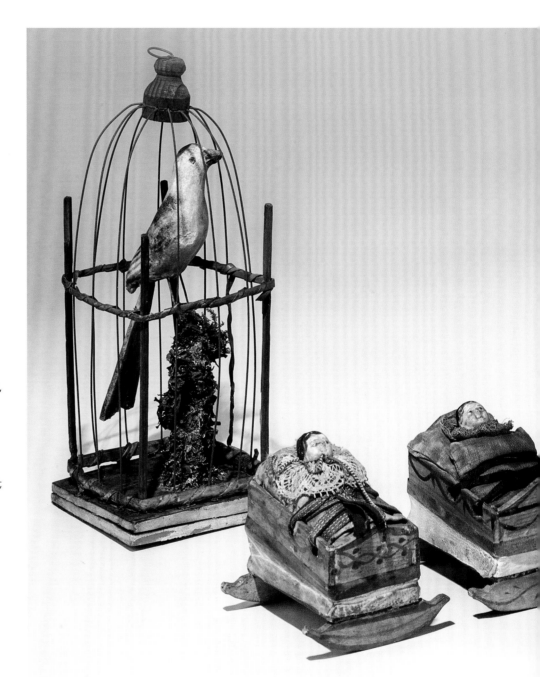

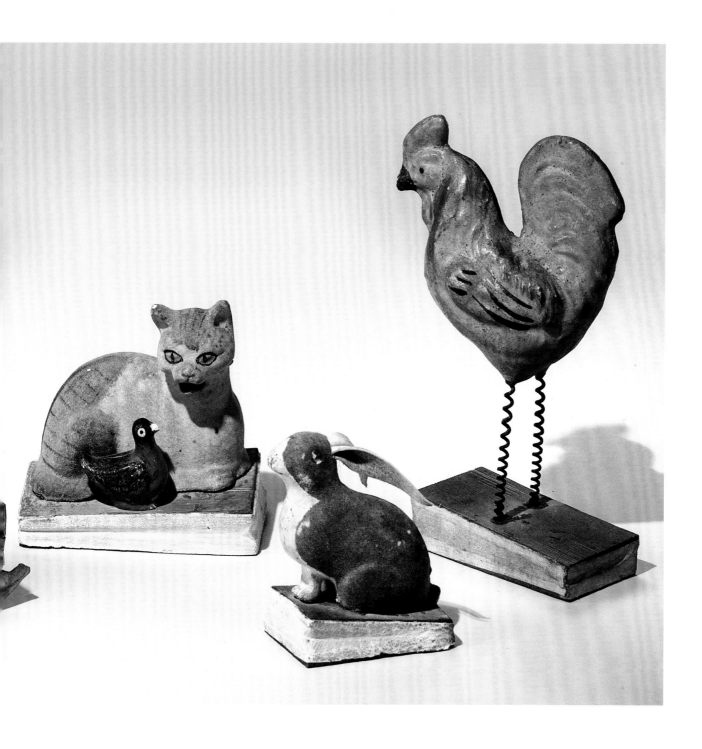

The MFPA cards list between two and three dozen objects that the Nadelmans each identified as a "Bellows toy," although they are more commonly known as "squeaks" or "squeakies." According to the MFPA inventory, forty-seven were displayed in Gallery IX, the Toy Room.[1] In her important article on German toys, Mary Audrey Apple illustrates two examples of a toy that are nearly identical to a pair in the Nadelman collection, calling each a "pipsqueak (doll in cradle)."[2] In this and subsequent studies she demonstrates that the well-organized German toy industry provided American children with most of their "bought" toys, including these handmade squeakies.

Many of these toys, previously thought to be American, were in fact German, proving that German artisans and their toymaking industry played a largely overlooked role in American culture. By the late eighteenth century and the beginning of the nineteenth, toymaking was a well-developed "cottage" or "home" industry in five major Germanic regions with economic problems but with forests rich in raw materials for toymaking (see also cats. 78, 79). A middleman, or *Verleger*, marketed the handmade toys in the international commercial center of Nuremberg, which as early as the fifteenth century was known as "Toy City," and from which toys took the name "Nürnberger ware." Lavish pattern books or catalogues, such as the 1831 volume for the Lindner firm in the town of Sonneberg in Thuringia (fig. 107), were sent to foreign dealers, although by that time American wholesalers traveled regularly to the toymaking areas to make purchases.[3] The Americans were encouraged by the *Verleger* to comment on the styling and salability of the toys, and their ideas played an increasingly important role in toy design. Lewis Page, a New York City toy wholesaler and merchant, was part of this network and his letters from 1829–33 provide a window onto the toy trade before American manufacturers took control in the second half of the nineteenth century.[4] "Although these toys seem simple and even crude by today's standards," Apple notes, "they were at the time among the most sophisticated available anywhere, produced and distributed by the most organized toy industry in the world."[5]

Since relatively few of these toys survive, it is difficult to imagine the astounding number that entered the United States before the Civil War. In 1830 alone, Page's order from Lindner included 17,000 dolls, 1,000 pieces of wooden doll furniture, 17,622 musical instruments, 3,000 soldiers, and 6,000 "screechers" (noisemakers). Orders for "squeaks," simple action toys, and animals on wheels totaled more than 1,500.[6] The squeaks, which were made of painted papier-mâché, wood, and frequently leather bellows, must have delighted small children by their appearance and sound (fig. 108).[7]

The Nadelmans were so passionate about these light-hearted, boldly painted German squeak toys, which originally cost pennies per dozen, that they paid the high price of $8 for the caged bird (INV.7625) from McKearin's.[8] The MFPA cards record, however, that the couple paid less for many of the other squeakies.[9]

The squeakies would have especially appealed to Elie Nadelman, whose creative energies extended to inventions. He valued objects for their ingenuity and was fascinated by how they worked. Moreover, the sculptor was also interested in papier-mâché and experimented with many different types of paper for sculptures in that medium.[10]

RJMO

Fig. 107. *Das Sonneberger Spielzeugmusterbuch: Spielwaren-Mustercharte von Johann Simon Lindner in Sonneberg*, ed. Manfred Bachmann (Leipzig: Edition Leipzig, 1979; facsimile of edition published in Sonneberg, 1831), p. 95. Courtesy of the Brian Sutton-Smith Library and Archives of Play, Rochester, NY

1 The Index of American Design records three "Bellows" toys from Elie Nadelman, all identified as "Pa German," continuing the misconception that these objects were made in the United States.

2 Apple 1999, 12. One of them is MFPA Toy 5, and they are singled out in the MFPA inventory as "2 babes in cradles."

3 Elizabeth P. Reynolds and Judith Winslow Blood, "Nuremberg Toys in the Abby Aldrich Rockefeller Folk Art Collection," *The Magazine Antiques* 106:6 (December 1974): 1038, reproduces a page of squeak toys from the catalogue of another firm, Gi Mohrhard (1830–50).

4 See Apple 1999, 11–14; idem, "German Toys in Antebellum America," *The Magazine Antiques* 162:6 (December 2002): 92–101, which also details the exploitation of the artisans by the middlemen. Page's letter book is in the Joseph Downs Collection of Manuscript and Printed Ephemera, Doc. 610, Winterthur Library, Winterthur, DE. Page ordered from England, France, and Germany, on one occasion requesting patterns and/or samples. Items such as dominoes, rope dancers, small animals, tin magic lanterns, paper dolls, varnished heads for dolls, leather dolls, swords, painted pistols, chessmen, caricatures, dancing jacks, small standing soldiers, and pewter or lead toys are noted, in addition to miniature furniture.

5 Apple, "German Toys," 100. See also Fritzsch and Bachmann 1978; Leipold, Leipold, and Bickert 2012.

6 Ibid., 98.

7 For another representation of a child with a squeak toy, see Reynolds and Blood, "Nuremberg Toys," 1038: Asahel Powers, *Charles Mortimer French*, ca. 1832, oil on wood, Fenimore Art Museum, Cooperstown, NY, N0039.1961.

8 The card for MFPA Toy 491 does not state from which of McKearin's two locations they purchased the work. The toy has a Nadelman collection label inscribed "491/ Am." The cloth of the bellows has been removed, although a few remnants remain, and the two platforms glued together.

Fig. 108. Unidentified American artist, *Child in White Dress Holding Toy Spaniel (Squeak Toy)*, ca. 1845. Pastel on paper; 16¾ × 13 in. (42.7 × 33 cm). Shelburne Museum. Shelburne, VT, Gift of Mrs. J.C. Rathbone, 1958, 1961-1.24

9 The squeak toy of the cat and bird (INV.5306) has a Nadelman collection label inscribed, probably with a price: ". . . [illegible]/5.00"; the first baby in the cradle (INV.11517) has a Nadelman collection label inscribed "2.00"; and the rabbit (INV.4464) has a price written directly on its wood base in graphite: "1.50". The couple purchased the rooster squeak toy (INV.8127; MFPA Toys 426), one of several in their collection, for $2.50. Either INV.11517 (base inscribed in graphite "2.00") or INV.11519 is MFPA Toy 5 (n. 2 above), which the couple purchased in February 1925 for $1.50 from Mary Walker.

10 Cynthia Nadelman, "Elie Nadelman: Patents Pending," in *Elie Nadelman*, exh. cat. (New York: Salander-O'Reilly Galleries, 1996), 4–5.

78

Unidentified German makers

Soldiers, 1830–80
Wood, paint; each 10 × 2 in. (25.4 × 5.1 cm)
1937.501, .502, .508, .509, .510*

Hoop toy with soldier, 1830–80
Wood, cardboard, papier-mâché, paint, feather;
8½ × 2 in. (21.6 × 5.1 cm)
INV.1423

Wheeled boat, 1830–80
Wood, paint; 10⅝ × 12½ × 4 in.
(27 × 31.8 × 10.2 cm)
INV.4507

The MFPA Toy Room displayed numerous examples of wooden toys from the German toy-making centers of Thuringia, Nuremberg, and the Erzgebirge region, which supported a thriving manufacture during the nineteenth century. Hundreds of villages participated in a cottage industry that produced cheap toys for worldwide export (cats. 77, 79).[1] Toy soldiers, which date back as far as ancient Egypt and became popular in the eighteenth century with the exploits of Frederick the Great, King of Prussia, were a staple product of German toy manufacturers during the nineteenth century. Although wooden figures such as these competed with mass-produced metal soldiers (frequently referred to as tin or lead but typically made of an alloy), they continued to find a steady market.[2] The MFPA cards record the Nadelmans' 1927 purchase of a group of ten wooden soldiers (five of which are illustrated here), including one drummer and one officer, and their original wooden box.[3] The description also mentions a "folding stand," which may indicate that the soldiers were once part of a scissor-type toy, such as the one illustrated in an 1831 catalogue issued by the Lindner firm of Sonneberg.[4] Each figure wears a Napoleonic uniform of navy coat, red trousers, and plumed shako. A sword-wielding officer and a drummer accompany eight soldiers who stand at the ready with muskets. A painting of Emperor Napoleon and his children on the terrace at the palace of Saint-Cloud includes a young boy playing with a group of toy soldiers nearly identical to the Nadelman figures.[5]

More unusual is the hoop-mounted soldier, who maintains equilibrium as the wheel is rolled along the floor. He sports a bicorne hat (typically associated with Napoleon Bonaparte) topped by a real feather, and a vibrant uniform including a frock coat with colorful striped skirt. The hoop is made of a thin strip of wood, steamed and bent into a circle and painted with broad red and green stripes, while the figure's body is made of carved wood, with cardboard for the skirt and papier-mâché for the head and hat. The soldier is carefully balanced—with the help of a protrusion

from his back—so that he stands upright. Hoop toys that worked on a similar principle were popular products of American tin toy manufacturers during the late nineteenth century, but instead of soldiers, they contained horses, dogs, and children.[6]

German toymakers also produced rolling wooden ships, such as this pleasure boat ferrying a group of passengers.[7] The fanciful three-masted vessel with paddle wheel and stern bell is stenciled with bright colors and boasts a vivid orange hull. The turned figures outfitted in travel clothes have pegs that allow them to fit into holes on the ship's deck. The vessel's exaggerated scrolled bowsprit facilitates its use as a pull toy and adds to its folky charm. Related wheeled boats are illustrated in several mid-nineteenth-century German toy sample books.[8] One similar example survives with a label indicating that it was a gift to a young boy in Bradford, New York, in 1846.[9]

MKH

1 Leipold, Leipold, and Bickert 2012, 13–18.
2 Constance King, *Antique Toys and Dolls* (New York: Rizzoli, 1979), 203–8.
3 MFPA Toys 157, purchased in 1927 for $6, source and location unrecorded. The Nadelmans identified the group as French. The original box is unlocated.
4 Apple 1999, 11, ills. *Das Sonneberger Spielzeugmusterbuch: Spielwaren-Mustercharte von Johann Simon Lindner in Sonneberg*, ed. Manfred Bachmann (Leipzig: Edition Leipzig, 1979), is a facsimile of the catalogue. Small holes in the wooden bases support the theory that the soldiers were once attached to a wooden stand.
5 Louis Ducis, *Napoléon Ier entouré après son déjeuner des jeunes princes et princesses de sa famille*, Versailles, Châteaux de Versailles et de Trianon, acc. no. MV5147; Bruno Girveau and Dorothée Charles, *Des jouets et des hommes*, exh. cat. (Paris: Éditions de la RMN-Grand Palais, 2011), 238, ill.
6 Blood 1976, 1301, fig. 4; *The Magazine Antiques* 129:1 (January 1986): cover.
7 For a ship with soldiers, see *Jouets: Une sélection du Musée de Sonneberg R.D.A.*, exh. cat. (Paris: Musée des arts décoratifs, 1973), 19, no. 118.

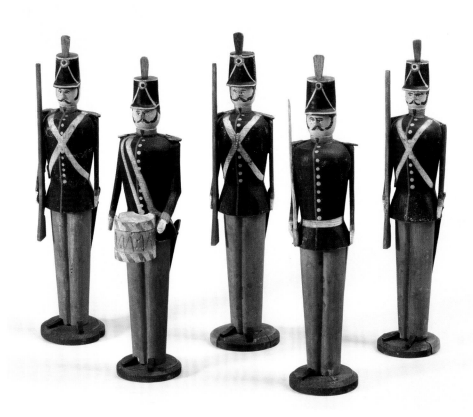

8 Karl Ewald Fritzsch and Manfred Bachmann, *An
 Illustrated History of Toys*, trans. Ruth Michaelis
 (New York: Hastings House, 1978), fig. 27; Leipold,
 Leipold, and Bickert 2012, 41, ill.

9 Leipold, Leipold, and Bickert 2012, 40–41, ill.

79

Unidentified German makers

Chest of drawers, 1825–75
Possibly Sonneberg
Wood, glass, paint; 6 × 7¾ × 6 in.
(15.2 × 19.7 × 15.2 cm)
1937.1384*

Basketmaker's stall, 1850–1900
Probably Erzgebirge region
Wood, straw, paper, paint; 8⅝ × 9½ × 5⅝ in.
(21.9 × 24.1 × 14.3 cm)
Provenance: Emerson, Philadelphia, PA, 1927
INV.5255*

Toy village, 1850–1900
Probably Erzgebirge region
Wood, paint; largest building 4 × 4¾ × 1¼ in.
(10.2 × 12.1 × 3.2 cm)
INV.8090

German toymakers offered a captivating variety of colorful playthings that fostered educational make-believe, allowing boys and girls to play while practicing the activities of adult life. The doll-sized chest of drawers here is one of many examples of painted furniture in the Nadelman collection (cats. 26, 29–33).[1] It was catalogued as Swiss upon its arrival at the N-YHS, which suggests it might have been purchased from the New York dealer C. Vandevere Howard, the Nadelmans' primary source for Swiss folk art. The simple, vibrantly painted chest has three full-length drawers, each with faceted blue glass pulls. The drawer fronts are painted with a distinctive design of clustered white houses with peaked red roofs and black doors and windows, set in a verdant landscape. Similar peaked-roof buildings appear on toy chests and boxes illustrated on sample sheets of 1829 from the Johann Lindner Company of Sonneberg.[2]

Toy shops of all types—belonging to a milliner, grocer, tobacconist, chemist, and even a butcher—delighted nineteenth-century children. High-end examples featured shelves filled with small moveable goods, counters displaying tiny models, and drawers to open and close, while simpler market fair stalls such as this example, made in quantity in the toymaking region of the Erzgebirge, had goods fixed in place.[3] This basketmaker's stall displays eighteen woven straw baskets hanging from the ceiling or stacked on the counter, once attended by a male papier-mâché basket seller.[4] The "BASKET MAKER" sign leaves no doubt about the type of wares on offer and also indicates that the toy was made for the American or English market. The Nadelmans catalogued it as American in the MFPA cards, perhaps guessing from the sign. They purchased the basket shop from Emerson of Philadelphia, who sold them a variety of toys between 1927 and 1930. Similar wooden stalls with a vendor surrounded by their products are illustrated in the ca. 1850 sample book of toy agent Carl Heinrich Oehme of Waldkirchen, in the Erzgebirge region.[5]

The Nadelmans' toy village is composed of sixty-one pieces, which can be used to create an animated town scene: in addition to thirty-one houses, the grouping includes three barns, five churches, a jail, a birdhouse, and an assortment of figures and trees. The set, typical of the villages produced in the Erzgebirge region, would have originally come packaged in a matchwood box for young builders to unpack and then use for storage.[6] A page from Carl Heinrich Oehme's sample book of ca. 1850 illustrates a set with similar three-story buildings with the same window and door configuration.[7] The Nadelman set was enjoyed by an English-speaking child: one church has been transformed into a jail, the back of which is inscribed in ink, "The place / where / Harry is / going."
MKH

1 MFPA Toys 372, purchased for $8, source and date unspecified. Based on its MFPA number, it was probably purchased around 1925. An illegible MFPA label is on the underside of the chest, along with a dealer's label indicating a sale price of $12, reduced to $8, and the graphite notation, "agreed price."
2 Leipold, Leipold, and Bickert 2012, 192–93, ills.
3 Betty Cadbury, *Playthings Past* (Newton Abbot, Eng.: David and Charles, 1976), 24–25; Fritzsch and Bachmann 1978, 74–76.
4 MFPA Toys 440, purchased for $15. The stall has a MFPA label on the underside inscribed "440 / Am." The papier-mâché figure described on the MFPA card is unlocated.
5 Manfred Bachmann, ed., *Das Waldkirchner Spielzeugmusterbuch* (Leipzig: Edition Leipzig, 1979), 93, ill.
6 Fritzsch and Bachmann 1978, 51–56.
7 Bachmann, *Waldkirchner Spielzeugmusterbuch*, 71.

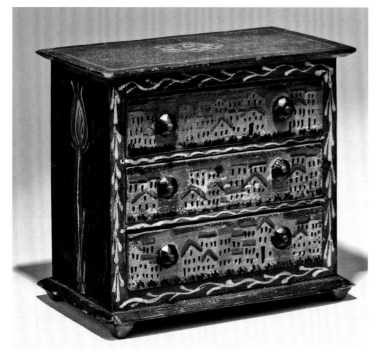

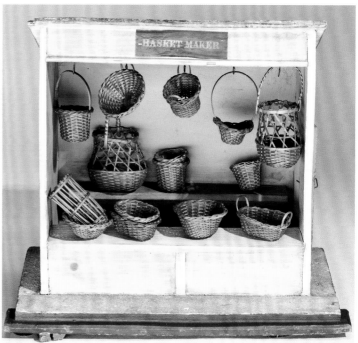

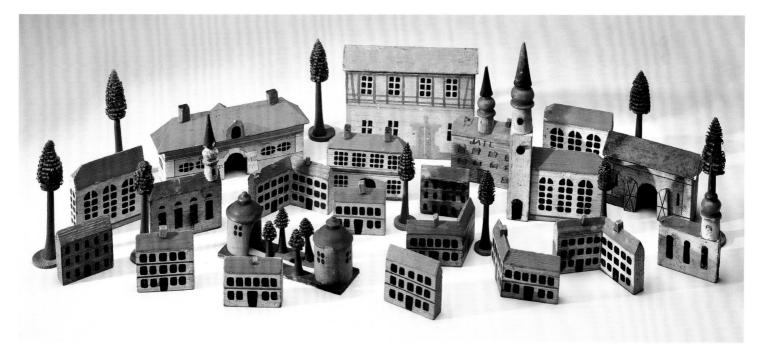

80

Unidentified American maker
Miniature chair, 1730–60
Probably New York
Wood, probably maple and ash, rush, paint;
10⅜ × 5⅜ × 4 in. (26.4 × 13.7 × 10.2 cm)
INV.7813

Unidentified European maker, possibly Swiss
Doll's cradle, 1760–1800
Walnut, spruce; 8¼ × 15¼ × 10 in.
(21 × 38.7 × 25.4 cm)
Provenance: C. Vandevere Howard, New York City,
1928
INV.5220a-d*

The MFPA Toy Room overflowed with miniature furniture. Child-size beds and cradles crowded the center of the room, while doll-size furniture in glass display cabinets provided places for the dolls to sit or slumber (see fig. 15). Hundreds of even smaller dollhouse-sized miniatures, from elegant chests to humble kitchen utensils, also filled the shelves. Many of these miniatures echoed the forms of full-size objects on display in other galleries of the MFPA.

The craze for collecting tiny objects can be traced to sixteenth- and seventeenth-century Holland, where adults collected costly miniatures and displayed them in cabinets.[1] When the Nadelmans were acquiring folk art during the 1920s and 1930s, many other collectors shared their fascination with diminutive furniture, ceramics, and household implements, and the prices paid by the couple reflect the high demand for miniatures (see cat. 45). In 1928, they acquired this doll-size cradle from one of their preferred sources, New York City dealer C. Vandevere Howard.[2] The walnut cradle follows traditional Germanic form with its inward-sloping sides, scalloped head and foot, and turned finials. Also typical are the turned knobs projecting from each side, used to attach lacing that kept the baby securely strapped in bed (a practice illustrated in the pair of cradle-bound infant squeak toys in cat. 77). The Nadelmans must have had a particular appreciation for the form, as they acquired at least thirteen full-size cradles—including six Swiss examples purchased from Howard in December 1925—and no fewer than four sized for dolls.[3] Their collection undoubtedly demonstrated similarities between full-size cradles and their miniature equivalents, as well as the connection between American cradles and their European antecedents.

Unlike the cradle, which could accommodate a large baby doll, the tiny slat-back armchair is closer to dollhouse scale, although it may not have been intended for that purpose.[4] The miniature's ring-turned posts, ball finials, mushroom-shaped hand grips, and gently arched slats link it to a tradition of chairmaking in late seventeenth- and early eighteenth-century New York documented by a small group of surviving examples.[5] The chair retains its original rush seat and an old layer of black paint that shows traces of red beneath. Finely crafted models such as this were long believed to have been produced as apprentice pieces—furniture made at the end of a craftsman's training to demonstrate his competence.[6] Another romantic (and undocumented) notion is that such objects served as salesman's samples.[7] While the original purpose of these models is unclear, many of them found their way into the nursery before entering the marketplace as desirable antiques.

MKH

1 Katharine Morrison McClinton, *Antiques in Miniature* (New York: Scribner, 1970), 3–5; Edward Gelles, *Nursery Furniture: Antique Children's, Miniature and Dolls' House Furniture* (London: Constable, 1982), 110–11; Nancy Akre, *Miniatures* (Washington, DC: Cooper-Hewitt Museum, 1983), 44–46.

2 MFPA Toys 480, purchased for $16. A MFPA collection label on the underside is inscribed "480 / Swiss."

3 In addition to the thirteen referenced in the MFPA cards, the N-YHS collection includes two leather-covered cradles not cited therein: 1937.1776[dup] and 1937.1777[dup].

4 The chair does not appear to be itemized in the MFPA cards, but it may be one of several objects described in the inventory as "little wooden chair."

5 For instance, Art Institute of Chicago, 1946.507 in Judith A. Barter et al., *American Arts at The Art Institute of Chicago* (Chicago: Art Institute of Chicago, 1998), 53–54, cat. 5; Metropolitan Museum of Art, 1999.219.2.

6 Akre, *Miniatures*, 47–49; Jane Toller, *Antique Miniature Furniture in Great Britain and America* (London: G. Bell and Sons, 1966), 43–48.

7 Akre, *Miniatures*, 47–49; Toller, *Antique Miniature Furniture*, 43–48.

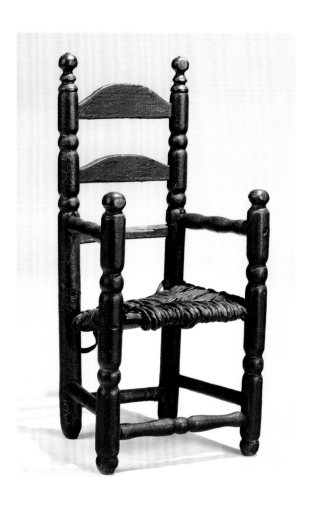

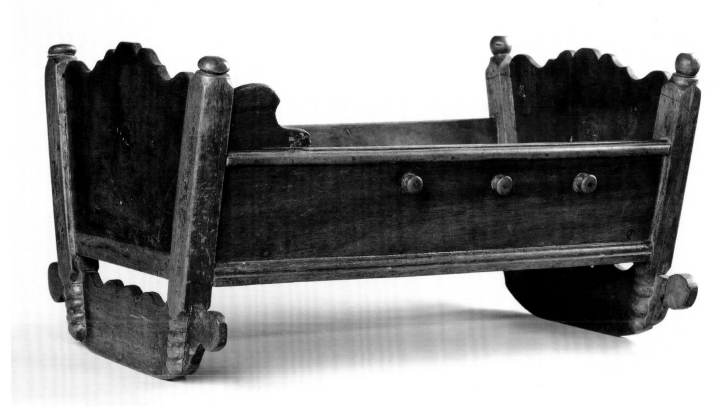

81

Unidentified makers, probably English

Jumping jack, 1830–70
Wood (probably pine), paint, string;
12½ × 7½ × 2 in. (31.8 × 19 × 5.1 cm)
Provenance: C. Vandevere Howard, New York City,
1928
1937.1258*

Doll, 1830–70
Wood (probably pine), paint; 9½ × 4½ × 2¾ in.
(24.1 × 11.4 × 7 cm)
Provenance: C. Vandevere Howard, New York City,
1928
1937.1252*

The Nadelmans purchased these two toys together in December 1928 from one of their favored sources, the Fifty-seventh Street antiques dealer C. Vandevere Howard. The jumping jack and carved and painted doll each cost $28; the couple identified both as English and made in the seventeenth or early eighteenth century. While the couple's dating of the toys was off by at least a century, they may have been correct in identifying the country of origin. The toys were displayed together in the MFPA Toy Room, with the wooden doll standing on the second shelf from the bottom and the jumping jack in a split in front of her (see fig. 15).

The jumping jack, called *hampelmann* in Germany, was known there as early as the sixteenth century.[1] Related to French *pantins*, or jointed dolls made out of cardboard, these pull-string animated toys were popular among the Parisian nobility during the mid-1700s.[2] During the nineteenth century, *hampelmänner* were produced in large quantities in certain toymaking centers of Germany—such as Oberammergau, Berchtesgaden, Nuremberg, and the Erzgebirge region—for local retail and for export.[3] The fad also spread to England and America, where jumping jacks were produced on a smaller scale. This sprightly clown jumping jack has a distinctive rounded body with incised lines delineating his costume, carved facial features with prominent forehead and nose, and mitten-like hands and feet.[4] Unlike typical jumping jacks, his legs are each one piece rather than jointed. Perhaps most striking is the painted detail, including the figure's red cheeks and bowtie, striped arms and legs, and stippled costume. Jumping jacks sharing these features, clearly from the same region, have been cited variously as German, English, and American in origin.[5] A well-documented example in the Victoria and Albert Museum points to England as a probable source.[6]

The sturdy painted doll, whose body is carved from a single block of wood, shares certain features with the jumping jack, including incising to delineate the costume, a carved face with prominent forehead and

nose, and stippled costume.[7] With an economy of form, the carver crisply rendered the doll's body and facial features, creating a buxom woman whose piercing gaze is framed by a ruffled bonnet and bow. The doll has been published as Pennsylvania-made and similar dolls have been called American, but, like the jumping jack, no documented examples survive to clinch the attribution.[8] With a curious combination of playfully rendered costume and formidable face, the figure bridges the Nadelmans' collecting interests in carved and painted vernacular objects and in dolls and children's toys.

MKH

1 Harry B. Weiss, *Something about Jumping Jacks and the Jack-in-the-Box* (Trenton, NJ: Harry B. Weiss, 1945), 12.

2 Maurice Richards, ed., *The Encyclopedia of Ephemera* (New York: Routledge, 2000), 186.

3 Weiss, *Jumping Jacks*, 11; Charlotte Angeletti, *Aus Münchner Kinderstuben, 1750–1930: Kinderspielzeug, Kinderbüchner, Kinderporträts, Kinderkleidung, Kindermöbel: Aus den Beständen des Münchner Stadtmuseums*, exh. cat. (Munich: Stadtmuseum, 1976), 187, nos. 598–602.

4 MFPA Toys 501.

5 For example, Ketchum 1981, 25, fig. 14; McClintock and McClintock 1961, 103, ill.; Weiss, *Jumping Jacks*, 17, fig. 15C.

6 Victoria and Albert Museum, London, MISC.43-1980. The jumping jack was made in 1860–61 in Great Yarmouth.

7 MFPA Toys 500. A MFPA label on the underside of the doll is inscribed "500 / English."

8 McClintock and McClintock 1961, 50, ill.; Constance E. King, *Antique Toys and Dolls* (New York: Rizzoli, 1979), 99.

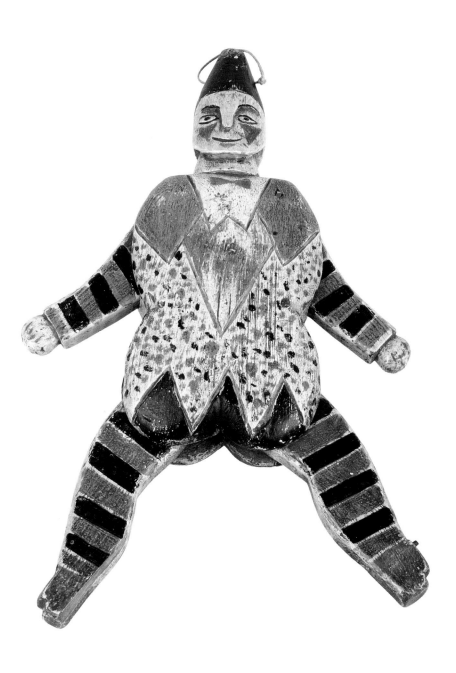

82

Unidentified maker
Doll, 1900–25
Probably Brazil or the Caribbean Islands
Silk, linen, cotton, glass, brass, celluloid;
16½ × 7¾ × 2¾ in. (41.9 × 19.7 × 7 cm)
1937.1207*

Unidentified German maker
Doll, 1850–1900
Wood, cotton, paint; 10¾ × 4 × 1⅛ in.
(27.3 × 10.2 × 2.9 cm)
1937.474

Unidentified German maker
Shoulder head doll, 1860–80
Probably Thuringia
Bisque, paint, gilding, glaze; 6½ × 5 × 3 in.
(16.5 × 12.7 × 7.6 cm)
1937.1234

Fig. 109. Billiard Room at
Alderbrook, Riverdale, NY,
ca. 1946–60. NP

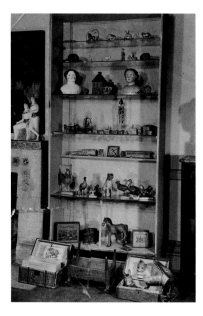

Gallery IX of the MFPA, known as the Toy Room, displayed close to one hundred dolls. A photograph of the room (see fig. 15) shows a glass-fronted case with five shelves of dolls—in no apparent taxonomic order—standing, seated in chairs, and lounging on beds. According to the MFPA inventory, the dolls were crafted from wood, cloth, composition (a plaster-like composite of sawdust, glue, and other materials), wax, shell, cardboard, papier-mâché, and "china." It is unclear whether Elie or Viola was more attached to their collection of miniature beings. Lincoln Kirstein maintained that the sculptor had an interest bordering on obsession: "He had been fascinated by dolls all his life. Dolls were domesticated gods. The high gods of Greece have their temples no longer in Hellas, but in museums. But dolls are housed in every home, and they resemble not only the gods of their owners, their parents, but retain an essential mystery and meaning."[1] Kirstein also believed that Elie collected dolls in order to study their painted faces—their "impassive masks"—and in them found inspiration for his own figurines.[2] On the other hand, Viola clearly played an important role in curating the doll collection. A 1928 article made special note of "Madame" Nadelman as an "enthusiastic collector" of dolls and mentioned the significant holdings "in her private museum."[3]

The regal black-skinned doll is clearly visible in figure 15 standing on the second shelf from the bottom. The MFPA cards record her as an American-made "black satin negress."[4] Expertly crafted, the doll has glass eyes, celluloid fingernails, and a black silk body stuffed with cotton. She wears a necklace with a metal shoe charm, green glass bead earrings, and rings on her fingers (rendered in stitching), and her cream-colored linen dress is accented by a boldly colored plaid silk sash. The doll may have been a favorite, as she was included in the Index of American Design (see Olson Hofer essay, p. 29).[5] She was also singled out in a WQXR broadcast about the Nadelmans' museum. Reporter Alice Pentlarge enthused that "the toy collection alone is worth the

journey to the museum," and cited the early American "negro woman, about 14 inches high, of black satin, with earrings hanging through her well-shaped ears, and real finger nails."[6] In fact, the doll is neither early nor North American, but was likely made in Brazil or the Caribbean Islands not long before the Nadelmans purchased her. A similar stuffed silk doll with elaborate costume is held by the Abby Aldrich Rockefeller Folk Art Museum.[7]

The wooden doll in a floral printed dress and black lace fichu typifies the penny dolls or "penny woodens" made in Germany from the eighteenth into the twentieth century. Like many German toys, the dolls were generated as a cottage industry, made in assembly-line fashion with various households contributing specialized skills. The heads and bodies might be carved in one house and limbs in another, the parts joined with pins in yet another, and the face painted by still a different craftsperson. The dolls were produced in great numbers and could thus be sold inexpensively; retailing in Britain for a penny each, they became known as "penny dolls."[8] These dolls were a particular specialty of the Gröden Valley, which exported ten thousand dozen annually by 1823.[9] This example—catalogued by Elie Nadelman as eighteenth-century English upon her acquisition by the N-YHS—has the features typical of penny woodens, including the high forehead and minimalist painted facial features. She was probably sold without clothing and dressed in this hand-stitched costume by her owner.

The bisque shoulder head doll, depicting a dapper young man with upswept curly blond hair, bright blue eyes, and flushed cheeks, is also a product of the German toy industry. During the 1830s, doll heads of papier-mâché began to be supplanted by heads made of porcelain, many of them made by factories in Thuringia.[10] The heads, typically with painted blue eyes, were stitched to bodies made of leather or sold loose to be made up at home. This shoulder head has three piercings—apparently never used—for attachment to a body. Boy dolls in porcelain gained in popularity toward the end of the

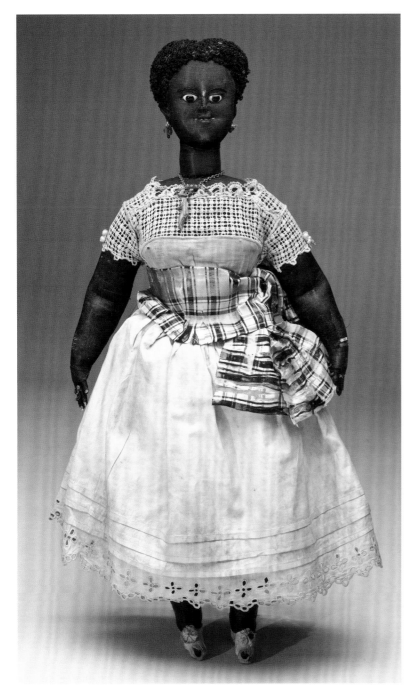

nineteenth century.[11] The Nadelmans had a particular interest in these bisque heads: two large female busts are visible in a photograph of Alderbrook's billiard room, where they dominate a case of toys displayed next to the room's fireplace (fig. 109). Interestingly, a duo of glazed ceramic circus figures (cat. IX) made by Nadelman around 1930–35 sit on the adjacent mantel, as if in conversation with the two heads.

MKH

1 Lincoln Kirstein, *Elie Nadelman Drawings* (1949; repr., New York: Hacker Art Books, 1970), 29.

2 Ibid., 29–30.

3 Mr. and Mrs. G. Glen Gould, "Dolls for the Antiquarian," *International Studio* 91:379 (December 1928): 51.

4 MFPA Toys 112, no date, source, or price specified.

5 The watercolor rendering by Mina Lowry is National Gallery of Art, Washington, DC, 1943.8.11221. See also Helen Bullard, "A Pictorial Selection of American Handmade Wooden Dolls," *Spinning Wheel* 17:6 (June 1961): 20–21, fig. 1.

6 Alice Pentlarge, "So You Haven't the Time?" transcript of WQXR broadcast, May 28, 1937, NP.

7 Susan Hight Rountree, *Dollhouses, Miniature Kitchens, and Shops from the Abby Aldrich Rockefeller Folk Art Center* (Williamsburg, VA: Colonial Williamsburg, 1996), 56–58.

8 Gordon Campbell, ed., *The Grove Encyclopedia of Decorative Arts* (New York: Oxford University Press, 2006), 2: 487.

9 Rita Stäblein and Robert Moroder, "Toy Manufacture as a Cottage Industry in Old Gröden," http://lusenberg.com/chiena/toymanufacture.html.

10 *Jouets: Une sélection du Musée de Sonneberg R.D.A*, exh. cat. (Paris: Musée des arts décoratifs, 1973), 9–11; Ruth Freeman, *American Dolls* (Watkins Glen, NY: Century House, 1952), 12–13.

11 Constance E. King, *Antique Toys and Dolls* (New York: Rizzoli, 1979), 116.

83

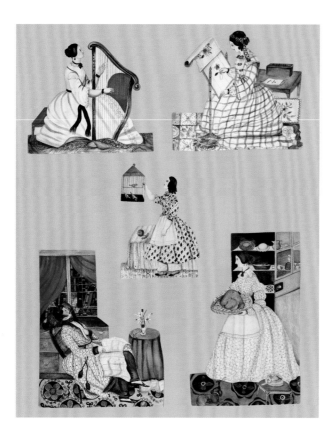
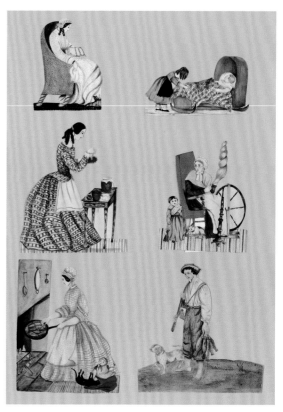

Unidentified Canadian maker (Drummondville, Quebec, Canada)

Selection of paper dolls, ca. 1855
Watercolor, graphite, and touches of black ink on paper: various measurements, tallest 9¾ in. (24.8 cm), irregular
1937.1794d, 1937.1794b; 1937.1794m, 1937.1794p, 1937.1794o

Selection of paper dolls, ca. 1855
Watercolor, graphite, and touches of black ink on paper; various measurements, tallest 6⅝ in. (16.8 cm), irregular
INV.10267nn, INV.10267a, INV.10267qq, INV.10267bb, INV.10267aa, INV.10267t

Selection of paper dolls, ca. 1855
Watercolor, graphite and touches of black ink on paper; various measurements, tallest 10⁹⁄₁₆ in. (26.8 cm), irregular
2013.17.22, 2013.17.23, 2013.17.21, 2013.17.8, 2013.17.9, 2013.17.10

Provenance of all groups: Sutherland family, Drummondville, Quebec, Canada; Miss Lenox E. Chase, Amesbury, MA, 1924

An unidentified Canadian woman of the Sutherland family painted the eighty-five "paper dolls" in the Nadelman collection, presumably for her children. The seventeen reproduced here suggest the range of the group, which can be divided by size into three clusters that may indicate different series or dates of execution.[1] While the Nadelmans called them "paper dolls," they are actually hand-painted, cut-out vignettes in which each figure or group is fully clothed and involved in an activity within an abbreviated setting. As the figures cannot have costume changes, they fall outside the paper dolls tradition. The verso of each is inscribed with the name(s) of its character(s) in pen and brown ink in the same hand. Two inscriptions also date the group to 1855 and place it in Drummondville, an English town outside of Québec City.[2] Another cut-out, representing a woman reading *Harper's Magazine*, was reproduced in that periodical in 1924.[3] The short accompanying article contains important clues about its provenance, and hence of the entire group. The object's owner, Miss Lenox E. Chase, a Sutherland descendant, noted that it "was found among a collection of paper dolls painted for a little girl who lived in the Province of Quebec. As the little girl was born in 1841. . . ."[4]

These enchanting cut-outs are a time capsule of a mid-nineteenth-century domestic world and reveal the influence on women of fashionable illustrated magazines. The vignettes mostly portray genteel women engaged in indoor and outdoor tasks and leisure activities, and like reward plates (cat. 44), they contain didactic elements, as noted by a radio broadcaster who described them in 1937 at the MFPA.[5] With the exception of a youth carrying a fishing rod and tackle, one with a scythe, and a newspaper reader smoking a cigar in a library, very few represent men, although some portray children and animals. It is not known whether the names inscribed on them are fictional or associated with the Sutherland family and their friends. The only obvious literary reference is to *Jane Eyre*.[6]

The models for the vignettes are unknown, although they were influenced by illustrations in periodicals and books, as well as by certain types of paper dolls. While handmade paper dolls date from as early as the eighteenth century in Europe, they permitted changeable costumes. Printed versions appeared in the early 1800s, the most famous of which were English examples dating from ca. 1810. Many were packaged with moral stories and booklets about virtues, such as "Little Fanny," which may be a prototype for the Nadelman series. Soon thereafter, American versions were published.[7] With the appearance of paper dolls in periodicals around 1850, their mass commercial appeal reached a crescendo. Coincidentally, the 1854 magazine article

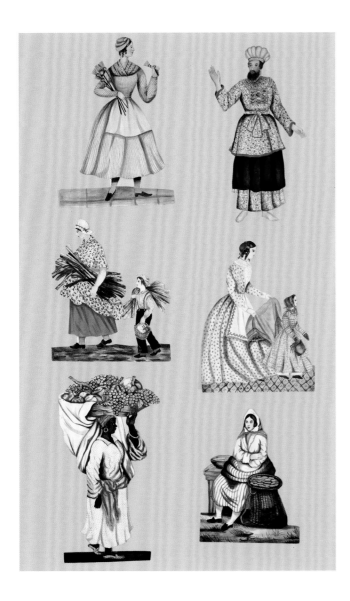

"Fanny Gray: A History of Her Life" included six lithographed costumed figures with settings that resemble those of the Nadelman sets.[8]

Several examples from the third group, consisting of twenty-six larger figures, depend on different models. While some of the figures may have been associated with the Sutherland household, others are professional street vendors related to the illustrated genre known as "The Cries" (see cat. 11); among them are an African American fruit seller and an oyster vendor, both executed in a broader, bolder style. Perhaps Muta, a Bavarian broom girl, bridged the gap between the family figures and those of "The Cries." Then, there is the Jewish High Priest, whose headdress is inscribed: "HoLiNess To THe Lord."[9] He is related to figures in early nineteenth-century Italian series illustrating costumes from antiquity on, reflecting the historicism of the era.[10]

Certainly the Nadelmans, especially Viola, would have been attracted to clothes worn by the figures and their rich interiors with patterned textiles. It must have been enthralling for them to see how some of the utensils they collected were used in mid-nineteenth-century daily life.

RJMO

1 Given the variations in the stock and coloration of the paper and the differing proportions of the figures, they may have been produced over time. The three clusters are 1937.1794a-p; INV.10267a-qq; 2013.17.1–27 (tallest measures 12⅛ in.).

2 INV.10267d is inscribed "Drummondville 14th Nov.ʳ 1855."; 2013.17.1 is inscribed on a piece of paper attached to it "Drummondville, 13th Nov.ʳ 1855."

3 INV.10267a; "Personal and Otherwise," *Harper's New Monthly Magazine* 149:894 (November 1924): 811 (unpaginated). There is another illustration with a similarly engaged figure in "Fashions for December," *Harper's New Monthly Magazine* 7:43 (December 1853): 143; it features two women, one standing and the other seated with a copy of *Harper's* in her lap.

4 "Personal and Otherwise": 811 (unpaginated).

5 Alice Pentlarge, "So You Haven't the Time?" transcript of WQXR broadcast, May 28, 1937, NP; "There is a beautiful set of delicately colored paper dolls made by a loving mother for her own little daughter showing all the charms and virtues of 19th Century womanhood in household duties and accomplishments." The first page of the MFPA inventory with objects that are not exhibited records seventy-five paper dolls; later in the inventory of the Toy Room appears "Collection paper dolls— Canadian 1860—".

6 INV.10267w.

7 Among them was "The History and Adventures of Little Henry" in 1812. See McClintock and McClintock 1961, 135, who in subsequent pages detail the development of the genre; Judy M. Johnson, "History of Paper Dolls," updated in 2005, http://www.opdag.com/History.html.

8 It was first published in the United States in 1854 by Crosby, Nichols & Company of Boston. See Morgan Towne, "Protean Figures, *Alias* Paper Dolls," *The Magazine Antiques* 43:6 (June 1943): 271, fig. 2; McClintock and McClintock 1961, 170; Joanne Haug, "American Paper Dolls," http://www.victoriana.com/paperdolls/paperdolls.htm. The Nadelmans collected a few other paper dolls, some uncut.

9 It resembles the traditional Tzitz, a small rectangular plate of solid gold, engraved in Hebrew letters on the priest's turban.

10 For example, Bartolomeo Pinelli produced a series of costumes in the 1830s, including those of Jewish high priests; see Roberta J.M. Olson, "An Album of Drawings by Bartolomeo Pinelli," *Master Drawings* 39:1 (2001): 37–38, fig. 19.

Genealogical records suggest that the dolls originally belonged to the Sutherland family, a Canadian family of British descent that had arrived in Drummondville by the 1840s. The dolls were passed down to Ms. Chase, from whom the Nadelmans may have acquired them for the MFPA after reading about them in *Harper's Magazine*. The couple also purchased an accordion from the Sutherlands in 1925 (MFPA card 1141). The group may have been made for Margaret Sutherland, born in 1841. These vignettes were also highlighted in "City to Receive Rare Collection of Primitive Art," *New York Herald Tribune*, October 30, 1931.

84

Unidentified maker, probably French
Girl on a velocipede, 1870–80
Iron, metal, composition, textile, glass, paint;
8¾ × 7½ × 4 in. (22.2 × 19 × 10.2 cm)
Provenance: Katharine Willis, Jamaica, NY, 1929
1937.1228*

Unidentified maker, possibly J.A. Issmayer
(Nuremberg, Germany)
Waltzers, 1890–1910
Tinned sheet iron, paint; 8 × 7 in. (20.3 × 17.8 cm)
1937.1557

Unidentified maker, possibly Siegfried Günthermann
or Ernst Planck (Nuremberg, Germany)
Clown, 1880–90
Tinned sheet iron, paint; 9½ × 6 × 4½ in.
(24.1 × 15.2 × 11.4 cm)
INV.4529

Fernand Martin (French, active 1887–1919)
"Le Gai violiniste," patented 1897
Paris, France
Tinned sheet iron, textile, paint; 8 × 4¾ × 3¼ in.
(20.3 × 12.1 × 8.3 cm)
INV.4541

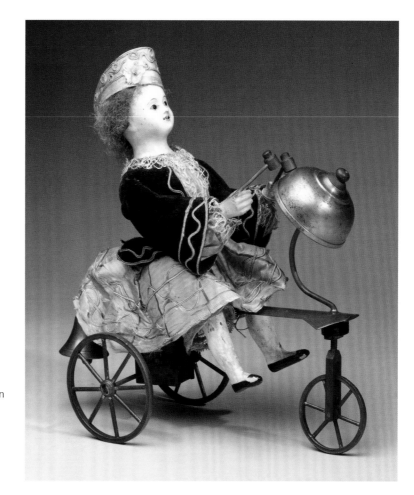

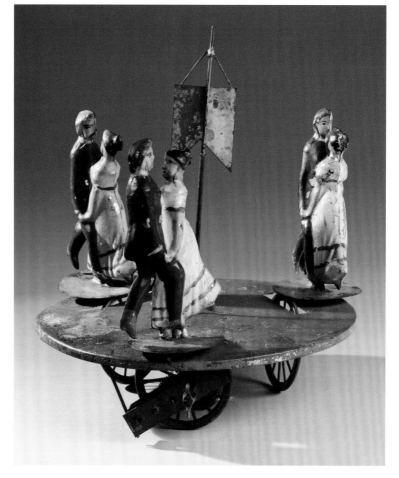

The popularity of mechanical toys in the United States and Europe beginning in the mid-nineteenth century reflected a growing fascination with transportation and mechanical and animal locomotion. Horse-pulled carriages, paddling steamboats, and chugging locomotives had become fixtures of the landscape, and children delighted in playing with and propelling their miniature versions. The proliferation of moving toys also reflects an era of ingenuity and invention, when manufacturers competed to produce ever more captivating toys for a widening market of consumers. In Connecticut, which had an established tradition of tinsmithing and clockmaking, toy manufacturers adapted the brass clockwork mechanisms to animate their toys.

While American clockwork toys flourished from the 1860s through the 1880s, they faced increasingly stiff competition from German and French imports powered by clockwork or less expensive spring-wound mechanisms.[1] The girl on a velocipede, though published as an American toy and included in the Index of American Design, may in fact be of French manufacture (see Olson Hofer essay, p. 29).[2] The velocipede, a forerunner of today's bicycle, was first produced in quantity in 1868 by the Olivier and Michaux firms of France.[3] While most men favored two-wheel velocipedes, women favored less risky tricycles. A velocipede boom swept through France and the United States in the late 1860s, and their popularity was reflected in a flurry of patents for child's velocipedes and their toy counterparts.[4] The Connecticut firm of Stevens & Brown, for instance, produced a clockwork toy velocipede patented by Arthur M. Allen in 1870.[5] When pushed or pulled, this toy's rider strikes a gong with mallets, and the rear bell rings. Made of composition with painted facial features, the figure is outfitted in an ornate costume, including a stylish hat and a brown velvet jacket trimmed in rickrack. The Nadelmans catalogued the toy as American, although the vehicle, with its small front wheel, mounted bell, and elaborately dressed figure, resembles velocipedes made by the Parisian mechanical toymaker Gustave Vichy.[6]

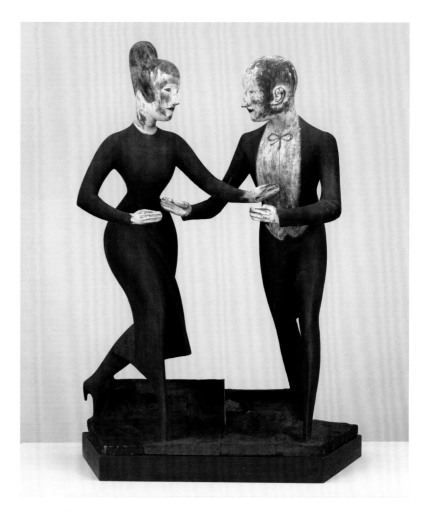

Fig. 110. Elie Nadelman, *Tango*, ca. 1920–24. Cherry, stain, paint, and gesso; 35⅞ × 26 × 13⅞ in. (91.1 × 66 × 35.2 cm). Whitney Museum of American Art, New York City; purchase with funds from the Mr. and Mrs. Arthur G. Altschul Purchase Fund, the Joan and Lester Avnet Purchase Fund, the Edgar William and Bernice Chrysler Garbisch Purchase Fund, the Mrs. Robert C. Graham Purchase Fund in honor of John I.H. Baur, the Mrs. Percy Uris Purchase Fund, and the Henry Schnakenberg Purchase Fund in honor of Juliana Force, 88.1a-c

Mechanical toys depicting waltzing couples were another late nineteenth-century fad. The waltz, which first became popular in Vienna during the 1780s, was criticized by some as indecent because of its closed dance position and rapid tempo. Twirling waltzers lent themselves to mechanical imitation, and German and American toy manufacturers produced many versions, either single couples or groups of dancers on a circular platform. Stevens & Brown illustrated an "automatic waltzer" in their 1870 price list, for instance, featuring three dancing couples spinning within a decorative gazebo.[7] The Nadelmans' trio of waltzing couples, who twirl in place on a platform with a decorative banner, was probably made in Germany. Elie Nadelman's fascination with the popular entertainments of his adopted country inspired him to execute sculptures of dancing couples as early as 1918.[8] His *Tango* of ca. 1920–24 (fig. 110) captures the dancers in mid-movement, much like the mechanical toy waltzers.[9]

Along with dancers, Nadelman also added circus performers to his sculptural vocabulary around 1919 (cats. VI, VIII, IX), and it is no surprise that the MFPA Toy Room included a wealth of circus-related toys, including clowns, horse riders, and exotic caged animals. This winsome whiteface clown wears a multi-colored pointed hat and a ruffled collar. When a key under the base is wound, his right arm moves up and down, ringing the bells on his tambourine, while his head rotates. This toy was manufactured in multiple variations, some with two or three musicians, and the base occasionally concealed a music box.[10]

The "Gai violiniste" was patented in 1897 by the celebrated Parisian toymaker Fernand Martin, whose factory employed over two hundred men and women to stamp out the metal parts, and solder, assemble, paint, and dress his ingenious clockwork toys.[11] Martin's violinist is a droll, top-hatted figure in checked pants. When the key is wound, his bow arm sweeps back and forth and the musician sways on his feet, displaying remarkable rhythmic balance. The charming figure, with his direct gaze, brings to mind Nadelman's *Pianiste* (cat.

IV), who, like the fiddler, is captured mid-movement while playing her instrument.

MKH

1 Blair Whitton, *American Clockwork Toys, 1862– 1900* (Exton, PA: Schiffer, 1981), 207–12.

2 MFPA Toys 534, purchased for $15 in May 1929. The IAD drawing is National Gallery of Art, Washington, DC, 1943.8.15439; Hornung 1972, 631, no. 2257. The toy was published as American in Ketchum 1981, 36.

3 Bruce D. Epperson, *Peddling Bicycles to America: The Rise of an Industry* (Jefferson, NC: McFarland, 2010), 25–28.

4 Whitton, *Clockwork Toys*, 35.

5 Ibid.; Bernard Barenholtz and Inez McClintock, *American Antique Toys, 1830–1900* (New York: Harry N. Abrams, 1980), 179.

6 See, for instance, Bertoia Auctions, Vineland, NJ, "Toybox Treasures," September 21–23, 2012, lot 1083; Patrizia Bonato, *Bambole, giocattoli, automi: 1830–1930; Il trascorso presente*, exh. cat. (Venice: Marsilio, 1982), 111, fig. 165 (for a velocipede sold by the Paris toy retailer Guiton).

7 *Price List of Mechanical and Britannia Toys . . . Manufactured by the Stevens & Brown Mf'g Co.* (1870; repr., Brookfield Center, CT: Margaret Whitton, 1962), no. 32.

8 Haskell 2003, fig. 125.

9 Nadelman's drawing of the same title (Metropolitan Museum of Art, New York, 65.12.10) depicts the tangoing couple in a close embrace, similar to the pose in the mechanical toy.

10 Jac Remise and Jean Fondin, *The Golden Age of Toys* (Lausanne, Switzerland: Edita, 1967), 105, ill. See also N-YHS INV.7629, with three musicians.

11 Mary Hillier, *Automata & Mechanical Toys* (London: Bloomsbury Books, 1976), 163–65; Edouard Charles, "Making Mechanical Toys," *English Illustrated Magazine* 34:33 (December 1905): 222– 27. The "Gai violiniste" continued in production after Victor Bonnet & Cie. acquired Martin's business in 1919.

85

George W. Brown (American, 1830–1889)
Riverboat *Excelsior* pull toy, ca. 1870
Forestville or Cromwell, CT
Tinned sheet iron, iron, paint, paper; 14 × 21 × 7 in.
(35.6 × 53.3 × 17.8 cm)
1937.478

It is difficult to imagine who was more thrilled by this enormous pull toy: the adult who purchased it around 1870, the fortunate child who played with it, or the savvy collectors who added the fanciful riverboat to their folk art museum. The designer of the vessel, George W. Brown, began his career as a clockmaker and added toys to his repertoire in 1856. In 1869 the Connecticut native launched a partnership with J. & E. Stevens (see cat. 87), and together the Cromwell firm of Stevens & Brown offered a complete line of mechanical and non-mechanical tin and iron toys that successfully competed with European imports.[1] While some designs took inspiration from European models, many of the firm's toys, including the riverboat *Excelsior*, are distinctly American.

George W. Brown's pattern book, containing sixty-five pages in watercolor of original toy designs, includes a sketch of the *Excelsior* with every last decorative detail.[2] Unlike many of the book's designs, however, the riverboat is unpriced and does not appear in the Stevens & Brown trade catalogue of 1872. In addition, a large "X" was penciled over the original design. The toy may have been too elaborate to be commercially viable and thus never put into general production.[3] The Nadelman example is one of only two *Excelsiors* known to have been produced.[4]

Although larger and more elaborate than Brown's standard production items, the *Excelsior* incorporates many of the trademark features of his toys. The main body was formed by stamping sheets of tin with a drop hammer and then soldering them together. Much of the painted decoration—executed in rich primary colors—was achieved with stenciling, including the boat's name and the profusion of windows. The stencil work and freehand painting may have been done by young women; the Cromwell factory is known to have employed twenty girls in the painting and packing departments.[5] The stamped bands of anthemions that encircle the upper decks and crown the pilot house and smokestacks are frequently found on Brown tin toys. One incongruous element found in both the original design and this toy is the lithograph decal of a formally attired woman that adorns the vessel's paddlebox. Large sidewheelers were often decorated with imposing ornamental paintings referring to the name of the vessel. Brown settled on the printed decal as a cost-effective method of replicating the grandeur of nineteenth-century paddlewheel steamboats.

Unfortunately, the Nadelmans' purchase and display of the *Excelsior* does not appear to be documented. The MFPA cards record the purchase of a toy boat for $6 in 1925, but the lack of any further description makes it an unlikely candidate for such a major acquisition.[6] The MFPA inventory lists "3 tin boats" in the Toy Room, which may include this vessel. When he catalogued the boat for the N-YHS in 1937, Elie Nadelman listed the maker as unknown. While the details of Brown's career would not emerge for several decades, Nadelman surely appreciated the monumental stature of this object in the history of the American toy industry.
MKH

1 Edith F. Barenholtz, ed., *The George Brown Toy Sketchbook* (Princeton, NJ: Pyne Press, 1971), vii–x; Shirley S. DeVoe, "19th-Century Connecticut Toymaking," *Connecticut Historical Society Bulletin* 36:3 (July 1971): 70–71; Blood 1976, 1300–3. Although Brown was the designer of the riverboat, it could have been manufactured by either George W. Brown & Co. of Forestville or, after 1869, by Stevens & Brown of Cromwell.

2 The original sample book, discovered in a Connecticut home in 1964, is in a private collection. A facsimile with explanatory text was published in 1971; see Barenholtz, ed., *The George Brown Toy Sketchbook*, n.p., pl. 31. The design is noted as model number 187.

3 Ibid., viii, pl. 31.

4 Blair Whitton, *American Clockwork Toys, 1862–1900* (Exton, PA: Schiffer, 1981), 48. Whitton mentions a second example of the *Excelsior* but does not cite its location.

5 DeVoe, "Connecticut Toymaking," 71.

6 MFPA Toys 6, purchased from Mary D. Walker, Marion, MA.

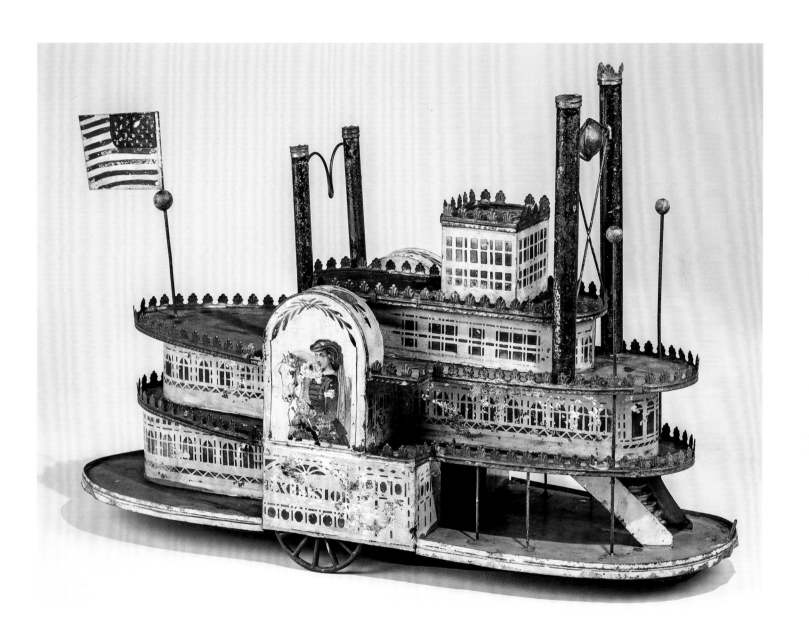

86

Unidentified American maker (possibly George W. Brown or Hull and Stafford)
Horse and rider balance toy, ca. 1870–90
Tinned sheet iron, paint; 8¾ × 5¼ × 4 in.
(22.2 × 13.3 × 10.2 cm)
Provenance: Mary D. Walker, Marion, MA, 1925
INV.7623ab*

Unidentified maker
Goat and cart, ca. 1870–90
Tinned sheet iron, paint; 2½ × 6 × 2½ in.
(6.4 × 15.2 × 6.4 cm)
Provenance: William A. Davis, Albany, NY, 1929
1937.1555*

Tin toys, easily fashioned with stamps and dies and decorated with stencils and paint, emerged as a popular alternative to wooden toys around the middle of the nineteenth century. The locus of the tin toy industry was central Connecticut, where manufacturers such as George W. Brown, Hull and Stafford, and Ives and Company turned out charming playthings for a burgeoning middle-class market.[1] The Nadelmans delighted in these toys and purchased a wide variety, from buggies and boats (cat. 85) to circus performers and a menagerie of animals. The horse balance toy, bought for $50, was one of the Nadelmans' most significant tin toy acquisitions.[2] Whether they were fascinated by the physics of the toy—in which the horse balances on one hoof as if by magic—or charmed by the circus stuntman poised on the horse's back, the Nadelmans clearly appreciated the form: their collection included two additional horse balance toys made of wood.[3] Balance toys had a long history in Europe and America, where they were initially carved in wood; American tin toy manufacturers, including Hull and Stafford, added them to their repertoire by the 1870s.[4] Horses, goats, cats, and dogs were popular subjects for tin toys. The simple goat-pulled cart here, with its original bright red paint, reflects the Victorian pastime of children riding goats or being pulled in goat carts. The Nadelmans purchased this example along with another tin toy portraying a basket-carrying dog pulling a covered wagon; the pair cost them just $2.[5] Although the Nadelmans identified both toys as American, the origin of tin toys can be difficult to establish. This cart does not appear in any of the published catalogues issued by American toy manufacturers, and the style of its iron wheels suggests a possible German origin.[6]
MKH

1 Elisabeth Donaghy Garrett, "Playthings of the Past: The Bernard Barenholtz Collection of American Antique Toys," *The Magazine Antiques* 129:1 (January 1986): 220–31; Blood 1976, 1300–5; Ketchum 1981, 61–63.

2 MFPA Toys 21, described as "horse balance" in the MFPA cards.

3 MFPA Toys 574, purchased from W.P. Prentice at an unspecified date for $6; MFPA Toys 443, purchased from Nora G. Landis in January 1928 for $3.50.

4 For wood examples, see Historic New England, Boston, MA, 1923.496; Bernard Barenholtz and Inez McClintock, *American Antique Toys, 1830–1900* (New York: Harry N. Abrams, 1980), 102.

5 MFPA Toys 514, purchased in January 1929.

6 Inez McClintock assumed the goat cart was American when she published it in 1961. See McClintock and McClintock 1961, 185.

87

J. & E. Stevens Co.
Tammany mechanical bank, patented 1873
Cromwell, CT
Cast iron, paint; 5¾ × 4⅜ × 3 in.
(14.6 × 11.1 × 7.6 cm)
Provenance: Charles Burns, Mamaroneck, NY, 1928
1937.1237*

J. & E. Stevens Co.
Cabin mechanical bank, patented 1885
Cromwell, CT
Cast iron, paint; 3½ × 4½ × 2⅞ in.
(8.9 × 11.4 × 7.3 cm)
Provenance: Charles Burns, Mamaroneck, NY, 1928
1937.1238*

Shepard Hardware Company
Speaking Dog mechanical bank, patented 1885
Buffalo, NY
Cast iron, paint; 7 × 7⅛ × 3 in.
(17.8 × 18.1 × 7.6 cm)
Provenance: Sara M. Sanders, Closter, NJ, 1927
1937.482*

J. Barton Smith Co.
Boy on Trapeze mechanical bank, ca. 1888
Philadelphia, PA
Cast iron, paint; 9½ × 5 × 5 in.
(24.1 × 12.7 × 12.7 cm)
Provenance: Catherine Chase, Brooklyn, NY, 1926
1937.480*

After the close of the Civil War, American toy manufacturers began to produce cast-iron toys in large numbers. The first cast-iron mechanical bank—a savings device in which the deposit of a coin triggered a mechanical action—was manufactured by 1869, and by 1910 toy manufacturers had produced over three hundred designs.[1] With humorous and sometimes satirical subjects and brightly painted surfaces, mechanical banks amused children while encouraging them to save money.

J. & E. Stevens was one of the earliest and most innovative manufacturers of mechanical banks, producing models in the shape of animals, buildings, and figures. The popular Tammany bank satirized the corruption of Tammany Hall, the Democratic Party machine led by the notorious politician William M. "Boss" Tweed.[2] The bank depicts a plump, satisfied gentleman seated in an ornate chair; when a penny is placed in his right hand, he drops the money in his vest pocket while nodding a polite thank-you. The bank was first patented by John Hall of Watertown, Massachusetts, in December 1873, one month after Tweed was tried, convicted, and sentenced for stealing millions of dollars from New York City taxpayers.[3]

A decade later, Stevens introduced the Cabin mechanical bank, in which placing a coin on the roof and pulling the broom forward causes the figure, an African American depicted as a country bumpkin, to flip over and kick the coin into the bank, a dilapidated shack with holes in its paper-covered windows.[4] A griddle, animal skin, and banjo hanging on the side are all elements of the caricatured Tom, a contented, banjo-strumming black man who has retired from servitude to live in his own cabin.[5]

More innocuous is the Speaking Dog bank featuring a young girl trying to train her giant pet.[6] The manufacturer explained: "The coin is placed in a plate held by the girl. The thumb piece is pressed upon, when the girl's arm moves quickly and deposits the coin through a trap door in the bench that opens to receive it. At the same time the dog opens and closes his mouth as if 'speaking' and also wags his tail." The Speaking Dog proved a popular model, in part because it appealed to both boys and girls. After Shepard Hardware sold their line of toy banks in 1892, the Stevens Company continued to produce this model.[7]

The mechanism operating the Boy on Trapeze bank has an American spin to its message: the more money "paid" to the acrobat, the harder he works.[8] The manufacturer promoted the bank as the "children's choice," noting that one penny dropped in the boy's head makes him revolve once, a nickel twice, a quarter three times, and a half dollar six times. With its droll circus performer, this bank must have had a special appeal for Elie Nadelman, who relished the popular entertainments of his adopted country (see cats. V, VI, VIII, IX).

The Nadelmans collected at least fourteen mechanical banks from four different dealers between December 1926, when they purchased the Boy on Trapeze, and October 1928.[9] The couple's interest in cast-iron banks may have been stimulated by an article on them in *The Magazine Antiques* in October 1926.[10] It illustrated several models that they purchased shortly thereafter, including the Tammany bank and other popular designs manufactured by J. & E. Stevens. Although the banks they collected were mass-produced items and thus could hardly be characterized as folk art, they appealed to the Nadelmans as a quintessentially American form of vernacular culture.[11]

MKH

1 Corine Wegener and Karal Ann Marling, *Money in the Bank: The Katherine Kierland Herberger Collection* (Minneapolis: Minneapolis Institute of Arts, 2006), 11; William C. Ketchum, Jr., *Toys & Games* (Washington, DC: Cooper-Hewitt Museum, 1981), 116; H. Blair Hull, "The First Five Years of Patented Toy Banks," *The Magazine Antiques* 39:3 (March 1941): 129–31.

2 MFPA 459, purchased for $5 in March 1928.

3 Hull, "Patented Toy Banks," 131, fig. 9.

4 MFPA 460, purchased for $5 in March 1928.

5 Christopher J. Metzler, *The Construction and*

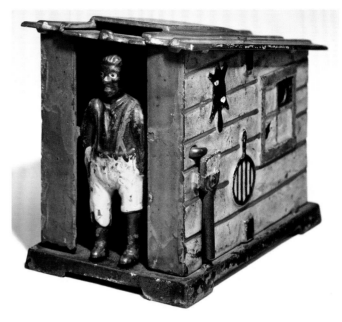

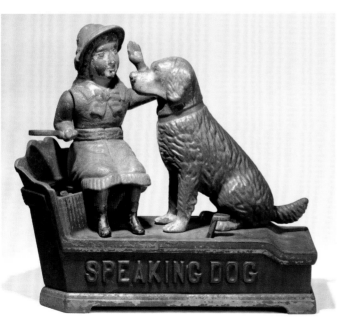

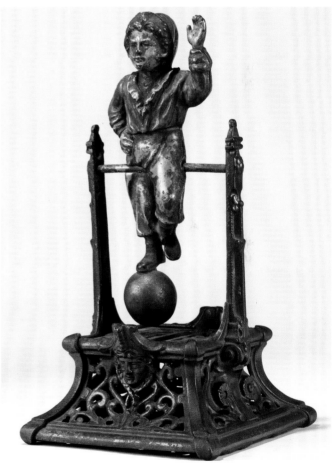

Rearticulation of Race in a "Post-Racial America" (Bloomington, IN: AuthorHouse, 2008), 110–11.

6 MFPA 1296, purchased for $7.50 in February 1927.

7 Bill Norman, "Old Mechanical Banks of the Shepard Hardware Company," *Collectors' Showcase* 1:4 (March/April 1982): 27–34.

8 MFPA 285, purchased in December 1926 (no price noted).

9 In addition to the four here, the Nadelman mechanical banks at N-YHS include 1937.481, .483, .484, .679, .780a, .780b, .781, .782, .1236, and .1392. They also collected at least twenty-six still banks made in cast iron, tin, and pottery.

10 Willard Emerson Keyes, "Toy Banks," *The Magazine Antiques* 10:4 (October 1926): 290–92.

11 See Karal Ann Marling, "American 'Argyrothecology,' or The Art and Commerce of the Penny Bank," in Wegener and Marling, *Money in the Bank*, 16–31, for discussion of toy bank collecting in the 1930s and the inclusion of banks in the Index of American Design.

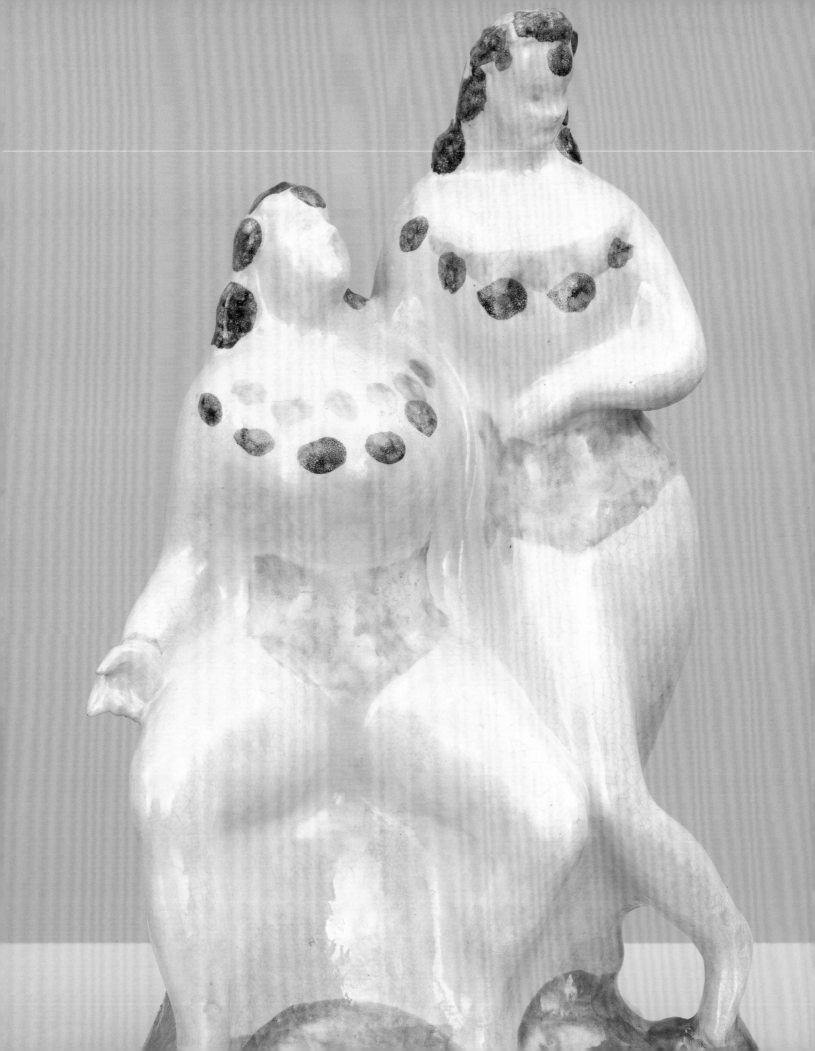

CATALOGUE

SELECTED SCULPTURES BY ELIE NADELMAN

Elie Nadelman (1882–1946)
The Four Seasons, ca. 1912
Terracotta; largest figure 31½ × 9½ × 8½ in.
(80 × 34.1 × 21.6 cm)
New-York Historical Society
2001.223a-d

This group of terracotta figures is first documented in 1915 in the New York beauty salon of Helena Rubinstein—the Polish-born, Jewish American cosmetic magnate—when it was reproduced in an issue of *Vogue*. The article vaguely describes Rubinstein's first establishment at 15 East Forty-ninth Street, and places the *Four Seasons* in a small room off the main salon; it also identifies Nadelman as "Russian" and a "theorist" (code for an abstract artist). "One may rest in another small room which opens through French doors upon the main hall. A sofa, two chairs, and a table of the Empire period, and, set in alcoves, four statuettes by the Russian sculptor whose work appears in the large salon—only these stand upon the green velvet carpet and are silhouetted against the lighter green walls."[1]

Helena Rubinstein's exclusive beauty salons on three continents blurred the conceptual boundaries among fashion showrooms, art galleries, and deluxe domestic interiors.[2] Indeed, the "Queen of Beauty" was known as a great collector of modernist art and in 1929 introduced a line of "Cubist" lipstick. Her taste, like Nadelman's, was eclectic, and she

acquired art and assorted objects from many periods, including folk art, such as the two carousel horses that adorned her Greenwich, Connecticut, property by 1941.[3]

A cosmetics entrepreneur, Rubinstein was the founder of the company Helena Rubinstein, Incorporated, and one of the world's richest women. She had met Nadelman in London, where in 1911 he exhibited a group of his sculptures at William B. Paterson's Gallery on Bond Street. Madame Rubinstein (later Princess Gourielli-Tchkonia), his "compatriot," bought his entire exhibition outright. Her patronage was the most influential of his career: in 1914 she arranged for the young sculptor's passage to New York, even offering the garage of her home in Greenwich as a temporary studio. Rubinstein also mounted his pieces in her handsome establishments in London, Paris, Boston, New York (first, the townhouse at 15 East Forty-ninth Street), and Buenos Aires, where "they became her trademark for the quasi-scientific beautifications of modern womanhood."[4] In her 1966 biography, she claimed that "Nadelman's purity of line and his feeling for form say 'beautiful' better than all the fancy words coined for the beauty industry by Madison Avenue."[5]

After moving her shop to 8 East Fifty-seventh Street in 1928,[6] she began to plan for a palatial new salon at 715 Fifth Avenue, between Fifty-fifth and Fifty-sixth streets, which opened in 1937. In chic Art Deco style, this seven-story flagship store filled with art remained her New York offices until the sale of her business in 1966. Surrounded by extravagant "swank," Rubinstein reinvented herself in sync with the modern woman, allying her image with the elegant realm of fashion and fashionable art. Nadelman's *Four Seasons* decorated the salon's dramatic oval waiting room: its walls papered in metallic blue set off the terracotta quartet displayed on brackets (fig. 111).[7]

The visual prototypes for Nadelman's suite of four females have long been recognized as the Late Classical, fourth-century B.C. Greek terracottas of women that were mass-

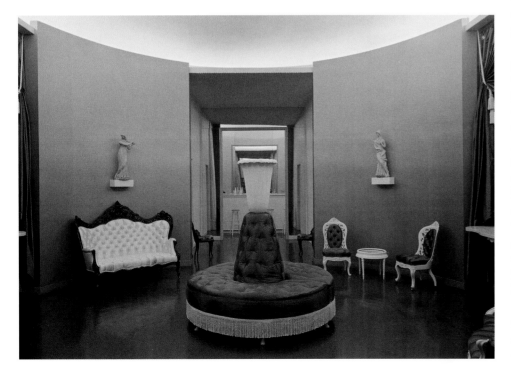

Fig. 111. Samuel H. Gottscho, Helena Rubinstein's Salon, 715 Fifth Avenue, November 27, 1936. Museum of the City of New York, 88.1.1.4147

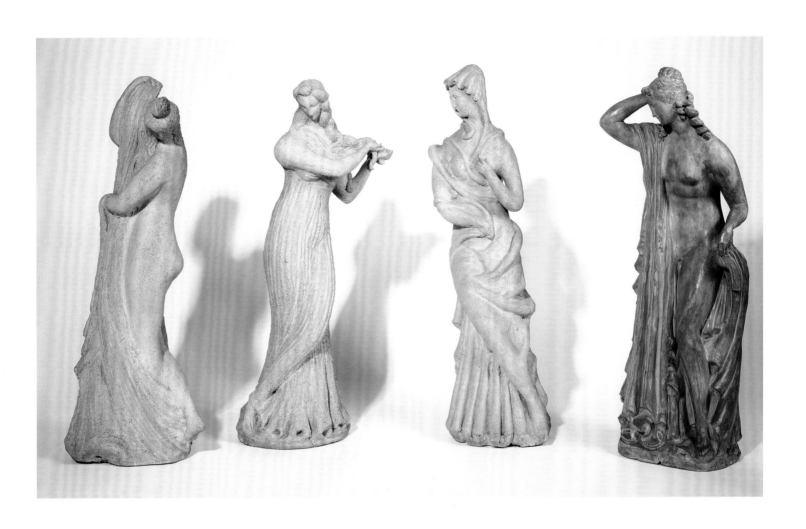

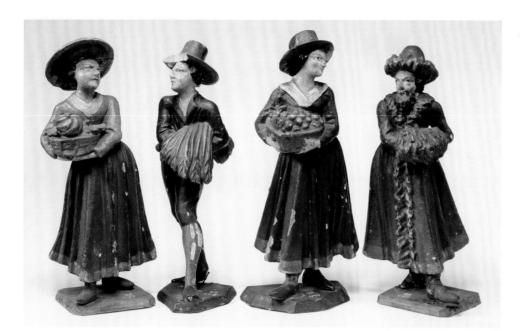

Fig. 112. *Vier Jahreszeiten*, eighteenth century. Wood, paint; 7 in. (18 cm) high. Bayerisches Nationalmuseum, Munich

produced in Boeotia from interchangeable sectional molds (fig. 77). Since many of these statuettes, dressed stylishly in chitons and himations (cloaks), were discovered near the city of Tanagra, they are frequently called "Tanagra figurines," examples of which Nadelman could have seen in the Musée du Louvre and the British Museum.[8] According to Lincoln Kirstein, Nadelman was fascinated with them and had museum models and original fragments on his workbench "from Tanagra, Myrina, Tarentum, Priene, Athens, Alexandria" and "[c]herished those in the Boston Museum of Arts . . . of which he kept many photographs."[9] The linear nature of the quartet's cascading draperies resembles that in earlier Archaic Greek sculpture, suggesting that each figure draws on a number of sources.[10] For example, the figure twisting her long hair references Pliny's description of the lost painting by Apelles of Venus/Aphrodite Anadyomene, in which the goddess of love and beauty, rising from the sea, wrings out her hair. That description was echoed in ancient works in many media, including terracotta. It also inspired later artists, such as Sandro Botticelli in his *Birth of Venus* (ca. 1483), which embodies the Neoplatonic ideal of beauty.[11] Nadelman also carved two wood reliefs with representations of a woman washing her hair and a related plaster relief (formerly called "Spring"), with two women, one drying the other's hair, which was displayed over the fireplace in Rubinstein's salon in 1915.[12]

By 1948 the Historical Society's quartet was called the "*Four Seasons*," a thematic subject whose roots lie in the classical Greek tradition.[13] The Seasons were originally represented as four female figures, *Horae*, with more or less fixed attributes: flowers for Spring, sheaves of grain for Summer, grapes for Autumn, and heavy drapery for Winter. In later Roman Imperial times, chiefly on sarcophagi and triumphal arches, the Seasons became male winged *genii* with the same attributes. During later periods they sometimes were personified as two females and two males, as in the eighteenth-century polychromed wood figures depicting the Four Seasons in Munich's Nationalmuseum (fig. 112), where Nadelman may have seen them.[14] The sculptor also may have known later nineteenth-century female figures of the Four Seasons holding attributes, such as freestanding marble suites that were produced by Italian carvers who catered to tourists.[15] By contrast, Nadelman's elegant quartet lacks attributes. Rather than personifying the cyclical seasons, they seem to be involved in the daily but timeless grooming activities traditionally called the "toilette"—bathing, coiffing their hair, and arranging their costume—all subjects appropriate to a modern salon of beautification. On entering Rubinstein's oval salon (fig. 111), one would have seen the two center figures flanking the entry to the Health Bar: to the right stood Winter, with heavy drapery, and to the left Spring, twisting her hair like Venus Anadyomene. Summer was placed at the left removing her drapery and Autumn on the far right gathering her himation to warm herself.[16]

RJMO

1 "On Her Dressing Table," *Vogue* 45:9 (May 1, 1915): 82. For their dating, see Haskell 2003, 205–6 n. 69, who notes that Kirstein, through conversations with Viola Nadelman, determined that Rubinstein commissioned two works from him soon after his 1911 show in London: a large plaster relief, *Spring* (ibid., fig. 76), and the quartet of statuettes now known as the *Four Seasons*. Haskell believes that their style supports this dating. Lincoln Kirstein, *The Sculpture of Elie Nadelman*, exh. cat. (New York: Museum of Modern Art, 1948), 26–27, was the first to refer to the quartet as *The Four Seasons*.

2 Marie J. Clifford, "Helena Rubinstein's Beauty Salons, Fashion, and Modernist Display," *Winterthur Portfolio* 38:2–3 (2003): 84.

3 Elaine Brown Keiffer, "Madame Rubinstein: The Little Lady from Krakow has Made a Fabulous Success of Selling Beauty," *Life* 11:3 (July 21, 1941): 37, ill.

4 Kirstein 1973, 193. See Suzanne Slesin, *Over the Top: Helena Rubinstein: Extraordinary Style, Beauty, Art, Fashion Design* (New York: Pointed Leaf Press, 2003), 38, which notes that the New York salon's designer, Paul T. Frankl, who had been introduced to Rubinstein by Nadelman and worked on her succession of salons in the city, claimed that Nadelman was worried that Rubinstein might get interested in collecting painting and approached Frankl for help. To ensure her patronage of sculpture Frankl shaped the rooms as oval or put sculptures in niches.

5 Helena Rubinstein, *My Life for Beauty* (New York: Simon and Schuster, 1966), 95.

6 Clifford, "Helena Rubenstein," 91.

7 Slesin, *Over the Top*, 49. The sober exterior was designed by Harold Sterner; the interior, which reflected Rubinstein's eclectically Baroque and bold taste, was by Ladislas Medgyes and Martine Kane.

8 See Kirstein 1973, figs. 160, 192; Kertess 2001, figs. 2, 3; Haskell 2003, fig. 45, states that they caught his attention in London (ibid., 41–42). See also Reynold Alleyne Higgins, *Tanagra and the Figurines* (London: Trefoil Books, 1986); idem, *Catalogue of the Terracottas in the Department of Greek and Roman Antiquities, British Museum*, 4 vols. (London: British Museum, 1954–2008).

9 Kirstein 1973, 234–35. Photographs of these figurines remain in the NP, including two of a "Flying Nike" in the Museum of Fine Arts, Boston (see Olson essay, p. 89, n. 35).

10 Notably the *Kore of Cheramyes* (ca. 570–560 B.C.) from the Temple of Hera at Samos in the Musée du Louvre, Paris, MNB 3226, Ma 686; also Nadelman no doubt noticed the drapery of the *Venus Genetrix* in the same museum (MR 367).

11 In the Musée du Louvre, Nadelman could have seen various representations of the type (Ma 3079, Myr 631, Cp 3719) or a reproduction of the more famous, later copy in marble from the first century B.C. after the Hellenistic bronze attributed to Doidalsas of Bithynia in the Archaeological Museum of Rhodes.

12 The dates of the wood panels are disputed (ca. 1911–15); one is in the Gerald Peters collection, and the other, formerly in a private Texas collection, is in the Gerald Peters Gallery, New York. See Kirstein 1973, 296, no. 90, which remarks that the first "may have been an *essai* for the style and technique of the decorations undertaken for Madame Helena Rubinstein's billiard room in London ca. 1912–1913." It is not clear if the relief for the billiard room was *Spring* (in the National Gallery of Art, Washington, DC, 1975.79.1); Haskell 2003, fig. 76. For the 1915 installation, see Grace Hegger, "Beauty Bought and Paid For," *Vogue* 46:10 (November 15, 1915): 68, ill. Nadelman was obsessed with the Seasons theme during the mid-1910s, as seen in his drawing *Study of Autumn* (Metropolitan Museum of Art, New York, 65.12.4); see Haskell 2003, fig. 77.

13 On the subject of the Four Seasons in ancient art, see George M.A. Hanfmann, *The Seasons Sarcophagus in Dumbarton Oaks*, 2 vols. (Cambridge, MA: Harvard University Press, 1951); for later periods, see Ilja M. Veldman, "Seasons, Planets and Temperaments in the Work of Maarten van Heemskerck: Cosmo-Astrological Allegory in Sixteenth-Century Netherlandish Prints," *Simiolus: Netherlands Quarterly for the History of Art* 11:3–4 (1980): 149–76.

14 Nationalmuseum, Munich, 28/494–97; see Hans Karlinger, *Deutsche Volkskunst* (Berlin: Im Propyläen, 1938), 126, 493, no. 442, ill.

15 See *Antiques and Fine Art* 11:1 (Spring 2011): 95, ill.

16 Kirstein, *The Sculpture of Elie Nadelman*, 20, ill. (Summer is misidentified as Spring), 21, ill. (correctly identified as Winter).

||

Elie Nadelman (1882–1946)
Orchestra Conductor (Chef d'orchestre),
1920–24 (plaster, ca. 1919)
Cherry, paint, and gesso; 38 × 22 × 11 in.
(96.5 × 55.9 × 27.9 cm)
Amon Carter Museum of American Art, Fort Worth,
TX, Partial gift of the Anne Burnett and Charles
Tandy Foundation 1988.33

Fig. 113. Elie Nadelman, Maquette for
*Orchestra Conductor (*Chef d'orchestre*),*
ca. 1919 (destroyed, preserved in
a photograph by Mattie E. Hewitt).
Collection of Cynthia Nadelman

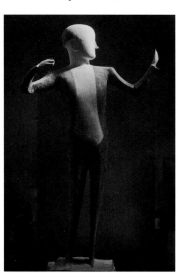

While in Munich and Paris, Nadelman was exposed to radical modernist ideas and produced art that responded to them. Later, in the United States, he created figures in plaster dressed in contemporary garb that reflected the popular culture of its more open, democratic, and dynamic society. In 1917 he exhibited several of these smaller plaster figures, such as *Tree of Life* at the Whitney Museum and the maquette for *Seated Woman* at the Ritz-Carlton benefit (see fig. 115). For his solo show at M. Knoedler Gallery in October 1919, he presented a tableau of sixteen plaster sculptures of middle-class figures, together with forty drawings. Among the plasters were those for *Host* and *Orchestra Conductor* (fig. 113), as well as *Piano Player* (fig. 116) and *Tango*, the last representing the new risqué dance in vogue at the time.[1] Unfortunately, Nadelman's plasters were destroyed, but they are preserved in photographs by Mattie E. Hewitt, which were issued in a portfolio of sixty-five gelatin silver prints of sculptures (with a limited edition of one hundred), and were sold at Knoedler for $500 each.[2] As Lincoln Kirstein and other writers have pointed out, the subjects of Nadelman's works were influenced by the people that he encountered in New York society—and possibly (but more controversially) by his emerging interest in folk art. Many of Nadelman's patrons, expecting to see his classical figures,[3] found his newer works satirical and were offended by their debonair insouciance. Undeterred, Nadelman exhibited ten plasters, including one for *Orchestra Conductor*, a plaster study of the head alone, and eighty-nine drawings at Galerie Bernheim-Jeune in Paris in 1920.[4]

Sculptors traditionally used plaster for their working models. As with his earlier work, Nadelman intended to translate his plasters into more durable materials and produce his sculptures in multiples of between two and four. According to an annotated copy of the Knoedler catalogue, he envisioned editions in bronze and wood. Reversing the normal hierarchy of prices, he offered the wood ones at higher prices than the bronzes, but no

orders were placed.[5] Unlike other sculptors of the period, Nadelman was not interested in resurrecting the direct carving method. Nor did he plan to carve the figures from solid timber, as he had some of his earlier wood sculptures. Instead, most of his works in wood of the 1920s consist of block-like components, secured by glue. Rather than being driven by a financial necessity, this method of fabrication was a conscious aesthetic and practical choice, as laminating wood can retard and even prevent warping.[6] Valerie Fletcher first noted invoices in the Nadelman Papers documenting that contract carvers roughed out Nadelman's wood sculptures and delivered them to him for finishing. She posited that these artisans were trained as commercial carvers of carousel animals and employed the same methods for Nadelman's sculptures, assembling the figures in a joined wood technique from pieces rather than carving them. The practice can also be connected to methods favored in Poland during the nineteenth century through Nadelman's youth when multiples could be created by use of a pantograph. Fletcher believes that with this technique Nadelman created a sophisticated rapprochement between traditional European wood carving and American wood crafts for fabricating and articulating his plaster maquettes in wood.[7]

Invoices in the Nadelman Papers for wood-carvers and subcontractors allow us to date many of Nadelman's multiple wood sculptures to 1920–21. John H. Halls, an architectural sculptor, invoiced Nadelman on May 30, 1920, for "furnishing mahogany, cherry wood, / cabinet work, roughing out by machine / & delivery" for two sets of four figures, one set of two figures, and one set of four heads.[8] In another invoice the following year, Halls billed the sculptor for "furnishing twelve cherry figures made to / owner's models and two pianos."[9] Still more invoices reveal that "John J." or "J. Hall" (who is the same as John H. Halls) subcontracted part of the work for Nadelman to Pettin, Rappaport & Ubl, artistic wood-carvers and modelers, for "2 Figures roughed / 2 ditto ditto"; "2 Figures roughed / 4 Figures ditto"; and "2 Figures

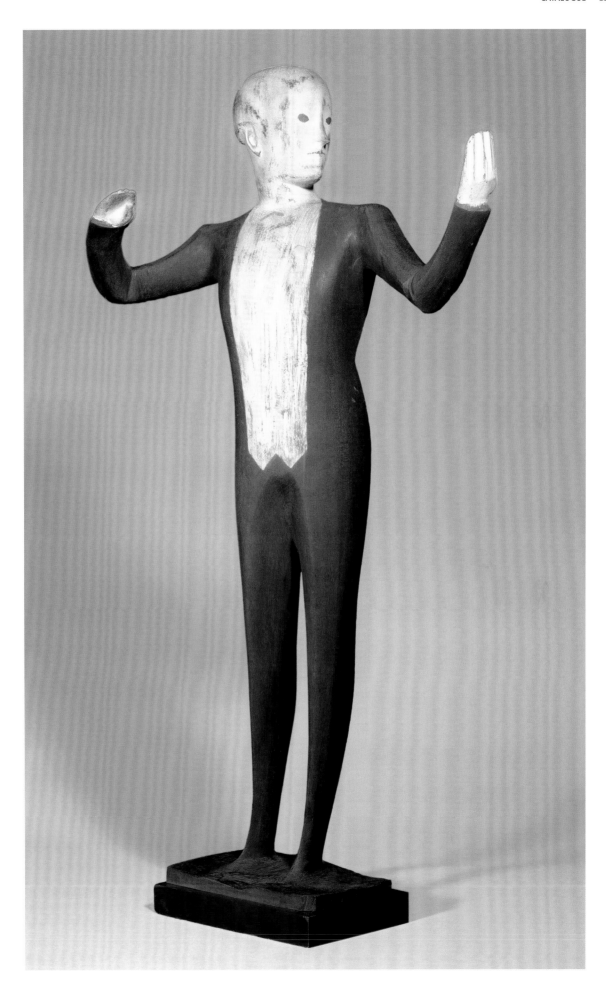

roughed."[10] Yet another invoice from the subcontractor J. & W. Robb, manufacturers of interior woodwork, to J.H. Halls, charged for "2 pianos, 2 platforms, etc. /"[11] This information allows us to date the two wood versions of *Piano Player* to 1921 (cat. IV).

The tuxedo-clad *Orchestra Conductor* at the Amon Carter Museum is known in another wood version with more distressed polychromy in the Hirshhorn Museum; Nadelman stored at least one version in the attic at Alderbrook where it was photographed in 1947 (see fig. 119).[12] Whereas this figure's stance, elegant elongation, and simplification echo those traits characteristic of fashion manikins, its style also looks forward to the modernist streamlining of American designs of the late 1920s and 1930s and suggests the influence of wooden shop figures (see cat. 2). No doubt these trade figures, which were usually displayed outdoors, inspired his palette and the figures' weathered appearance. By painting and staining both his plaster maquettes and wood sculptures, the sculptor betrayed the duality of his formal influences, acknowledging the original polychromy of Greek marbles and terracottas, but also responding to the colors and surfaces of vernacular carvings to achieve his own eclectic aesthetic goals.[13]

Unlike the smooth plaster of Nadelman's maquettes, many of his wooden sculptures from 1920–25 retain the marks of rasp and chisel, as well as crude sanding, all of which are apparent on the surface of the *Orchestra Conductor*. Although the sculptor painted the plasters directly, his approach to the wood versions was different. He applied brown stain to the wood, irrespective of its grain. Like commercial wood-carvers he sometimes added a layer of broadly brushed, homemade gesso to the heads and chests, as he did in the *Orchestra Conductor*. In some cases, Nadelman left the details, such as the eyes, in the red-brown stain and other times he drew them in graphite on the gesso. He frequently painted the hair or clothing with a diluted or slightly gray Prussian blue. By thinning the paint to almost a wash, he varied it from opaque to translucent and used brushstrokes to model the forms. Afterwards he thinned or rubbed the gesso to reveal the reddish wood. When first made these works were more vivid and energetic. Over time, however, many of them deteriorated in their damp storage at Riverdale, leaving them more weathered than Nadelman had intended.[14]

RJMO

1 See Knoedler 1919, no. 3, ill. Of the sixteen plasters exhibited, four were given French titles and twelve received English titles.

2 A copy of the catalogue (ibid.) annotated with prices is in the Knoedler Gallery Archives, Getty Research Institute, Los Angeles, CA (a photocopy is in the NP).

3 Fletcher 2001, 85.

4 Bernheim-Jeune 1920, no. 1, ill. The plaster also lacks a baton. For the plaster head, see Kirstein 1973, 300, no. 137, pl. 77. Martin Birnbaum reported that Nadelman originally had intended the figure to hold a violin but "canceled the idea as unstructural." *Orchestra Conductor* was also reproduced in New Society of Artists, E. Gimpel and Wildenstein, *Second Annual Exhibition of the New Society of Artists*, exh. cat. (New York: E. Gimpel and Wildenstein, 1920), 52, ill.

5 Fletcher 2001, 87, 95 n. 16. The catalogue annotated with prices in the Knoedler Gallery Archives (see n. 2 above) lists versions of the *Orchestra Conductor* in wood ($1,300) and bronze ($800).

6 Fletcher 2001, 89; Valerie Fletcher, e-mail message to Roberta J.M. Olson, May 1, 2014, notes that the Hirshhorn's *Circus Girl* (cat. VI) is made of two wood blocks glued together with a well-camouflaged join. One hopes that future conservation examinations of Nadelman's sculpture in wood will yield additional information.

7 Fletcher 2001, 89–90. She notes that the opening of Coney Island in the 1870s and its expansion in the 1890s launched a wave of amusement parks and a demand for carvers. She also notes that Nadelman used cherry, a wood strongly associated with American furniture, and mahogany.

8 Halls was listed at 245 West Twenty-eighth Street, New York City; the charge was $327.63, NP.

9 Ibid., April 22, 1921; Halls's charge was $832.26.

10 Ibid., April 4, April 8, and April 14, 1921; the charges were $158, $124, and $104, respectively. Halls was now listed at 162 East Thirty-fifth Street. Pettin, Rappaport & Ubl were located at 305 West Thirty-eighth Street, New York City.

11 Ibid., April 21, 1921; the charge was $55.03. Halls was listed at 162 East Thirty-fifth Street. J. & W. Robb, listed at 245–47 West Twenty-eighth Street, New York City, may be related to the ship carver with the same surname (see cats. 2, III). Robb was also mentioned in both copies of Halls's invoice (see n. 9 above) to Nadelman of April 22, 1921, as a subcontractor for "preparing and gluing- / up blocks & some cherry lumber" and "For marking out – band sawing – / jointing and gluing – w/ cherry wood for 12 figures / and furnishing a certain quantity of cherry wood & glue." The twelve figures from Pettin, Rappaport & Ubl were also itemized.

12 Hirshhorn Museum and Sculpture Garden, Smithsonian Institution, Washington, DC, 66.3769; see Ramljak 2001a, pl. 53; Haskell 2003, fig. 147.

13 Nadelman's awareness of chalkware figures (cats. 10, 11), which the couple collected, may also have predisposed him to select plaster for his maquettes and to paint them. Unfortunately, there is no way of determining when the couple acquired their first examples, although the majority that are recorded in the MFPA cards were purchased between 1924 and 1927 (see cat. 10).

14 Fletcher 2001, 91–92; figs. 8–11 illustrate how the Hirshhorn Museum has conserved some wood sculptures so that their colors and surfaces approximate their original conditions.

III

Elie Nadelman (1882–1946)
Seated Woman (Femme assise), 1920
(plaster, ca. 1917)
Cherry and iron; 31¾ × 12¾ in. (80.7 × 32.4 cm)
Addison Gallery of American Art, Phillips Academy,
Andover, MA
1955.8

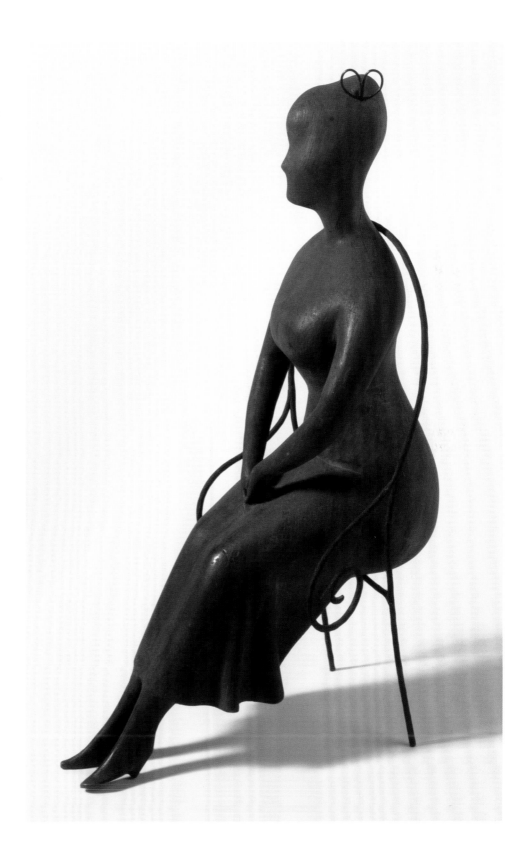

Nadelman's wooden *Seated Woman* and its plaster maquette are the earliest in a group of works in which the sculptor attempted to create a vernacular American expression that would endow his calm classicism with contemporaneity, authenticity, and playfulness (see cat. II). Together with many modernist artists, like the Cubists who employed collaged lettering from newspapers, Nadelman sought to enliven his art by annexing elements from popular culture. His choices of materials—cherry wood and iron—certainly link this figure of a seated woman to American furniture, while the figure's overall form resembles that of a dressmaker's dummy. Moreover, the woman's chair derives from the wrought-iron soda shop chairs that were ubiquitous in the 1910s and 1920s across America and resembles café furniture popular in Parisian bistros at the turn of the century. The sculptor also employed a similar chair for his versions of *Host*, representing a seated portly man with a bowler hat.[1] Not coincidentally, this wood version of *Seated Woman*, positioned next to one of the two versions of *Host* in a photograph of 1947 taken in the attic of Alderbrook (see fig. 119), has also been termed "Hostess."[2] There is also a second version of *Seated Woman* in the Museum of Art, Portland, Oregon.[3] Whereas the artist commissioned professional wood-carvers to fabricate his slightly later wood sculptures (see cat. II), Nadelman may have carved this unpainted sculpture himself.[4] The resemblance of the replacement hand and legs that he fashioned in cherry wood for the damaged figurehead "Rosa Isabella" (cat. 3) to those of *Seated Woman* supports this conclusion.

As was Nadelman's modus operandi for this early group of wood sculptures, *Seated Woman* is based on a painted plaster maquette, now destroyed (fig. 114).[5] Instead of his earlier, classicizing nudes and women wearing chitons, this work represents a matronly woman dressed in a contemporary clinging dress that emphasizes her ample cleavage.[6] Nadelman exhibited its maquette along with three other sculptures (two plasters and one bronze) in the exhibition *Allies of Sculpture*, held on the roof of the Ritz-Carlton Hotel in New York City in mid-December 1917 (fig. 115) for the benefit of various war-relief committees.[7] Two of the plasters, including the maquette for *Seated Woman*, sported hair tinted in Prussian blue. This color, familiar in rinses for white hair, and the woman's coy posture were interpreted as a mockery of the socialites who had sponsored the benefit, causing a scandal. Within two days of the show's opening, two of Nadelman's plasters (including that for *Seated Woman*) were removed from their prominent positions and hidden in the farthest corner of the exhibition space. Eventually the offending works were returned to their original locations, although someone knocked the maquette for *Seated Woman* off its pedestal, smashing it to bits. The press coverage of the incident lent notoriety to all three plasters as well as the imprimatur of aesthetic radicalism to Nadelman's work.[8] Although sculptures by Constantin Brancusi and Henri Matisse included in the exhibition today seem more radical than Nadelman's, only his were singled out for opprobrium. Perhaps the casual nature of his seated figure and her iron chair and hallmark iron hair bow made the sculpture resemble a found object and contributed to its being dismissed as "indecent" and questioned as art. Nadelman surmised that the public's dislike was based on the work's unconventional appearance as compared with more familiar works of art. "It proves," he said, "that habit and not logic makes people accept or reject things."[9] It also reveals that Nadelman's effort to update his innate classicism with seemingly dissonant popular elements left his viewers confused.[10] Nonetheless, this distasteful event had a silver lining, because it led to a friendship between the sculptor and the art patron Gertrude Vanderbilt Whitney.

Nadelman had offered to execute bronze and wood versions of most of his plasters at the time of his 1919 exhibition at Knoedler Gallery in New York, but there was no interest.[11] It was only the following November that he showed the unpainted wood figure of *Seated Woman* and an unpainted bronze *Acrobat* at the *Second Annual Exhibition of the New Society of Artists* at E. Gimpel and Wildenstein in New York.[12] By the time Nadelman exhibited this wood version of *Seated Woman* in 1925 at Scott & Fowles in New York City, its reception was much more positive, and some critics interpreted Nadelman's modernist works as "witty caricatures."[13]

RJMO

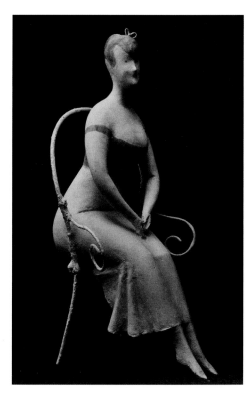

Fig. 114. Elie Nadelman, Maquette for *Seated Woman* (*Femme assise*), ca. 1917–19 (destroyed, preserved in a photograph by Mattie E. Hewitt). Collection of Cynthia Nadelman

1 There are two versions: Hirshhorn Museum and Sculpture Garden, Smithsonian Institution, Washington, DC, 66.3768; see Fletcher 2001, 89–91, figs. 4–9; Columbus Museum of Art, Ohio, 2001.001; Haskell 2003, fig. 145.

2 Kirstein 1973, 220. References to the plaster "Hostess" appear in Knoedler 1919, no. 13, ill., which may be the same work exhibited in Paris under a different title (Bernheim-Jeune 1920, no. 7, "L'invitée").

3 Portland Museum of Art, Portland, OR, 78.8; see Cynthia Nadelman's entry describing the differences between the two versions; *Addison Gallery of American Art: 65 Years: A Selective Catalogue* (Andover, MA: Addison Gallery of American Art, 1996), 132–33.

4 According to the conservation records in the Addison Gallery, "The hardwood figure is formed with glued laminations, and the surface texture is partly rough. The surface appears to be coated with a red-brown stain, and UV autofluorescence suggests a slight resin component." Susan C. Faxon, e-mail message to Alexandra Mazzitelli, April 29, 2014.

5 Kirstein 1973, 149, no. 98, pl. 98 (plaster), gives its height as thirty inches; see also no. 97, fig. 97 (a study in pen and ink on paper); Haskell 2003, fig. 117.

6 See Berman 2001, 59, fig. 9 for the plaster, pl. 39 for the sculpture in the Addison; Haskell 2003, fig. 117, for the plaster, fig. 134 for the Addison sculpture. For Nadelman's drawing related to *Seated Woman*, see Kirstein 1973, 312, no. 83, pl. 97.

7 See Haskell 2003, 212, ill.

8 "Nadelman Statuette Maimed; Spite, He Says," *New York World*, December 29, 1917. Haskell 2003, 103, observes, "His malefaction seems to have been his marriage of illustrative realism and classical simplification, which confounded expectations and assumptions and endowed his work with satirical implications. Nadelman had conflated these apparent dichotomies out of a desire to keep the classical tradition alive by infusing it with the vitality of the present."

9 "His 'Modest' Art Offends Exhibit," *New York World*, December 19, 1917. For additional discussion, see Berman 2001, 59; Haskell 2003, 101–11.

10 *Seated Woman* is close to a more classical marble of a related seated figure in the Collection of Cynthia Nadelman; see Berman 2001, pl. 38.

11 See also cat. II for a discussion of the plasters and their 1919 exhibition at M. Knoedler & Co. (New York City) and in 1920 at Bernheim-Jeune & Cie. (Paris). The question remains: was this same plaster (reconstructed after its exhibition at the Ritz-Carlton) photographed by Hewitt ca. 1919 and reproduced in the Knoedler catalogue (see n. 2 above), or did Nadelman make a second, perhaps slightly larger plaster after its "destruction" in 1917? Cynthia Nadelman, e-mail message to Roberta J.M. Olson, May 3, 2014, agrees that the available information does not permit a definitive answer to the question. There is correspondence dated December 1919 about a portfolio of Hewitt photographs of Nadelman's sculpture that supports a terminus date for them in late 1919, NP.

12 Haskell 2003, 117. New Society of Artists, E. Gimpel and Wildenstein, *Second Annual Exhibition of the New Society of Artists*, exh. cat. (New York, 1920), no. 88.

13 Helen Appleton Read, "New York Exhibitions: Eli Nadelman," *Arts* 7:4 (April 1925): 228–29, which also praised their expert craftsmanship; the "wooden statuette" is illustrated on p. 228. The exhibition had no catalogue.

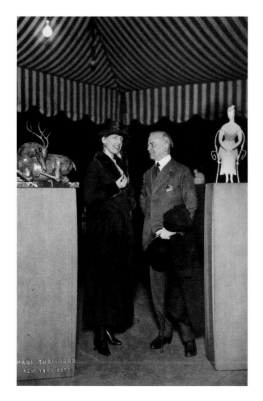

Fig. 115. Paul Thompson, *Allies of Sculpture* exhibition with Nadelman sculptures and Muriel Draper and Christian Brinton at the Ritz-Carlton Hotel, New York, December 1917. NP

IV

Elie Nadelman (1882–1946)
Piano Player (Pianiste), 1921 (plaster, ca. 1919)
Mahogany, stain, paint, and iron wire; 36½ × 22 ×
11¾ in. (92.7 × 55.9 × 29.8 cm)
Harvard Art Museums / Fogg Museum, Cambridge,
MA, Gift of Dr. and Mrs. John P. Spiegel
1956.200

Nadelman's prototype for this sculpture was a painted plaster maquette (fig. 116), whose face resembles a plaster Mycenaean mask, as opposed to the more conventional, doll-like visage of the wood sculpture. The plaster, long since destroyed,[1] was exhibited at Knoedler Gallery in New York in 1919 and at Bernheim-Jeune in Paris the following year.[2] In 1921 Nadelman produced two versions in wood that by comparison seem to reveal an influence of folk art: this one, in the collection of the Harvard Art Museums, and a smaller one in painted cherry wood at MoMA.[3] Documents reveal that Nadelman ordered the pianos, platforms, and probably the figures from commercial wood-carvers (see also cat. II).[4]

These pioneering works belong to a group of plasters dating from 1917–19 that depict defiantly contemporary subjects (see cats. III, V, VI; figs. 80, 113, 114, 117, 118). In them the sculptor departed from his classical ideals and customary materials to work in plaster, a medium traditionally used by sculptors for preparatory maquettes. Nadelman's adoption of plaster might also have been influenced by folk art chalkware figures (cats. 10, 11), but it was more likely inspired by painted Late Classical and Hellenistic terracottas. He also focused on movement, a quality that so fascinated him in both his sculpture and the works that he collected. Here, the piano player, who is not a concert pianist, is playing an ordinary upright piano. She is poised in mid-action, half-sitting and half-standing with her hands springing off the keyboard.

Whereas the proportions of the original plaster figure approach a classical ideal, those of the wooden versions are more elongated and their faces are nearly abstract, almost like puppet heads. Moreover, their painted surfaces, created by rubbing or smudging paint, look distressed and resemble some of the folk art pieces that the Nadelmans had begun to acquire after 1920. Since the sculptor was a smoker, he may have been familiar with painted wooden shop figures, many of which appeared weathered, in front of tobacconists' shops in New York City (see cat. 2).[5] Like Nadelman's other painted plaster

maquettes and their wooden counterparts (for example, *Seated Woman*, cat. III), the wooden pianist wears a coquettish bow, a Nadelman hallmark. In fact, she sports not one but two: the first in her coiffure and the other at the back of her waist, adding a flirtatious touch and a naïveté that complement her simplified form and homespun costume. The bow at her waist also suggests the wind-up apparatus of mechanical toys, a class of objects that the Nadelmans would soon collect. Toys like the "Gai violiniste" (cat. 84) may have helped inspire the plaster models for the *Piano Player* and the *Cellist*, both of which were included in the 1919 Knoedler exhibition, even though Nadelman is not known to have purchased any toys by this date.[6]

Nadelman's work in painted wood represented a real departure for the sculptor, who must certainly have considered these works an ambitious new aesthetic expression. Many scholars have commented that this change in direction was probably linked to his discovery of American folk art, but it is unclear how much exposure he would have had to vernacular carving at this early date. By 1921 Nadelman was corresponding with Hamilton Easter Field, who had begun collecting in the 1910s in Ogunquit, Maine. As early as 1923 he had met the sculptor and Americana enthusiast Robert Laurent.[7] In search of a modern visual vocabulary, Nadelman could have made complex connections between antique and modernist idioms—when he observed, for example, the unexpected combinations of Italian sixteenth- and seventeenth-century furniture and modernist art in the Paris apartment of Leo and Gertrude Stein (see fig. 57), and the juxtaposition of early American wooden furniture and modernist art that he may have seen in the New York apartment of Louise and Walter Arensberg.[8] Nadelman realized that the formalist qualities and intimate charm he was seeking were present in both indigenous folk art objects and earlier art. Furthermore, Nadelman's allusion to American vernacular forms must also have conveyed a hint of American patriotism (see Olson essay, pp. 86–87).

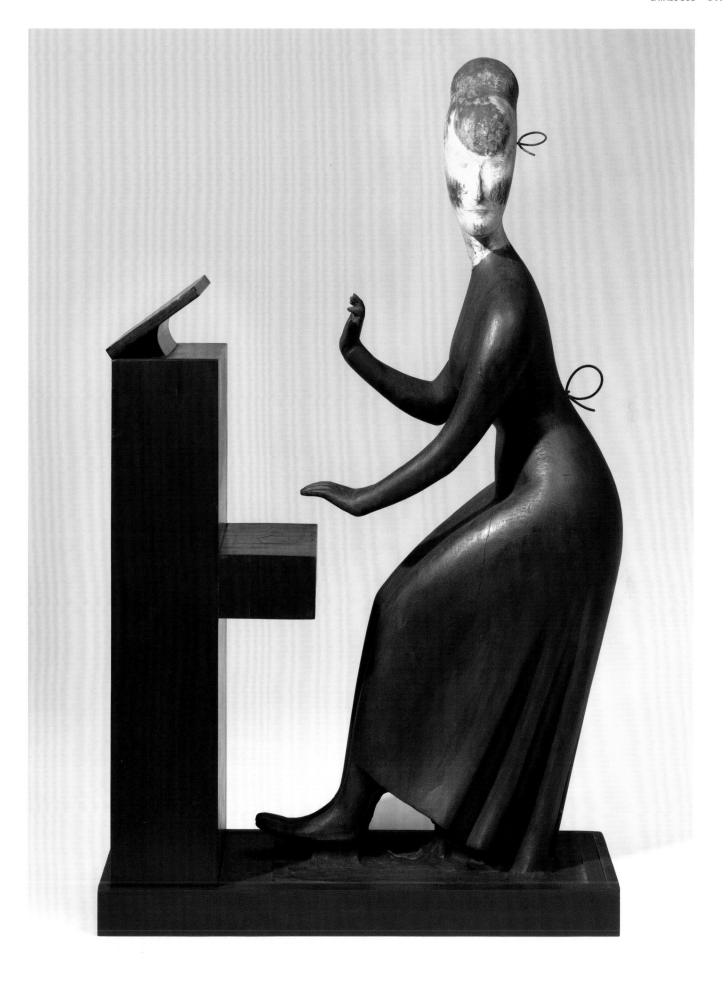

There are minor differences between the two wood versions of the *Piano Player*, one of which was exhibited in March of 1925 at the Scott & Fowles Gallery in New York City.[9]

Whereas the more elongated figure at Harvard sports a vivacious red dress, MoMA's musician wears a somber russet-brown frock. The face of the latter is also more distressed. Both works suggest, however, that as Nadelman's exposure to folk art increased, his wooden sculptures reveal a more definitive response to it.

RJMO

1 Kirstein 1973, 150, no. 117, pl. 117 (plaster); 298, no. 121 (wood; see also n. 3 below). When the plaster was reproduced in *Vanity Fair* in April 1918, the magazine's editor, Frank Crowninshield, gave it a French flair by titling it *La Pianiste: La Marseillaise*. See also ibid., 313, no. 88, pl. 116, for an ink and wash drawing with two studies; Berman 2001, 53, fig. 6.

2 Knoedler 1919, no. 5; Bernheim-Jeune 1920, no. 3. An annotated copy of Knoedler 1919 with prices in the Knoedler Gallery Archives, Getty Research Institute, Los Angeles, CA (a photocopy in the NP), lists only one option for replication in wood for $1,500.

3 Museum of Modern Art, New York, 105.6; 35¼ × 23⅞ × 9 in.; Kirstein 1973, 298, no. 121, pl. 118; Berman 2001, 53, fig. 5; Haskell 2003, fig. 146.

4 Invoice from the subcontractor J. & W. Robb, manufacturers of interior woodwork, to J.H. Halls, charged for "2 pianos, 2 platforms, etc. / . . . ," April 21, 1921; the charge was $55.03, NP.

5 Berman 2001, 57, offers possible catalysts for Nadelman's sculpture: among the most convincing are wooden manikins used by artists, a staple at art supply stores to this day; the faces of circus clowns; and a small Cycladic head.

6 Knoedler 1919, no. 1, which may be the same as the "Violoncelliste" exhibited in Paris (Bernheim-Jeune 1920, no. 9); for the destroyed plaster, see Kirstein 1973, 149, no. 92, pl. 92.

7 Berman 2001, 57; Stillinger 2011, 180.

8 Stillinger 2011, 148, observes this parallel in the Arensberg apartment and reproduces Charles Sheeler's photograph of it (fig. 3.2).

9 On the price list for the exhibition (there was no catalogue), signed by Nadelman, the wood sculpture was offered as "limited to 3," each for $700; Martin Birnbaum Papers, reel N698A, frame 553, AAA. Frank Brangwyn, "Nadelman Exhibits in Triple Capacity," *Art News* 23:23 (March 14, 1925): 2, terms it "his lady pianist"; R.F. [Ralph Flint], "New York Gallery Findings," *Christian Science Monitor*, March 18, 1925, mentions this work and associates the figures with the cabaret and dance hall, calling them "boulevardier figures" and citing the "Pierrot patches of white paint" on the faces and shirt fronts.

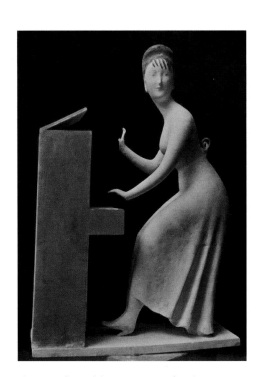

Fig. 116. Elie Nadelman, Maquette for *Piano Player* (*Pianiste*), ca. 1919 (destroyed, preserved in a photograph by Mattie E. Hewitt). Collection of Cynthia Nadelman

V

Elie Nadelman (1882–1946)

*Dancer (**Danseuse**)*, 1920–22 (plaster, ca. 1919)
Cherry; 28¼ in. (71.8 cm) high
Jewish Museum, New York City, Gift in memory of
Muriel Rand by her husband William Rand
1992.37

*Dancer (**Danseuse**)*, 1921–24 (plaster, ca. 1919)
Cherry and mahogany, gesso, stain, and paint; 28¼
in. (71.8 cm) high
Wadsworth Atheneum Museum of Art, Hartford,
CT, Philip L. Goodwin Collection, Gift of James L.
Goodwin, Henry Sage Goodwin, and Richmond L.
Brown
1958.224

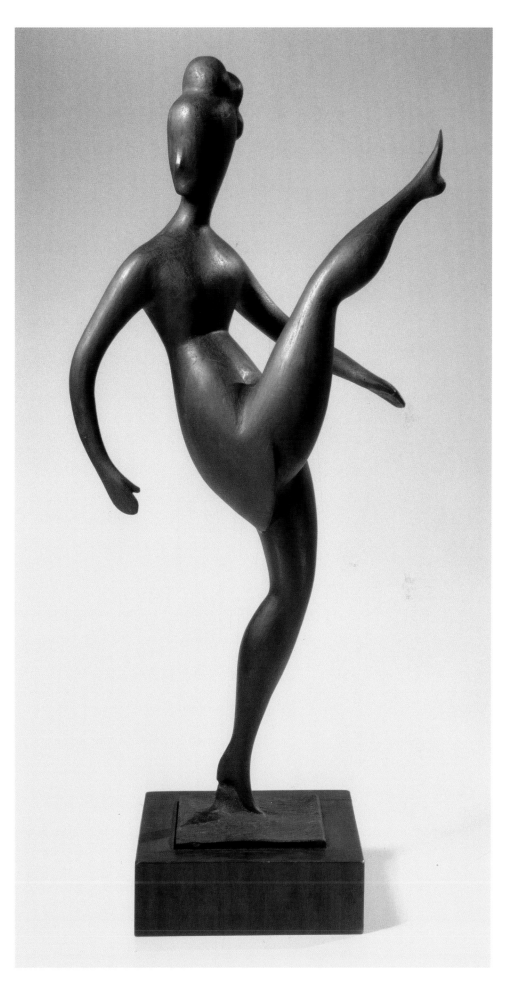

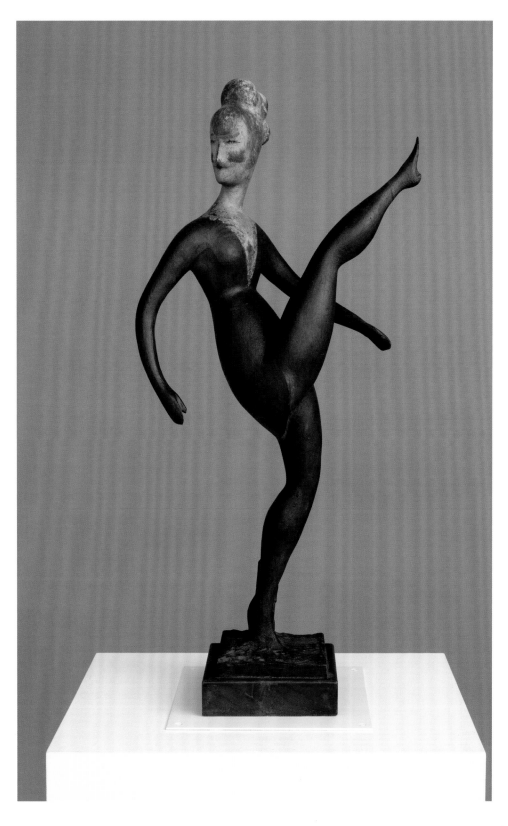

Nadelman's sculptures portraying high-kicking dancers have a rich and complicated background. The type can be linked to European dancers and to the indigenous circus and vaudeville entertainers that the sculptor encountered during his early years in New York City. As Avis Berman has observed, "the high kick was an actual specialty number in vaudeville, a loose-jointed version of the can-can in which the dancer showed off her leg lifts and splits."[1] Already in 1917 Nadelman had made a series of drawings on the theme of a high-kicking dancer.[2]

According to Lincoln Kirstein, the inspiration for Nadelman's sculpture was a photograph from ca. 1916 in the artist's files of the unconventional vaudevillian dancer Eva Tanguay, whose wild abandon forecast the flapper spirit of the 1920s. A self-made populist hero, the stage star electrified her audiences with her sensuality.[3] Although Nadelman believed that vaudeville was a transformative cultural force in America, his sources may have been multiple. He was an ice skater who had become infatuated with ice dancing in Paris, where he watched skaters gliding over the ice with one leg raised in a feat of balance. While in Paris in 1905, he must have seen the Georges Seurat retrospective at the Salon des Indépendants, and in it the pointillist's *Le chahut* (1890) with its provocative, acrobatic can-can dancers in nearly identical poses.[4] That canvas and Seurat's *Le cirque* were also shown in Paris at Bernheim-Jeune, one of Nadelman's dealers, in 1908–9, and photographs of these were offered by Nadelman's other dealer Druet. The sculptor, who shared Seurat's passion for simplicity and elemental gestures, executed a drypoint of the popular and probably marketable subject in 1920.[5]

Nadelman produced several sculpted versions of the *Dancer*, formerly known as "High Kicker," in unpainted and painted cherry wood, carved to evoke a vernacular technique. One of them was photographed in the attic of Alderbrook in 1947 (see fig. 119).[6] As with his other wood figures, Nadelman hired a specialized wood-carver to construct

duplicates after his plaster maquette (see cat. II),[7] intending to differentiate each wooden work through his surface treatment.[8] In the 1919 exhibition at Knoedler, Nadelman exhibited two plasters entitled "Dancer," one of which must have been the prototype for the wooden sculptures (fig. 117).[9] In 1920 the sculptor again showed one of these plasters at Bernheim-Jeune as *Danseuse*.[10]

The plain wood version of *Dancer* held by the Jewish Museum, composed of laminated pieces of cherry wood, has been dated earlier than the painted example in the Atheneum, whose polychromy is redolent of American folk art and fifteenth-century German wooden sculpture.[11] The polychromed dancer was exhibited in March of 1925 by Martin Birnbaum at the Scott & Fowles Gallery in New York City.[12] Notably it is the only wood version after a plaster maquette that Nadelman sold during his lifetime.[13] It was purchased by Stevenson Scott, his dealer, for the special

price of $200.[14] As Barbara Haskell observed, "[T]he elegantly stylized genre figures Nadelman showed in 1925 are among the masterpieces of twentieth-century American sculpture. . . . [T]hese pieces radiated an insistent classicism that recalled the lessons he had learned in Munich and Paris."[15]

RJMO

1 Berman 2001, 68.
2 Lincoln Kirstein, "Elie Nadelman: Sculptor of the Dance," *Dance Index* 7:6 (June 1948): 143, 145, ills.
3 Kirstein 1973, 296–97; Berman 2001, 68, fig. 12.
4 Haskell 2003, 130–31, fig. 136. Kröller-Müller Museum, Otterlo, Netherlands, KM 107.757.
5 Metropolitan Museum of Art, New York, 51.603.32.
6 Berman 2001, 68. For the version in the Jewish Museum, see Haskell 2003, fig. 135. For the one in the Wadsworth Atheneum, see Kirstein 1973, 296–97, no. 100, pl. 72; Haskell 2003, fig. 139. The third version is in the Smithsonian American Art Museum, Washington, DC, 1999.102; the fourth is in a private collection. All four were in the Whitney Museum's exhibition *Elie Nadelman: Sculptor of Modern Life* in 2003.
7 The plaster model was reproduced in Kirstein, "Elie Nadelman: Sculptor of the Dance," 144, ill. See also Kirstein 1973, 296–97, no. 100, pl. 72 (the Atheneum version).
8 Haskell 2003, 132.
9 See the annotated copy of Knoedler 1919 in the Knoedler Gallery Archives, Getty Research Institute, Los Angeles, CA (a photocopy in the NP), nos. 11 (wood $600 and bronze $400) and 14 (wood $1,000 and bronze $700).
10 Bernheim-Jeune 1920, no. 6.
11 See Berman 2001, 46, for a photograph revealing its construction by piecing and lamination.
12 The wood sculpture was termed "High Kicker" on the price list for the exhibition (there was no catalogue), signed by Nadelman, and was offered as "limited to 3," each for $600; Martin Birnbaum Papers, reel N698a, frame 553, AAA. R.F. [Ralph Flint], "Nadelman Exhibits in Triple Capacity," *Art News* 23:23 (March 14, 1925): 2, terms it "his kicking chorister."
13 Haskell 2003, 132.
14 See Nadelman 2001, 118. The work is cited in R.F. [Ralph Flint], "New York Gallery Findings," *Christian Science Monitor*, March 18, 1925, which associates Nadelman's wood figures with the cabaret and dance hall.
15 Haskell 2003, 130.

Fig. 117. Elie Nadelman, Maquette for *Dancer (Danseuse)*, ca. 1919 (destroyed, preserved in a photograph by Mattie E. Hewitt). From Lincoln Kirstein, "Elie Nadelman: Sculptor of the Dance," *Dance Index* 7:6 (June 1948): 144

VI

Elie Nadelman (1882–1946)

Circus Performer, 1920–24 (plaster, ca. 1919)
Cherry, gesso, paint, and graphite;
31⅜ × 8¾ × 9⅜ in. (79.7 × 22 × 23.8 cm)
Hirshhorn Museum and Sculpture Garden,
Smithsonian Institution, Washington, DC, Gift of
Joseph H. Hirshhorn, 1966
66.3767

Circus Performer, 1920–24 (plaster, ca. 1919)
Cherry, gesso, stain, and paint; 33¼ × 8½ × 5½ in.
(84.5 × 21.6 × 14 cm)
Colby College Museum of Art, The Lunder
Collection, Waterville, ME
2013.214

Circus Girl, 1920–24 (plaster, ca. 1919)
Cherry, gesso, paint, and graphite;
31¼ × 12¼ × 6⅜ in. (79.2 × 31 × 16.1 cm)
Hirshhorn Museum and Sculpture Garden,
Smithsonian Institution, Washington, DC, Gift of
Joseph H. Hirshhorn, 1966
66.3771

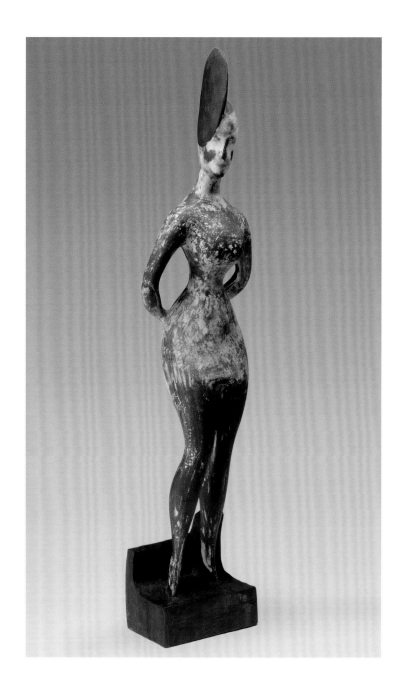

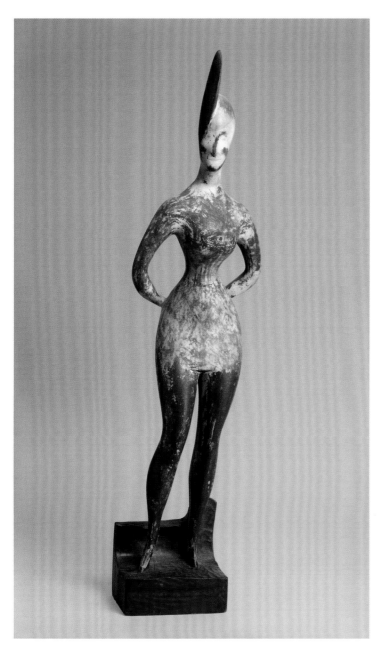

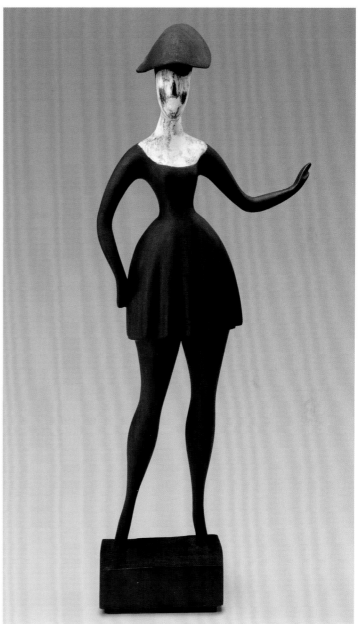

Circus and vaudeville performers were an enduring theme in Nadelman's sculpture over several decades (cats. V, VIII, IX). And there is evidence that carvers of circus animals and figures may have influenced his iconography and his artistic process.[1] Nadelman's circus performers were colorful, popular figures of mass appeal that had also been topical subjects for artists in Paris— including Henri de Toulouse-Lautrec and Pablo Picasso—and in the 1910s they were becoming fashionable in American art as well. Possibly as early as the 1919 Knoedler exhibition in New York City, and certainly the following year at Bernheim-Jeune in Paris, Nadelman showed a plaster equestrian circus figure holding a hoop.[2]

The three wood sculptures discussed here were first modeled by Nadelman in two plaster maquettes. The sculptor fabricated the plaster for *Circus Girl* in 1918–19 (fig. 118),[3] which was photographed by Mattie E. Hewitt (see cat. II). Nadelman then made at least three versions in wood, as evidenced in the 1947 photograph of them stored together in the attic at Alderbrook (fig. 119).[4] Nearby stood three polychromed wood versions of *Circus Performer*, each wearing a side headpiece, tights, and an abbreviated clinging costume.[5] No doubt the painted surfaces of all six works became more distressed because of exposure to dampness and heat while in storage at Alderbrook.[6] Jean Lipman gives a wonderful account of visiting Riverdale, especially the attic and its sculpture:

> I arrived by taxi in a violent storm, was greeted by Mr. Nadelman, tall, piercing black eyes, shabby dark suit, who in the first lightning-flash glimpse in the doorway of the great house looked to me like Heathcliff in *Wuthering Heights*. The house had been stripped of almost all the furniture and rugs and—was lit only by a few candles. Mr. Nadelman showed me the folk art, we talked about it, and he asked if I'd like to see his sculpture. We climbed to the attic where several dozen pieces were

covered with sheets, which he removed one by one for me to look—still by candlelight. They were all there— the greatness of the now famous Nadelman sculptures—all unsold. It was a splendid—and a bit eerie—day.[7]

Both types of circus performers depicted in his six sculptures were more than likely fabricated by wood-carvers whom Nadelman employed; later he applied the paint, gesso, staining, and graphite to their surfaces to animate and individualize them.[8] While he was certainly aware of the tradition of polychromed wooden sculpture that flourished in Western Europe from the medieval through the Gothic and Renaissance periods, it was the palette of distressed indigenous shop figures (cat. 2) that caught his attention and that he evoked with these sculptures. His taste for weathered finishes is also present in the chalkware figures (cats. 10, 11) that he and Viola collected so passionately, as well as in the Cycladic "idols," which may have also informed his plaster maquettes.

Circus themes played a role in the Nadelmans' collection of folk art. The couple was, no doubt, attracted, for example, to the *tirggel* mold (cat. 70), partly because of its subject matter as well as its beautiful wooden

form. It is one of a group of objects with circus subjects that were in the MFPA, including a number of toys (cats. 84, 86, 87).
RJMO

1 Berman 2001, 62; Fletcher 2001, 89.

2 Knoedler 1919, no. 4, "Equestrienne," which may be the same as "Ecuyère de cirque" in Bernheim-Jeune 1920, no. 2; Kirstein 1973, 149, no. 74, pl. 74. At Knoedler he also showed plasters of "Vaudevillistes" and "Acrobat."

3 Haskell 2003, fig. 130.

4 Valerie Fletcher, e-mail message to Roberta J.M. Olson, May 1, 2014, notes that the Hirshhorn's *Circus Girl* is made of two wood blocks glued together with a well-camouflaged join. See Haskell 2003, fig. 143, for a second version in the collection of Lois and Irvin Cohen.

5 The second version of *Circus Performer*, now in the Colby College Museum of Art, was in a private collection when reproduced in Haskell 2003, fig. 142. Another version is in the Carnegie Museum of Art, Pittsburgh, PA, 74.33.1.

6 See Fletcher 2001, 90–91.

7 Lipman and Armstrong 1980, 221.

8 Fletcher 2001, 89; both Hirshhorn sculptures are reproduced in Whitney Museum of American Art, *The Sculpture and Drawings of Elie Nadelman, 1882–1946*, exh. cat. (New York: Whitney Museum, 1975), pls. 68, 67, respectively.

Fig. 118. Elie Nadelman, Maquette for *Circus Girl*, ca. 1918–19 (destroyed, preserved in a photograph by Mattie E. Hewitt). Lincoln Kirstein Photograph Collection, Jerome Robbins Library for the Performing Arts, New York Public Library, Box 4, Nadelman 1, no. 10

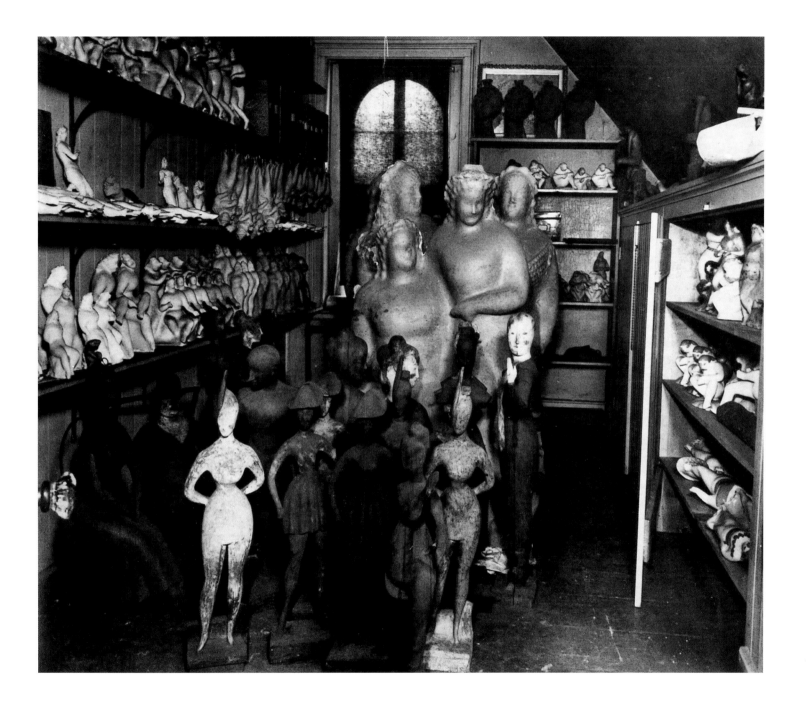

Fig. 119. Unknown photographer, Alderbrook attic, Riverdale, 1947. Lincoln Kirstein Photograph Collection, Jerome Robbins Library for the Performing Arts, New York Public Library

VII

Elie Nadelman (1882–1946)
Bust of a Woman, 1924–25
Painted bronze; 24 × 18 × 11 in.
(61 × 45.7 × 27.9 cm)
Collection of Cynthia Nadelman

Unlike the sculptor's early, more classical gilt-bronze heads, *Bust of a Woman* hints at the growing influence of folk art on Nadelman's aesthetic and technique.[1] This work was completed no later than March of 1925, when it was reproduced in a review of the exhibition *Sculpture by Elie Nadelman* at the Scott & Fowles Gallery in New York City.[2] It was described in the gallery's price list as one of the "large bronze painted busts" limited to an edition of three, each priced at $1,500.[3] The other two busts in the trio— *Man in a Top Hat* at MoMA,[4] and *Bust of a Woman (Ettie Stettheimer?)* in a Houston private collection[5]—have been dated slightly earlier and have truncated terminations without the hint of arms or torsos. All three subjects wear contemporary fashions and are embellished with color in their hair, costume, and accoutrements. While their polychromy is distantly connected with that of ancient Greek sculpture, here it adds humor rather than gravitas. As Cynthia Nadelman has observed, "His work began to riff on the classical, and it began to address modern life, often combining those two elements. The moment he put hats on heads or bows on necks, hairdos, and waists, something caricatural began to happen in his work."[6]

Bust of a Woman, unlike the other two bronze busts in Nadelman's trio, may demonstrate a knowledge of folk art at a juncture when the sculptor's energies had turned from creating his own works to collecting. Perhaps it reflects the influence of chalkware busts, like the one that the Nadelmans purchased in April 1925 from Renwick Hurry in New York City (cat. 11), which features arms and a torso morphing into its base. Is it a coincidence that Nadelman ornamented his bust's dress with a scalloped blue collar that reverses the red scalloped bodice trim in the chalkware piece? The sculptor crowned the bust's coiffure with his hallmark, insouciant bow, adding another whimsical element in the spirit of folk art. At the time it was interpreted as an element of caricature.[7]

RJMO

1 See Fletcher 2001, 91–92, pl. 57; Haskell 2003, 116, 130.

2 "News and Views on Current Art," *Brooklyn Daily Eagle*, March 15, 1925, ill. See also Nadelman 2001, 118; Haskell 2003, 130 (which also comments on the sculptor's friendship with Stevenson Scott and Martin Birnbaum), 215.

3 Martin Birnbaum Papers, reel N698a, frame 553, AAA.

4 Museum of Modern Art, New York, 260.48; 26 × 14⅞ × 13¼ in.; see Berman 2001, pl. 41; Haskell 2003, fig. 141.

5 Private collection; 23⅝ × 15 × 10 in.; see Berman 2001, pl. 44; Haskell 2003, fig. 140. Cynthia Nadelman, "Elie Nadelman as Caricaturist," *Sculpture Review* 54:2 (Summer 2005): 20, speculates about the identity of the female sitters in the two busts.

6 Nadelman, "Elie Nadelman as Caricaturist," 19. See the entire article for additional arguments about Nadelman as a caricaturist (ibid., 18–25).

7 Helen Appleton Read, "New York Exhibitions: Eli Nadelman," *Arts* 7:4 (April 1925): 228–29; Henry McBride, "Modern Art: Elie Nadelman Sculptures," *Dial* 78 (June 1925): 527–29.

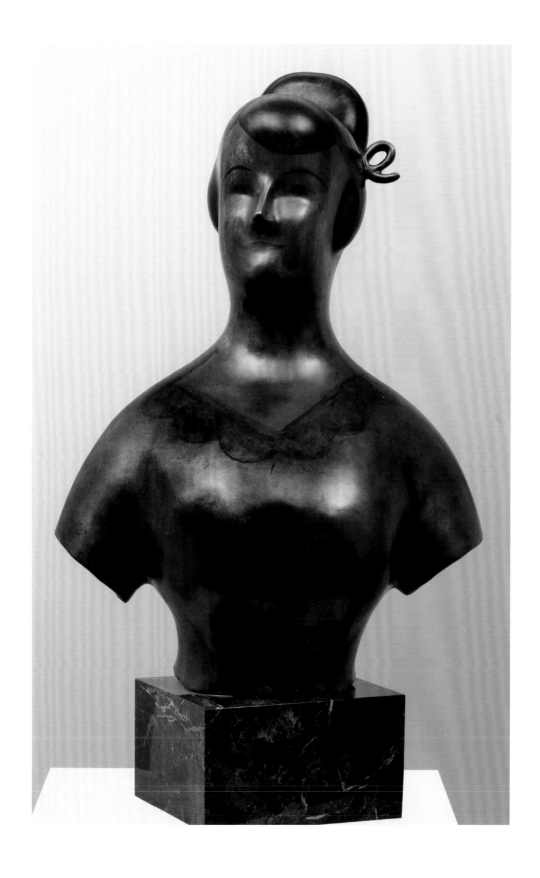

VIII

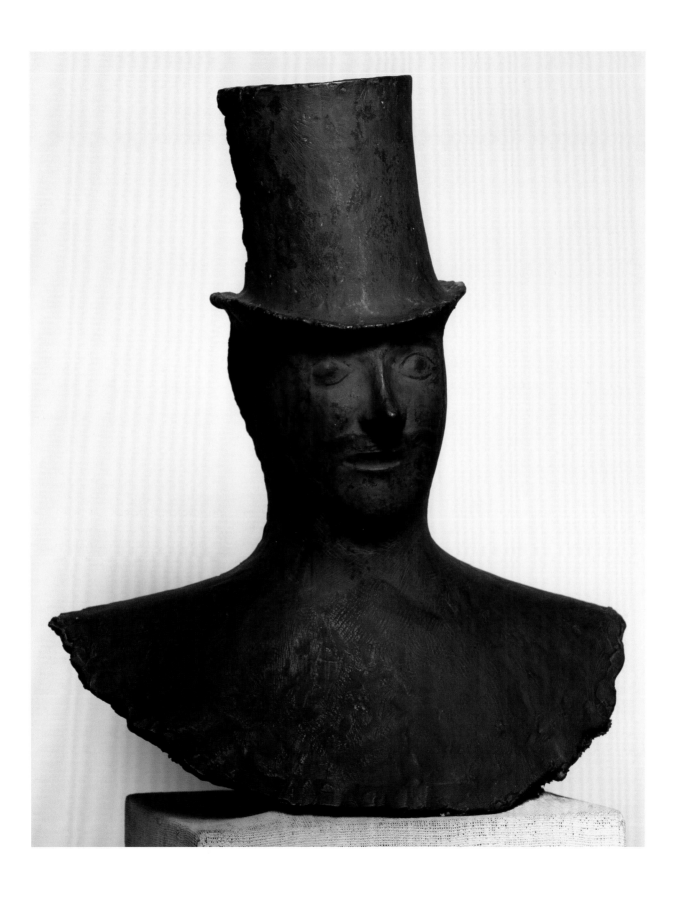

Elie Nadelman (1882–1946)
Man in Top Hat, 1925–26
Painted galvano-plastique; 29¼ × 22¼ × 12⅜ in.
(74.3 × 56.5 × 31.4 cm)
Whitney Museum of American Art, New York City,
Purchase, with funds from The Lauder Foundation,
Evelyn and Leonard Lauder Fund
99.90.1

In 1927, just two years after his successful show at Scott & Fowles, Nadelman presented an entirely new body of work that represented a major shift in his style, subject, and media. As with his maquettes of 1917–19, the starting point was again plaster, but this time Nadelman electroplated the plaster with a metal alloy (bronze or brass) and used the French term "galvano-plastique" to refer to the medium.[1] In this process, a plaster sculpture is submerged in liquid with a piece of metal that, when electrified, coats the plaster with the metal, a technique related to electrotyping.[2] This medium had long been used commercially to simulate bronze for such items as commemorative medals, reliefs, and busts, but it was also used for artistic purposes by Auguste Rodin and other sculptors in the nineteenth century.[3] Nadelman must have seen the connection between the commercial process and the traditional practice of gilding, which he had employed in Paris.[4] No doubt the quasi-industrial connotation of the medium's name pleased the sculptor, who employed the S.C. Tarrant Company, which specialized in "Galvano-bronze products," to execute his works.[5]

In January 1927 Nadelman exhibited ten galvano-plastiques at M. Knoedler & Company. Priced at $1,000 for full figures and $500 for busts, they were far less expensive than his commissioned portraits in marble and bronze ($8,000 and $5,000, respectively). From the gallery's price list and a letter addressed to various museum directors offering these sculptures for sale, it seems the sculptor considered the galvano-plastiques to be final works, not prototypes for later translations into marble or bronze.[6]

Like Nadelman's 1919 show at Knoedler, his 1927 exhibition—consisting of five near-lifesize female figures and several busts—communicated a lightness and buoyancy that embodied the artist's playful side and reflected his current prosperity. Unlike the 1925 exhibition at Scott & Fowles, meant to appeal to blue-blood collectors, these works were directed at fellow artists and critics.[7] The theme of the 1927 show was the circus, a longtime favorite source of inspiration for the sculptor (see cats. VI, IX), and *Man in Top Hat* portrayed the circus ringmaster. "To spice things up," Cynthia Nadelman writes, "there was a bust called *Ringmaster*, a bemused roué in top hat and painted-on mustache. (Perhaps he was a stand-in for ringmaster Nadelman, who sported a mustache at the time.)"[8]

This sculpture is related to several other works on the theme, including a more elegant, cosmopolitan, and unpainted galvano-plastique *Man in Top Hat* of 1926–27 in a private collection.[9] The latter work is closer to the much more detailed, debonair, painted bronze of the same title in the Museum of Modern Art that is dated ca. 1924.[10] From pen and ink sketches, we know that Nadelman's interest in this vernacular type—whether urbane or more casual and folky—dates from the 1910s (see for example, fig. 78).[11]

Without a protective lacquer coating, the copper component of the Whitney Museum's *Man in Top Hat* has oxidized and darkened, muting its painted details.[12] The bust's soft, almost melting contours are a twentieth-century extension of the "melting gaze" of Praxiteles and approach the waxy forms of works by twentieth-century Italian sculptor Medardo Rosso. The general softness of the ringmaster's features also evokes that of traditional plaster squeezes (casts after casts) and the chalkware objects the Nadelmans collected (cats. 10, 11). The very name of the material, "galvano-plastique," incorporates the quality that for Nadelman was the essential criterion for sculpture: "plastique." Both the material's inexpensive nature and its fluid forms point in the direction of Nadelman's later media and oeuvre.
RJMO

1 Cynthia Nadelman, "Plastiques fantastiques," in *Elie Nadelman [1882–1946]: Galvano-plastiques*, exh. cat. (New York: Salander-O'Reilly Galleries, 2001), n.p. See also Fletcher 2001, 91–92.
2 For electroplating and electrotyping, see: http://www.metmuseum.org/metmedia/video/collections/esda/electrotyping-process.
3 Nadelman, "Plastiques fantastiques," n.p. For Rodin's work in this medium, see http://www.auction.fr/_fr/lot/auguste-rodin-tete-coupee-de-saint-jean-baptiste-galvanoplastie-a-patine-cuivree-52786; http://mediatheque-numerique.inp.fr/index.php/content/view/print/7172. Thanks to Constance and David Yates for these references.
4 Fletcher 2001, 92.
5 Nadelman, "Plastiques fantastiques," n.p. Stanley C. Tarrant is recorded in the 1930 U.S. Census as living in Bridgewater, CT; his company, S.C. Tarrant Co., Inc., was listed in the New York City directories at 62 Ninth Avenue from at least 1926 to 1931. It was probably a subsidiary of Galvano Bronze. Thanks to Natalie Brody for this information.
6 See M. Knoedler & Co., *Sculpture by Elie Nadelman*, exh. cat. (New York, 1927); copy in the Knoedler Gallery Archives, Getty Research Institute, Los Angeles, CA. See also Nadelman, "Plastiques fantastiques," n.p.; Haskell 2003, 161, which both discuss this issue and the reasons why the galvano-plastiques may have been considered as prototypes for bronzes.
7 Nadelman, "Plastiques fantastiques," n.p.
8 Ibid.
9 In the collection of Richard and Camila Lippe; see Haskell 2003, fig. 189.
10 Museum of Modern Art, New York, 260.1948; see Ramaljak 2001a, pl. 41; Haskell 2003, fig. 141, dates it ca. 1920–24.
11 See Ramaljak 2001a, pls. 42, 43.
12 See Kirstein 1973, no. 141, pl. 141, reproducing a photograph showing the paint.

IX

Elie Nadelman (1882–1946)

Untitled (Two Acrobats), ca. 1930–35
Painted glazed ceramic; 16¼ × 10⅞ × 6⅝ in.
(41.3 × 27.6 × 16.8 cm)
Whitney Museum of American Art, New York City,
Purchase with funds from The Lauder Foundation,
Evelyn and Leonard Lauder Fund
99.90.12

Two Women (Two Acrobats), ca. 1930–35
Glazed ceramic; 16 × 8 × 5 in.
(40.6 × 20.3 × 12.7 cm)
Collection of Catherine Tinker

Popular entertainers from the circus world fascinated Nadelman, who used them as subjects in many sculptures and drawings from at least 1919 through the 1930s (cats. VI, VIII). In 1928 and 1929 he executed over-life-size sculptures of paired, massive, physically connected female circus performers or acrobats that were more generalized and monumental than his previous sculptures (fig. 119).[1] During the 1930s he continued to explore the theme in smaller-scale figures, pairing two substantial female performers at rest in interconnected intimate poses. He executed many of them serially, like themes and variations, in the democratic media of glazed ceramic or papier-mâché, akin to the ephemeral squeak toys in his collection (cat. 77). In some of these pairs, the figures stand in tandem,[2] or one arranges the hair of her companion.[3] In others, including the works shown here, a standing woman leans against her seated companion.[4] The sculptor decorated each one in a highly individualistic manner, using color schemes that resemble some of the couple's folk art objects.

Nadelman's concept for these works arose from his infatuation with two other forms of art for the masses, both of which were made in molds and of unpretentious and inexpensive materials: Late Classical and Hellenistic figurines from Tanagra, Myrina, and other Mediterranean cities (see fig. 77) and chalkware figures that he and his wife had been collecting since the 1920s (cats. 10, 11).[5] No doubt he was pleased with the interconnections that he observed between these ancient forms and certain American folk art objects. In their muted facial features and generalized contours, the female circus performers also resemble contemporary plaster prizes distributed at carnivals and fairs. Through their veiled forms Nadelman attempted to achieve the more generalized effect of plaster squeezes and recast sculptures.

To produce these smaller ceramic figures more easily, Nadelman constructed a kiln in a specially built annex in his studio at Alderbrook.[6] By September 1930 he was firing multiple versions of the small clay figurines.

Rather than combining body parts from different figures, as Greek and Hellenistic craftsmen had done, Nadelman individualized each sculpture by varying their surface decoration, a technique used by chalkware manufacturers. Some he glazed spontaneously with different details and colors, others he left unglazed and/or decorated with graphite. In his experiments with paper mixtures he cast pieces in plaster and covered their damp surfaces with brown paper, thus developing a special papier-mâché composite that he cast and painted with inventive surfaces (fig. 85).

These idyllic twosomes in ceramic, one of which stood on the mantel at Alderbrook (fig. 100), look forward to the colossal marble circus duos that grace the promenade of the David H. Koch Theater, at Lincoln Center, a commission that was arranged after Nadelman's death by his champion, Lincoln Kirstein.[7]

RJMO

1 Haskell 2003, 169, figs. 192, 196.
2 Ramljak 2001a, pl. 49.
3 Haskell 2003, fig. 197.
4 See Ramljak 2001a, pl. 24; Haskell 2003, figs. 198–99.
5 For two compelling prototypes, see Haskell 2003, figs. 193 (a terracotta of two women, ca. 100 B.C., probably from Myrina, in the British Museum, London), 194 (Johann Gottfried Schadow, *The Crown Princesses Luise and Friederike of Prussia*, 1795–97, in the Staatliche Museen, Berlin).
6 Haskell 2003, 171.
7 Kertess 2001, fig. 1.

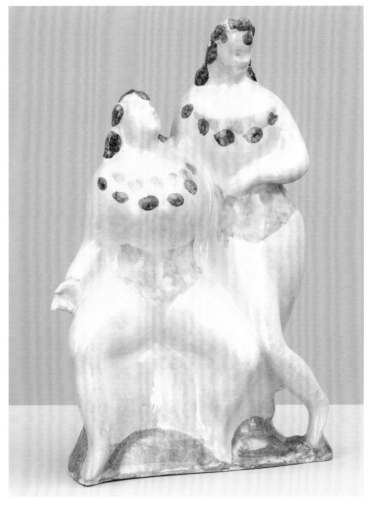

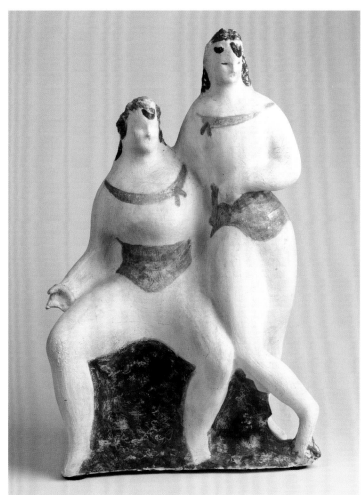

APPENDIX I
Checklist of Dealers and Auction Houses Patronized by the Nadelmans, 1920–1936

The following data is derived principally from the 4,628 catalogue cards in the Nadelman Papers documenting objects in the Museum of Folk and Peasant Arts. As the cards account for only about one-third of the items acquired for the museum, this list is necessarily incomplete; yet, it offers a revealing glimpse into the Nadelmans' purchasing patterns. Since the cards typically record only the last name of the dealer, sources such as advertisements, directory listings, and related correspondence were consulted to complete the listings.

AMERICAN DEALERS

NAME	LOCATION	NO. OF RECORDED ACQUISITIONS	TRANSACTION YEARS	CATALOGUE ENTRY NUMBERS
William Van Rensselaer Abdill	Titusville, NJ	1	1926	
Adams (possibly Norman R. Adams)	Possibly Boston, MA	1	1930	
Alaquah (Alaquah Flood)	New York, NY	7	1924–26	
American Indian League	New York, NY	1	1924	
Amsterdam Art Gallery (Charles Strub & James T. Morgan)	New York, NY	78	1924–25	25, 32
Anthony Wayne Shop	Possibly Maumee, OH	4	1925	23
Arden Studios/Arden Galleries	New York, NY	67	1924–29	76
Armstrong	Norwich, CT	1	1927	
Art Alliance of America	New York, NY	3	n.d.	
Artcraft Galleries	New York, NY	4	1924–25	
Attic Treasure Shop (Frances Wolfe Carey)	Haddonfield, NJ	2	1925	
Jane E. B. Atwater (Scarsdale's Antique Shop)	Scarsdale, NY	10	1928	
Mrs. Baer	Unknown	1	1925	
Frederick C. Bassick	Bridgeport, CT	37	1928	51
William Baumgarten & Co.	New York, NY	19	1924–26	
Teina Baumstone (Early America)	New York, NY	4	1930	
M. Dawod Benzaria	New York, NY	1	1923	
Estelle Berkstresser	York, PA	98	1925–30	10, 31, 52, 72
Binder	Unknown	7	1924	
Brentano's	New York, NY	15	1924–25	
Mrs. Helen Bruce	New York, NY	12	1924–29	
Joseph Brummer	New York, NY	32	1924–30	
Buckley	Unknown	1	1926	
Elizabeth Burchenal	New York, NY	1	1930	
Burgard (possibly Louisa Burgard)	Possibly York, PA	3	1926–30	
Charles Burns	Mamaroneck, NY	37	1924–30	51, 87
Mrs. Campbell	New Rochelle, NY	14	1927–29	
Carvalho Brothers of Portugal (Alvaro R. and Abilio R. de Carvalho)	New York, NY	36	1925–27	
Catherine Chase	Brooklyn, NY	8	1925–27	87
Chaucer Head Book Shop	New York, NY	16	1924–25	
Childhood Incorporated	New York, NY	2	1930	
Children's Book Shop (Marian Cutter)	New York, NY	21	n.d.	
Norah Churchman	Philadelphia, PA	2	1930	24
Hugo Cipriani	New York, NY	2	1924	
J. E. Clark	Columbus, OH	2	1929	
Aaron Cohen	Kingston, NY	5	1926	
Mrs. (Florence L.) DeWitt Clinton Cohen	New York, NY	17	1924–30	
Coit	Unknown	1	1925	
Colby	Pennsylvania	1	1929	
Gilman Collamore	New York, NY	1	1925	
Colony Shops (John Ginsburg & Isaac Levy)	New York, NY	28	1924–35	41
J. M. Connor Jr.	Metuchen, NJ	1	1935	
W[illiam] F. Cooper	New York, NY	8	1927	40
Costello	Ohio	1	1927	
Cradle Antique Shop (Alice and Florence Licht)	Lodi, NY	1	1926	
Florence Ballin Cramer	Woodstock, NY	18	1925–27	69
W[arren] W[eston] Creamer	Waldoboro, ME	2	1932	
Cumming (possibly Rose Cumming)	Possibly New York, NY	2	1926	
A. L. Curtis & Co. (Alice L. and Dorothy Curtis)	Harrington Park, NJ	70	1924–26	

NAME	LOCATION	NO. OF RECORDED ACQUISITIONS	TRANSACTION YEARS	CATALOGUE ENTRY NUMBERS
Czechoslovak Art Shop	New York, NY	43	1925–28	
William A. Davis	Albany, NY	13	1926–29	10, 86
Thomas Dean	Dobbs Ferry, NY	9	1924	
Diane Del Monte	New York, NY	4	1924–25	
Disosway	Staten Island, NY	6	1926	58
Dodge (possbily Mary H. Dodge)	Possbily Pawling, NY	15	1925	72
Mrs. A[ileen] K. Dresser	New York, NY	11	1924–25	
Dudensing Gallery (F. Valentine Dudensing)	New York, NY	1	1925	
E. P. Dutton & Co.	New York, NY	13	1925	
Albert Duveen	New York, NY	1	1934	
Early American Antiques	Unknown	9	1925	10, 72
James Eham	Philadelphia, PA	2	1927	
Ehrich (Possibly Ehrich Galleries)	Possibly New York, NY	2	1924	
Elder	Unknown	1	n.d.	
Ann Elsey (French Provincial Antiques)	New York, NY	6	1927–28	9
Emerson	Philadelphia, PA	7	1927–30	79
English Antique Shop	New York, NY	3	1926	
Willoughby Farr	Edgewater, NJ	3	1926	
Fawcett	Unknown	1	1927	
Frankl Galleries (Paul T. Frankl)	New York, NY	1	1924	
Arthur F. Freeman	Quentin, PA	2	1928	
P. W. French & Co.	New York, NY	1	1924	
George W. Funk	New York, NY	1	1927	
Ernest R. Gee & Co.	New York, NY	4	1925–26	
Norman Gehri	Morristown, NJ	1	1935	
Miss Gheen, Inc. (Gertrude Gheen Robinson)	New York, NY	2	1924	
Guerin, Inc.	Washington, DC	2	1928	
Mrs. Flora Howard Haggard	Ridgefield, CT	6	1932	
Sumner Healey	New York, NY	156	1924–33	66
M[atthew] Holden	Jamaica, NY; Rye, NY	43	1926–30	36, 39, 40, 41, 50
Madge Farquhar Holstein	Great Neck, NY	5	1929	8
Home of Childhood (Sara P. Smart)	New York, NY	1	1925	
C[larence] Vandevere Howard	New York, NY	473	1924–31	27, 68, 70, 74, 80, 81
Howards of York ("Blue Spruce")	York, PA	7	1926	48
Howe's House of Antiques (Elmer C. Howe)	Boston, MA	37	1925–29	
Renwick C. Hurry	New York, NY	103	1924–32	8, 10, 11, 21, 48
Isabella Paxson Iredell	Painted Post, NY	2	1925	
Joffe Importing Co. (Meyer Joffe)	New York, NY	12	1924	
C[harles] K. Johnson	Greenwich, CT; Hurley, NY	7	1924–29	
H. Johnson	Unknown	2	1925	
John Barret Kerfoot and Annie Haight Kerfoot (House with the Brick Wall)	Freehold, NJ	7	1926	
Kirkham & Hall, Inc. (William Kirkham and Glenn Hall)	New York, NY	3	1927	
Samuel H. Laidecker	Shickshinny, PA	2	1928	
Nora Landis	York, PA	34	1926–30	
Larkin (possibly Charles Ernest Larkin)	Possibly Newburyport, MA	13	1924	
Ruth Webb Lee	Pittsford, NY	4	1929–30	
Richard W. Lehne	New York, NY	10	1930	
Mary Lent	New York, NY	4	1924–27	
C. F. Libbie & Co.	Boston, MA	7	1925–27	

NAME	LOCATION	NO. OF RECORDED ACQUISITIONS	TRANSACTION YEARS	CATALOGUE ENTRY NUMBERS
Jane White Lonsdale	New York, NY	1	1924	
Lord & Taylor, Inc.	New York, NY	1	n.d.	
Bernice Adams Loring	New Rochelle, NY	4	1927–28	
Louis XIV Antique Co.	New York, NY	1	1928	
Charles Woolsey Lyon	New York, NY	50	1924–30	10, 19
MacDonald	Unknown	1	1926	
Macy (possibly R. H. Macy & Co.)	Possibly New York, NY	1	1925	
Mallory's Antique Shop	New Haven, CT	2	1925–26	
Martha Jane's (Martha Jane Reed)	Marcellus, NY	4	1924–33	
Nancy McClelland	New York, NY	4	1924–30	30
McKearin's (George S., Helen A., and Katherine S. McKearin)	Hoosick Falls, NY; New York, NY	41	1924–29	7, 8, 77
Elinor Merrell	New York, NY	31	1929–30	
Merritt	Bronxville, NY	1	1929	
Meyer (Things Unique)	Unknown	4	1925	
Frans Middelkoop	New York, NY	6	1924–25	
Mills	Gloversville, NY	1	1929	
Martha Morgan	New York, NY	13	1927–28	
Charles R. Morson	New York, NY	4	1926	
Morton	Unknown	1	n.d.	
J. W. Needham's Antiques	New York, NY	10	1930	
J[ames] E. Nevil	Washington Court House, OH	9	1928–30	
Nichols & Hughes	Unknown	1	1925	
F. Noble Co. (Fred Noble and Joseph Lyons)	New York, NY	1	1926	
North Node Book Shop (Malcolm B. Schloss)	New York, NY	1	1925	
Oak Tree Studio (Ruth D. Knox)	Niagara Falls, NY	7	1925–27	
Florian Papp	New York, NY	4	1925	
Frank Partridge	New York, NY	1	1925	
Fred J. Peters	New York, NY	8	1930	
William H. Plummer & Co.	New York, NY	4	1926–30	
Polish Handicraft Shop	New York, NY	2	1924	
Pontil Mark Antique Shop (Mrs. French)	Wilkes-Barre, PA	1	1925	
Porter	Lincolnville, ME	1	1932	
W[illiam] P. Prentice	Elmira, NY	28	1928–30	34
Rand (possibly Edith Rand)	Possibly New York, NY	2	1924	
Martha de Haas Reeves	Philadelphia, PA; Haddonfield, NJ	44	1924–29	72
Mabel I. Renner	York, PA	55	1926–29	10, 77
Reyes	Unknown	6	1924–27	
Louis Richmond	Freehold, NJ	4	1926	
H. Rick	Unknown	1	1924	
Elsa Rogo	New York, NY	4	1925	10
Royston	New Bern, NC	4	1928–30	
Russian Peasant Art	New York, NY	1	1924	
Israel Sack	Boston, MA; New York, NY	2	1931–35	
The Sampler	Orleans, MA	4	1926	
Sara M. Sanders (Closter Antique Shop)	Closter, NJ	83	1924–29	10, 87
Schmitt Brothers	New York, NY	6	1925	
Dorothy Obermayer Schubart	New Rochelle, NY	12	1925–27	
S. Serota	New York, NY	5	1925–1935	
Nancy Shostac	New York, NY	1	1930	
Anna F. Snow	Buffalo, NY	1	1926	
Spanish Antique Shop	New York, NY	14	1925–27	

NAME	LOCATION	NO. OF RECORDED ACQUISITIONS	TRANSACTION YEARS	CATALOGUE ENTRY NUMBERS
Stair & Andrew	New York, NY	1	1925	
Marie Sterner [Lintott]	New York, NY	1	1926	9
Philip Suval	New York, NY; Southhampton, NY	13	1926–31	18, 45, 46
Henry Symons & Co.	New York, NY	3	1925	
Jane Teller	New York, NY	51	1924–25	
S[tanley] N. Thompson	New York, NY	1	1936	
R. W. Tiffany	Cambridge, NY	1	1927	
Todhunter, Inc. (Arthur Todhunter)	New York, NY	17	1924–31	
Madelon H. Tomlinson	Hoosick, NY	2	1927	47
C[atherine] M. Traver Co.	New York, NY	8	1924–26	
Mrs. (Lillian S.) Lawrence J. Ullman	Tarrytown, NY	2	1933	
Ulrich	Pennsylvania	1	1929	
Claude W. Unger	Pottsville, PA	33	1926	40, 41
Stephen Van Rensselaer (Sundial Shop, Wilson Tavern Shop, Crossroads)	New York, NY; Peterborough, NH	6	1924–26	
Arthur S[tannard] Vernay, Inc.	New York, NY	12	1924–30	
Mary D. Walker	Marion, MA	64	1925–35	77, 86
John Wanamaker, Inc.	New York, NY	5	1925	
Wernick	West Hartford, CT	4	1930	
West Point Shop	Unknown	3	1925	
E[rhard] Weyhe, Inc.	New York, NY	4	1925	
Wheeler	Unknown	1	1924	
Jemima Wilkinson Antique Shop (Florence W. Upson)	Dundee, NY	5	1928–29	
Williams	Unknown	3	1925	
Lenore Wheeler Williams	New York, NY	4	1928	
Max Williams	New York, NY	2	1923 or 1924	3
Katharine Willis	Jamaica, NY; Port Chester, NY	57	1924–30	33, 40, 44, 54, 84
H. J. Worthington	Doylestown, PA	1	n.d.	
York (possibly S. Elizabeth York)	Possibly Mattapoisett, MA	2	1924	

EUROPEAN DEALERS

NAME	LOCATION	NO. OF RECORDED ACQUISITIONS	TRANSACTION YEARS	CATALOGUE ENTRY NUMBERS
Michael Bauer	Nuremberg, Germany	40	1924–26	
Galerie R. Bertrand	Calais, France	6	1926	
Bouten	Bruges, Belgium	1	1933	
Charnoz	Paris, France	1	1927	
J. Doppler	Munich, Germany	3	1924	
Einstein	Probably Germany	2	1924	
James Falcke	London, England	21	1928–30	59
Fournier	Milan, Italy	3	1924	
Galerie Raspail	Paris, France	1	1927	
Gasperi	Probably Italy	5	1924	
Klasszis Corporation	Budapest, Hungary	147	1925–26	
Kovar	Probably Czechoslovakia	10	1928	
Siegfried Laemmle	Munich, Germany	26	1924–31	75
Lambert	Paris, France	1	1926	
Lasalle	Montreuil-sur-Mer, France	2	1926	
Lascialfari	Milan, Italy	4	1924	
Lenygon & Morant	London, England	1	1925	
G. Mouchel	Versailles, France	68	1927–31	70
Muller	Budapest, Hungary	2	1926	
Questa	Genoa, Italy	1	1924	
Rossi	Milan, Italy	14	1924	
Galerie Simon (André Simon)	Paris, France	1	1926	
Sutherland	Probably Canada	5	1925	
Vilmos Szilárd	Budapest, Hungary	45	1925–31	57
S. Tourrette	Boulogne-sur-Mer, France	1	n.d.	
Tuzin	Versailles and Limours, France	1	n.d.	
Moritz Wallach	Munich, Germany	19	1924	62

AUCTION HOUSES AND SELECTED SALES

American Art Galleries	New York, NY	144	1922–29	
Georges Spetz Museum Collection sale, January 1925		21		59
Raoul Tolentino sale, April 1924		35		
Raimundo Ruiz sale, February 1926		4		
Sumner Healey sale, December 1924		39		
Mr. and Mrs. G. G. Ernst sale, January 1926		12		48
Anderson Galleries	New York, NY	76	1923–30	26, 41, 53
Frederick W. Fuessenich sale, October 1925		19		28
Karl Freund sale, December 1930		11		
Clarke Art Galleries	New York, NY	48	1924–26	61
Raimundo Ruiz sale, May 1924		6		
"Vellorese" sale, April 1924		22		
Dobbs Ferry Sales Rooms	Dobbs Ferry, NY	3	1924	73
George F. Ives collection auction	Danbury, CT	46	1924	71
Silo's Auction Galleries	New York, NY	1	1925	
Walpole Galleries	New York, NY	144	1924–25	
Mrs. J. Killbourne Hayward sale, February 1924		36		
Sophy Von Holstein-Rathlou sale, March 1925		18		

The Museum

of

Folk Arts

Riverdale on Hudson
City of New York

Open Free to the Public on
Saturdays from 10 A. M. to 5 P. M.
Sundays from 2 P. M. to 5 P. M.

May 15, 1935

F128
AM3
.M51
1935

Advisory Committee
ALFRED H. BARR, Jr.
HOLGER CAHILL
RENE D'HARNONCOURT
FLORENCE N. LEVY
MRS. ELIE NADELMAN, *Director*

PREFACE

The Museum of Folk Arts was founded in 1926 by Mr. and Mrs. Elie Nadelman.

The Carnegie Corporation of New York, through a grant, has now made it possible to open this Museum regularly to the public.

It is the only Museum in existence which shows examples of both European and American Folk Arts. Among the countries represented are: The United States, England, France, Italy, Germany, Spain, Switzerland, Hungary, Austria, Yugoslavia and the Scandinavian Countries. The range of these collections makes it possible for visitors to appreciate the universal scope and importance of Folk Arts. Nowhere else can there be found such a wealth of material for comparative study.

The chief interest, however, of these collections lies in their aesthetic significance, and every one of these exhibits has been chosen with this object in view.

It is this Museum which has first shown American primitive paintings and sculpture because of their intrinsic artistic significance and of their importance in any total view of American Art.

By G. W. MARK, *Circa 1830*

WASHINGTON CROSSING THE DELEWARE

AN ABRIDGED GUIDE

GALLERY I

Early American Drug-Store — Case containing American flasks in rare colorings; 18th century Stiegel glass, three mould contact blown glass and Sandwich glass. Case containing American and European blown glass.

GALLERIES II AND III

American Collections: Furniture. Primitive paintings; historical subjects, portraits and still lifes. Hooked rugs. Pennsylvania plaster. Collections of Spatterware, Gaudy Dutch and King's Rose china.

GALLERY IV

Early French carved wardrobes. American candle dipper and drier. Carved mangle boards, wash beaters and whetstone holders from various European countries. Case containing carved cake moulds — American and European.

GALLERY V

American and English broad-sides and posters. Printing blocks for wood cuts. Printing blocks for materials.

GALLERY VI

Connecticut Connestoga wagon. Dutch and Norwegian sleighs. American wagon seats. American and European field bottles. Early American farm implements.

GALLERY VII

Wardrobes from Austria and Germany. Glass paintings from Czecho-Slovakia. Swiss, Spanish, German and Italian furniture. American, Spanish and German figure heads. American seamen's chests. Norwegian and German bridal chests. German, Swiss and French pewter.

GALLERY VIII

Pottery room. American, English, Spanish, French, Italian, Hungarian and German pottery from the 16th to the mid 19th centuries.

GALLERY IX

American and European dolls, pewter soldiers, toys, games and children's furniture.

GALLERY X

Needlework and textiles — American, German, French, Scandinavian, Hungarian, Czecho-Slovak, Spanish, Italian and Russian. Carved door from Normandy, France. Wood work from a house in Normandy. Early French drug store.

GALLERY XI

Hungarian Baroque bed and furnishings. Iron altar screen; Swiss. Case containing Religious objects: Nativities, Rosaries, Crucifixes. Case containing implements for weaving, lace making, sewing and knitting.

GALLERY XII

Important collection of European wrought iron from the 13th to the 19th centuries. Collections of various tools and planes.

GALLERY XIII

American and European weather vanes, knives and forks, pipes, snuff-boxes, and steel jewelry.

GALLERY XIV

Sculpture from various European countries, in stone, wood and alabaster; Romanesque, Gothic and early Renaissance. Examples of religious sculpture of the type seen in wayside shrines and provincial churches in Spain, France, Germany, Italy and Hungary, and a monumental Spanish Crucifixion group. Frieze representing a wedding celebration, painted in the characteristic style of the Swedish folk painters, 18th century.

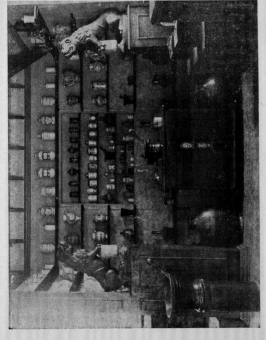

EARLY FRENCH PHARMACY

EARLY AMERICAN PORTRAIT By an Unknown Artist

"MARION FEASTING WITH A BRITISH OFFICER ON SWEET POTATOES"

By G. W. MARK

BY G. W. MARK

BEAR HUNT IN A SNOW STORM

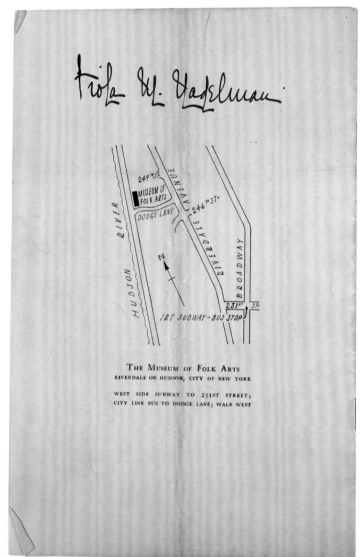

THE MUSEUM OF FOLK ARTS
RIVERDALE ON HUDSON, CITY OF NEW YORK

WEST SIDE SUBWAY TO 231ST STREET;
CITY LINE BUS TO DODGE LANE; WALK WEST

FREQUENTLY CITED SOURCES

Apple 1999
Apple, Mary Audrey. "German Toymaking: The Forgotten Antecedent." *Toy Chest* 33:3 (December 1999): 11–14.

Berman 2001
Berman, Avis, "Sculptor in the Open Air: Elie Nadelman and the Folk and Popular Arts," in *Elie Nadelman: Classical Folk*. Ed. Suzanne Ramljak. Exh. cat. New York: American Federation of Arts, 2001, 47–79.

Bernheim-Jeune 1920
Chez MM. Bernheim-Jeune & Cie., Paris. *Exposition Nadelman: sculptures et dessins*. Exh. cat. Paris, 1920.

Blackburn and Piwonka 1988
Blackburn, Roderic H., and Ruth Piwonka. *Remembrance of Patria: Dutch Arts and Culture in Colonial America 1609–1776*. Exh. cat. Albany: Albany Institute of History and Art, 1988.

Blood 1976
Blood, Judith. "American Tin Toys at the Abby Aldrich Rockefeller Folk Art Collection." *The Magazine Antiques* 110:6 (December 1976): 1300–5.

Clayton 2002
Clayton, Virginia Tuttle. *Drawing on America's Past: Folk Art, Modernism, and the Index of American Design*. Exh. cat. Washington, DC: National Gallery of Art in association with the University of North Carolina Press, 2002.

Comstock 1994
Comstock, H.E. *The Pottery of the Shenandoah Valley Region*. Chapel Hill, NC: University of North Carolina Press for the Museum of Early Southern Decorative Arts, 1994.

Cuisenier 1977
Cuisenier, Jean. *French Folk Art*. Trans. Thomas W. Lyman. Tokyo: Kodansha International, 1977.

Earnest and Earnest 1997
Earnest, Russell D., and Corinne P. Earnest. *Papers for Birth Dayes: Guide to the Fraktur Artists and Scriveners*. 2nd ed. 2 vols. East Berlin, PA: Russell D. Earnest Associates, 1997.

Fischer 2005
Fischer, David Hackett. *Liberty and Freedom*. New York: Oxford University Press, 2005.

Fletcher 2001
Fletcher, Valerie J., "Elie Nadelman: Art and Craft in Context," in *Elie Nadelman: Classical Folk*. Ed. Suzanne Ramljak. Exh. cat. New York: American Federation of Arts, 2001, 81–95.

Flower 1965
Flower, Milton E. *Wilhelm Schimmel and Aaron Mountz*. Exh. cat. Williamsburg, VA: Abby Aldrich Rockefeller Folk Art Collection, 1965.

Flower 1986
Flower, Milton E. *Three Cumberland County Wood Carvers: Schimmel, Mountz, and Barrett*. Carlisle, PA: n.p., 1986.

Garvan 1982
Garvan, Beatrice B. *The Pennsylvania German Collection*. Philadelphia: Philadelphia Museum of Art, 1982.

Haskell 2003
Haskell, Barbara. *Elie Nadelman: Sculptor of Modern Life*. Exh. cat. New York: Whitney Museum of American Art distributed by Harry N. Abrams, 2003.

Hollander 2001
Hollander, Stacy C. *American Radiance: The Ralph Esmerian Gift to the American Folk Art Museum*. New York: American Folk Art Museum in association with Harry N. Abrams, 2001.

Hollander and Anderson 2001
Hollander, Stacy C., and Brooke Davis Anderson. *American Anthem: Masterworks from the American Folk Art Museum*. New York: American Folk Art Museum in association with Harry N. Abrams, 2001.

Hornung 1972
Hornung, Clarence P. *Treasury of America Design: A Pictorial Survey of Popular Folk Arts Based upon Watercolor Renderings in the Index of America Design, at the National Gallery of Art*. 2 vols. New York: Harry N. Abrams, 1972.

Kertess 2001
Kertess, Klaus, "Clay Acting: The Late Works of Elie Nadelman," in *Elie Nadelman: Classical Folk*. Ed. Suzanne Ramljak. Exh. cat. New York: American Federation of Arts, 2001, 97–109.

Ketchum 1981
Ketchum, William C., Jr. *Toys & Games*. New York: Cooper-Hewitt Museum, 1981.

Kirstein 1973
Kirstein, Lincoln. *Elie Nadelman*. New York: Eakins Press, 1973.

Knoedler 1919
M. Knoedler & Co., New York. *Sculpture and Drawings by Elie Nadelman*. Exh. cat. New York, 1919.

Koke 1982
Koke, Richard J., ed. *A Catalog of the Collection, Including Historical, Narrative, and Marine Art*. 3 vols. New York: New-York Historical Society in association with G.K. Hall, 1982.

Lampe 2010
Lampe, Anne M. *Elie Nadelman and the Influence of Folk Art*. Exh. cat. Lancaster, PA: Demuth Museum, 2010.

Leipold, Leipold, and Bickert 2012
Leipold, Maria, Dieter Leipold and Susan Bickert. *Frühes Spielzeug aus Thüringen und dem Erzgebirge / Early Toys from Thuringia and the Erzgebirge Region*. Munich: Swantje-Koehler, 2012.

Lipman 1942
Lipman, Jean. *American Primitive Painting*. New York: Oxford University Press, 1942.

Lipman 1948
Lipman, Jean. *American Folk Art in Wood, Metal and Stone*. New York: Pantheon Books, 1948.

Lipman and Armstrong 1980
Lipman, Jean, and Tom Armstrong, eds. *American Folk Painters of Three Centuries*. Exh. cat. New York: Hudson Hills, 1980.

Lipman, Warren, and Bishop 1986
Lipman, Jean, Elizabeth V. Warren, and Robert Bishop. *Young America: A Folk Art History*. New York: Hudson Hills in association with the Museum of American Folk Art, 1986.

McClintock and McClintock 1961
McClintock, Inez B., and Marshall McClintock. *Toys in America*. Washington, DC: Public Affairs Press, 1961.

MFPA 1935
Museum of Folk and Peasant Arts. *The Museum of Folk Arts, Riverdale on Hudson, City of New York*. Riverdale, NY, 1935.

MFPA inventory
"Museum of Folk Arts," Typescript with handwritten notations, [1936–1937], NP.

Nadelman 2001
Nadelman, Cynthia, "Chronology," in *Elie Nadelman: Classical Folk*. Ed. Suzanne Ramljak. Exh. cat. New York: American Federation of Arts, 2001, 111–22.

Norton 2011
Norton, Louis Arthur. "The Bald Eagle as an American Icon." *Maine Antique Digest* 39:4 (April 2011): 26–27C.

N-YHS 2000
The New-York Historical Society. *Perspectives on the Collections of The New-York Historical Society: The Henry Luce III Center for the Study of American Culture*. New York: New-York Historical Society, 2000.

Oaklander 1992
Oaklander, Christine I. "Elie & Viola Nadelman: Pioneers in Folk Art Collecting." *Folk Art* 17:3 (Fall 1992): 48–55.

Olson 2008
Olson, Roberta J.M. *Drawn by New York: Six Centuries of Watercolors and Drawings at The New-York Historical Society*. Exh. cat. New York: New-York Historical Society in association with D Giles, London, 2008.

Parke-Bernet 1943a
Parke-Bernet Galleries, New York. "Arms and Armor from the Bashford Dean Collection . . . XV–XIX Century Wrought Ironwork Belonging to a N.Y. State Educational Institution," October 13–14, 1943.

Parke-Bernet 1943b
Parke-Bernet Galleries, New York. "Mid-European Folk Art and Utilitarian Articles," December 16, 1943.

Priddy 2004
Priddy, Sumpter. *American Fancy: Exuberance in the Arts, 1790–1840*. Exh. cat. Milwaukee: Chipstone Foundation, 2004.

Ramljak 2001a
Ramljak, Suzanne, ed. *Elie Nadelman: Classical Folk*. Exh. cat. New York: American Federation of Arts, 2001.

Ramljak 2001b
Ramljak, Suzanne, "The Sculptor of Poise: Elie Nadelman," in *Elie Nadelman: Classical Folk*. Ed. Suzanne Ramljak. Exh. cat. New York: American Federation of Arts, 2001, 11–45.

Rossiter 1962
Rossiter, Henry P. *M. & M. Karolik Collection of American Water Colors and Drawings, 1800–1875*. 2 vols. Boston: Museum of Fine Arts, 1962.

Rumford 1988
Rumford, Beatrix T., ed. *American Folk Paintings: Paintings and Drawings Other than Portraits from the Abby Aldrich Rockefeller Folk Art Center*. Boston: Little, Brown in association with the Colonial Williamsburg Foundation, 1988.

Sessions 2005
Sessions, Ralph. *The Shipcarvers' Art: Figureheads and Cigar-Store Indians in Nineteenth-Century America*. Princeton: Princeton University Press, 2005.

Stillinger 1994
Stillinger, Elizabeth. "Elie and Viola Nadelman's Unprecedented Museum of Folk Arts." *The Magazine Antiques* 146:4 (October 1994): 516–25.

Stillinger 2011
Stillinger, Elizabeth. *A Kind of Archeology: Collecting American Folk Art, 1876–1976*. Amherst, MA: University of Massachusetts Press, 2011.

Weiser and Heaney 1976
Weiser, Frederick S., and Howell J. Heaney. *The Pennsylvania German Fraktur of the Free Library of Philadelphia*. 2 vols. Breinigsville, PA: Pennsylvania German Society and Free Library of Philadelphia, 1976.

Wertkin 2004
Wertkin, Gerard C., ed. *Encyclopedia of American Folk Art*. New York: Routledge in association with the American Folk Art Museum, 2004.

PHOTOGRAPHY CREDITS

All objects from the New-York Historical Society Collections were photographed by Glenn Castellano; also Fig. 5 (right); Fig. 74; Fig. 91; Cat. VII; Cat. IX (right)

All works by Elie Nadelman © Estate of Elie Nadelman

All photographs from the Nadelman Papers © Estate of Elie Nadelman

Courtesy Addison Gallery, Phillips Academy, Andover, MA: Cat. III

Courtesy Amon Carter Museum, Fort Worth, TX: Cat. II

© Stefano Baldini / Bridgeman Images: Fig. 64

Bayerisches Nationalmuseum, Munich: Fig. 37; Fig. 82; Fig. 112

Courtesy of Beinecke Rare Book and Manuscript Library, Yale University, New Haven, CT: Fig. 57

BPK, Berlin / Staatliche Museen / Jürgen Liepe / Art Resource, NY: Fig. 65

© Christian Science Monitor, 1935: Figs. 14, 15, 17, 18; Fig. 104

Colby College Museum of Art, Waterville, ME: Cat. VIb

Culver Pictures, Inc.: Fig. 87

Photography by Isidore Dushman: Figs. 7, 11, 12

Fenimore Art Museum, Cooperstown, NY: Figs. 58, 59; Cat. 12, Cat. 15, photography by Richard Walker; Cat. 16, photograph by John Bigelow Taylor, NY, NY.

Getty Images / The *LIFE* Picture Collection, photography by W. Eugene Smith: Fig. 86; Endpiece

Harvard Art Museums / Fogg Museum, Imaging Department, photo © President and Fellows of Harvard College: Cat. IV

Hirshhorn Museum and Sculpture Garden, Smithsonian Institution, Washington, DC: Cat. VIa, Cat. VIc, photography by Lee Stalsworth

Courtesy of Historic New England. Photograph by David Bohl: Fig. 30

Jewish Museum, New York, NY: Cat. V

Erich Lessing / Art Resource, NY: Fig. 62

Library Company of Philadelphia: Fig. 49

© The Metropolitan Museum of Art, The Cloisters Collection, NY / Art Resource, NY: Fig. 45

© The Metropolitan Museum of Art Libraries & The Cloisters Library, NY / Art Resource, NY: Fig. 41

Courtesy of the Ministero dei beni e delle attività culturali e del turismo di Venezia: Fig. 61

Mondadori Portfolio / Electa / Arnaldo Vescovo / Bridgeman Images: Fig. 66

© Museum Associates / LACMA / Art Resource, NY: Fig. 78

© Museum of the City of New York: Fig. 46, photograph by Berenice Abbott; Fig. 111, photograph by Samuel H. Gottscho

Museum of Fine Arts, Boston, MA: Cat. 22; Cat. 23a, 23b, 23c; Fig. 97

© The Museum of Modern Art / Licensed by SCALA / Art Resource, NY: Fig. 79

National Gallery of Art, Washington, DC: Fig. 99

Photography by Joshua Nefsky: Fig. 81

From the Collection of the New York City Fire Museum, New York: Fig. 94

© The New York Public Library, Milstein Division of United States History, Local History & Genealogy: Fig. 5 (left)

© The New York Public Library, Astor, Lenox and Tilden Foundations: Fig. 56; Fig. 67; Fig. 80; Fig. 84, photograph by R.V. Smutny; Fig. 118; Fig. 119, photograph by Henri Cartier-Bresson [?]

Norsk Folkemuseum, Oslo: Fig. 38

Courtesy of Pennsylvania Academy of the Fine Arts: Fig. 33

Private collection: Fig. 83

Private collection / The Bridgeman Art Library: Fig. 92

Private collection. Photo courtesy of Hyland-Granby Antiques: Fig. 90

Private collection. Photography by Paul Waldman: Fig. 85

© RMN-Grand Palais / Art Resource, NY: Fig. 60; Fig. 77, photography by Hervé Lewandowski

© Shelburne Museum, Shelburne, VT: Fig. 39, photograph by Andy Duback; Fig. 108

Smithsonian Institution / Archives of American Art: Fig. 51

© Vanni Archive / Art Resource, NY: Fig. 63; Fig. 76

Wadsworth Atheneum, Hartford, CT: Cat. V

White Star Illustrated Photo Service: Fig. 36

Digital image © Whitney Museum: Fig. 110; Cat. VIII, photography by Jerry L. Thompson; Cat. IX (left)

INDEX
Page numbers in *italics* indicate illustrations and their captions

A

Abbott, Berenice (1898–1991), *64*, 65
Abby Aldrich Rockefeller Folk Art Museum, 30, 314
Abdill, William Van Rensselaer, 356
Acrobat (Elie Nadelman), 338, 348n.2
Adams (possibly Norman R. Adams), 356
Adams, John Quincy (1767–1848), 214
Addison Gallery of American Art, Phillips Academy, Andover, MA, 337
Aegina, pedimental sculptures Temple of Aphaia, 83, 105, *106*
Alaquah (Alaquah Flood), 61, 256
Alderbrook, Riverdale, NY, 13, *13*, 27, 38n.12, 38n.44, 41, 59, 65, 93n.31, 98–99, *99*, 103n.1, 103n.27, 120, 224, *314*, 315, 354
 attic with Elie's sculpture, *113*, 336, 338, 344, 348, *349*
 studio, 13, 110, 354
Allan, W. (active early nineteenth century), *119*
Charles Allerton & Sons (active ca. 1859–1942), 224, *225*
Allies of Sculpture exhibition (1917) Ritz-Carlton Hotel, New York City, 85, 338
 photograph by Paul Thompson, *339*, 339n.8
American Art Galleries, New York City, 59, 232, 360
 Georges Spetz Museum Collection sale (1925), 256, 360
 Mr. and Mrs. G.G. Ernst sale (1926), 232, 233n.5, 360
 Raimundo Ruiz sale (1926), 360
 Raoul Tolentino sale (1924), 360
 Sumner Healey sale (1924), 360
"American Drugstore" exhibit, MFPA, *20*, 21, 26, 35, 49, 236
Amon Carter Museum of American Art, Fort Worth, TX, 334
Amsterdam Art Gallery, New York City *see* Strub & Morgan
"Amusement" child's plate (English), 224, *225*
Anderson, Cornelius V. (1808–1858), 154, 155n.6
Anderson Galleries, New York City, 59, 61, 126, 132, 186, 190, 220, 242, 360
 Frederick W. Fuessenich sale (1925), 150, 151, 190, 360
Andrews, Edward Deming (1894–1964), 31, 49
animals and birds
 chalkware, 144–47
 earthenware, 218–19
 glass, 14, *15*, 41, *42*, 55n.18, 86, 110
 metal, 130–35
 wooden, 126–27, 136–39
Anne, Queen of England (1665–1714), 120
Anthony Wayne Shop, 176, 356
antique shops, 50, *56*, 61, 62, 63, 202n.2, 356, 357, 358
Aphaia, Temple of, pedimental sculptures, Aegina, 83, 105, *106*
Aphrodite of Knidos (Praxiteles), *84*, 85, *85*, 93n.11
Apollinaire, Guillaume (1880–1918), 84, 85, 106, 107, 113n.3
Apollo, bust (Skillin Workshop), 87, *88*, 93n.32
apothecary-related items, *20*, 21, 22, *24*, 26, 35, 49, 120, 236–37, 237n.1, 237n.2

Arden Studios/Arden Galleries, 300, 356
Armstrong, 211n.2, 356
Art Alliance of America, 61, 356
art and folk art, 17, 28, 44, 57, 59, 67, 68, 69, 71n.30, 74–76
Artcraft Galleries, 356
Arthur, Prince of Wales (1486–1502), 249
Arzouyan, Alexander (ca. 1873–1933), 59
At the Milliners (Chalon), *142*
Attic Treasure Shop (Frances Wolfe Carey), 356
Atwater, Jane E.B. (Scarsdale's Antique Shop), 356
auctions and auction houses, 43, 46, 50, 57, 59–60, 61, 62, 98, 103n.20, 186, 190, 360
Audubon, John James (1785–1851), 126
Augustus of Prima Porta (Roman), 89, *90*
Augustus with the Corona Civica (Roman), 87, *89*
Aulus Metellus ("The Orator") (Etruscan), 89

B

baby walker (European), 188, 188n.6, *189*
Baer, Mrs., 356
Bakewell, Pears & Co. (active 1842–1882), *236*, 237
baptism certificates *see* birth and baptism certificates
Barber, Edwin AtLee (1851–1916), 49, 212, 214, 215n.2, 233, 238, 239n.3
Barnard, George Grey (1863–1938), 14
Barr, Alfred H., Jr. (1902–1981), 28, 29, 102
J. Barton Smith Co. (active late nineteenth century), *326*, *327*
Bassick, Frederick C. (1876–1951), 238, 356
Baudelaire, Charles (1821–1867), 106–7
Bauer, Michael, 360
William Baumgarten and Co., 61, 356
Baumstone, Teina (Early America), 62, 356
Bayerisches Nationalmuseum, Munich, Germany, 51, *52*, 83, 109, 287n.9
Beauport, Gloucester, MA, 13, 41–42, *43*, 55n.18, 103n.9, 238
Beaux, Cecilia (1855–1942), 16
bellows toys *see* squeak toys
Benzaria, M. Dawood, 61, 356
Berkstresser, Estelle (b. ca. 1879), 66, 144, 146, 147n.8, 147n.10, 196, 240, 292, 356
Betrothal Celebration of Miss Frances Taylor and Her Fiancé (Young), *174*, 175
Binder, 356
The Birds of America (Audubon), 126
birth and baptism certificates or records, 75, 176, 178, 180n.9, 183–84, 186
 Catharina König (Mayer), *181*, 183
 Chonerath Jost (Ritter), *182*, 184
 Friederich Rottenberger, of Berks County, PA (Speyer), *176*, 179
 Johannes Seybert (Speyer), 180n.9
 Joseph Flor (Starck and Lange), *182*, 183, 184
 Maria Catherine Ziegenfus (unidentified American fraktur artist), *114*, 179, *179*
 Maria Magdalena Kaup (unidentified American fraktur artist), 75, *75*
 see also marriage certificates
Birth of Venus (Botticelli), 332, 333n.11
Blair, Mrs. J. Insley (Natalie K.) (1887–1951), 33, 35, 59, 65
Bonaparte, Napoleon (1769–1821), 306
Boni, Albert (1892–1981), 13

bonnet stands *see* milliner's heads
Botticelli, Sandro (1445–1510), 332
bottles
 glass (European), 234, *235*
 Indian Queen bitters bottle (Whitney Brothers Glass Works), 238–39, *239*, 239n.5
 Kossuth figured bottle or calabash (American), 238, *239*, 239n.3, 239n.5, 239n.7
 medicine (American), *236*, 237
 nursing bottle (unidentified maker), 240, 240n.2, *241*
 ring (American), 209, *209*, 211, 211n.5
Bouché, Louis (1896–1969), 16, 45
Le boulevardier (Elie Nadelman), *108*
Bouten, 360
Bowers, Jonathan (1825–1894), 126, 128, 129n.1
bowls
 earthenware (S. Miller), 216, *217*
 Mocha ware (English), 232, *233*, 233n.3
Bowman flag, 268, 269n.6
boxes
 bandbox (American), 202, *203*
 earthenware (American), 216, *217*
 keepsake box (European possibly Hungarian), 260, *260*, *261*, 261n.1, 261n.3, 261n.6
 sewing box (American), 254–55, *255*, 255n.7
 tramp art (American), 204, *205*
 see also chests; coffers; snuffboxes
boxes, painted, 66
 bride's box (German), *40*, 196, *197*
 dome-topped (American), 200, *200*, 200n.6, *201*
 marriage box or *coffret de mariage* (French), 194, *195*
 slide-lid (European, probably Swiss), 198, 198n.3, *199*
Brancusi, Constantin (1876–1957), 59, 142, 338
brass objects, 45, *132*, 186n.6, 204, 254, 255n.4, 272, 280, *281*
Brentano's, 356
Brewster, Sir David (1781–1868), 246
Brooklyn Museum, New York, 27, 30, 39n.69, 98, 102
Brooks, Thomas V. (1828–1895), *119*, 120
Brown, George W. (1830–1889), 322, *323*, 324
Bruce, Mrs. Helen, 61, 356
Brummer, Ernest (1891–1964), 57, 71n.6, 86
Brummer, Joseph (1883–1947), 14, 30, 39n.69, 39n.94, 57–59, 61, 62, 71n.6, 71n.25, 356
Brummer Gallery, New York City, 58, 59, *59*, 71n.6, 86, 93n.22
Buckley, 356
Burchenal, Elizabeth, 356
Burgard (possibly Louisa Burgard), 356
Burns, Charles, 238, 240, 326, 356
bust of a woman (chalkware, American), 65, 148, *149*, 350
Bust of a Woman (Elie Nadelman), 350, *351*
Bust of a Young Man (Roman), 87, *89*
butter prints and molds, 26, *33*, 66, 292, 293n.8, 293n.9, 293n.14, 293n.15
 eagle design (American or European), 292, *293*, 293n.13
 heart and leaves design (American or European), *293*

palm tree and initials design (American or European), 292, *293*, 293n.3
six-part radial and inscription double-sided design (American or European), 292, *292*, *293*, 293n.11, 293n.12
six-part radial design and eight flowers design (American or European), 292, *293*, 293n.6
urn with plant and five tulips design (American or European), 292, *293*, 293n.5
Byron, George Gordon, 6th Baron Byron (1788–1824), 290

C

Cahill, (Edgar) Holger (1887–1960), 27, 28, 29, 38n.23, 70, 103n.30
cake prints and molds, 49, 60, 68, 101, 286, 287n.8, 287n.11, 288, 290n.3, 290n.7, 290n.10, 290n.12, 348
 allegory of Greek independence design (American), 288, *289*, 290, 290n.14
 fire engines double-sided design (American), 290, 290n.16, 290n.17, *291*
 Lafayette design (American), 288, *289*
 Tirggel mold with circus and entertainment scenes (Swiss), *285*, 286, 286n.1, 348
 see also cookie molds
Calligraphic Horse (possibly Sutes), 172, *173*
Campbell, Mrs., 356
Canova, Antonio (1757–1852), 83
Carey, Frances Wolfe (Attic Treasure Shop), 356
Carnegie Corporation, 29, 49, 50, 100, 102
Carvalho Brothers of Portugal, 61, 63, 356
cast iron objects, 67, 276, *277*, 326–27
Caswell, Mrs. L.B., Jr. (1858–1949), 206, 208
Catherine of Aragon (1485–1536), 249
Catherine of Siena, Saint (1347–1380), 260, 261n.4
Celebrating Couple: General Jackson and his Lady (Young), *174*, 175
Cellist (Violincelliste) (Elie Nadelman), 340, 342n.6
Ceres bust (Skillin Workshop), 87, *88*, 93n.32
Le chahut (Seurat), 344
chair, miniature (American), 310, 310n.4, *311*
chalkware, 21, 60, 65, 66, 69, 89–90, 110, 138, 138n.2, 144–49, 147n.1, 147n.3, 147n.5, 218, 336n.13, 340, 354
Chalon, John James (1778–1854), *142*
Chambers, William Bell (1855–1925), 242
Chanteuse (Elie Nadelman), *109*
Chapman, Carlton T. (1860–1925), 126
Charnoz, 360
Chase, Catherine, 326, 356
Chase, Miss Lenox E. (1893–1975), 316, 317n.4
Chaucer Head Book Shop, 356
chest of drawers, miniature (German), 308, *309*
chests
 with drawers or trinket box (European), 191, *193*, 193n.3
 Pennsylvania German (American), 186, 186n.4, *187*
 Swiss (unidentified maker), 184, *185*
 see also coffers
Chichester, Henry (ca. 1762–1849), 216

Child in White Dress Holding Toy Spaniel (American), *305*
Childhood Incorporated, 61, 356
Children's Book Shop (Marian Cutter), 61, 356
Churchman, Norah (1881–1950), *182*, 356
"Cigar Store Indians," *119*, 120, *120*
Cipriani, Hugo, 356
Circus Girl (Elie Nadelman), 336n.6, *347*, 348, 348n.4, *349*
 maquette, 348, *348*
Circus Performer (Elie Nadelman, Colby College Museum of Art version), *347*, 348, 348n.5, *349*
Circus Performer (Elie Nadelman, Hirshhorn Museum version), *346*, 348, *349*
circus performers, 36, *319*, 321, 326, *327*, 348
 sculptures by Elie Nadelman, 107, *112*, 286, 315, 321, 346–48, 348n.2, 353, 354–55
Le cirque (Seurat), 344
"Le Cirque d'Hiver," Beaux-Arts Charity Ball (1923), 16
Clark, Francine Clary (1876–1960), 103n.35
Clark, J.E., 356
Clark, Robert Sterling (1877–1956), 103n.35
Clark, Stephen Carlton, Sr. (1882–1960), 37, 54, 93n.32, 102, 103n.35, 150, 151n.1, 158, 160
Clarke Art Galleries, New York City, 59, 61, 260, 261n.6, 360
 Raimundo Ruiz sale (1924), 59, 261n.6, 360
 "Vellorese" sale (1924), 360
classical art
 folk art relationship, *82*, 85, 86–90, *88*, 92, 120, 122
 influence on modern art, 105, 106
 sculpture of Elie Nadelman, 83, 84, 85, 93n.2, 93n.4, 105, 106, 107–8, 111, 330, 332, 340, 348, 350, 353
Cleveland, Grover (1837–1908), 216
Clinton, DeWitt (1769–1828), 155, 155n.11
Clinton Engine Company No. 41 fire engine condenser case (American), 90, 92, *153*, 154, 155, 155n.10
clothespins (unidentified makers), 266, 266n.1, *267*
Codman, Martha *see* Karolik, Martha Codman
coffers, betrothal (European), *191*, 191–92, *192*, *193*, 193n.1, 193n.10
Cohen, Aaron, 356
Cohen, Mrs. Florence L. DeWitt Clinton, 356
Colby, 356
Colby College Museum of Art, Waterville, ME, 346
Collamore, Gilman, 61, 356
collectors and collecting, 77–78, 80
 folk art in America, 14, 17, 30, 31, 41, 42–47, 49–50, 54, 59–60, 65, 69, 77–80, 87, 121n.3, 143, 196, 200, 202, 268
Colony Shops (Ginsburg & Levy), 63, 211n.2, 218, 262
Colt, 356
Columbus, Christopher (1451–1506), 272
Colyar, Pauline M. (1873–1928), 169n.3

Commeraw, Thomas W. (active ca. 1797–1819), *210*, 211, 211n.7
"compass artist," Lancaster County, Pennsylvania, 200
Conger, John (1803–1869), 288
Connor, J.M., Jr., 356
cookie mold (European), *284*, 286, 286n.1
 see also springerle cookie molds; cake prints and molds
Cooper, W[illiam] F., 216, 356
copper objects, 45, *54*, *132*, *133*, 135n.1, 272
Cornwallis, Charles, 1st Marquess Cornwallis (1738–1805), 288
Costello, 356
coverlets, 35, 98, 246, 246n.1, 246n.3
Covill, Herbert Eugene (1854–after 1930), 162, *163*
cow creamers
 earthenware (American), 230, *231*, 231n.10
 earthenware (English), 228, 228n.1, *229*, 231n.10
 silver, 228, 228n.8
Cradle Antique Shop (Alice and Florence Licht), 356
craft and folk art, 69, 77, 95, 252, 280, 294
Cramer, Florence Ballin (1884–1962), 50, 69, 103n.37, 280, 280n.2, 356
Cramer, Konrad (1888–1963), 50, 69, *99*
Creamer, W[allace] W[eston], 356
The Cries of New York (S. Wood), *148*, 148n.5, 317
Crolius, Clarkson, Sr. (1773–1843), 21–22, 67, 206, *206*, *207*, 208, 208n.5, 208n.6, 209, *209*, 211
Cubism, 85, 179, 296, 338
Cumming, Rose, 61, 356
Cummings, Charles Amos (1823–1911), 168
Curtis, Alice L (A.L. Curtis American Antiques), (b. 1860), 66, 356
Curtis, Dorothy (A.L. Curtis American Antiques) (1890–1979), 66, 356
Czechoslovak Art Shop, 62, 63, 357

D
Dancer (Danseuse) (Elie Nadelman, Jewish Museum version), *343*, 344–45, 345n.11
 maquette, 345, *345*
Dancer (Danseuse) (Elie Nadelman, Wadsworth Atheneum Museum version), *344*, 344–45
 maquette, 345, *345*
Danjard, Louis (active 1860–1882), 143n.4
Davies, Arthur B. (1863–1928), 85
Davis, Joseph H. (1811–1865), 92, 170, *171*
Davis, William A., 144, 146, 357
De Chirico, Giorgio (1888–1978), 142
De Oliva, Pepita (stage name of Josefa Durán y Ortega, 1830–1871), 122, 125n.3, 125n.4
dealers, 30, 50, 57, 60–63, 65–70, 356–60
 see also named dealers
Dean, Thomas, 357
Del Monte, Diana, 357
Delafield estate, Riverdale, NY, 13
Delasser, Yolande (b. 1903)
 Index of American Design watercolors 138n.5, *206*, 208, 217n.5, 219n.8
Delaunay, Robert (1884–1941), 296
Demuth, Charles (1883–1935), 45
Demuth, William (1835–1911), 121n.16
dendritic ware, 232–33

Dickens, Charles (1812–1870), 121n.10
Diederich, Hunt (1884–1953), 16
Dilworth, Thomas (d.1708), 184
Dioscuri (Horse Tamers of Monte Cavallo), 90, *92*
dishes
 earthenware (probably A.E. Smith), 216, *217*
 sgraffito ware (Troxel), 67, 214, *215*, 215n.2
 Staffordshire ware (English), 222, *223*
Disosway, 357
Dobbs Ferry Sales Rooms, 360
Dodge, Mary H., 292, 357
Dodge family, Middletown, NY, 206, 208
"The Dog of Alcibiades," 93n.31
dollhouse miniatures, 95, 310
 furniture, 308, *309*, 310, *311*
 pottery, 226–27
dolls, 67, 69, 95, 312, *313*, 314–17
doll's cradles, 310, 310n.3
 possibly Swiss, 310, 310n.2, *311*
door with ironwork, St.-Léonard-de-Noblat, Haute-Vienne, *64*, 65, 71n.25, 276
Doppler, J., 360
Doryphoros (Spear Bearer) (Polykleitos), 83
Downing, Andrew Jackson (1815–1852), 38n.12
Downtown Gallery, 70, *70*, 166
Drake, Alexander W. (1843–1916), 45, *45*, 46, 55n.18, 202
Draped Standing Female Figure (Elie Nadelman), *111*
Dresser, Mrs. A[ileen] K., 357
Du Pont, Henry Francis (1880–1969), 29–30, 36, 39n.62, 51, 53, 60, 65, 129n.1, 206
Dubois, Oliver (ca. 1790–1860), *77*
Duchamp, Marcel (1887–1968), 55n.19
Dudensing Gallery (F. Valentine Dudensing), 357
Dunikowski, Xawery (1875–1964), 109
Dutton, E.P., 61, 357
Duveen, Albert, 357
Dyott, Thomas W. (1771–1861), 238

E
eagle architectural ornament (American), 130, *131*
eagle motif in folk art, 90, 92, 93n.41, 126–28, 130–31, 136–37, 138, 172, 292–93
eagles (carved wooden figures by Schimmel), 136, *137*, 138
The Eall [sic Fall] of Man (R. & W.S.), *183*, 184
Early American Antiques, 144, 146, 292, 357
earthenware, 66, 212
 glazed, 224–25
 lead-glazed, 214–19, 222–23, 226–33
 tin-glazed, 220–21
East Ninety-third Street, New York City, 13–14, *14*, *15*, 16, 27, 38n.13, 38n.14, 39n.80, 41, 86, 98, 238
Eberly, Jacob Jeremiah (1830–1908), 216–17
J. Eberly & Co. (active 1874–1903), 216–17, *217*
Eham, James (ca. 1841–1930), *56*, 67, *67*, 357
Ehrich Galleries, 61, 357
Einstein, Charles (Viola's first stepfather), 95–96, 103n.5

Einstein, 360
Elder, 357
ell rules (German), 264, *265*
Elsey, Ann (French Provincial Antiques), 61, 62, 140, 142, 357
Emerson, 308, 357
English Antique Shop, 61, 63, 357
Equestrienne or *Ecuyère de cirque* (Elie Nadelman), 348, 348n.2
Excelsior (riverboat) pull toy, 322, *323*

F
face jugs (American), *35*, 37, 212, *212*, *213*, 213n.8, 213n.9, 218
Falcke, James, 256, 360
The Fall of Man (R. & W.S.), *183*, 184
"Fancy ware" *see* Rockingham ware
Farr, Willoughby (b. 1883), 357
Farrow, William (active 1815–1834), 288, 290n.9
Fawcett, 357
Fawkes, Francis (1721–1777), 230
Federal Art Project (WPA), 28, 29, 103n.30
Fenimore Art Museum, Cooperstown, NY, *88*, 150, 151n.1, 151n.3, 158, 160, 160n.3
Fenton, Christopher Webber (1806–1865), 230
Ferris, Oscar C. and Ada Woodworth, 38n.12
Field, Hamilton Easter (1873–1922), 38n.5, 42–44, 46, 55n.11, 340
Fine Points of Furniture (A. Sack), 76
Fire Chief Harry Howard (American), 37, 87, 89, 116, *117*, 118n.3, 118n.4, 118n.7, 118n.8
fire engine condenser cases, 90, 93n.38, 152–55, *154*, 155n.1, 155n.2, 155n.3, 155n.5
fireboards, 158–59
 "Bear and Pears" design (American), 158, *159*
The Fireman: The Nobleman of Our Republic (Strong), *154*
The First of May (Den Ersten Maÿ) (American), *178*, 179
Flannery, Aileen (b. 1902, Viola's daughter), 11, 96, *96*
Flannery, Joseph A. (1874–1915, Viola's first husband), 11, 96, 103n.6
Flannery, Viola (b. 1898, Viola's daughter), 11, 38n.4, 96, *96*
flasks
 Flora Temple figured flask (Whitney Brothers Glass Works), 238, *239*, 239n.5, 239n.9
 George Washington figured flask (Kensington Glass Works), 238, *239*, 239n.5, 239n.6
 mermaid (English), 230, *231*
Fogg Museum, Harvard Art Museums, Cambridge, MA, 340, 342
folk art
 as art, 17, 28, 44, 57, 59, 67, 68, 69, 71n.30, 74–76
 classical art relationship, *82*, 85, 86–90, *88*, 92, 120, 122
 as craft, 69, 77, 95
 European, 11, 17, 29, 50–51, 67–68, 93n.4, 95
 influence on modern art, 11, 29, 46–47, 86, 142

Elie Nadelman's art and sculpture, 11, 86, 105, 108–9, 110–11, 286, 304, 314, 321, 326, 334, 336, 336n.13, 338, 340, 342, 348, 350, 354
terminology, 17, 30, 47, 65, 71n.30, 76–77
and tradition, 11, 69, 73–74
see also folk art in America; Museum of Folk and Peasant Arts
folk art in America, 11, 14, 17, 29, 73, 76, 80
and African Americans, 37, 67, 211, 212, 218, 326
classical symbolism, 86–87, 237
collectors and collecting, 14, 17, 30, 31, 41, 42–47, 49–50, 54, 59–60, 65, 69, 77–80, 87, 121n.3, 143, 196, 200, 202, 268
European influences, 11, 17, 23, 26, 29, 36, 45, 49, 120, 269
patriotic motifs, 82, 86, 87, 92, 93n.41, 126, 130, 136, 150, 151, 154, 156, 162, 172, 211, 214, 238
Force, Juliana (1876–1948), 17, 47
The Four Seasons (Elie Nadelman), 83, 106, 330, 330, 331, 332n.1
Fournier, 360
frakturs, 36, 37, 66, 75, 75, 114, 174, 176, 176–84, 177, 178, 179, 186
see also birth and baptism certificates or records; marriage certificates
Frankl, Paul T. (1886–1958), 69, 71n.65, 332n.4, 357
Frankl Galleries, 69, 357
Franklin, Benjamin (1706–1790), 224
Franklin's maxims child's plates (English), 224, 225
Frederick the Great, King of Prussia (1712–1786), 306
Freeman, Arthur F., 357
"French Apothecary" exhibit, MFPA, 22, 24, 26, 49, 236
P.W. French & Co, 61, 357
French folk art, 21, 22, 24, 26, 49, 63, 64, 65, 69, 140–43, 194–95, 236, 250–51, 320
Fuessenich, Frederick W. (1886–1973), 150, 151, 190
Funk, George W., 357
Funk, Wilhelm (Heinrich) (1866–1949), 97, 103n.15
furniture see dollhouse miniatures; Pennsylvania German folk art; Shaker; types of furniture

G
"Le gai violiniste" mechanical toy (Martin), 319, 321, 340
Galerie Bernheim-Jeune, 13, 102, 334, 339n.11, 344, 345, 348, 348n.2
Galerie E. Druet, 83, 84, 85, 106, 340
Galerie R. Bertrand, 360
Galerie Raspail, 360
Galerie Simon (André Simon), 360
Gambier factory (active 1780–1926), 274, 274n.4, 275
games, 95, 298
kakelorum marble game (European), 298, 298n.3, 299
Gardner, Isabella Stewart (1840–1924), 168
Gasperi, 360
Gaudy Dutch ware see Staffordshire pottery
Ernest R. Gee & Co., 357
Gehri, Norman, 357

German Expressionism, 184
German folk art, 22, 68–69, 196, 197, 248, 249, 264–65, 298, 304, 306, 308, 320, 321
Ginsburg, John see Colony Shops
Girl in Yellow Dress (American), 176, 179
Girl's Half-Length Torso (Elie Nadelman), 112
glassware, 234, 234n.1, 238 see also types of glassware
Gleason, William B. (1824–1886), 30, 87, 125n.15, 125n.18, 129n.3
Glyptothek, Munich, Germany, 83, 105, 106
Golberg, Mécislas (1869–1907), 86, 110, 113n.8
Greenwood, Edna (1888–1972), 31, 49–50, 51
Grider, Rufus Alexander (1817–1900), 269n.2
Guerin, Inc., 357
Günthermann, Siegfried (d. 1886), 319
Gussow, Bernard (1881–1957), 98

H
Hagedorn, Friedrich von (1708–1754), 180n.11
Haggard, Mrs. Flora Howard, 357
Hall, Michael and Julie, 74, 78–79, 80
Halls, John H. (active early twentieth century), 334, 336n.8, 336n.9, 336n.10, 336n.11, 342n.4
Halpert, Edith Gregor (1900–1970), 27, 30, 31, 39n.68, 39n.74, 53–54, 70, 70, 71n.70, 164, 246n.4
Halpert, Samuel (1884–1930), 14
Hamilton, Sir William (1751–1801), 151n.5
Harding, Chester (1792–1866), 166
d'Harnoncourt, René (1901–1968), 18, 28, 38n.34, 103n.30
Hartley, Marsden (1877–1943), 13
Harvard Art Museums, Cambridge, MA, 340, 342
Hayward, Mrs. J. Kilbourne (Phoebe Pamela Martin) (1866–1948), 59
Hazelius, Artur (1833–1901), 17, 50, 237n.1
Head of a Man (Elie Nadelman), 84, 85
Head of a Woman (Fernande) (Picasso), 93n.12
Healey, Sumner (1871–1936), 61, 62, 63, 64, 65, 129n.1, 236, 270, 272, 357
Hearst, William Randolph (1863–1951), 98
Helena Rubinstein salons, 71n.65, 106, 330, 330, 332, 332n.4, 333n.7
Helleu, Paul-César (1859–1927), 96, 97, 103n.12
Hemphill, Herbert Waide (1929–1998), 74, 78, 80
Henry, Edward Lamson (1841–1919), 202
Hess, Loeb (ca. 1831–1895), 95
Hewitt, Edwin, 158
Hewitt, Mattie Edwards (1869–1956), 109, 334, 334, 338, 342, 345, 348, 348
Hicks, Edward (1780–1849), 157n.3
Hildebrand, Adolf von (1847–1921), 83, 105
Hirshhorn Museum and Sculpture Garden, Smithsonian Institute, Washington, DC, 336, 336n.6, 336n.14, 346
Holden, Matthew (1863–1938), 67, 206, 208, 209, 211n.2, 214, 216, 217n.4, 218, 236, 237, 357
Holstein, Madge Farquhar, 138, 357

Home of Childhood (Sara P. Smart), 61, 357
Host (Elie Nadelman), 334, 338, 339n.1, 339n.2
household objects, wooden, 21, 26, 48, 262, 262, 263n.6, 266–67, 288, 294–95
Howard, C[larence] Vandevere (1877–1959), 61, 62, 62, 63, 71n.18, 71n.21, 185, 188, 193n.5, 262, 277, 278n.6, 284, 290n.12, 296, 308, 310, 312, 357
Howard, Harry (1822–1896), 116
statue, 37, 87, 89, 116, 117, 118n.3, 118n.4, 118n.7, 118n.8
Howard, William (active 1806–1809), 211, 211
Jonathan Howard & Company, 132, 135
Howards of York ("Blue Spruce"), 232, 357
Howe's House of Antiques (Elmer C. Howe), 270, 272, 357
Hudson Engine Company No. 1 fire engine condenser case (American), 152, 154, 155n.6, 155n.9
Hull and Stafford (active 1866–1880s), 324
Hungarian folk art, 22, 68, 252–53, 260–61, 268–69, 269, 290n.12
Huntington, Anna Vaughn Hyatt (1876–1973), 16
Hurry, Renwick C. (1874–1954), 61, 62, 63, 65, 71n.27, 138, 144, 148, 148n.1, 172, 232, 290n.12, 350, 357

I
image peddlers, 146, 148, 148
Index of American Design (WPA), 102, 126, 138, 138n.5, 216, 219n.8, 290n.16, 305n.1, 314, 320, 321n.2
inkwell (Crolius, Sr.), 209, 209, 211
Inness, George (1825–1894), 97
The Invention of Art (Shiner), 74
The Invention of Craft (Adamson), 77
The Invention of Tradition (Hobsbawm and Ranger), 73, 74
Iredell, Isabella Paxson, 357
iron and metalwork, 22–23, 25, 36, 54, 98, 103n.22, 130–35, 276–79 see also tinned objects
J. Issmayer, 318
Ives, George F. (1864–1923), 60, 146
auction of collection, Danbury, CT, 59–60, 132, 144, 146, 203n.5, 288, 290n.11, 360
Ives Manufacturing Company (1868–1932), 324

J
Jackson, Andrew (1767–1845), 214
fraktur, 174, 175
sgraffito dish, 214, 215
ship's figurehead, 128
James and Sarah Clark Tuttle (J.H. Davis), 92, 170, 171, 171n.5
James I, King of England (James VI of Scotland) (1566–1625), 169n.10
jars, show (Bakewell, Pears & Co.), 236, 237
Jarvis, John Wesley (ca. 1781–1839), 155n.11
Jewell, Alvin L. (d. 1867), 134–35
Jewish Museum, New York City, 343
Joffe Importing Co. (Meyer Joffe), 357
Johnson, Brother Theodore E. (d. 1986), 255
Johnson, C[harles] K, 357
Johnson, H., 357

jugs
stoneware (Commeraw), 209, 210, 211, 211n.6
stoneware (W. Howard), 211, 211
see also cow creamer; face jugs; Toby jugs
jumping jack (probably English), 312, 312n.4, 313

K
Karfiol, Bernard (1886–1952), 14, 41
Karolik, Martha Codman (1858–1948), 178, 179
Karolik, Maxim (1893–1963), 54, 87, 174, 176, 178, 179, 180n.5
Kensington Glass Works (active 1816–1838), 238, 239
Kerbs & Spiess, 95, 95, 121n.1, 273n.2
Kerfoot, John Barret and Annie Haight (House with the Brick Wall), 357
Keyes, Homer Eaton (1875–1938) (The Magazine Antiques), 28, 101
Kirkham & Hall, Inc. (William Kirkham and Glenn Hall), 61, 357
Kirstein, Lincoln (1907–1996), 16, 36, 58, 83, 86, 93n.32, 103n.21, 180n.5, 314, 332, 332n.1, 334, 344, 354
Klasszis Corporation, 252, 253n.5, 360
knitting sheaths (English and French), 256, 257, 257n.7, 257n.8
M. Knoedler & Co., 85, 108, 334, 336n.1, 336n.5, 338, 339n.11, 340, 342n.2, 342n.6, 345, 348, 348n.2, 353
Kossuth, Lajos (Louis) (1802–1894), 238
Kovar, 360
Krüger, Paul (1825–1904), 274n.1
Kuniyoshi, Yasuo (1893–1953), 14, 41, 47, 49

L
lace bobbins (Hungarian), 68, 252, 253, 253n.1
lacemaker's pillows (tambours de dentellière), 250
French, 250, 250, 251, 251n.1
German (possibly), 250, 251n.2
Lady Liberty and Washington painted window shade (American), 82, 87, 90, 150, 151
Laemmle, Carl (1867–1939), 71n.56
Laemmle, Siegfried (1863–1953), 68–69, 71n.56, 251n.2, 258, 259n.9, 298, 360
Laemmle, Walter (1902–1996), 298
Lafayette, Marquis de (Gilbert du Motier de La Fayette) (1757–1834), 288
La Guardia, Fiorello (1882–1947), 29
Laidecker, Samuel H., 357
Lambert, 360
Landis, George Diller and Henry Kinzer, 49, 266n.1
Landis, Nora G., 324n.3, 357
Lang, George S. (1799–after 1883), 157n.3
Lange, Daniel (b. 1783, partnership with Starck 1807–15), 182, 183, 184
Larkin (possibly Charles Ernest Larkin), 357
Lasalle, 360
Lascialfari, 360
Laurent, Robert (1890–1970), 42, 46, 340
Learning to See (Gowans), 75
Lee, Henry, III (1756–1818), 151
Lee, Ruth Webb (1894–1958), 357
Leeds Pottery, England, 232
Lehne, Richard W., 63, 357
Lent, Mary, 357
Lenygon & Morant, 360

Levy, Isaac *see* Colony Shops
Lewyn & Martin, 204, 204n.4, *205*
C.F. Libbie & Co., 357
Liberty/Liberté installation (F. Wilson), 37
Lind, Jenny (Johanna Maria) (1820–1887), 122
Lindner, Johann Simon: toy catalogue, 304, *304*, 306, 306n.4
Lipman, Jean (1909–1998) and Howard (1905–1992), 55n.37, 134, 135, 159n.1
Lonsdale, Jane White, 358
Lord & Taylor, Inc., 358
Loring, Bernice Adams, 358
Louis XIV Antique Co., 61, 358
Lyman, Fenton & Co. (active 1849–52), 230, *231*, 231n.2
Lyon, Charles Woolsey (1872–1945), 59, 62, 144, 166, 290n.12, 358

M

MacDonald, 358
Macy (possibly R.H. Macy & Co.), 358
Made with Passion (Hartigan), 78
Madison, Dolley (1768–1849), 148, 148n.6
The Magazine Antiques, 28, 33, 71n.17, 101, 136, 178, 196, 222, 288, 290n.18, 326
Mallory's Antique Shop, 358
Man in a Top Hat (Elie Nadelman), 350, *352*, 353
Man in the Open Air (Elie Nadelman), 107, *108*
Manet, Édouard (1832–1883), 27, 122
mangle board (Northern European), *69*, 262, *263*
Mark, Francis Wilson (1852–1927), 220
Mark, George Washington (1796–1879), 156, *157*
marriage certificates, 176, 178
 Johannes Lein and Margretha Leinin (American), *177*, 179
Martha Jane's (Martha Jane Reed), 358
Martin, Fernand (active 1887–1919), *319*, 321
match safe (French), *271*, 272, 273n.13
Matisse, Henri (1869–1954), 44, 59, 338
Mayer, Salomon (active 1792–1811), *181*, 183
McClelland, Nancy Vincent (1877–1959), 61, 62, 194, 358
McKearin's (George S., Helen A. and Katherine S.), 136, 138, 211n.6, 234, 302, 304, 358
mechanical banks, 326–27, 327n.9
mechanical toys, 318–21, 340 *see also* mechanical banks
Memories (Henry), 202
Menzel, Adolf (1815–1905), 125n.4
Mercer, Dr. Henry (1856–1940), 47, 49
Merrell, Elinor (1905–1993), 61, 62, 358
Merritt, 358
metalwork *see* iron and metalwork
Metropolitan Museum of Art, New York City, 30, 39n.72, *64*, 71n.25, 77, 97, 98, 102
Meyer (Things Unique), 358
Michelangelo Buonarroti (1475–1564), 84
Middelkoop, Frans, 61, 262, 358
Miller, Solomon (1832–1916), 216, *217*
milliner's heads, 69, 110, 140, *141*, 142–43
Mills, 358
Miss Gheen Inc. (Gertrude Gheen Robinson), 61, 357
Mocha ware, 232–33, *233*

Modern Artists of America, 14, 38n.16, 41
modernism, 11, 45, 70, 86, 142, 334, 336, 338, 340
Monsanto, Louis M. (b. ca. 1849), 122, 124, 125n.17
Morgan, James T. *see* Strub & Morgan
Morgan, Martha, 358
Morse, Samuel F.B. (1791–1872), 166
Morson, Charles R., 61, 211n.2, 358
Mouchel, G., 284, 360
mourning pictures, 172, 249
 Henrietta Schnip, *247*, 249, 249n.7
Mrs. Joseph Flannery (Funk), 97, *97*, 103n.15
Mrs. Joseph Flannery (Helleu), *96*, 97, 103n.12
Muller, 360
Müller, Hippolyte (1865–1933), 250
Munich, Germany, 11, 44, 51, *52*, 68, 69, *69*, 83, 105
Murphy, Kevin, 86
Museum of Fine Arts, Boston, 37, 54
 Karolik Collection, 174, 176, 178–79, *180*
Museum of Folk and Peasant Arts (MFPA), later Museum of Folk Arts, 11, 14, *16*, 17–31, 38n.31, 38n.34, 55n.27, 105, 110, 147n.10
 architectural blueprints, 17, 18, *18*, 19, 100
 collection labels, 36, *36*, 39n.91
 curatorial cards, 57, *58*, 59, 63, 69, 71n.3, 71n.4, 209, 220n.2, 246
 financial problems, 27–30, 49, 110, 143n.11, 228
 Galleries, 18, 20–27, 190, 191, 209, 212, *212*, 220, 228n.8, *232*, 233, *363–64*
 Gallery I (glassware and American Drugstore), *20*, 21, 26, 234, 234n.5, 236, 238, *238*, 240, 242, *363*
 Gallery II (American Collections), *20*, 146, 186n.5, 190, 200, *363*
 Gallery III (American Collections), *21*, 156, 164, 166, 170, *363*
 Gallery IV (furniture and wooden household objects), 21, 26, *48*, 262, *262*, 263n.6, 288, 296, *363*
 Gallery V (wooden objects and paintings), 21, 162, *363*
 Gallery VI (wagons and farming equipment), 26, *26*, 280, *363*
 Gallery VII (American and European furniture and wooden objects), 21, *22*, 116, 122, *122*, 125n.9, 126, 154, 185, *363*
 Gallery VIII (American and European pottery), 21, *23*, 71n.4, 208, 209, 211n.1, 212, *212*, 214, 216, 218, 220, 226, 228n.8, 230, *232*, 233, *364*
 Gallery IX (toys), 22, *24*, 136, 138, 188, 191, 218, 224, 226, 300, 304, 310, 312, *364*
 Gallery X (French Apothecary and textiles), 22, *24*, 26, 142, 143n.5, 236, 254, *364*
 Gallery XI (textiles and sewing tools), 22, 254, 256, 264, *364*
 Gallery XII (iron and metalwork), *25*, 134, 276, *364*

Gallery XIII (iron and metalwork and tobacco-related items), 23, *25*, 38n.35, 130, 134, 160, 272, 276, *364*
 Gallery XIV (European sculpture and decorative arts), 23, *25*, *364*
 guide, 17–18, 28, *28*, 38n.48, 164, *361–67*
 inventories, 18, 21, 38n.34, 38n.35, 57, 116, 122, 126, 129n.3, 146
 New-York Historical Society acquires collection, 31–37, 38n.31, 53, 111
 renamed Museum of Folk Art, 28–30, 38n.1
 sale of items by Nadelmans, 29–30, 39n.62, 39n.68, 39n.69, 39n.72, 53–54, 110
 Viola as manager and director, 17, 41, 51, 100–101
Museum of Modern Art (MoMA), 28, 102, 166, 340, 342, 353

N

Nadelman, Elie (1882–1946), *10*, *12*, *100*
 artwork
 art, 11, 69, 85, 93n.11, 102, 103n.27, 135, 321n.9
 drawings, 13, 59, 85, 93n.11, *101*, *134*, 135, 321n.9, 333n.12, 344, 353
 sculpture, 11, 13, 14, 53, 83–85, 93n.8, 106, 107–11, 336n.1, 342n.5
 bronze, 93n.12, 103n.35, 108, 109, 110, 334, 336n.5, 338, 345n.9, 350, 353
 ceramic, 110–11, 315, 354
 circus performers, 107, 286, 315, 321, 346–48, 348n.2, 353, 354–55
 classical influences, 83, 84, 85, 93n.2, 93n.4, 105, 106, 107–8, 111, 330, 332, 340, 348, 350, 353
 electroplated busts (galvano-plastique), 110, *112*, 353
 folk art as a possible influence, 11, 86, 105, 108–9, 110–11, 286, 304, 314, 321, 326, 334, 336, 336n.13, 338, 340, 342, 348, 350, 354
 maquettes, 334, 336, 336n.12, 340, 345, 348, 353
 marble, 103n.35, 106, 109, 353, 354
 papier-mâché, 44, 304, 354
 plaster, 44, 83, 85, 93n.12, 107–8, 120, 125n.12, 142–43, 332, 332n.1, 334, 336, 336n.1, 336n.4, 338, 339n.2, 339n.11, 340, 340n.1, 345, 348, 348n.2, 353, 354 *see also* maquettes
 terracotta, 83, 330
 wood, 108–10, 120, 121, 121n.8, 124, 125n.12, 142, 332, 333n.12, 334, 336, 336n.11, 338, 339n.4, 340, 342, 342n.9, 344, 345, 345n.12
 see also named artworks
 biographical details, 11, 16, 37, 44, 53, 57, 99, 102, 103n.25, 105–6, 107, 120
 clubs, social and professional, 14, 38n.16, 41

collections, 13, 14, 17, 41, 57, 58
 classical art, 86, 93n.21, 93n.22
 folk art, 11, 13–14, 16, 17, 27, 32, 35, 36, 44, 45, 47, 49, 50, 57, 65, 80, 85–90, 92, 98, 105, 110 *see also* MFPA
 and the N-YHS, 31–32, 33, 35–36, 39n.86, 39n.90, 39n.91, 53, 204
 sale of items, 30, 39n.69, 53–54, 101–2
 sources, 57–63, 65–70
 marriage to Viola, 13, 38n.4, 41, 98, 99, 110
 financial problems, 36, 38n.43, 68, 100, 110, 143n.11, 218
 houses *see* Alderbrook; Beauport; East Ninety-third Street
 social life, 13, 14, 16, 55n.19
 travels, 13, 14, 16, 36, 50, 51, 55n.34, 57, 68, 102, 272, 276
 patriotism, 87, 93n.31, 130, 155n.4, 156, 162, 194, 211, 340
 travels (before marriage), 11, 44, 83, 84, 105–6, 107, 296, 334, 344
Nadelman, (E.) Jan (1922–2007), 14, 50, 85, 100, *100*, 102, 103n.1, 103n.27, 224
Nadelman, Viola Spiess Flannery (1878–1962), *10*, *12*, *96*, *97*, *100*, *101*
 biographical details, 11, 49, 95–97, 98–99, 103n.4, 103n.25, 103n.27
 collections, 13, 14, 17, 41, 120
 classical art, 93n.22
 folk art, 11, 13–14, 16, 17, 32, 36, 41, 45, 47, 49, 50, 57, 65, 80, 86–90, 92, 98 *see also* MFPA
 and the N-YHS, 31
 sale of items, 30, 37, 39n.69, 39n.70, 53–54, 55n.37
 sources, 57–63, 65–70
 textiles and related tools, 17, 97–98, 110, 142, 254, 258, 266
 manager and director of MFPA, 17, 41, 51, 100–101
 marriage to Elie, 13, 38n.4, 41, 98, 99, 110
 financial problems, 36, 38n.43, 68, 100, 110, 143n.11, 218
 houses *see* Alderbrook; Beauport; East Ninety-third Street
 social life, 13, 14, 16, 55n.19
 travels, 13, 14, 16, 36, 50, 51, 55n.34, 57, 68, 102, 272, 276
 patriotism, 87, 93n.31, 130, 156, 162, 194, 211
Naselli, Count Girolamo (Consul General of Italy, 1902–1906, Viola's second stepfather), 96
J.W. Needham's Antiques, 61, 358
Needle and Bobbin Club, 41, 97–98, 254, 258
needlecases, 68, 258–59, 259n.4, 259n.9
needlework *see* textiles
Neoclassical style, 83, 87, 93n.2, 106, 151, 154
Nevil, J[ames] E., 358
A New Guide to the English Tongue (Dilworth), 184
The New Teapot Drawing Book, 232, 233n.9
New-York Historical Society (N-YHS)
 Nadelman collection, 31–37, *32*, *33*, *33*, *34*, 38n.31, 39n.90, 39n.91, 50, 53, 73, *73*, 111
 European objects, 36, 39n.94, 39n.95

sale of part of collection, 36, 39n.94, 39n.95, 71n.25
 see also named examples of folk art
Nadelmans, relationship with, 31–32, 33, 35–36, 39n.86, 50, 53, 204
staff members, 35, *35*
New York State Historical Association, 37, 54, 102, 150, 160
Newark Museum, 27, 102, 103n30, 121n.3
Newsam, Albert (1809–1864), 155n.11
Nichols & Hughes, 358
Nietzsche, Friedrich Wilhelm (1844–1900), 83
Nike (Paionios of Mende), 89, *90*, 93n.34
F. Noble Co. (Fred Noble and Joseph Lyons), 358
Nordiska Museet, Stockholm, Sweden, 17, 38n.23
Norsk Folkemuseum, Oslo, Norway, 13, 50–51, *53*
North Node Book Shop (Malcolm B. Schloss), 61, 358
nursing bottles, 240–41, 240n.4, 240n.5

O

Oak Tree Studio (Ruth D. Knox), 67, 358
O'Brian, E. (early nineteenth century), 268, *268*, 269n.4
Oehme, Carl Heinrich (1796–1876), 308
Ogunquit (Maine) School of Painting and Sculpture, 14, 42, 46–47
Orchestra Conductor (Chef d'orchestre) (Elie Nadelman), 334, *335*, 336, 336n.4, 336n.5
 maquette, *334*
Out of the Attic (Greenfield), 75
Outing on the Hudson (American), 30, 69

P

Pach, Walter (1883–1958), 85
Page, Lewis (d. 1881), 304, 305n.4
paintings, 21, 22, 27, 29, 30, 90 *see also* frakturs; named paintings; portraits
Paionios of Mende (active ca. 430–420 B.C.), 89, *90*, 93n.34
paper dolls (Canadian), *72*, 316, 316–17, *317*, 317n.1, 317n.2, 317n.3, 317n.5, 317n.6
Papp, Florian (1883–1965), 61, 358
Paris, France, 11, 13, 14, 44, 57, 84, 102, 105–7, 113, 179, 272, 274, 296, 334, 344, 353
Parke-Bernet Galleries, New York City, 36, 39n.94, 39n.95, 71n.25, 222, 246n.3
Partridge, Frank, 61, 358
Paths to Heaven and Hell (G.S. Peters), *183*, 184
Peale, Charles Willson (1741–1827), 151
pearlware, 226, 227n.8
"peasant art," use of term, 17, 30, 71n.30, 76–77
Pease, David Mills and family, 294, *295*
Peaseware (David Mills Pease and family), 294
Pelican Feeding Her Young (American), 179, *180*
Pennsylvania German folk art
 boxes, 196, 200
 chalkware, 21, 146, 147n.1, 147n.3, 218
 earthenware pottery, 214, 216, 218, 222
 frakturs, 75, *75*, 174, *176*, 176–84, *177*, *178*, *179*, *180*, *181*, *182*, *183*, 186
 furniture, 186, *187*

Pentlarge, Alice (1895–1990), 314, 316, 317n.5
People of Plenty (Potter), 79–80
Peters, Fred J., 61, 62, 63, 358
Peters, G.S. [Gustav Samuel] (b. 1793), *183*, 184
Pettin, Rappaport & Ubl, 334, 336n.10
pharmacy museums, 236, 237n.1
Piano Player (Pianiste) (Elie Nadelman), *104*, 321, 334, 336, 340, *341*, 342
 maquette, 340, *342*, 342n.1
Picasso, Pablo (1881–1973), 44, 59, 84–85, 93n.12, 135, 142, 348
Picnic at Bedford Hills (Florine Stettheimer), *46*, 55n.19
Pigna (Pinecone) fountain, Rome, 90, *91*
Pinelli, Bartolomeo (1771–1835), 287n.10, 317n.10
pipes, figural (Gambier factory), 274, 274n.1, *275*, 275n.7, 275n.8
pitchers
 Mocha ware (English), 232–33, *233*
 spouted (Crolius, Sr.), 21–22, 67, 206, *206*, *207*, 208, 208n.1, 209
 Toby pitcher (Lyman, Fenton & Co.), 230, *231*
Planck, Max (1858–1947), 83
Ernst Plank Company (active 1866–1935), *319*
plates, children's, 224, *225*, 286, 316
William H. Plummer & Co., 58
Poland, 11, 16, 44, 51, 105, 109, 334
Polish Handicraft Shop, 358
Polk, James K. (1795–1849), 214
Polykleitos (active fifth century BC), 83
Pontil Mark Antique Shop (Mrs. French), 358
Porter, 358
Porter, Rufus (1792–1884), 158
Portrait of a Woman (R.W. Shute and possibly S.A. Shute), *165*, 165n.6
Portrait of a Woman (S.A. Shute and/or R.W. Shute), 164, *164*, 165
portraits, 27, 29, 30, 59, 69, 76, 90, 92, 164–71, 169n.8
pottery *see* earthenware; stoneware
powder flask (Hungarian), 268–69, *269*
powder horns, 268, 269n.1, 269n.3
 Australian (O'Brian), 268, *268*
Pratt ware, 228, 228n.4
Praxiteles (active fourth century BC), 83, 106, 107, 353
Prentice, W[illiam] P., 202, 324n.3, 358
Pseudo-Otto Artist (active ca. 1773–1809), *181*, 183
pull toys, 166, *168*, 306, 322–23
Pyne, Percy Rivington (1820–1895), 38n.12

Q

Questa, 360
quilts, 98, 246, 246n.1, 246n.3, 246n.4
 Seek No Further or Many Mansions pattern (American), *244*, 246, 246n.6
 Sunburst pattern (American), *245*, 246

R

R. & W.S. (nineteenth century), *183*
Rand (possibly Edith Rand), 358
Rapport, Joseph (N-YHS), *35*, 212
Ray, Man (1890–1976), 59
Reeves, Martha de Haas (1898–1984), 292, 293n.14, 358
religious objects (Christian), 22, 23, *25*, 68, 98, 101, 103n.23, 103n.31, 134

Remmey, John, III (1765–after 1831), 211
Renner, Mabel I. (1884–1958), 67, 144, 146, 302, 358
Reyes, 358
Richmond, Louis, 358
Rick, H., 358
Riemenschneider, Tilman (ca.1460–1531), 109, *110*
Ringmaster (Elie Nadelman), 353
Ritter, Johann (1779–1851), *182*, 184
Robb, John M. (1859–1937), 121, 336, 336n.11, 342n.4
Robb, Samuel A. (1851–1928), *119*, 120, 121, 121n.16
Robb, William (1895–1983), 121, 336, 336n.11, 342n.4
Rockefeller, Abigail "Abby" Aldrich (Mrs. John D. Jr.) (1874–1948), 30, 54, 70, 71n.70, 246n.4
rocking horse (Swiss), 300, 300n.1, *301*
Rockingham ware, 230–31, 231n.2
Rodin, Auguste (1840–1917), 83, 353
Rogo, Elsa, 144, 146, 358
Rolfe, Professor Alfred G. (1860–1942), 214
rolling pins, 242, 243n.11, 243n.12
 glass (English, probably Sunderland), 242, *243*, 243n.3
Rooster (drawing by Elie Nadelman), *134*, 135
Rosenthal, Albert (1863–1969), *31*
Rossi, 360
Rosso, Medardo (1858–1928), 353
Rousseau, Henri (1844–1910), 158
Royston, 358
Rubinstein, Helena (1870–1965), 71n.65, 106, 330, 332, 332n.1, 332n.4, 333n.7
Ruiz, Raimondo, 59, 261n.6
Ruppert, Jacob (1842–1915), 38n.13
Russian Peasant Art, 358

S

Sack, Israel, 71n.17, 358
Sackville-West, Lionel (1827–1908), 125n.3
Sackville-West, Vita (1892–1962), 125n.3
Saint James the Greater (Riemenschneider), *110*
Salon des Indépendants, Paris, France, 84, 107, 344
The Sampler, 358
samplers, 249, 249n.1
 Ana Asensio, *247*, 249
 Christiane Bauer, *248*, 249
 German (unidentified maker), *94*, *248*, 249
 see also mourning pictures
Sanders, Sara M. (Closter Antique Shop) (b. ca. 1882), 66, 144, 146, 211n.2, 217n.4, 326, 358
sarcophagi (Roman), 90, *91*
Savage, Edward (1761–1817), 151n.5
Savery, Rebecca Scattergood (1770–1855), 246
Scarsdale's Antique Shop (Jane E.B. Atwater), 356
Schimmel, Wilhelm (1817–1890), 92, 136, *137*, 138, 138n.4, *139*
Schley, Admiral Winfield Scott (1839–1911), 237n.2
Schley, Dr. Fairfax (1823–1903), 237, 237n.2, 237n.4
Schmitt Brothers, 61, 358
Schnakenberg, Henry (1892–1970), 17, 47
School Art League, 27–28, 29, 100
Schopenhauer, Arthur (1788–1860), 83

Schubart, Dorothy Obermayer, 358
Schuppe, John (active 1753–73), 228
Scott & Fowles Gallery, New York City, 338, 342, 342n.9, 345, 345n.12, 350, 353
Sculpture of Elie Nadelman (1925), Scott & Fowles Gallery, 338, 342, 342n.9, 345, 345n.12, 350, 353
Sears, Willard T. (1837–1920), 166, 168
 portrait by Stock, 27, 59, 90, 166, *167*, 168
Seated Woman (Femme assise) (Elie Nadelman), 70, *70*, *337*, 338, *338*, 339n.4, 339n.10, 339n.13
 maquette, 334, 338, *338*
secretary desk (American), *76*
Serota, S., 61, 358
Seurat, Georges (1859–1891), 84, 108, 344
Seward, William H. (1801–1872), 126
sewing bird, 254, *255*, 255n.6
sewing box (American), 254–55, *255*, 255n.7
sewing tools, 254
sgraffito ware, 67, 214–15
Shaker objects, 31, 47, 86, 255, 266n.2
Sheeler, Charles (1883–1965), 47, 49
Shelburne Museum, Vermont, 30, 54, *54*, 102, 202, 202n.2
Shepard Hardware Company (1862–present), 326, *327*
ship's figureheads, 65, 87, 89, 122, 124, 125n.6, 125n.8, 125n.15, 125n.17, 126, 128, 129n.3
 American Indian (American), *128*
 Andrew Jackson, 128
 eagle (American), 126, *127*, 128, 129n.3, 129n.5
 Jenny Lind, 122
 "Maria Spatz," 21, 124, 125n.18, 129n.3
 "Minnehaha" (Gleason), 30, 87, 125n.15, 125n.18, 129n.3
 "Rosa Isabella" (German), 21, 89, 122, *122*, *123*, 124, *124*, 125n.12, 125n.18, 129n.3, 338
shop figures, 87, 110, 118–20, 121n.5, 204, 239, 272, 336, 340, 348
 Highlander tobacco figure (Allan), *119*, 120, 272
 Indian maiden tobacco figure (possibly Robb workshop), *119*, 120–21, 121n.16
 Sailor tobacco figure (probably Brooks workshop), *119*, 120
 see also trade signs
Shostac, Nancy, 358
Shute, Dr. Samuel Addison (1803–1836), 164, 164–65, *165*, 165n.3
Shute, Ruth Whittier (1803–1882), 164, *164*, 165, *165*, 165n.3
Silo's Auction Galleries, New York City, 360
Skansen, Stockholm, Sweden, 17, 38n.23, 50, 236, 237n.1
Skillin, John (1745–1800), 87, *88*
Skillin, Simeon Jr. (1756–1806), 87, *88*
Slaves (Michelangelo for Tomb of Pope Julius II), 84
Sleeper, Henry Davis (1878–1934), 13, 41–42, *43*, 55n.18, 96, 103n.9, 238
slip marbling, 232–33, *233*
Sloan, John (1871–1951), 14
Smith, Asa E. (1798–1880), 216, *217*, 217n.4
Smith, David M. (1809–1881), 266

smoking-related objects *see* tobacco-related objects
Snow, Anna F., 358
snuffboxes, 120, 272
 horn (British possibly Scottish), *271*, 272, 273n.9
 wood (American and French), *271*, 272, 273n.10, 273n.12
Spanish Antique Shop, 61, 63, 358
Spanish folk art, 220–21, *247*, 249
Spetz, Georges (1844–1914), 256, 360
Speyer, [Georg] Friederich (active ca. 1774–1801), *176*, 178–79
Spiess, Amelia Hess (b. 1855, Viola's mother), 95, 103n.5
Spiess, Louis (1843–1878, Viola's father), 95, 120, 121n.1, 272, 273n.2
Spinario (Thorn Puller) (Praxiteles), 83
Spring (plaster relief by Elie Nadelman), 332, 332n.1, 333n.12
springerle cookie molds, 286, 286n.3, 286n.5
squeak toys, 146, 302–4, *305*, 305n.4, 310, 354
Staffordshire pottery, England, 148, 218, 222–23, 222n.1, 222n.2, 222n.3, 224, *225*, 226–27
Stair & Andrew, New York City, 61, 359
Standing Woman in Hat (Elie Nadelman), *109*
Starck, Johan (active early nineteenth century, partnership with Lange 1807–15), *182*, 183, 184
Stein, Gertrude (1874–1946), 14, 44, 84, *85*, 93n.11, 340
Stein, Leo (1872–1947), 14, 44, 84–85, *85*, 93n.11, 340
Sterner, Marie (later Lintott) (1880–1953), 69, 140, 143n.6, 359
Stettheimer, Carrie (1869–1944), 45, 46, 55n.19, 107
Stettheimer, Ettie (1875–1955), 45, 46, 55n.19, 103n.4, 107, 350
Stettheimer, Florine (1871–1944), 45, 46, *46*, 55n.19, 107
Stevens & Brown (active 1869–1880), 320, 321, 322
J. & E. Stevens Co. (active 1843–1930s), 322, 326, *327*
Stiegel, Henry William (1729–1785), 234
Stiegel glass, 234, 234n.4, 234n.5, 238, 240
Stieglitz, Alfred (1864–1946), 13, 107
Stock, Joseph Whiting (1815–1855), 27, 59, 90, 166, *167*, 168, 169n.5, 169n.9
stoneware, 21–22, 36, 67, 69, 92
 alkaline-glazed, 212–13
 salt-glazed, *77*, 206–11
Stoss, Veit (ca.1450–ca.1533), 109
T.W. Strong, publisher, *154*
Strub, Charles (Karl) (1879–1954), 63, 71n.21, 185, 185n.3, 198, 356
Strub & Morgan, 63, 71n.22, 185, 185n.2, 198, 356
Stuart, Gilbert (1755–1828), 148n.6
Sully, Thomas (1783–1872), 156
Sunderland glass, England, 242, *243*, 243n.6
Sutcliffe, Arthur T. (1876–1973), 17, 103n.28
 architectural blueprints, 17, 18, *18*, 19
Sutes, James (active mid-nineteenth century), 172, *173*
Sutherland, 360

Sutherland family, Quebec, Canada, 316, 317n.4
Suval, Philip (1866–1942), 62, 63, 164, 165n.1, 226, 228, 228n.3, 359
Swan, Dr. James (1794–1846), 166
Swiss folk art, 22, 36, 63, 185, *185*, 193n.5, 290n.12
Henry Symons & Co., 61, 359
Szilárd, Vilmos, 68, 71n.48, 252, 253n.5, 253n.6, 290n.12, 360

T
Tanagra figurines, 83, 93n.22, 106, *107*, 330, 332, 354
Tango (drawing by Elie Nadelman), 321n.9
Tango (Elie Nadelman), *320*, 321, 334
Tanguay, Eva (1878–1947), 344
Tarrant, Stanley C. (b. ca. 1887), 353, 353n.5
tea and coffee sets, miniature (English, Staffordshire or Leeds), 226, *227*, 228n.3, 310
Teller, Jane (ca. 1881–1949), 67, 240, 266n.1, 359
textiles and sewing tools, 17, 22, 97–98, 110, 142, 254, 258 *see also* knitting sheaths
Thompson, S[tanley] N., 61, 211n.2, 237, 237n.4, 359
Thorvaldsen, Bertel (1789–1839), 93n.2
Three Midnight Stories (Drake), *45*, 55n.18
Tiffany, R.W. (b. 1886), 359
tiles, earthenware (Spanish), 220–21
Time Stone Farm, Marlborough, MA, 31, *51*
tin toys, 318, *319*, 322–25
tinned objects, 200, *200*, *201*, 280–83, 322–23, 324, *325*
tobacco-related objects, 35, 37, 121n.2, 204, *270*, *271*, 272
 shop figures, 119–21, 204, 239, 272, 340
 tobacco grinder (European, possibly French), *270*, 272, 273n.8
 see also pipes; snuffboxes
Toby jugs, 230, *231*, 231n.7
Todhunter, Inc. (Arthur Todhunter), 63, 359
Tomlinson, Madelon H., 230, 359
Toulouse-Lautrec, Henri de (1864–1901), 348
Tourrette, S., 360
toy shops, 308, *309*
toy soldiers (German), 306, 306n.3, *307*
toy village (German), 308, *309*
toys, 22, *24*, *34*, 35, 37, 68, 95, 138, 166, 218, 300–313 *see also* cast iron objects; dollhouse miniatures; dolls; games; mechanical toys; tin toys
trade signs, 120, 160, 162
 "Briant Hall" boot and shoemaker (American), 160, *161*
 "Ye Boston Baked Beans" (Covill), 162, *163*
 see also shop figures
tradition and folk art, 11, 69, 73–74, 122, 134, 166, 174, 178, 186, 198, 214, 250, 256, 260, 276, 298, 310, 320
tramp art, 204, 204n.1, 204n.3
C[atherine] M. Traver Co., 359
Tree of Life (Elie Nadelman), 334
Trego, Jonathan K. (1817–1901), 173n.3
Trego, William T. (1858–1909), 173n.3
Troxel, Samuel (1803–1870), 67, 214, *215*
Tuttle, James (1777–1852), 170, 171n.1
 portrait by J.H. Davis, 92, 170, *171*

Tuttle, Sarah Clark (1779–1840), 170, 171n.1
 portrait by J.H. Davis, 92, 170, *171*
Tuzin, 360
Tweed, William M. (1823–1878), 326
Two Circus Women (Elie Nadelman), *112*
Two Women (Two Acrobats) (Elie Nadelman), 354, *355*

U
Ullman, Mrs. (Lillian S.) Lawrence J., 246n.3
Ulrich, 359
Unger, Claude W. (1882–1945), 216, 218, 359
Untitled (Two Acrobats) (Elie Nadelman), *328*, 354, *355*

V
Van Rensselaer, Stephen (Sundial Shop, Wilson Tavern Shop, Crossroads), 62, 211n.2, 238, 359
Vaudevillistes (Elie Nadelman), 348n.2
Vaux, Calvert (1824–1895), 38n.12
Arthur S[tannard] Vernay, Inc. (1877–1960), 359
Vichy, Gustave (1839–1904), 320
Vier Jahreszeiten (Four Seasons), 332, *332*
Viola Nadelman (drawing by Elie Nadelman), *101*
Volkskunsthaus Wallach, Munich, Germany, 69, *69*, 262

W
Wadsworth Atheneum Museum of Art, Hartford, CT, 343
wafer iron (European, possibly French or Swiss), 277, *278*, 278n.6
Walker, A. Stewart (1876–1952), 103n.19, 143
Walker, Mary D., 66–67, 302, 359
Walker & Gillette, 13, 39n.80, 143
Wall, Alexander J. (1884–1944), 31, 32, 33, 35, 36, 39n.86, 50
 portrait by Rosenthal, *31*
Wallach, Moritz, (1878–1963), 68, 69, 262, 360
Walpole Galleries, New York City, 59, 360
 Mrs J. Killbourne Hayward sale (1924), 360
 Sophy Von Holstein-Rathlou sale (1925), 360
John Wanamaker, Inc., 359
Washington, George (1732–1799), 155n.4, 249
 bust, *82*, 87, *150*, 151
 essay by Elie, 155n.4
 figured flask, 238, *239*
 portrait, 29, 30
Washington Crossing the Delaware (Mark), 156, *157*
Washington's Passage of the Delaware (Sully), 156
watercolors, 37, 174–75 *see also* frakturs
Watson, Forbes (1879–1960) (*American Magazine of Art*), 28
weathervanes, 23, *25*, 29, 35, 39n.68, 60, 134–35, 135n.1
 Gabriel (Herald Angel) (American), 60, *133*, 134
 horse (American), *133*, 134
 Indian Archer (American), *54*
 rooster (Jonathan Howard & Company, active 1850–1868), *132*, 134
 rooster (American), *132*, *133*, 134

Webb, Electra Havemeyer (1888–1960), 30, 39n.68, 54, 102, 121n.3, 202
Wedgwood, Josiah (1730–1795), 227n.8
Wernick, 359
West Point Shop, 359
E[rhard] Weyhe, Inc. (1882–1972), 359
Wheeler, 59
whetstone holders (Swiss), 296, 296n.4, *297*
"Whieldon ware" (Staffordshire), 226, 226n.5, *227*, 227n.6
Whitcomb, Henry D.: portrait by Stock, 166
White, Franklin (1813–1870), 166
White, Thomas (1825–1902), 121n.16
Whitney, Gertrude Vanderbilt (1875–1942), 338
Whitney Brothers Glass Works (active 1838–1918), 238
Whitney Museum of American Art, New York City, 353, 354
Jemima Wilkinson Antique Shop (Florence W. Upson), 202n.2, 359
Willard T. Sears with a Horse Pull Toy (Stock), 27, 59, 90, 166, *167*, 168
William B. Paterson's Gallery, 106, 330
Williams, 359
Williams, Lenore Wheeler, 359
Williams, Max (1874–1927), 61, 122, 124, 128, 359
Willis, Katharine E. (b. ca. 1875), *66*, 67, 71n.41, 200, 208, 209, 211, 216, 217, 224, 244, 246, 318, 359
Wilson, Fred (b. 1954), 37
Winckelmann, Johann Joachim (1717–1768), 87
window shades, *82*, 87, 90, 150–51
Wodehouse, P.G. (1881–1975), 228
Wölfflin, Heinrich (1864–1945), 84
wooden dolls
 carved and painted (probably English), 312, 312n.7, *313*
 penny doll (German), 314, *315*
wooden objects, 296–301, 306–13 *see also* animals and birds; household objects; sculpture; snuffboxes
Works Progress Administration (WPA), 28, 103n.30
Worringer, Wilhelm (1881–1965), 110
Worthington, H.J., 359
Würtz, Felix (1518–1574), 188n.2

Y
Yellin, Samuel (1884–1940), 38n.14
Yellow Coach (American), 30
York (possibly S. Elizabeth York), 359
Young, Henry (1792–1861), 174, 174n.3, *175*
Young Man in Hat (Elie Nadelman), 107, *108*

Z
Zabriskie, George (1868–1954), 35, 36, 39n.86
Zorach, William (1887–1966), 45–46

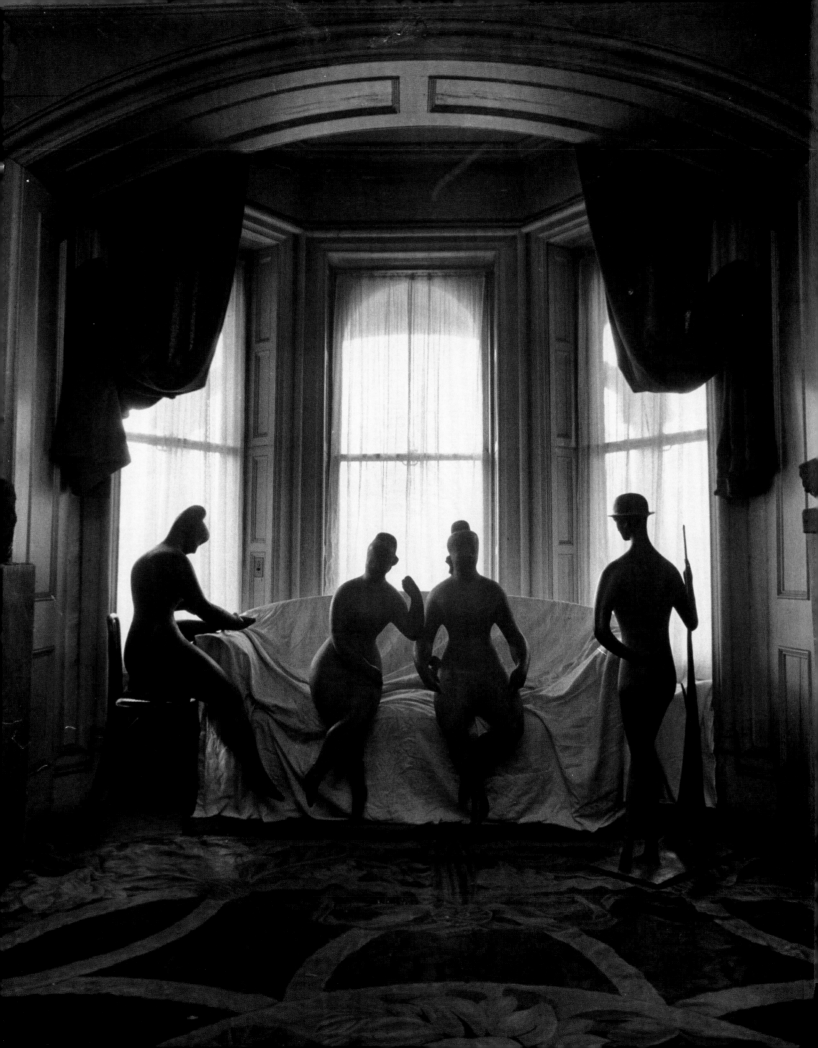

A B C D E F G H I J
S T U V

a b c d e f g h i k l l m n o

A B C D E F G H I K L
W X

a b c d e f g h i k l l m n o p

1. 2. 3. 4. 5. 6

Christiens

G. Bauer

18

E. Bauer

M. B.